KB091130

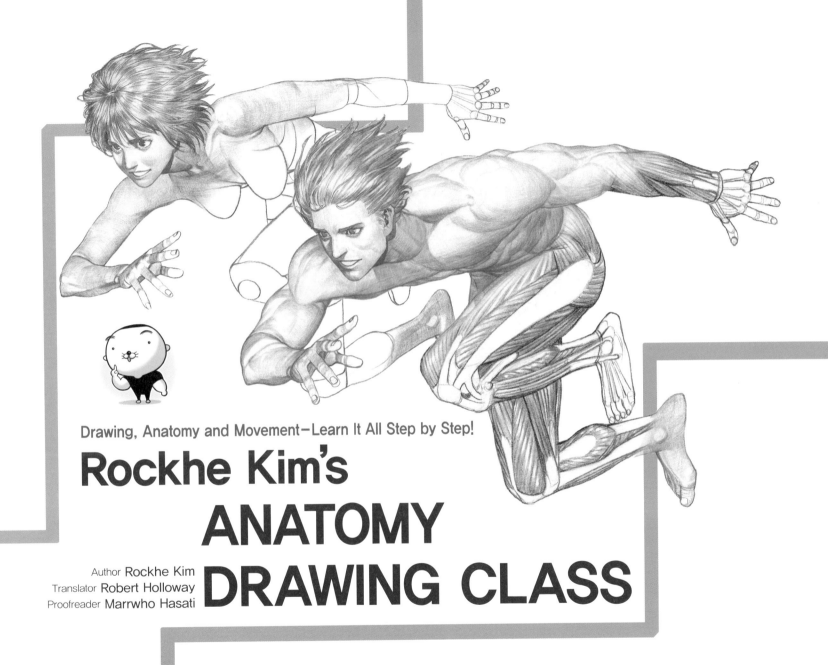

Drawing, Anatomy and Movement—Learn It All Step by Step!

Rockhe Kim's
ANATOMY
DRAWING CLASS

Author **Rockhe Kim**
Translator **Robert Holloway**
Proofreader **Marrwho Hasati**

SungAnDang

Congratulatory Message

The human body is just like the universe.
Greek artists were already aware of this fact long ago.
For this reason, all Greek gods were expressed in human form.
It meant that all literature and art in this world exists in the human body.

The very first time I saw Rockhe was a long time ago in a lecture hall at Sejong University.
He was quietly sitting by himself in a corner of the lecture hall carefully drawing with a pencil.
The sight of him engulfed in that drawing was amazingly beautiful.

Rockhe wasn't a genius, but at a certain time he began to resemble one.
I felt happy just being able to observe a genius-in-the-making.
Nonetheless, Rockhe needed an ample amount of time before he would showcase his drawings to the world.

Now, that genius-in-the-making has made his know-how public and created a book.
In the same way that a master will have a heroic vision that common people will never
have imagined, this book will present a new world of anatomy drawing to many artists never before seen.

This book became the ultimate present for me,
someone who didn't even major in human anatomy.

I wish for great honors and happiness in the future for this humble artist.

<div align="center">

November, 2019
Hyunse Lee

</div>

Testimonials

It was about 2015 when I first heard the name of Rockhe Kim, the era when I was finishing up the last of *Stonehouse's Anatomy Note*. For not majoring in medicine, I worried quite a bit as I neared the end. As it would be around that time, I found Kim working on the *Fantastic 4* comic. I tried hard not to show it, but it was shocking. I often see artists that draw one picture well, but it's extremely rare to see someone who has mastered drawing many pictures of the human body freehand. My admiration as an anatomy book author and my jealousy as a writer in the same field both showed themselves simultaneously. If only I could have the knowledge that this writer has!

No matter how much of an authority on anatomy you say that you have, you can't be good at drawing everything. It's beyond merely facing a blank sheet of paper and going to battle with it while calling forth your "anatomy art skills". I had to dig up his know-how somehow.
I wrapped up my book in a hurry, mustered up all of my eloquent speech and coaxed (more like "threatened") Rockhe, who was an utter stranger at that time, to write a book. I put pressure on him to the publisher and in the end, succeeded. I jumped with joy.

However, after receiving the edited version I had a "Gosh" moment. Honestly, looking at this book and writing a testimonial makes me complicated. I'm troubled because we have to market it. It's my wish that this book doesn't sell well because I want it all for myself.

Junghyun Seok
(Die-hard Artist. Author of *Stonehouse's Anatomy Note*)

I think back to a long time ago when I saw Rockhe Kim's original short sketches. I was so astonished by his power of expression and his completeness, both of which had high precision. What was more astonishing was when he switched out his 0.5mm mechanical pencil for a knife and said, "Younggon, I'm not done yet."

The way that Rockhe Kim treats drawing is even more than a focused perfectionism. He memorized even the location of the veins and expressed his very fine portraits, which were enough to humble even artists who have studied the human body. That's why I was so excited when he first told me he was going to make a human anatomy drawing book.

In *Rockhe Kim's Anatomy Drawing Class* you'll find years of powerful lecture material broken down into simple explanations. From beginners to those who need intensive courses, there are tons of diverse illustrations that clearly lay everything out so that you don't have to worry. What makes it even more special is that the book contains "understandable 3D illustrations", which we all think anatomy drawing textbooks must contain. The way this material is presented can come off as curt or blunt, but there are cute illustrations mixed in that help you to understand. I am very happy for the fact that a close colleague of mine created such a fantastic textbook from his own hand.

Whether it is a writing, a picture, or a video, I believe that all works that express the human being are noble. It's my wish that this book finds itself in the hands of all those who need the skills to breathe life into their figures, including myself as a comic book artist.

Younggon Lee (Comic Book Artist)

Testimonials

I was in college 10 years ago when I first met Rockhe Kim. We were all studying drawings and comics, but among us Rockhe Kim's method of studying anatomy drawing was notably impressive. He would watch videos of bodybuilders and observe the movement of their bodies from all angles. It was very impressive to watch him study as he captured the changes in muscle movement according to a figure's posture. I remember Rockhe repeatedly putting his textbook down next to him, and turn on videos related to the human body on his computer screen. He would always do this, even when he was working on a piece.

As time has passed and now he's put out an anatomy drawing book of his own, From the body's frame to expressing three-dimensional shapes, this book is easy to understand. It provides a method that allows you to easily approach drawing a shape that takes any posture. It allows you to practically feel the movement of muscle and skin.

Many years of comics, illustration and lecturing know-how have all been melted down into this single book. If you follow this book, I'm positive that you'll gain the confidence that comes from a deep understanding of the various postures of the human body.

Joonggeun Yoon_FEELMONG
(Illustrator)

I've known Rockhe for over 10 years, starting from my early twenties when I was attending university, to my time living in the United States up until now. I admired his spirit and consistency. As I observed him from the outside, I became one of the people that trust him more than anyone else. His passion for anatomy drawing was extraordinary, and knowing that he has acquired knowledge over time, you can't help but put your trust in him.

From the time I first met him, his professional awareness for art was something special compared to other die-hard artists. That showed itself in his works. Even today he's still a developing creator. More than 10 years that I've been teaching students, he's still a creator that I continue to recommend to my students.

His drawings are a form of study in and of themselves. Even if you don't take a closer look in this book to study, the book will still help you. It helped me and many others would agree. It will help you. Many people who've read this book will get what I mean. He's a big help.

Inhyuk Lee
(Illustrator)

Foreword

I often got lost a lot while studying drawing by myself. There was no one next to me giving me answers, so I asked myself, "Is this really the right way?" over and over again. Drawing is an activity where you face yourself. By looking at one's drawing, you can understand how absorbed you are, and whether you're being impatient or you're calm. It's said that the pictures you draw contain what's on your heart, which also means that you must be calm when you draw in order to produce your best works. If you go through trial and error again and again and keep drawing page-by-page, then one day you'll discover this too; how you yourself change together with your drawings.

This book is comprised of content that researches methods to interpret the complicated human body with ease and through these methods you also learn about the body's principles of movement. Also included are examples of how these methods are applied to actual drawings. I have systematized theories I researched up until now so that many students can understand them. When I created pictures for them, this book became another opportunity to again study basic skills from square one.

The more you study the basics, the more you discover. Without even noticing, it became the same feeling as when you correct an uneven stance. Studying the basics is the "work of objectifying the self" in order to rid oneself of bad habits— even after becoming proficient in drawing—while at the same time learning about oneself for the first time. That is, when you first get into drawing. It's not a rite of passage that you traverse, but it's something similar to stretching which you must always do in order to maintain balance in the body.

Working as an animator, a film storyboard artist, an illustrator, American comics artist, etc., when I worked in these various fields I felt that the most important thing was the basics, regardless of the genre. If a drawing didn't come out the way I thought it would, or if it took too long in order to draw the picture that I really liked, the solution was to study anatomy drawing again.

While teaching students who study drawing, I was able to see up close what was most difficult and tiring for them. They had various concerns, but the basic problem was "a lack of the basics," as expected. The methods I present in this book aren't merely methods to help you understand theories, but also methods of drawing that I always use when creating actual pieces.

It's my wish that this book, *Rockhe's Anatomy Drawing Class,* not only helps guide you in a good direction, but also provides you with that strength you need in those moments when you become sick and tired of drawing and say that you just can't go any further, just like a pacemaker in a marathon.

November, 2019
Rockhe Kim

Here I introduce to you... your study-mates!

Nice to meet you!

Mr. Kim Anna & Tommy

Table of Contents

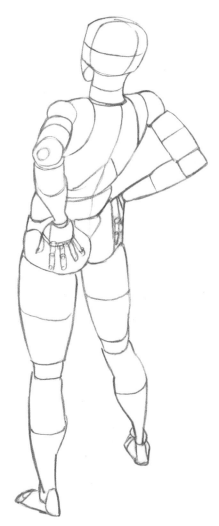

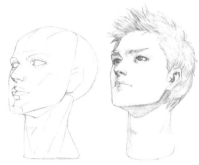
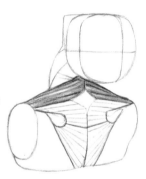

Table of Contents

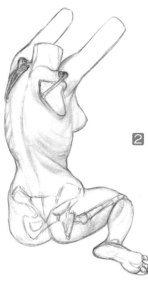

04 Understanding Anatomy Through Motion

The Collaboration Between Shaping & Anatomy • 190

Now's When the Real Battle Starts! • 191

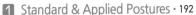

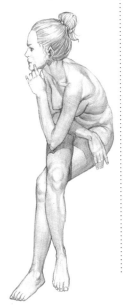

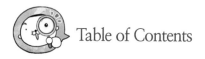

Table of Contents

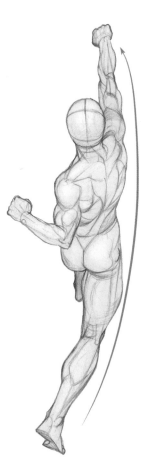

05 Using the Basics For Your Character Concepts

The World of Characters • 362

"What is creation," you ask? • 363

01
Figure Shaping

Proportion, weight center, motion, and volume are the very basics and core of figure drawing.
How about we look into "figure shaping," the most efficient method of calculating each of these 4 elements?

Shaping the Frame

When you first start learning to sing you begin practicing vocals and when you start to work out you do basic strength training. This is how it is with figure drawing. If you want to draw a figure well, "shaping" must be your foundation. Figure shaping is similar to a type of blueprint in that it's not something that you anxiously piece together that would all fall apart if you tap it once. It's a body that's given shape by wearing another shape that expresses the flow of the body. Through the body's frame you can check the proportion, weight center, and motion, the most fundamental and important pieces of information. Plus, as you put the shape onto the body's frame, you'll be able to study the body's volume and it's major flow. If the frame isn't stable, the body will look awkward, even if you try to complete the drawing. Shaping is a very effective method which allows you to understand the body--which is complicated--in 3D. Through this you are able to express various angles and postures after freeing yourself from the 2nd dimension. In this chapter you will understand the core driving factor for each joint by simplifying the body's basic frame and learn to dress the body with "silicone material". If you draw the form like a stiff wooden doll or don't draw the form when you're shaping because "it doesn't show on the outside anyway," then the joints move differently than they actually do in the body and that movement becomes limited. For this reason you must apply a soft silicone shape over the frame which becomes the center of movement. Then, you'll be able to realize the natural motion of the body just like how a real human being moves.

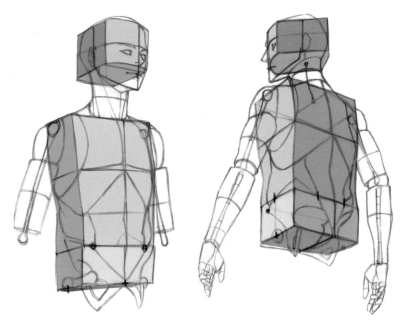

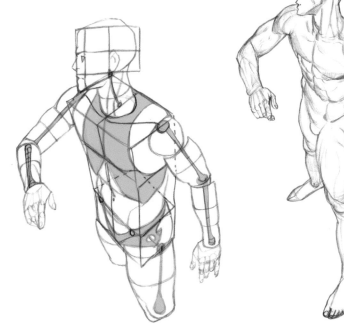

Figure Shape's Job Interview

Woody

Hello? My name is Woody.

I grew up in a high altitude area and am made from bamboo, so I'm environmentally friendl--

I'm sorry but we don't have a position for you.

What? Why?

President

Because...

...our company bathrooms have Korean-style toilets!

You know as well as I do that you can't squat down!

No, wait! I can do it-- Ahhh!

Crrrr...

Crr... Uh, security!

Craaaack!!!

Roche Kim - President

The Flow-y Type

Hey there~ Everybody what's up?!

Boom! Chicka- Boom!

Okay now rhythm! And beat!

Okay and very nice! I'm feeling the vibe~

Clang

Er...

Let's calm down for a moment and talk...

Security!

Hey Cutie, let's dance!!

Boom! Boom!

The Muscle Man

Nice to meet you. My name is Arnold.

Oh, really? Nice to meet you.

Shake hands?... No... Then shall we sit?

· · ·

(shakes)

I'm the one in charge of standing, so...

I've come to sit.

Very nice to meet you.

??

The Handshaker

The Sitter

You must pay for each one of us. We all have different poses.

They're swarming in!

Body

The Oval Type

I'm so sorry to be late! So much traffi--

Uh- oh

Clunk

Here, let me put you together...

Hahaha! That tickles!

I'm sensitive there!

Oh boy

Could you go a little more to the left? A little more.

Which side did you say is the front?

Yes, right there... stop!

No, no. Where you were before.

Q&A

 Shaping is different in every book, so I don't know how to study.

 "How will we simplify the figure?" The way to interpret the answer to this question varies from author to author. What's important is the fact that you must create all movements of the body in 3D, regardless of the angle. The type of shaping that is far off from the flow of the body, one that only works for one type of posture, or one that doesn't express the movements of the human body is incorrect.

Woody

This type has a limitation when it comes to embodying the body's movements because the number of joints is too small and the material is solid.

The Flow-y Type

This type over-exaggerates the flow for all postures, or has a habit of excessively creating deformations.

The Muscle Man

This type doesn't understand the principles of movement and the form is too complicated.

The Oval Type

The borders between the front, sides and rear are vague. The form for this type is too simple to put into theory.

Well, we won't be able to use each one of you to study shaping in all different poses.

So, instead I'll take you to your respective departments.

Exciting!

Alright!

We passed!

Yahoo!!

Depth Department

I told you not to start with detailed drawings, didn't I?!

Motion Research Department

Such passion!

So dynamic!

Boom!

Muscle Siding Department

Would you like a protein shake?

Yesss...

Vrrrr

Proportion Department

It looks complicated but don't be scared!

What Not To Do **Material Used for Body Shaping**

 This type of material is too stiff, so you can't press or expand the surface, and the flow of the outline is too simple. So, it's not suitable for use when shaping the human body.

 This shaping surface is similar to our actual skin in that you can press or expand it and it expresses the overall flow of the body well. So, it's appropriate.

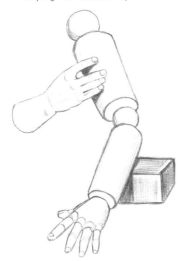

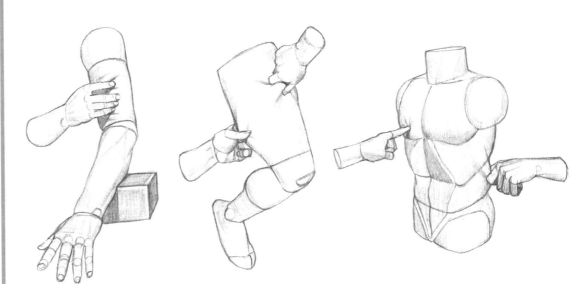

The term "shaping" often has a hard or stiff feel to it. For this reason, it's easy to see our own drawings as a fixed and stiff entity. However, if you think of the body with an overly simplified shape then when you draw you become confused because the shaping depth is different than the actual flow of the human body.

The shaping method that we use is similar to the human body in that the outside is soft and the inside is made of a hard frame. The areas around the joints are not drawn like the joints of a toy. Rather, you can realize the movement of the body with a form that simplifies the body's actual bone joints.

Shaping forms of the body are not meant to make a clunk sound when they hit each other. They should be pressed down when you apply pressure and expand when you pull them.

In other words shaping forms are not a collection of spheres and cylinders, but are an entity that expresses the overall flow of the body.

Many people neglect shaping because they treat it as merely a basic study method. They scribble something a few times and then move on to the next step thinking that they fully understood how to do it. In order to draw the shaping of the body in accordance with proportion, depth, weight center, and natural motion one needs ample research and study. The shape of the body is a frame that's identical with the actual body itself, so if you just erase the lines of the appropriate connected areas then the body will be properly revealed. Whether a novice or a pro, body shaping is a study method necessary for all.

I'm done learning about body shaping!

Should I try studying the body now? ~

1 Body Proportion Through Shapes

■ Understanding Frontal Points

In this book we focus on handling "Body Boxes", which are the basic frame for body shaping. For your convenience I'll refer to the boxes as ❶, ❷, and ❸.

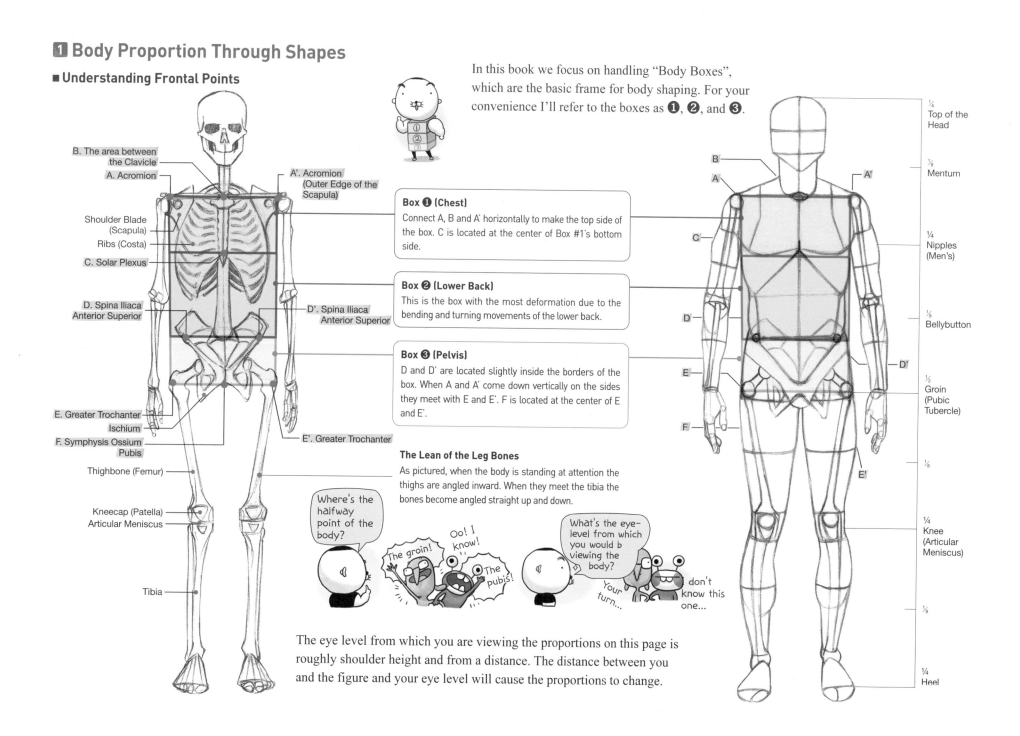

B. The area between the Clavicle

A. Acromion

A'. Acromion (Outer Edge of the Scapula)

Shoulder Blade (Scapula)

Ribs (Costa)

C. Solar Plexus

D. Spina Iliaca Anterior Superior

D'. Spina Iliaca Anterior Superior

E. Greater Trochanter

Ischium

F. Symphysis Ossium Pubis

E'. Greater Trochanter

Thighbone (Femur)

Kneecap (Patella)

Articular Meniscus

Tibia

Box ❶ (Chest)
Connect A, B and A' horizontally to make the top side of the box. C is located at the center of Box #1's bottom side.

Box ❷ (Lower Back)
This is the box with the most deformation due to the bending and turning movements of the lower back.

Box ❸ (Pelvis)
D and D' are located slightly inside the borders of the box. When A and A' come down vertically on the sides they meet with E and E'. F is located at the center of E and E'.

The Lean of the Leg Bones
As pictured, when the body is standing at attention the thighs are angled inward. When they meet the tibia the bones become angled straight up and down.

Where's the halfway point of the body?

The groin!

Oo! I know!

The pubis!

What's the eye-level from which you would b viewing the body?

Your turn...

don't know this one...

¼ Top of the Head

⅛ Mentum

¼ Nipples (Men's)

⅛ Bellybutton

½ Groin (Pubic Tubercle)

⅛

¼ Knee (Articular Meniscus)

⅛

¼ Heel

The eye level from which you are viewing the proportions on this page is roughly shoulder height and from a distance. The distance between you and the figure and your eye level will cause the proportions to change.

■ Understanding Side Points

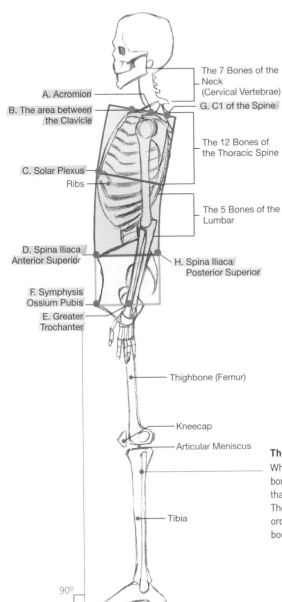

A. Acromion
B. The area between the Clavicle
C. Solar Plexus
Ribs
D. Spina Iliaca Anterior Superior
F. Symphysis Ossium Pubis
E. Greater Trochanter

The 7 Bones of the Neck (Cervical Vertebrae)
G. C1 of the Spine
The 12 Bones of the Thoracic Spine
The 5 Bones of the Lumbar
H. Spina Iliaca Posterior Superior

Thighbone (Femur)

Kneecap
Articular Meniscus

Tibia

90°

The spinal column is made up of 7 cervical, 12 thoracic, and 5 lumbar bones, totaling 24 in all. The cervical and lumbar bones have lots of movement while the thoracic bones don't move much at all. They move somewhat when the body bends backwards, forwards or twists, but it's not much at all when compared to the cervical and lumbar bones.

The ribs look just like a grain of rice when you look at them from the side.

Box ❶ (Chest)
G is C1 of the thoracic bones. When you touch the back of your neck, it's the one that sticks out and is located directly below the 7th neck bone. A, B and G are on the same line and A is not located at the center of the box, but rather slightly more towards the spine.

Box ❷ (Lower Back)
As pictured, Box ❷ connects Box ❶ to Box ❸ at a slight angle.

Box ❸ (Pelvis)
- Top Side: D is connected to H horizontally. H is the point at which the spina iliaca posterior superior comes out.
- Height: For men D and F are connected vertically.
- Bottom Side: F and E are located on the same line. E is at the area of the halfway point on the body.

The Lean of the Leg Bones
When viewed from the side, the thighbones and shin bones are connected in a straight line, which is different than when viewed from the front.
The overall lean of the legs must come slightly back in order to achieve the correct weight center for the upper body. Thus, they don't make a perfect 90 degree angle.

Parabolas
The parabolas that form at different points come to explain the body's lean, irregardless of proportion.

The "entire body" starts at the top of the head and stretches to the heels, not to the ankles.

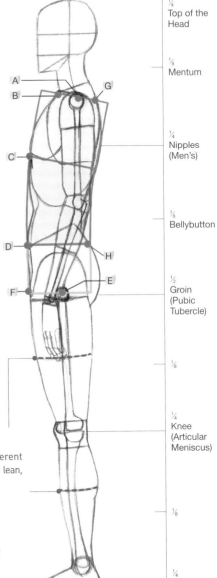

A
B
C
D
F
G
H
E

¼ Top of the Head
⅛ Mentum
¼ Nipples (Men's)
⅛ Bellybutton
½ Groin (Pubic Tubercle)
⅛
¼ Knee (Articular Meniscus)
⅛
¼ Heel

■ Frontal View: Men & Women

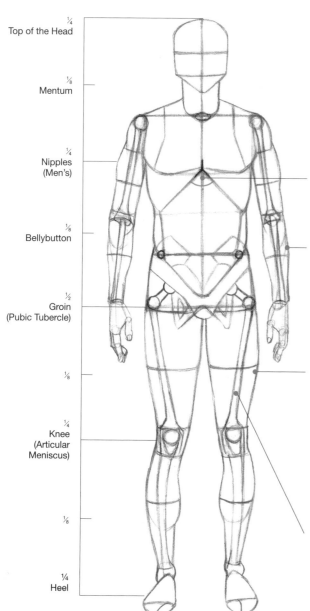

Top of the Head — ¼
Mentum — ⅛
Nipples (Men's) — ¼
Bellybutton — ⅛
Groin (Pubic Tubercle) — ½
Knee (Articular Meniscus) — ¼
— ⅛
Heel — ¼

When you study men's and women's bodies and you practice drawing men and women who are the same height, then you can more clearly compare the differences between their bodies.

The Solar Plexus: Angular Difference
The angle at which the ribs spread apart is greater on men than women.

The Bend of the Arm: Angular Difference
When the arm is relaxed on men the elbow sticks out and on women it sticks in. This difference occurs due to the thickness of the muscles around the armpit.

The Thigh: Angular Difference
On men the thickness of the thigh becomes sharply smaller at the knee due to the muscles. On women there is a difference in that the smooth flow gradually becomes thinner. On the legs of female athletes with developed muscles, the flow is similar to men's.

The Femur
Compared to other areas in the body the location of the femur as seen from the front is not centered. Rather, it leans outward. This is a commonality between men and women.

Women's Body Proportions
The 1/4 point in terms of the body's proportions is slightly above the solar plexus on men and women. On men this point is on the same line as the nipples. On women the 1/4 point is located slightly above the nipples. This is because women's breasts come further down on the body than men's.

The Ribs
On men the depth of the ribs is deeper than women. For women as you go further down on the body, the depth of the ribs narrows sharply moreso than men.

The Thinnest Part of the Body

I feel like a daddy long legs!

Young Man · Young Woman · Middle-aged man

When men wear pants they wear their belt at the level of their pelvic line. For women the point at which the ribs end is the most narrow, so they are able to wear so-called "high-waist pants" which go up to their belly buttons. From the outside it looks as if their legs are longer than men's. Men can wear "high-waist pants" only when they have stomachs protrude.

■ Side View: Men & Women

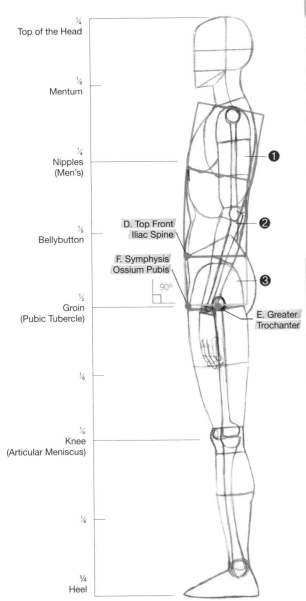

- 1/4 — Top of the Head
- 1/8 — Mentum
- 1/4 — Nipples (Men's)
- 1/8 — Bellybutton
- 1/2 — Groin (Pubic Tubercle)
- 1/8 — Knee (Articular Meniscus)
- 1/8
- 1/4 — Heel

D. Top Front Iliac Spine

F. Symphysis Ossium Pubis

90°

E. Greater Trochanter

Q&A

Why is the spinal column bent in the shape of an S?

When we run or walk and our feet hit the surface of the ground, then our body weight shifts in the direction of our weight center. When this occurs, thanks to the spinal column's spring-like curve the shock is mitigated. If the spinal column were straight like a pole or post, then it wouldn't be able to mitigate the shock and would end up breaking.

Box ❶'s (The Chest) Lean

Due to the fact that the body leans slightly back when you are standing still, you lean back towards the box. Women lean back more because their chests are heavier than men's.

Box ❷'s (The Lower Back) Thickness

The width of the box from the side is the same for men and women.

Box ❸'s (The Pelvis) Lean

The angle from D to F is straight. However, it leans forward and isn't straight up and down for women. This is in order to achieve the best balance for Box ❶.

E is located at the center of the bottom of Box ❸.

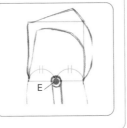

E

Box Proportions

If you want to accurately portray the volume of the body, then it will be very important to practice finding a picture and then locating the box points. Afterwards, practice drawing the box.

Side View Tip! The box for the torso is bent slightly backwards.

A lot of stars!!

E. Greater Trochanter

Q&A

scratch

scratch

I think I'll draw the arm too long.

If the body is standing at attention, then the wrist makes contact with the Greater Trochanter, which is the midpoint of the entire body. If you use this in order to determine the length of the arm, then it'll be a bit easier.

Joint Size
Draw the joints small for women.

■ Rear View: Men & Women

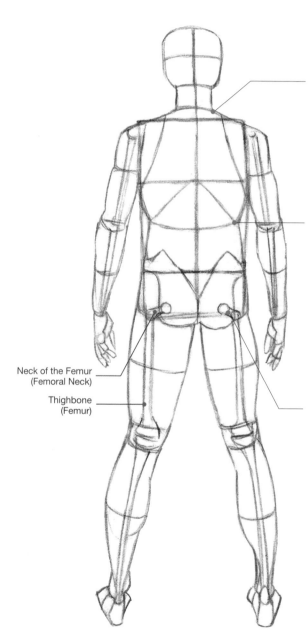

Trapezius Muscle (Muscle Trapezius)
Men's muscles are more developed and therefore the trapezius muscle is higher than women's. Women's trapezius muscle is lower than men's, so their neck looks longer.

Torso
Men's love handles are straight, while women's small ribs and buttocks are contrasted. So, the center of the torso has a concave flow.

Neck of the Femur
(Femoral Neck)

Thighbone
(Femur)

The reason women's butts are big is just because... their pelvises are big???

Even though women's pelvises are larger than men's, the difference between them isn't as great as you think. There are many comprehensive reasons why women's butts look big. It's not only because their pelvises are big, but also the angle of the neck of their femurs are bent more than men's, the effect of women's hormones that send fat to their butts, and more. Additionally, due to the angle of women's femoral necks there is a space between the groin that's created.

Neck of the Femur

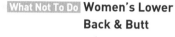

Women's Lower Back & Butt

Box ❸

Bottom Part of the
Ramus of the Hip Bone

1. If you want to express women's narrow lower back, then rather than drawing the flow of the lower back as excessively curvy, it's better to maintain the point at which the angle changes where the ribs end and the pelvis begins.

2. You cannot fill Box ❸ with the butt. The butt protrudes from the box as much as the bottom part of the ramus of the hip bone is long. The ramus is like a handle at the bottom of the pelvis. This is a common trait that both men and women share.

■ Diagonal View: Men & Women

It is easy to think that a stable weight center is "vertical". If an entity is leaning or curved, then the weight center feels very risky and unstable, for whatever reason. However, the flow of the body is made according to the angle of the spinal column, as I stated earlier. When you are drawing from a diagonal view, what you'll need is 1) The angle of the bones as viewed from the front and sides; 2) The thickness of each portion; and 3) The flow of movement. If, by chance, you don't draw a diagonal view well then, perhaps because the understanding of the frontal and side views are limited, you'll have to take a closer look at the information surrounding the frontal and side views!

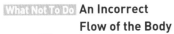 **An Incorrect Flow of the Body**

Here's a sample of a figure drawn with the idea that the body must be drawn vertically in order for it to not fall over.

He's standing upright, but he seems somewhat unstable...?

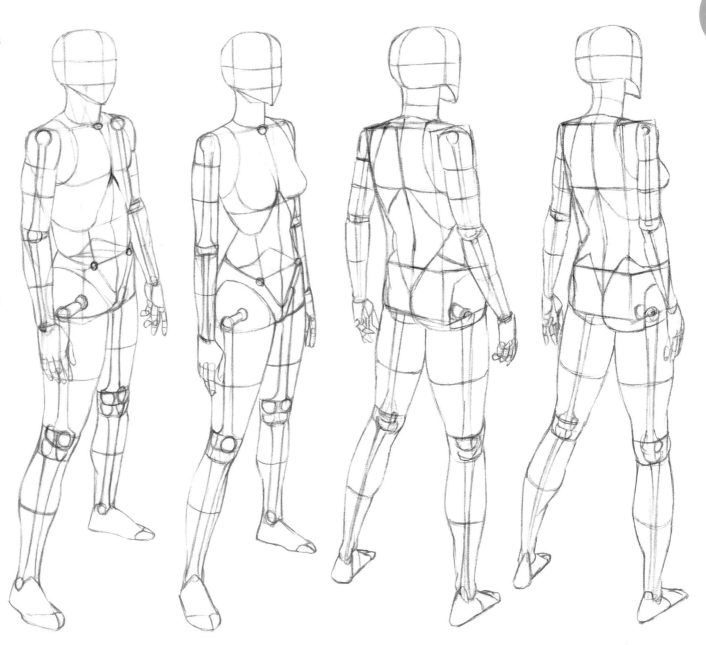

■ High & Low Angles: Men & Women

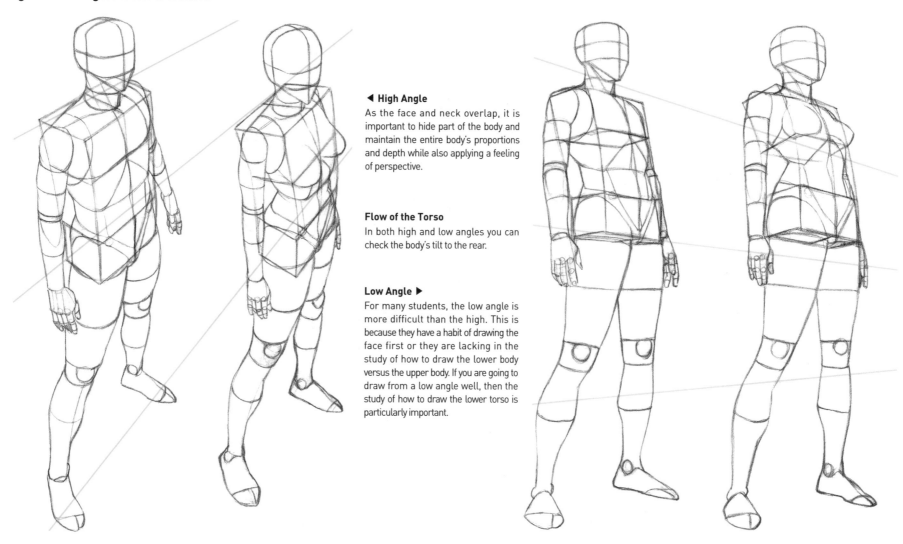

◀ High Angle

As the face and neck overlap, it is important to hide part of the body and maintain the entire body's proportions and depth while also applying a feeling of perspective.

Flow of the Torso

In both high and low angles you can check the body's tilt to the rear.

Low Angle ▶

For many students, the low angle is more difficult than the high. This is because they have a habit of drawing the face first or they are lacking in the study of how to draw the lower body versus the upper body. If you are going to draw from a low angle well, then the study of how to draw the lower torso is particularly important.

In high and low angles, the body's proportion changes according to the viewpoint. For this reason, applying sections is complicated and difficult. At this point you must get a feel in order to grasp the body's proportions, but you can't get a feel in order to grasp spacing. The probability of drawing a body for which the angles aren't right becomes greater if you draw the figure without thinking about the spacing at all, or if you only loosely get a feel for the perspective. After correctly setting the eye level, it's important to draw the body and make the space in accordance with the lean of the lines that face towards the vanishing point.

■ High & Low Angles: Common Slip-Ups

In Mistake #1 the feeling of perspective is exaggerated and the head is large. The body was drawn so that it sharply decreases in size.

In Mistake #2 neither the high nor low angles were applied and it was drawn using the normal perspective.

As shown in Mistakes #1 & #2 they are too warped or there wasn't any effort at all to change the angle. This is due to the habit of drawing according to "feel".

Even before studying the body one must study "spacing".

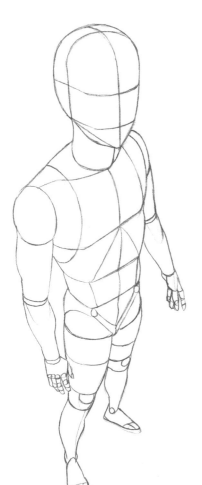

◀ Mistake #1

This is a mistake that often occurs for those who don't set the spacing and just draw the figure. For high and low angles, if you get into the habit of drawing figures without a background, then even if you don't intend to create an exaggerated feeling of perspective you end up drawing a figure with excessive perspective. There is a high probability of drawing a figure with a sense of proportion that is incorrect and has an over-exaggerated perspective.

Mistake #2 ▶

This is a figure in which one may try to draw from a low angle perspective where the eye level is close to the foot. However, no definitive change was applied to the perspective and so it was drawn from the normal perspective's proportions. It is opposite to Mistake #1, but the solution is the same. Set an accurate eye level. Then, after making the spacing, you can draw a body with the correct angles you're looking for. But, you'll have to draw the figure according to theory in order to break those proportion habits.

Steps to Studying Pictures

Many novices who study drawing often try to express figures with a very impactful stance or angle without having the basics. However, when one studies drawing one point that you cannot overlook is "application".

In the same way where you must understand the basic theory of addition and subtraction in order to apply all numbers, the basics of drawing must come first.

2 The Chest Box (Thoracic Cage)

■ Aerial View

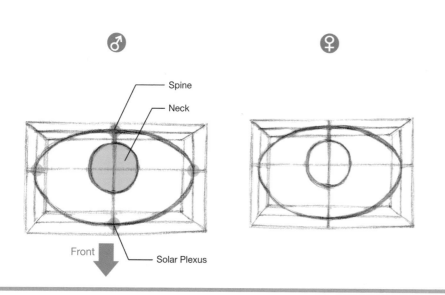

Spine
Neck
Front
Solar Plexus

■ Side View

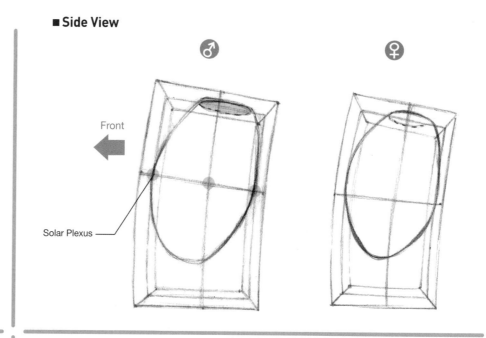

Front
Solar Plexus

■ Frontal View

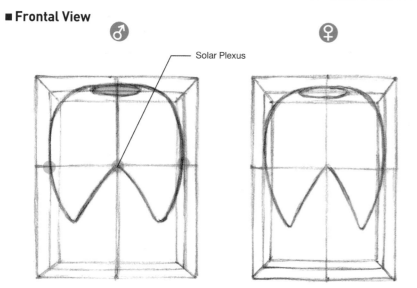

Solar Plexus

■ Diagonal View

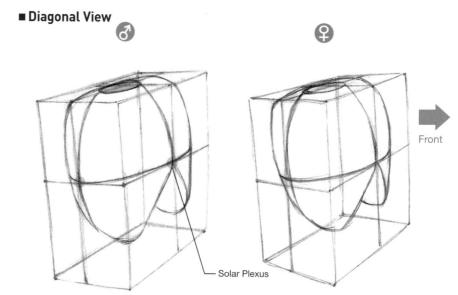

Front
Solar Plexus

 What Not To Do **Shaping the Thoracic Cage**

Drawing #1 is incorrect because the location of the neck is in the middle of the box. The location of the neck must be close to the back.
The points at which the sides of the thoracic cage meet the sides of the box must also be located slightly towards the rear.
As is shown in drawing #2, if you fill the box all the way to the borders with the thoracic cage, then the body becomes fat, as shown in drawing #3.

Drawing #3

X O

Drawing #1

Front

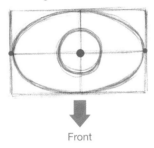

Front

— **Drawing #2** —

Front

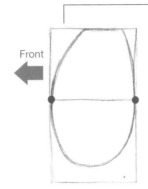
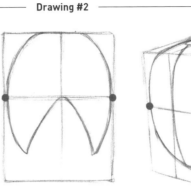

Collarbone — Rib #1

out!

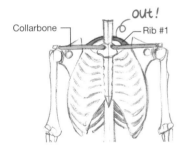

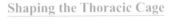

Shaping the Thoracic Cage

The shaping of the thoracic cage does not include the section of the #1 rib that rises above the collarbone. The upper part of the ribs is covered by the trapezius muscle (Muscle Trapezius), so it doesn't affect the outline of the body. I omitted the upper portion of the collarbone in order to show how the upper part of the box makes that section of the collarbone. In actuality, the depth of the ribs becomes more shallow the higher you go up.

So, in actuality the actual ribs and shape of the thoracic cage are not entirely identical.

It looks like a tooth, doesn't it?

The ribs, sternum and backbone all make up the "thoracic cage"

Box Depth

You can't think of the body box as flat if you intend to accurately draw the depth of the thoracic cage inside of it. You have to see it as an elliptical thoracic cage inside of a hexahedron box, and you must see it in 3D.

Make a 3D box with perceptional depth while taking into consideration the sides that you can't see.

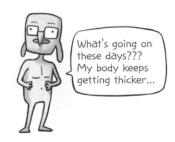

What's going on these days??? My body keeps getting thicker...

■ 45 Degrees (Front View)

♂ A > B ♀

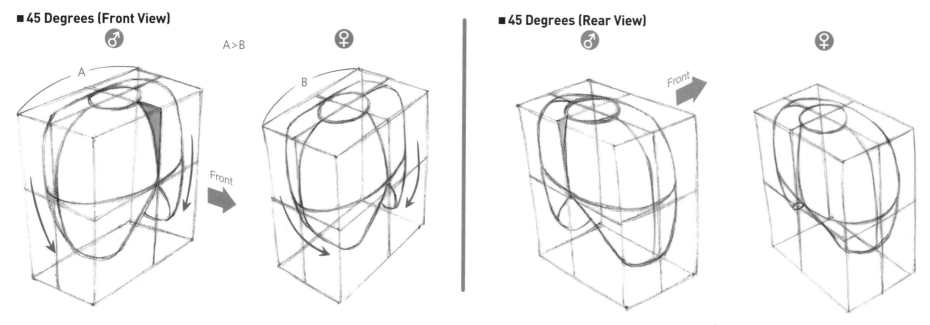

■ 45 Degrees (Rear View)

♂ ♀

The side width for a man's box is wider than that of a woman's, and as you move down, the woman's ribs become more narrow than a man's.

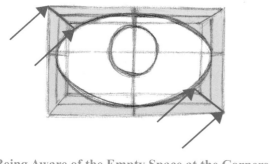

Being Aware of the Empty Space at the Corners

Due to the fact that you are putting a circular object inside of a square box, there is empty space at the corners. From a diagonal view, the corners and the space in between the ribs and the side of the box appear wider.

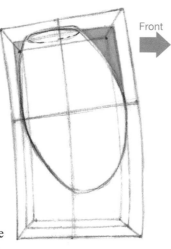

Front

The Difference Between the Front & Back Sides of the Thoracic Cage Shape

If you observe the thoracic cage shape from a side angle, you may see that the front appears curved while the rear appears straight.
Due to this, a difference occurs in the empty space of the front and rear boxes.
Watch out!

Wee woo

Wee woo

Don't forget all the details!

■ **Low Angle**

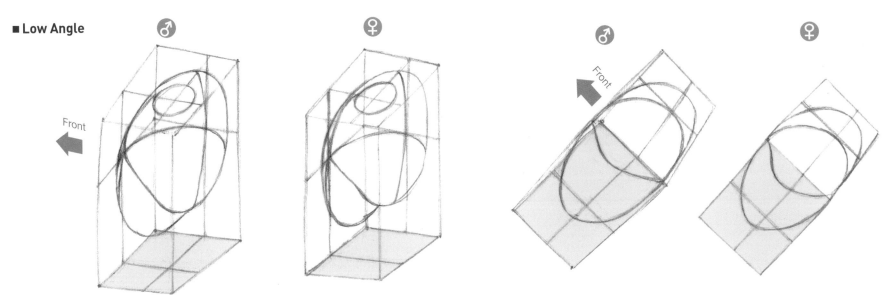

The Benefit of Setting the Frame of Your Box

If you set the frame of your box, then using the box's angle you can accurately detect at what eye level it should be and which direction the ribs' oval should face. Afterwards, you'll be able to draw the figure. Additionally, when you draw the neck (which is blocked from view) or the shoulder joints on the opposite side, you'll be able to set an accurate location by penetrating the box.

What Not To Do **The Order in Which You Draw the Thoracic Cage (The Chest)**

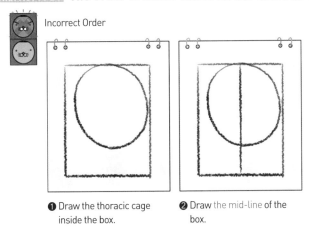

Incorrect Order

❶ Draw the thoracic cage inside the box. ❷ Draw the mid-line of the box.

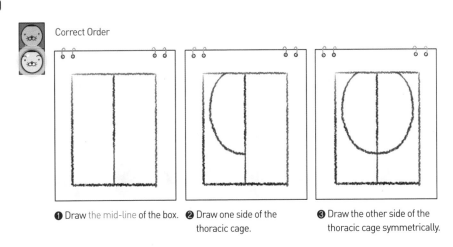

Correct Order

❶ Draw the mid-line of the box. ❷ Draw one side of the thoracic cage. ❸ Draw the other side of the thoracic cage symmetrically.

3 Collarbone (Clavicle): Moving According to the Shoulders

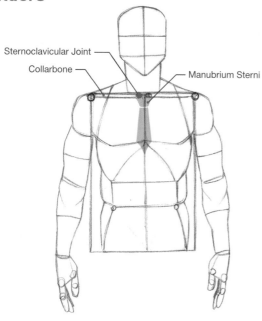

Sternoclavicular Joint

Collarbone

Manubrium Sterni

The Movement of the Collarbone when You Raise the Shoulders

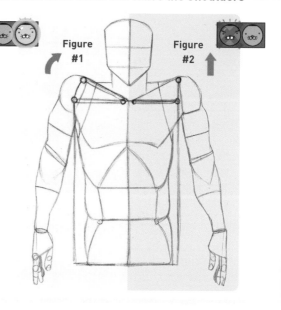

Figure #1

Figure #2

If you shrug and raise your shoulders then they create a parabola, as is shown in Figure #1. The shoulder doesn't rise straight up like you see in Figure #2. Since the length doesn't change according to the movement of the bone, what happens is that only the angle of the collarbone shifts on the sternoclavicular joint's axis.

The sternoclavicular joint connects the collarbone and manubrium sterni.

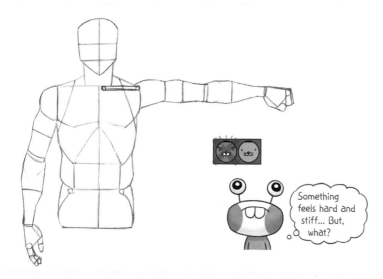

Something feels hard and stiff... But, what?

The Movement of the Collarbone when You Raise the Arm

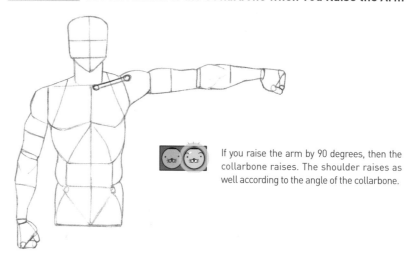

If you raise the arm by 90 degrees, then the collarbone raises. The shoulder raises as well according to the angle of the collarbone.

Body Shaping

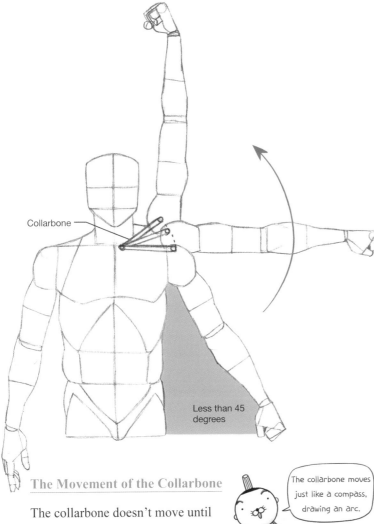

Collarbone

Less than 45 degrees

The Movement of the Collarbone

The collarbone doesn't move until you raise your arms by 45 degrees, unless it is moved intentionally. The point where the collarbone starts to raise is from 45 degrees or higher.

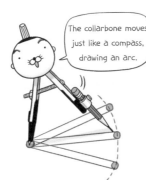

The collarbone moves just like a compass, drawing an arc.

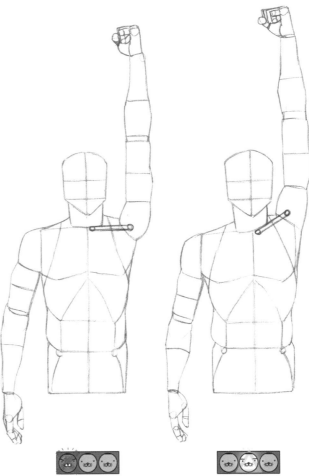

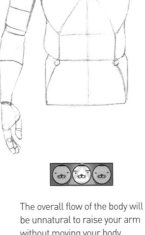

When you raise your arm, if the collarbone is fixed and only the shoulders move, the body will look like a toy. This is the most common mistake.

The overall flow of the body will be unnatural to raise your arm without moving your body.

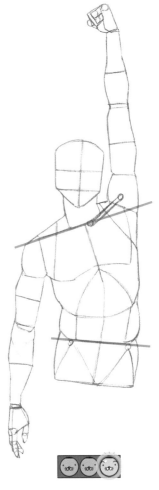

The most natural movement in raising arms is when the grade of the shoulder and the grade of the pelvis crosses each other.

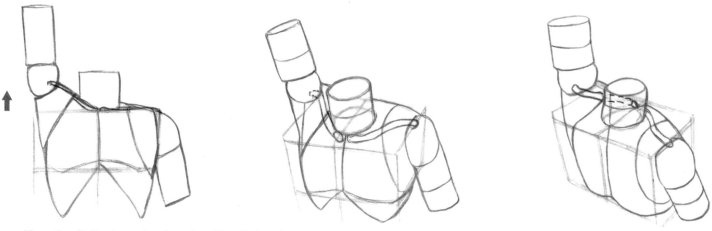

How the Collarbone Looks when You Raise the Arm at Various Angles

When you raise the arm you can observe the end of the collarbone moving towards the back.

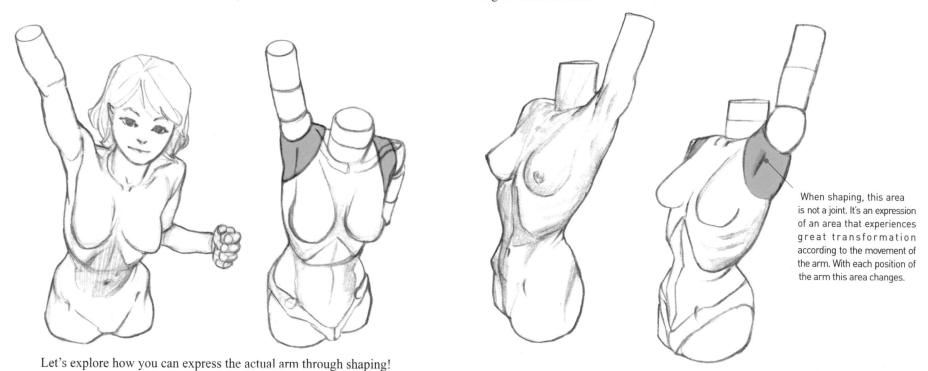

When shaping, this area is not a joint. It's an expression of an area that experiences great transformation according to the movement of the arm. With each position of the arm this area changes.

Let's explore how you can express the actual arm through shaping!

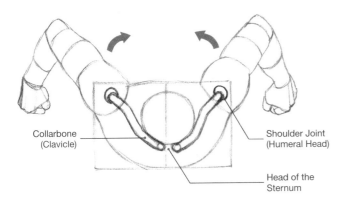

Collarbone
(Clavicle)

Shoulder Joint
(Humeral Head)

Head of the
Sternum

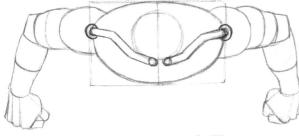

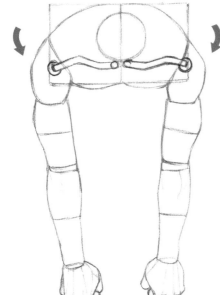

Movement of the Collarbone when You Move the Arm Up & Down

If you move the arm up and down, then the collarbone also moves accordingly. The shoulder moves in up and down circular motions at the joint which connects the collarbone and sternum. If you bring the arms together in the back, the location of the shoulder joint enters the box, so when the point of view is from the front the shoulder depth appears shallow. On the other hand, when you bring the arms together in the front the collarbone becomes horizontal, so the shoulders widen. Take a look at the diagram to the left. We provided the information on the greatest possible range of motion that the arms can move up and down.

The collarbone and shoulders always move together!

What Not To Do **The Motion of the Shoulder Joints**

If the shoulder joints move in a straight line according to the sides of the box, then they appear dislocated. The shoulder joint must be located at the very end of the collarbone's facet joint.

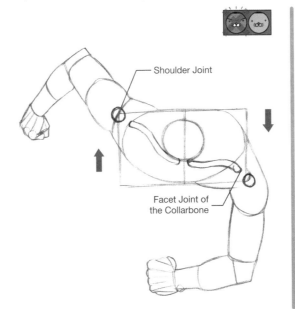

Shoulder Joint

Facet Joint of
the Collarbone

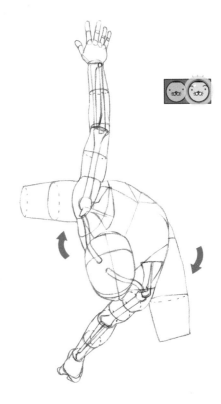

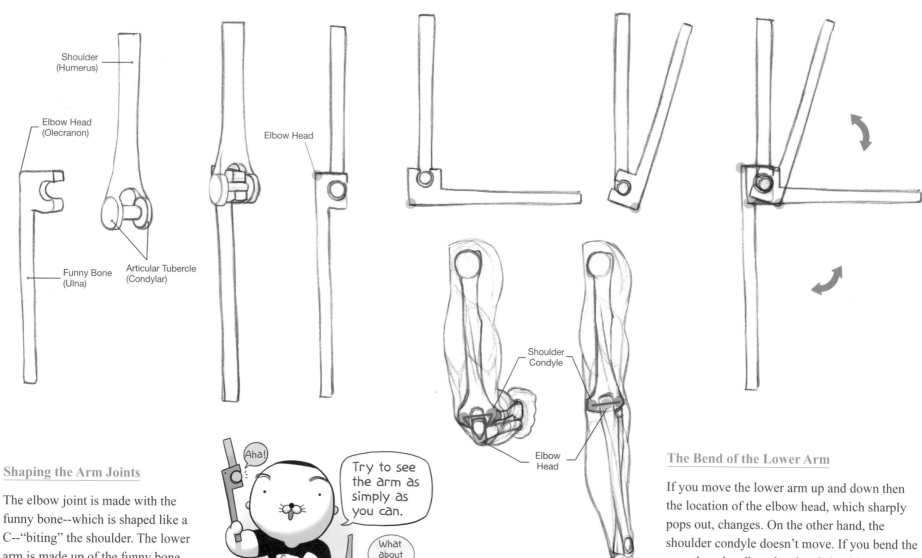

Shoulder
(Humerus)

Elbow Head
(Olecranon)

Elbow Head

Funny Bone
(Ulna)

Articular Tubercle
(Condylar)

Shoulder
Condyle

Elbow
Head

Aha!

Try to see
the arm as
simply as
you can.

What
about
me?

←Radius

Shaping the Arm Joints

The elbow joint is made with the
funny bone--which is shaped like a
C--"biting" the shoulder. The lower
arm is made up of the funny bone
and the radius, but for shaping
we'll only express the funny bone.

The Bend of the Lower Arm

If you move the lower arm up and down then
the location of the elbow head, which sharply
pops out, changes. On the other hand, the
shoulder condyle doesn't move. If you bend the
arm, then the elbow head and shoulder condyle
form a triangle. If you extend the arm, then they
line up straight.

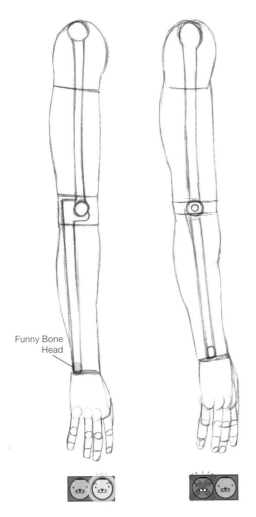

Funny Bone
Head

Compare the difference between these two elbow
joints. The funny bone head isn't located in the center
of the wrist but rather towards the pinky finger.

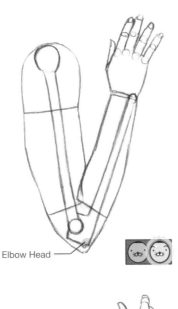

Elbow Head

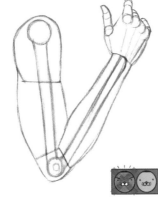

Whenever you move the arm there is an external
shift that occurs because the location of the
elbow head (olecranon) changes. The change in
position of the elbow head can't be seen when the
elbow joints are just drawn in circle. .

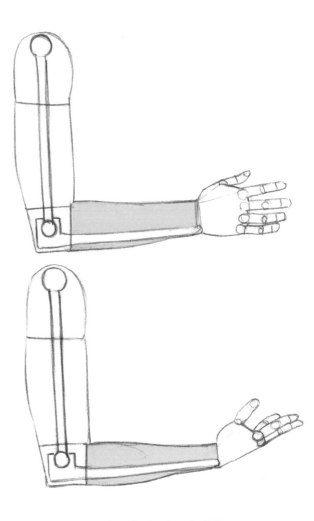

The Hand's Direction & the Arm's Silhouette

The arm's silhouette changes according to the direction that the
palm faces. By turning the bone in the lower arm the muscles
attached to the bone twist or release and a change occurs.
When drawing the arm, don't start with the upper arm and then
move downwards. Instead, after establishing the location and
direction of the hand first, then draw the flow of the arm.

The Location of the Funny Bone Head

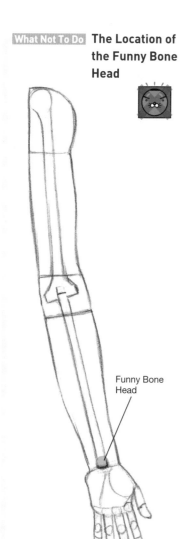

Funny Bone Head

If you place the funny bone head in the middle of the wrist then the angle of the entire arm is incorrect when you turn the arm.

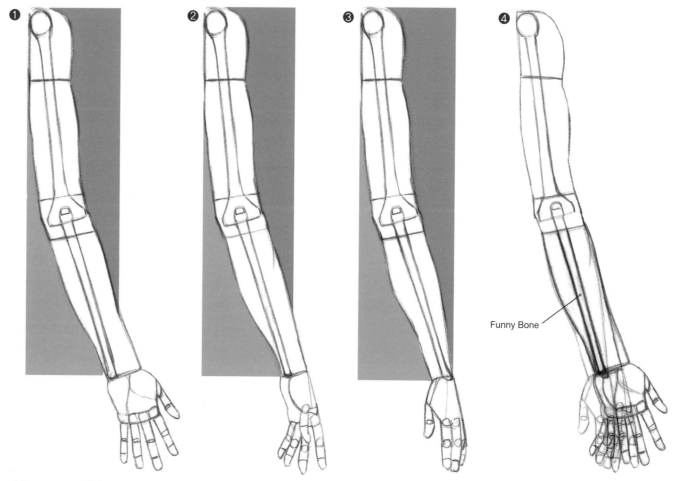

❶ ❷ ❸ ❹

Funny Bone

Movement of the Arm: Turning

When the palm is facing the artist then the angle of the arm, as it bends, comes out the most, as in Figure ❶. If you position the arm so that the back of the hand is facing the artist like in Figure ❸, then you can observe that the entire flow of the arm makes a straight line, straighter than that of Figure 1. If you look at Figure ❹, which is a combination of Figures ❶, ❷, and ❸, you can see how the funny bone becomes the base, but it doesn't move even as the hand flips. As far as the frame of an arm that's shaped, the reason I use the funny bone as the basis is because the funny bone isn't affected by the movements of the hand.

The above drawings were drawn from this angle.

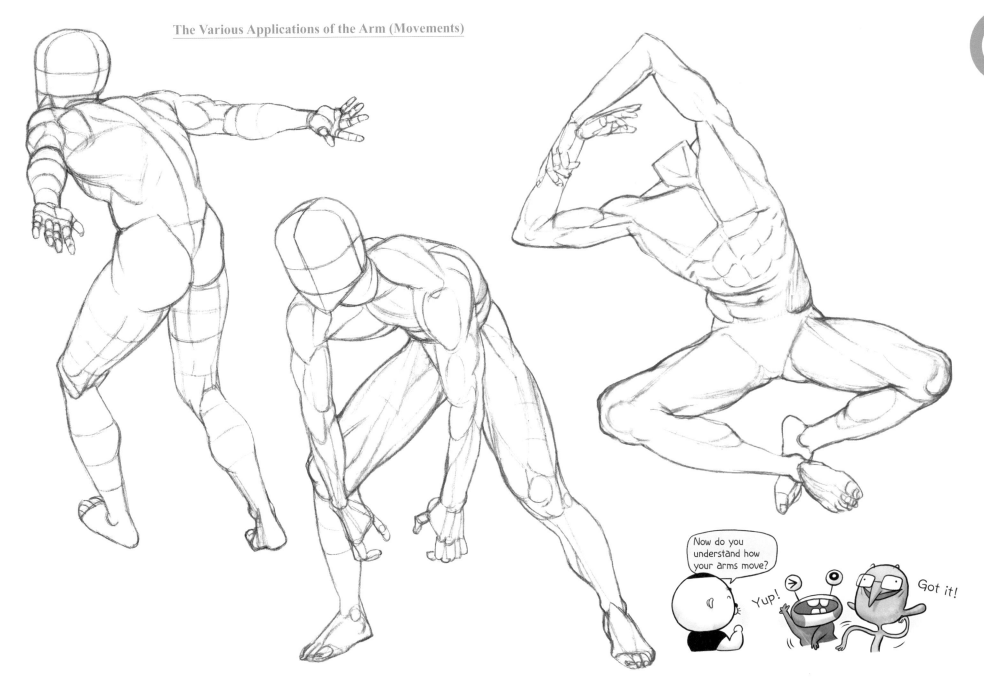

5 Understanding the Pelvis

Two Ways to Shape the Pelvis

#1. Box the entire pelvis, then cut out the details.

#2. After boxing in an area with great depth, combine parts A and B
(We'll learn in detail B from the rear).

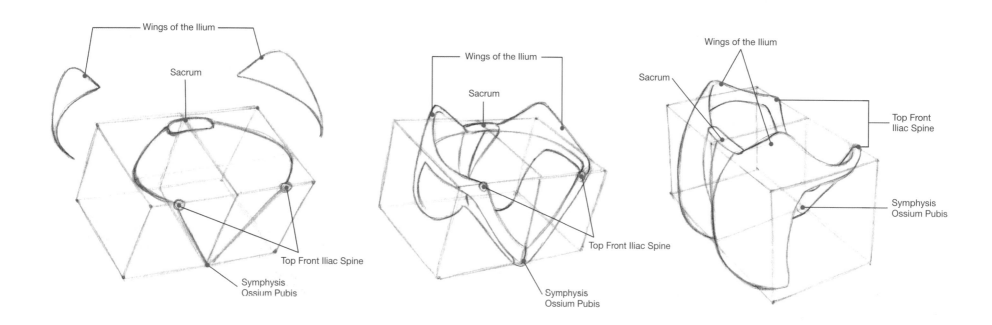

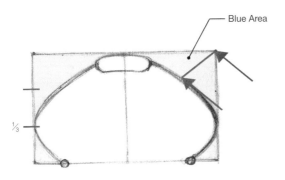

Blue Area

1/3

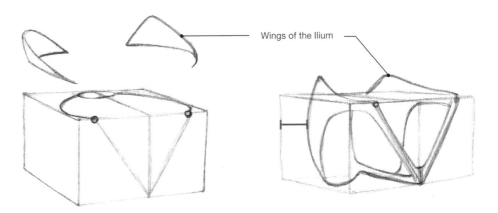

Wings of the Ilium

Feeling Your Way Through the Pelvis

The part of the sides of the pelvis which touch the box are at the 1/3 point. The shape of the pelvis is not similar to that of the ellipse that the ribs make. The shape is close to a triangle.

Shaping in the Pelvis

The pelvis is a very complicated bone. The more difficult the shape, the more you must simplify it in order to understand. The shape of the pelvis is the triangular shape of the panty line as it follows the flow of the wings of the ilium and connects to the butt. The blue area of the drawing all the way to the left is a space which you must cut out. For this reason, you must be careful not to allow the pelvis to make contact with the corners on both sides of the box when drawing a figure from a diagonal view.

What Not To Do **Shaping in the Pelvis**

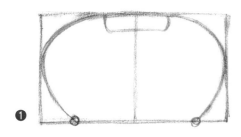

❶

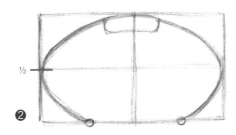

1/2

❷

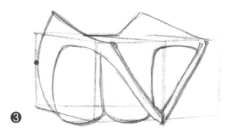

❸

You must not fill the box to the brim by expanding the pelvis as shown in Figure ❶, or set the halfway point of the box as the location which the pelvis meets the box, as shown in Figure ❷. Figure ❸ is different than these points of caution in that the pelvis makes contact with the corners of the sides of the box. This is still incorrect form. If you draw the pelvis like this then the butt would get bigger, right?

6 The Meeting Place for the Chest (Thoracic Cage) & Pelvis

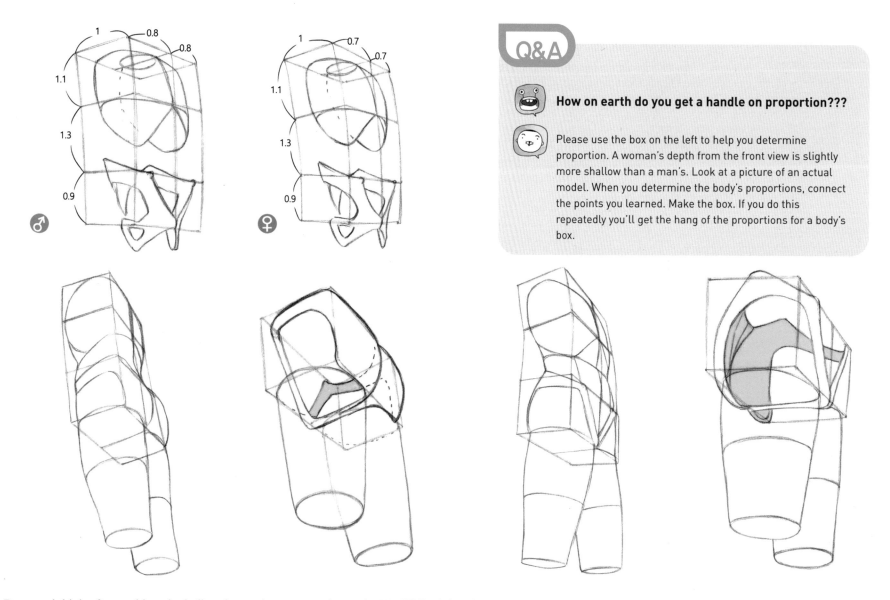

Q&A

How on earth do you get a handle on proportion???

Please use the box on the left to help you determine proportion. A woman's depth from the front view is slightly more shallow than a man's. Look at a picture of an actual model. When you determine the body's proportions, connect the points you learned. Make the box. If you do this repeatedly you'll get the hang of the proportions for a body's box.

Draw and think of everything--including the portions you can't see--in 3D. While doing this, set the pelvic points at their correct locations. It's very important to practice this.

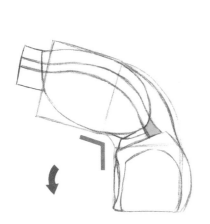
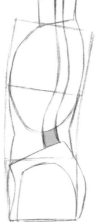
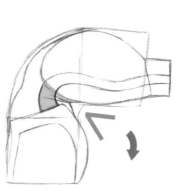

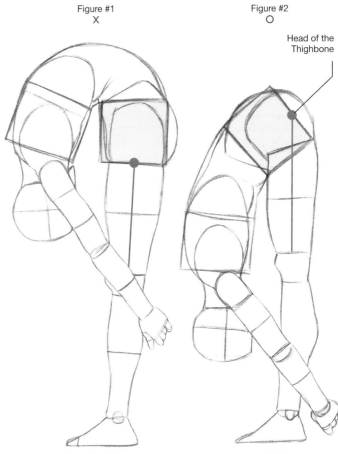

Figure #1
X

Figure #2
O

Head of the Thighbone

The Movement of the Lower Back

If you bend forward at the hip then pressure is applied to the organs. So, the angle of the spine as the body bends forward isn't major. On the other hand, the spine bends further back. The portion of the lower back that's colored in on the above drawings is the point at which the spine bends. When bending backwards, the lower back touches the spinous process and because of this you must not think that the spine is all the way at the back. The main body of the spine, which is the center of movement, is located in a deeper part of the body than you think.

What Not To Do **The Movement of the Lower Back**

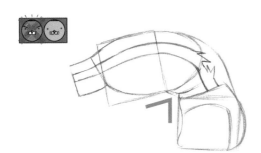
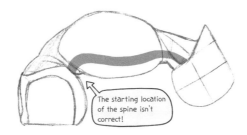

The starting location of the spine isn't correct!

The lower back doesn't bend forward this far. If you incorrectly decide the main location at which the spine bends, then you'll end up drawing a lower back that looks broken, as shown in the above figure. Compare the incorrectly drawn figure with the correctly drawn one.

The Relationship Between the Lower Back & the Thigh Bone

The reason the body can bend like a folder (as shown in Figure 1) is not because the spine bends. It is because the thigh bone head's axis, the coxa, moves and causes the pelvis to slant. This is shown in Figure 2.

BEEEEEE

YOU KEEP MAKING MISTAKES ON THIS PART!!

Bending at the Lower Back

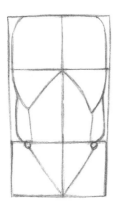 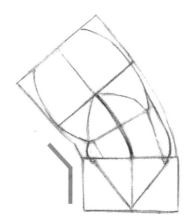

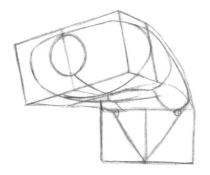 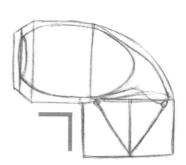

When the upper body is facing forward, if you bend the lower back to the side the bottom part of the ribs and the pelvis hit each other, so the lower back can't bend a lot.

If you twist the upper body then the groove in the ribs make a space while facing the pelvis. For this reason you'll be able to make a posture with more bend in the lower back.

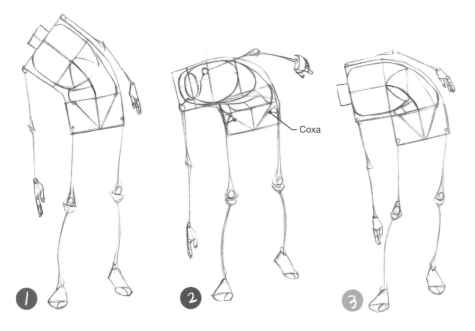

Coxa

Crack! Struggling

1. If you try to pick up an item that's fallen on the ground by leaning to the side, the ribs and pelvis will meet and then movement becomes limited. You won't be able to bend the upper body much.

2. As I stated on the previous page, when you bend the body forward the coxa, which is in between the pelvis and thighbone, moves more than the lower back. This motion is the most natural when picking up a fallen item off the floor.

3. If you exaggerate the movement of the lower back when bending to the side like the drawing, the ribs would damage the organs, right? In actuality, this posture is impossible to do.

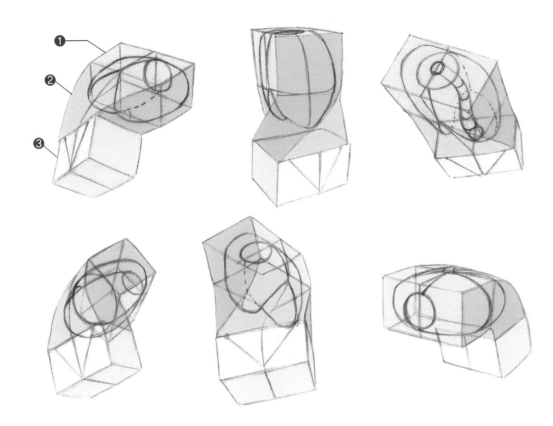

Movement of the Box

A slight deformation can occur according to the movement for Box ❶.

Box ❷'s form changes loosely by bending forward, twisting, etc. The shape is already drawn curved according to the flow of motion.

There is absolutely no change in the form for Box ❸.

Degree of Deformation

Box ❷ (Lower Back) > Box ❶ (Chest) > Box ❸ (Pelvis)

If you don't give attention to the characteristics of the box, then you end up making a mistake like this one.

Men & Women: Differences in Lower Back Movement

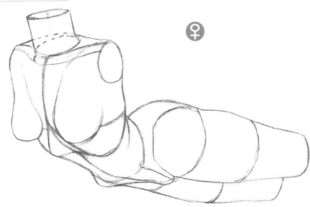

♀

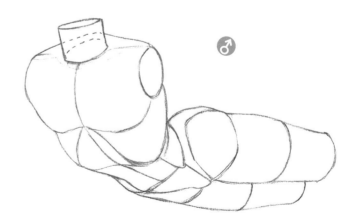

♂

⑦ Points of Leg Movement

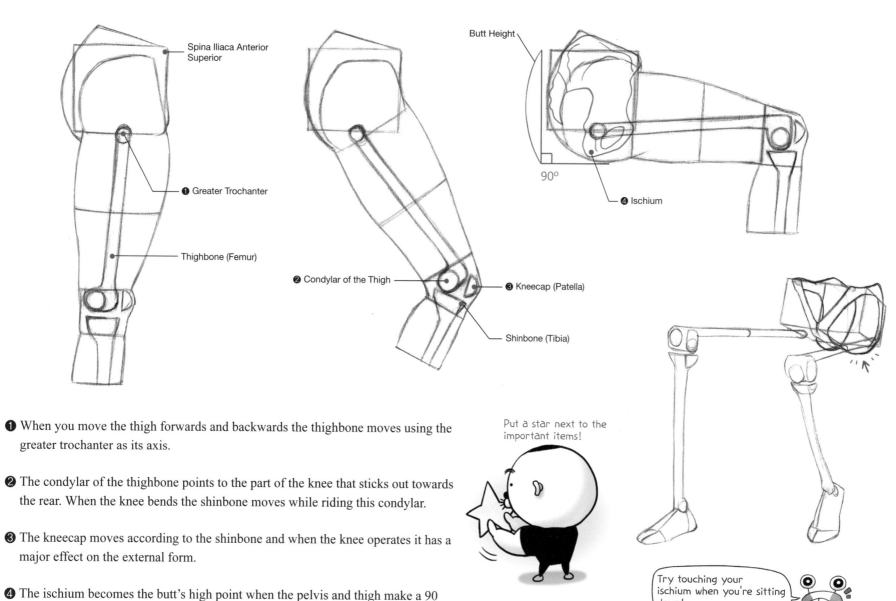

Spina Iliaca Anterior Superior

❶ Greater Trochanter

Thighbone (Femur)

Butt Height

90°

❹ Ischium

❷ Condylar of the Thigh

❸ Kneecap (Patella)

Shinbone (Tibia)

Put a star next to the important items!

Try touching your ischium when you're sitting down!

❶ When you move the thigh forwards and backwards the thighbone moves using the greater trochanter as its axis.

❷ The condylar of the thighbone points to the part of the knee that sticks out towards the rear. When the knee bends the shinbone moves while riding this condylar.

❸ The kneecap moves according to the shinbone and when the knee operates it has a major effect on the external form.

❹ The ischium becomes the butt's high point when the pelvis and thigh make a 90 degree angle.

What Not To Do Shaping the Legs

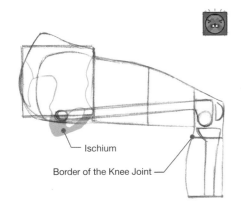

Ischium

Border of the Knee Joint

When seated the ischium supports the butt and for this reason you must not draw the area where the butt is flat. Plus, the thigh must come down to the border of the knee joint.

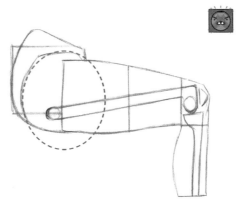

Here, the shaped-in thigh broke into the area of the pelvis. The border of the area of the joints changes location every time the body moves. If you establish the area you see from the outside as your standard for proportion, then when the shape moves the form becomes unnatural. In order to have congruity with proportion you must shape using the bone frame as the standard, which doesn't change in length.

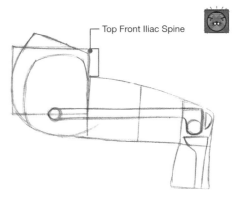

Top Front Iliac Spine

When the legs are bent you must be careful not to put too much space at the area where the top front iliac spine and thigh begin.

Bent Legs - Applied Motion

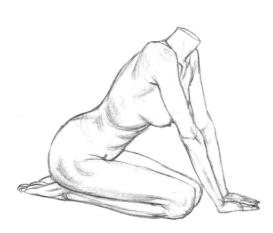

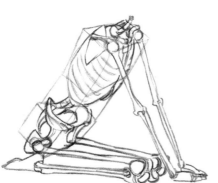

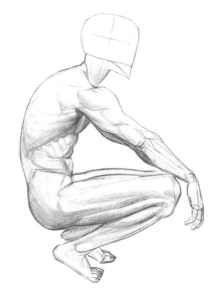

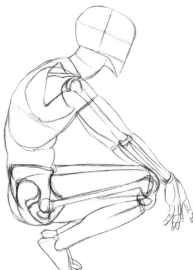

Men & Women: Differences in the Thigh & Movement of the Femur Head

There is not much fat above the greater trochanter on men, so the greater trochanter comes into close contact with the skin. Due to women's hormones fat accumulates around women's butts and thighs. Thus, the greater trochanter is covered in a layer of fat and doesn't stick out on the outside, which is different than men. When the thighs move front and back the greater trochanter becomes the axis. When the legs move side-to-side, as is shown in the below figures, then be sure to draw them using the femur head as the axis.

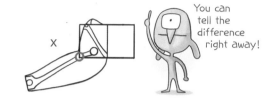

You can tell the difference right away!

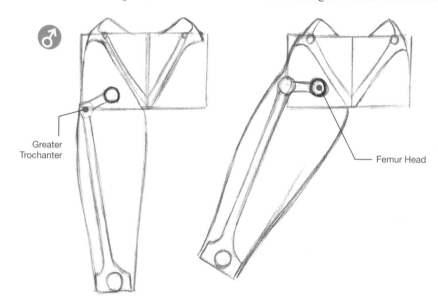

Greater Trochanter

Femur Head

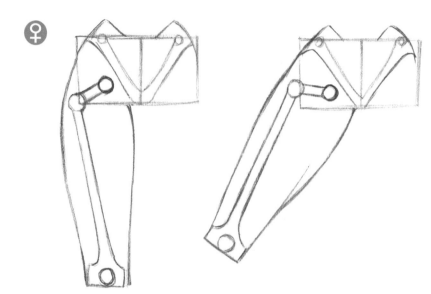

What Not To Do Femur Head & Greater Trochanter

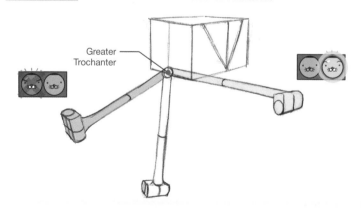

Greater Trochanter

If you don't fully understand the shape of the joints, which are the axis of movement, then when you move the shape the form becomes incorrect. The joint area where the pelvis and thighbone meet is bent much like a golf club. So, you must not think of it as straight like you did with the humerus (We learned about the humerus earlier on, if you remember). When the leg moves to the side it uses the femur head as its axis, so it's important to be aware of that location.

When you move the legs front to back (As seen in the drawing of the green thighbone on the left) your drawing won't be wrong if the greater trochanter becomes the center. But, when you spread the legs side-to-side then an error occurs, as is shown in the drawing of the red thighbone. What do you think? Easy, right?

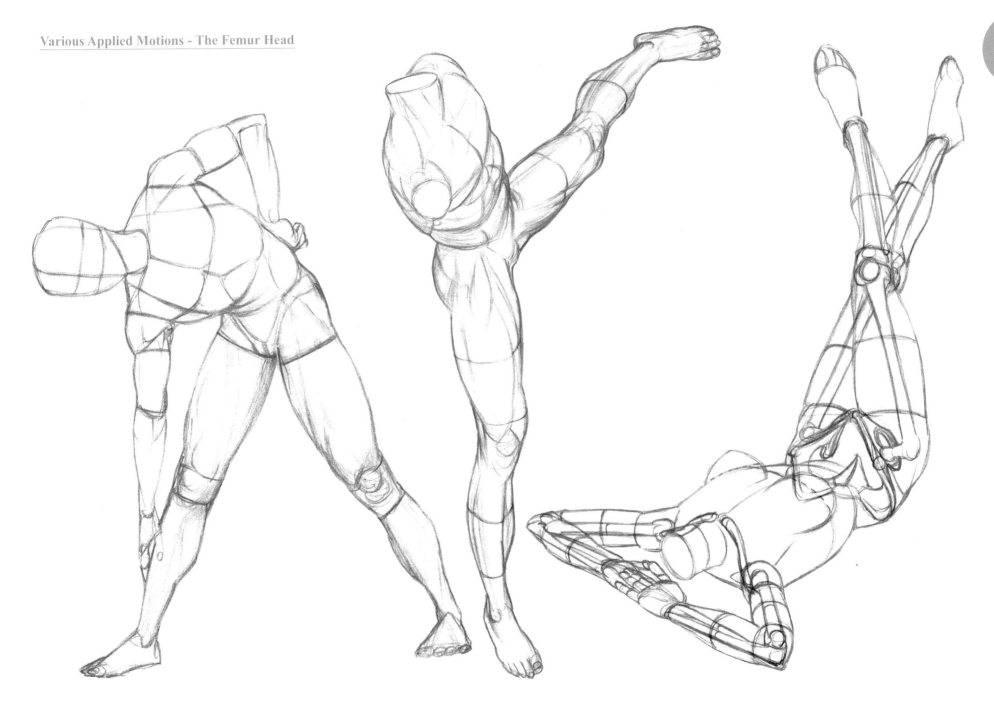

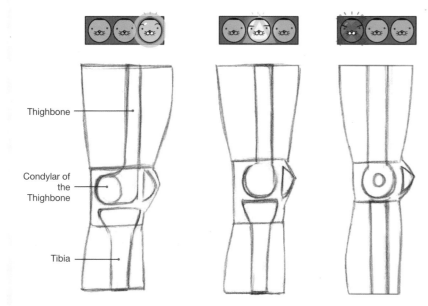

Thighbone

Condylar of the Thighbone

Tibia

 When you view the knee from the side the joints extend and become longer towards the rear, much like a golf club. Similarly, the part of the bone that sticks out is referred to as the "condylar".

 If you draw the thighbone condylar using circular joints unlike a golf club, then when you view from the side the knee will have a shallow expression and will feel flat.

 The worst case would be to draw the thighbone condylar circular and the tibia straight. This is the worst method for drawing a straight knee.

Oh my... He's so weak and frail even when we give him medicine.

Shake

Shake

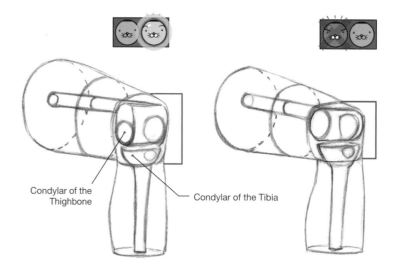

Condylar of the Thighbone

Condylar of the Tibia

The knee becomes higher if you bend the legs and the thighbone condylar is erected. You have to think of and draw the knee as squarish rather than circular.
(Thighbone Condylar + Tibia Condylar = Increased Thickness)

The shape of the knee joint when the knee is completely bent.

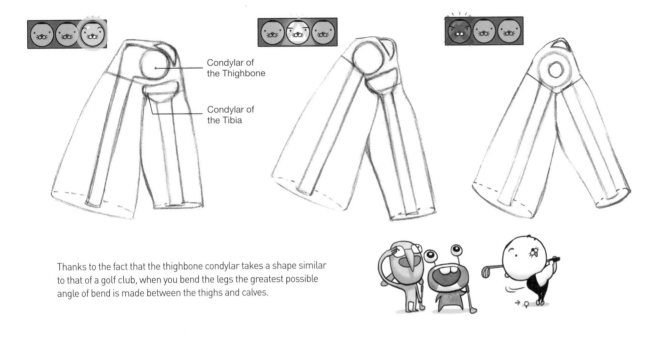

Condylar of
the Thighbone

Condylar of
the Tibia

Thanks to the fact that the thighbone condylar takes a shape similar
to that of a golf club, when you bend the legs the greatest possible
angle of bend is made between the thighs and calves.

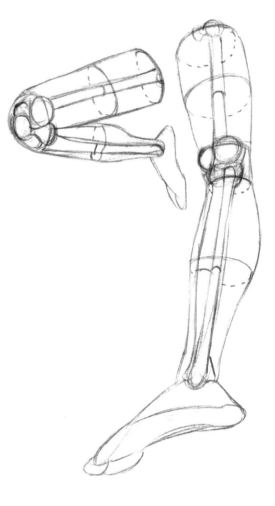

Let's take a
look and see
how to really
shape in the
legs!

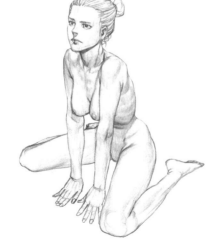

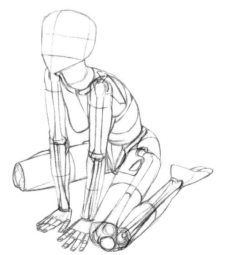

8 The Importance of Weight Center

Ana got tired of studying weight center...

Ana is sad because the character she drew couldn't ever figure out their weight center and kept falling on their back.

And that's when Mr. Kim appeared!

Looking at Drawings Objectively

I said it in the form of a joke, but we already have within us the ability to determine weight center. For example, we can sense how the differences would be for the centers of weight in the running figures to the right. Similarly, when you look at a picture or someone else's drawing you can easily see whether the posture is stable or unstable and whether the figure is standing still or is moving. If this is the case, why do we make mistakes with weight center when we draw figures ourselves? The reason is because we can't look at our own drawings objectively as we do when we look at other drawings. Also, there are many instances where we don't know exactly what needs to be fixed even though we can sense something about the center of weight is off.

① Taking a running stance

② In the middle of actually running

③ Falling

If the proportion, depth and form are accurate but the body looks like somewhere it's off then weight center is the culprit. But, since the weight center changes every time the body moves there's no other theory that can be formally made. For example, you're trying to make a figure stand up straight but it keeps falling backwards, then what should you do?

You'll have to correct the center by bending the lower back forward or bringing the legs out towards the rear. Keep making corrections until the center of weight no longer looks "off". As you're making corrections get the hang of feeling your way through it. First, in order to establish a stable weight center, then the location of the foot that's pressing on the ground is very important. We'll look into foot depth and their direction.

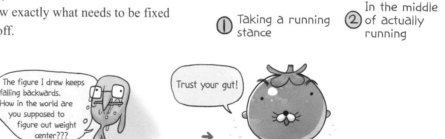

Weight Center & Foot Location

Foot Stride and Location	❶	❷	❸
Weight Center	Can fall over easily	Can fall over if weight is applied towards the front or rear	The most stable stance

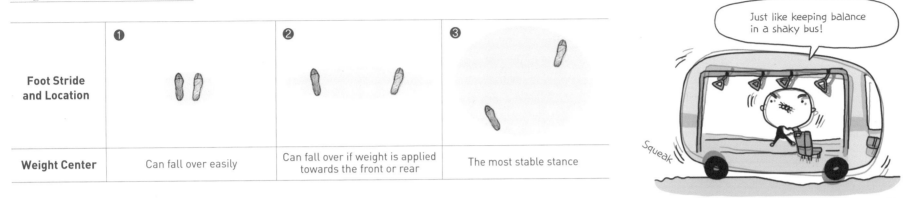

Just like keeping balance in a shaky bus!

Squeak

If the feet are planted in the shape of the number 11 as in ❶ the range the upper body can move in is limited to the colored-in space. It is easiest to fall over when standing at attention and it's easy to make a mistake when drawing a figure in this stance. When standing with the feet spread as in ❷ it's possible for the upper body to move left to right, but if it moves front to back then the center is lost. In ❸ the front-back and side-to-side ranges are expanded. If you place the feet diagonally then the range of motion for the upper body increases, so the possibility of drawing with correct weight center is the greatest.

Let's Try the Stances

In many dynamic movements you can see the feet being placed in the diagonal position. Whenever you take a pose you can make a substantially more stable position, but only when you draw after feeling for yourself which foot the weight had been allocated to. On the other hand, when the body is in the air there's no need to think deeply about the center of weight like you do when the body's on the ground.

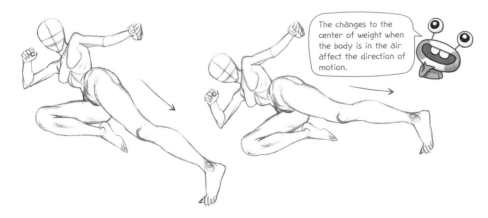

The changes to the center of weight when the body is in the air affect the direction of motion.

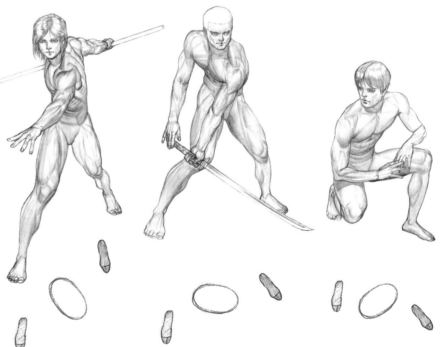

If you're looking to draw a human body with a stable weight center, then you must establish the body's lean first and foremost, as is shown in Stage ❶. This is because the posture of the lower torso differs according to the type of flow for the heaviest bodies. Stage ❷ shows that not only must you choose the correct location of the feet according to the body's weight center, but also you must find the position of the legs using the flow you're trying to express. In Stage ❸ I drew the arm movements according to the body and leg flow drawn prior and I drew it in a way so that it wouldn't affect the weight center. An object being held in the hands of course affects the weight center. This is an important factor that can't be omitted in your calculations.

The Orders of Drawing a Body Frame

TIP: How to Set the
Weight Center

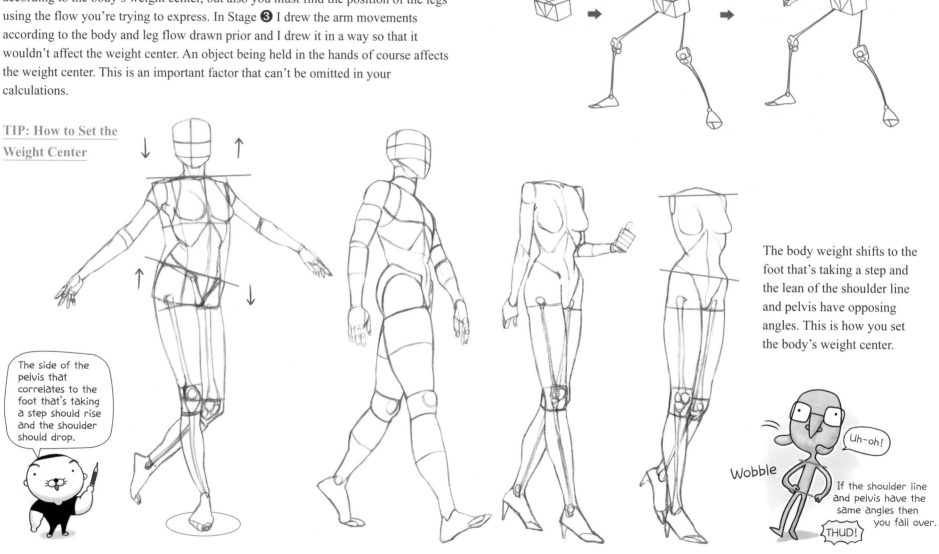

The side of the pelvis that correlates to the foot that's taking a step should rise and the shoulder should drop.

The body weight shifts to the foot that's taking a step and the lean of the shoulder line and pelvis have opposing angles. This is how you set the body's weight center.

Uh-oh!

Wobble

If the shoulder line and pelvis have the same angles then you fall over.

THUD!

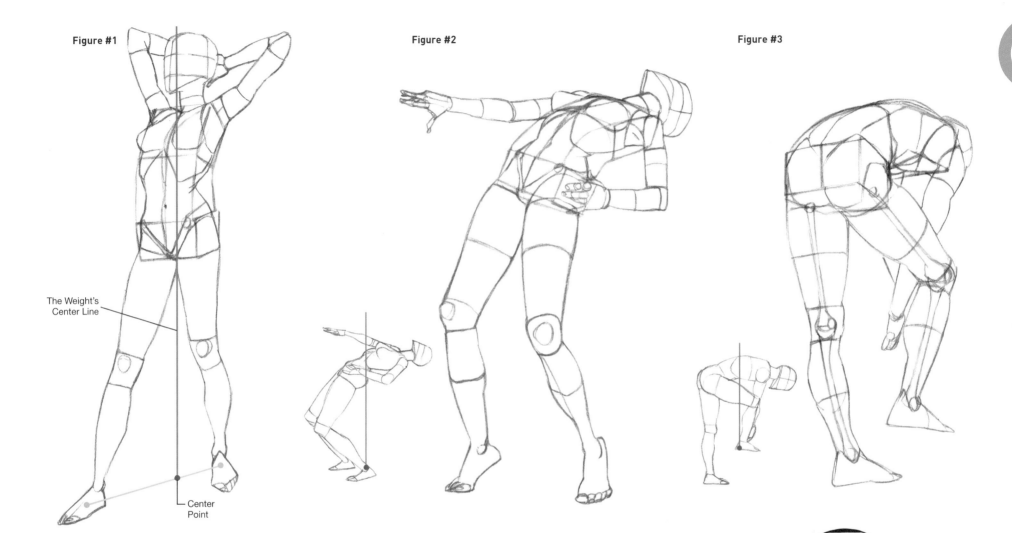

Figure #1

The Weight's Center Line

Center Point

Figure #2

Figure #3

Setting the Weight Center According to Posture

When setting the weight center line take a look at the body from a side angle. After, distribute the body's weight equally on the right and left sides to the point where these lines intersect perpendicularly. The point at which the weight center line and floor meet is referred to as the "Center Point". If you want to have correct weight center, then you must either have the feet directly touch the center point as in Figures 2 and 3, or when they do not touch the center point must be raised above the line that you draw in between the feet (Figure 1). There are several methods to set weight center. This is just one of them. Please keep it in mind.

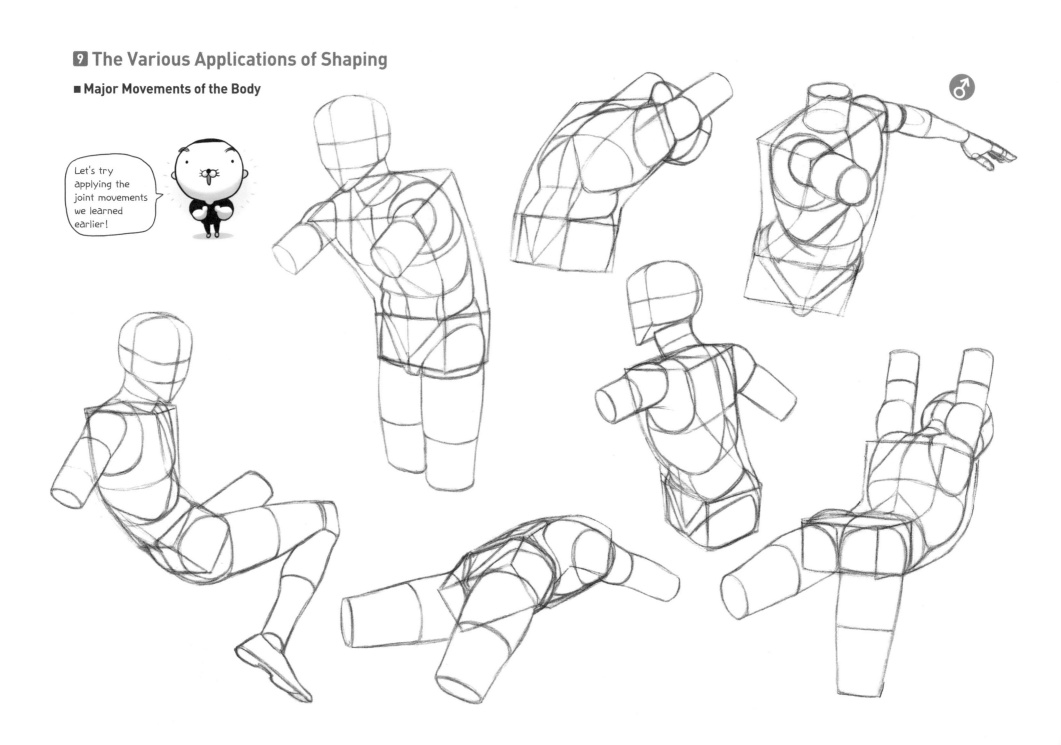

9 The Various Applications of Shaping

■ **Major Movements of the Body**

Let's try applying the joint movements we learned earlier!

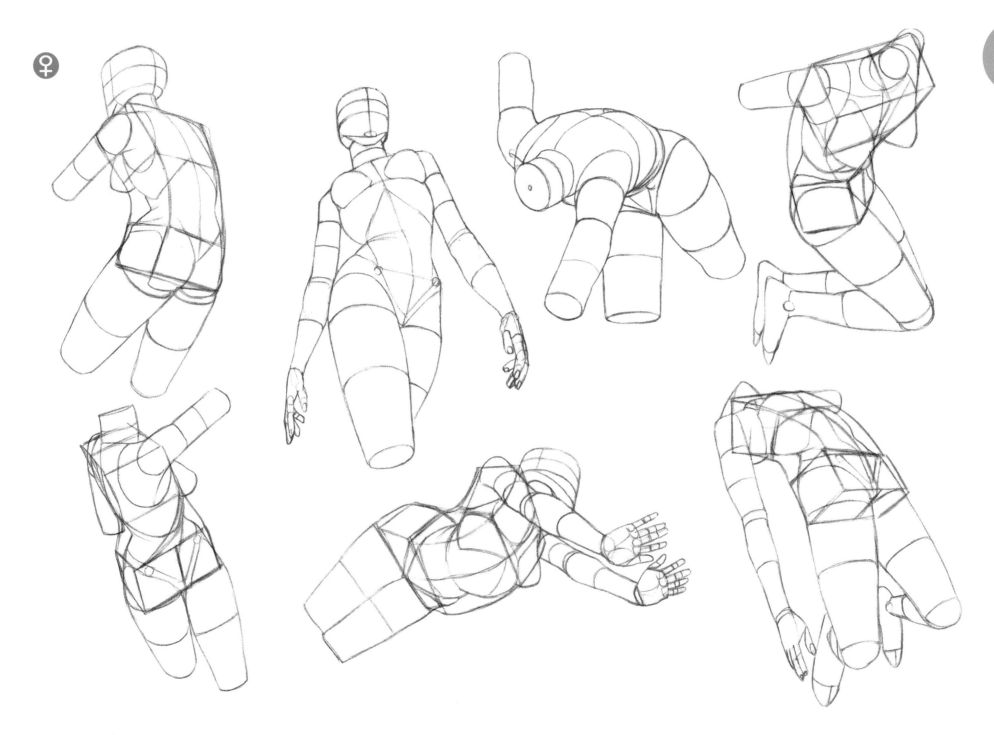

■ **Stable Weight Centers**

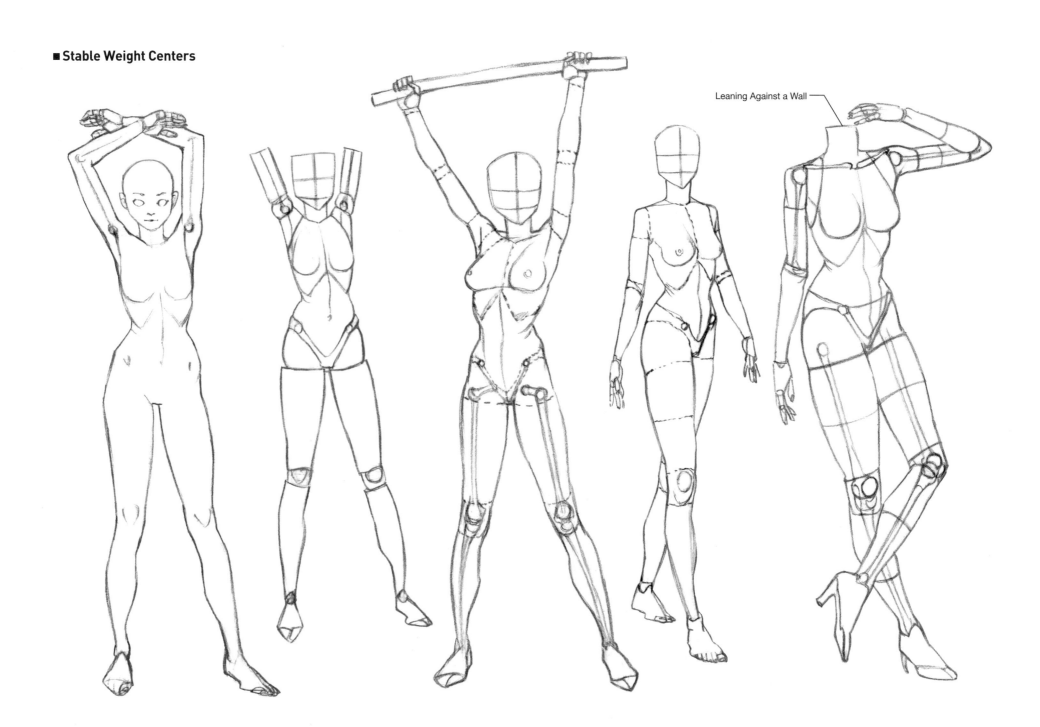

Leaning Against a Wall

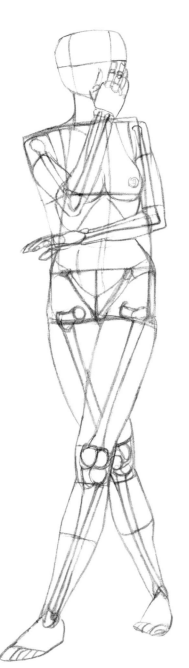
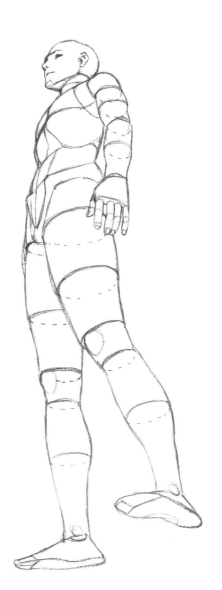
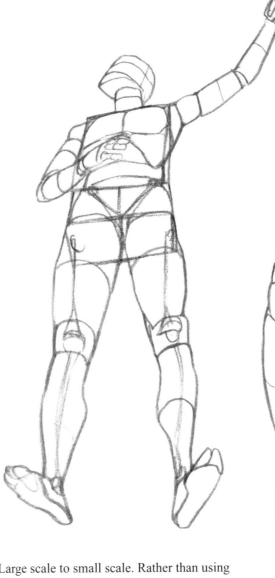

When drawing, you express depth in this order: Large scale to small scale. Rather than using small parts in order to draw something large, if you use large parts and split them into smaller parts the possibility of drawing accurate proportions increases. When drawing the body you must start with drawing a large body with depth. Then, it will be easy to do proportion or motions.

■ Various Seated Positions

If you draw one position from different angles it helps you understand the body's flow and depth in 3D. Try making minor changes to the posture and research how the joints move.

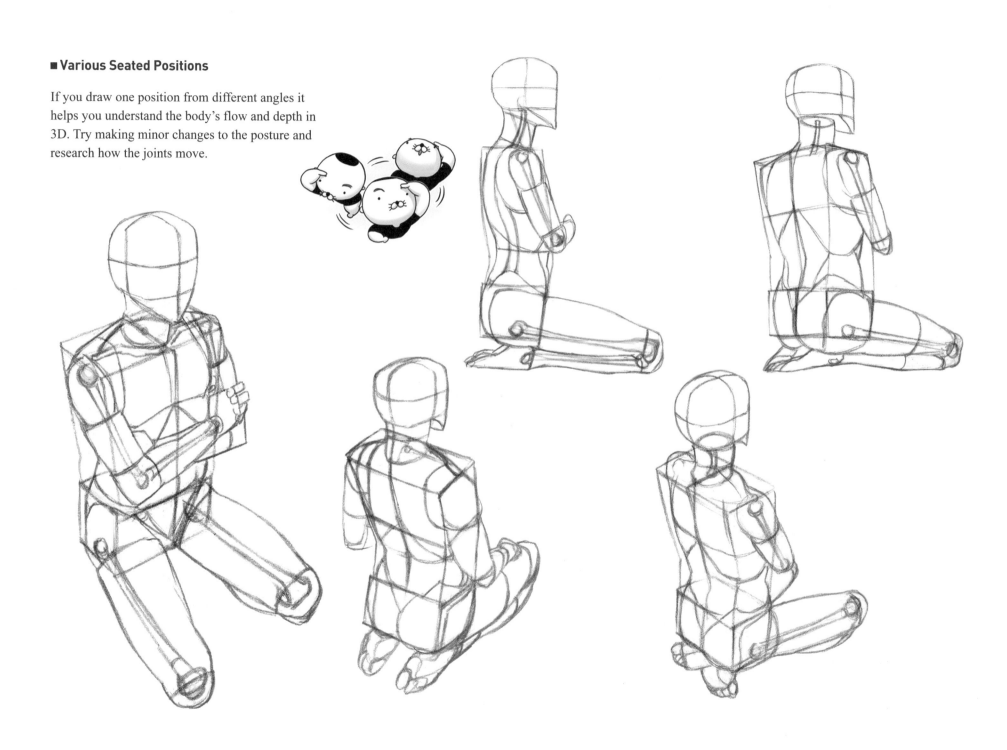

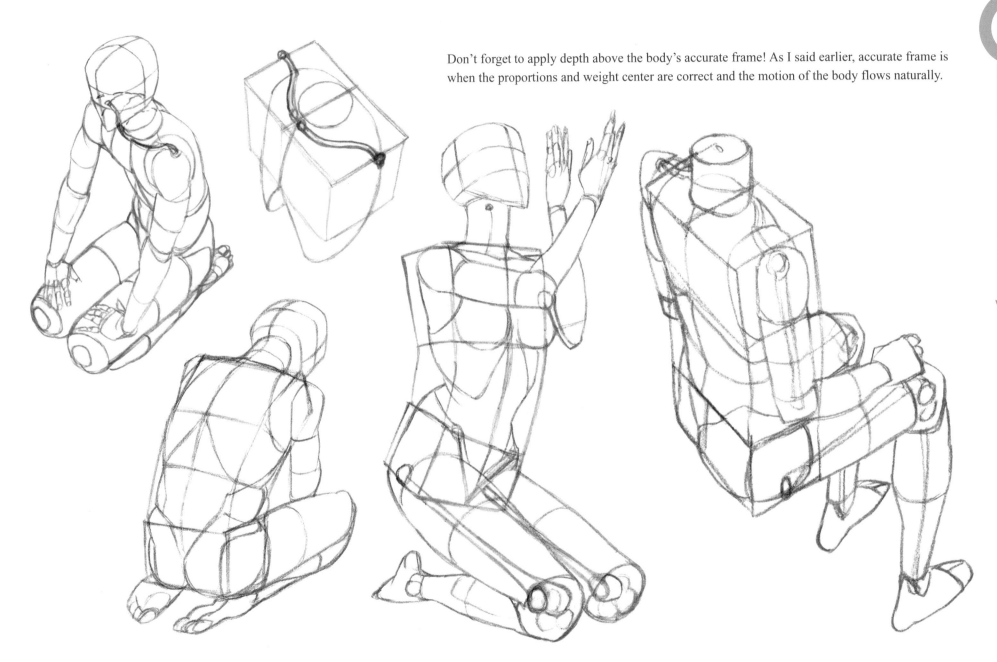

Don't forget to apply depth above the body's accurate frame! As I said earlier, accurate frame is when the proportions and weight center are correct and the motion of the body flows naturally.

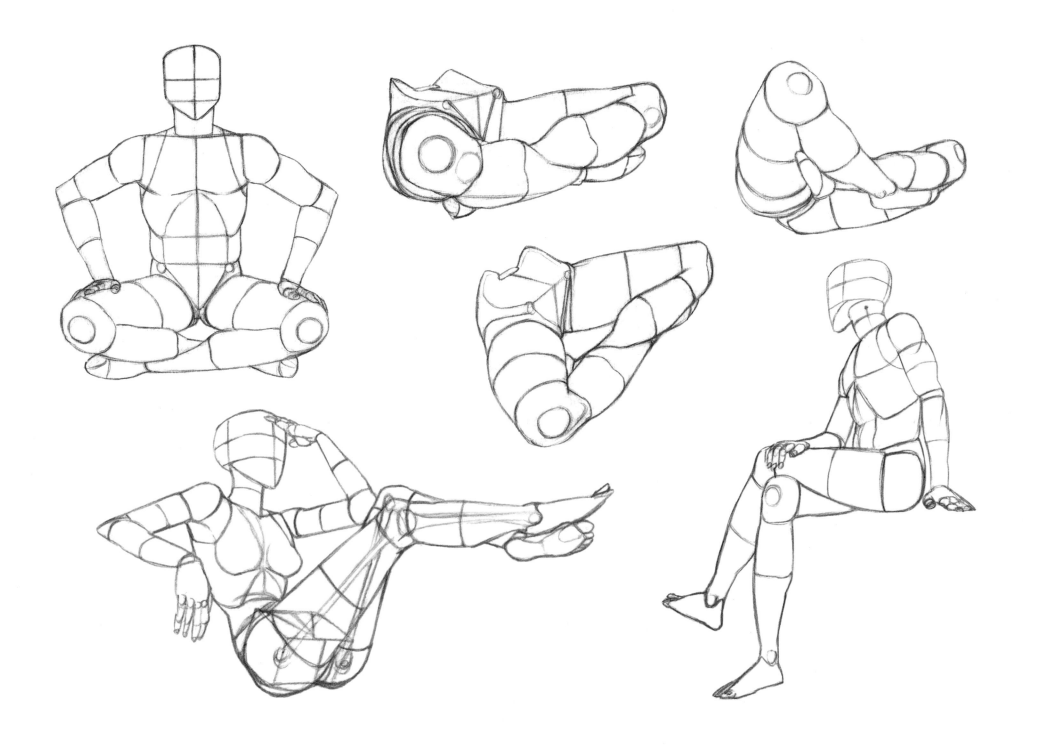

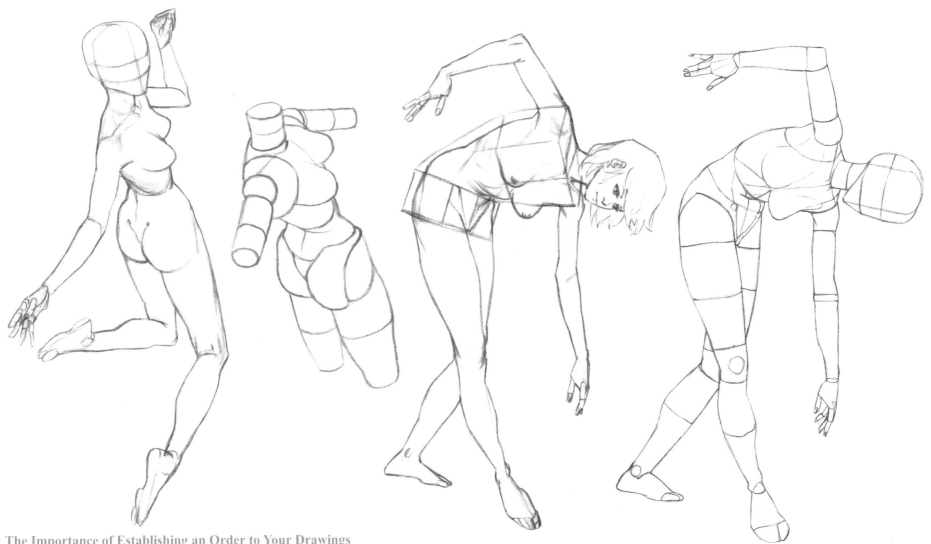

The Importance of Establishing an Order to Your Drawings

If you intend on drawing strong basic components, then theory and practice must work hand-in-hand. If you focus too much on theory you end up drawing a stiff figure. The opposite would be to only practice and not have any knowledge of theory.
If you do this your application ability decreases and it will be difficult to draw diverse postures or structures. When you practice, do like the pros and don't try to finish a drawing all at once. Go through the framing and shaping processes in order.
This is very important. Professional artists practice so much that they calculate the framing and shaping processes in their heads--they don't skip over them.

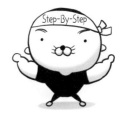

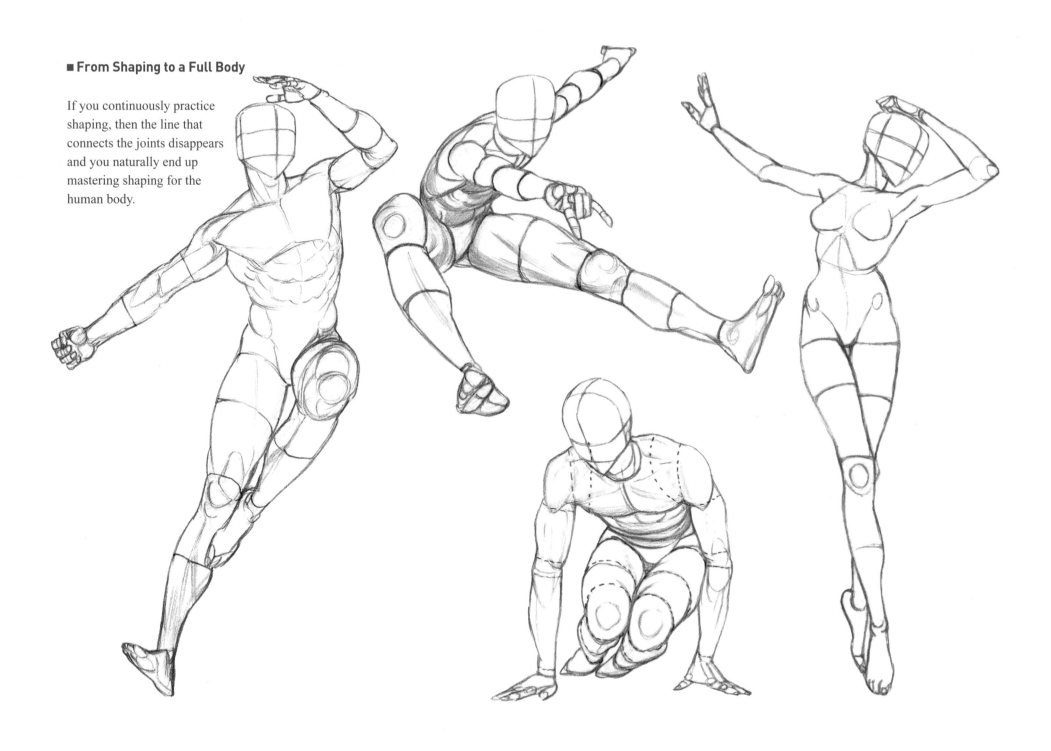

■ From Shaping to a Full Body

If you continuously practice shaping, then the line that connects the joints disappears and you naturally end up mastering shaping for the human body.

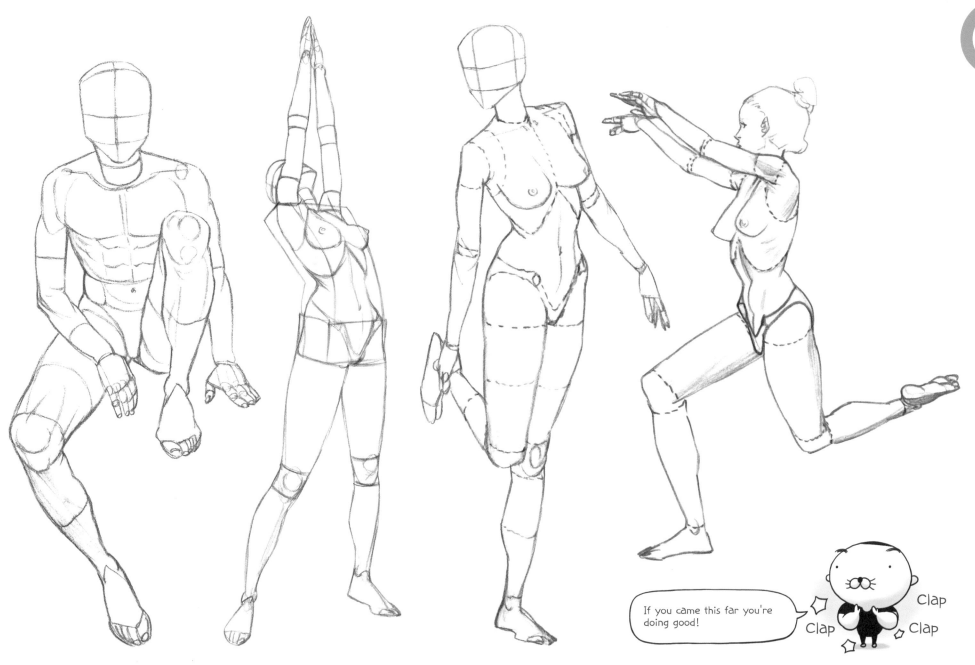

If you came this far you're doing good!

Clap
Clap
Clap

■ Understanding Deformed Characters Through Shaping

You can apply actual proportions not just in real life drawings but also in other various types of drawings.
When you design SD(Super Deformed) characters or creatures that have deformations, if you apply shaping you'll be able to more easily draw a figure with a three-dimensional effect. Whenever you draw characters, if the ratio or appearance changes or it's difficult to apply changes to the character's posture and angles, then practice shaping!
Keep practicing until you increase your understanding of the basics.

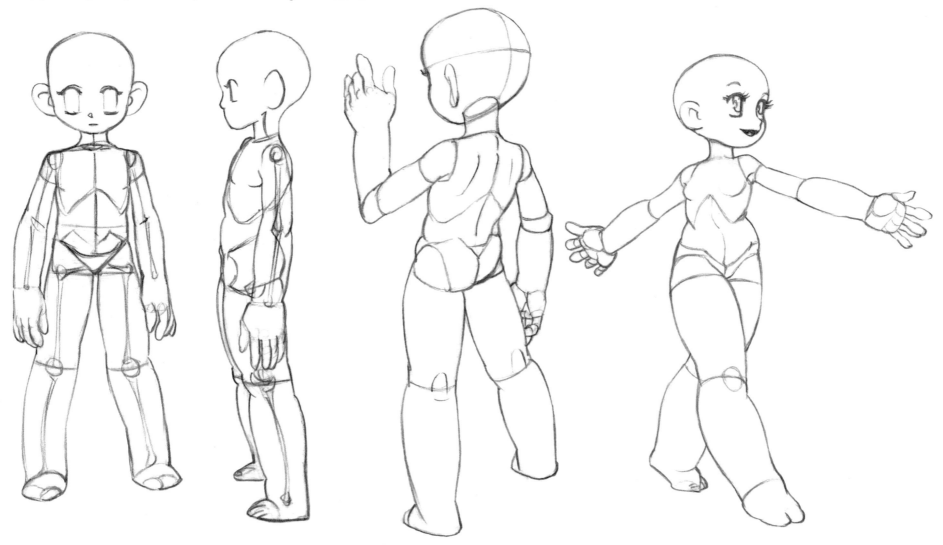

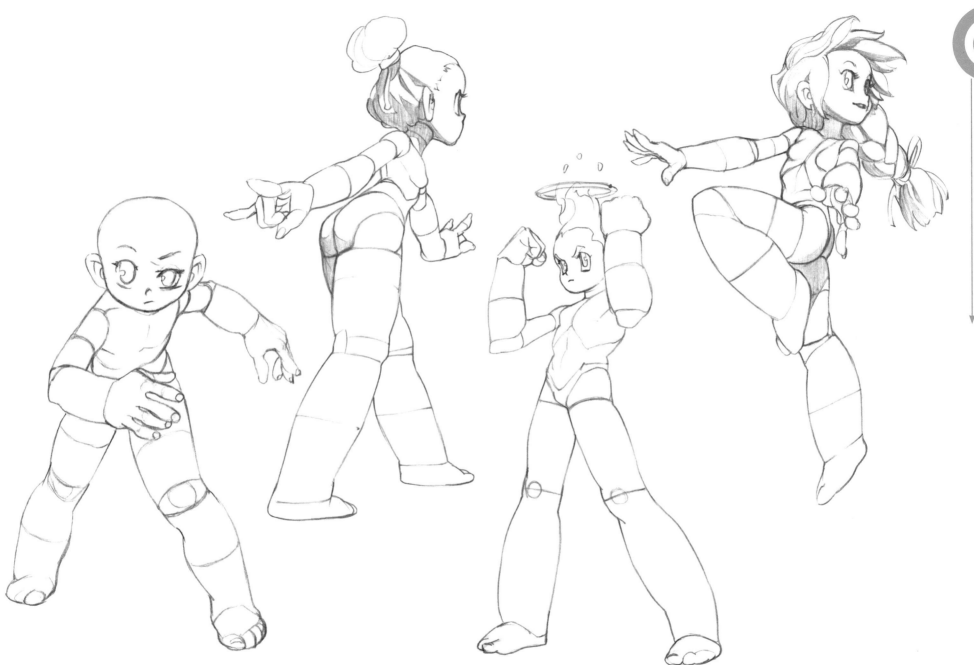

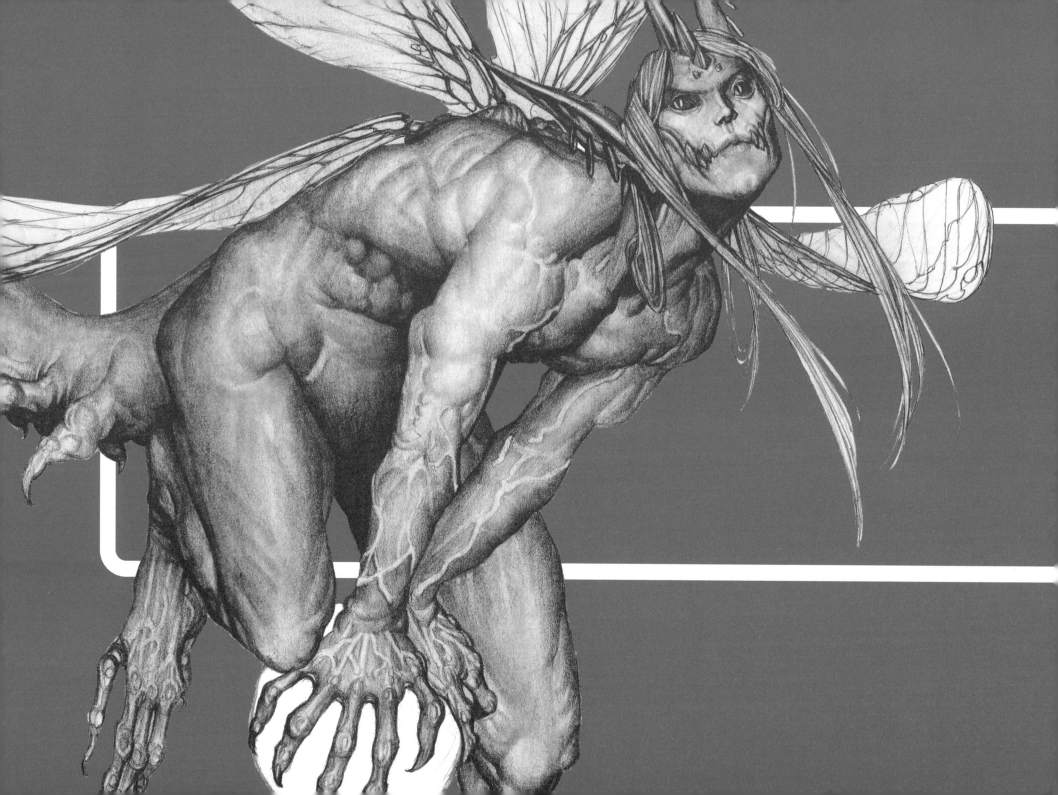

02
The Face

If you approach the face by simplifying its shape it will be substantially easier to make 3D drawings of the face from different angles. This chapter we'll learn about eye, nose and lip form as well as the movements of the muscles in the face.

Facial Recognition

Why is it important to draw the face? Since times past, human beings have banded together to live and they developed communication techniques among groups. Observing the face was also a complicated but important form of communication. Human beings needed to be able to read the minute expressions which contained the other person's emotions and intent, and also they needed to grasp the differences in appearance so they could differentiate between who's who. They made it so that communal life was about becoming aware and sensitive to facial information. Scientifically speaking, when the human brain looks at an object only the territory responsible for vision is activated. But, when the brain looks at a human being's face it's said that most of the senses including vision, sense of smell, hearing, and sense of touch are activated all at the same time. When our brains look at drawings of faces they also exemplify the same sensitivity and reaction as when looking at an actual face. It is in this way that the senses used in discerning faces are instant and detailed, so drawing faces calls for a high level of precision.

Faces are the most enjoyable part of the human body to draw. This is because it is a strong tool of expression that allows you to directly display your characters' emotions and impressions. This also tends to be what art students practice the most. When students draw the face, their biggest concern is typically the fact that they end up always drawing from one limited angle. It's like how the best selfies are always shot using similar angles. If you want to express a drawing from diverse angles with an attractive appearance and a convincing expression, then it's necessary to do some fundamental research into faces.

In this chapter you'll learn how to understand faces in 3D after shaping them in. You'll learn this from a variety of different angles without sacrificing form and proportion. Additionally, you'll discover the anatomy of how light and shade are expressed on the face through the structure of the facial bones, and how the muscles are used when making facial expressions.

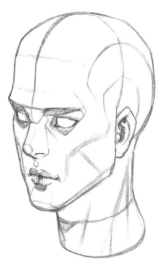
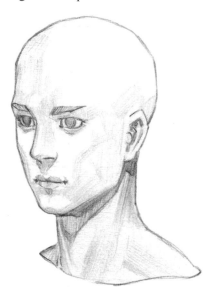
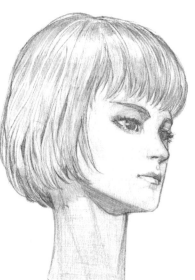
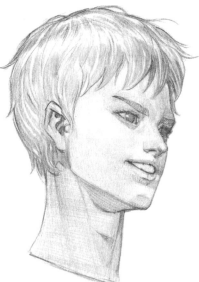

Drawing Faces is No Easy Task!

Ana was lacking in drawing skills and hid herself from others.

Thanks to studying hard, Ana was able to go on an outing with her character.

What? My character wants to go biking...

Ana's taken aback.

Ana's character came to know why he was only ever drawn at eye-level.

Ana makes up her mind to try to expand her character's scope.

Ana once again realizes just how difficult it is to draw a face from another angle.

So... let's study how to draw faces together with Mr. Kim!

❶ Facial Proportions

■ Characteristics & Sections of Men's Faces

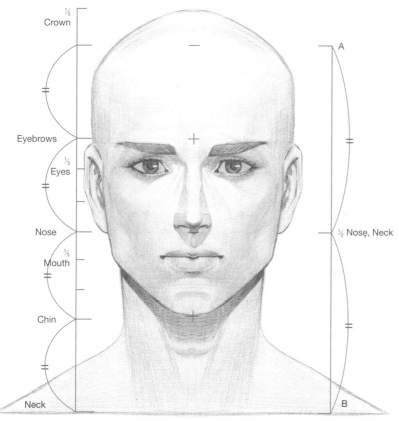

Crown — ⅓

Eyebrows

Eyes — ⅓

Nose

Mouth — ⅓

Chin

Neck

A · ½ Nose, Neck · B

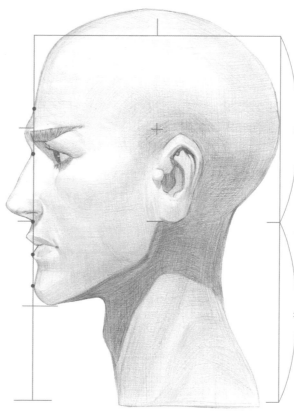

How to Measure the Width of the Ears, Eyes, Mouth & Nose

There is the distance of one eye in between the eyes. The width of the nose is equivalent to the width of one eye.

If you draw a line on both eyes from the inner starting points of the pupil straight down then they meet the corners of the mouth.

The distance between the point of the end of the eye to the edge of the face is the width of half an eye.

Proportions: Frontal View (Men)

Facial ratios differ among artists. For this reason, there's no one answer when it comes to proportion. In the above drawings, I established facial proportions by placing each point at a location that's the same as a particular section of the face. If you cut the distance from A to B in half then it becomes the location of the nose and neck. The distance between the end of the jaw and the clavicle is the halfway point of the neck. The width of the head when viewed from the front is narrower than the width of the head when viewed from the side.

Baseline of the Face's Sideline

- **Areas Which Protrude Outside the Line:** Supraorbital Ridge, Nose, Upper Lip
- **Areas Which Touch the Line:** The Start of the Forehead Above the Supraorbital Ridge, Bridge of the Nose, Under the Nose, Bottom Lip, the Area that Protrudes in Front of the Jaw
- **Areas Which Retract Inside the Line:** Forehead, Oral Fissure, Mentolabial Sulcus, The Side of the Chin that Curves Inwards

Keep the proportions in mind when drawing faces.

■ Characteristics & Sections of Women's Faces

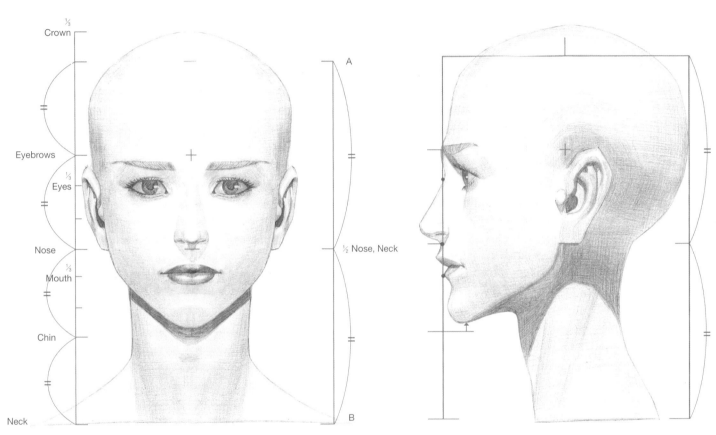

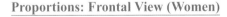

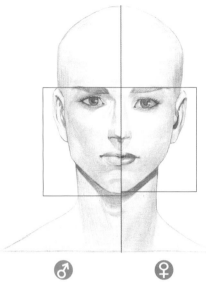

♂ ♀

Proportions: Frontal View (Women)

The area above the eyes (in between the eyes and eyebrows) is wide and the chin is small on women, so their face has the feel of a baby's face. Due to hormonal effects, women's chins are more slender than men's.

The size of the ears is equivalent to the distance between the eyebrows and the nose, and I draw the eyebrows longer than the length of the eyes.

Side View: Facial Characteristics

When viewing from the side the incline of the nostril is vertical, but the incline of the area below the nose is not. On women, the degree of protrusion of the supraorbital ridge is less steep and the starting point of the bridge of the nose is lower. Also, the lower chin is more developed than men's, so the part of the chin that sticks out doesn't touch the baseline of the face's sideline.

Differences: Men's & Women's Faces

When you compare a man's and woman's face from the front then you'll immediately notice how the distance from the top of the eyebrows to the bottom of the chin is smaller on women. The flow of the chin for men is straight, while a woman's is curved. The length of the neck is the same for men and women, but women's necks are thinner and the trapezius muscle is low so their necks look longer when you compare the two.

■ How to Draw a Standard Face

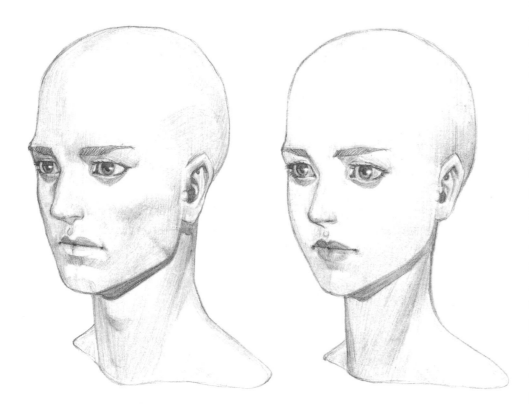

Westerners & Asians: Facial Characteristics

Facial development is very diverse and depends on climate, topography, and ethnicity, so there are many differences in form. In order to protect the eyes from ultraviolet rays that beam directly down while living in plains, Westerners' supraorbital ridges were developed to create a shadow. Also, the eyeballs contain a greater amount of moisture the colder the environment is, so the eyes retract in to be able to protect against the cold weather so they don't freeze. In order to warm cold air, the passage through which air comes in is longer and the nose is higher. For this reason Westerners' eyes, ears, nose and mouth have a three-dimensional curve. Asians were protected from sunlight by forests, so the supraorbital ridges are undeveloped. The eyes protrude to be able to release the higher temperatures from the tropical climate and the lips are thicker. There's no need for a higher nose so the face has an overall even form. The form of the head also has a difference in its three-dimensional feel in that Westerners' heads are long (dolichocephalic) while Asians' heads are short (brachycephalic). When drawing, a face that appropriately mixes the characteristics of Western and Eastern-style faces is preferred. When starting out, rather than drawing several different faces with various impressions, it's good to sufficiently practice until you're able to maintain proportion for a standard face at frontal, side, and diagonal views. Then, using these as a foundation, make an attempt at changing the various impressions.

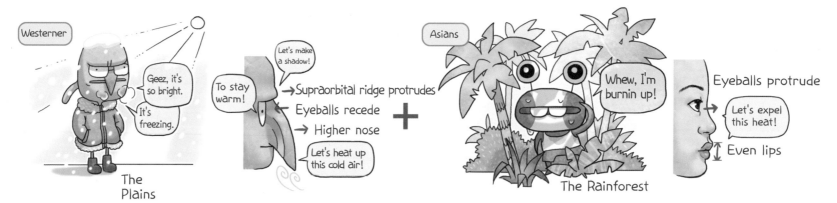

■ Changes to Appearance & Age from Proportion

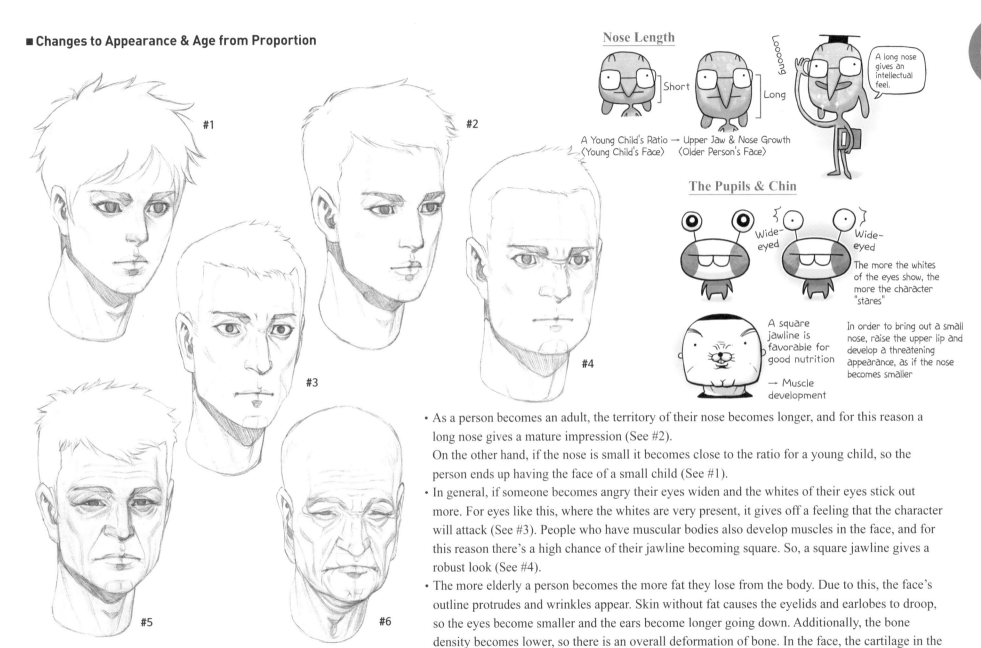

Nose Length

Short

Looooong

Long

A long nose gives an intellectual feel.

A Young Child's Ratio → Upper Jaw & Nose Growth
〈Young Child's Face〉　〈Older Person's Face〉

The Pupils & Chin

Wide-eyed

Wide-eyed

The more the whites of the eyes show, the more the character "stares"

A square jawline is favorable for good nutrition

→ Muscle development

In order to bring out a small nose, raise the upper lip and develop a threatening appearance, as if the nose becomes smaller

#1 #2 #3 #4 #5 #6

- As a person becomes an adult, the territory of their nose becomes longer, and for this reason a long nose gives a mature impression (See #2).
 On the other hand, if the nose is small it becomes close to the ratio for a young child, so the person ends up having the face of a small child (See #1).
- In general, if someone becomes angry their eyes widen and the whites of their eyes stick out more. For eyes like this, where the whites are very present, it gives off a feeling that the character will attack (See #3). People who have muscular bodies also develop muscles in the face, and for this reason there's a high chance of their jawline becoming square. So, a square jawline gives a robust look (See #4).
- The more elderly a person becomes the more fat they lose from the body. Due to this, the face's outline protrudes and wrinkles appear. Skin without fat causes the eyelids and earlobes to droop, so the eyes become smaller and the ears become longer going down. Additionally, the bone density becomes lower, so there is an overall deformation of bone. In the face, the cartilage in the nose comes down, the nose becomes longer, and it bends like a beak (See #5 and #6).

2 The Skull

You Must Know the Skull to Know Where the Bends Are

The Head (Skull) makes an overall spherical shape, however it's not completely round like a ball. It is long at the front and back and thus has an overall oval shape. The places where bone is touched are places where the skull has its bends. Typically you'll have the supraorbital ridge and cheekbone, which protect the eyes. Areas of light and shade are divided according to the flow of the frame, which protrudes.

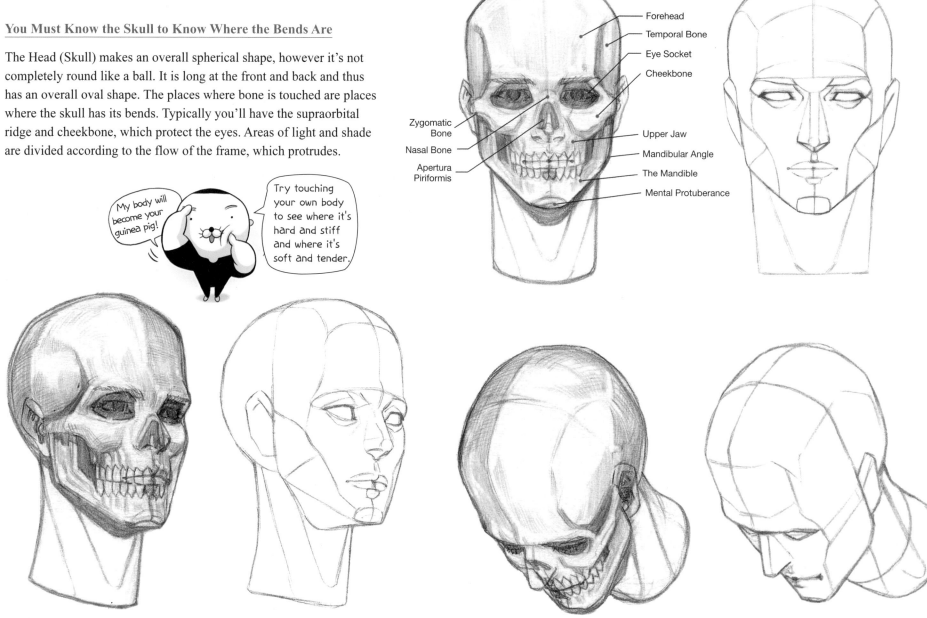

My body will become your guinea pig!

Try touching your own body to see where it's hard and stiff and where it's soft and tender.

Forehead
Temporal Bone
Eye Socket
Cheekbone
Zygomatic Bone
Nasal Bone
Apertura Piriformis
Upper Jaw
Mandibular Angle
The Mandible
Mental Protuberance

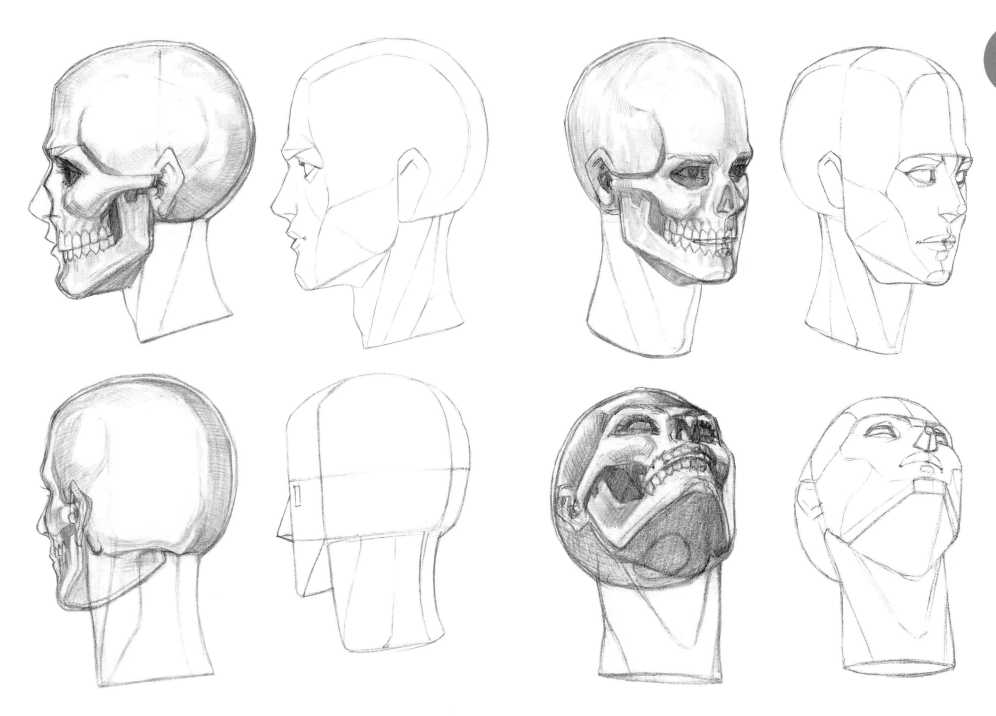

❸ The Necessity of "Siding"

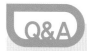

Q&A

 There aren't any sharp edges on the face. Why study siding?

 If you approach the face only thinking of it circularly, then it will be difficult to understand it from a three-dimensional point of view. So, when you add light and dark shades or draw various angles the form becomes obscured. Siding is effective in accurately grasping the structure and form, which is complicated. You partition the sides by omitting minute curves and grouping similar areas. After grasping the major flow, you gradually shave off the angles while making the actual face.

> Understand the form structurally, just like when working with the sides of plaster figures!

"Siding" Order

After accurately establishing the locations of the eyes, nose and mouth, divide the face into the front and sides, then take a look at the basic structure of the face. Subdivide the sides by following the very detailed flow of the muscles. Use the front and sides as your basis. There are many sides that are split with the cheekbones, supraorbital ridge, and nose at the center.

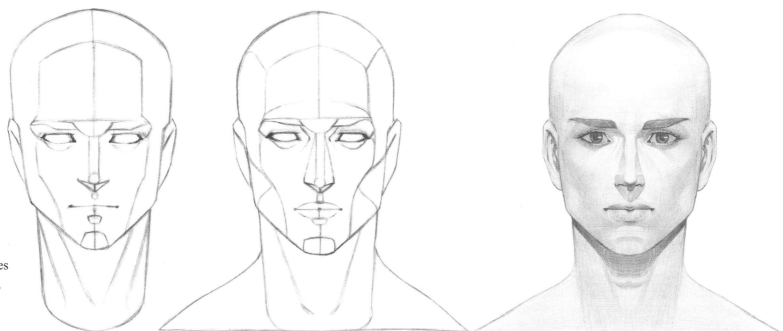

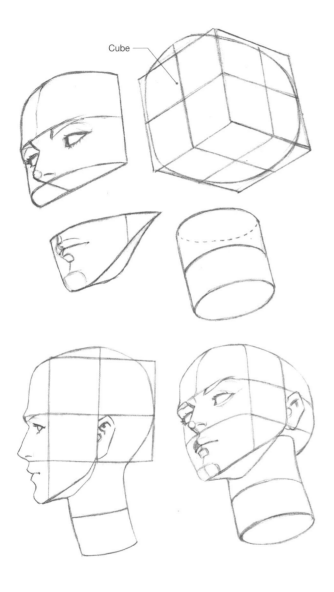

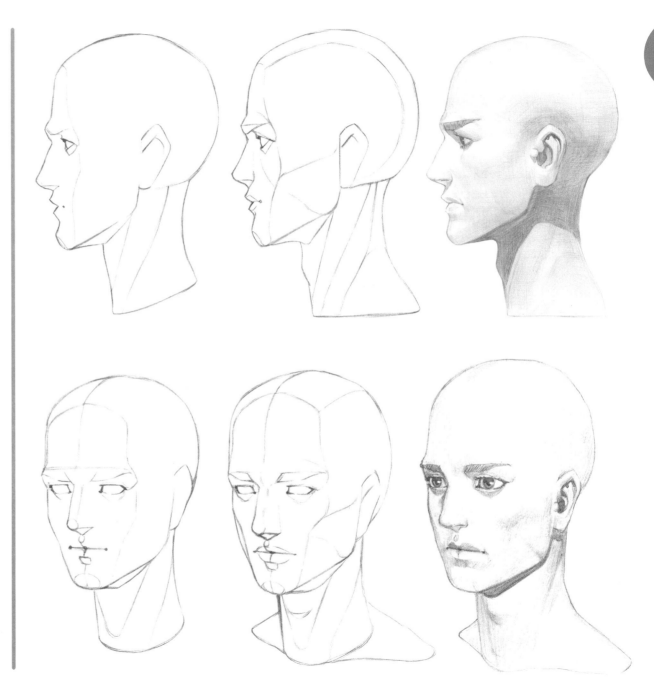

Segmenting the Face

You can more easily understand the structure of the face by dividing the face into 4 segments and thinking of the head as a cube.

4 Understanding the Face Through Shaping

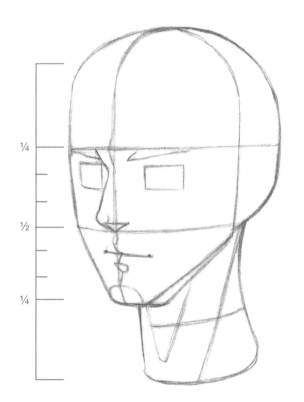
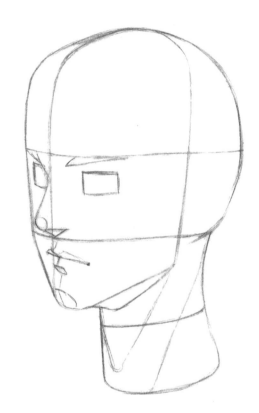

¼

½

¼

Focus on Volume--Simplify the Form of the Head

When drawing the body, you start with drawing a head with great volume, like how we drew an upper torso with great volume. Draw a horizontal line between the eyebrows and nose to establish proportion and draw vertical center lines on the front of the face and on the sides. These lines guide you to be able to draw and accurately perceive what angle the face is pointed at. If you draw the eyes with a squarish shape, then when the face turns it's easy to determine the symmetrical point between the eyes and measure the angle of the eyes and the degree to which they squint.

Practice shaping as you observe how the proportion and angle of the face changes at various angles.

Try maintaining the face's 3D effect at different angles through shaping!

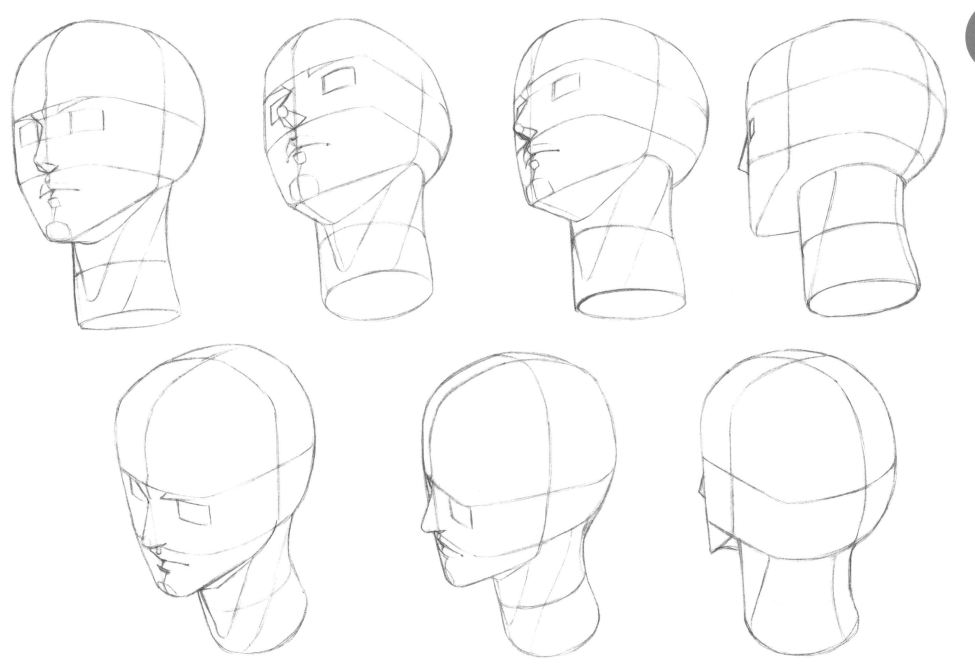

5 The Eyes, Mouth, & Nose

■ The Eyes in 3D

Human beings are the only species with wide white parts of the eyes. If the white part of animals' eyes are too distinct then it's easily revealed what they are staring at. For this reason, it becomes disadvantageous for survival. This is because when hunting, predators can read when their prey's guard isn't up, when they're emotionally disturbed, and the direction in which they intend to move. On the other hand, human beings endure that burden of danger. We look at each other as we live communally. In order to communicate we widened the parts of the eyes that are white.

(Eyeballs tremble) (Avoids eye contact)

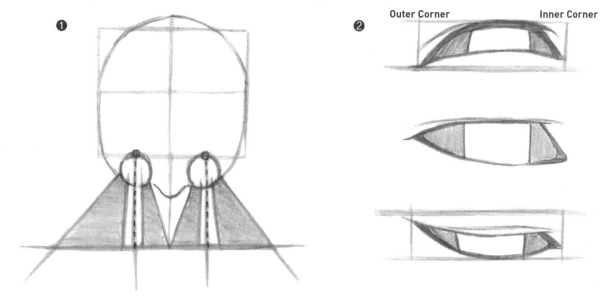

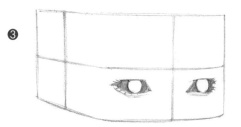

What Not To Do **Eye Form from a Diagonal View**

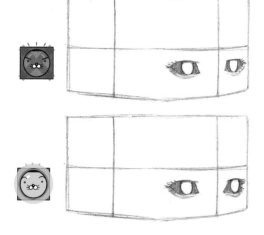

If you draw the whites of the eyes symmetrically, then the figure will look cross-eyed and the eyeballs will appear flat.

❶ The nose is located in between the eyes and obstructs their range of view, so there's no reason to widen the angle of view towards the inside. For this reason, the range of vision increases laterally for the outer corners of the eyes.

❷ The eyelids cover the eyeballs, which are spheres. So, when you look at them from above or below they are curved, like crescent moons. The point here is that you must draw the outer and inner corners of the eyes asymmetrically because the outer and inner corners open up differently.

❸ If you shift the angle which you are using to view the face, then the opposite eye's outer corner starts to disappear and the eye loses width. Be mindful not to draw the left and right sides of both eyes symmetrically when you are not drawing the face from a full front angle.

Westerners' & Easterners' Eyes

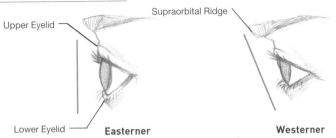

Upper Eyelid

Supraorbital Ridge

Lower Eyelid **Easterner**

Westerner

Easterners' upper and inner eyelid angles are vertical (90 degrees). However, Westerners' supraorbital ridge sticks out, so you must draw the eyes with an inward slant.

Plaster figures don't have eyelashes, so in order to truly express the line where the eyeball meets the upper eyelid you must thicken the part of the upper eyelid where it meets the eye and you must give it a shadow.

In actuality, our eyelids aren't thick like a plaster figure's eyelids are. You must keep this in mind when studying plaster figures!

Eye Characteristics at Different Angles

When looking up at the eyes from a low angle the gap between the eyebrow and eye itself increases. The thickness of the eyelid changes depending on the angle of view, so you must take great care in researching the flow of the eyelid, which encases the eye.

When looking down at the eyes from a high angle the gap between the eyebrow and eye itself decreases and the eyes become covered by the eyelashes. Be mindful not to draw the lower eyelashes so definitively.

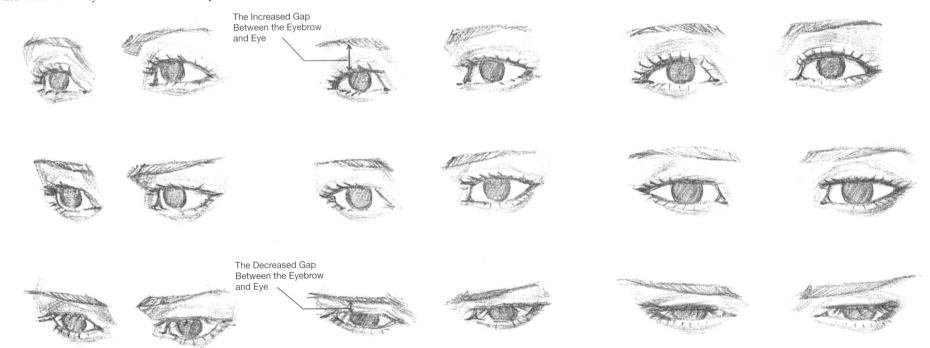

The Increased Gap Between the Eyebrow and Eye

The Decreased Gap Between the Eyebrow and Eye

■ Why Do Our Mouths Look Like This?

Why Our Mouths Are Small

As human beings came to utilize our hands, the need to bite with our mouths during hunting became obsolete and our mouths became smaller. Also, it became unnecessary to eat large amounts of food in one bite as we learned to store food, so the size of our mouths decreased.

The lips--the part of the mouth that expels heat--and the extra fat used to open the mouth all come together, so that area is thick.

When you understand the form of the mouth then what becomes important is that the lips cover the teeth in an outwardly curved shape (not straight up and down). Have you seen a horse? It's like that the teeth stick out and the lips cover the teeth, but their lips curve outwards in order to do so.

The Upper & Lower Lips

Why do you think our upper lip sticks out more than our lower lip? It's not because our upper lip is more thick. In fact, it's said that it's a phenomena that's due to the relationship between the two. Often times the lower row of teeth will cover the upper and create an "underbite". If this occurs then the lower lip ends up sticking out more than the upper. The reason why you can't see all of a person's upper and lower front teeth when they slightly open their mouth is because the location where the lips meet is actually the midway point of the upper row of teeth.

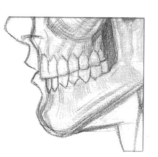

`What Not To Do` The Structure of the Lips

As is shown in the below drawings, the form of the lips can be divided into the central part of the upper lip that sticks out, the sections that form either side of that part that sticks out, and then the two sections of the bottom lip. If you express the line where the lips shut as straight, or if you put the part of the upper lip that sticks out at the center, then the lips will have a flat, 2D appearance.

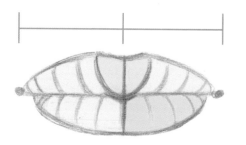 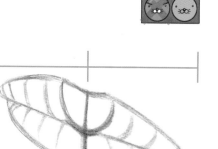

Take note of the different points that change according to the angle:

✔ The bend and curve of central lines
✔ The center and corners of the mouth

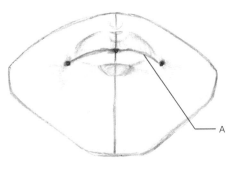

A

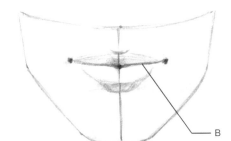

B

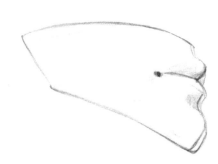

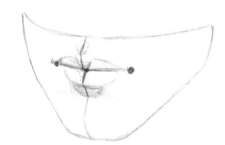

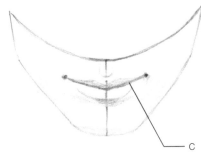

C

Shapes of the Lips According to the Angle

A: When you look up at the lips there is a line that appears in accordance with the shape of the lower lip.

B: This is the line that's formed between the upper and lower lips when you close your mouth.

C: When you look down at the lips there is a line that appears in accordance with the shape of the upper lip.

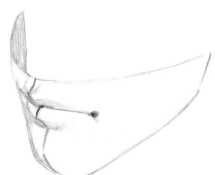

Ready for your lesson on giving your lips a three-dimensional feel? ;-)

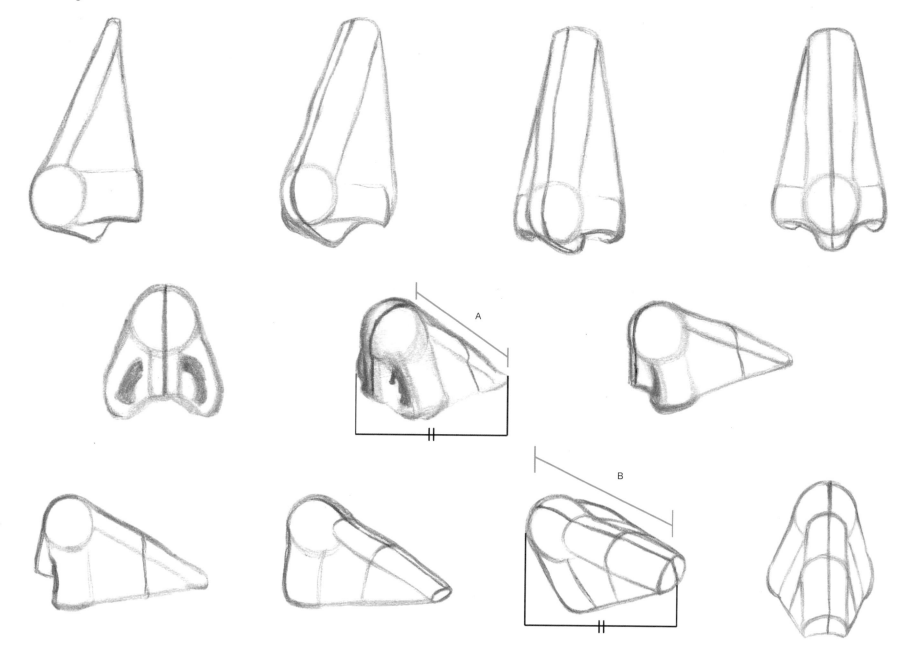

The nose is the part of the face that rises the highest and gives off the greatest 3D effect. It's located at the center of the face, so it plays the role of being the center line when deciding on the direction of the face. As is shown in Figure A on the previous page, when viewing the face from a low angle you see the bottom of the nose and the bridge of the nose becomes smaller. Figure B shows how when viewing the face from a high angle, the bridge of the nose doesn't become smaller but rather looks longer due to its incline. How about we take a closer look below?

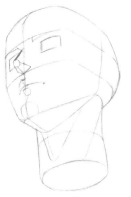

Nose Length According to the Angle

Looking at the face from the side, the length of the nose appears smaller than the distance from the tip of the nose to the bottom of the chin. However, when looking at the face from a high angle, the length of the nose and the distance from the tip of the nose to the bottom of the chin are almost the same. If you end up looking at the face from a high angle like this, you can observe that the nose becomes relatively longer.

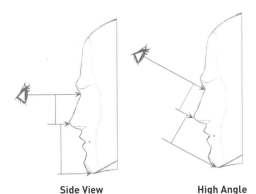

Side View **High Angle** **A Shorter Nose (Low Angle)** **A Longer Nose (High Angle)**

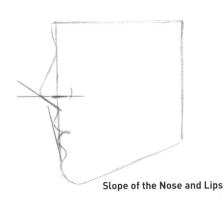

Slope of the Nose and Lips

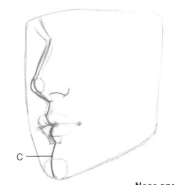

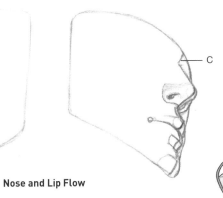

Nose and Lip Flow

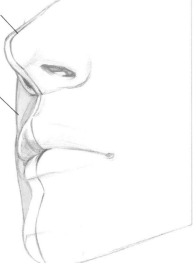

Green Area

Angle of the Face that Separates the Flow of the Nose and Lips from the Cheek on the Other Side Using a Line

The Connection Between the Nose & Mouth

Understand the formation and compare the slope of the nostrils, area below the nose, and upper and lower lips. Through C, the face's central line, take a good look at the flow of the slope that's created through the combination of the nose and lips. This is the part of the face that protrudes the most. When you draw the face from a diagonal angle you'll notice that there's a portion of the face that exists on the other side (the opposite cheek). I've colored it green. If you understand the structure and can express that area on the other side, then you have a solid understanding of the structure of the face!

6 Muscles in the Face & Expressions

■ Why Are There So Many Muscles in the Face?

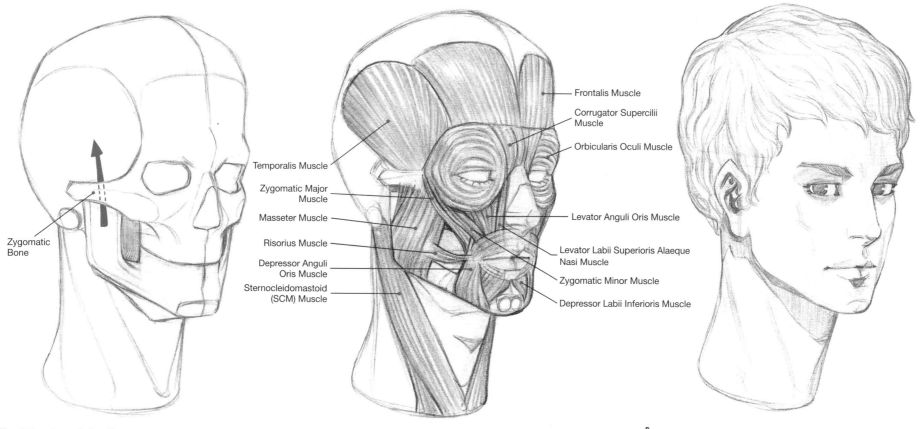

Temporalis Muscle

Zygomatic Major Muscle

Masseter Muscle

Risorius Muscle

Depressor Anguli Oris Muscle

Sternocleidomastoid (SCM) Muscle

Zygomatic Bone

Frontalis Muscle

Corrugator Supercilii Muscle

Orbicularis Oculi Muscle

Levator Anguli Oris Muscle

Levator Labii Superioris Alaeque Nasi Muscle

Zygomatic Minor Muscle

Depressor Labii Inferioris Muscle

The Muscles of the Face

The empty space in between the zygomatic bone, which stretches from the cheekbone to the ears, and the skull create a path and connect the muscles on the side of the forehead. This path heads towards the chin.

Additionally, if you look at the direction of the muscle fibers you can see in which direction the muscles contract and can thus predict the use of that muscle. There are many muscles that connect at the corners of the mouth, so the sides of the mouth are quite thick.

The muscles related to expression do not connect bone to bone--they connect bone to skin. So, expressions are created as the skin is pulled. What's interesting is that the only place you'll see muscle connecting bone to skin is in the face.

Let's take a look at the muscles that create facial expressions!

■ Smiling

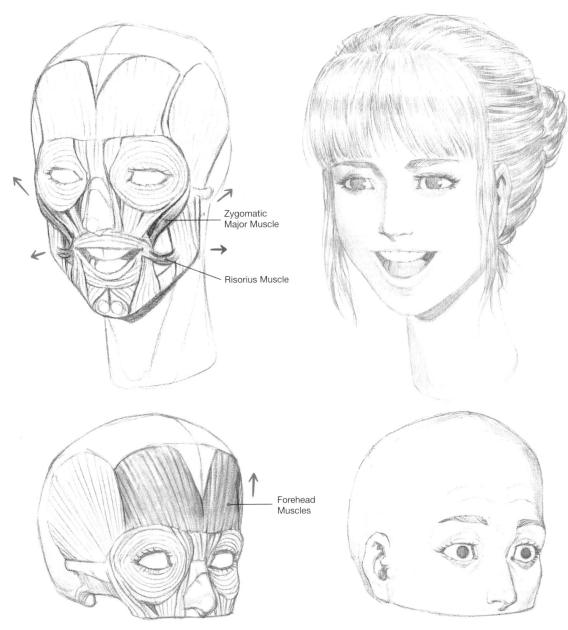

Zygomatic
Major Muscle

Risorius Muscle

Forehead
Muscles

The Muscles Used When Smiling

When you smile the muscles that typically move are the zygomatic major muscle and risorius muscle. When your wrinkles from smiling form and your cheekbones stick out, it's because of the way fat is pushed. The fat in the cheek that's pushed up also affects the eyes, so your eyes take a half-moon shape. When a person laughs you only see the top row of teeth. This is natural. If you end up seeing the bottom row of teeth it gives the feeling that you're giving a fake smile or you look mad.

HAHAHA!

Expression-less

If you show the bottom row of teeth it gives a scary feel, for whatever reason.

Forehead Muscles: The Reason Your Eyebrows Rise

You'll probably never see an older person without wrinkles on their forehead. You may be aware of the fact that from the time we're young we often raise our eyebrows when expressing ourselves. With a little bit of awareness you can see that not only do the forehead muscles create a "surprising" expression when a person lifts their eyes, but they are also used when making various other expressions. The wrinkles in the forehead appear when the muscles in the forehead contract and the surplus fat overlaps. Even now, you're probably contracting your forehead muscles and you're not even aware of it.

■ Angry Faces

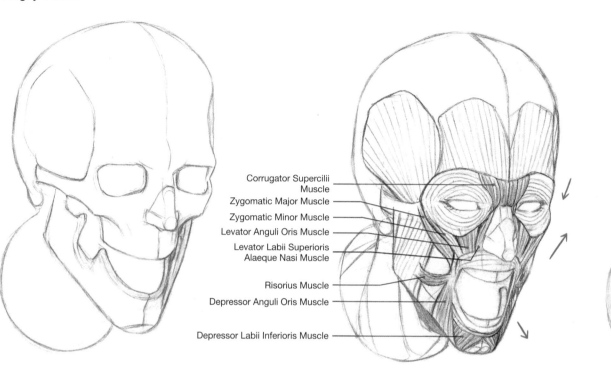

- Corrugator Supercilii Muscle
- Zygomatic Major Muscle
- Zygomatic Minor Muscle
- Levator Anguli Oris Muscle
- Levator Labii Superioris Alaeque Nasi Muscle
- Risorius Muscle
- Depressor Anguli Oris Muscle
- Depressor Labii Inferioris Muscle

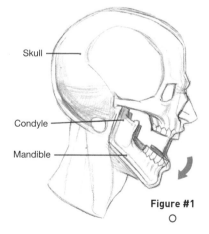

- Skull
- Condyle
- Mandible

Figure #1
O

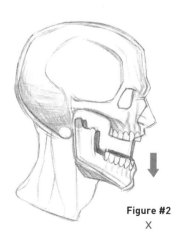

Figure #2
X

Shouting

A person uses more muscles in the face when they are frowning or shouting compared to when they are laughing. The main focus here in these expressions is the movement of the jaw joints. As is shown in Figure #1, when the mouth is opened, the lower jaw bone must draw a curve and the condyle must serve as the axis. However, many students often make the mistake of drawing their mouths to open vertically and not curved, as is shown in Figure #2. If the mouth opens vertically then the jaw joints drop. For this reason, you can see how this type of movement would be anatomically impossible. The condylar is a joint which connects the skull and lower jaw bone, so keep in mind that it can't be dislocated.

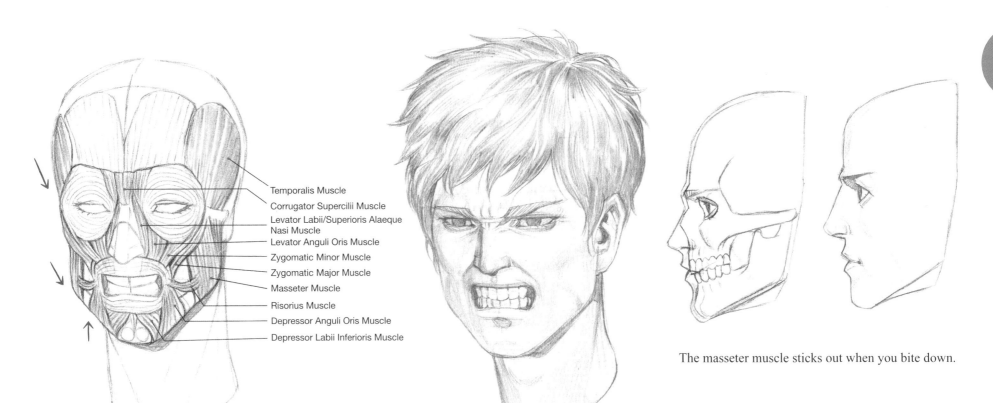

Temporalis Muscle

Corrugator Supercilii Muscle

Levator Labii/Superioris Alaeque Nasi Muscle

Levator Anguli Oris Muscle

Zygomatic Minor Muscle

Zygomatic Major Muscle

Masseter Muscle

Risorius Muscle

Depressor Anguli Oris Muscle

Depressor Labii Inferioris Muscle

The masseter muscle sticks out when you bite down.

Frowning & Showing Teeth

Of all the expressions we reviewed so far this one takes the greatest amount of muscles to do. When a person bites down on their molars and the teeth show, it gives off a threatening expression to an onlooker. You may also often observe this expression in animals. In all animals it takes more strength to close the mouth rather than open it. The reason is to allow for biting prey or chewing food. So, there are substantially more muscles used to close the mouth compared to opening it. As you can see in the above expression, when closing the mouth it gives off a more threatening feel compared to when opening the mouth. The temporalis and masseter muscles are used to close the mouth. The temporalis muscle has endurance when it comes to lightly closing the mouth, while the masseter muscle shows off great muscle strength when it comes to chewing something hard.

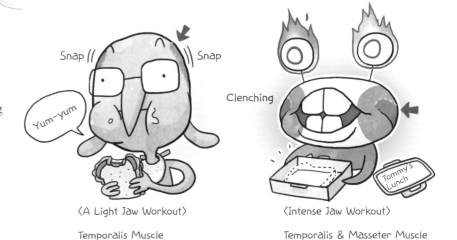

Snap Snap

Yum-yum

Clenching

Tommy's Lunch

〈A Light Jaw Workout〉

Temporalis Muscle Contraction

〈Intense Jaw Workout〉

Temporalis & Masseter Muscle Contraction

7 Natural Hair Styles

When drawing the head you can avoid the mistake of drawing the hair in a way where it burrows into the head or looks too smoky by drawing the hair with volume while at the same time being conscious of the head's appearance. There's a difference between men and women with regards to the starting location of the hairline. Men's hairline makes an "M" shape, while women's hairline takes a round shape. When expressing the hair, you don't draw it strand by strand. You must gather hair into a large bundle and as you go towards the end of the hair itself you separate the sections from one another. This is because hair overlaps as it's collected into bundles. Bundles of hair extend from hair whorls or parts and create a pattern or direction of flow from there.

Droop

Sir, your hair texture really isn't doing so well.

What Not To Do **Hair Volume & Flow**

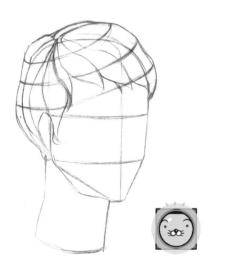

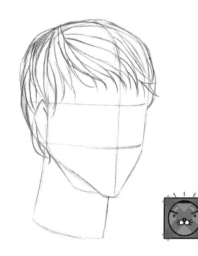

The hair makes layers and is piled up on top of the head, so you must give it volume. If you draw the hairline too perfectly then the head will look scant, as if it doesn't have any hair at all. The hair texture's flow has its center at hair whorls or parts. You must start depicting the hair after gaining a grasp on the flow. This would be even more important for long-haired characters, don't you think?

You're probably asking about my hair, right? I shaved my head ;-)

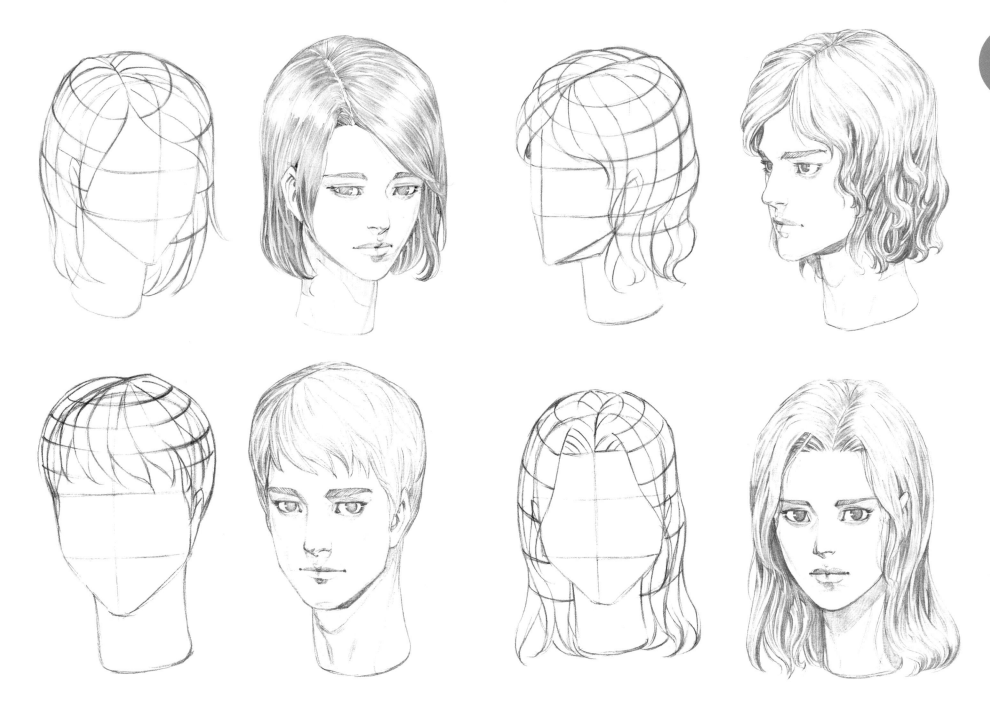

Various Hairstyles

Hair whorl and part locations have the greatest effect on hair style, and professional hair styles are more present depending on hair length.
So, don't imagine and create hair styles of your own. Refer to actual professional hair designs so that you can express sophisticated hair styles in line with the times.

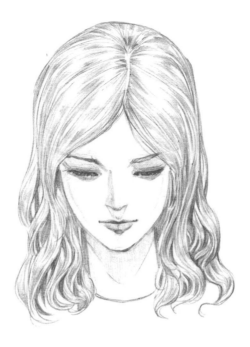

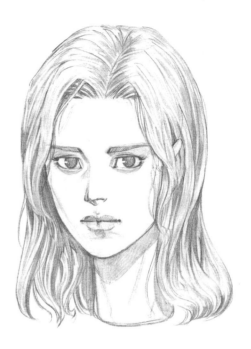

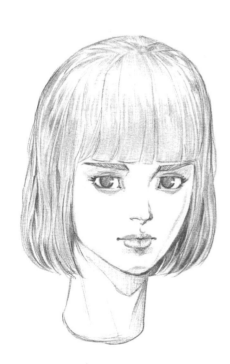

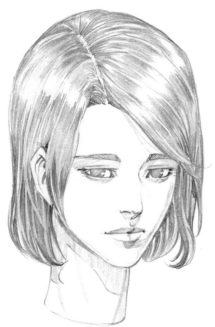

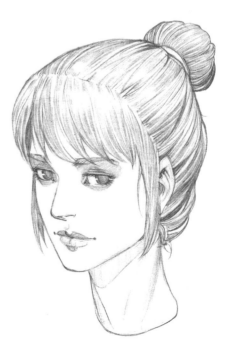

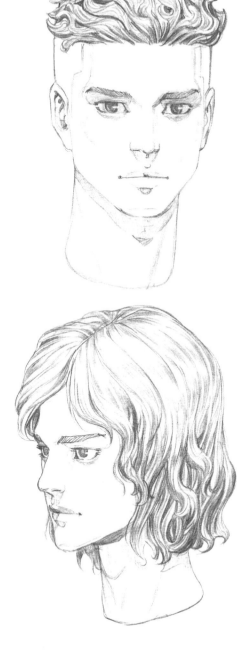
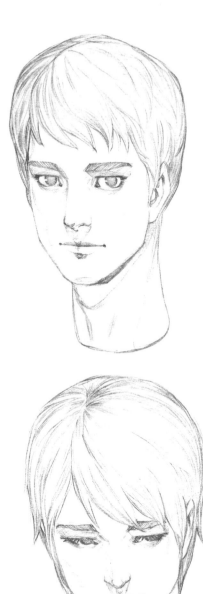
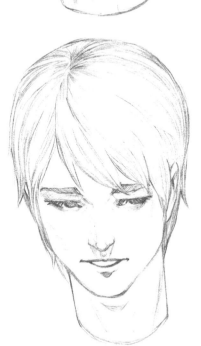
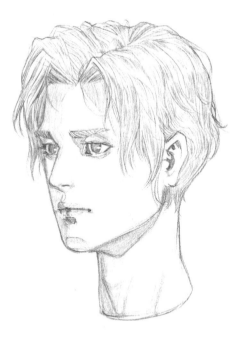
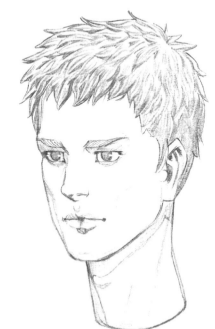

8 Various Head Angles

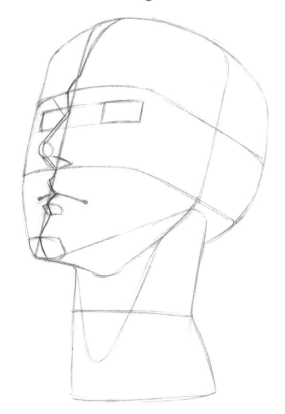
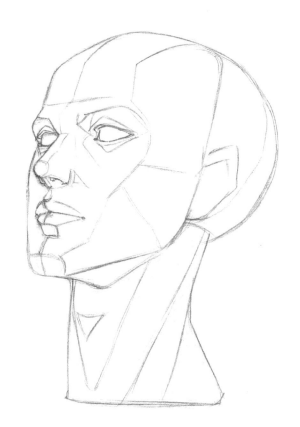
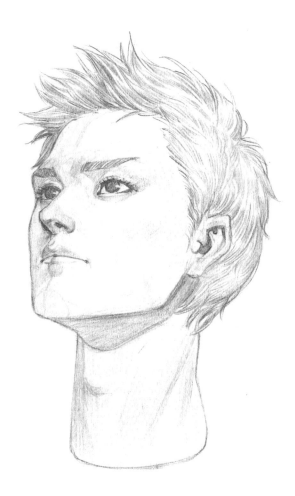

We recognize faces more than we do any other points on the body. And, the shape of the eyes, nose and mouth, which make up the face, are complicated. For this reason, when you turn the angle of the head you need an understanding of accurate proportion and form. No matter how precisely you understand eye form, nose form, and mouth form alone, if you're lacking in your understanding of the different territories of the face then you can't draw a face at different angles. In order to understand the areas that connect the eyes, nose and mouth you need practice developing your siding technique after shaping.

The bone structure must serve as the basis for your shaping. When you draw the face you first determine the direction of the face, then draw the entire volume of the head accordingly, and lastly decide on the location and proportions of the eyes, nose and mouth according to the angle. If you intend to add real-life light and shade, then you must understand the flow of the structure of the face through each side.

Kim TV

Do not, I say do not start by drawing the eyes, like Tommy does.

Eyelashes and pupils!

Yeah, yeah~

Tommy

What do you draw first on the face? —The EYES, of course!

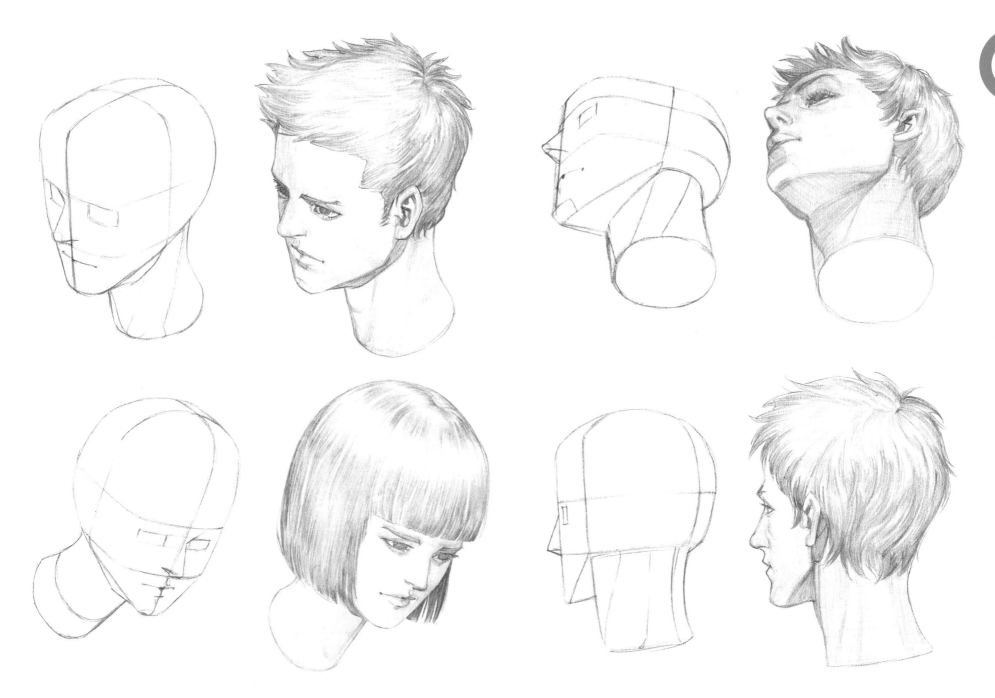

9 Muscles & Movement of the Neck

■ The Sternocleidomastoid Muscle Stands Out the Most!

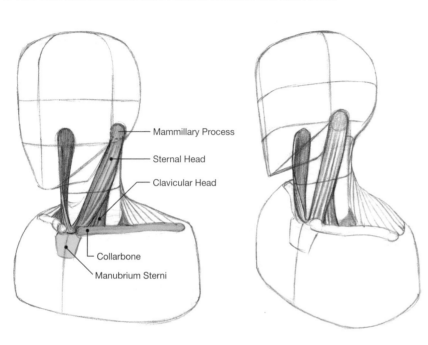

Mammillary Process
Sternal Head
Clavicular Head
Collarbone
Manubrium Sterni

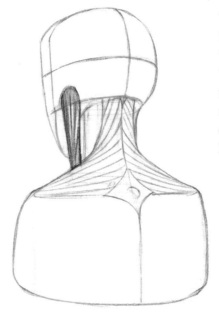

Start & End Points

Try touching the back of your ear. There's a bone there that sticks out, right? This is your "mammillary process".
The sternocleidomastoid muscle starts here at the mammillary process, travels to the manubrium sterni, and then is divided by the clavicular head, which is made up of the sternal head and collarbone.

Look at a mirror and try turning your head side-to-side.

Mirror, mirror on the wall...

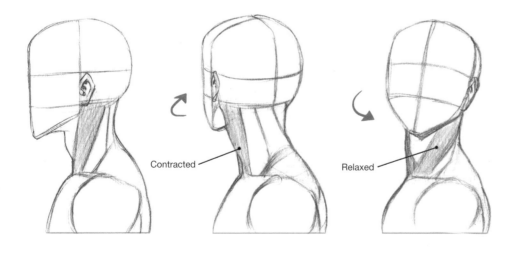

Contracted

Relaxed

Use

Turn your head left to right and bend it forward.

Characteristics

The sternocleidomastoid muscle has the greatest effect on the neck's outline and brings out the thickness of the neck. So, it's a very important point that you can't leave out when expressing the neck. There are several muscle heads in the neck outside of the sternocleidomastoid muscle, but they don't stick out well. Express the sternocleidomastoid muscle and trapezius muscle when you draw. For the rest, it's natural to group them together into one large muscle.

■ Upper Trapezius Muscle - The "Bridge"

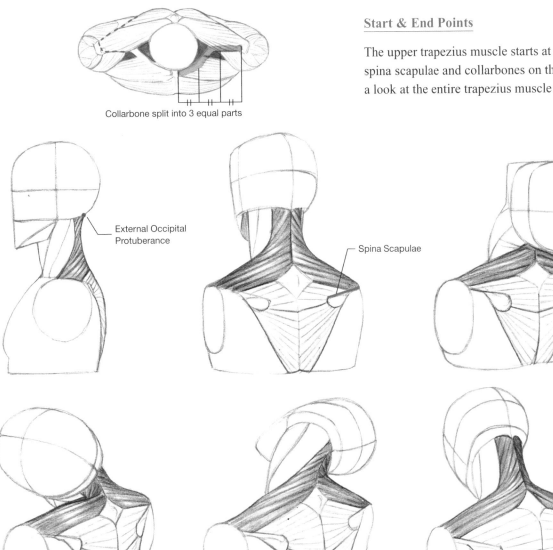

Collarbone split into 3 equal parts

External Occipital Protuberance

Spina Scapulae

Start & End Points

The upper trapezius muscle starts at the external occipital protuberance and connects at both of the spina scapulae and collarbones on their lateral sides at 1/3 of the way through its length. Let's take a look at the entire trapezius muscle from the rear.

Use

The upper trapezius muscle plays the role of lifting the head, leaning it to either side, and turning it. The clavicle and shoulder blades are connected to the neck bone and play the role of supporting the shoulders.

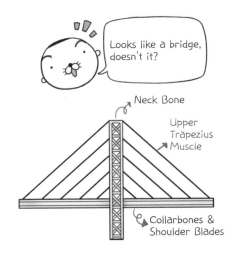

Looks like a bridge, doesn't it?

Neck Bone

Upper Trapezius Muscle

Collarbones & Shoulder Blades

■ Understanding the Movements of the Neck

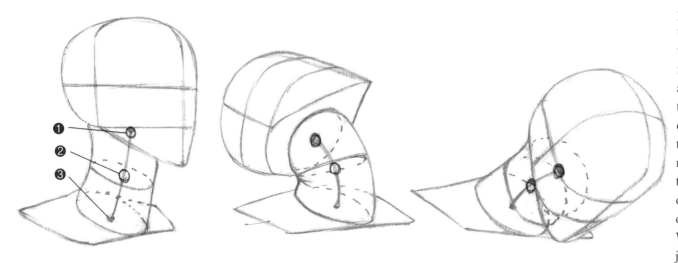

The joints of the neck bone are located at the center of the neck. The neck bends more when you lean the head back versus when you bend the neck forward. When you bend the neck back, wrinkles form at the nape. If you bend the neck forwards and backwards the neck's length appears to change when you are looking from the outside, so you must always keep your mind on the neck's central bone frame when you are thinking of the movement of the neck. When you move the neck, joint ❷ is at the center and has the greatest amount of bend. The joint in the area of ❸ doesn't have a large degree of bend, so it only serves to support the movement of joint ❷. When you turn the neck from left to right it's joint ❶ that becomes the center and does the turning.

What Not To Do **The Space Between the Collarbone & Neck**

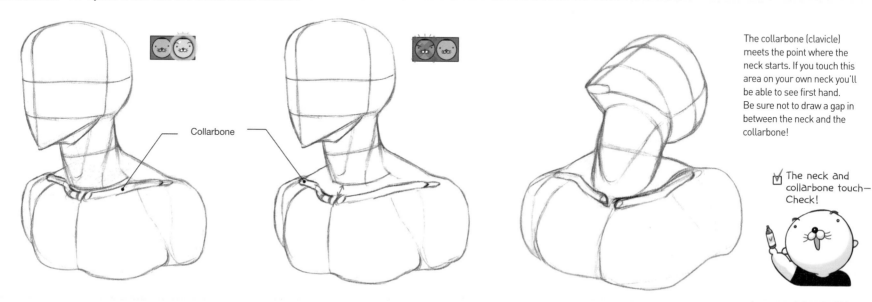

Collarbone

The collarbone (clavicle) meets the point where the neck starts. If you touch this area on your own neck you'll be able to see first hand. Be sure not to draw a gap in between the neck and the collarbone!

☑ The neck and collarbone touch— Check!

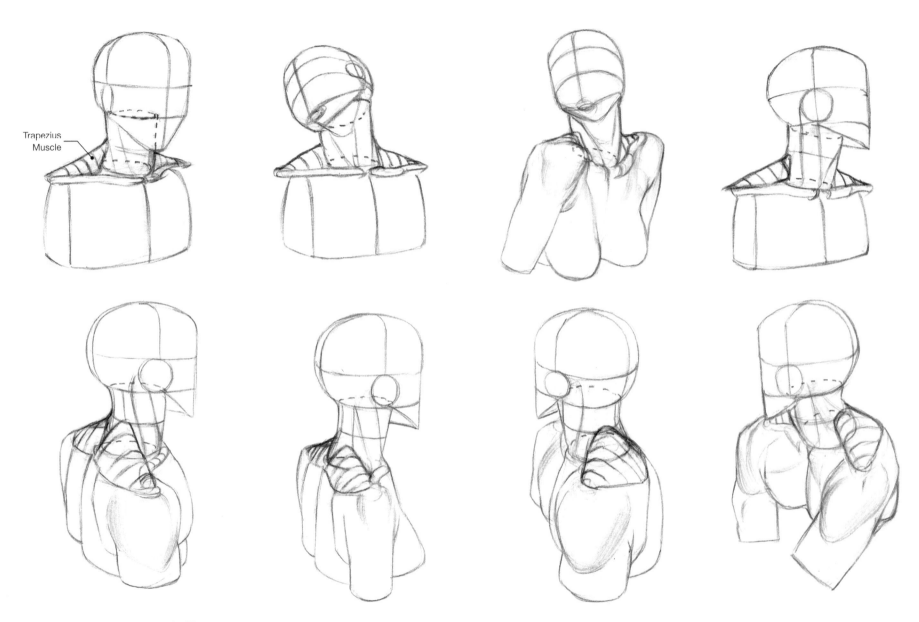

Trapezius
Muscle

Trapezius Muscle - Changes in Form

Don't think of the area where the neck and trapezius muscle connect as having the same flow. Instead, look at the neck like a cylinder (see above) and the trapezius as a muscle that isn't fixed. This is because the trapezius muscle's form changes in accordance with the location of the point at which the shoulder ends.

03
Anatomy Drawing

Let's understand the body's principles of motion through muscle location and form.
By understanding the internal body structure you can naturally express a body's appearance when it changes through movement.

Muscle Structure & Movement

Despite living in an era where body anatomy was taboo, why did Leonardo da Vinci and Michelangelo focus on it? They produced works by placing actual models in front of them. The two artists felt limited by using only external information about the body. Consequently, as they themselves researched the body's internal structure they were able to innovate and develop levels of body depiction. If they were to rely solely on reference materials without a structured understanding, then it would have taken great deals of time in order to depict the postures they wanted to or locate material that had the exact angles they desired. There was also the possibility of incorrectly drawing a body while looking at an inaccurate form due to a model's body type or the angle of light. They were illustrators and cartoonists, and illustrators and cartoonists must learn to create and draw bodies from various angles and in different postures without the use of actual models. Moreover, it's necessary to know the structure of the body and principles of movement. There are often educators who state that there's no need to put a great deal of weight on the study of anatomy, claiming that by studying anatomy one harms the natural appearance of the body. If I'm to state my opinion as the author of a book on human anatomy then I would say that one can't study the body through anatomy alone. But, anatomy is a necessary subject when it comes to properly creating the human body. Of course, if one overdoes it with anatomy and tries to draw a figure, then the body will come out stiff or have an unnatural flow, which would be in line with the claim of various educators I mentioned earlier. However, you mustn't neglect the study of anatomy after taking into consideration these side effects. In order to draw the human body naturally you must be able to apply anatomy according to the situation at-hand after studying it deeply. I think that "After properly studying anatomy I'll use it as necessary" is a good stance, rather than "I'm not going to bother with it at all if I can't use it fully". A high level of understanding of the human body will provide you with a reinforced foundation with which you can express what you're trying to express without blockages. I'm going to reiterate once again the fact that overexaggerating, underexaggerating, omissions, and changes with regards to the body are possible when you are well-informed about basic form. With that I'll ask, are you ready to start this next chapter and learn about Figure Drawing?

Rather than starting like this it's better to...

...practice like this...

...and look up things you want to know the moment they come up.

You'll get a lot more studying done this way.

Tips for Studying Muscles

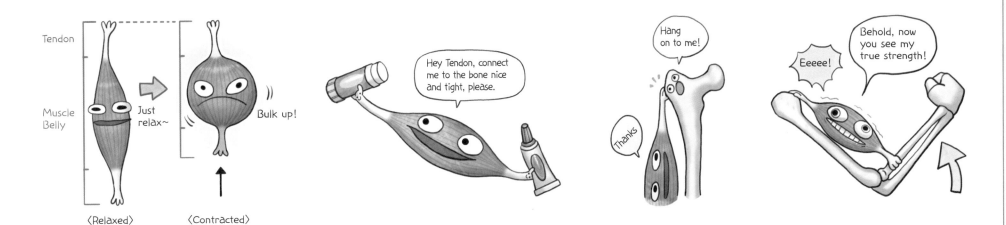

Tendon

Muscle Belly

Just relax~

Bulk up!

〈Relaxed〉 〈Contracted〉

Hey Tendon, connect me to the bone nice and tight, please.

Hang on to me!

Thanks

Behold, now you see my true strength!

Eeeee!

If you learned the movements of the joints through a simplified frame in Chapter 1 (Shaping), then in this part of the book you'll learn about the muscles which are attached to the actual bone structure. First, know that muscles are made up of tendons and muscle bellies and when muscles are engaged the muscle belly becomes shorter and its volume increases. On the other hand, tendons don't contract and release. Tendons play the role of an adhesive, as they attach muscle belly to bone. For this reason, Tendons always exist at the end of fat bellies. Tendons vary in length and area according to the muscle.

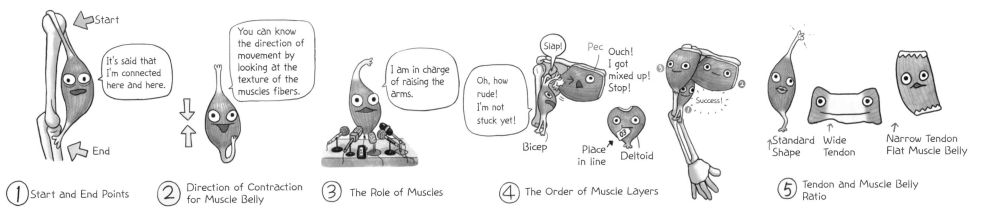

Start

It's said that I'm connected here and here.

End

① Start and End Points

You can know the direction of movement by looking at the texture of the muscles fibers.

② Direction of Contraction for Muscle Belly

I am in charge of raising the arms.

③ The Role of Muscles

Oh, how rude! I'm not stuck yet!

Slap!

Pec Ouch! I got mixed up! Stop!

Success!

Bicep

Place in line

Deltoid

④ The Order of Muscle Layers

Standard Shape

Wide Tendon

Narrow Tendon Flat Muscle Belly

⑤ Tendon and Muscle Belly Ratio

1 Location & Usage of the Muscles in the Upper Torso

■ The "Pushin' Pecs" (Pectoralis Major Muscles)

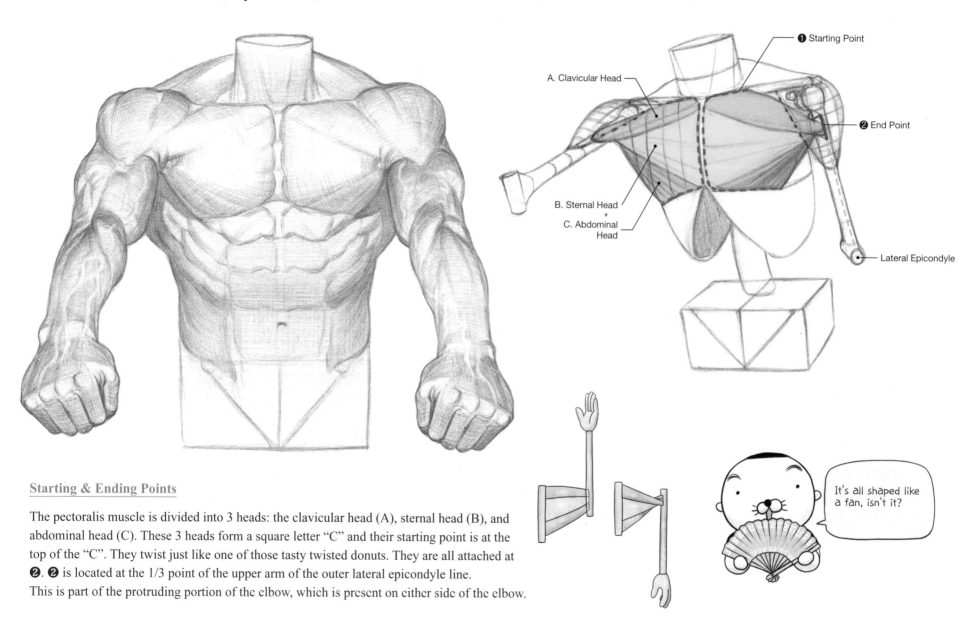

❶ Starting Point

A. Clavicular Head

❷ End Point

B. Sternal Head

C. Abdominal Head

Lateral Epicondyle

It's all shaped like a fan, isn't it?

Starting & Ending Points

The pectoralis muscle is divided into 3 heads: the clavicular head (A), sternal head (B), and abdominal head (C). These 3 heads form a square letter "C" and their starting point is at the top of the "C". They twist just like one of those tasty twisted donuts. They are all attached at ❷. ❷ is located at the 1/3 point of the upper arm of the outer lateral epicondyle line. This is part of the protruding portion of the elbow, which is present on either side of the elbow.

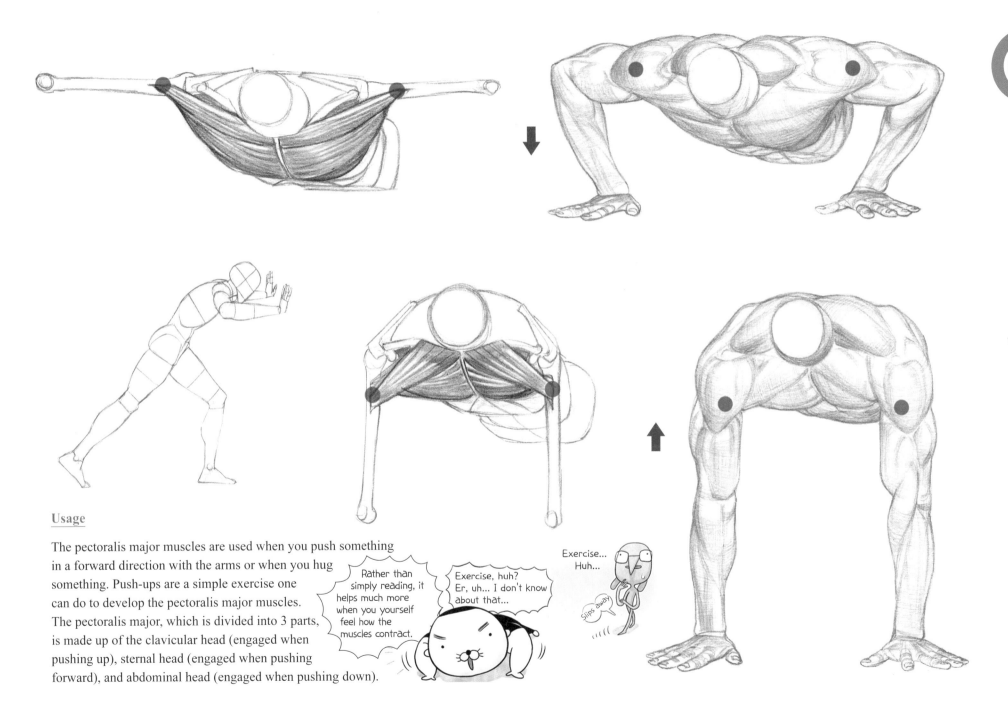

Usage

The pectoralis major muscles are used when you push something in a forward direction with the arms or when you hug something. Push-ups are a simple exercise one can do to develop the pectoralis major muscles. The pectoralis major, which is divided into 3 parts, is made up of the clavicular head (engaged when pushing up), sternal head (engaged when pushing forward), and abdominal head (engaged when pushing down).

Rather than simply reading, it helps much more when you yourself feel how the muscles contract.

Exercise, huh? Er, uh... I don't know about that...

Exercise... Huh...

Slips away

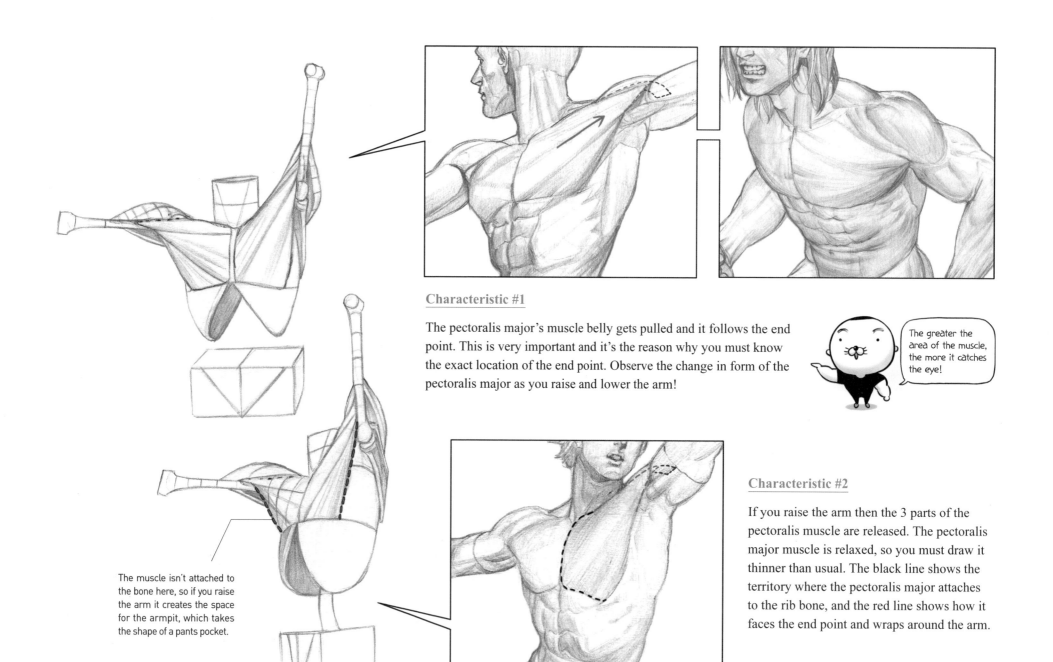

Characteristic #1

The pectoralis major's muscle belly gets pulled and it follows the end point. This is very important and it's the reason why you must know the exact location of the end point. Observe the change in form of the pectoralis major as you raise and lower the arm!

The greater the area of the muscle, the more it catches the eye!

The muscle isn't attached to the bone here, so if you raise the arm it creates the space for the armpit, which takes the shape of a pants pocket.

Characteristic #2

If you raise the arm then the 3 parts of the pectoralis muscle are released. The pectoralis major muscle is relaxed, so you must draw it thinner than usual. The black line shows the territory where the pectoralis major attaches to the rib bone, and the red line shows how it faces the end point and wraps around the arm.

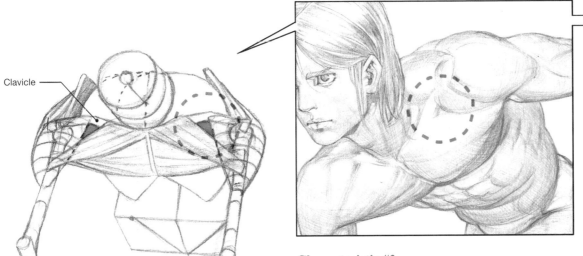

Clavicle

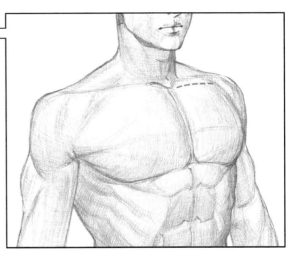

Characteristic #3

The area under the clavicle that's caved in is empty. The more you develop the muscle the more concave it becomes.

Characteristic #4

The pectoralis muscle is attached below the clavicle, so even if you develop the muscle the lower part of the clavicle doesn't protrude.

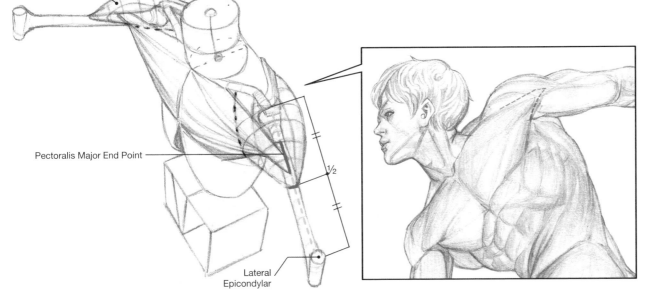

Deltoid Muscle

Pectoralis Major End Point

1/2

Lateral Epicondylar

Overlapping

The deltoid muscle covers the top of the end point of the pectoralis muscle. The deltoid muscle is attached at the halfway point of the humerus' lateral epicondyle.

Be sure to know the starting and ending points of muscles!

Find the hidden end point!

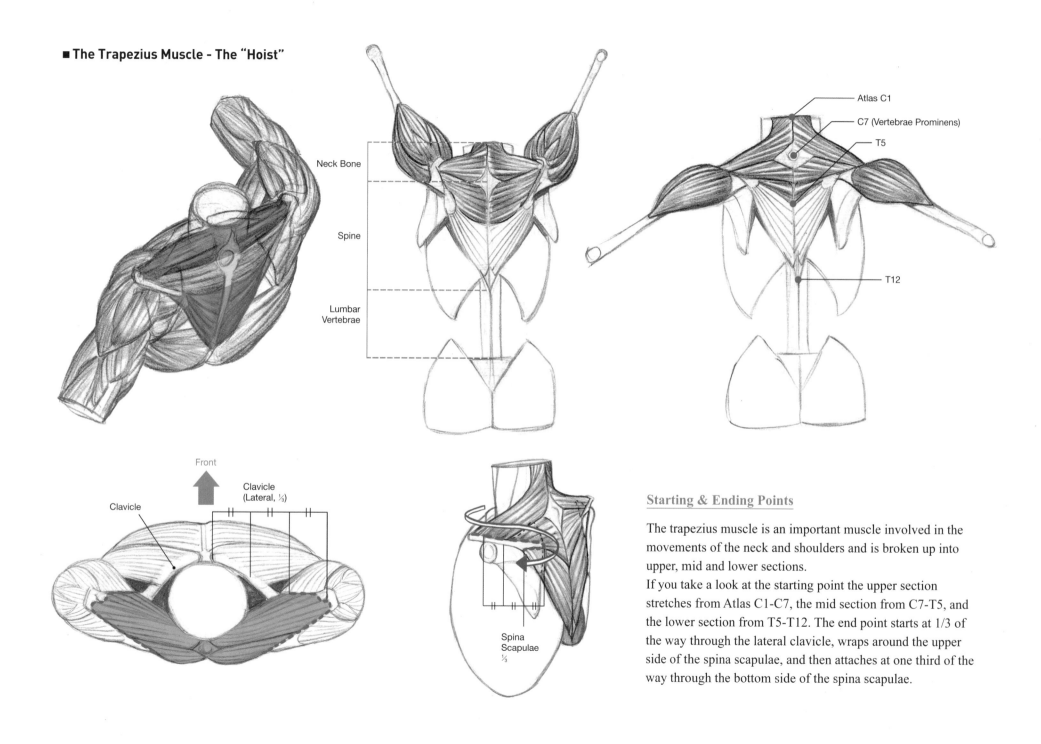

■ The Trapezius Muscle - The "Hoist"

Neck Bone

Spine

Lumbar
Vertebrae

Atlas C1

C7 (Vertebrae Prominens)

T5

T12

Front

Clavicle

Clavicle
(Lateral, ⅓)

Spina
Scapulae
⅓

Starting & Ending Points

The trapezius muscle is an important muscle involved in the
movements of the neck and shoulders and is broken up into
upper, mid and lower sections.

If you take a look at the starting point the upper section
stretches from Atlas C1-C7, the mid section from C7-T5, and
the lower section from T5-T12. The end point starts at 1/3 of
the way through the lateral clavicle, wraps around the upper
side of the spina scapulae, and then attaches at one third of the
way through the bottom side of the spina scapulae.

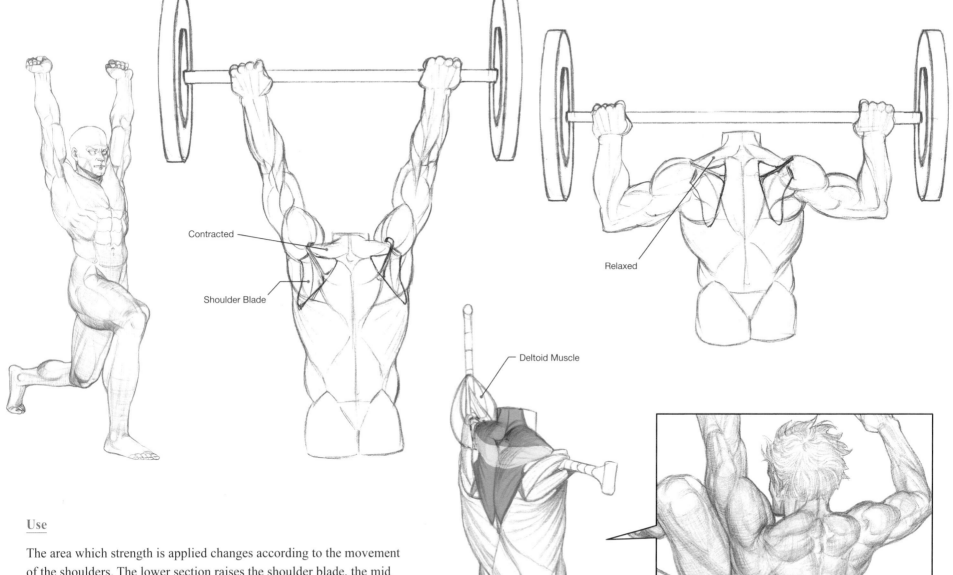

Contracted

Shoulder Blade

Relaxed

Deltoid Muscle

Use

The area which strength is applied changes according to the movement
of the shoulders. The lower section raises the shoulder blade, the mid
section pulls the shoulder blade to the rear, and the lower section
lowers the shoulder blade. When you lift something heavy, as is shown
in the above drawing the lower and mid sections of the trapezius
muscle are used and the deltoid muscle assists.

Characteristics

A, the empty sections located in between the lower trapezius muscle and neck, is a section that protrudes outward,
so please remember it. B and C are tendons for the trapezius muscle. When the muscles contract they become more concave.

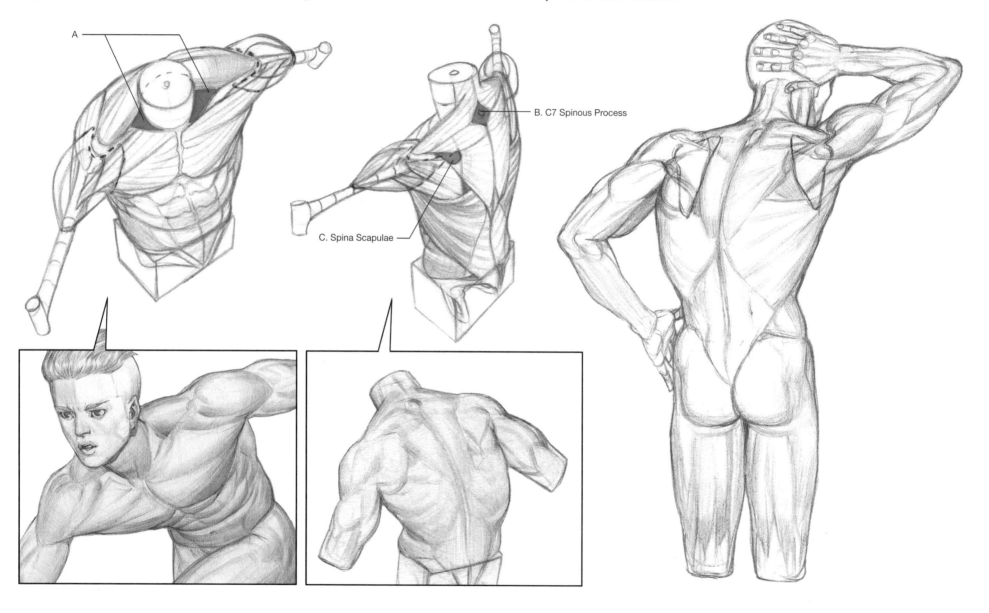

A

B. C7 Spinous Process

C. Spina Scapulae

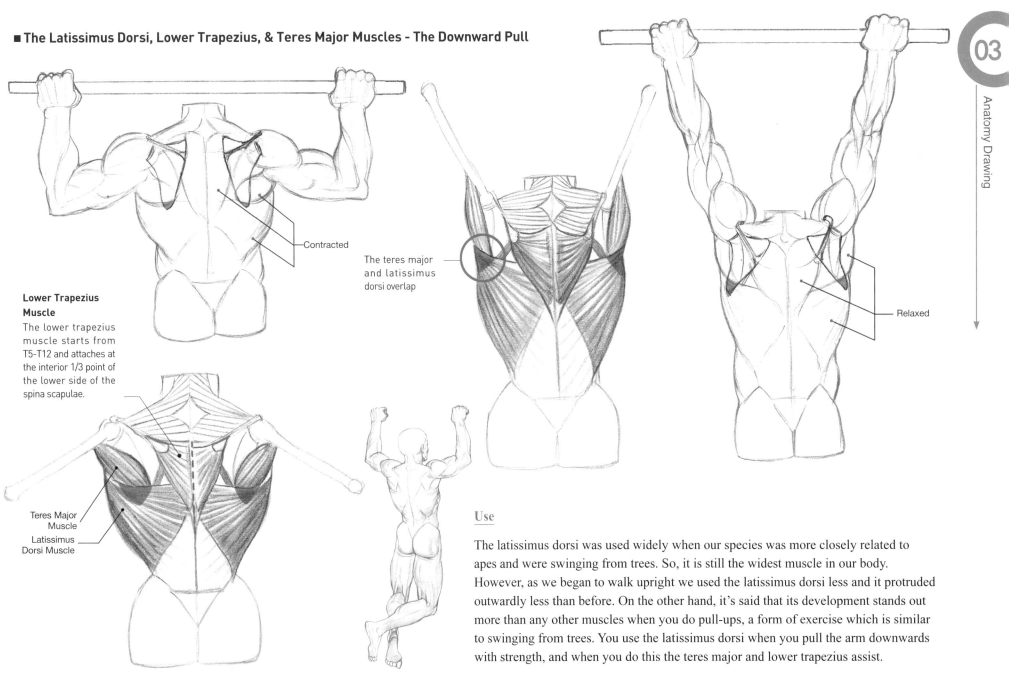

■ **The Latissimus Dorsi, Lower Trapezius, & Teres Major Muscles - The Downward Pull**

Contracted

Lower Trapezius Muscle

The lower trapezius muscle starts from T5-T12 and attaches at the interior 1/3 point of the lower side of the spina scapulae.

The teres major and latissimus dorsi overlap

Relaxed

Teres Major Muscle

Latissimus Dorsi Muscle

Use

The latissimus dorsi was used widely when our species was more closely related to apes and were swinging from trees. So, it is still the widest muscle in our body. However, as we began to walk upright we used the latissimus dorsi less and it protruded outwardly less than before. On the other hand, it's said that its development stands out more than any other muscles when you do pull-ups, a form of exercise which is similar to swinging from trees. You use the latissimus dorsi when you pull the arm downwards with strength, and when you do this the teres major and lower trapezius assist.

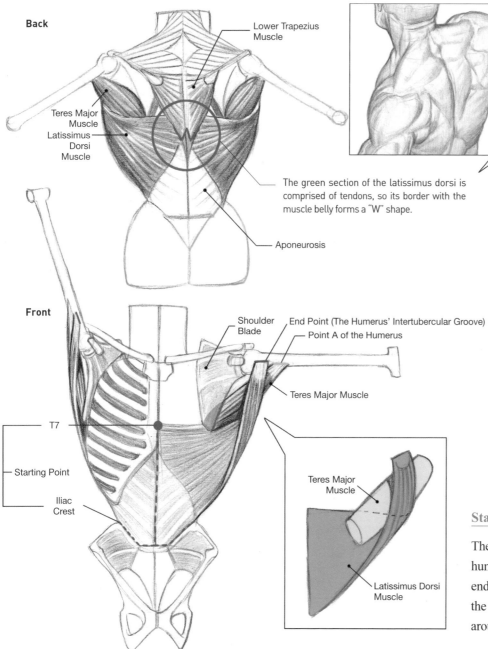

Back

Lower Trapezius Muscle

Teres Major Muscle

Latissimus Dorsi Muscle

The green section of the latissimus dorsi is comprised of tendons, so its border with the muscle belly forms a "W" shape.

Aponeurosis

Front

Shoulder Blade

End Point (The Humerus' Intertubercular Groove)

Point A of the Humerus

Teres Major Muscle

T7

Starting Point

Iliac Crest

Teres Major Muscle

Latissimus Dorsi Muscle

Characteristic

The "aponeurosis" is the area of widely spread tendons in the latissimus dorsi muscle. The area of the aponeurosis appears significantly wider than the area of tendons for other muscles. You must have a good grasp of the border between the muscle belly fibers and area of tendons in order to give an accurate portrayal when muscles are contracting and relaxing.

Overlap

The latissimus dorsi and trapezius muscles overlap from T7 to T12 and the amount that the trapezius muscle covers the latissimus dorsi is shown in the colored portion of the figure below.

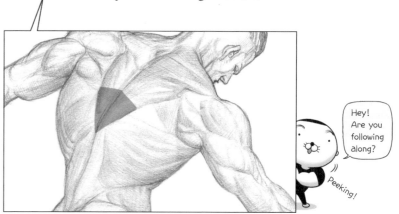

Hey! Are you following along?

Peeking!

Starting & Ending Points

The latissimus dorsi follows the spine at T7 and starts at the iliac crest, then it ends at the humerus' intertubercular groove. After the starting point widens it aims towards the ending point and the muscle appears to thin out. The teres major attaches at Point A of the humerus below the scapula. The latissimus dorsi covers the teres major as it wraps around it. We'll look more into the teres major in the following pages.

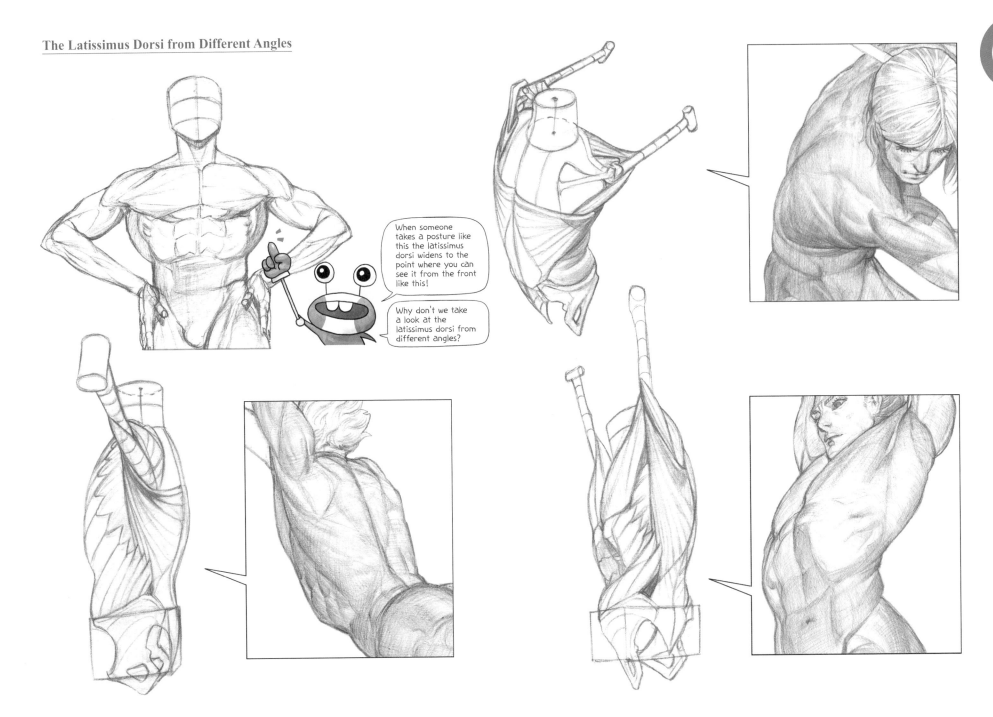

When someone takes a posture like this the latissimus dorsi widens to the point where you can see it from the front like this!

Why don't we take a look at the latissimus dorsi from different angles?

■ Infraspinatus & Teres Major - The Muscles that Assist with Pulling

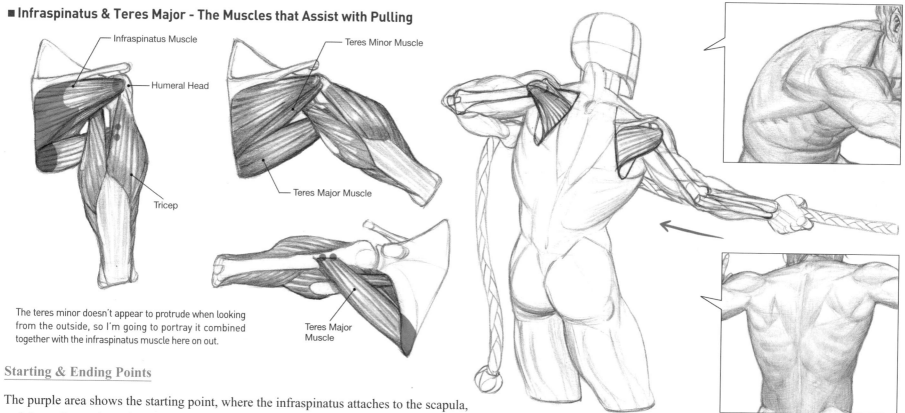

Infraspinatus Muscle

Humeral Head

Tricep

Teres Minor Muscle

Teres Major Muscle

Teres Major Muscle

The teres minor doesn't appear to protrude when looking from the outside, so I'm going to portray it combined together with the infraspinatus muscle here on out.

Starting & Ending Points

The purple area shows the starting point, where the infraspinatus attaches to the scapula, and the ending point, where it touches the humeral head.

The crimson area shows the teres major's starting point, where it attaches to the bottom of the humerus, and the ending point, where it touches the anterior side of the arm of the humerus.

Use

The infraspinatus and teres major pull the arm to the rear in order to carry out a pulling motion.

Overlap

The trapezius muscle covers most of the region where the infraspinatus and teres major muscles intertwine, so this complex structure doesn't really protrude. However, it's a region that you must study in order to understand principles of movement and operation. The more movement there is in this area the more complex it becomes, so we will navigate it in great detail.

I'm loosing my mind...

On vacation

Ana! Don't give up!

■ The Rhomboid Muscles - Shoulder Hoists

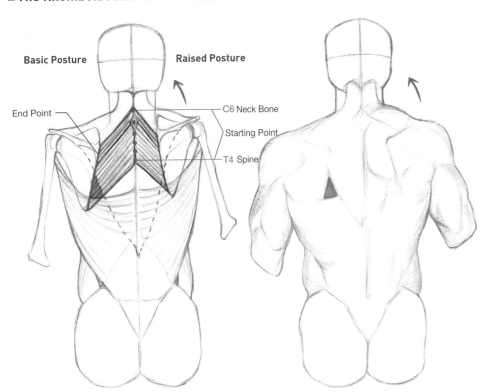

Basic Posture **Raised Posture**

End Point

C6 Neck Bone

Starting Point

T4 Spine

Figure 1-1

Figure 1-2

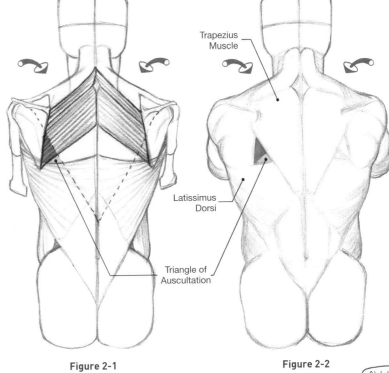

Trapezius
Muscle

Latissimus
Dorsi

Triangle of
Auscultation

Figure 2-1

Figure 2-2

You must know the numbers of the areas of the spinal column attached to the back muscles.

Starting & Ending Points

As is shown in Figure 1-1 the rhomboid muscles start at C6, pass T4, then touch the interior edge of the scapula.

Use

The rhomboid muscles pull the shoulders towards the back while also raising them. If you look at Firgure 1-2 then you can observe how the rhomboid muscles protrude when they contract. If you push the shoulders as far forward as possible, then the rhomboids will go into their most relaxed state. If you look at Figure 2-1 and 2-2 you'll see that they don't affect the outward appearance, which is different compared to when they are contracted.

Overlapping

The rhomboid muscles are mostly covered up by the trapezius and latissimus dorsi (with the exception of the triangle of auscultation).

Characteristics

The triangle of auscultation is the area where doctors place the stethoscope on you, hence the name "Triangle of Auscultation". This area widens when you push the shoulders forward, as is shown in Figures 2-1 and 2-2.

Alright. Now, bend forward at the waist.

Oh, my..

■ The Erector Muscles of the Spine (Erector Spinae) - Lower Back Support

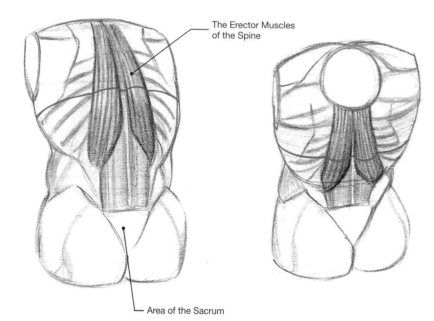

The Erector Muscles of the Spine

Area of the Sacrum

Starting & Ending Points

The "erector muscle of the spine" is made up of the spinalis, longissimus, and iliocostalis. The picture to the left is simplified, as it shows these three muscles grouped into one. Please understand that I portrayed these muscles differently than their actual form in order to help you understand them. The erector muscle of the spine starts below the skull and follows the spinal cord all the way to the sacrum, where it ends.

Use

You use the erector muscle of the spine when you bend your lower back backwards and it supports your posture.

The muscle is deep inside the body. But, it is a large muscle with so much volume and thickness that it protrudes.

Erector spinae workout

Overlapping

The muscle is located at the deepest level among the back muscles and it's directly connected to the bone.

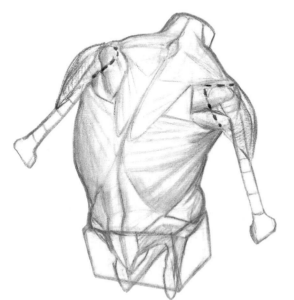

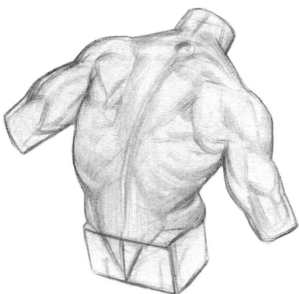

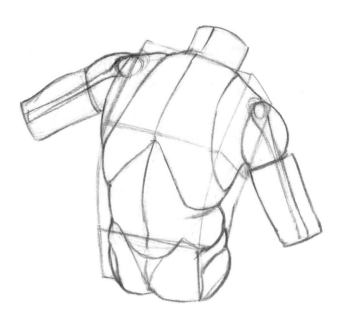

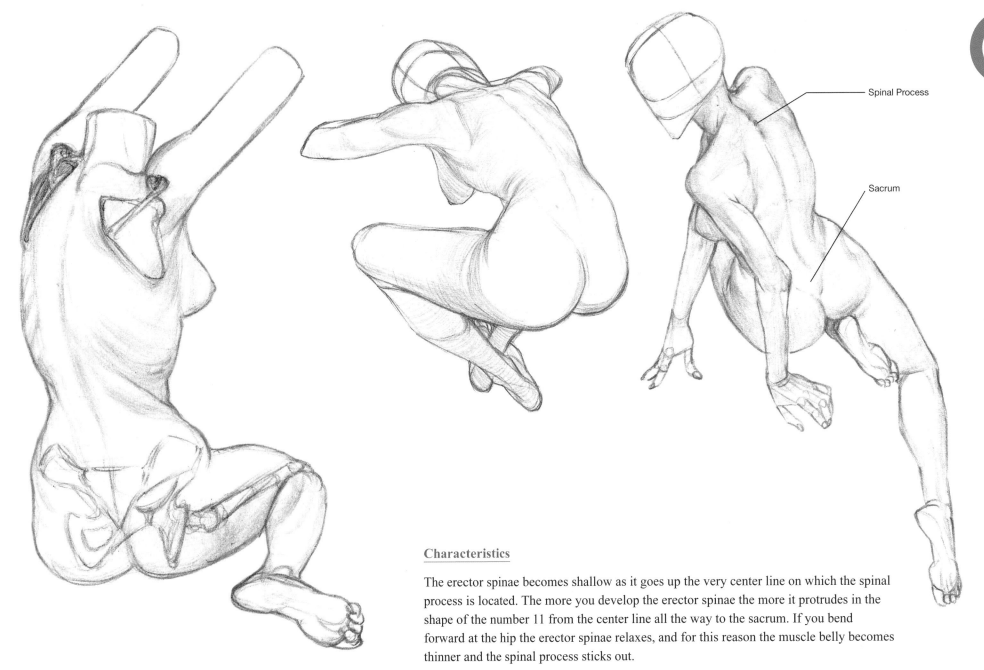

Spinal Process

Sacrum

Characteristics

The erector spinae becomes shallow as it goes up the very center line on which the spinal process is located. The more you develop the erector spinae the more it protrudes in the shape of the number 11 from the center line all the way to the sacrum. If you bend forward at the hip the erector spinae relaxes, and for this reason the muscle belly becomes thinner and the spinal process sticks out.

■ Serratus Anterior - Push Those Shoulders Forward!

Starting & Ending Points

The serratus anterior is attached from ribs #1-9 and connects at the interior edge of the scapula. It looks just as if you were to wrap your hand around the thoracic cage.

Overlapping

The pectoralis majors cover the top of the serratus anterior as well as the heads of 4-5 of the serratus anterior. The area which connects to the external oblique abdominal muscles and appear like a saw stick out when you raise the arm.

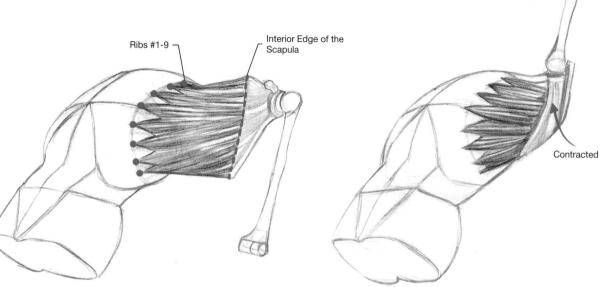

Ribs #1-9

Interior Edge of the Scapula

Contracted

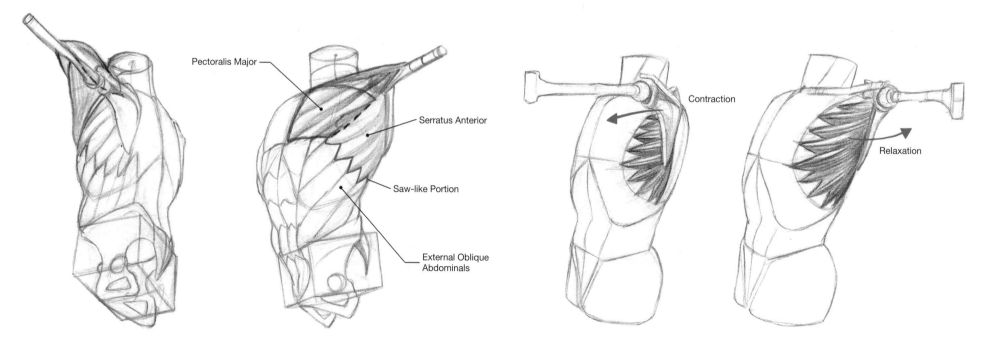

Pectoralis Major

Serratus Anterior

Saw-like Portion

External Oblique Abdominals

Contraction

Relaxation

Use

The serratus anterior is used whenever you hug something or push forward with the shoulders.

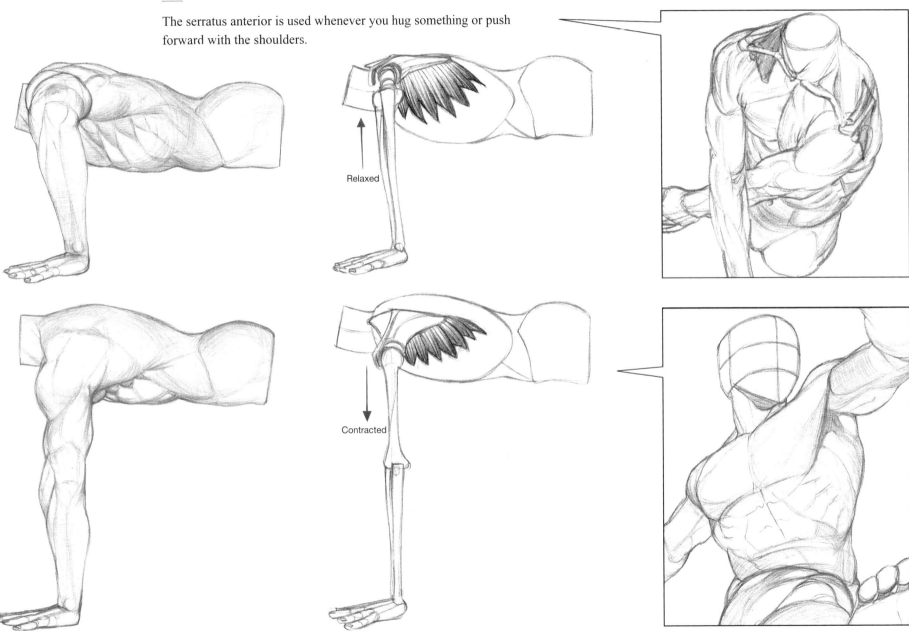

Relaxed

Contracted

■ The External Oblique Abdominal Muscles – Twist that Waist!

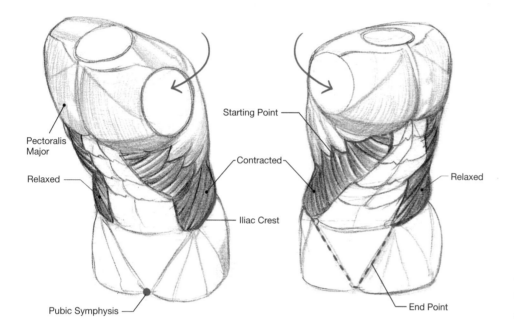

Pectoralis Major

Relaxed

Starting Point

Contracted

Iliac Crest

Pubic Symphysis

Relaxed

End Point

Starting & Ending Points

The external oblique abdominals start with eight ribs, #5-12, then ride the iliac crest all the way to the pubic symphysis, where they end and attach.

Use

The area is used when you bend the upper body to the side or twist. The ribs protect the organs around the chest, but at the level of the abdomen there aren't any ribs and only the spinal column, which allows the hip to move. For this reason the body is vulnerable to external shock. Instead of bone we have the "aponeurosis", a tendon with a large area, which plays the role of protecting the internal organs.

Overlapping

The external oblique abdominal aponeurosis covers the top of the abs (Rectus Abdominis), which appear on the following page.

Characteristics

The serratus anterior and external oblique abdominal muscle belly fibers increase their downward angle as they go down.

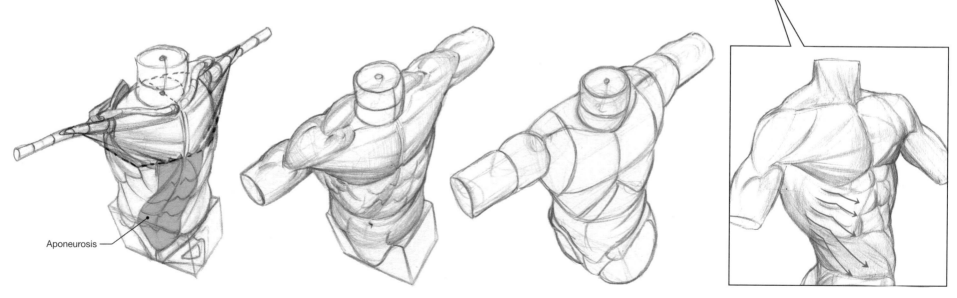

Aponeurosis

■ Rectus Abdominis - Bending Forward at the Waist

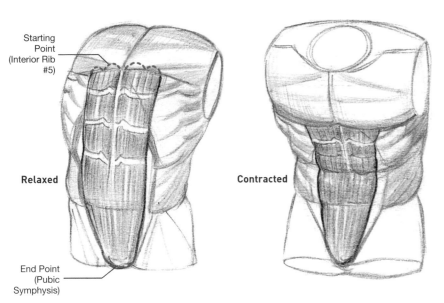

Starting Point (Interior Rib #5)

Relaxed

End Point (Pubic Symphysis)

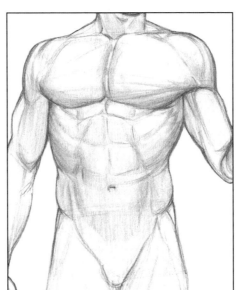

Contracted

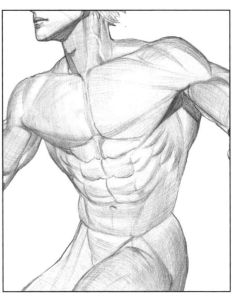

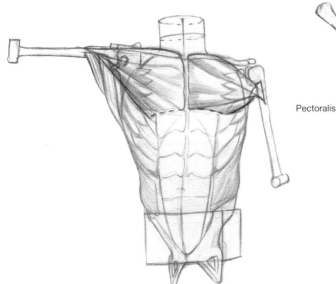

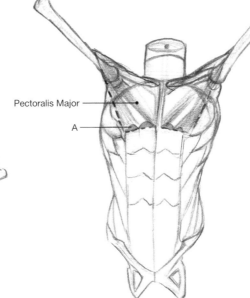

Pectoralis Major

A

Starting & Ending Points

The muscle starts at rib #5 and stretches to the pubic symphysis.

Use

The abdominal muscles contract when you bend the torso forward and relax when you bend the torso backwards.

Overlapping

The pectoralis majors partially cover Point A, which is in the vicinity of the starting point for the abs. The external oblique abdominal aponeurosis covers the top of the abs.

Let's take a look at how the torso actually looks like anatomically.

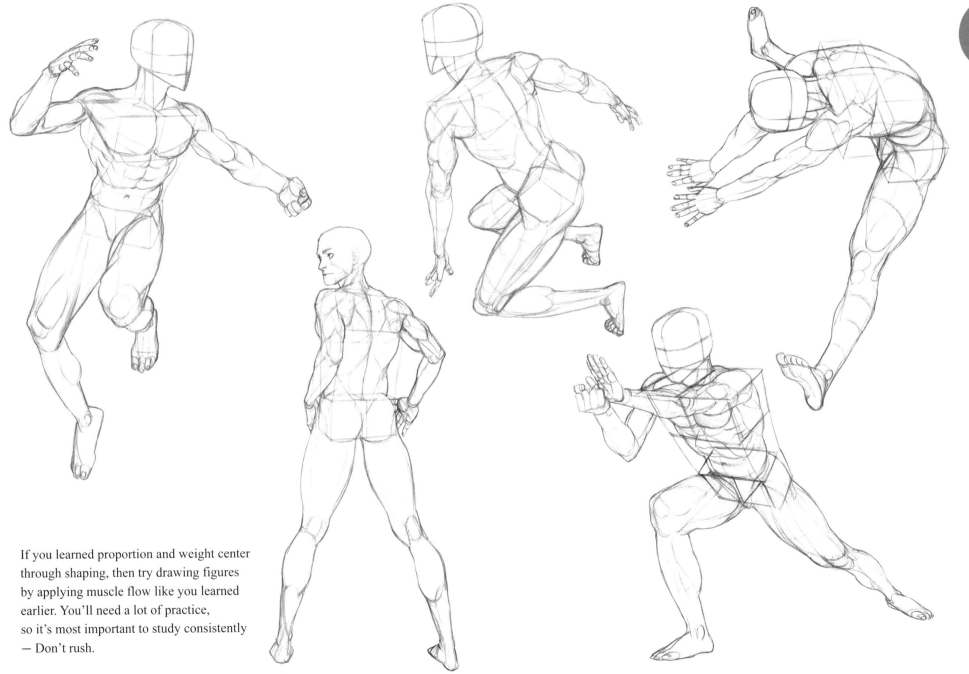

If you learned proportion and weight center
through shaping, then try drawing figures
by applying muscle flow like you learned
earlier. You'll need a lot of practice,
so it's most important to study consistently
— Don't rush.

■ Women's Chests

Pectoralis Major

Figure 1

Figure 2

Women's pectoralis major muscles are located in the same place as men's, however they are less thick so they hardly protrude. Also, their form is hidden, given that the breasts--which are made of fat tissue--are resting directly above. There are many situations where people will see the area which the breasts take up and the pectoralis major area as the same area. In actuality, the breasts come down further than the pectoralis major muscles, as in Figure 1. There is a change to the form of the breasts as they are pulled, pushed, and lean towards the direction of motion. This change occurs according to the type of posture or movements the body does. What you must pay attention to is the area outlined by red dotted lines in Figure 1. It looks as if the area is stitched. If you look at the chest from a side that allows you to see the morphological aspects as in Figure 2, then it's said that you'll be able to divide the chest into two regions and grasp the flow.

Observe the form until you're able to draw the natural flow of the breasts.

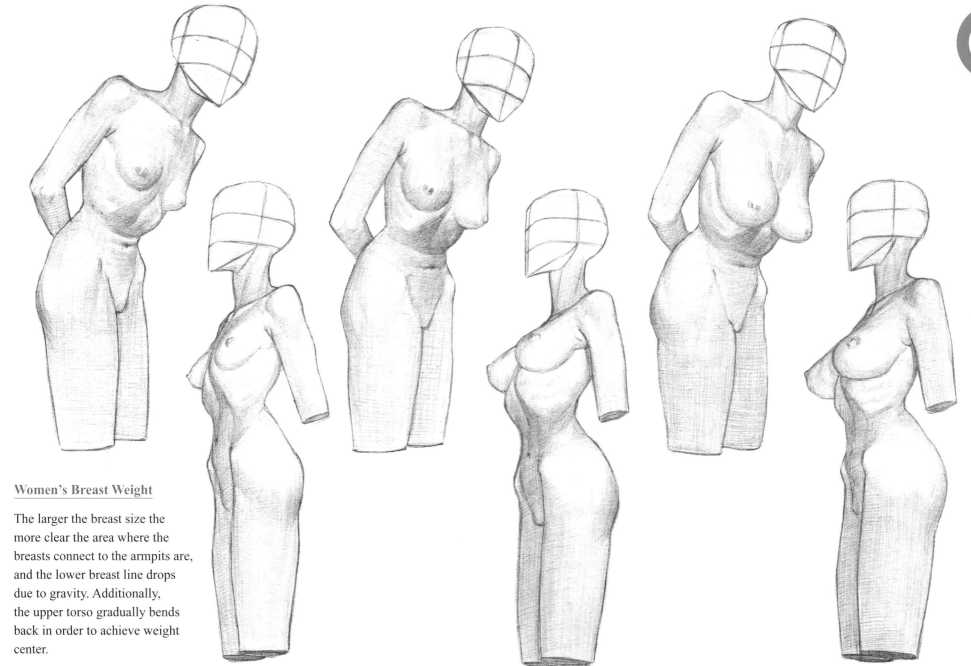

Women's Breast Weight

The larger the breast size the more clear the area where the breasts connect to the armpits are, and the lower breast line drops due to gravity. Additionally, the upper torso gradually bends back in order to achieve weight center.

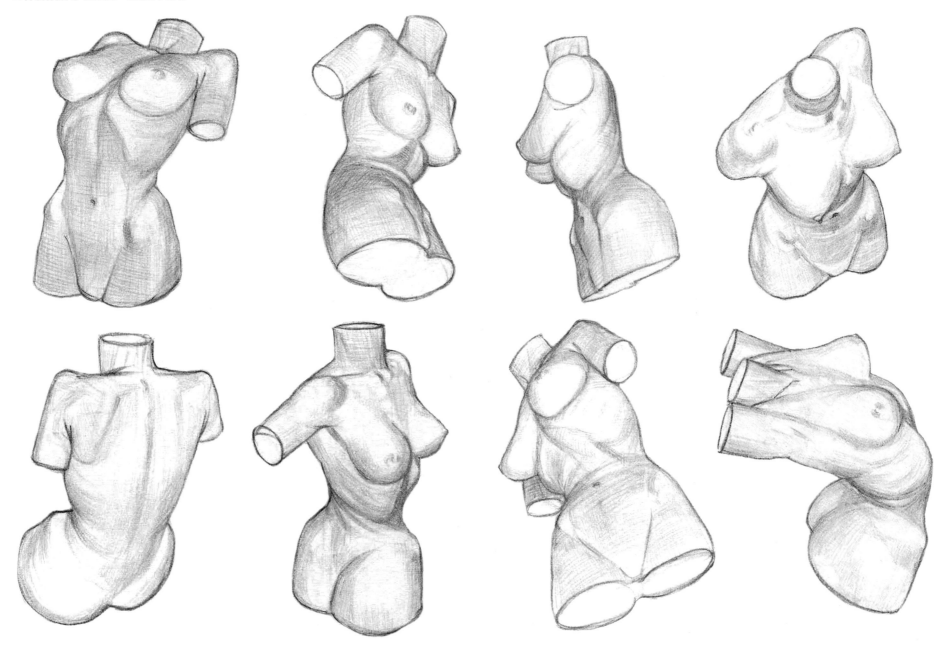

Women's muscles are thinner than men's and have less elasticity, so there are many areas where bone form protrudes. From the drawings you can see how the clavicle, shoulder blade and rib lines stand out more so than men's. On the other hand, the fat layer that exists on the chest or pelvis due to the effect of women's hormones covers the form. So, it creates a curvy flow that is only present on women.

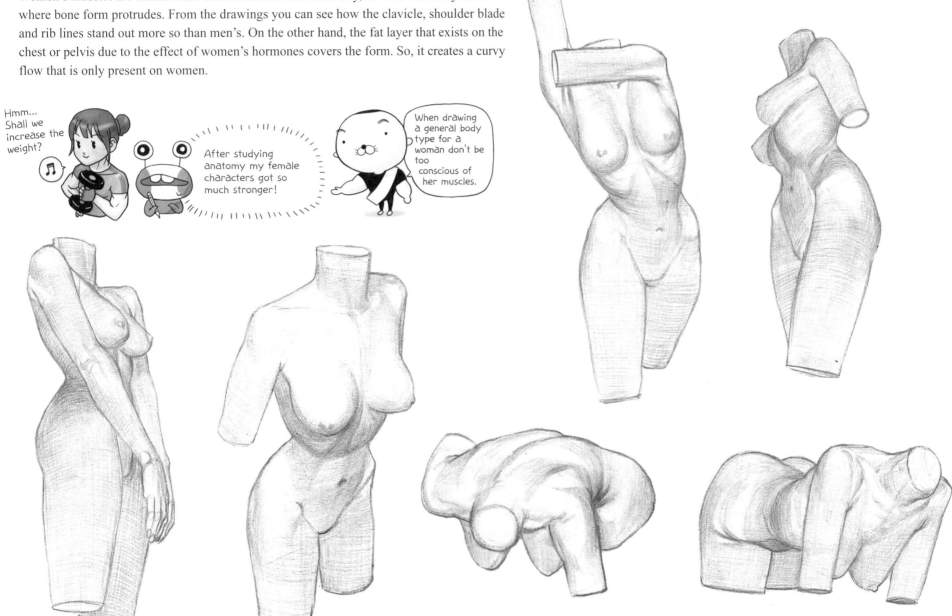

Hmm... Shall we increase the weight?

After studying anatomy my female characters got so much stronger!

When drawing a general body type for a woman don't be too conscious of her muscles.

2 Arm Muscle Location & Use

■ General Arm Movement & Terms

How about we take a look into arm muscle movement and terms?
Try comparing the actual anatomical appearance of the muscles with their external appearance!

Yahoo!
I finally learned the muscles in the arm!

You can show off the muscles in areas where they commonly protrude!

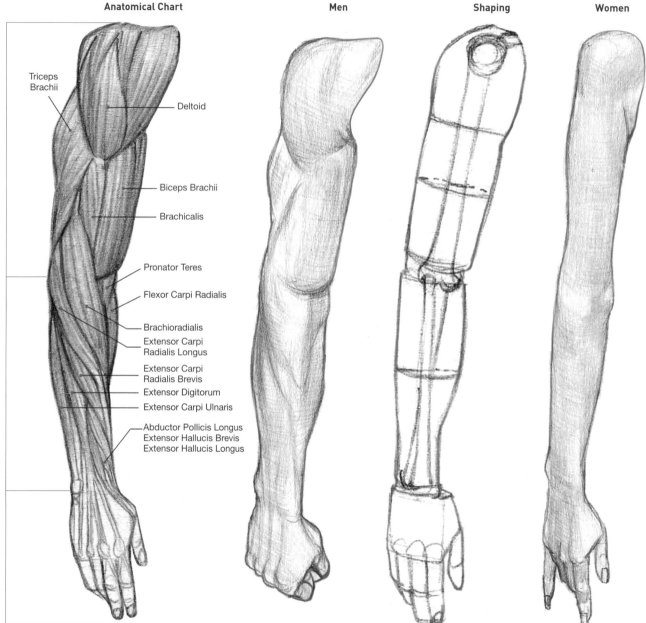

Anatomical Chart **Men** **Shaping** **Women**

Triceps Brachii

Deltoid

Biceps Brachii

Brachicalis

Pronator Teres

Flexor Carpi Radialis

Brachioradialis

Extensor Carpi Radialis Longus

Extensor Carpi Radialis Brevis

Extensor Digitorum

Extensor Carpi Ulnaris

Abductor Pollicis Longus
Extensor Hallucis Brevis
Extensor Hallucis Longus

1

0.8

0.6

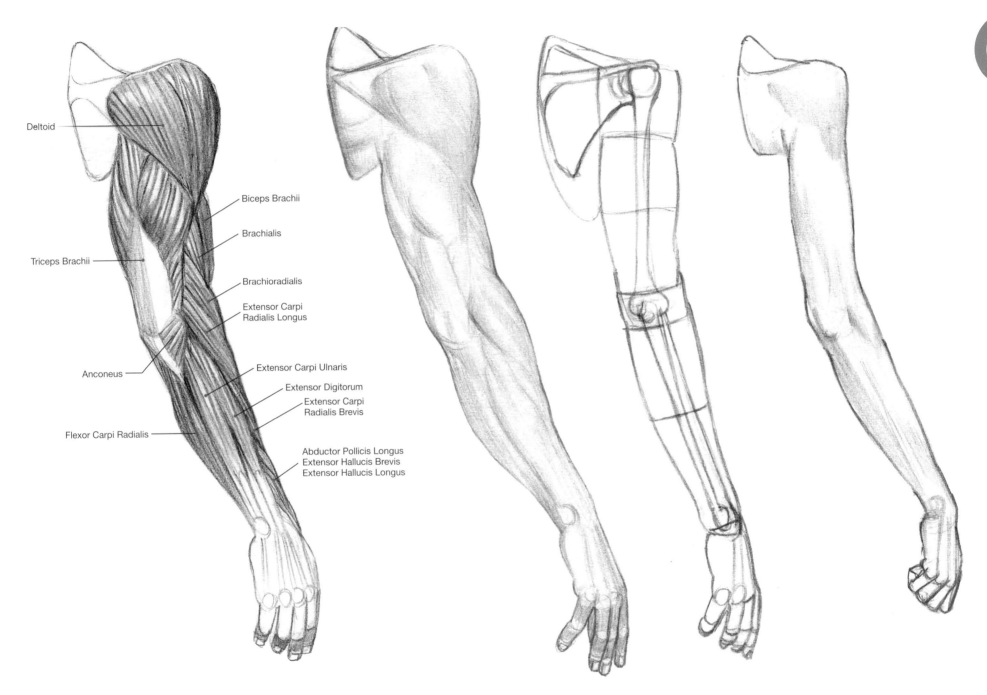

Deltoid

Biceps Brachii

Brachialis

Triceps Brachii

Brachioradialis

Extensor Carpi
Radialis Longus

Anconeus

Extensor Carpi Ulnaris

Extensor Digitorum

Extensor Carpi
Radialis Brevis

Flexor Carpi Radialis

Abductor Pollicis Longus
Extensor Hallucis Brevis
Extensor Hallucis Longus

■ Deltoid Muscles - Raise Those Arms!

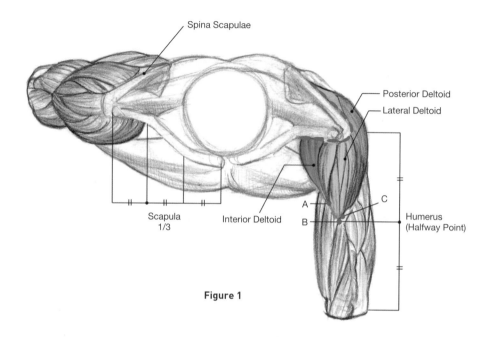

Spina Scapulae

Posterior Deltoid

Lateral Deltoid

A

C

B

Interior Deltoid

Scapula
1/3

Humerus
(Halfway Point)

Figure 1

The anterior and posterior deltoid muscles are smaller compared to the lateral deltoids. Check it out for yourself!

Starting & Ending Points

The deltoid muscle starts at the lateral one-third point of the clavicle and the lateral two-thirds point of the spina scapulae. It then ends at Point B, the humerus' halfway point. The deltoid is largely divided into 3 heads: the anterior, lateral and posterior. The anterior deltoid doesn't reach all the way to B, the end point, and combines with the lateral deltoid at Point A. It is almost as if the anterior deltoid disappears. C, the end point for the posterior deltoid, is almost identical to the location of Point B, the end point for the lateral deltoid.

The Incline of the Clavicle & Spina Scapulae

If you compare front and rear muscle locations with appearance as we did in Figure 2, then it will be of major help in understanding muscle structure and connections from a 3D standpoint. When looking from the front the deltoid connects at the clavicle, so the top of it becomes horizontal. From the rear it folds downwards following the incline of the spina scapulae.

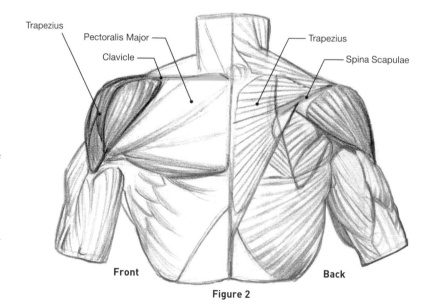

Trapezius

Pectoralis Major

Clavicle

Trapezius

Spina Scapulae

Front

Back

Figure 2

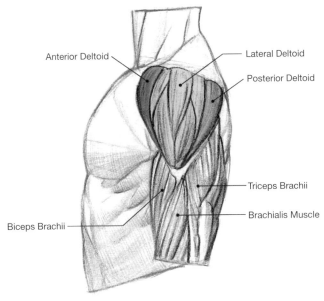

Anterior Deltoid

Lateral Deltoid

Posterior Deltoid

Triceps Brachii

Brachialis Muscle

Biceps Brachii



Lateral Deltoid - Split
Muscle Belly Fibers

Use

The deltoid raises the arm using the shoulder as the center.
The anterior deltoid raises the arm to the front, the lateral
deltoid to the side, and the posterior deltoid to the rear.

Overlapping

Among the pectoralis majors, biceps brachii, triceps brachii,
infraspinatus, teres minor, and teres major, the deltoid is the
uppermost muscle.

Characteristics

The muscle belly fibers of the lateral deltoid are split and look
just like a crocodile's teeth when it's biting down. While the
length of the muscle when contracted is smaller than other
general muscle fibers, this muscle provides great strength.
As is shown in the figure furthest to the right, when the arm is
raised the deltoid is structured so that it crosses over to the back.

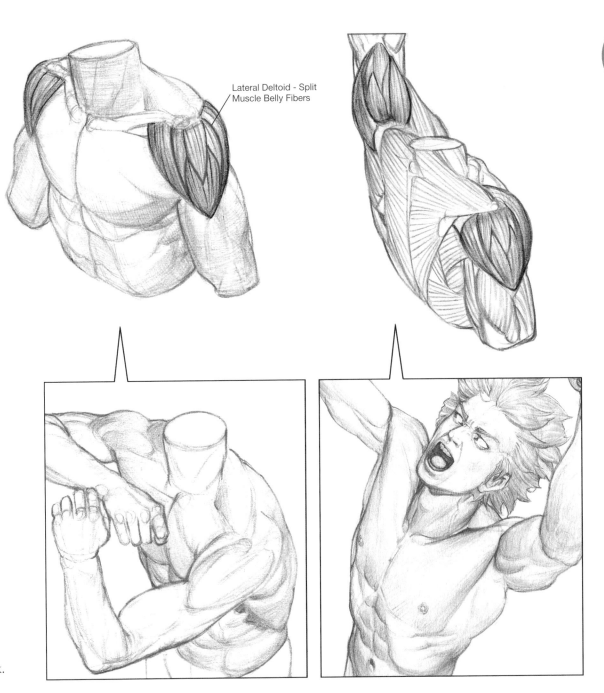

■ Bending the Arm – The Humerus, Biceps Brachii, Triceps Brachii, Brachioradialis, & Extensor Carpi Radialis Longus Muscles

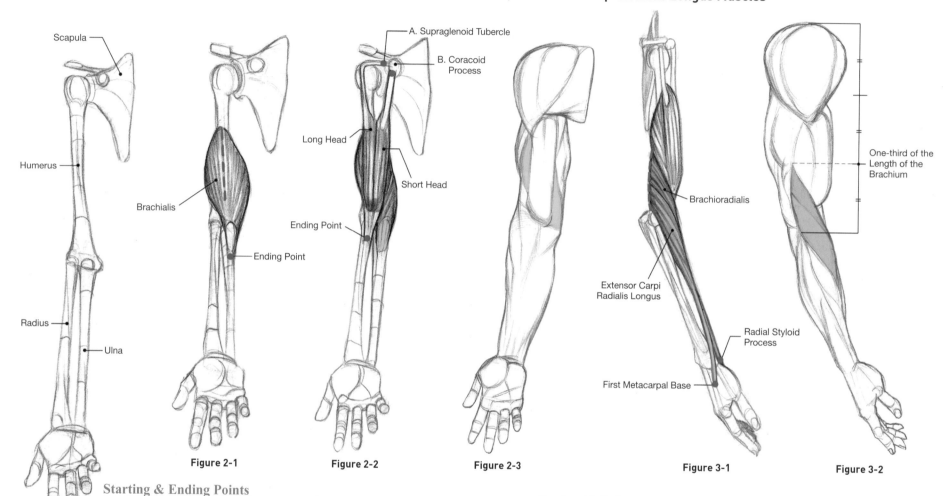

Figure 1

Figure 2-1

Figure 2-2

Figure 2-3

Figure 3-1

Figure 3-2

Starting & Ending Points

The brachialis starts in the area of the dotted line close to the humerus and ends where the ulna ends, as is shown in Figure 2-1. The biceps brachii is divided into a long and short head, as you can observe in Figure 2-2. The long head starts at the supraglenoid tubercle (Point A) of the scapula and the short head starts at the coracoid process (Point B). They come together and connect at the radius. The biceps brachii covers the top of the brachialis and most of the brachialis itself.

The brachialis is more wide and flat than the biceps so it pops out to either side, as can be seen in Figure 2-2. Take a look at Figure 2-3. You can see the final location and how it actually looks from the outside. In Figure 3-1 the brachioradialis and extensor carpi radialis longus start at approximately one-third of the full length of the brachium. The brachioradialis travels to the radial styloid process and attaches, while the first metacarpal base is the ending point of the extensor carpi radialis longus.

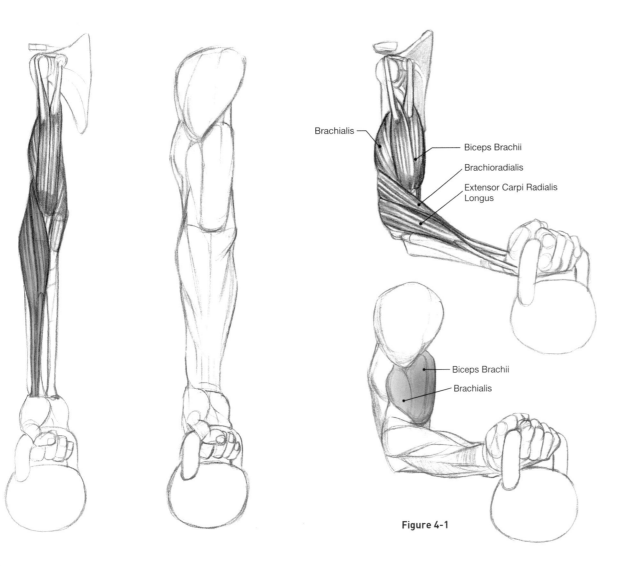

Brachialis

Biceps Brachii

Brachioradialis

Extensor Carpi Radialis
Longus

Figure 4-1

Biceps Brachii

Brachialis

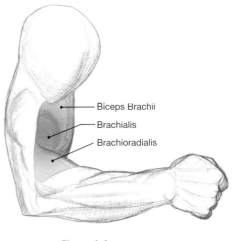

Biceps Brachii

Brachialis

Brachioradialis

Figure 4-2

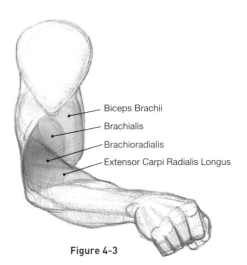

Biceps Brachii

Brachialis

Brachioradialis

Extensor Carpi Radialis Longus

Figure 4-3

Use

If you bend the arm with the palm facing up as in Figure 4-1 you use the brachialis and biceps. When you bend the arm with the thumb facing up as is shown in Figure 4-2 you use the brachialis, biceps, and brachioradialis muscles. If you bend the arm with the palm facing down (Figure 4-3) then you use all four of the following muscles: brachialis, biceps, brachioradialis, extensor carpi radialis longus. For the crimson-colored area in the figure the darker the area the more the muscle/s are used. Due to the fact that the muscles cross like this according to the position of the hand, the silhouette of the arm and the muscles you use also change.

■ Bending the Fingers – Carpi Longus, Abductor Pollicis Longus, & Extensor Pollicis Brevis

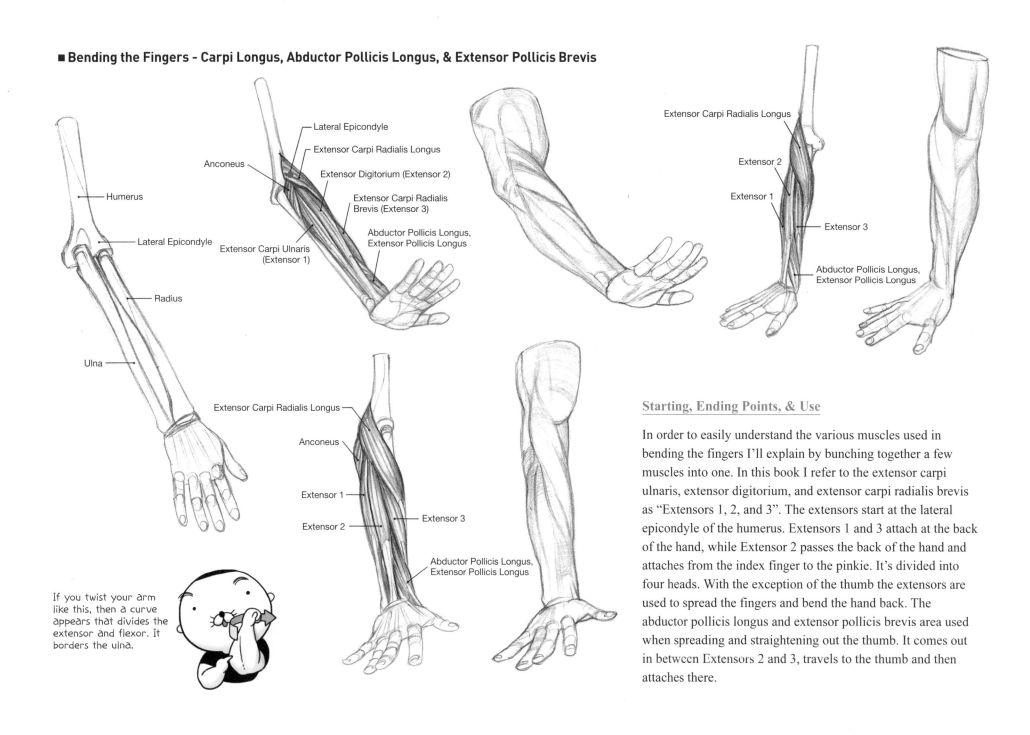

Humerus

Lateral Epicondyle

Radius

Ulna

Lateral Epicondyle

Anconeus

Extensor Carpi Ulnaris
(Extensor 1)

Extensor Carpi Radialis Longus

Extensor Digitorium (Extensor 2)

Extensor Carpi Radialis
Brevis (Extensor 3)

Abductor Pollicis Longus,
Extensor Pollicis Longus

Extensor Carpi Radialis Longus

Anconeus

Extensor 1

Extensor 2

Extensor 3

Abductor Pollicis Longus,
Extensor Pollicis Longus

Extensor Carpi Radialis Longus

Extensor 2

Extensor 1

Extensor 3

Abductor Pollicis Longus,
Extensor Pollicis Longus

If you twist your arm
like this, then a curve
appears that divides the
extensor and flexor. It
borders the ulna.

Starting, Ending Points, & Use

In order to easily understand the various muscles used in bending the fingers I'll explain by bunching together a few muscles into one. In this book I refer to the extensor carpi ulnaris, extensor digitorium, and extensor carpi radialis brevis as "Extensors 1, 2, and 3". The extensors start at the lateral epicondyle of the humerus. Extensors 1 and 3 attach at the back of the hand, while Extensor 2 passes the back of the hand and attaches from the index finger to the pinkie. It's divided into four heads. With the exception of the thumb the extensors are used to spread the fingers and bend the hand back. The abductor pollicis longus and extensor pollicis brevis area used when spreading and straightening out the thumb. It comes out in between Extensors 2 and 3, travels to the thumb and then attaches there.

■ Twisting & Turning the Thumb - The Pronator Muscle

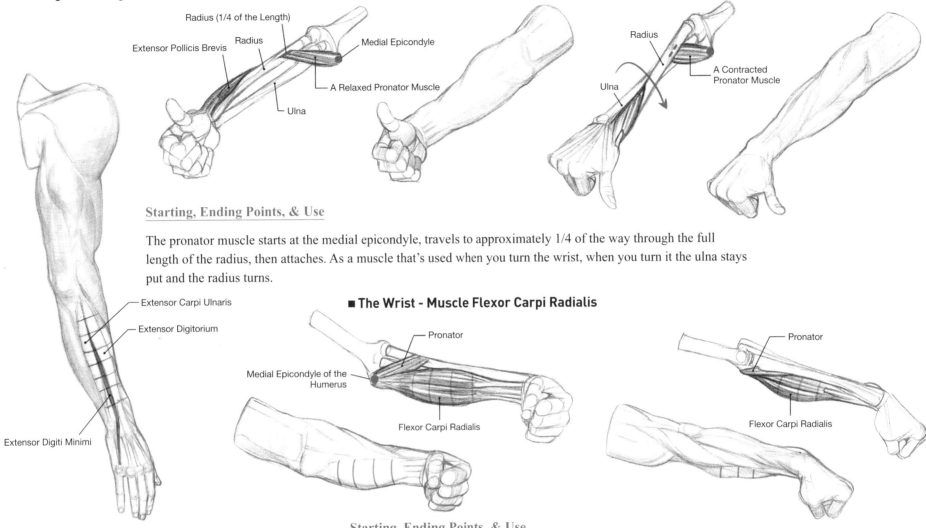

Radius (1/4 of the Length)

Radius

Extensor Pollicis Brevis

Medial Epicondyle

A Relaxed Pronator Muscle

Ulna

Radius

Ulna

A Contracted Pronator Muscle

Extensor Carpi Ulnaris

Extensor Digitorium

Extensor Digiti Minimi

Starting, Ending Points, & Use

The pronator muscle starts at the medial epicondyle, travels to approximately 1/4 of the way through the full length of the radius, then attaches. As a muscle that's used when you turn the wrist, when you turn it the ulna stays put and the radius turns.

■ The Wrist - Muscle Flexor Carpi Radialis

Pronator

Medial Epicondyle of the Humerus

Flexor Carpi Radialis

Pronator

Flexor Carpi Radialis

In between the extensor carpi ulnaris and extensor digitorium exists the extensor digiti minimi. This muscle is small and almost doesn't stick out at all, so I will not be addressing it in this book.

Starting, Ending Points, & Use

There are 6 muscles which allow the hand to bend inwards. In this book I bunched them all together and refer to them as "flexor carpi radialis". This is because they all share a single flow when looking from the outside. The muscles of the flexor carpi radialis all start at the medial epicondyle of the humerus, pass the wrist, then split into each of the fingers. They are responsible for bending the fingers and wrist.

■ Opening the Arm - The Triceps (Triceps Brachii)

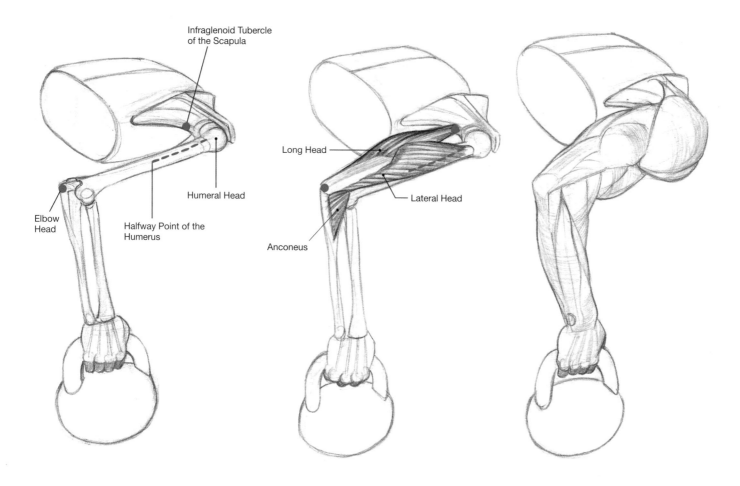

Infraglenoid Tubercle of the Scapula

Humeral Head

Elbow Head

Halfway Point of the Humerus

Long Head

Lateral Head

Anconeus

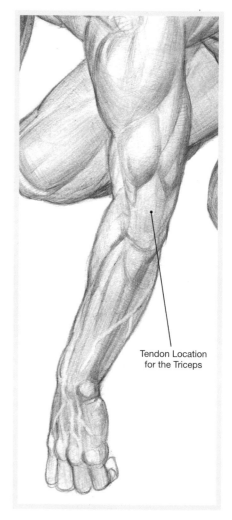

Tendon Location for the Triceps

Starting & Ending Points

The triceps brachii include the interior head, lateral head, and long head. Hence the "tri" in "triceps". The long head starts at the infraglenoid tubercle and the lateral head starts from the lower portion of the humeral head to approximately the halfway point of the humerus. They then attach at the elbow head. If you look at the interior head laterally, then it is covered by the long head and you can't see it well. For this reason, I will omit it. When you look at a complete drawing of an arm most of the starting point for the triceps is covered by the deltoid muscle.

Characteristics of the Triceps

Compared to other muscles, the territory of the tendons is wide. The more developed the muscle is the flat tendons and muscle belly are contrasted and the border between them sticks out.

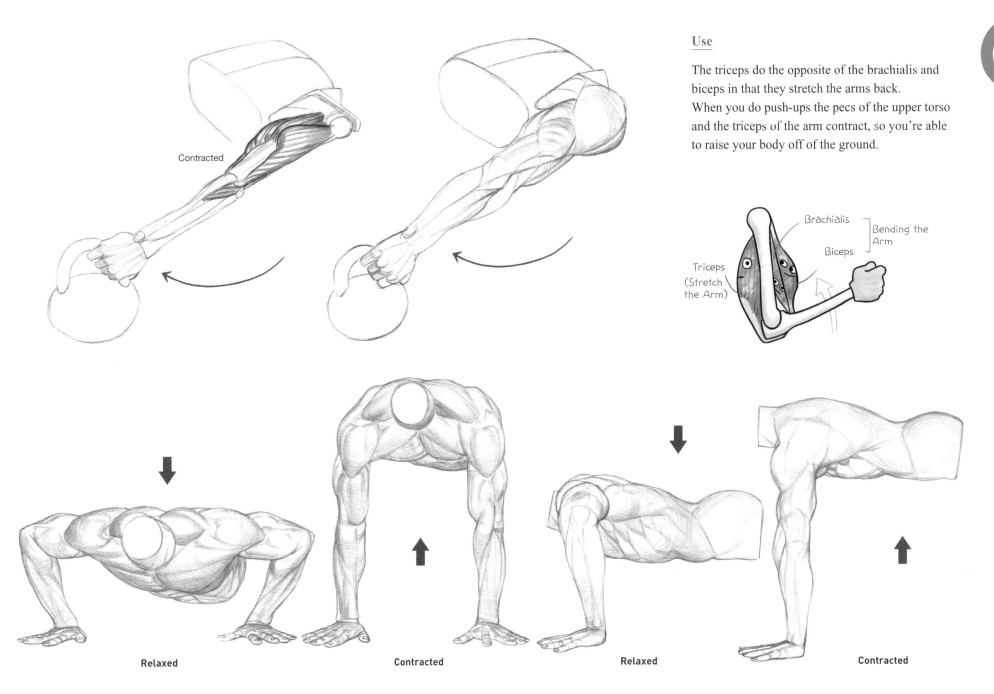

Contracted

Use

The triceps do the opposite of the brachialis and biceps in that they stretch the arms back.
When you do push-ups the pecs of the upper torso and the triceps of the arm contract, so you're able to raise your body off of the ground.

Brachialis

Biceps

Bending the Arm

Triceps (Stretch the Arm)

Relaxed

Contracted

Relaxed

Contracted

3 Structure & Movement of the Hand

■ Hand Proportion & Sections

Third Proximal
Phalanx of the
Middle Finger

Metacarpal

1/2
Way
Point

The Shape & Evolution of Our Hands

What part of the body do you think we look at the most? Some commonly think the face, but it's actually the hand. So, when drawing bodies the part of the body that most resembles their own is the hands. Different than animals, the use of the hands became natural for human beings through bipedalism. It became possible to grab objects with the hands, make tools, and hunt. Human beings, who have weak physical abilities, needed weapons which allowed us to attack from great distances in order to hunt animals. So, by developing weapons similar to spears we were able to hunt animals much stronger than we were. With this sort of hunting technology background human beings were able to survive to this day. In order to make weaponry with precision and throw them accurately we needed to develop our thumb function. Compared to other anthropoids, human beings' thumbs evolved to be longer in relation to the other fingers of the hand, and the other remaining four fingers became smaller, thus our hands are the way they are today.

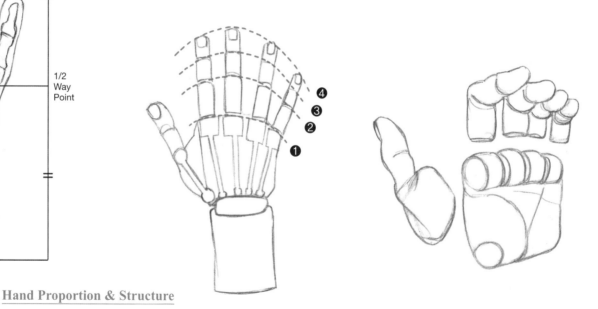

❹
❸
❷
❶

Hand Proportion & Structure

In this chapter I won't take an anatomical approach to the hands. Instead, I'm going to interpret them more easily using shaping. In the figure to the left the red dot which portrays where the metacarpal and third proximal phalanx of the middle finger meet is the halfway between the end of the palm and end of the middle finger. Additionally, if you connect each of the joints of each finger, then it creates an arc with the middle finger at the center (see above). In the figure in the middle, the flow of line ❶ and other lines are the same, so you must be careful not to draw them as straight lines. If you look at the hand structurally, then you'll be able to think of it as a palm, a thumb, and then the remaining four fingers.

■ **Territories of the Palm**

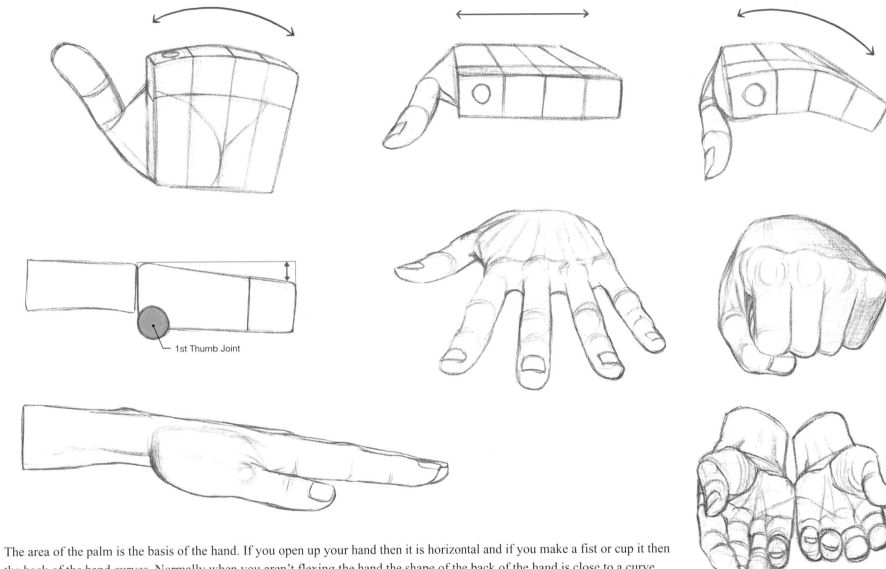

1st Thumb Joint

The area of the palm is the basis of the hand. If you open up your hand then it is horizontal and if you make a fist or cup it then the back of the hand curves. Normally when you aren't flexing the hand the shape of the back of the hand is close to a curve. When you look from the side the thickness of the back of the hand decreases as you move from the wrist towards the fingers. Don't forget! -- The 1st joint of the thumb is located on the side of the palm!

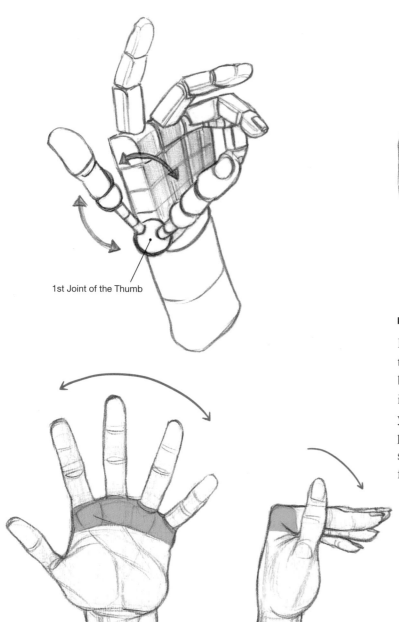

1st Joint of the Thumb

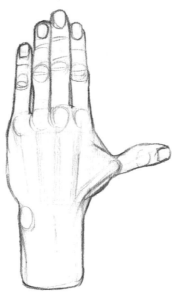
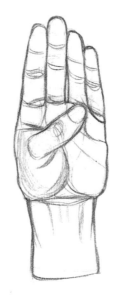

■ The Movements of Each Finger

In order to grab objects and make tools the thumb evolved a great degree of freedom compared to the other fingers. The 1st joint of the thumb only turns towards the inside of the palm and not the back of the palm. For this reason, it's a "spheroidal" ("ball-and-socket") and a "saddle" joint, which is similar. The complex forms of the hand are made using the 1st joint of the thumb as an axis, so you should want to observe the movements of the thumb very closely, right? The movements of the proximal phalanges of the remaining four fingers are characterized by being able to move side-to-side and front-to-back. The middle and distal phalanges are hinge joints only capable of bending forwards and backwards.

Distal Phalanx

Middle Phalanx

Proximal Phalanx

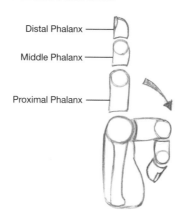

Figure 1

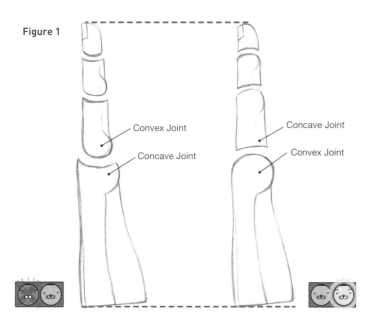

Convex Joint
Concave Joint

Concave Joint
Convex Joint

Figure 2

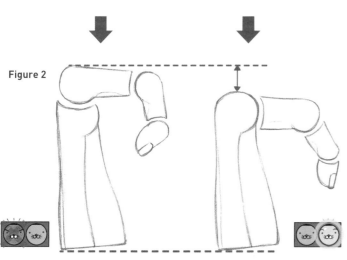

■ Convex & Concave Joints

Most of the joints of the human body operate on the premise that if one side is convex then the other receives it as a concave joint. Should we check out Figures 1 & 2 and see what type of difference there is in movement according to the location of the concave and convex joints? Figure 1 shows a finger before it's bent where the concave and convex joint locations are opposite each other. In this case you can see how the length of the hand is identical. However, if the finger is bent as is shown in Figure 2 then there's a difference in the length of the back of the hand. Figures 1 & 2 display the proper joint structure of the right hand. When carrying out movements of the convex and concave joints according to their locations the state of the hand changes, so you must have a good grasp of the locations of the joints. This is of even greater importance because the fingers in particular are a part of the body that contain substantially more joints.

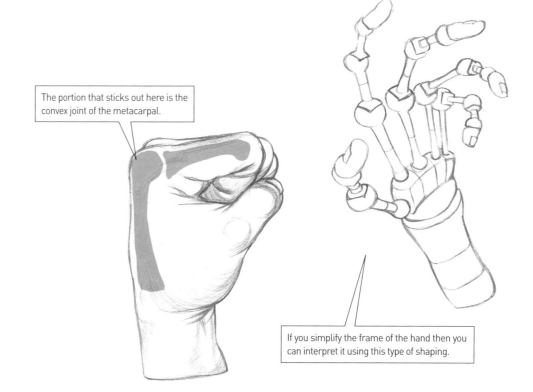

The portion that sticks out here is the convex joint of the metacarpal.

If you simplify the frame of the hand then you can interpret it using this type of shaping.

■ Divisions of the Hand's Structure

Let's take a look at some drawings of the various movements of the hand through shaping. These movements were explained earlier on.

Should I Draw Fingernails or Not?

It can be a pain to add to something that is already so complicated, so there are instances where I omit the fingernails. But, the fingernails let you know the direction of the fingers and they make the hands look even better, so they say it's still good to draw them!

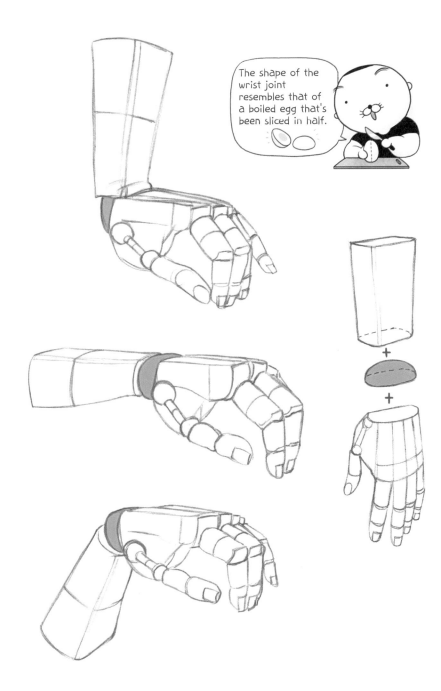

The shape of the wrist joint resembles that of a boiled egg that's been sliced in half.

What Not To Do **The Radiocarpal Joint**

You draw the wrist, which connects the arm to the hand, as an oval that's been chopped in half. As is shown in the incorrectly draw figure if you think of the joint as circular, then when you bend the wrist the arm rides on top of the radiocarpal joint and the palm gets longer. If you raise the wrist as in the correctly drawn figure, then the back of the hand must appear as if it's being pressed down on.

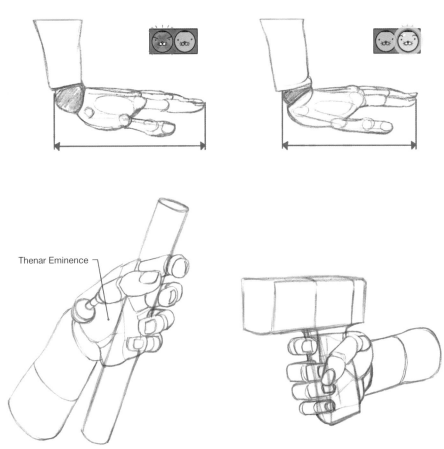

Thenar Eminence

Gripping Tools

Our wrists do not become vertical when we grab tools. As is shown in the above drawings, the grip is slightly askew. In order to grab something and keep the wrist vertical you wouldn't be able to grip firmly due to the thickness of the thenar eminence. Express the hand slightly askew when gripping a knife, bar, gun, etc.

■ Movement & Direction of the Fingers

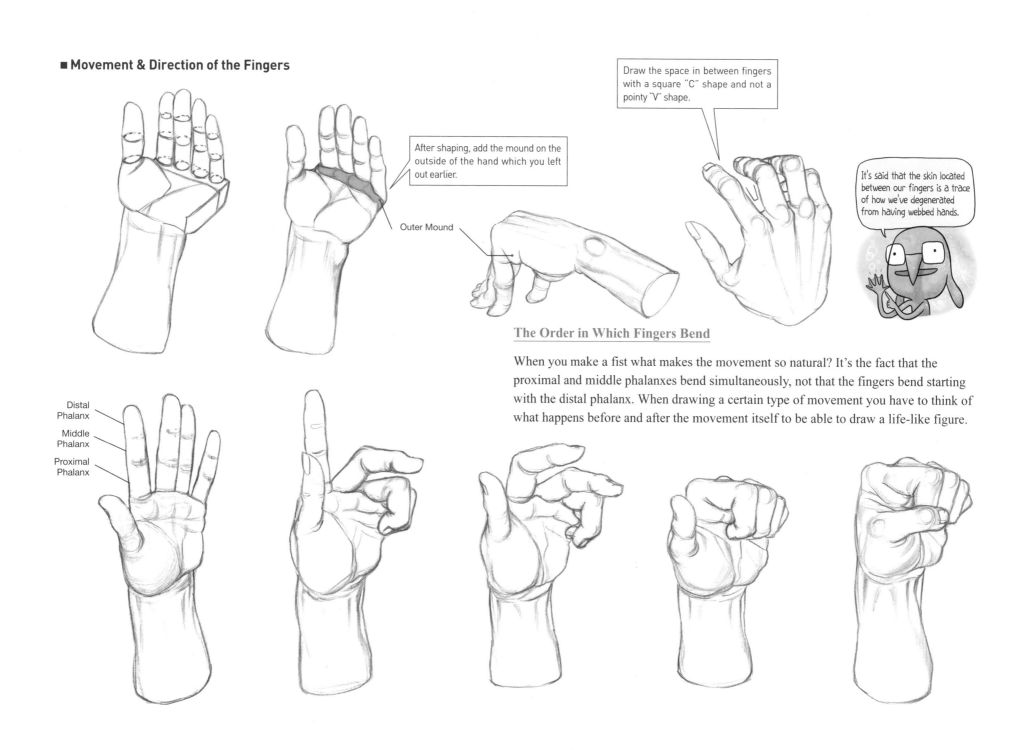

Draw the space in between fingers with a square "C" shape and not a pointy "V" shape.

After shaping, add the mound on the outside of the hand which you left out earlier.

Outer Mound

It's said that the skin located between our fingers is a trace of how we've degenerated from having webbed hands.

The Order in Which Fingers Bend

When you make a fist what makes the movement so natural? It's the fact that the proximal and middle phalanxes bend simultaneously, not that the fingers bend starting with the distal phalanx. When drawing a certain type of movement you have to think of what happens before and after the movement itself to be able to draw a life-like figure.

Distal Phalanx

Middle Phalanx

Proximal Phalanx

The Shape of the Hand - Unflexed

The index finger is opened up and the fingers gradually bend as you move towards the pinkie.

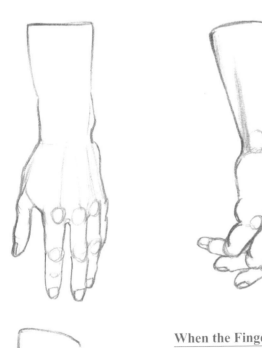

When the Fingers Are Spread Out

If you spread the fingers then they spread in radial form.

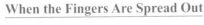

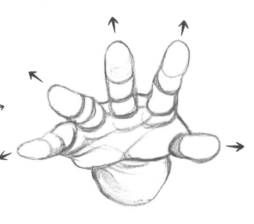

Retracting the Fingers

If you retract the hand then each finger bends in the direction of the middle of the palm. Due to the fact that all fingers face the center of the palm and gather like this, if you make a fist then there won't be any space in between any of the fingers because they come so closely together. The angle of bend varies for each finger, so it's more difficult to draw fingers when they're bent rather than when they're straight.

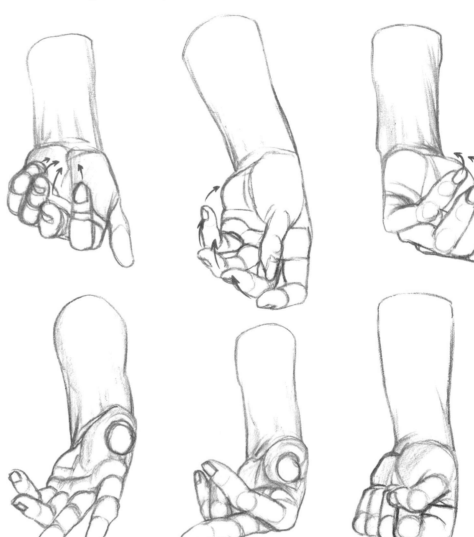

C03

Anatomy Drawing

4 The Flow of the Arm

■ The "Twisted Donut" and the "Knot"

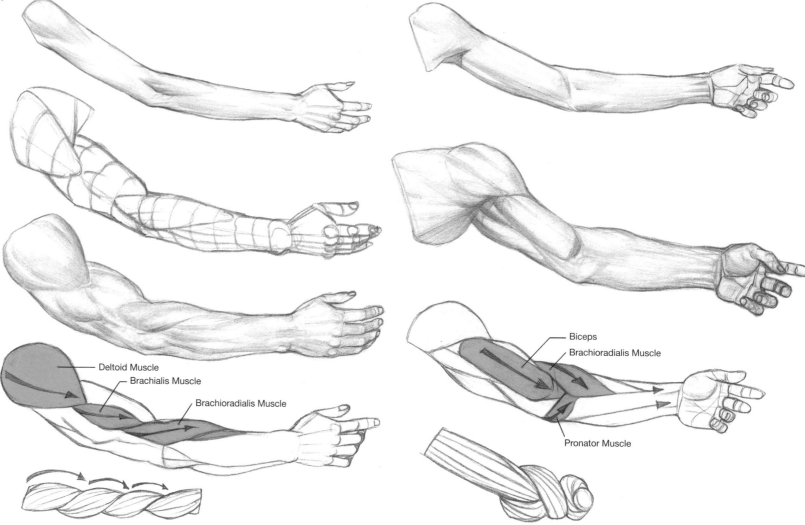

Deltoid Muscle
Brachialis Muscle
Brachioradialis Muscle

Biceps
Brachioradialis Muscle
Pronator Muscle

Main Flow of the Outer Arm

When you look at the outer arm the deltoid, brachialis and brachioradialis twist like one of those delicious twisted donuts. If you establish this flow at the center and then add the remaining muscles on top of it you'll be able to easily draw the flow of the arm.

Main Flow of the Inner Arm

For many people it is difficult to draw areas where joints bend. In the case of the arm, think of the "burrowing" bicep, which is located in between the pronator and brachioradialis, as a knot in a rope. Then, it'll be easier to understand.

■ The 3 Sections of the Arm

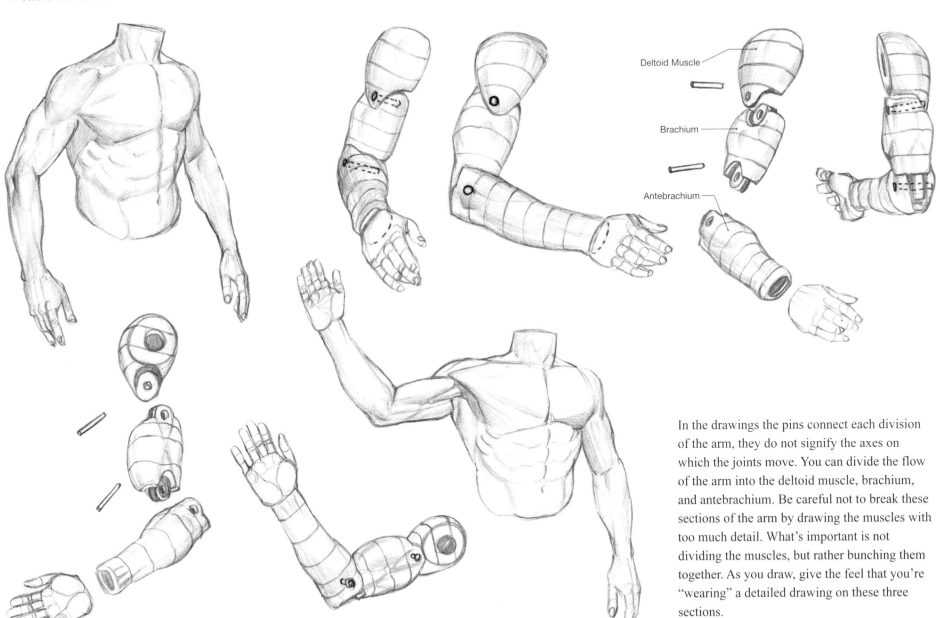

Deltoid Muscle

Brachium

Antebrachium

In the drawings the pins connect each division of the arm, they do not signify the axes on which the joints move. You can divide the flow of the arm into the deltoid muscle, brachium, and antebrachium. Be careful not to break these sections of the arm by drawing the muscles with too much detail. What's important is not dividing the muscles, but rather bunching them together. As you draw, give the feel that you're "wearing" a detailed drawing on these three sections.

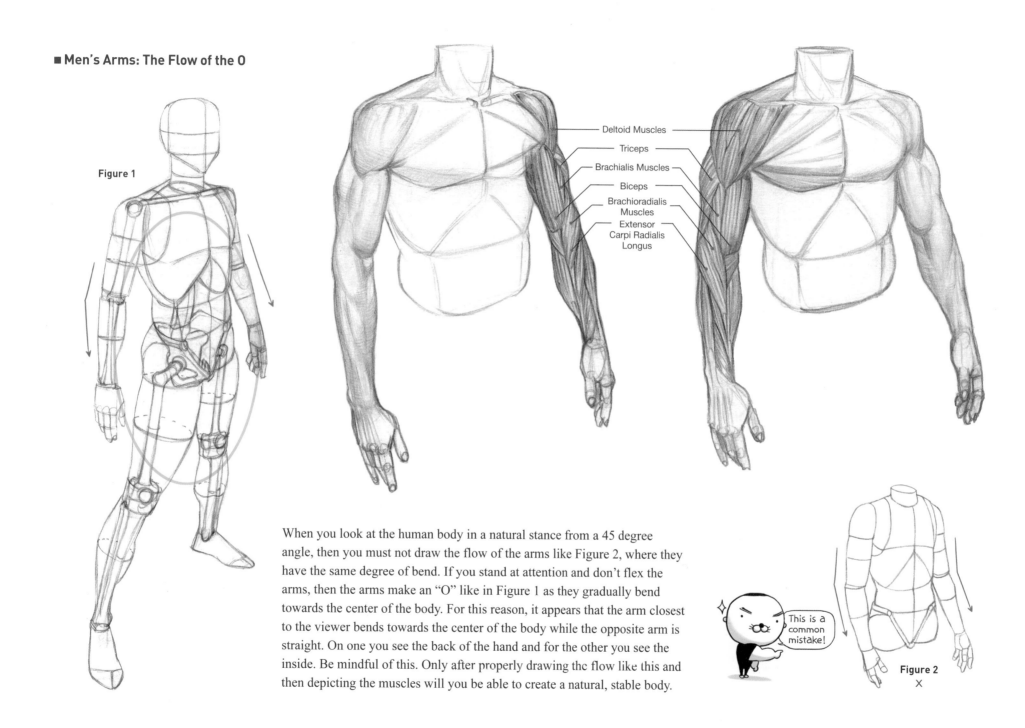

■ Men's Arms: The Flow of the O

Figure 1

Deltoid Muscles
Triceps
Brachialis Muscles
Biceps
Brachioradialis Muscles
Extensor Carpi Radialis Longus

When you look at the human body in a natural stance from a 45 degree angle, then you must not draw the flow of the arms like Figure 2, where they have the same degree of bend. If you stand at attention and don't flex the arms, then the arms make an "O" like in Figure 1 as they gradually bend towards the center of the body. For this reason, it appears that the arm closest to the viewer bends towards the center of the body while the opposite arm is straight. On one you see the back of the hand and for the other you see the inside. Be mindful of this. Only after properly drawing the flow like this and then depicting the muscles will you be able to create a natural, stable body.

This is a common mistake!

Figure 2
✕

■ **The Biceps: Flexing**

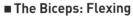

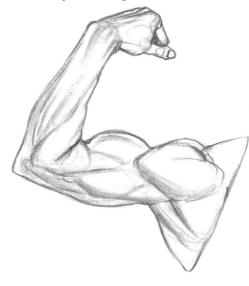

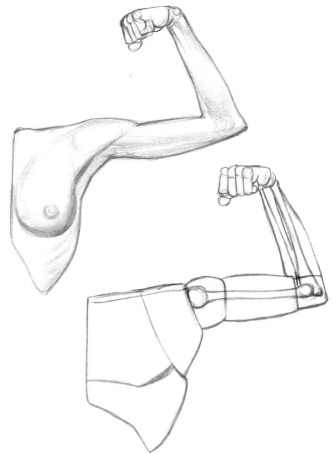

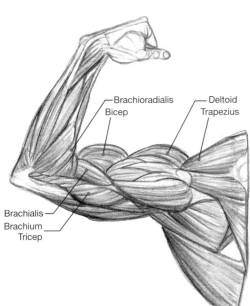

Brachioradialis
Bicep
Deltoid
Trapezius

Brachialis
Brachium
Tricep

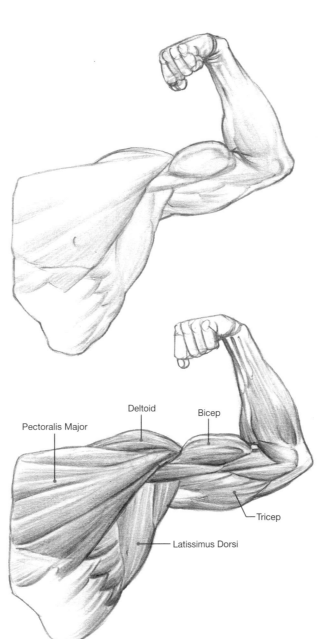

Deltoid
Bicep

Pectoralis Major

Tricep

Latissimus Dorsi

This is a classic body builder's posture in which all of the muscles of the upper torso protrude. When viewing from the front the biceps and latissimus dorsi are accented, and when viewing from the rear the deltoids, biceps, and all of the back muscles are accented. When drawing a figure in this posture with a frontal view it's difficult to grasp the location of the armpits, where many muscles all come together. From a rear view it's difficult to grasp the location of the triceps, which carry over to the figure's back. Whatever the posture what comes first is grasping the silhouette, rather than drawing the muscles in detail. For this reason, the more complicated the structure try to find the flow after simplifying and shaping.

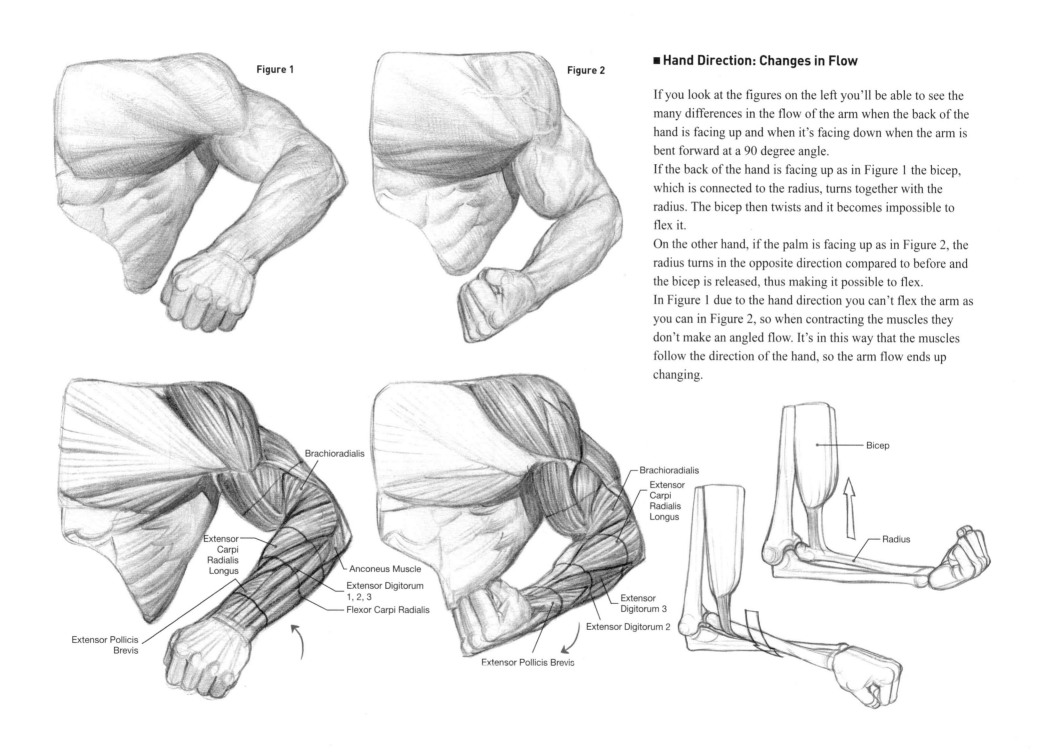

Figure 1

Figure 2

■ Hand Direction: Changes in Flow

If you look at the figures on the left you'll be able to see the many differences in the flow of the arm when the back of the hand is facing up and when it's facing down when the arm is bent forward at a 90 degree angle.

If the back of the hand is facing up as in Figure 1 the bicep, which is connected to the radius, turns together with the radius. The bicep then twists and it becomes impossible to flex it.

On the other hand, if the palm is facing up as in Figure 2, the radius turns in the opposite direction compared to before and the bicep is released, thus making it possible to flex.

In Figure 1 due to the hand direction you can't flex the arm as you can in Figure 2, so when contracting the muscles they don't make an angled flow. It's in this way that the muscles follow the direction of the hand, so the arm flow ends up changing.

Brachioradialis

Extensor Carpi Radialis Longus

Anconeus Muscle

Extensor Digitorum 1, 2, 3

Flexor Carpi Radialis

Extensor Pollicis Brevis

Brachioradialis

Extensor Carpi Radialis Longus

Extensor Digitorum 3

Extensor Digitorum 2

Extensor Pollicis Brevis

Bicep

Radius

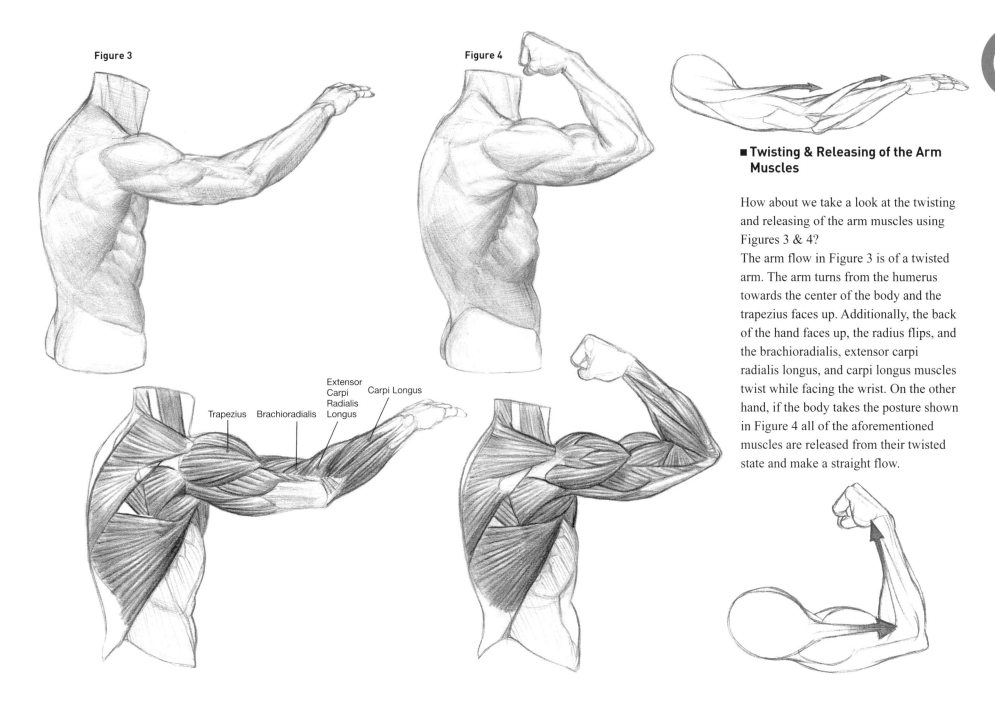

Figure 3

Figure 4

Trapezius Brachioradialis

Extensor
Carpi
Radialis
Longus

Carpi Longus

■ Twisting & Releasing of the Arm Muscles

How about we take a look at the twisting and releasing of the arm muscles using Figures 3 & 4?

The arm flow in Figure 3 is of a twisted arm. The arm turns from the humerus towards the center of the body and the trapezius faces up. Additionally, the back of the hand faces up, the radius flips, and the brachioradialis, extensor carpi radialis longus, and carpi longus muscles twist while facing the wrist. On the other hand, if the body takes the posture shown in Figure 4 all of the aforementioned muscles are released from their twisted state and make a straight flow.

■ The Triceps: Flexing

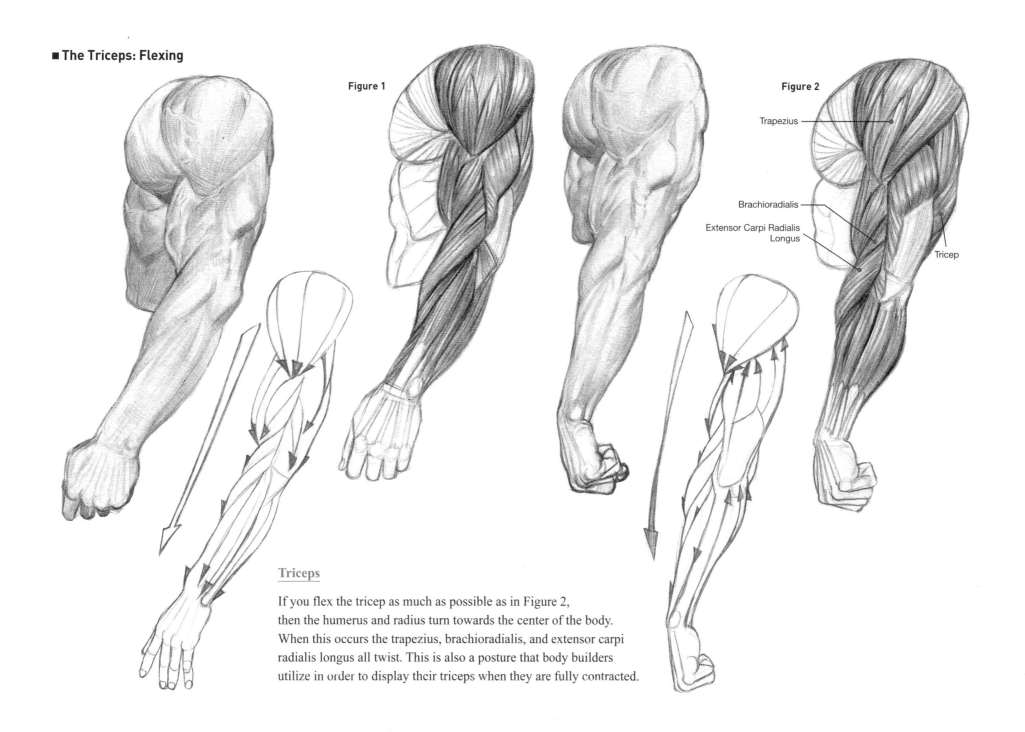

Figure 1

Figure 2

Trapezius

Brachioradialis

Extensor Carpi Radialis
Longus

Tricep

Triceps

If you flex the tricep as much as possible as in Figure 2,
then the humerus and radius turn towards the center of the body.
When this occurs the trapezius, brachioradialis, and extensor carpi
radialis longus all twist. This is also a posture that body builders
utilize in order to display their triceps when they are fully contracted.

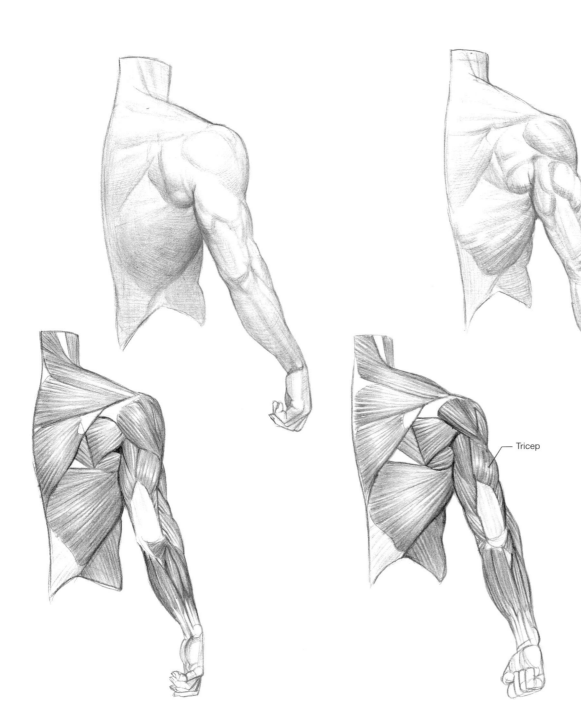

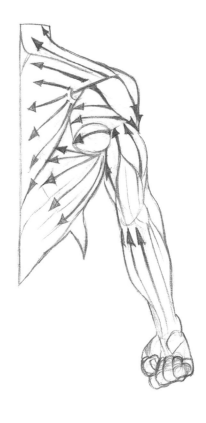

Tricep

Natural Relaxation & Contraction

All of the drawings on the left hand page are for figures viewed entirely from the rear. If you end up flexing the triceps then it's not just the area of the triceps that contract; all surrounding muscles follow suit and contract. You can intentionally flex just one muscle, but if you flex naturally and unintentionally then the surrounding muscles end up flexing, too. If you take this into consideration when you draw, then it's said that your figure will have a more natural flow of movement. You must be able to express the differences that arise in accordance with the relaxation and contraction of the muscles.

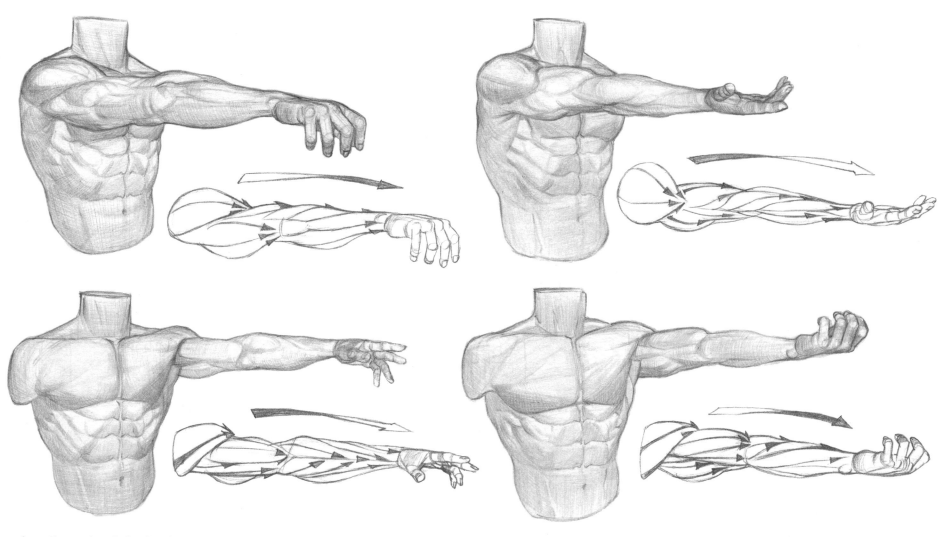

■ Arm Pronation & Supination

Through the above drawings you are able to see the changes in the entire outline of the arm when the humeral head and radius turn in accordance with the pronation and supination of the hand. If the bone turns then the muscles follow and turn, so the external flow changes. It is in this way that the arm flow is decided according to the direction of the hand, so you should draw the arm after first determining the hand's movement. The reason muscles are so difficult is because their directions change with every movement.

So you can't just memorize one piece of information. You actually have to understand the muscles' operating principles...

Am I lacking in one area?

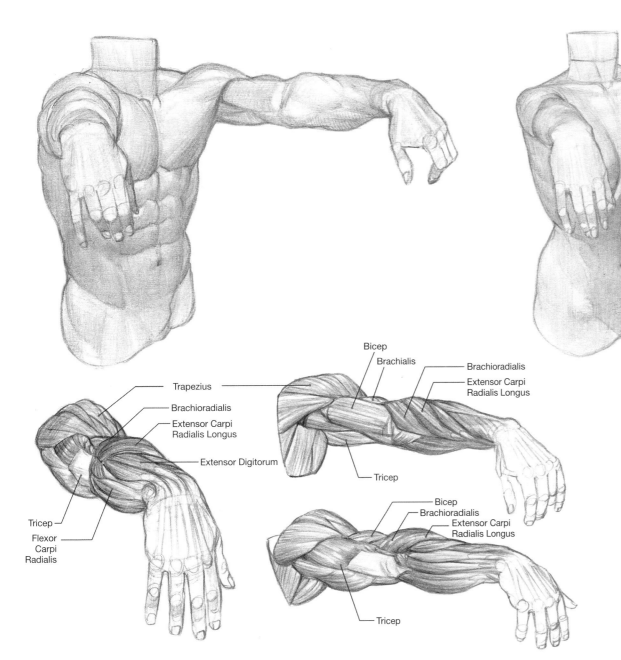

Trapezius

Brachioradialis

Extensor Carpi
Radialis Longus

Extensor Digitorum

Tricep

Flexor
Carpi
Radialis

Bicep
Brachialis
Brachioradialis
Extensor Carpi
Radialis Longus

Tricep

Bicep
Brachioradialis
Extensor Carpi
Radialis Longus

Tricep

■ Foreshortened Arm Flow

Of the entire body the hands in particular have a great concentration of muscle and joint heads. This is in order to do very precise and also complicated actions. The various muscles that move the fingers are connected to the arm, so the entire arm is a complicated structure. The sections of the various heads of the arm muscles stick out more than other areas of the body, so if you're actually intending to draw the arm it's necessary to have anatomical knowledge of the arm itself. In particular, if you intend to draw the arm from frontal view angles as is shown in the above figures, you'll need more information than what a view from the side can offer you. For starters you must know accurate perspective and the order in which muscles overlap, and you must be able to combine muscle thickness in 3D. Only by knowing and doing these things will you be able to draw an arm from a straight-on view.

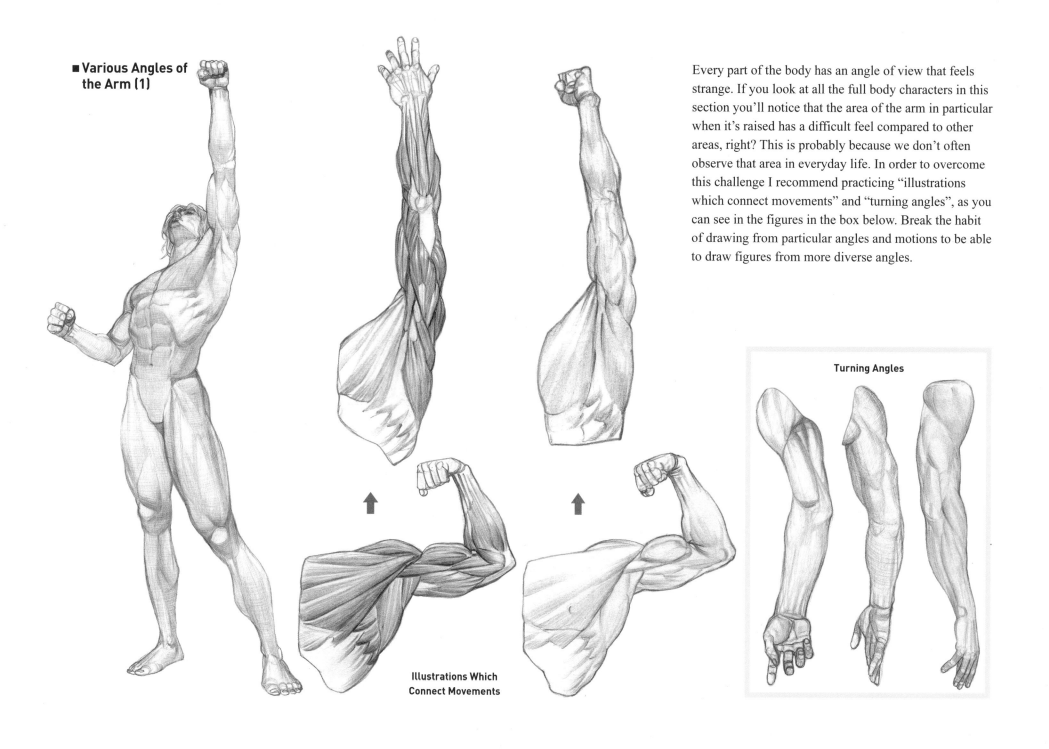

■ Various Angles of the Arm (1)

Every part of the body has an angle of view that feels strange. If you look at all the full body characters in this section you'll notice that the area of the arm in particular when it's raised has a difficult feel compared to other areas, right? This is probably because we don't often observe that area in everyday life. In order to overcome this challenge I recommend practicing "illustrations which connect movements" and "turning angles", as you can see in the figures in the box below. Break the habit of drawing from particular angles and motions to be able to draw figures from more diverse angles.

Turning Angles

Illustrations Which Connect Movements

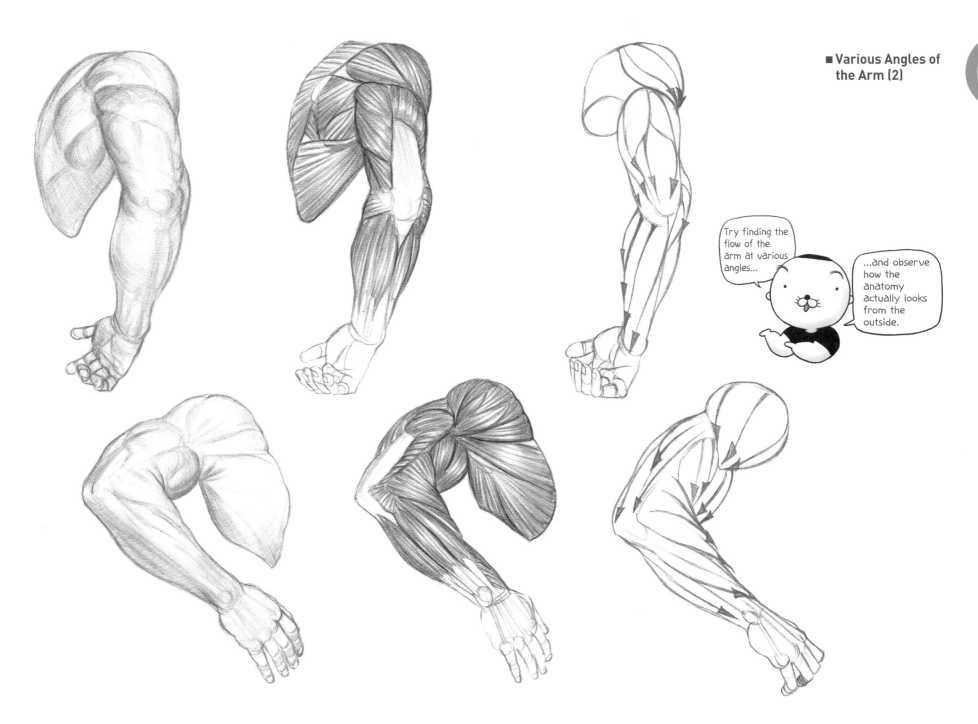

Try finding the flow of the arm at various angles...

...and observe how the anatomy actually looks from the outside.

5 Leg Muscles: Location & Use

■ The Pelvis in Box

Main Areas of the Pelvis

Let's look into the pelvis, which is notoriously known for having the most complicated structure of all the bone structures in the body. As you learned in Chapter 1: Figure Drawing, the more complicated a form is, simplifying through shaping is a method where you can easily understand its structure. For the pelvis the parts that protrude are the most important. The areas of the iliac crest, spina iliaca interior superior, symphysis ossium pubis, and the sacrum touch the skin and have an affect on the way the body looks externally. If you properly understand the location and form of these four sections then it's said that there's no need for you to know in detail about the remaining areas of the pelvis.

What Not To Do **Bird's Eye View of the Pelvis**

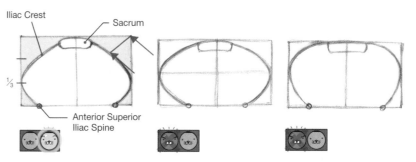

Let's first take a look at the form of the iliac crest. When you look at the pelvis from a bird's eye view observe the locations of the anterior superior iliac spine and sacrum, and the flow of the iliac crest. If you take the pelvis from a bird's eye view and place it right inside of a rectangle, then the iliac crest touches the sides of the box at 1/3 of the length of the sides of the rectangle, and the sacrum touches the halfway point of the back side of the box. You can observe this in the picture above which is correctly drawn. Keep in mind that the anterior superior iliac spine doesn't touch the corners of the box. Be sure to accurately understand the flow of the iliac crest as you compare the correctly and incorrectly drawn pictures above.

The Pelvis with a Cube

Length of Y: The height of the anterior superior iliac spine and symphysis ossium pubis
Length of X: The distance from the wings of the illium to either edge
Length of Z: The vertical distance between the anterior superior iliac spine and sacrum

As is shown in the figures to the left, after you draw the box using lengths X, Y and Z (with the exception of the top portion of the wings of the ilium and the bottom of the ramus of the hip bone) draw the shape of the pelvis that's inside the box and then complete the pelvis by combining the top portion of the wings of the ilium and the bottom of the ramus of the hip bone. It looks complicated, but as I stated earlier the shape of the pelvis touching the skin is most important. So, simplify and connect the other complicated areas.

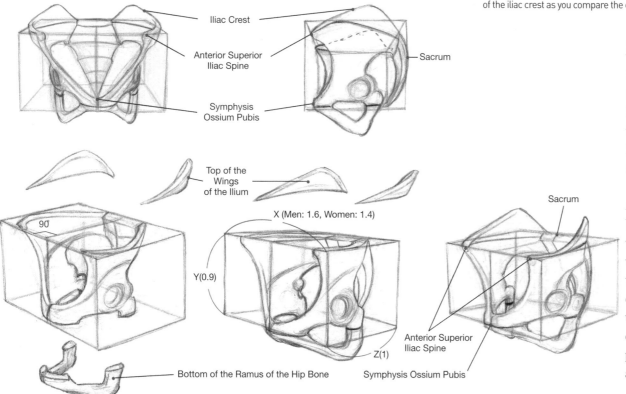

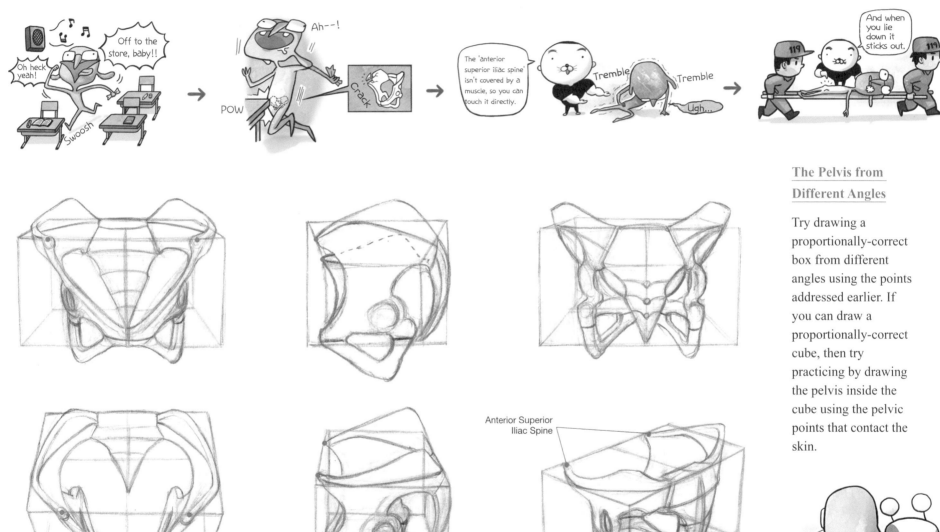

The Pelvis from Different Angles

Try drawing a proportionally-correct box from different angles using the points addressed earlier. If you can draw a proportionally-correct cube, then try practicing by drawing the pelvis inside the cube using the pelvic points that contact the skin.

■ The Leg Bones of the Lower Torso

Characteristics of the Leg Bones (1)

The lower torso is made up of the pelvis, thighbone, kneecap, shinbone, and fibula. When looking from the side, the angle of men's anterior superior iliac spine and symphysis ossium pubis is perpendicular to the floor, while women's anterior superior iliac spine has the same angle of the pelvis, which sticks out to the front. Men's pelvises are taller than women's. Additionally, when looking from the side men's thighbone sticks slightly out towards the front--it isn't straight. The calf is divided into the shinbone and the fibula, much like how the forearm is divided into the ulna and radius. The arm has the ulna at the center and the wrist turns as the radius pronates and supinates, but because the ankle supports the weight of the entire body the ankles have evolved to have a very strong structure and they don't turn like the wrists are able to turn.

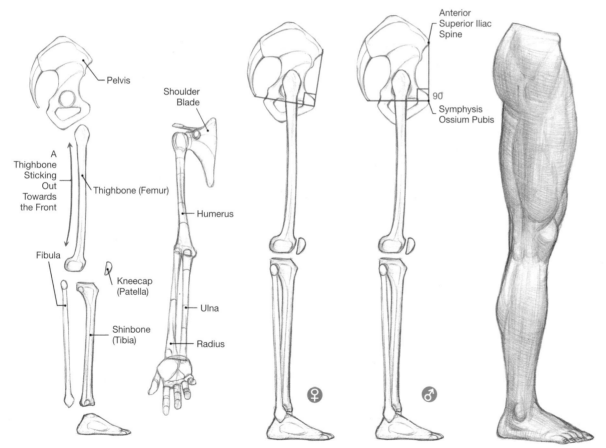

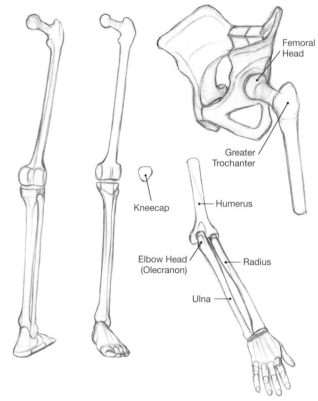

Characteristics of the Leg Bones (2)

The femoral head is the joint where the femur and pelvis meet. Of all the joints in the body it is the ball joint which has the most natural movement. The reason that the greater trochanter sticks out like a lump is so that it can connect with the butt muscles. Originally, the arms were used as front legs and evolved, so it will help greatly in understanding the legs if you compare and study the arms and legs together. There are many similarities between the arms and legs, but it's only the leg that has a kneecap. It's in the same location that the elbow head is for the arm.

It's said that the kneecap acts as a lever that allows for the leg, which is heavy, to move more easily.

■ Spreading the Legs: The Flat Leg Muscles (Tensor Fasciae Latae), Gluteus Medius (Mesogluteus), & Gluteus Maximus

Starting & Ending Points

The butt muscles play the same role as the shoulder muscles in the arm. As with the shoulder muscles, the butt muscles are also divided into three sections. In the bottom picture (1) shows the flat leg muscles. They start at the anterior superior iliac spine and then end after traveling to the area of the greater trochanter. (2), which shows the gluteus medius, faces the side of the butt. Following the iliac crest it starts at the wings of the ilium, travels to the greater trochanter and connects. In (3) the gluteus maximus is attached at the rear of the butt. It then starts at the sacrum and travels to the rear of the greater trochanter.

Use

The role of the butt muscles is to allow the legs to move up, back, and to the sides. If the flat leg muscles in (A) contract, then it has a large effect on the expression of the flow that connects the pelvis and thigh. If the gluteus medius in (B) contracts, then the thighbone raises to the side. Finally, if the gluteus maximus contracts, then the thighbone raises to the rear. The gluteus maximus is the largest of the three muscles, as it raises the body or pushes the body forward.

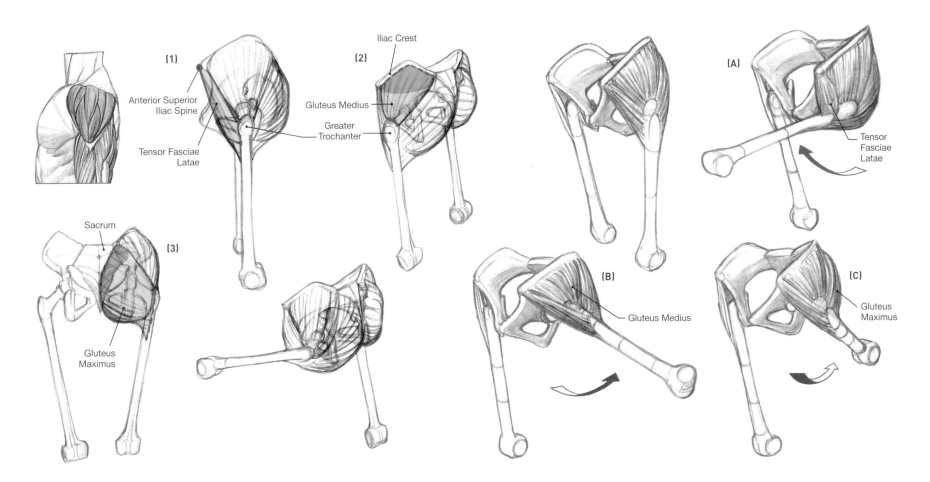

(1)

Anterior Superior
Iliac Spine

Tensor Fasciae
Latae

Iliac Crest

(2)

Gluteus Medius

Greater
Trochanter

(A)

Tensor
Fasciae
Latae

Sacrum

(3)

Gluteus
Maximus

(B)

Gluteus Medius

(C)

Gluteus
Maximus

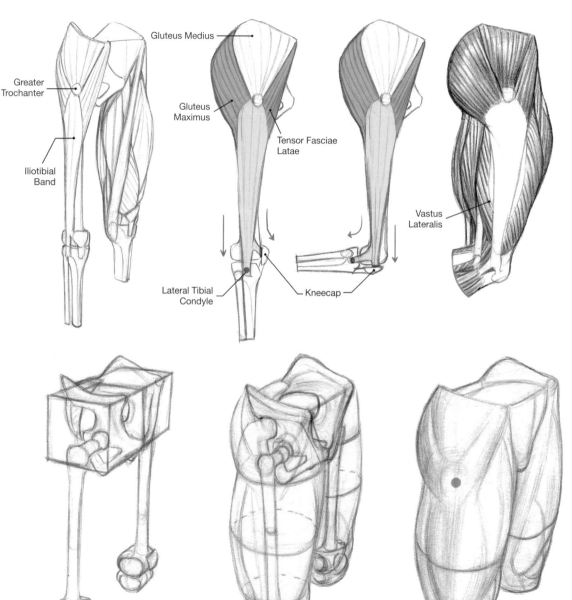

Gluteus Medius

Greater
Trochanter

Gluteus
Maximus

Tensor Fasciae
Latae

Iliotibial
Band

Vastus
Lateralis

Lateral Tibial
Condyle

Kneecap

Iliotibial Band

Earlier, I simplified the gluteus maximus and tensor fasciae latae as they traveled to the thighbone and attached. However, anatomically speaking these two muscles change due to the iliotibial band tendon. They actually stretch all the way down towards the kneecap and lateral tibial condyle. This is where they attach. In between the iliotibial band and thighbone exists the vastus lateralis muscle. Every time you fold and release the knee the direction in which the iliotibial band's end point faces changes. Take a look at the drawing to the left to observe the change.

This protrusion is visible when you look at the skin, so you can't omit it when you draw. The gluteus medius travels to the greater trochanter and attaches directly. The top of the greater trochanter isn't covered by a muscle and is thus closely touching the skin. This point protrudes when you look at the skin. You can also touch the outline of the bone with your hand. Another characteristic is that this point on men can be touched more definitively than on women.

Protruding Points of the Thigh

The red points on the drawing notate the ending points of the greater trochanter and iliotibial band. The circular dotted lines show the unique direction of the wrinkles that intersect the muscles above the tensor fasciae latae when the leg bends.

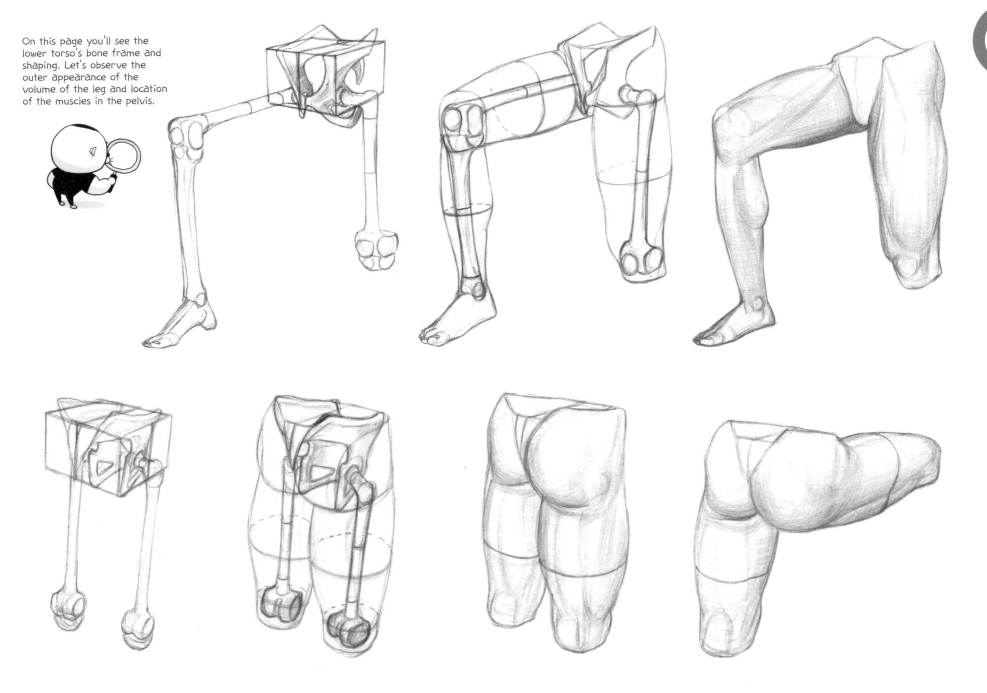

On this page you'll see the lower torso's bone frame and shaping. Let's observe the outer appearance of the volume of the leg and location of the muscles in the pelvis.

■ Knee Structure: Changes with Movement

The Relationship Between the Kneecap & Tibia

The reason that the thighbone joint bends backwards like a golf club is that it makes a space to ensure as much as possible that the thighbone and tibia don't touch when the knee bends.

The femoral condyles are convex joints while the tibial head is concave. The kneecap is the reason for the change to the knee's form whenever the knee moves and it is connected to the tibial tubercle with a ligament. The ligament is unable to contract and relax, so even when the knee moves the space between the kneecap and tibial tubercle is always the same, as you can see below.

When you look at the leg laterally the fibula is connected on the tibia's outer line. What's important on the fibula is that the fibular head is not attached at the center of the tibular head but rather to the back of the knee.

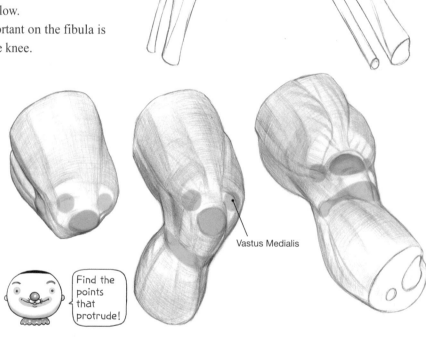

Medial Femoral Condyle

Vastus Medialis

Find the points that protrude!

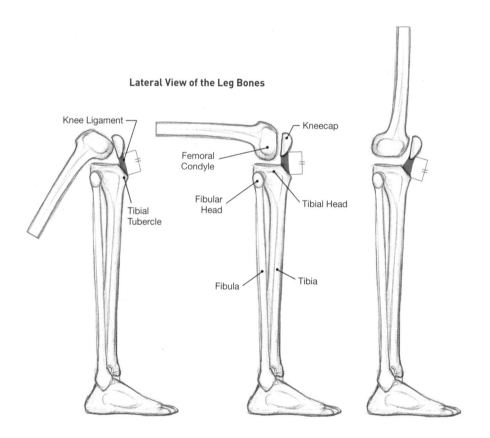

Lateral View of the Leg Bones

Knee Ligament

Kneecap

Femoral Condyle

Tibial Tubercle

Fibular Head

Tibial Head

Fibula

Tibia

Knee Form According to Posture

The form of the area around the knee is largely affected by bone. You must know the location of each bone according to the degree of bend in the knee to be able to create and draw knee form correctly for each type of posture and without reference materials. The vastus medialis covers the top of the medial femoral condyle, so it sticks out more than the amount of volume of the bone itself. The more developed the vastus medialis is the more this area protrudes.

■ The Frontal Thigh Muscles (Rectus Femoris, Vastus Lateralis, Vastus Medialis, & Sartorius)

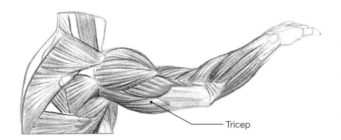

Tricep

Rectus Femoris: The Foremost Thigh Muscle - Vastus Lateralis: The Largest Muscle in the Lower Torso

The muscles on the front of the thigh are used when the knee straightens. If you compare them with the arm, they play the same role that the triceps play when you straighten the arm. If you look at the thigh from the outside the rectus femoris and vastus lateralis are on the front side of the thigh. The rectus femoris starts at the anterior inferior iliac spine, travels to the kneecap, then attaches. When you look at the thigh from the front it's the muscle that sticks out the most. Next, the vastus lateralis starts at the side of the thighbone, follows it to the kneecap, then attaches. The vastus lateralis looks small from the front, but when you look at the thigh from the side it has a wide area and volume and it actually boasts being the largest muscle in the lower torso.

When you look at an athlete's developed leg you can see the flow which protrudes towards the outside. The vastus lateralis creates this flow.

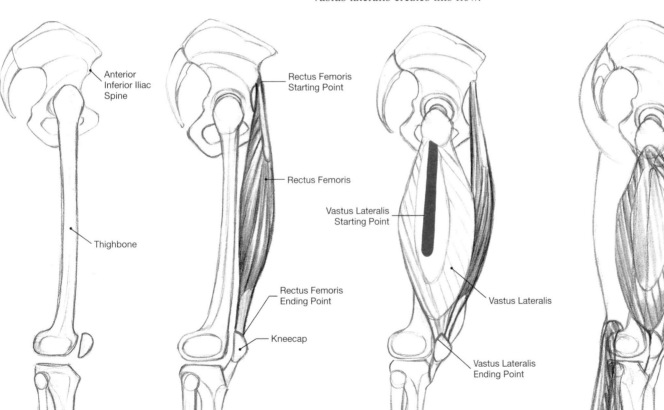

Anterior Inferior Iliac Spine

Rectus Femoris Starting Point

Rectus Femoris

Vastus Lateralis Starting Point

Thighbone

Rectus Femoris Ending Point

Kneecap

Vastus Lateralis

Vastus Lateralis Ending Point

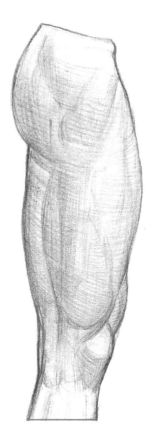

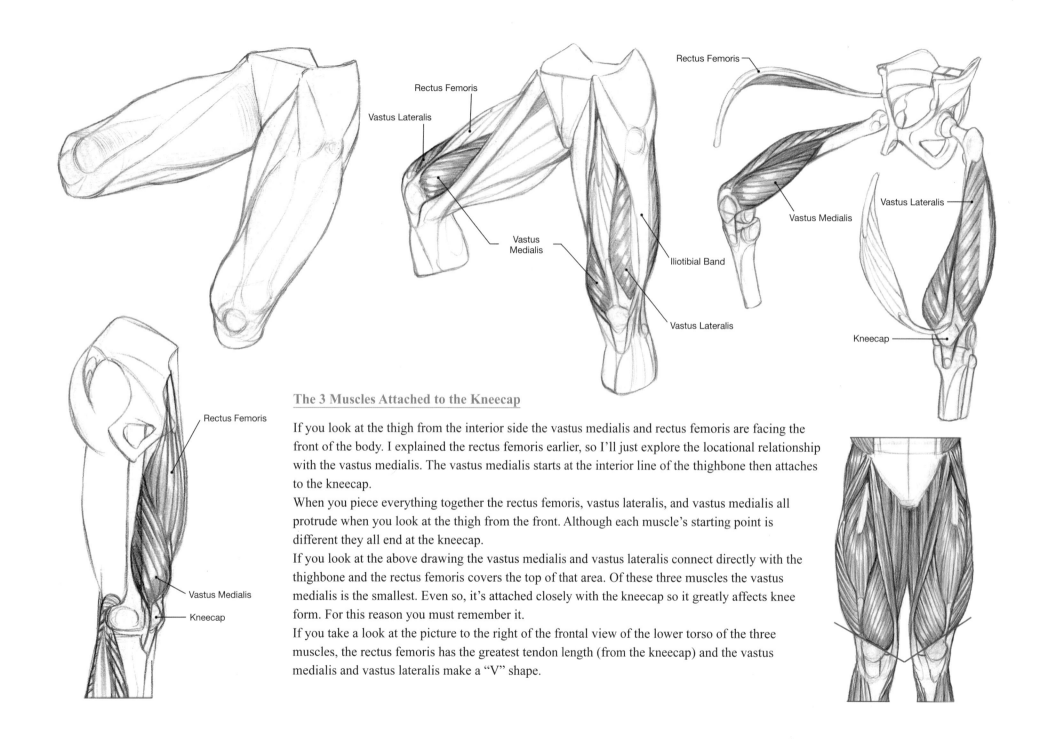

Rectus Femoris

Vastus Lateralis

Rectus Femoris

Vastus Medialis

Iliotibial Band

Vastus Lateralis

Rectus Femoris

Vastus Medialis

Vastus Lateralis

Kneecap

Rectus Femoris

Vastus Medialis

Kneecap

The 3 Muscles Attached to the Kneecap

If you look at the thigh from the interior side the vastus medialis and rectus femoris are facing the front of the body. I explained the rectus femoris earlier, so I'll just explore the locational relationship with the vastus medialis. The vastus medialis starts at the interior line of the thighbone then attaches to the kneecap.

When you piece everything together the rectus femoris, vastus lateralis, and vastus medialis all protrude when you look at the thigh from the front. Although each muscle's starting point is different they all end at the kneecap.

If you look at the above drawing the vastus medialis and vastus lateralis connect directly with the thighbone and the rectus femoris covers the top of that area. Of these three muscles the vastus medialis is the smallest. Even so, it's attached closely with the kneecap so it greatly affects knee form. For this reason you must remember it.

If you take a look at the picture to the right of the frontal view of the lower torso of the three muscles, the rectus femoris has the greatest tendon length (from the kneecap) and the vastus medialis and vastus lateralis make a "V" shape.

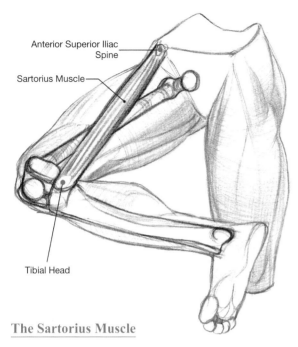

Anterior Superior Iliac Spine

Sartorius Muscle

Tibial Head

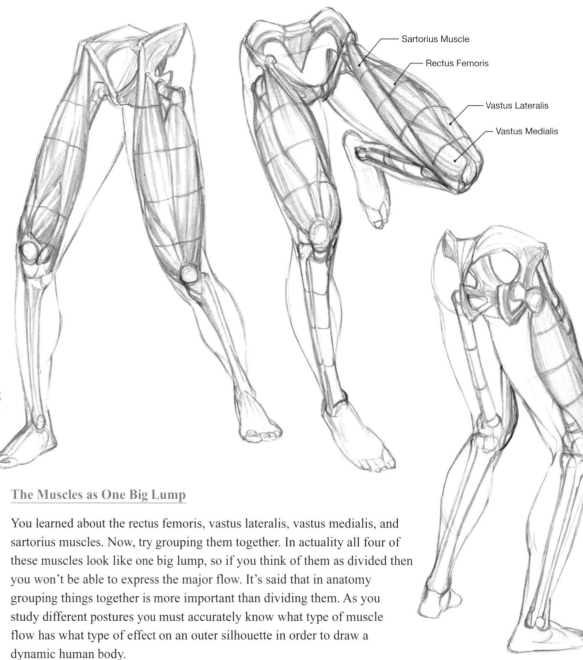

Sartorius Muscle

Rectus Femoris

Vastus Lateralis

Vastus Medialis

The Sartorius Muscle

Visually, the sartorius muscle serves as a border between the front and inside of the thigh. In order to accurately grasp the flow of this border you'd definitely have to know the starting and ending point locations, right? The sartorius muscle starts at the anterior superior iliac spine, travels to the inside of the tibial head, then attaches.

As is shown in the cartoon below of playing hackie-sack, when you take a playing posture this muscle plays the role of lifting the leg
as it turns inward.

Thanks to the sartorius muscle we can sit criss-cross apple sauce and play hackie-sack.

Whoo hoo!

Bang!

The Muscles as One Big Lump

You learned about the rectus femoris, vastus lateralis, vastus medialis, and sartorius muscles. Now, try grouping them together. In actuality all four of these muscles look like one big lump, so if you think of them as divided then you won't be able to express the major flow. It's said that in anatomy grouping things together is more important than dividing them. As you study different postures you must accurately know what type of muscle flow has what type of effect on an outer silhouette in order to draw a dynamic human body.

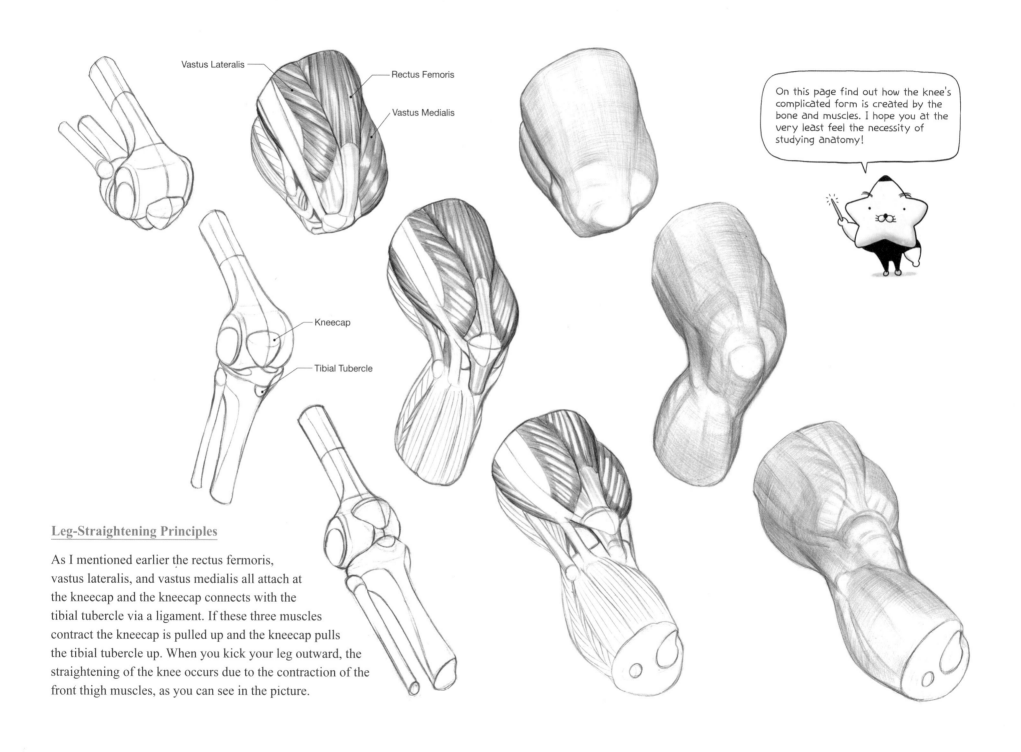

Vastus Lateralis

Rectus Femoris

Vastus Medialis

Kneecap

Tibial Tubercle

On this page find out how the knee's complicated form is created by the bone and muscles. I hope you at the very least feel the necessity of studying anatomy!

Leg-Straightening Principles

As I mentioned earlier the rectus fermoris, vastus lateralis, and vastus medialis all attach at the kneecap and the kneecap connects with the tibial tubercle via a ligament. If these three muscles contract the kneecap is pulled up and the kneecap pulls the tibial tubercle up. When you kick your leg outward, the straightening of the knee occurs due to the contraction of the front thigh muscles, as you can see in the picture.

■ The Adductor Muscles

Starting & Ending Points

The adductor muscles commonly refer to the adductor magnus, gracilis, adductor brevis, adductor longus, and pectineus muscles. These muscles look like one clump from the outside, so I'll group them together when explaining for the sake of ease.

The adductor muscles start at the iliopubic eminence, pubic tubercle, and the ramus of the ischium, then connect all the way from the upper part of the thighbone to the medial femoral condyle, then attach. It goes all the way from the front to the rear so you'll need a 3D understanding of it.

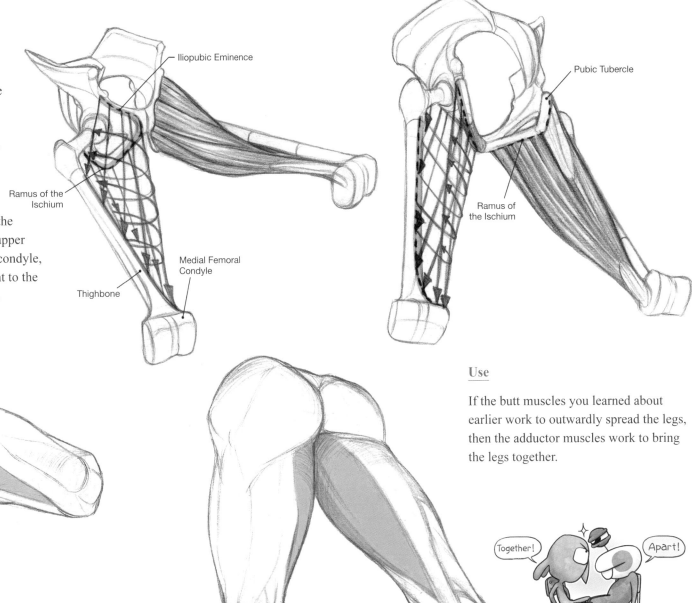

Iliopubic Eminence

Pubic Tubercle

Ramus of the Ischium

Ramus of the Ischium

Medial Femoral Condyle

Thighbone

Use

If the butt muscles you learned about earlier work to outwardly spread the legs, then the adductor muscles work to bring the legs together.

Together!

Apart!

Adductor Muscles vs. Butt Muscles
〈Thigh Wrestling〉

The Adductor Muscles from Various Angles

Many students draw the thigh flat. In many cases this is due to a lack of
awareness when it comes to the adductor muscles. On the other hand,
if you are too aware of the adductor muscles then you over exaggerate the
thickness of the lower body. Rather than feeling your way through the
adductor muscles you must research deeply using sketching and anatomy.

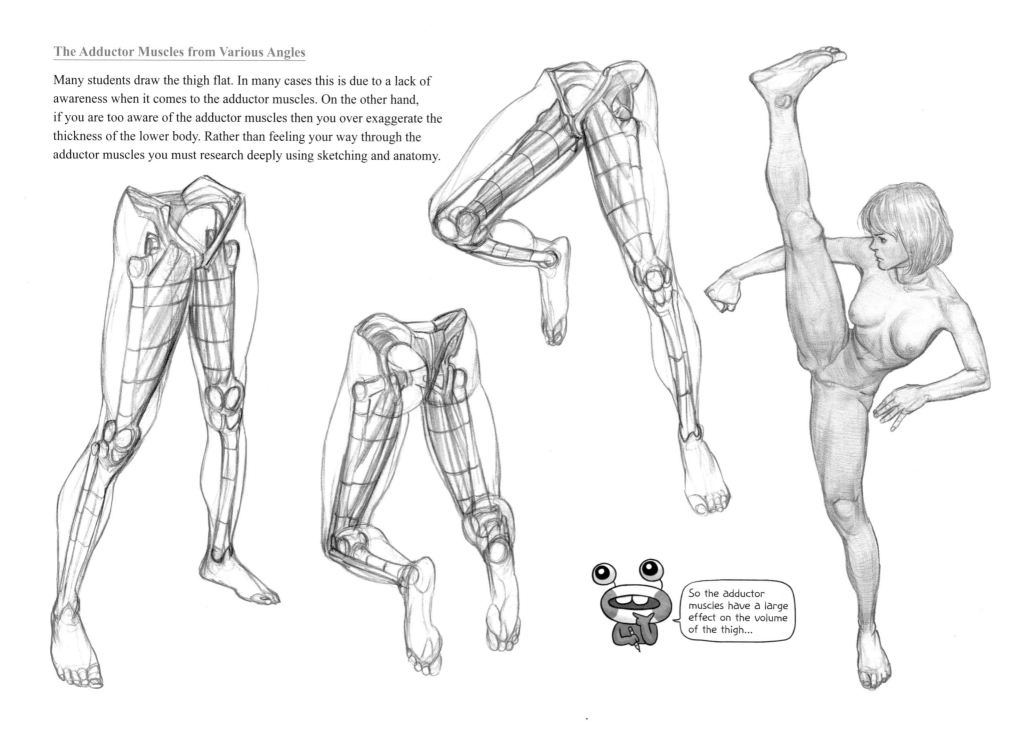

So the adductor muscles have a large effect on the volume of the thigh...

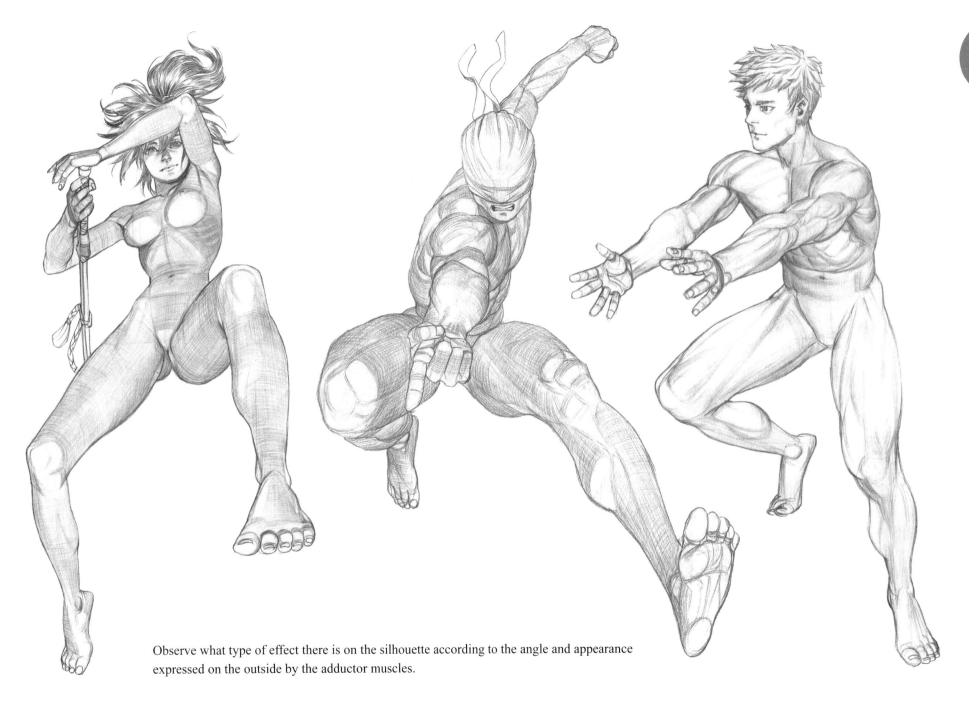

Observe what type of effect there is on the silhouette according to the angle and appearance expressed on the outside by the adductor muscles.

■ Bending the Knee: The Rear Thigh Muscles (Biceps Femoris, Semimembranosus Muscle, & Semitendinosus Muscle)

Starting & Ending Points

The rear thigh muscles are made up of the biceps femoris, semimembranosus muscle, and the semitendinosus muscle. These three muscles all start at the ischial tuberosity. The semitendinosus and semimembranosus muscles ride along the inner thigh line and connect at the medial tibial head. Structurally, the semitendinosus muscle covers the top of the semimembranosus muscle. The ending point of the biceps femoris is the fibular head, which is the lateral thigh line. It is in this way that the muscles start at one point, divide, then end at two different points. If you look at the picture to the right you'll see how they form an upside down "V".

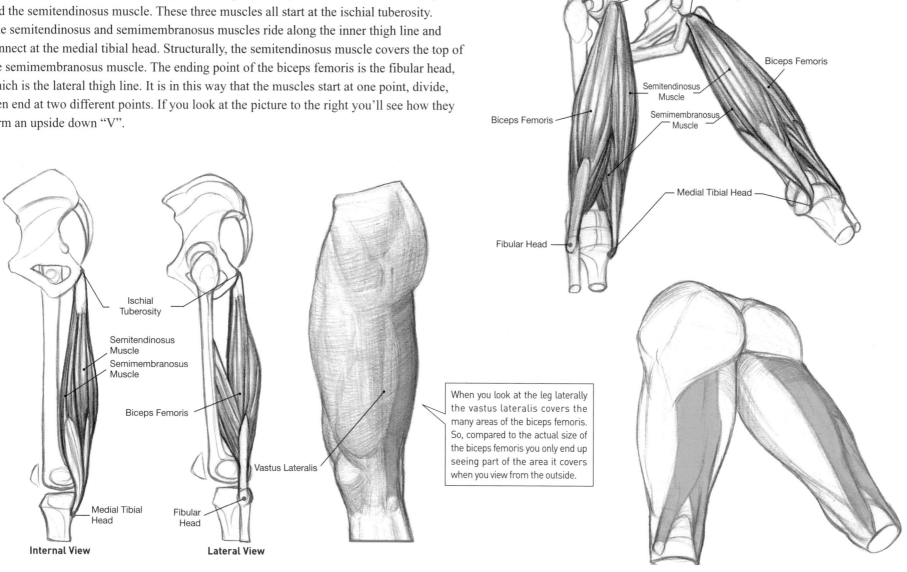

Ischial Tuberosity

Semitendinosus Muscle

Semimembranosus Muscle

Biceps Femoris

Biceps Femoris

Medial Tibial Head

Fibular Head

Ischial Tuberosity

Semitendinosus Muscle

Semimembranosus Muscle

Biceps Femoris

Medial Tibial Head

Vastus Lateralis

Fibular Head

Internal View

Lateral View

When you look at the leg laterally the vastus lateralis covers the many areas of the biceps femoris. So, compared to the actual size of the biceps femoris you only end up seeing part of the area it covers when you view from the outside.

Use

The rear thigh muscles are "flexor muscles"
which carry the same function as the biceps in the arm.
The biceps femoris, semitendinosus, and semimembranosus
muscles area used when bending the knee backwards,
which is opposite to the function of the frontal thigh muscles.
It's thanks to the rear muscles of the thigh that you're able to bring
your leg back when you jog.

Wha?!

It was like that??

Biceps Femoris

Fibular Head

Semitendinosus Muscle

Semimembranosus Muscle

Bicep

The Rear Thigh Muscles: Characteristics

When you draw the biceps femoris, semitendinosus, and semimembranosus muscles you have to make it a point to draw the rear tendons of the knee as taut and protruding. In particular, the biceps femoris is located on the outside, and the point of the tendon of the biceps femoris which connects to the fibular head must stick out regardless if it's for a man or woman.

Thus, it's very important to accurately know the location of the fibular head and direction of the tendons of the biceps femoris. As you look at the pictures on this page closely observe how the rear thigh muscles split into two when you flex them as you bend the leg, and how they bunch into one big lump because they aren't flexed as you straighten the leg.

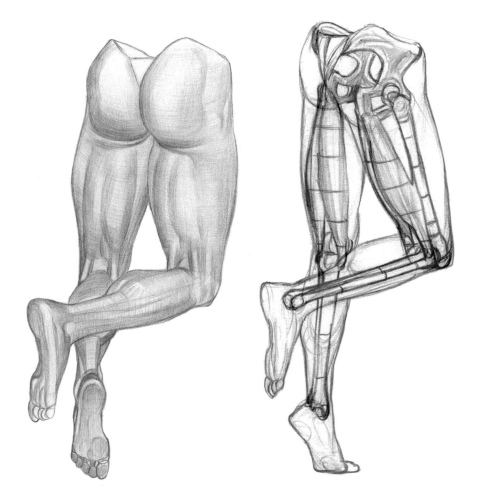

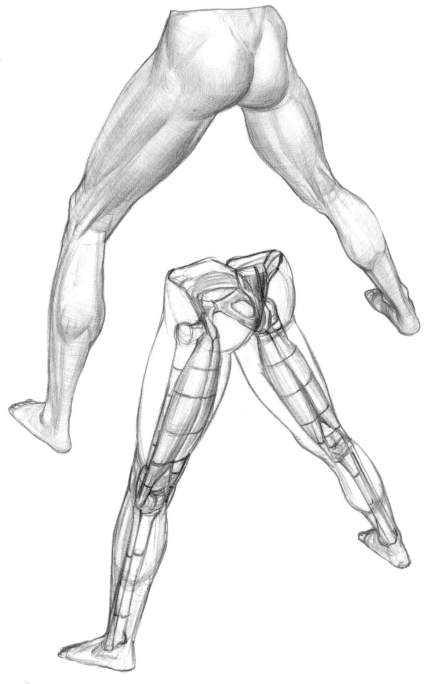

■ Rear Fibular Muscles (The Gastrocnemius & Soleus Muscles)

Starting & Ending Points

When you compare the rear muscles of the fibula with the flexor carpi radialis you'll see that it carries out the same function for the arm. The soleus muscle attaches at the tibia and the gastrocnemius muscle covers the top of it. The gastrocnemius muscle divides into two heads and each start at the top inner and top lateral sides of the femoral condyle. At roughly half the length of the entire gastrocnemius muscle it changes into the Achilles tendon. The Achilles tendon travels to the calcaneal tubercle and attaches. The soleus muscle is mostly covered by the gastrocnemius muscle, so you only see a small portion of either side of it. Let's take a closer look in the following 4 pages.

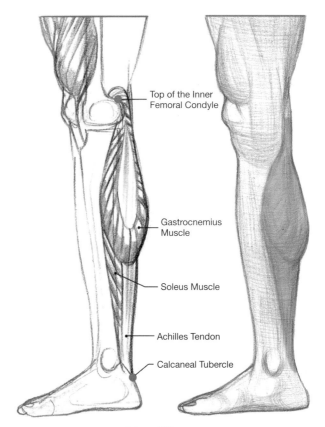

Flexor Carpi
Radialis

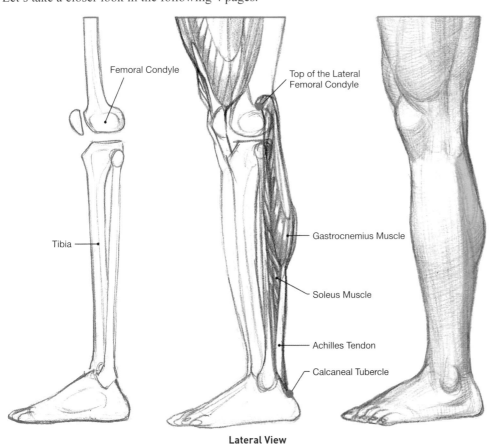

Femoral Condyle

Top of the Lateral
Femoral Condyle

Tibia

Gastrocnemius Muscle

Soleus Muscle

Achilles Tendon

Calcaneal Tubercle

Lateral View

Top of the Inner
Femoral Condyle

Gastrocnemius
Muscle

Soleus Muscle

Achilles Tendon

Calcaneal Tubercle

Internal View

The Fibula: Characteristics

Earlier I mentioned how the gastrocnemius and soleus muscles start as two segments and that the gastrocnemius covers the soleus near the Achilles tendon. You can see the gastrocnemius in the below drawing. The upper portion of the gastrocnemius muscle burrows into the rear part of the knee in between the upside down "V" that the biceps femoris and semitendinosus make, thus creating the form for the back of the knee. The green areas of the drawing display the gastrocnemius' tendons.

The tendons are flat and the muscle belly has thick volume, so be sure to observe the difference in the two forms. The length of the inner gastrocnemius muscle is longer than the length of the anterior gastrocnemius muscle, so you must always render this incline in order for the flow of the fibula to be natural. The flow of the area of the fibula is ever-changing according to the angle, so it's complicated to render. You must accurately understand both the bone curvature and the flow of the fibular muscles to render the various flows of the fibula by angle.

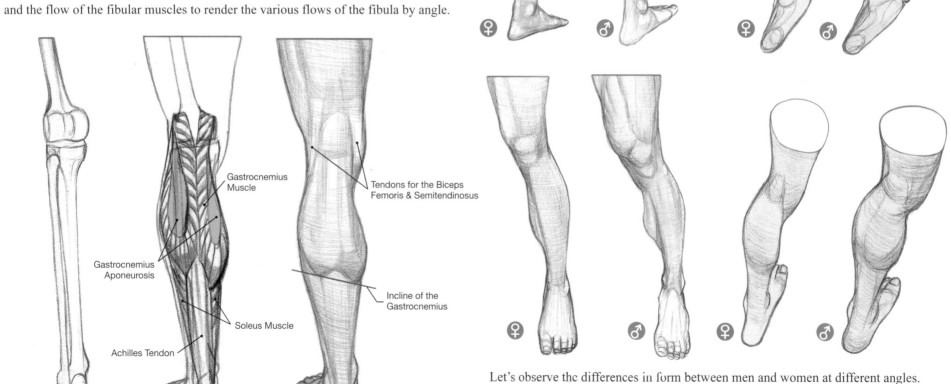

Gastrocnemius
Muscle

Gastrocnemius
Aponeurosis

Soleus Muscle

Achilles Tendon

Tendons for the Biceps
Femoris & Semitendinosus

Incline of the
Gastrocnemius

Let's observe the differences in form between men and women at different angles. The forms are different due to the differences in the amount of muscle.

Use

When you contract the gastrocnemius and soleus muscles the heel is pulled upwards and the feet point as if you're standing on your tippy-toes. These muscles are used in most basic movements such as jumping, walking and running.

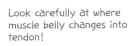

Look carefully at where muscle belly changes into tendon!

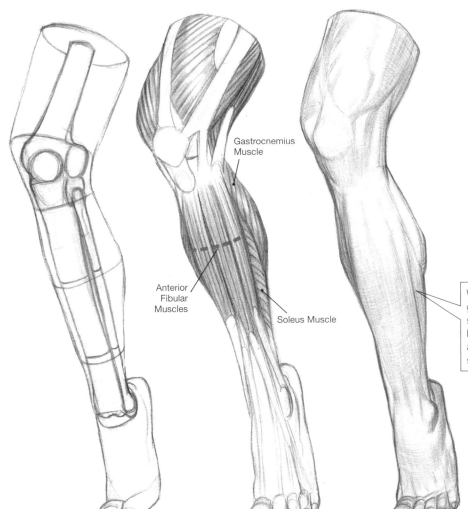

Gastrocnemius Muscle

Anterior Fibular Muscles

Soleus Muscle

When you contract the gastrocnemius and soleus muscles the border it has with the anterior fibular muscles sticks out clearly.

■ Anterior Fibular Muscles (Tibialis Anterior, Extensor Digitorum Longus, & Peroneus Longus)

Starting & Ending Points

In the same way that the extensor carpi radialis longus muscle is largely divided into three segments, the muscles of the anterior fibula are also "extensors" which are divided largely into three segments. The tibialis anterior and extensor digitorum longus start at the tibial head, while the peroneus longus starts at the fibular head. The tibialis anterior travels to the front of the medial malleolus and attaches. The extensor digitorum longus enters in the direction of the center of the top of the foot and attaches to each of the toes with the exception of the big toe. The peroneus longus travels around the rear of the lateral malleolus to the bottom of the foot and attaches. There are other small muscles as well but I am going to omit them because they don't protrude much when you look from the outside.

Use

The anterior fibular muscles are generally used to raise the top of the foot, so their function is opposite to that of the posterior fibular muscles. The tibialis anterior and peroneus longus raise the top of the foot and the extensor digitorum longus lift the toes together with the top of the foot.

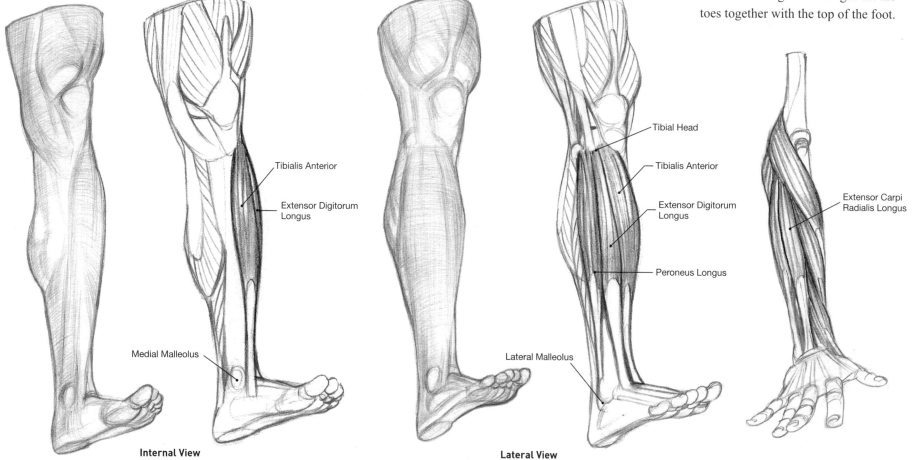

Tibialis Anterior

Extensor Digitorum Longus

Medial Malleolus

Internal View

Tibial Head

Tibialis Anterior

Extensor Digitorum Longus

Peroneus Longus

Lateral Malleolus

Lateral View

Extensor Carpi Radialis Longus

■ The Feet: Movements & Flow

The Relationship Between Weight Center & the Feet

If you study the body you tend to neglect the feet, which are the part of the body located furthest from the face. However, the feet are the part of the body that directly touch the earth. If you draw the feet and they appear unstable, then even if the posture has correct weight center when you look at it in its entirety the weight center will be off. For example, if our feet were like horse hooves then our posture would have to change in order to achieve correct weight center. Today's human being has achieved weight center according to the shape of our feet while at the same time we acquired our current bodily flow. The feet are fundamentally divided into the phalanges, metatarsals and tarsals. The halfway point of the entire foot is where the metatarsals and tarsals meet. The line that connects the ending points of the toes turns and goes downwards using the average point where the big toe and second toe meet. When shaping the feet it'll go easier if you think of the feet as having socks on.

In this book I'll proceed to simply shape and explain the flow and joint movement of the feet and not take an anatomical approach.

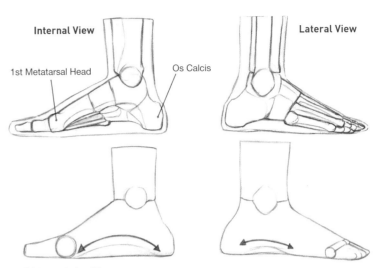

Internal View Lateral View

1st Metatarsal Head Os Calcis

The Sides of the Feet

When you look at the feet medially and laterally one typical characteristic you can observe is that there's an arch-like flow, and one other point is that the medial arch is wider than the lateral. This arch plays the role of a cushion that supports the body's weight.

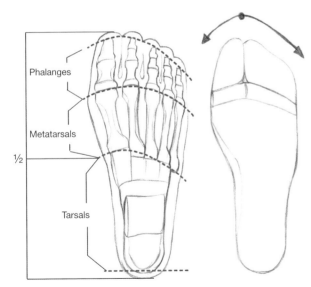

Phalanges

Metatarsals

½

Tarsals

Direction of the Instep

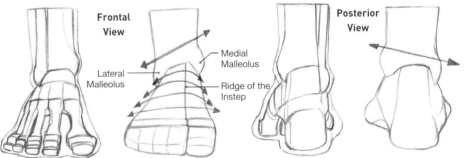

Frontal View

Lateral Malleolus

Medial Malleolus

Ridge of the Instep

Posterior View

Anterior & Posterior Foot

If you look at the foot from the front, the higher up you go from the end of the toes to the instep the more that the incline changes from being horizontal to being an arch. The flow of the medial arch, which has the ridge of the instep at its center, is very steep, while the flow of the lateral arch is more gentle of an incline. You can see this when you look at the above drawing. As with the side view the frontal view of the arch gives a buffering effect. The incline of the malleolus on either side of the ankle isn't horizontal, and the medial malleolus is higher up on the ankle than the lateral malleolus.

Side Movements of the Ankle

If you look at the side movements of the ankle the medial side of the ankle bends more than the outer side. The location of the malleoli are the reason for this. The lateral malleolus is lower than the medial, so the movement is limited (see the picture to the right). This is the reason why in everyday life there are more instances of twisting the ankle inwards as opposed to outwards.

The Feet: Characteristics

If you intend to understand the movement of the toes simply, then after bunching the big toe together with the remaining four toes, pivot the toes from the metatarsophalangeal joints (MTP Joints) (see below). The lateral longitudinal arch is straight, while the medial longitudinal arch is curved. Be careful, as many students often make the mistake of drawing the flow of the lateral longitudinal arch curved like the medial longitudinal arch. As in the first drawing, if the foot meets the floor the lateral side of the foot is pressed down by the weight of the body, so there's a curvature of the skin that occurs. If you look at the foot laterally you'll see all of the toes and if you look medially all of the toes are covered except for the big and second toes. This is because as you move from the big toe towards the pinky toe the distance and size decrease.

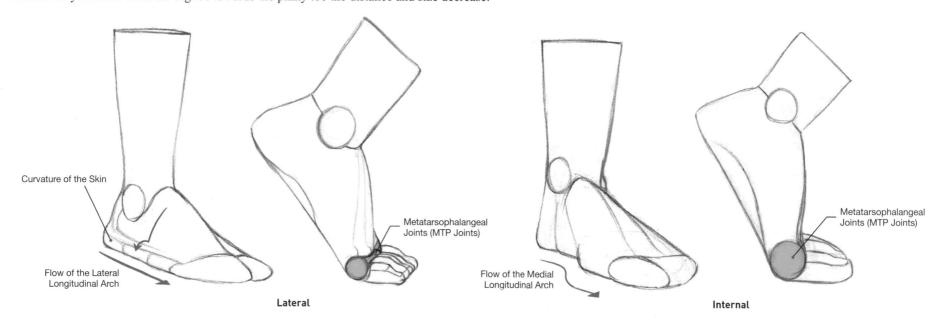

Curvature of the Skin

Flow of the Lateral Longitudinal Arch

Metatarsophalangeal Joints (MTP Joints)

Lateral

Flow of the Medial Longitudinal Arch

Metatarsophalangeal Joints (MTP Joints)

Internal

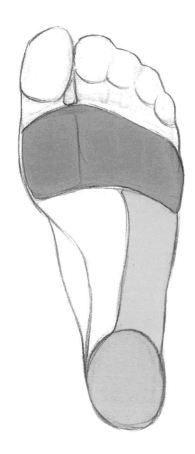

The Territories of the Sole of the Foot

Normally, since we almost never draw from an angle where you can see the sole of the foot we lack research into the sole, so it's generally difficult. When you draw the sole, if you divide it into three territories like in the picture above it's said that it will be easy to understand.

Utilize this method and practice drawing from angles where you can see the sole of the foot.

I see many foot soles nowadays...

Craack!

The Feet: Standard Shaping

The insteps have arches running from front-to-back and left-to-right, so there are major changes to the flow according to the angle you use. No matter how complicated the shaping is you'll be able to more easily understand the form if you draw after determining your point of reference. As in the picture to the right if you think to divide the medial and lateral sides using the ridge of the foot (the highest part of the foot) then you'll understand the structure a little more clearly.

Ridge of the Foot

The Toes: Structure

If you simplify the structure of the toes by shaping then draw each of them like stairs. Try developing the form on top of this type of basic flow.

Hello? This is the "foot", right?

Why in the worl–...My goodness. Hey, did you hang up on me?

Arrogance Level

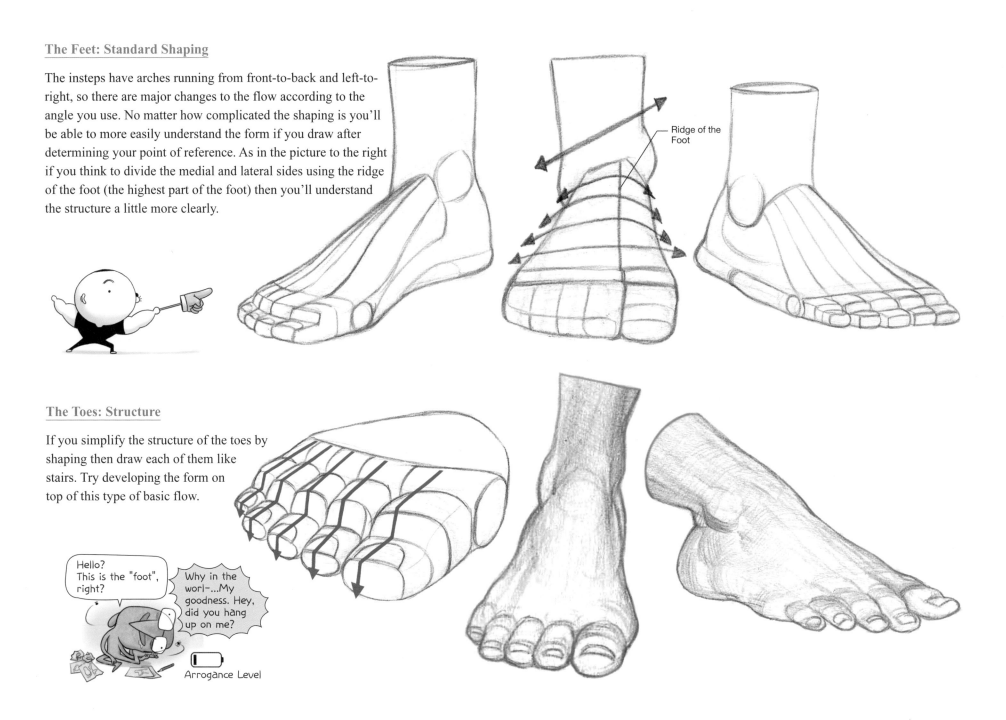

Apply the information you learned earlier to draw the foot at various angles.

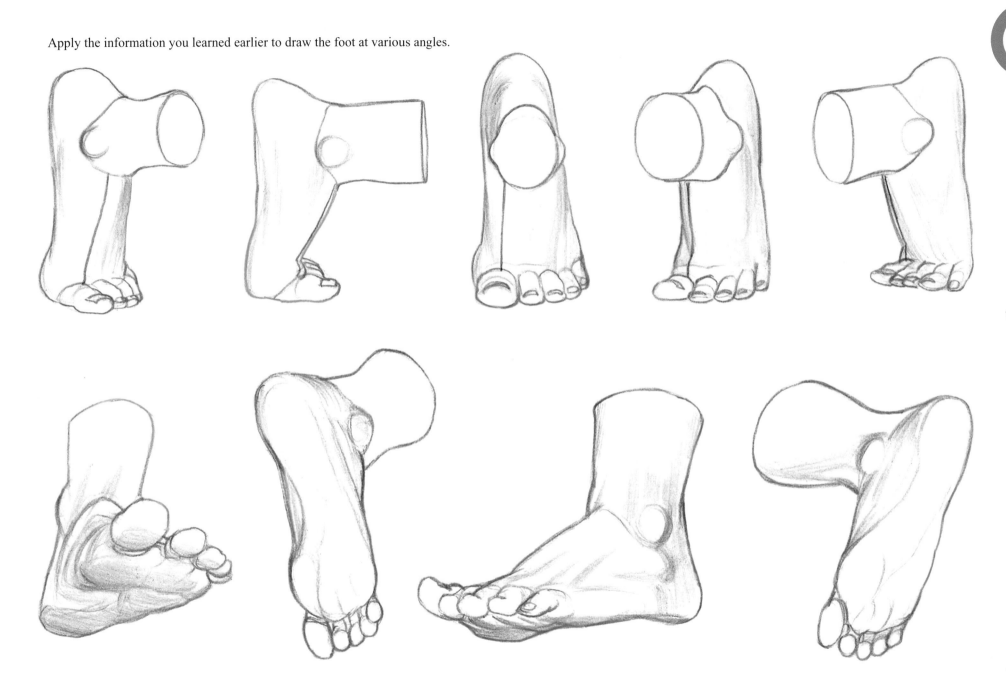

■ The Flow of the Leg Muscles at Various Angles

Sartorius Muscle

Vastus Medialis

Sartorius Muscle

Adductor Muscle

Kneecap

Semitendinosus Muscle

Sartorius Muscle

Rectus Femoris

Vastus Lateralis

Vastus Medialis

Kneecap

Adductor Muscle

Tibialis Anterior

Gastrocnemius Muscle

Soleus Muscle

Tibialis Anterior

Gastrocnemius Muscle

Soleus Muscle

Kneecap

Vastus Medialis

Sartorius Muscle

Adductor Muscle

Tibialis Anterior

Gastrocnemius Muscle

Soleus Muscle

Semitendinosus Muscle

Biceps Femoris

Gluteus Maximus

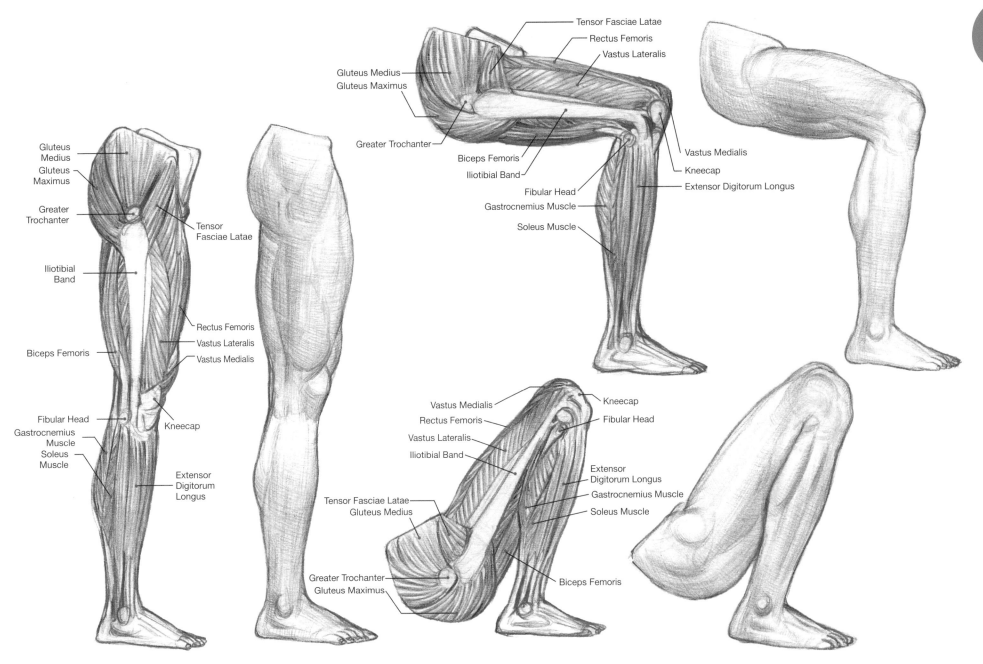

Gluteus
Medius

Gluteus
Maximus

Greater
Trochanter

Iliotibial
Band

Biceps Femoris

Fibular Head

Gastrocnemius
Muscle

Soleus
Muscle

Tensor
Fasciae Latae

Rectus Femoris

Vastus Lateralis

Vastus Medialis

Kneecap

Extensor
Digitorum
Longus

Gluteus Medius
Gluteus Maximus

Greater Trochanter

Biceps Femoris

Iliotibial Band

Fibular Head

Gastrocnemius Muscle

Soleus Muscle

Tensor Fasciae Latae

Rectus Femoris

Vastus Lateralis

Vastus Medialis

Kneecap

Extensor Digitorum Longus

Vastus Medialis

Rectus Femoris

Vastus Lateralis

Iliotibial Band

Tensor Fasciae Latae
Gluteus Medius

Greater Trochanter
Gluteus Maximus

Kneecap

Fibular Head

Extensor
Digitorum Longus

Gastrocnemius Muscle

Soleus Muscle

Biceps Femoris

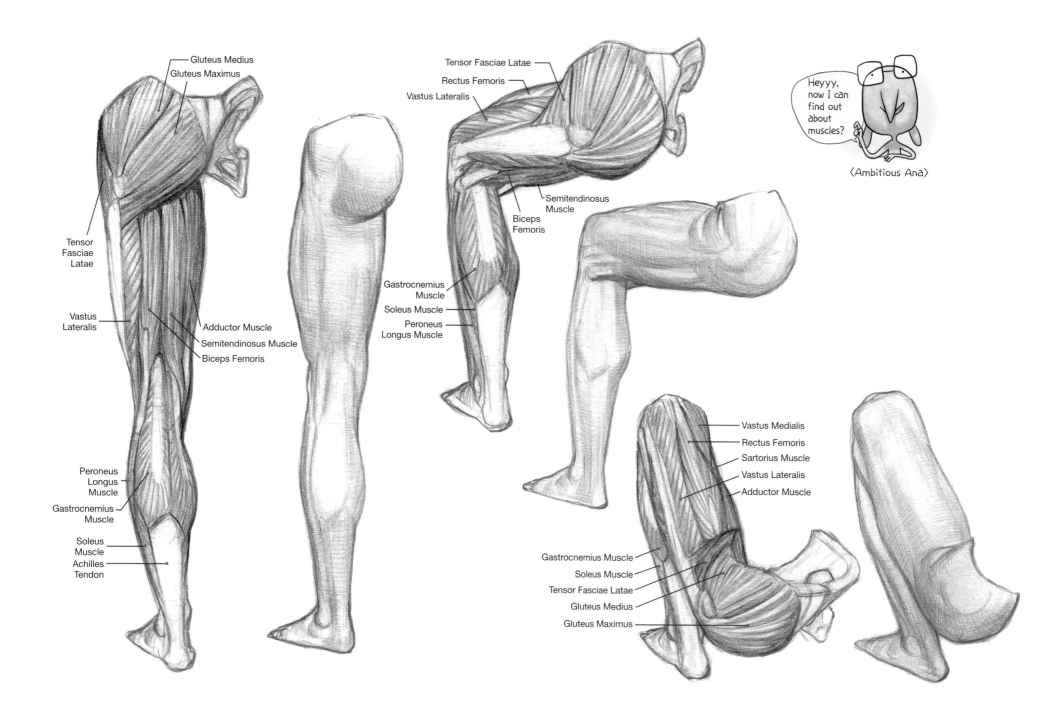

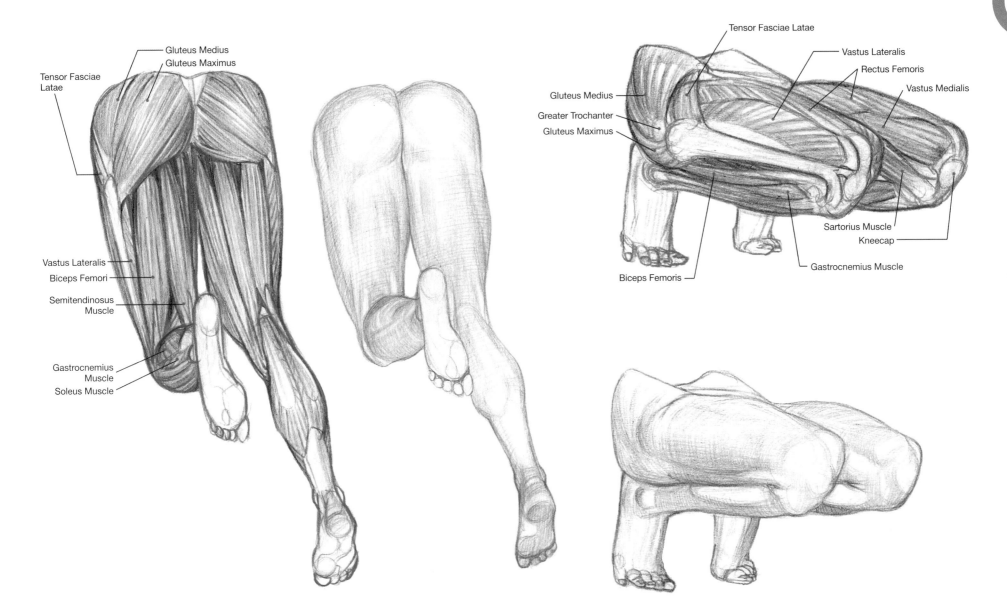

Gluteus Medius
Gluteus Maximus

Tensor Fasciae
Latae

Vastus Lateralis

Biceps Femori

Semitendinosus
Muscle

Gastrocnemius
Muscle

Soleus Muscle

Tensor Fasciae Latae

Vastus Lateralis

Rectus Femoris

Vastus Medialis

Gluteus Medius

Greater Trochanter

Gluteus Maximus

Sartorius Muscle

Kneecap

Biceps Femoris

Gastrocnemius Muscle

04

Understanding Anatomy
Through Motion

Now we'll research joint and muscle movement through different motions
and we'll take a look into how theories are applied in actual drawings.

The Collaboration Between Shaping & Anatomy

If after studying shaping and anatomy it becomes possible for you to render basic human bodies, it's time to start worrying about the type of life you're going to give to your characters. For example, when you say that you're going to draw a character that's sitting, the process of drawing a character that's simply in a "sitting" posture will be, well, boring. Not only that, it won't be particularly exciting for those who see your drawing. If you think about "how" your character will sit according to their emotions or personality then the range of expression becomes quite vast. In just one posture you can incorporate an entire story.

While there are many illustrators who happily map out and select concepts for their characters in this way, the next step is a pain in the butt. As much as possible you have to definitively map out factors such as, "Where will the body weight be shifted to?", "Is this joint moving naturally?", "Am I appropriately rendering the flexed and relaxed portions?", and "Am I displaying the bodily differences between men and women effectively?"

If you add this sense of reality into your characters then you provide them the force of life and they become convincingly real.

However, if you apply what you learned about theories to a character's posture then it's not as easy as you think.

When you learn theories separately one-by-one they make sense, but if you try to piece together and apply them practically each theory doesn't connect to the other and you end up reverting back to your original habits of drawing.

In this chapter we'll look into how to actually apply the theories you learned earlier using the information provided on actual men's and women's bodies, shaping, and anatomy. Additionally, as we explore each posture through various angles, consecutive movements and practical movements, you'll understand form on multiple levels and research the characteristics of motion.

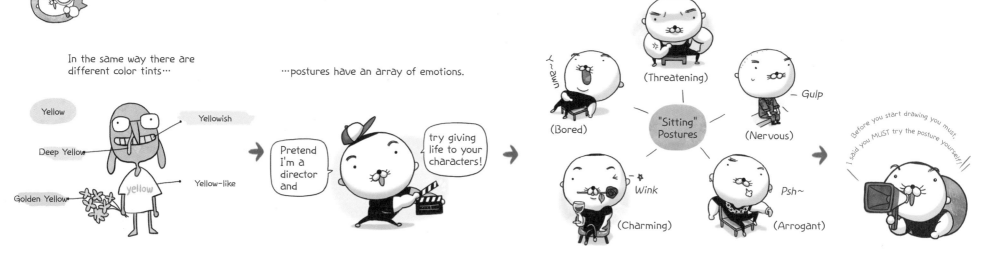

Now's When the Real Battle Starts!

Tommy the Walking Anatomy Dictionary

If there's a muscle you don't know just ask me!

Let's try drawing a leg today...

1 hour later...

OMG! Why can't I draw?!

I memorized the start and ending points and even the use of the leg. What's going on??

[Trembling] [Trembling]

Teacher... I know it's in my head

Hmm...

but I just can't draw it.

(O)

(X)

An artist is someone who speaks through drawing!

Therefore, I can say that...

There's no difference between "not being able to draw" and "not knowing".

Thud!

"Not knowing???"

Ack!

Ouch...my gluteus maximus is throbbing with pain...

The only advantage to studying anatomy is that you can clearly explain what hurts!

This exercise really develops your chest!

It's pretty easy.

Huff!

...

It's only through exercise that one develops their muscles. Drawing is the same thing.

Today's class will be on the structure of the back.

We learned this before...Where can I find some new things to learn?

If you think you know it's because you don't practice.

Tommy, you still don't understand.

When defining whether you "know" something or not, one must determine whether you can draw it or not. It's not a matter of theory.

Normally, once you know something your drawing comes naturally. So, don't beat yourself up so much.

Ok, there we go.

Really?

Flick

From now on I'm only focusing on the practical side of things.

Clunk!

Don't do that! If you exercise with incorrect technique you'll get hurt. In the same sense, you *must* study theory.

From now on, let's learn how to apply theory while drawing!

1 Standard & Applied Postures

■ Standing Posture from the Front

The Importance of Shapes

For a front stance the incline and the symmetry have to be very accurate, so even the most basic front stance is complicated. You can't see the sides of the body, so it's difficult to even produce a 3-D effect. Double check the ratio, centering, and how natural the stance is, then draw the frame. Afterwards, apply the framework of the basic flow while defining the mass.

Drawing the shape is the first step when it comes to drawing the human body!

What Not To Do **The Shape of a Man's Lower Body**

When drawing a man in an erect posture there's no space in between the two thighs. Also, if the pelvis widens in the shape of a curve then it has the feel of a woman's pelvis. Look at the drawing. When the legs are completely straight the direction of the kneecaps and feet must be the same.

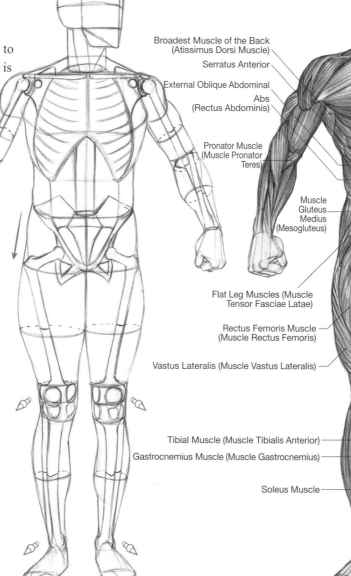

Broadest Muscle of the Back (Atissimus Dorsi Muscle)

Serratus Anterior

External Oblique Abdominal

Abs (Rectus Abdominis)

Pronator Muscle (Muscle Pronator Teres)

Muscle Gluteus Medius (Mesogluteus)

Flat Leg Muscles (Muscle Tensor Fasciae Latae)

Rectus Femoris Muscle (Muscle Rectus Femoris)

Vastus Lateralis (Muscle Vastus Lateralis)

Tibial Muscle (Muscle Tibialis Anterior)

Gastrocnemius Muscle (Muscle Gastrocnemius)

Soleus Muscle

Sternocleidomastoid Muscle (Muscle Sternocleidomastoideus)

Trapezius Muscle (Muscle Trapezius)

Pecs (Muscle Pectoralis Major)

Deltoid Muscle (Deltoid)

Triceps (Muscle Triceps Brachii)

Brachialis Muscle (Muscle Brachialis)

Biceps (Muscle Biceps Brachii)

Brachioradial Muscle (Muscle Brachioradi

Extensor Carpi Radialis Longus Muscle

Muscle Flexor Carpi Radialis

Extensor Carpi Radialis Longus Muscle

Adductor Muscle (Muscle Adductor Magnus)

Sartorius Muscle

Muscle Vastus Medialis

Kneecap (Patella)

For the sake of ease the muscles in blue may all be grouped together when referred to.
They are actually divided into different muscles but because their roles in the leg are the same they are easier to understand when referred to as one entire muscle.

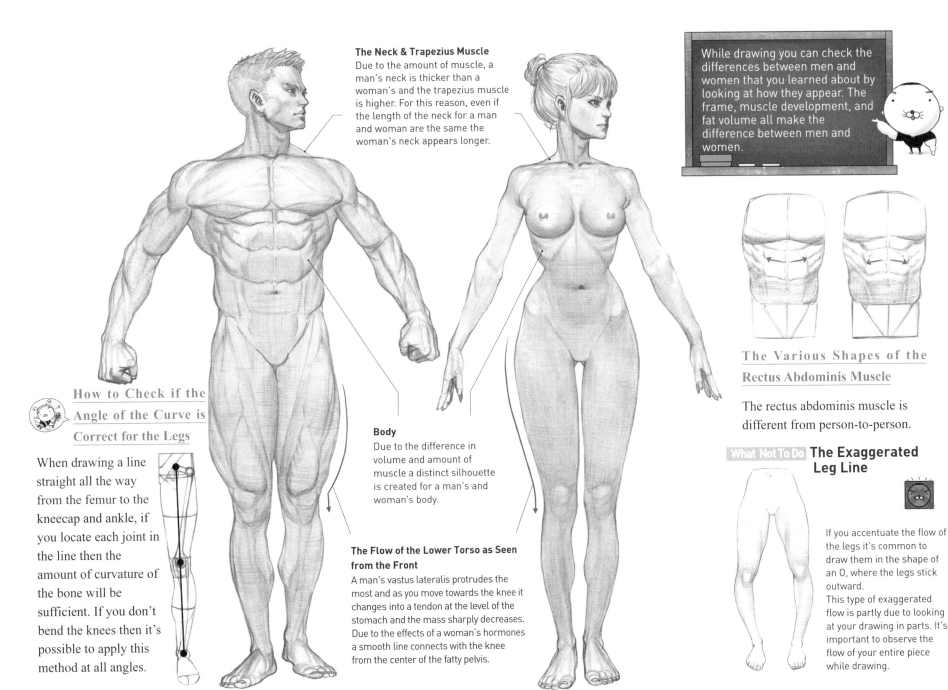

The Neck & Trapezius Muscle
Due to the amount of muscle, a man's neck is thicker than a woman's and the trapezius muscle is higher. For this reason, even if the length of the neck for a man and woman are the same the woman's neck appears longer.

While drawing you can check the differences between men and women that you learned about by looking at how they appear. The frame, muscle development, and fat volume all make the difference between men and women.

How to Check if the Angle of the Curve is Correct for the Legs

When drawing a line straight all the way from the femur to the kneecap and ankle, if you locate each joint in the line then the amount of curvature of the bone will be sufficient. If you don't bend the knees then it's possible to apply this method at all angles.

Body
Due to the difference in volume and amount of muscle a distinct silhouette is created for a man's and woman's body.

The Flow of the Lower Torso as Seen from the Front
A man's vastus lateralis protrudes the most and as you move towards the knee it changes into a tendon at the level of the stomach and the mass sharply decreases. Due to the effects of a woman's hormones a smooth line connects with the knee from the center of the fatty pelvis.

The Various Shapes of the Rectus Abdominis Muscle

The rectus abdominis muscle is different from person-to-person.

What Not To Do **The Exaggerated Leg Line**

If you accentuate the flow of the legs it's common to draw them in the shape of an O, where the legs stick outward.
This type of exaggerated flow is partly due to looking at your drawing in parts. It's important to observe the flow of your entire piece while drawing.

■ Angled Stance

What Not To Do **Angle of Diagonal View**

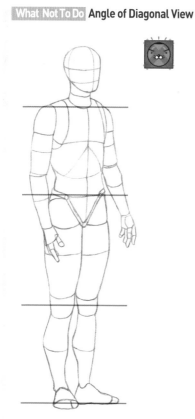

The angle of the shoulder line and of the line located at the feet cannot be congruent.

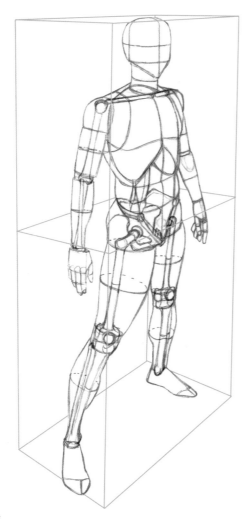

Drawing People with Good Spacing

The further away the angle of the body's horizontal line moves from eye level the steeper the incline. Even if you draw the body ratio and state of the body correctly, if the starting point and weight proportion is off, then it produces unstable look and the drawing ends up looking two-dimensional. First, establish the eye level and then draw a hexahedron. Then, if you draw your person within the hexahedron you'll more easily be able to draw a three-dimensional figure. Before drawing your figure prepare the space!!

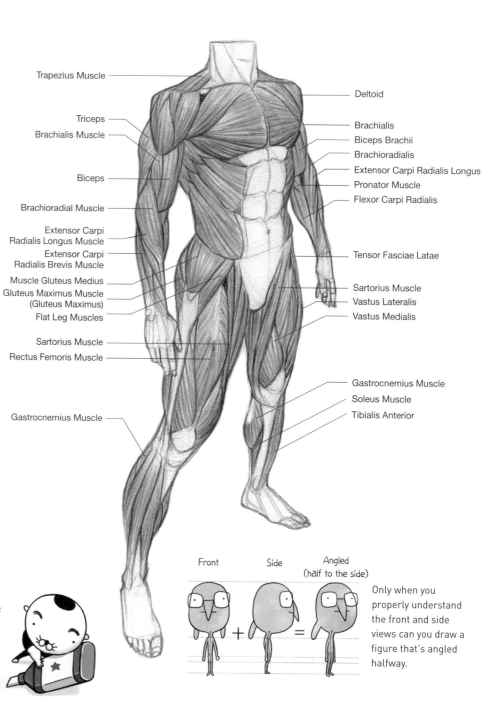

- Trapezius Muscle
- Triceps
- Brachialis Muscle
- Biceps
- Brachioradial Muscle
- Extensor Carpi Radialis Longus Muscle
- Extensor Carpi Radialis Brevis Muscle
- Muscle Gluteus Medius
- Gluteus Maximus Muscle (Gluteus Maximus)
- Flat Leg Muscles
- Sartorius Muscle
- Rectus Femoris Muscle
- Gastrocnemius Muscle
- Deltoid
- Brachialis
- Biceps Brachii
- Brachioradialis
- Extensor Carpi Radialis Longus
- Pronator Muscle
- Flexor Carpi Radialis
- Tensor Fasciae Latae
- Sartorius Muscle
- Vastus Lateralis
- Vastus Medialis
- Gastrocnemius Muscle
- Soleus Muscle
- Tibialis Anterior

Front Side Angled (half to the side)

Only when you properly understand the front and side views can you draw a figure that's angled halfway.

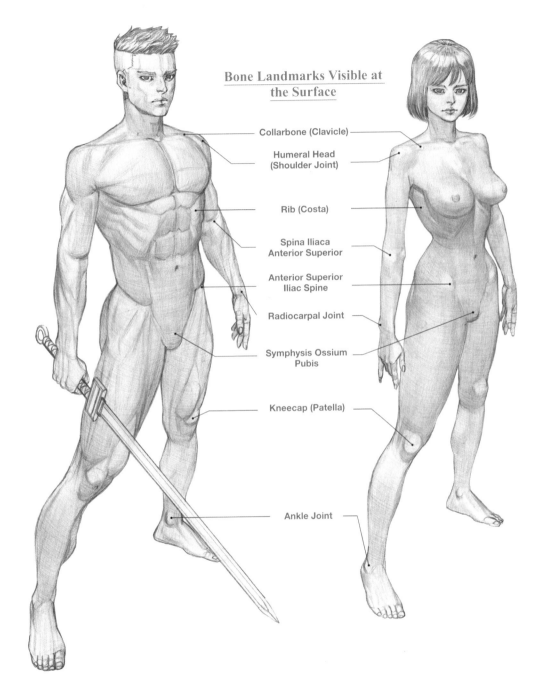

Bone Landmarks Visible at the Surface

Collarbone (Clavicle)

Humeral Head (Shoulder Joint)

Rib (Costa)

Spina Iliaca Anterior Superior

Anterior Superior Iliac Spine

Radiocarpal Joint

Symphysis Ossium Pubis

Kneecap (Patella)

Ankle Joint

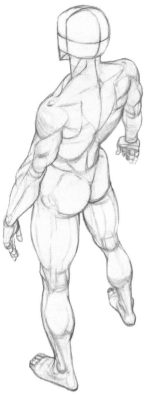

The Body's Flow as Seen from the Angled View

As you learned in Chapter 1 the lower body sticks out to the rear in order to balance an upper body that's bent back, with a non-vertical curve for the flow of the body for a figure that's drawn completely from the side. This peculiarity becomes more apparent from a rear angle that shows the flow of a bent spine. The reason why drawing a standing figure naturally is so difficult is because you must apply a shifting angle in accordance with the curved flow and perspective of the entire body.

The best gaming artists practice drawing characters from the side so much so that they memorize how to do it.

What Not To Do ## The Flow of Men's & Women's Arms

From a standing position where the arms are comfortably relaxed to the sides, women's arms stick out and men's arms bend inwards. This type of circular flow is particularly difficult to express from a side angle. As shown in the bottommost picture you must be careful not to make the mistake of thinking to draw the arms going straight down when drawing a figure from the side.

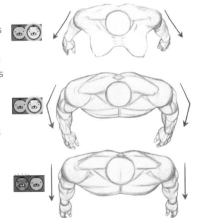

■ Angled Stance from the Rear

Difference in Flow Between Men & Women

There's a difference between the angles of the pelvis and shoulders when you are walking versus when you are standing still with your feet together. When you are walking the shoulders and hip shift back-and-forth, and when standing still the shoulders and hip shift up and down. Don't draw in parts, such as having the shoulders fixed in one position and then planting both feet, etc. You must draw the full flow of the body in accordance with its movement. The reason that the entire body reacts when there's even the slightest movement is because the body must maintain the center of weight.

What Not To Do | **Mistakes to Avoid when Drawing a Basic Stance**

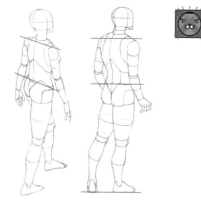

❶ Drawing the shoulders, hip, and location of the feet equally with the same angle or drawing them all horizontally.

❷ Drawing the feet from the side at all times regardless of the angle of the eyes.

❸ Drawing the lower back with a straight horizontal angle.

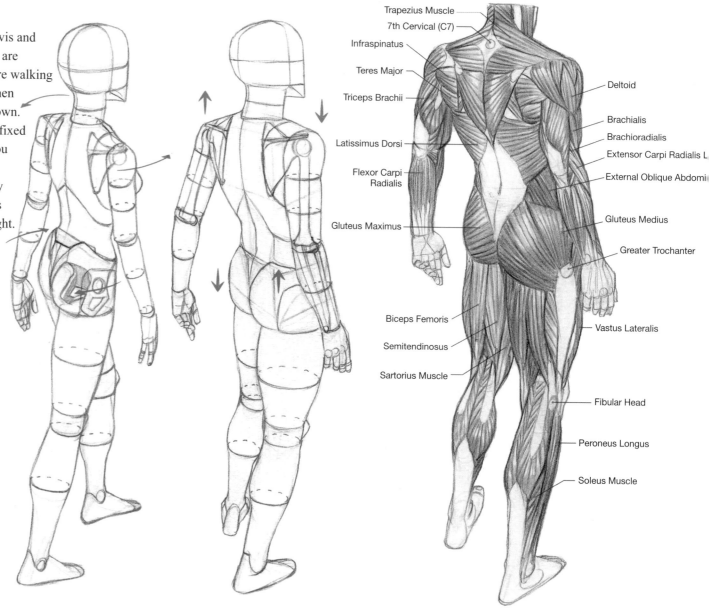

Trapezius Muscle
7th Cervical (C7)
Infraspinatus
Teres Major
Triceps Brachii
Latissimus Dorsi
Flexor Carpi Radialis
Gluteus Maximus
Biceps Femoris
Semitendinosus
Sartorius Muscle

Deltoid
Brachialis
Brachioradialis
Extensor Carpi Radialis L
External Oblique Abdomi
Gluteus Medius
Greater Trochanter
Vastus Lateralis
Fibular Head
Peroneus Longus
Soleus Muscle

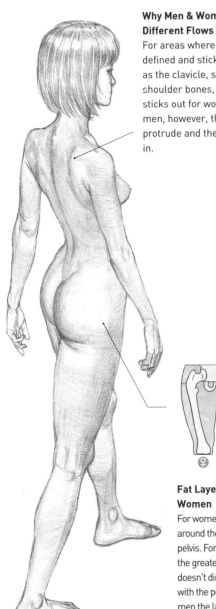

Why Men & Women Have Different Flows

For areas where bone is defined and sticks out such as the clavicle, spine, or shoulder bones, the bone sticks out for women. For men, however, the muscles protrude and the bone goes in.

Fat Layers: Men vs. Women

For women, fat sticks around the area of the pelvis. For this reason, the greater trochanter doesn't directly meet with the pelvis, but for men the layer of fat is thin, so it sticks out.

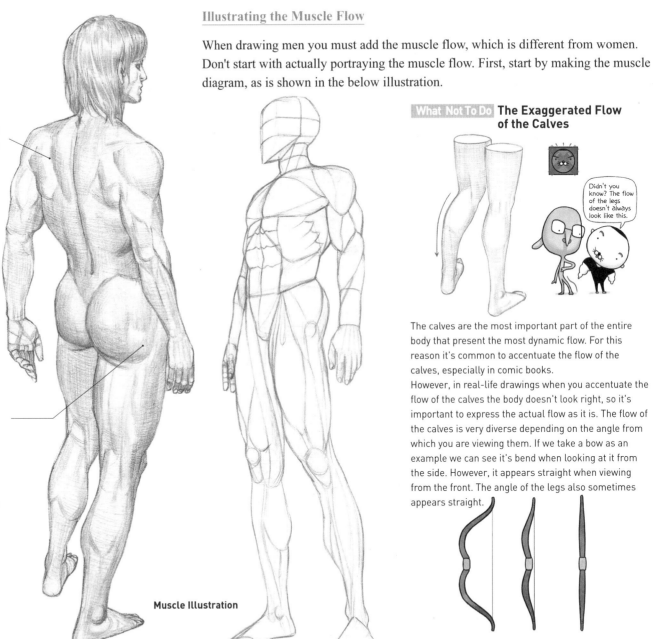

Muscle Illustration

Illustrating the Muscle Flow

When drawing men you must add the muscle flow, which is different from women. Don't start with actually portraying the muscle flow. First, start by making the muscle diagram, as is shown in the below illustration.

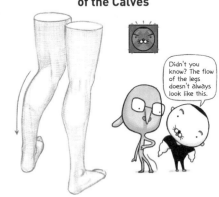

What Not To Do **The Exaggerated Flow of the Calves**

Didn't you know? The flow of the legs doesn't always look like this.

The calves are the most important part of the entire body that present the most dynamic flow. For this reason it's common to accentuate the flow of the calves, especially in comic books.

However, in real-life drawings when you accentuate the flow of the calves the body doesn't look right, so it's important to express the actual flow as it is. The flow of the calves is very diverse depending on the angle from which you are viewing them. If we take a bow as an example we can see it's bend when looking at it from the side. However, it appears straight when viewing from the front. The angle of the legs also sometimes appears straight.

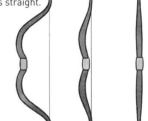

■ Positions that Emphasize the Back

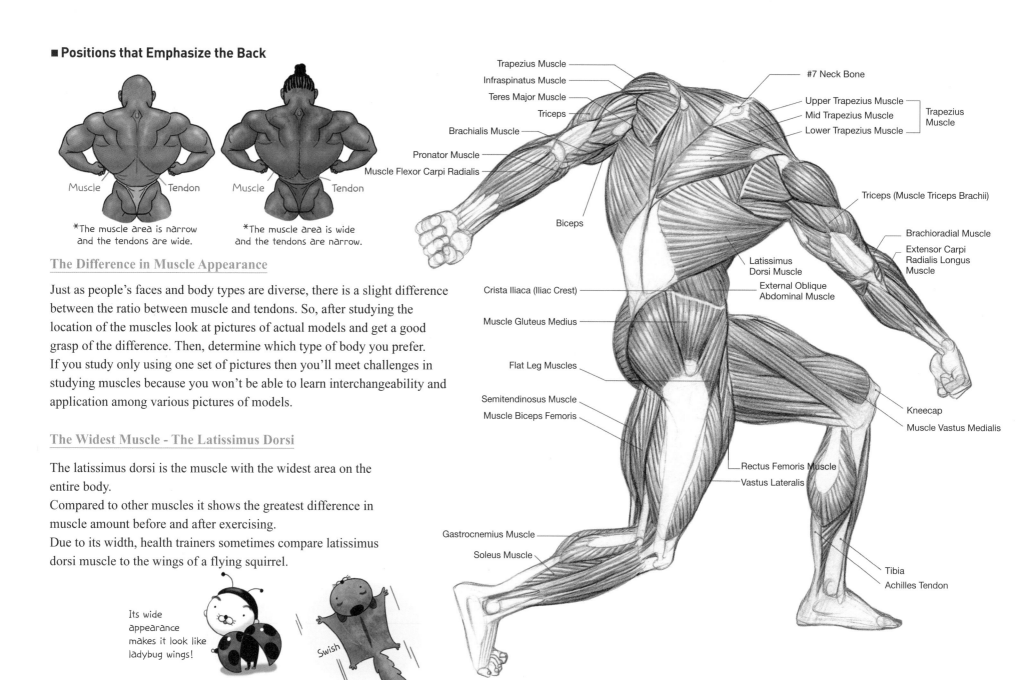

Muscle Tendon

*The muscle area is narrow and the tendons are wide.

Muscle Tendon

*The muscle area is wide and the tendons are narrow.

The Difference in Muscle Appearance

Just as people's faces and body types are diverse, there is a slight difference between the ratio between muscle and tendons. So, after studying the location of the muscles look at pictures of actual models and get a good grasp of the difference. Then, determine which type of body you prefer. If you study only using one set of pictures then you'll meet challenges in studying muscles because you won't be able to learn interchangeability and application among various pictures of models.

The Widest Muscle - The Latissimus Dorsi

The latissimus dorsi is the muscle with the widest area on the entire body.
Compared to other muscles it shows the greatest difference in muscle amount before and after exercising.
Due to its width, health trainers sometimes compare latissimus dorsi muscle to the wings of a flying squirrel.

Its wide appearance makes it look like ladybug wings!

Swish

Trapezius Muscle
Infraspinatus Muscle
Teres Major Muscle
Triceps
Brachialis Muscle
Pronator Muscle
Muscle Flexor Carpi Radialis
Biceps
Latissimus Dorsi Muscle
Crista Iliaca (Iliac Crest)
Muscle Gluteus Medius
Flat Leg Muscles
Semitendinosus Muscle
Muscle Biceps Femoris
Gastrocnemius Muscle
Soleus Muscle

#7 Neck Bone
Upper Trapezius Muscle
Mid Trapezius Muscle
Lower Trapezius Muscle
Trapezius Muscle
Triceps (Muscle Triceps Brachii)
Brachioradial Muscle
Extensor Carpi Radialis Longus Muscle
External Oblique Abdominal Muscle
Kneecap
Muscle Vastus Medialis
Rectus Femoris Muscle
Vastus Lateralis
Tibia
Achilles Tendon

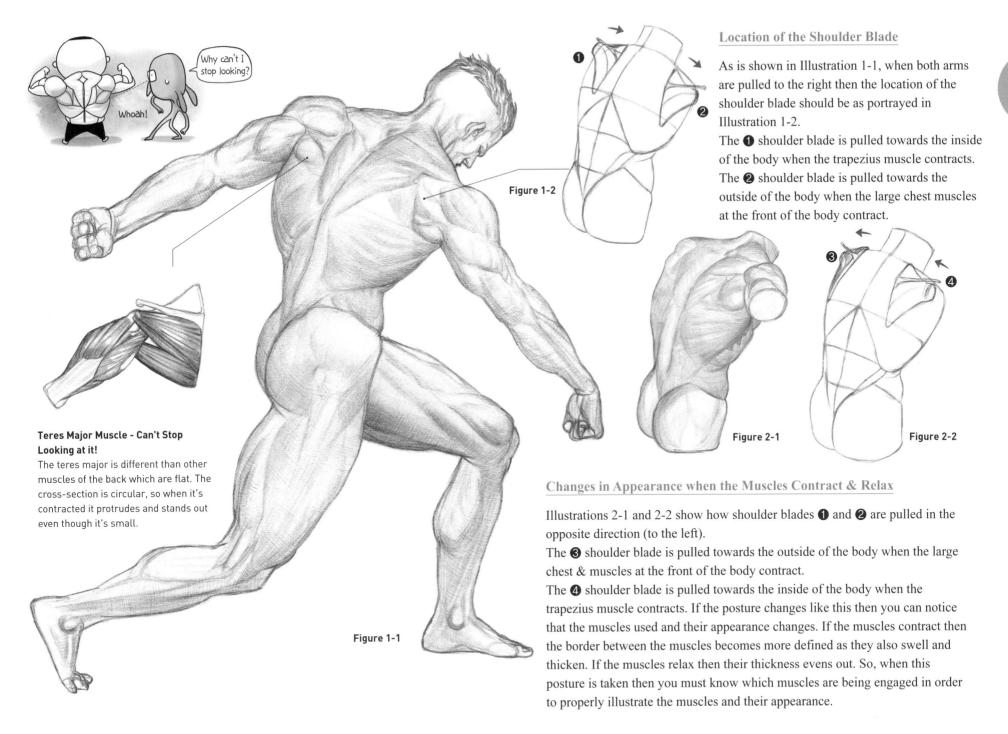

Why can't I stop looking?

Whoah!

Location of the Shoulder Blade

As is shown in Illustration 1-1, when both arms are pulled to the right then the location of the shoulder blade should be as portrayed in Illustration 1-2.

The ❶ shoulder blade is pulled towards the inside of the body when the trapezius muscle contracts.
The ❷ shoulder blade is pulled towards the outside of the body when the large chest muscles at the front of the body contract.

Figure 1-2

Figure 2-1

Figure 2-2

Changes in Appearance when the Muscles Contract & Relax

Illustrations 2-1 and 2-2 show how shoulder blades ❶ and ❷ are pulled in the opposite direction (to the left).

The ❸ shoulder blade is pulled towards the outside of the body when the large chest & muscles at the front of the body contract.

The ❹ shoulder blade is pulled towards the inside of the body when the trapezius muscle contracts. If the posture changes like this then you can notice that the muscles used and their appearance changes. If the muscles contract then the border between the muscles becomes more defined as they also swell and thicken. If the muscles relax then their thickness evens out. So, when this posture is taken then you must know which muscles are being engaged in order to properly illustrate the muscles and their appearance.

Teres Major Muscle - Can't Stop Looking at it!
The teres major is different than other muscles of the back which are flat. The cross-section is circular, so when it's contracted it protrudes and stands out even though it's small.

Figure 1-1

■ Pushing Out

View from the Side

Looking at the image on the right, it is hard to tell exactly how much the figure tilts and how much his legs are spread. Looking at the same pose from the side (picture below) gives us a lot of information, including the tilt of the torso and the width of the stride.

The Tilt of the Body

Stride

How to Know the Tilt of the Body

When you envision a posture, draw it from a completely lateral angle. You can look at the exact tilt of the body.

Infraspinatus

Teres Major Muscle

Triceps Brachii

The Importance of the Shoulder Blades

When you raise your arm to push an object, the shoulder blade, which connects to your arm, pulls forward, widening the gap between your shoulder blades. Back muscles usually stick to the shoulder blade, so you have to find the shoulder blade first to draw the back. With the shoulder blades as a reference point, you can start to see the flow of the back muscles that used to look only bumpy and complicated. Try to see how the trapezius, infraspinatus, teres major, and latissimus dorsi muscles overlap each other.

Trapezius Muscle

Triceps Brachii

Infraspinatus

Latissimus Dorsi

External Oblique Abdominals

Gluteus Medius

Tensor Fasciae Latae

Vastus Lateralis

Biceps Femoris

Semitendinosus Muscle

Gastrocnemius Muscle

Soleus Muscle

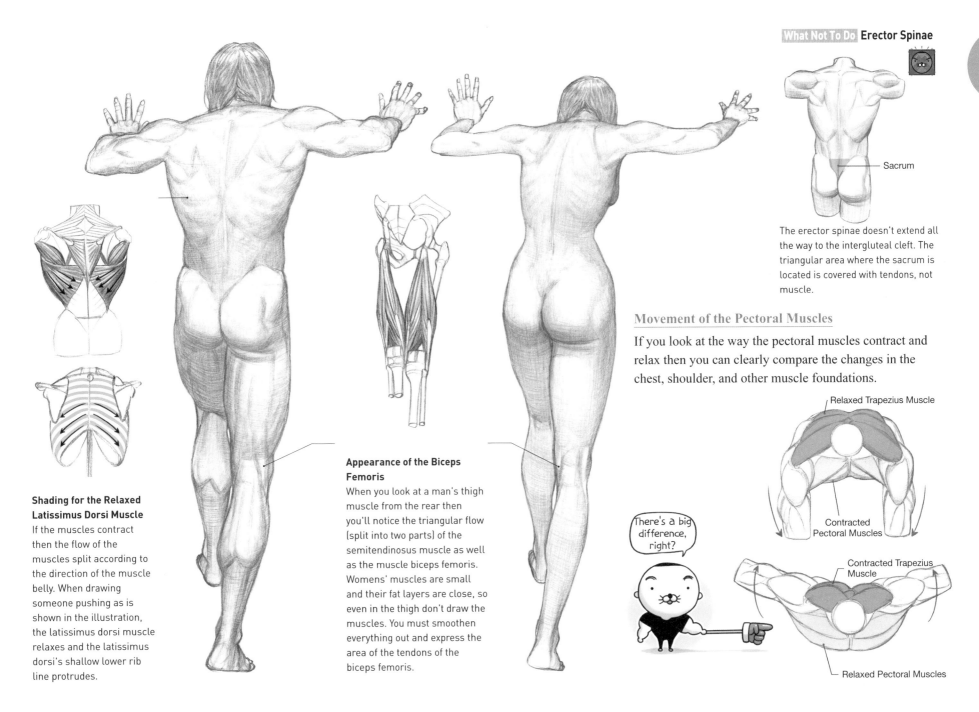

Sacrum

The erector spinae doesn't extend all the way to the intergluteal cleft. The triangular area where the sacrum is located is covered with tendons, not muscle.

Movement of the Pectoral Muscles

If you look at the way the pectoral muscles contract and relax then you can clearly compare the changes in the chest, shoulder, and other muscle foundations.

Relaxed Trapezius Muscle

Contracted Pectoral Muscles

There's a big difference, right?

Contracted Trapezius Muscle

Relaxed Pectoral Muscles

Shading for the Relaxed Latissimus Dorsi Muscle
If the muscles contract then the flow of the muscles split according to the direction of the muscle belly. When drawing someone pushing as is shown in the illustration, the latissimus dorsi muscle relaxes and the latissimus dorsi's shallow lower rib line protrudes.

Appearance of the Biceps Femoris
When you look at a man's thigh muscle from the rear then you'll notice the triangular flow (split into two parts) of the semitendinosus muscle as well as the muscle biceps femoris. Womens' muscles are small and their fat layers are close, so even in the thigh don't draw the muscles. You must smoothen everything out and express the area of the tendons of the biceps femoris.

■ Leaning to One Side

What Not To Do **Flow of the Thighs**

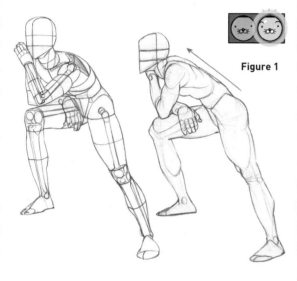

Figure 1

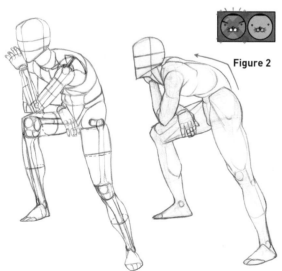

Figure 2

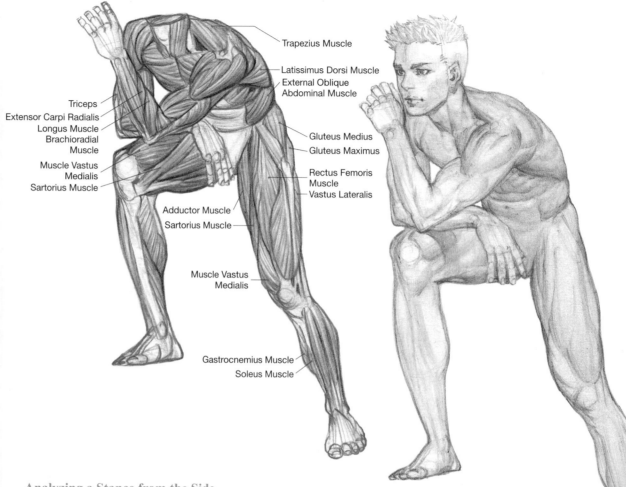

Trapezius Muscle

Latissimus Dorsi Muscle

External Oblique Abdominal Muscle

Triceps

Extensor Carpi Radialis Longus Muscle Brachioradial Muscle

Gluteus Medius

Gluteus Maximus

Muscle Vastus Medialis

Sartorius Muscle

Rectus Femoris Muscle

Vastus Lateralis

Adductor Muscle

Sartorius Muscle

Muscle Vastus Medialis

Gastrocnemius Muscle

Soleus Muscle

Analyzing a Stance from the Side

When someone takes the stance above then the lower back makes a straight line, as is portrayed in Figure 1. If it bends, as is portrayed in Figure 2, then the figure will appear as if there's a problem with the lower back. If you take a full look of a side stance then you'll be able to accurately determine what the problem is. We'll try to figure out the angle of the shoulder after finding the weight center.

The shoulder of the right arm which supports the body raises, while the left shoulder, which isn't carrying any of the weight, drops. You can just barely see the back when the left arm drops, so in order to portray the muscles of the back you must know the location of the scapula. By all means you must express the location of the scapula from when you are still drawing the figure.

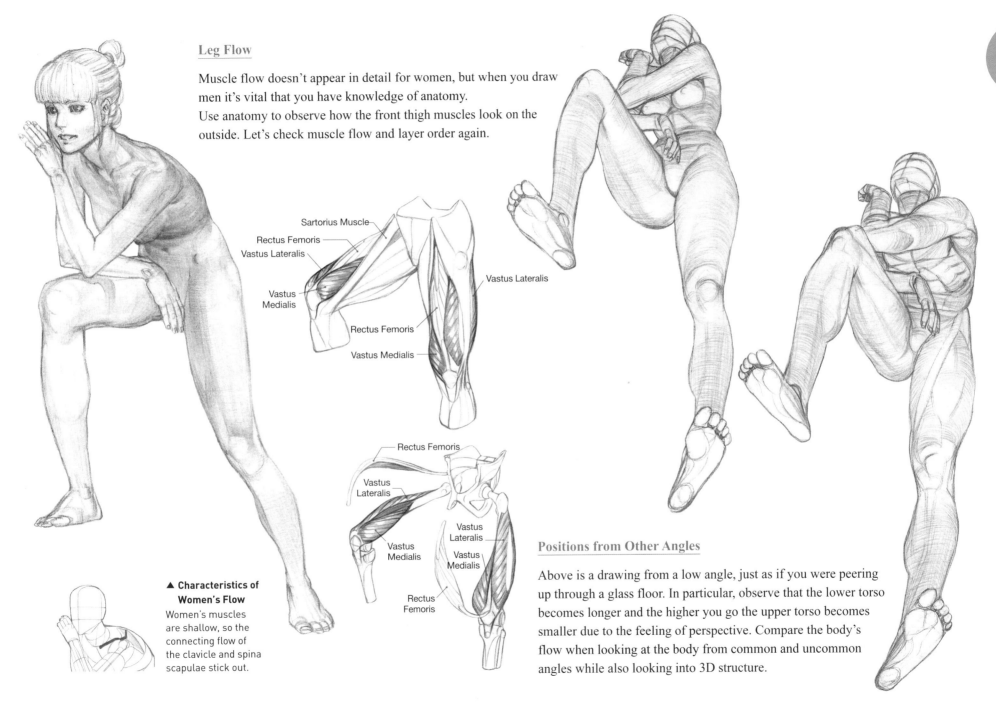

Leg Flow

Muscle flow doesn't appear in detail for women, but when you draw men it's vital that you have knowledge of anatomy.

Use anatomy to observe how the front thigh muscles look on the outside. Let's check muscle flow and layer order again.

Sartorius Muscle
Rectus Femoris
Vastus Lateralis
Vastus Medialis
Vastus Lateralis
Rectus Femoris
Vastus Medialis

Rectus Femoris
Vastus Lateralis
Vastus Medialis
Vastus Lateralis
Vastus Medialis
Rectus Femoris

▲ **Characteristics of Women's Flow**
Women's muscles are shallow, so the connecting flow of the clavicle and spina scapulae stick out.

Positions from Other Angles

Above is a drawing from a low angle, just as if you were peering up through a glass floor. In particular, observe that the lower torso becomes longer and the higher you go the upper torso becomes smaller due to the feeling of perspective. Compare the body's flow when looking at the body from common and uncommon angles while also looking into 3D structure.

■ Legs Bent with an Arm Down

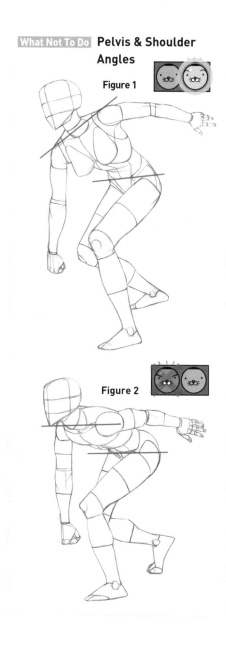

What Not To Do **Pelvis & Shoulder Angles**

Figure 1

Figure 2

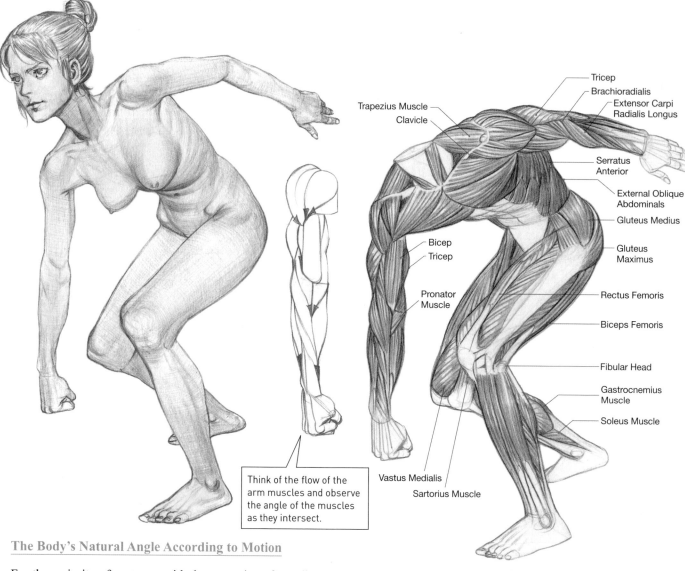

Trapezius Muscle
Clavicle

Tricep
Brachioradialis
Extensor Carpi Radialis Longus

Serratus Anterior

External Oblique Abdominals

Gluteus Medius

Bicep
Tricep

Gluteus Maximus

Pronator Muscle

Rectus Femoris

Biceps Femoris

Fibular Head

Gastrocnemius Muscle

Soleus Muscle

Vastus Medialis

Sartorius Muscle

> Think of the flow of the arm muscles and observe the angle of the muscles as they intersect.

The Body's Natural Angle According to Motion

For the majority of postures, with the exception of standing-at-attention, the angles of the pelvis and shoulders intersect. Rather than equally dispersing the weight it's more natural to have one side carrying more of it.
Try rendering a drawing where the positions of the pelvis and shoulders are angled and there is a rhythm to the motion as you can see in Figure 1 on the left. Figure 2 shows how even when the weight center, proportions and mass are all correct, the sense of reality diminishes if the angles of the pelvis and shoulders are identical.

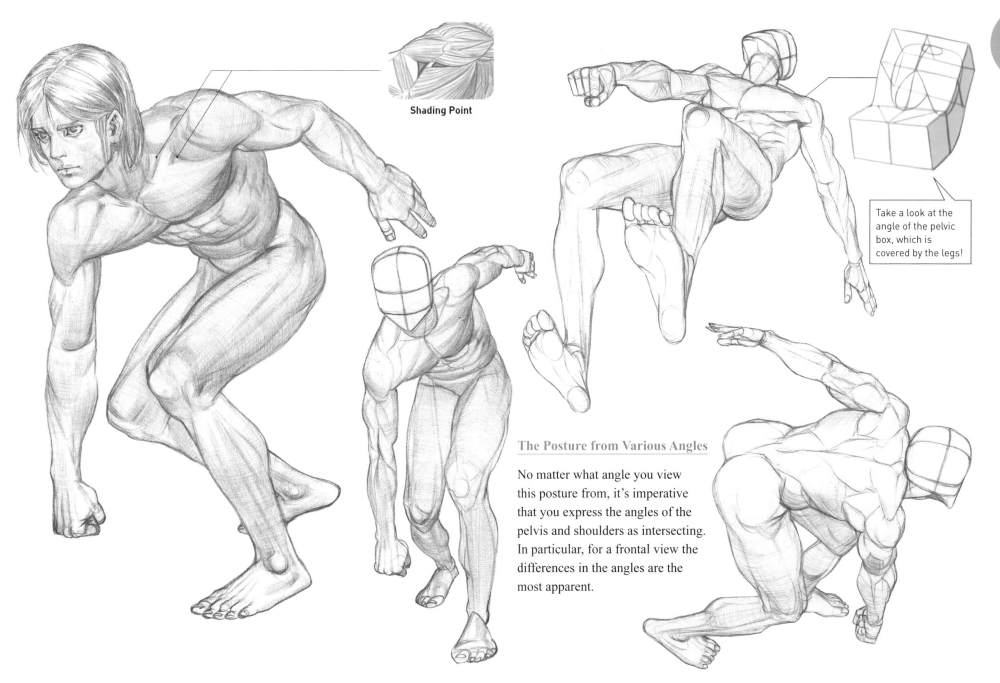

Shading Point

Take a look at the angle of the pelvic box, which is covered by the legs!

The Posture from Various Angles

No matter what angle you view this posture from, it's imperative that you express the angles of the pelvis and shoulders as intersecting. In particular, for a frontal view the differences in the angles are the most apparent.

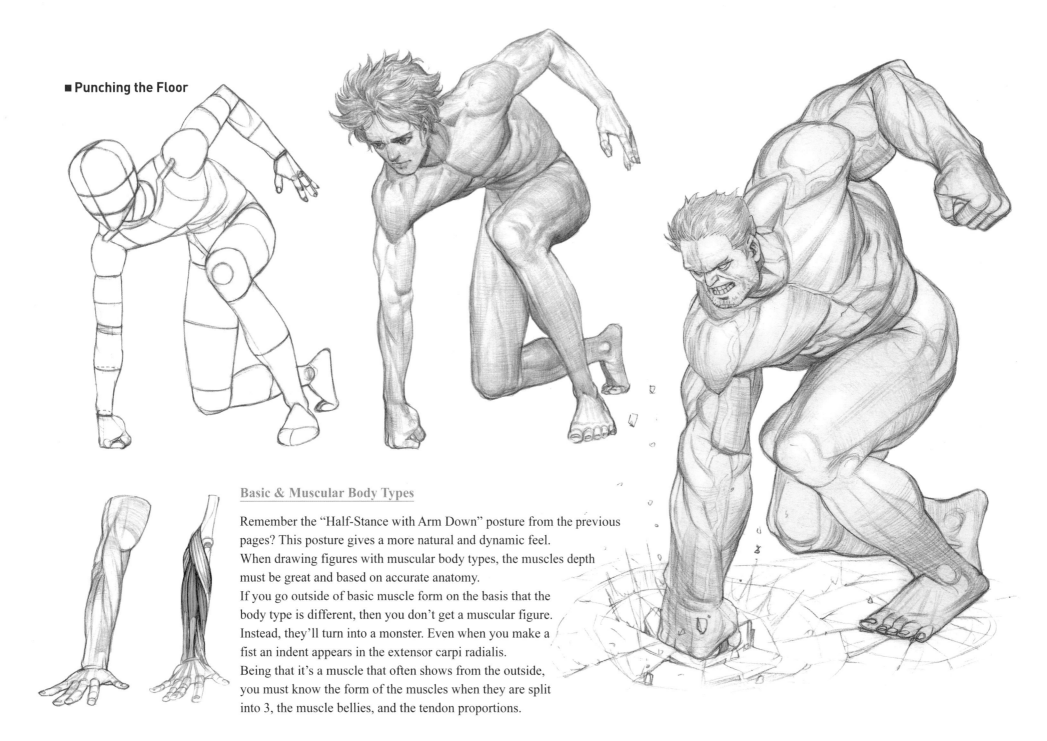

■ Punching the Floor

Basic & Muscular Body Types

Remember the "Half-Stance with Arm Down" posture from the previous
pages? This posture gives a more natural and dynamic feel.
When drawing figures with muscular body types, the muscles depth
must be great and based on accurate anatomy.
If you go outside of basic muscle form on the basis that the
body type is different, then you don't get a muscular figure.
Instead, they'll turn into a monster. Even when you make a
fist an indent appears in the extensor carpi radialis.
Being that it's a muscle that often shows from the outside,
you must know the form of the muscles when they are split
into 3, the muscle bellies, and the tendon proportions.

■ Bending Forward

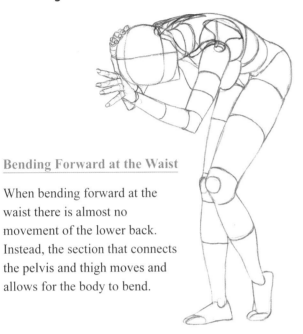

Bending Forward at the Waist

When bending forward at the waist there is almost no movement of the lower back. Instead, the section that connects the pelvis and thigh moves and allows for the body to bend.

What Not To Do **Lower Back Movement**

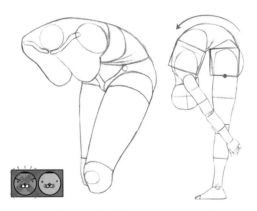

If only the lower back bends while the angle of the pelvis is set, then the movement will be incorrect.

When bending forward at the lower back, then before actually bending, the butt joint moves first.

Coxa

Thin Muscle Layers on Women
The trapezius muscle of the upper torso contracts to allow for the arm to move, but the thickness of the muscle when contracted doesn't stick out like it does for men.

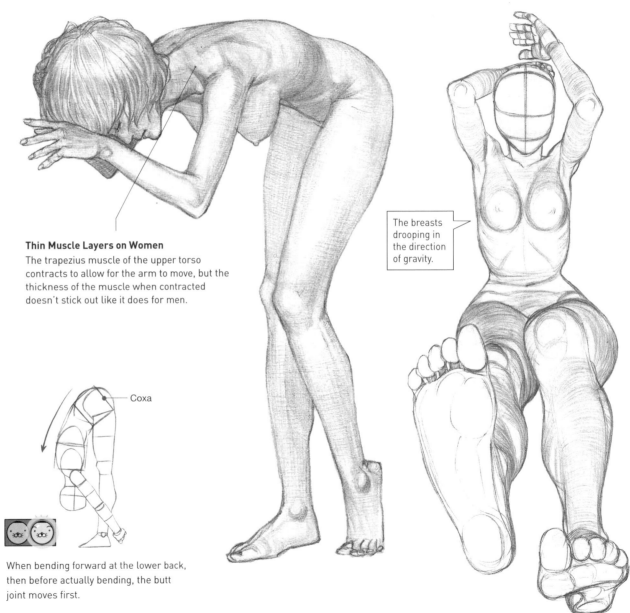

The breasts drooping in the direction of gravity.

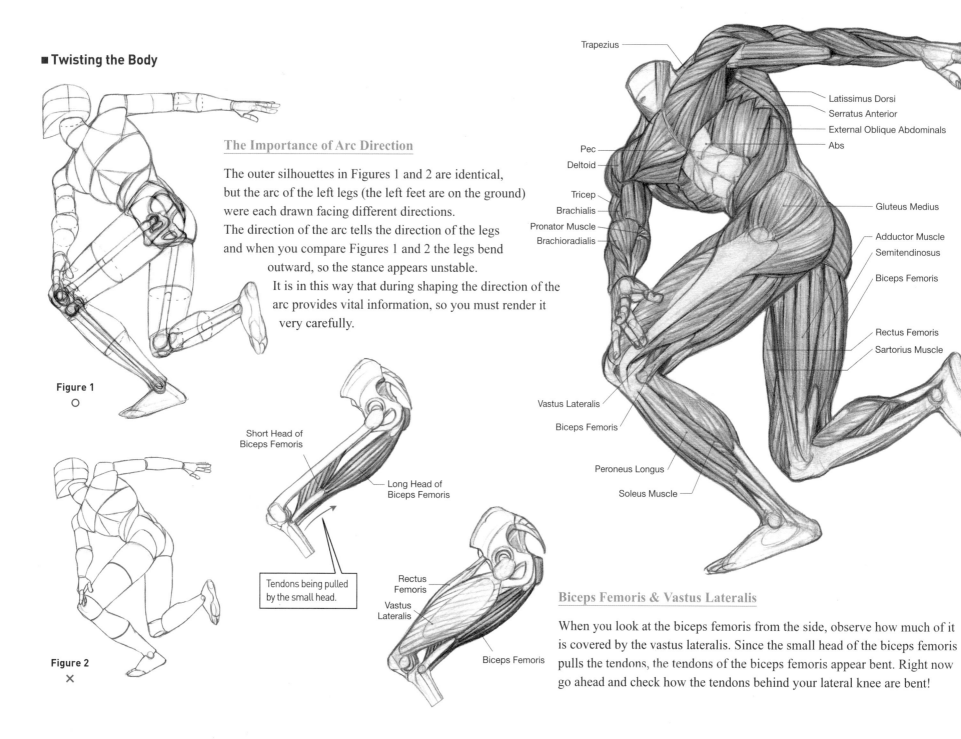

■ Twisting the Body

The Importance of Arc Direction

The outer silhouettes in Figures 1 and 2 are identical, but the arc of the left legs (the left feet are on the ground) were each drawn facing different directions.
The direction of the arc tells the direction of the legs and when you compare Figures 1 and 2 the legs bend outward, so the stance appears unstable.

It is in this way that during shaping the direction of the arc provides vital information, so you must render it very carefully.

Figure 1
○

Figure 2
✗

Short Head of Biceps Femoris

Long Head of Biceps Femoris

Tendons being pulled by the small head.

Rectus Femoris

Vastus Lateralis

Biceps Femoris

Trapezius

Latissimus Dorsi

Serratus Anterior

External Oblique Abdominals

Pec

Abs

Deltoid

Tricep

Brachialis

Pronator Muscle

Brachioradialis

Gluteus Medius

Adductor Muscle

Semitendinosus

Biceps Femoris

Rectus Femoris

Sartorius Muscle

Vastus Lateralis

Biceps Femoris

Peroneus Longus

Soleus Muscle

Biceps Femoris & Vastus Lateralis

When you look at the biceps femoris from the side, observe how much of it is covered by the vastus lateralis. Since the small head of the biceps femoris pulls the tendons, the tendons of the biceps femoris appear bent. Right now go ahead and check how the tendons behind your lateral knee are bent!

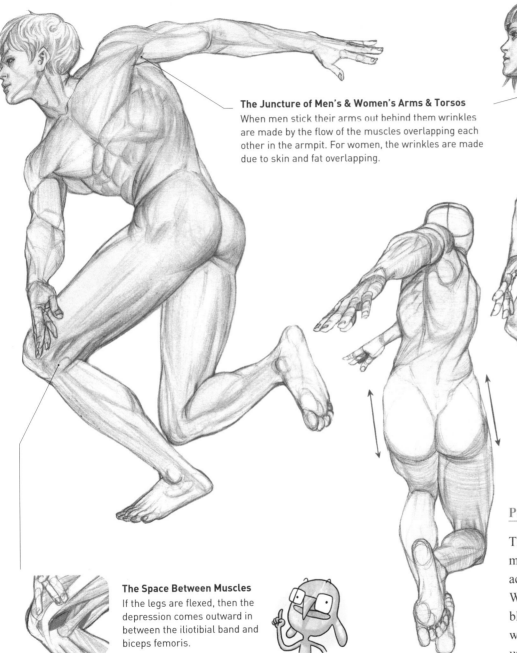

The Juncture of Men's & Women's Arms & Torsos
When men stick their arms out behind them wrinkles are made by the flow of the muscles overlapping each other in the armpit. For women, the wrinkles are made due to skin and fat overlapping.

The Line Beneath the Buttocks
The fat of the left butt cheek is pulled when the leg comes forward, so no butt line is made. For the leg that comes back, the thigh and buttocks fat of the right leg overlap and make the line beneath the buttocks.

Posterior View: Men's & Women's Body Flow

The butt flow on men is straight due to the effect of the muscles, while the butt flow on women is circular due to the accumulation of fat.

While men's back muscles stand out, the flow of the shoulder blades and spinal column appears on women. When you draw women's breasts first calculate the location of the mid-line of the upper body, then draw each breast symmetrically.

The Space Between Muscles
If the legs are flexed, then the depression comes outward in between the iliotibial band and biceps femoris.

■ Stretching

So, in this stance which muscles are contracted?

I'm using all the strength in my back and rear thigh muscles!!!

Muscle Contraction & Relaxation

Both hands and the right knee are supporting the body's weight and the left leg is fully stretched out to the rear, so the erector spinae and biceps femoris are stimulated. This movement is often performed in yoga or aerobics. It reinforces the erector spinae and gluteus maximus muscles, so it increases the butt's elasticity. The flexibility of the back, which creates an arch-like flow, and the stiffness of the fully flexed leg makes everything match harmoniously.

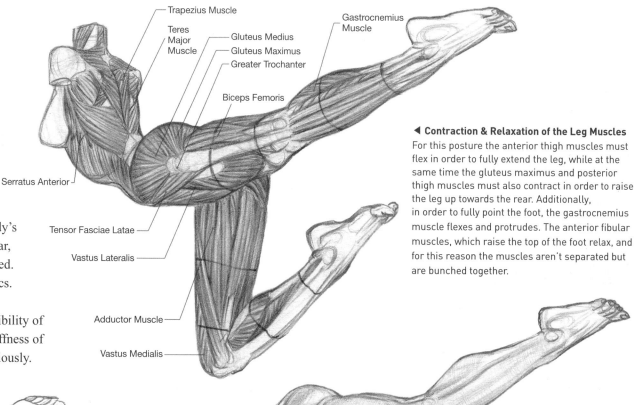

Trapezius Muscle
Teres Major Muscle
Gluteus Medius
Gluteus Maximus
Greater Trochanter
Biceps Femoris
Gastrocnemius Muscle
Serratus Anterior
Tensor Fasciae Latae
Vastus Lateralis
Adductor Muscle
Vastus Medialis

◀ Contraction & Relaxation of the Leg Muscles
For this posture the anterior thigh muscles must flex in order to fully extend the leg, while at the same time the gluteus maximus and posterior thigh muscles must also contract in order to raise the leg up towards the rear. Additionally, in order to fully point the foot, the gastrocnemius muscle flexes and protrudes. The anterior fibular muscles, which raise the top of the foot relax, and for this reason the muscles aren't separated but are bunched together.

Giving Life to Muscles ▶
The muscles that you see when studying anatomy don't actually all protrude on the outside of the body. You must render the grain direction for flexed muscles. For areas which are not flexed you don't separate the muscles and instead you must bunch them together into one group.
For this reason whatever posture you render you must know which areas are flexed and which areas aren't. Of course, you wouldn't apply this to characters who have small muscles or thick fat layers.

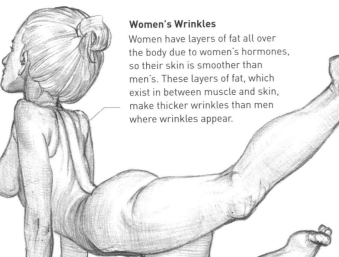

Women's Wrinkles

Women have layers of fat all over the body due to women's hormones, so their skin is smoother than men's. These layers of fat, which exist in between muscle and skin, make thicker wrinkles than men where wrinkles appear.

Rendering a Posture with Perspective ▶

To the right is a figure whose posture was rendered within the outline of the body. You'll know just how important it is to calculate the side of each section according to the body's outline.

What Not To Do **Incorrectly Rendering Wrinkles**

If you omit places where wrinkles are supposed to exist, the body becomes even and the signs that tell to what degree those parts of the body are bent disappear. On the other hand, if you draw wrinkles too long compared to the degree by which joints are bent, the limbs can be seen or the joints appear flat.

The direction of wrinkles are also as important as the length of wrinkles, so make sure to pay attention and observe this on other people's bodies.

Tee hee!

Streeetch

What You Can Tell from Wrinkles on the Skin

Rendering wrinkles on the skin let you know how flexible the skin's texture is. Additionally, they point out which areas are folded or bent.

◀ Leg Flexibility

In order to raise the leg to the rear as high as this figure to the left, it's not possible with just the strength of the leg by itself. It's only possible by either pulling the leg with the hand or by placing your leg on the ground and applying your body weight in order to bring the leg to the rear.

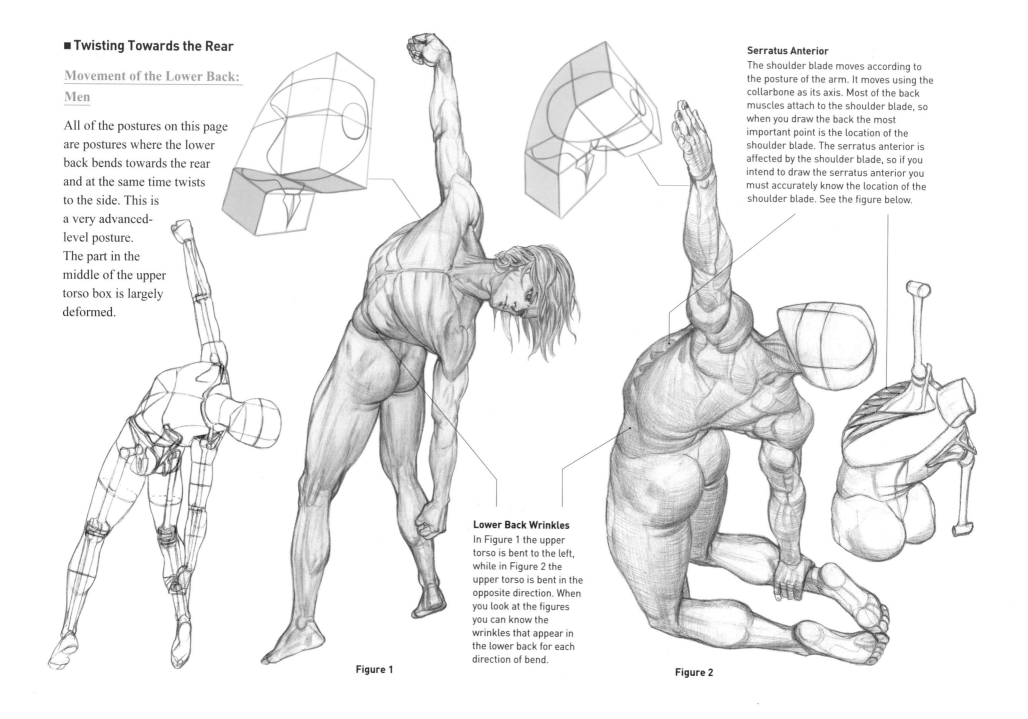

■ Twisting Towards the Rear

Movement of the Lower Back: Men

All of the postures on this page are postures where the lower back bends towards the rear and at the same time twists to the side. This is a very advanced-level posture. The part in the middle of the upper torso box is largely deformed.

Serratus Anterior
The shoulder blade moves according to the posture of the arm. It moves using the collarbone as its axis. Most of the back muscles attach to the shoulder blade, so when you draw the back the most important point is the location of the shoulder blade. The serratus anterior is affected by the shoulder blade, so if you intend to draw the serratus anterior you must accurately know the location of the shoulder blade. See the figure below.

Lower Back Wrinkles
In Figure 1 the upper torso is bent to the left, while in Figure 2 the upper torso is bent in the opposite direction. When you look at the figures you can know the wrinkles that appear in the lower back for each direction of bend.

Figure 1

Figure 2

■ Lower Back Movement: Women

Lower Back Characteristics - Women

Women's lower back area is more narrow than men's and the movement in that area is more flexible. Unless you're intending to draw a very muscular female character, be sure to preserve her unique flow and think about rendering the abs, latissimus dorsi, and serratus anterior.

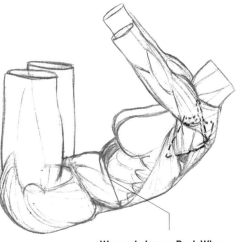

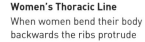

Women's Thoracic Line
When women bend their body backwards the ribs protrude and each rib line sticks out. This is because women's muscles are thinner than men's and people often mistake the shading for the serratus anterior and the external oblique abdominal muscles. However, this line appears due to the ribs.

Women's Lower Back When Bending Forward
The area where the ribs end is the thinnest area of the lower back and a wrinkle perpendicular to the body appears on this line.

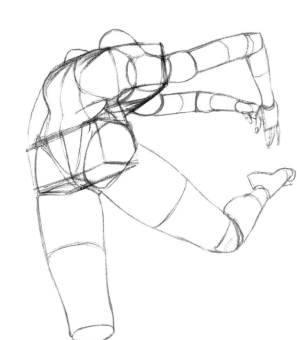

■ Laying on the Side

Women's Unique Body Flow

When women lie on their side, as is seen in the picture, the "V" that is created (see the figure to the right) is symbolic of women's flow. Additionally, when lying down the depth is shallow, so the arm and leg are both flexible and overlap.

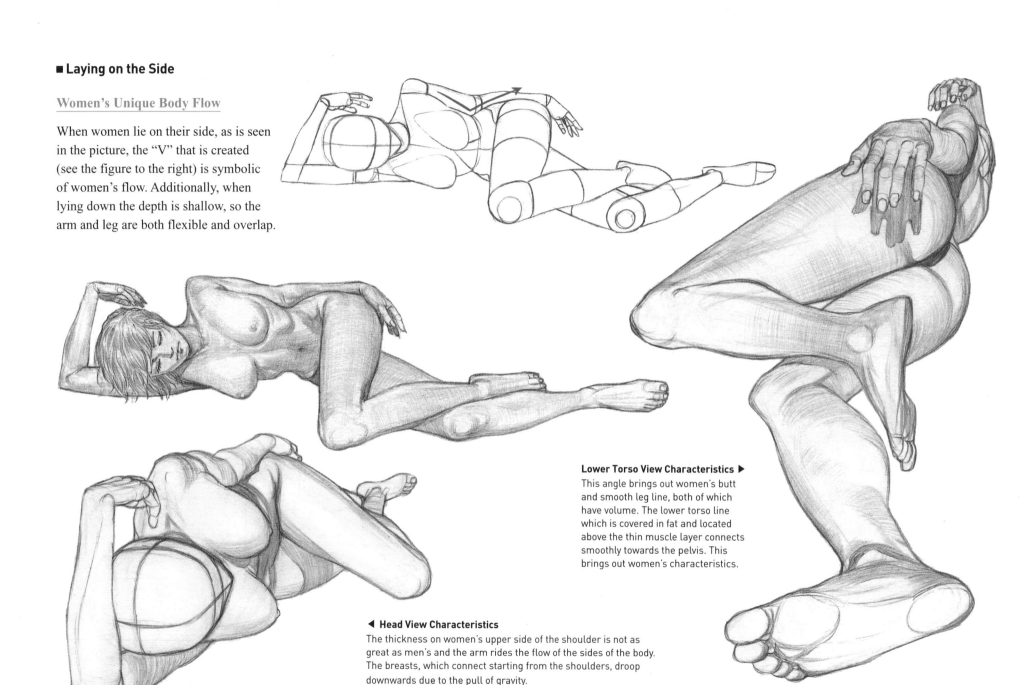

Lower Torso View Characteristics ▶
This angle brings out women's butt and smooth leg line, both of which have volume. The lower torso line which is covered in fat and located above the thin muscle layer connects smoothly towards the pelvis. This brings out women's characteristics.

◀ Head View Characteristics
The thickness on women's upper side of the shoulder is not as great as men's and the arm rides the flow of the sides of the body. The breasts, which connect starting from the shoulders, droop downwards due to the pull of gravity.

■ Fetal Position & Resting on the Elbows

Lying Down: Leg & Lower Back Movement

When you lie on your side and curl up into a fetal position it's more comfortable.

When you do this the legs bend more than the lower back.

When you lie face down and then push up on the arms you must pick up on and draw the location of the lumbar vertebrae in order to correctly render the flow of the body.

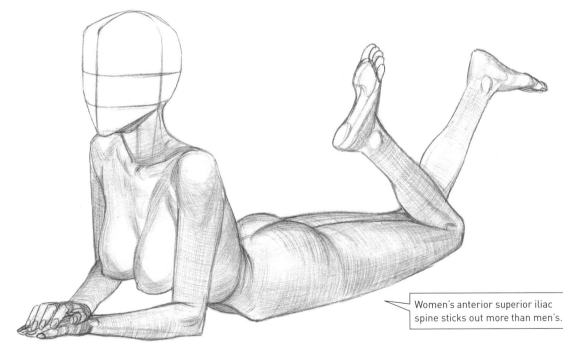

Women's anterior superior iliac spine sticks out more than men's.

What Not To Do **Bending Forward at the Waist**

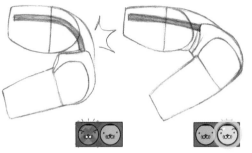

When bending forward be sure to avoid excessively expressing the bend in the lower back like what's shown in the incorrectly drawn figure on the left. It's an angle that exceeds the actual limit to which the spine can move.

What Not To Do **Bending Backwards at the Hip**

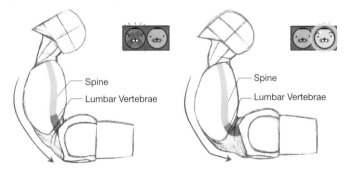

Spine

Lumbar Vertebrae

Spine

Lumbar Vertebrae

The lower back moves at the lumbar vertebrae, so you must accurately know the location and point of bend of the spinal cord. In the incorrectly drawn figure on the left the lumbar vertebrae doesn't bend, but the bend is where the lumbar vertebrae and sacrum connect. The lumbar vertebrae must bend as it does in the correctly drawn figure on the right. The flow of the upper body differs based on how you understand the movement of the lumbar vertebrae.

2 Various Seated Positions

■ Leaning on One Arm (1)

Characteristics:
Sitting Comfortably

When you sit comfortably the lower back isn't flexed, so the upper body and pelvis bend in a "C" shape. If the body isn't leaning against a wall, then the arm supports the weight of the upper torso, as seen in this figure to the right.

What Not To Do **The Arm Supporting the Body's Weight**

If the shoulder of the arm carrying the body weight doesn't raise, then the figure will end up appearing unstable, as if it's going to slip.

Slip!

Sternoclavicular Joint

When leaning on one arm the expression of the shoulder of the arm carrying the weight is important. Just as when you "hip sit" where the side of the pelvis which has the leg carrying the weight raises. However, the shoulders differ from the pelvis in that it contains many joints, so it can move in various ways. As you learned in shaping, the shoulder raises in the shape of a curve by following the collarbone and with the sternal joint side as its axis. If there's no movement in the shoulder for the arm carrying the weight, then there's no sense of gravity or body weight, so the figure looks like a toy.

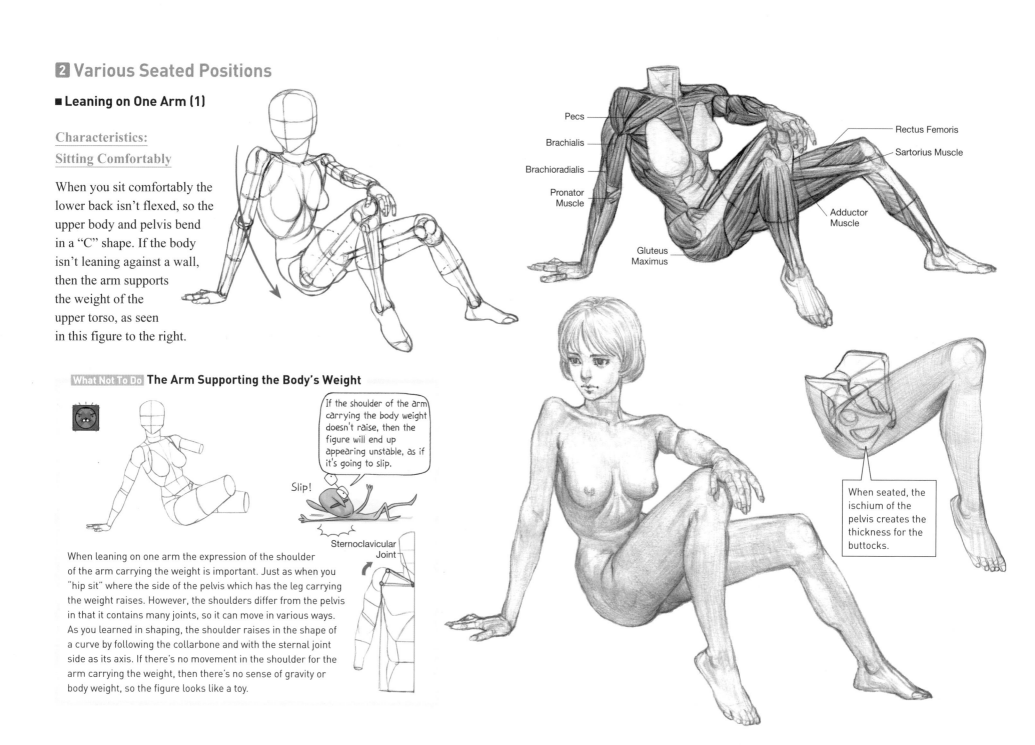

Pecs

Brachialis

Brachioradialis

Pronator Muscle

Gluteus Maximus

Rectus Femoris

Sartorius Muscle

Adductor Muscle

When seated, the ischium of the pelvis creates the thickness for the buttocks.

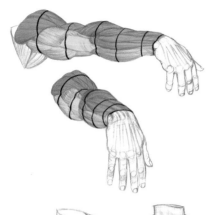

Foreshortening

In order to foreshorten a complicated body, don't start by trying to draw it too realistically. First, render the sense of perspective using simple shaping. Afterwards, bunch the muscles with similar flow together and place them on top of the shape. It will all overlap, as you can see in the picture to the left.

Observe how anatomical information of the arm is applied to an actual shortened arm flow.

Figure 1 **Figure 2**

Stomach Wrinkles: Men

When you look at the body of a muscular man who is bending his body slightly forward, a wrinkle appears marking the end of the ribs (See Figure 1). If the man bends forward further at the hip, a second wrinkle appears which marks the interior superior iliac spine.

The shape of the belly wrinkles depends on the amount of muscle or fat.

■ Leaning on One Arm (2)

What Not To Do **Spinal Column Flow While Seated**

Figure 1

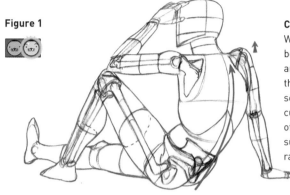

Curved Spinal Cord: Flow

When looking at a figure from behind when it's leaning on one arm and resting (see Figure 1), the erector spinae isn't flexed, so the flow of the spinal cord is curved. Additionally, the shoulder of the right arm, which is supporting the body's weight, raises.

Figure 2

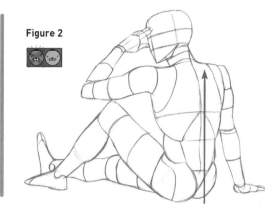

A Straight Spinal Cord's Flow

If you look at Figure 2, which has a spinal cord with a straight flow, it gives the feeling that the figure isn't leaning on one arm and is sitting by flexing the lower back, or that the figure is leaning against a wall. The reason that the posture in Figure 2 looks more static than Figure 1 is that the curve of the lower back disappeared.

Turning the Shoulder Blade & Spine

Due to the bias view that women can only be drawn with curves, you may not think of bones as important, but in actuality their bodies have more angles than you would think due to the bones.

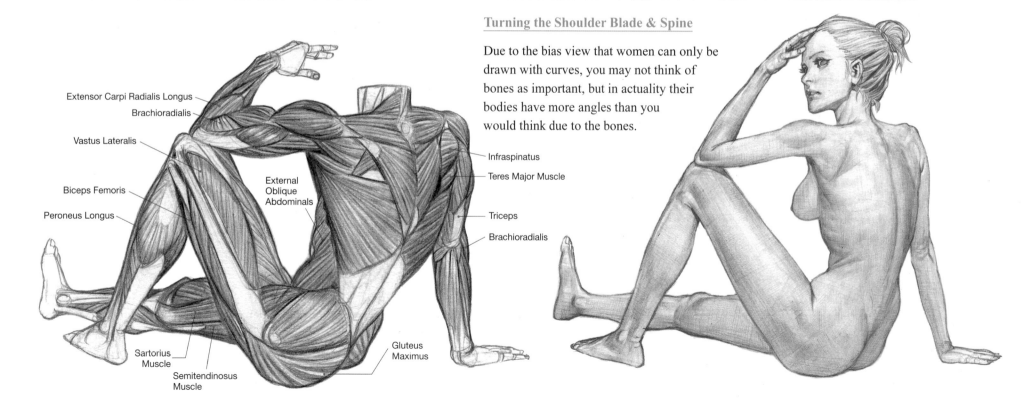

Extensor Carpi Radialis Longus
Brachioradialis
Vastus Lateralis
Biceps Femoris
Peroneus Longus
Sartorius Muscle
Semitendinosus Muscle
External Oblique Abdominals
Gluteus Maximus
Infraspinatus
Teres Major Muscle
Triceps
Brachioradialis

Bending the Hips: Differences Between Men & Women

Men moreso than women have a line made by the iliac crest that serves as a border in the lower back. It is for this reason that when men bend their lower backs the flow changes twice at the area where the ribs end and at the iliac crest. The flow changes once on women at the point where the ribs cnd.

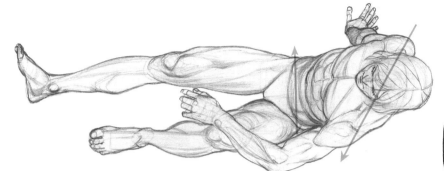

You can't see the shoulder and pelvic angles from the side, but you can see them from an aerial angle. Look at me fly!

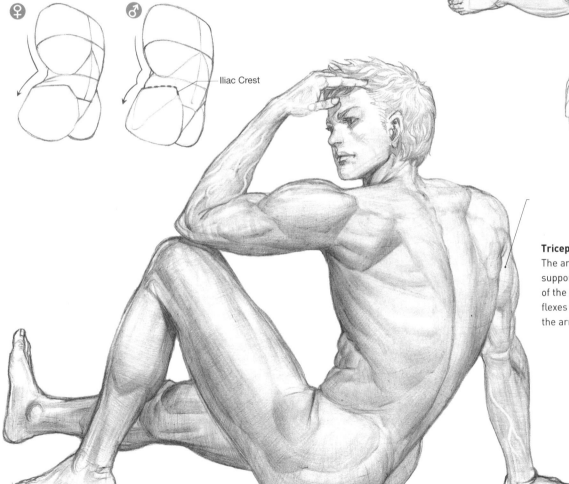

♀ ♂

Iliac Crest

Tricep Contraction
The arm, which supports the weight of the upper body, flexes to ensure that the arm doesn't bend.

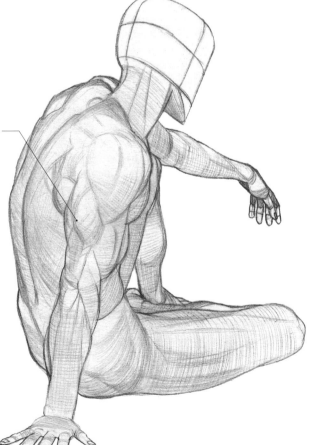

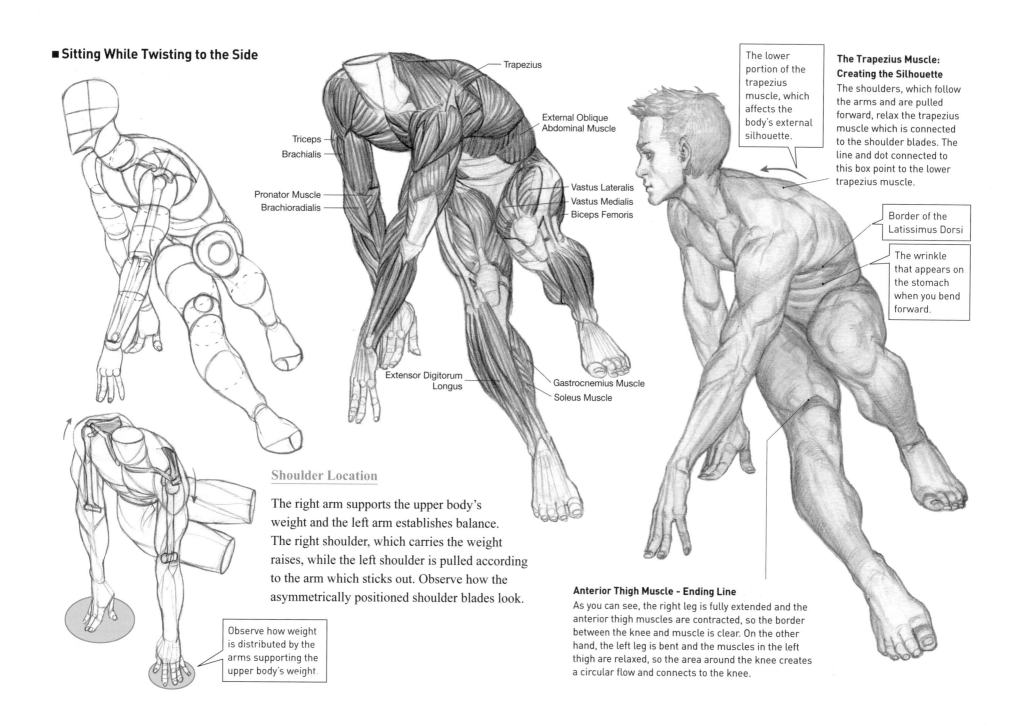

■ Sitting While Twisting to the Side

Trapezius

External Oblique
Abdominal Muscle

Triceps
Brachialis

Pronator Muscle
Brachioradialis

Vastus Lateralis
Vastus Medialis
Biceps Femoris

Extensor Digitorum
Longus

Gastrocnemius Muscle
Soleus Muscle

**The Trapezius Muscle:
Creating the Silhouette**
The shoulders, which follow the arms and are pulled forward, relax the trapezius muscle which is connected to the shoulder blades. The line and dot connected to this box point to the lower trapezius muscle.

The lower portion of the trapezius muscle, which affects the body's external silhouette.

Border of the Latissimus Dorsi

The wrinkle that appears on the stomach when you bend forward.

Shoulder Location

The right arm supports the upper body's weight and the left arm establishes balance. The right shoulder, which carries the weight raises, while the left shoulder is pulled according to the arm which sticks out. Observe how the asymmetrically positioned shoulder blades look.

Observe how weight is distributed by the arms supporting the upper body's weight.

Anterior Thigh Muscle - Ending Line
As you can see, the right leg is fully extended and the anterior thigh muscles are contracted, so the border between the knee and muscle is clear. On the other hand, the left leg is bent and the muscles in the left thigh are relaxed, so the area around the knee creates a circular flow and connects to the knee.

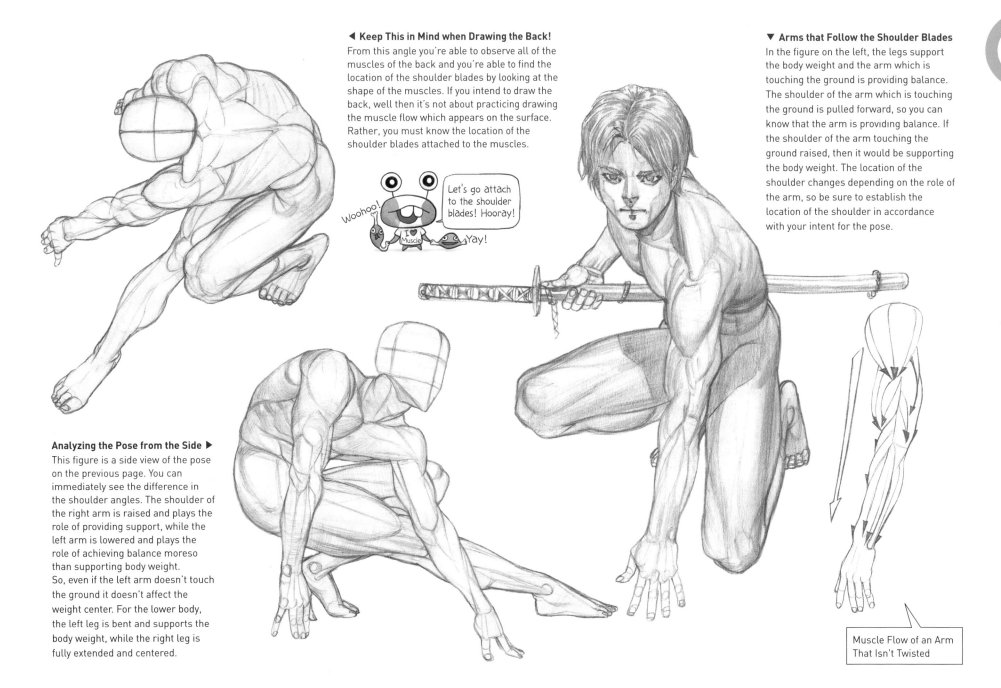

◀ Keep This in Mind when Drawing the Back!
From this angle you're able to observe all of the muscles of the back and you're able to find the location of the shoulder blades by looking at the shape of the muscles. If you intend to draw the back, well then it's not about practicing drawing the muscle flow which appears on the surface. Rather, you must know the location of the shoulder blades attached to the muscles.

Woohoo!
Let's go attach to the shoulder blades! Hooray!
I ♥ Muscle
Yay!

▼ Arms that Follow the Shoulder Blades
In the figure on the left, the legs support the body weight and the arm which is touching the ground is providing balance. The shoulder of the arm which is touching the ground is pulled forward, so you can know that the arm is providing balance. If the shoulder of the arm touching the ground raised, then it would be supporting the body weight. The location of the shoulder changes depending on the role of the arm, so be sure to establish the location of the shoulder in accordance with your intent for the pose.

Analyzing the Pose from the Side ▶
This figure is a side view of the pose on the previous page. You can immediately see the difference in the shoulder angles. The shoulder of the right arm is raised and plays the role of providing support, while the left arm is lowered and plays the role of achieving balance moreso than supporting body weight.
So, even if the left arm doesn't touch the ground it doesn't affect the weight center. For the lower body, the left leg is bent and supports the body weight, while the right leg is fully extended and centered.

Muscle Flow of an Arm That Isn't Twisted

■ Sitting with One Knee Up

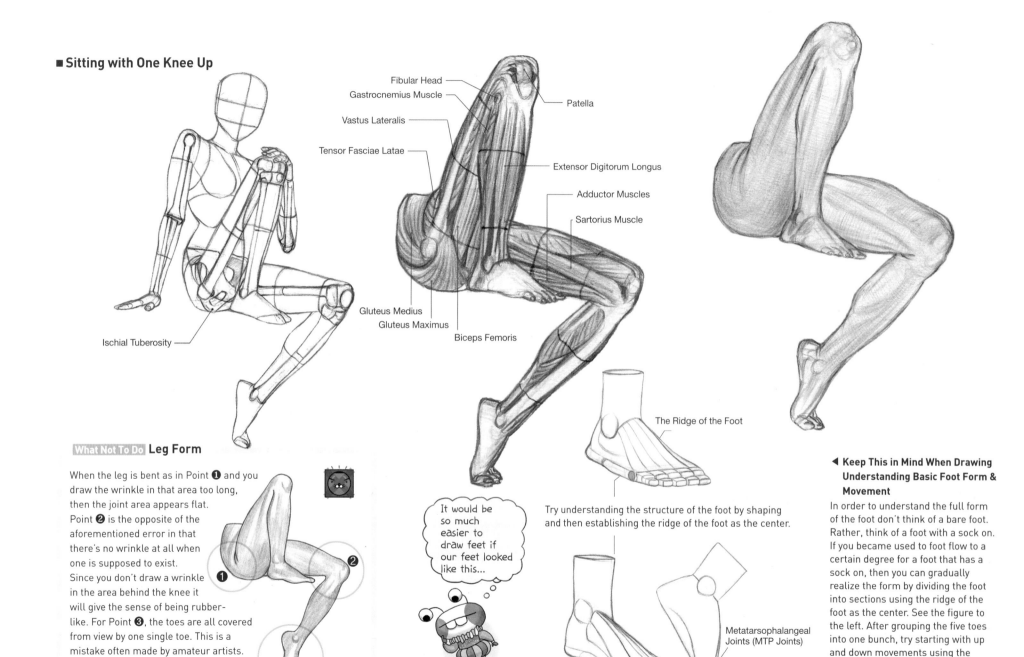

Fibular Head

Gastrocnemius Muscle

Vastus Lateralis

Tensor Fasciae Latae

Patella

Extensor Digitorum Longus

Adductor Muscles

Sartorius Muscle

Gluteus Medius

Gluteus Maximus

Biceps Femoris

Ischial Tuberosity

The Ridge of the Foot

Metatarsophalangeal
Joints (MTP Joints)

What Not To Do | Leg Form

When the leg is bent as in Point ❶ and you draw the wrinkle in that area too long, then the joint area appears flat. Point ❷ is the opposite of the aforementioned error in that there's no wrinkle at all when one is supposed to exist. Since you don't draw a wrinkle in the area behind the knee it will give the sense of being rubber-like. For Point ❸, the toes are all covered from view by one single toe. This is a mistake often made by amateur artists. Let's take a look at the different drawings of foot structure on this page.

It would be so much easier to draw feet if our feet looked like this...

Try understanding the structure of the foot by shaping and then establishing the ridge of the foot as the center.

◄ Keep This in Mind When Drawing Understanding Basic Foot Form & Movement

In order to understand the full form of the foot don't think of a bare foot. Rather, think of a foot with a sock on. If you became used to foot flow to a certain degree for a foot that has a sock on, then you can gradually realize the form by dividing the foot into sections using the ridge of the foot as the center. See the figure to the left. After grouping the five toes into one bunch, try starting with up and down movements using the metatarsophalangeal joints (MTP Joints) as the axis.

Women's Shoulders: Characteristics
The shoulder of the arm touching the ground raises and the outline of the bones in the shoulder area sticks out.

Weight Center when Seated

When sitting on your butt, the area of the body touching the floor is greater than when you are standing with two feet, so it's relatively easy to achieve your weight center. If you touch the ground with your arm, like in the figure to the right, then the shoulder of the arm supporting the weight must raise. Observe the various locations of the shoulder in the drawings on this page.

The Flesh Behind the Elbow
Women's hormones develop the thin fat layers around the body and make the muscles skinny. This is also the reason for the flesh behind the elbow.

Lateral Thigh Line Direction
If you bend your knee the thigh line faces the fibular head.

Let me just take a seat here...

Ouch!

Bony Butt Press

For people who don't have fatty butts (bony butts) it hurts when they sit on your lap. This is all due to the ischial tuberosity!

Seated Women: Characteristics
For women with a large amount of fat in their buttocks, the butt cheeks tend to spread out to the sides when they sit.

04

Understanding Anatomy Through Motion

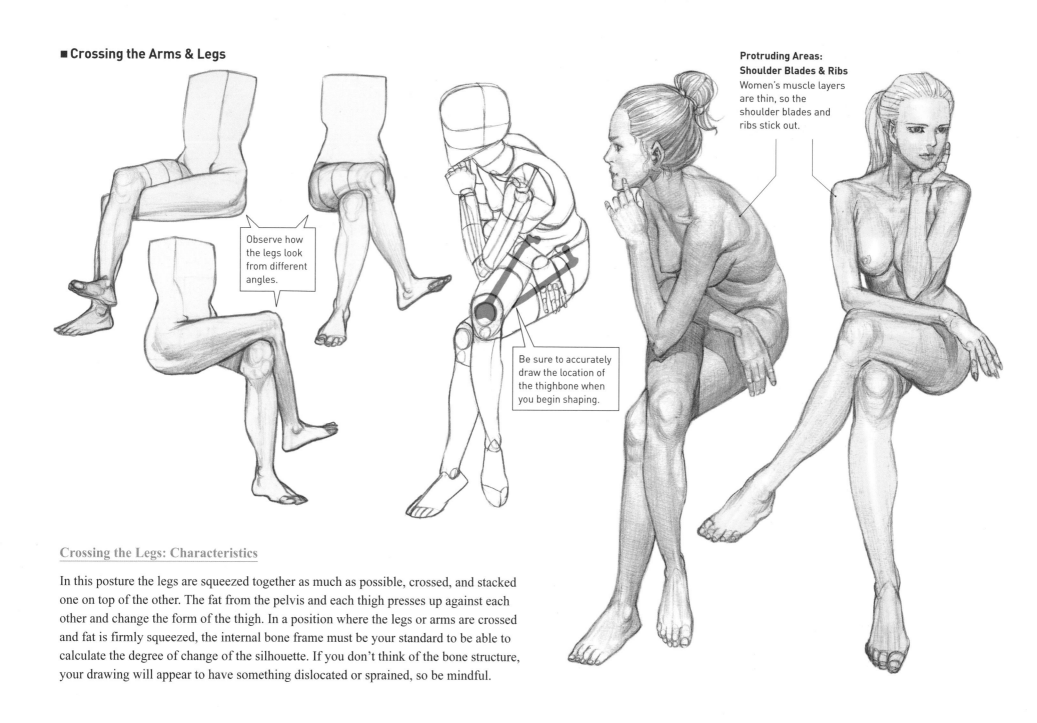

■ Crossing the Arms & Legs

Observe how the legs look from different angles.

Be sure to accurately draw the location of the thighbone when you begin shaping.

Protruding Areas: Shoulder Blades & Ribs
Women's muscle layers are thin, so the shoulder blades and ribs stick out.

Crossing the Legs: Characteristics

In this posture the legs are squeezed together as much as possible, crossed, and stacked one on top of the other. The fat from the pelvis and each thigh presses up against each other and change the form of the thigh. In a position where the legs or arms are crossed and fat is firmly squeezed, the internal bone frame must be your standard to be able to calculate the degree of change of the silhouette. If you don't think of the bone structure, your drawing will appear to have something dislocated or sprained, so be mindful.

When you stand with your arms crossed it's not just the arms that move. As you can see in the picture above the shoulders come forward.

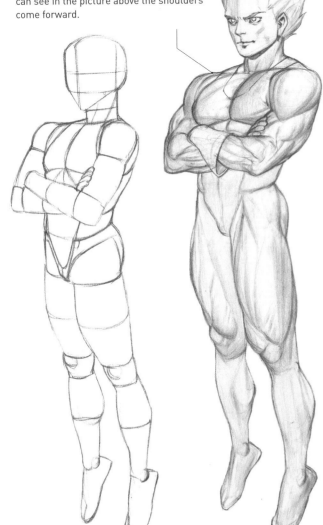

The Arms: Overlapping Skin

If you look at a posture from the side where the shoulders are raised, for women, the flow starts from the shoulders and moves downwards through the breasts. On men, the thickness of the flexed pecs sticks out and the border between the deltoid and pecs is divided. On women, the shoulder blades are affected by the flow of the back, and on men, the teres major and latissimus dorsi create the back's flow.

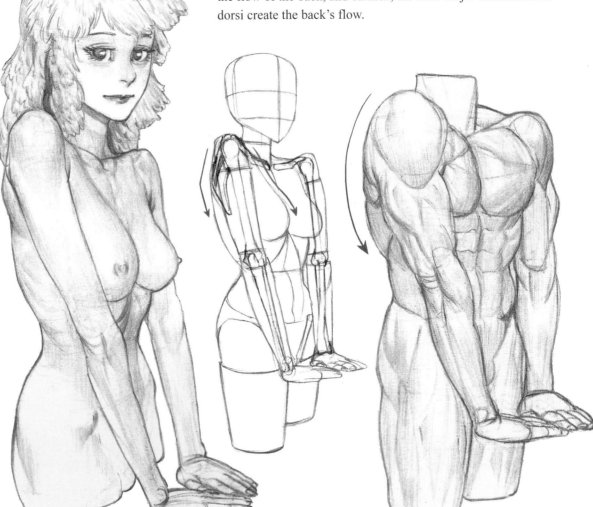

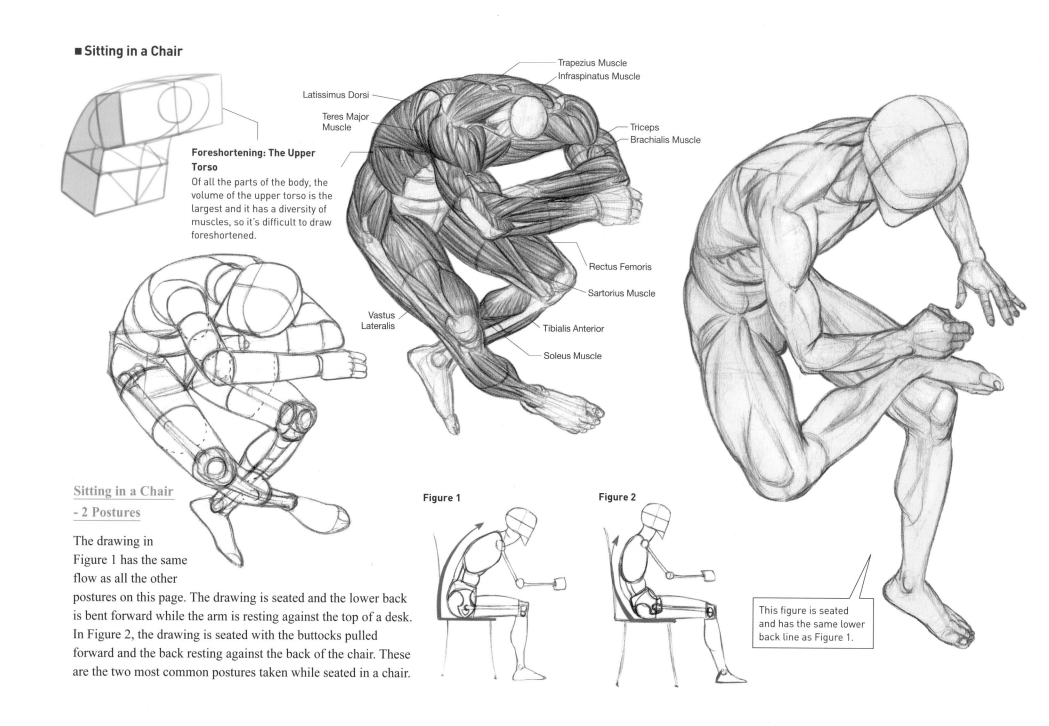

■ Sitting in a Chair

Foreshortening: The Upper Torso

Of all the parts of the body, the volume of the upper torso is the largest and it has a diversity of muscles, so it's difficult to draw foreshortened.

Trapezius Muscle
Infraspinatus Muscle
Latissimus Dorsi
Teres Major Muscle
Triceps
Brachialis Muscle
Rectus Femoris
Sartorius Muscle
Vastus Lateralis
Tibialis Anterior
Soleus Muscle

Sitting in a Chair
- 2 Postures

The drawing in Figure 1 has the same flow as all the other postures on this page. The drawing is seated and the lower back is bent forward while the arm is resting against the top of a desk. In Figure 2, the drawing is seated with the buttocks pulled forward and the back resting against the back of the chair. These are the two most common postures taken while seated in a chair.

Figure 1

Figure 2

This figure is seated and has the same lower back line as Figure 1.

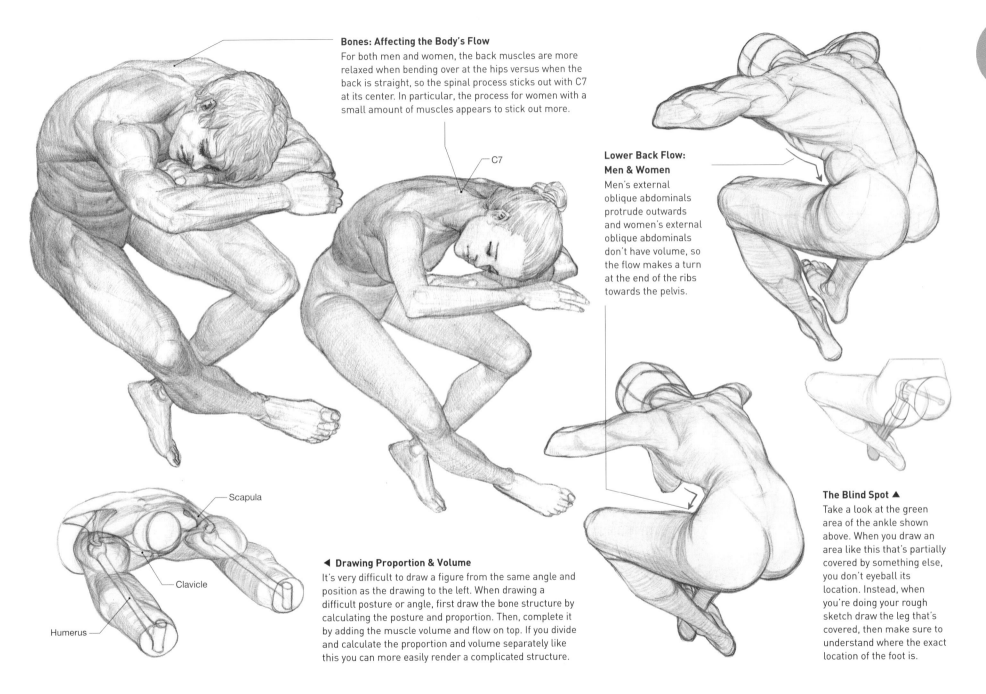

Bones: Affecting the Body's Flow
For both men and women, the back muscles are more relaxed when bending over at the hips versus when the back is straight, so the spinal process sticks out with C7 at its center. In particular, the process for women with a small amount of muscles appears to stick out more.

C7

Lower Back Flow: Men & Women
Men's external oblique abdominals protrude outwards and women's external oblique abdominals don't have volume, so the flow makes a turn at the end of the ribs towards the pelvis.

Scapula

Clavicle

Humerus

◄ Drawing Proportion & Volume
It's very difficult to draw a figure from the same angle and position as the drawing to the left. When drawing a difficult posture or angle, first draw the bone structure by calculating the posture and proportion. Then, complete it by adding the muscle volume and flow on top. If you divide and calculate the proportion and volume separately like this you can more easily render a complicated structure.

The Blind Spot ▲
Take a look at the green area of the ankle shown above. When you draw an area like this that's partially covered by something else, you don't eyeball its location. Instead, when you're doing your rough sketch draw the leg that's covered, then make sure to understand where the exact location of the foot is.

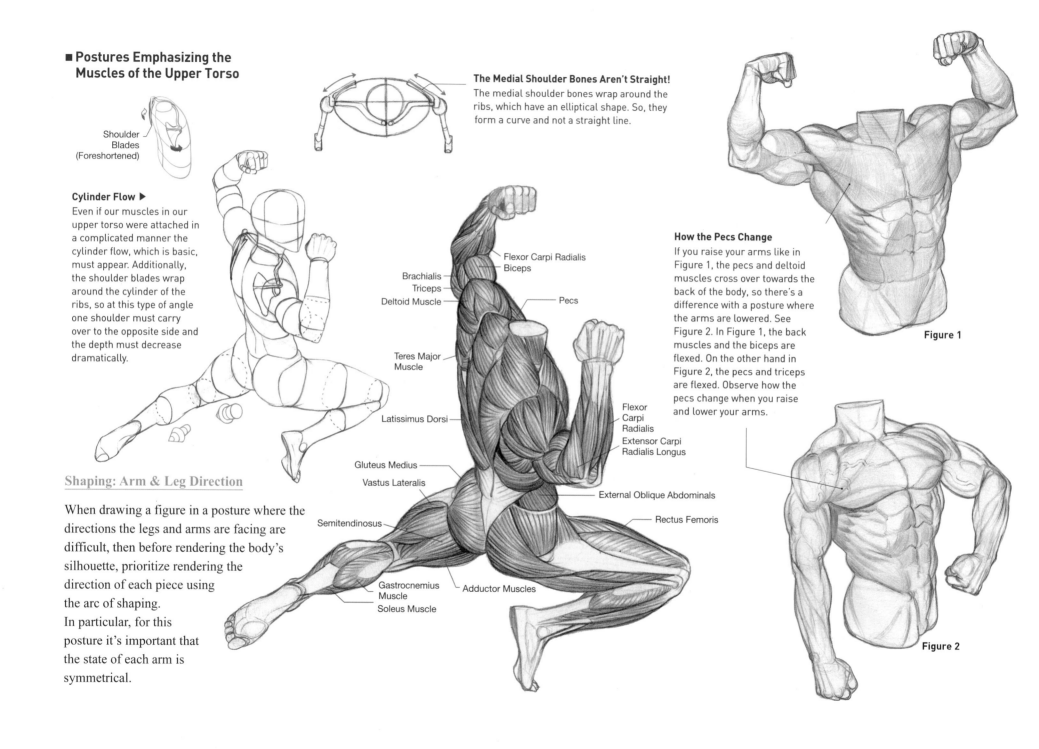

■ Postures Emphasizing the Muscles of the Upper Torso

Shoulder Blades (Foreshortened)

Cylinder Flow ▶
Even if our muscles in our upper torso were attached in a complicated manner the cylinder flow, which is basic, must appear. Additionally, the shoulder blades wrap around the cylinder of the ribs, so at this type of angle one shoulder must carry over to the opposite side and the depth must decrease dramatically.

The Medial Shoulder Bones Aren't Straight!
The medial shoulder bones wrap around the ribs, which have an elliptical shape. So, they form a curve and not a straight line.

Shaping: Arm & Leg Direction

When drawing a figure in a posture where the directions the legs and arms are facing are difficult, then before rendering the body's silhouette, prioritize rendering the direction of each piece using the arc of shaping.
In particular, for this posture it's important that the state of each arm is symmetrical.

Flexor Carpi Radialis
Biceps
Brachialis
Triceps
Deltoid Muscle
Pecs
Teres Major Muscle
Flexor Carpi Radialis
Latissimus Dorsi
Extensor Carpi Radialis Longus
Gluteus Medius
Vastus Lateralis
External Oblique Abdominals
Rectus Femoris
Semitendinosus
Gastrocnemius Muscle
Soleus Muscle
Adductor Muscles

How the Pecs Change
If you raise your arms like in Figure 1, the pecs and deltoid muscles cross over towards the back of the body, so there's a difference with a posture where the arms are lowered. See Figure 2. In Figure 1, the back muscles and the biceps are flexed. On the other hand in Figure 2, the pecs and triceps are flexed. Observe how the pecs change when you raise and lower your arms.

Figure 1

Figure 2

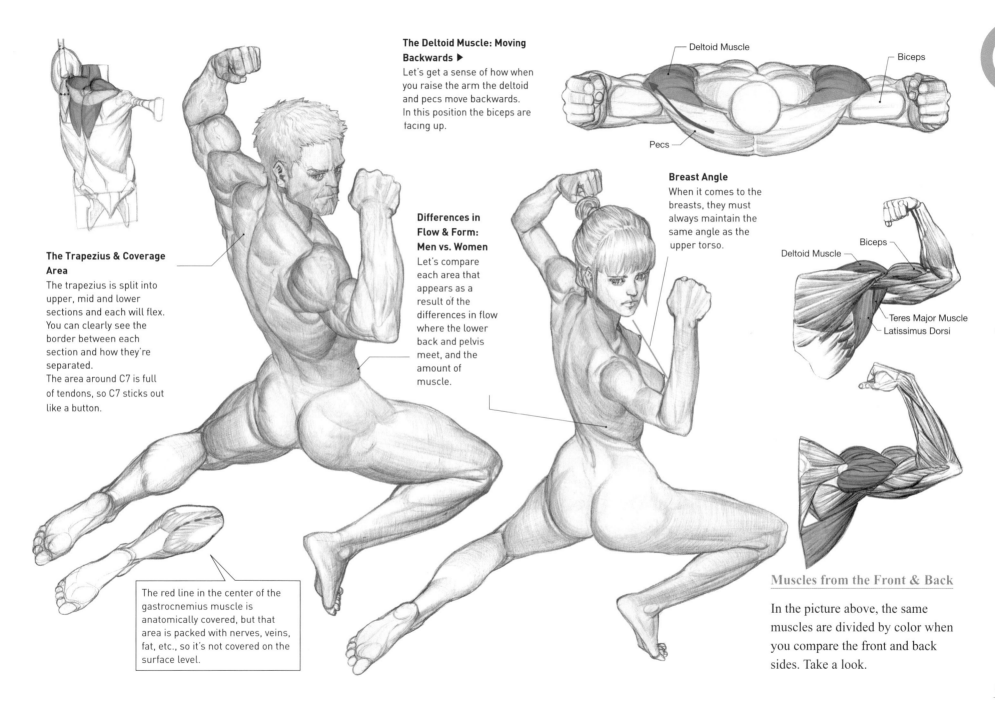

The Deltoid Muscle: Moving Backwards ▶
Let's get a sense of how when you raise the arm the deltoid and pecs move backwards. In this position the biceps are facing up.

Deltoid Muscle

Biceps

Pecs

Differences in Flow & Form: Men vs. Women
Let's compare each area that appears as a result of the differences in flow where the lower back and pelvis meet, and the amount of muscle.

Breast Angle
When it comes to the breasts, they must always maintain the same angle as the upper torso.

Deltoid Muscle

Biceps

Teres Major Muscle

Latissimus Dorsi

The Trapezius & Coverage Area
The trapezius is split into upper, mid and lower sections and each will flex. You can clearly see the border between each section and how they're separated.
The area around C7 is full of tendons, so C7 sticks out like a button.

The red line in the center of the gastrocnemius muscle is anatomically covered, but that area is packed with nerves, veins, fat, etc., so it's not covered on the surface level.

Muscles from the Front & Back

In the picture above, the same muscles are divided by color when you compare the front and back sides. Take a look.

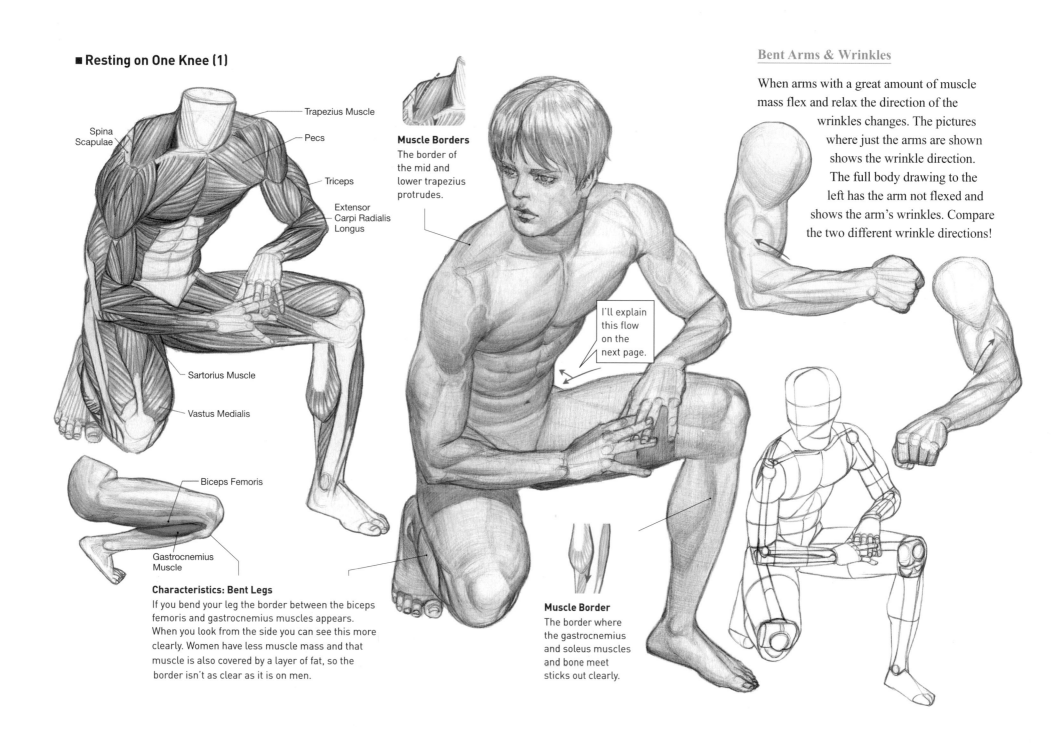

■ Resting on One Knee (1)

Spina
Scapulae

Trapezius Muscle

Pecs

Triceps

Extensor
Carpi Radialis
Longus

Sartorius Muscle

Vastus Medialis

Biceps Femoris

Gastrocnemius
Muscle

Muscle Borders
The border of
the mid and
lower trapezius
protrudes.

I'll explain
this flow
on the
next page.

Characteristics: Bent Legs
If you bend your leg the border between the biceps
femoris and gastrocnemius muscles appears.
When you look from the side you can see this more
clearly. Women have less muscle mass and that
muscle is also covered by a layer of fat, so the
border isn't as clear as it is on men.

Muscle Border
The border where
the gastrocnemius
and soleus muscles
and bone meet
sticks out clearly.

Bent Arms & Wrinkles

When arms with a great amount of muscle
mass flex and relax the direction of the
wrinkles changes. The pictures
where just the arms are shown
shows the wrinkle direction.
The full body drawing to the
left has the arm not flexed and
shows the arm's wrinkles. Compare
the two different wrinkle directions!

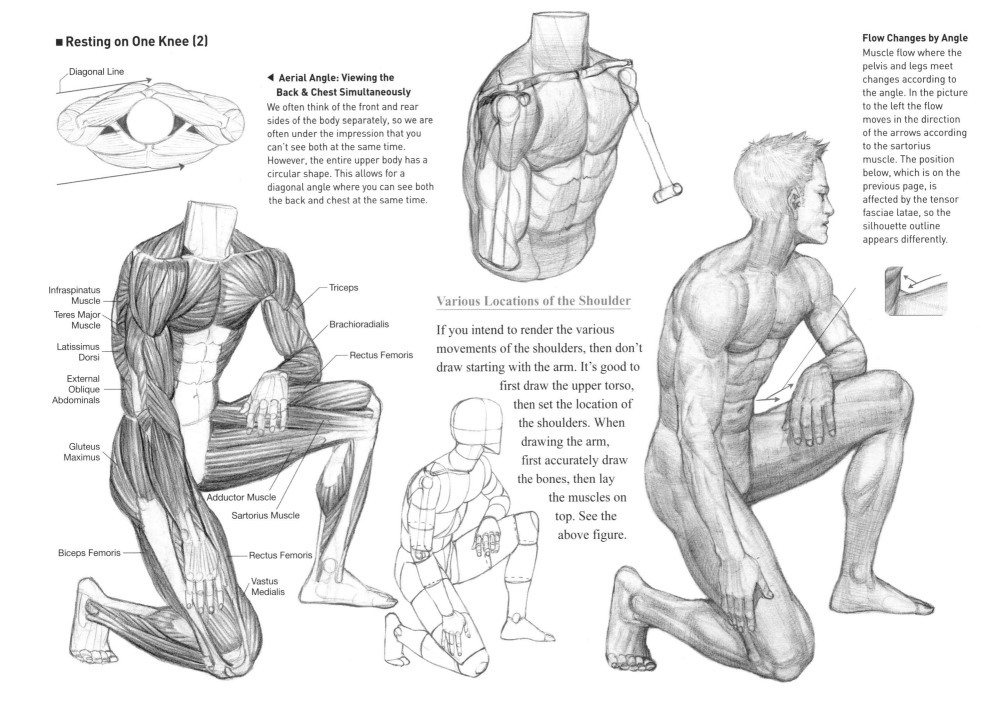

■ Resting on One Knee (2)

Diagonal Line

◄ Aerial Angle: Viewing the Back & Chest Simultaneously

We often think of the front and rear sides of the body separately, so we are often under the impression that you can't see both at the same time. However, the entire upper body has a circular shape. This allows for a diagonal angle where you can see both the back and chest at the same time.

Infraspinatus Muscle

Teres Major Muscle

Latissimus Dorsi

External Oblique Abdominals

Gluteus Maximus

Biceps Femoris

Triceps

Brachioradialis

Rectus Femoris

Adductor Muscle

Sartorius Muscle

Rectus Femoris

Vastus Medialis

Various Locations of the Shoulder

If you intend to render the various movements of the shoulders, then don't draw starting with the arm. It's good to first draw the upper torso, then set the location of the shoulders. When drawing the arm, first accurately draw the bones, then lay the muscles on top. See the above figure.

Flow Changes by Angle

Muscle flow where the pelvis and legs meet changes according to the angle. In the picture to the left the flow moves in the direction of the arrows according to the sartorius muscle. The position below, which is on the previous page, is affected by the tensor fasciae latae, so the silhouette outline appears differently.

■ Crouching Down with the Heels Up (1)

Understanding Weight Center

Please take a second to try crouching down. It's difficult to establish your weight center, right? For a posture where it's difficult to establish weight center in real life, it's also difficult to establish it when drawing a figure in the same position.

Figure 1
○

Figure 2
X

Triceps
Brachialis
Brachioradialis
Extensor Carpi Radialis

External Oblique Abdominals

Rectus Femoris
Vastus Medialis

Vastus Lateralis
Iliotibial Band

Gastrocnemius Muscle
Soleus Muscle
Adductor Muscle

Patella

Picture 1
When the angle of the thighs is vertical the heels raise.

Picture 2
When the thighs are set like this, the bottoms of the feet touch the ground.

Two Ways to Crouch Down

There are two ways to crouch down. You can crouch by raising the thighs and bringing the heels up off the ground (See Picture 1), or you can crouch with the entire bottoms of your feet touching the ground (See Picture 2). It is difficult for men to sit in the second position. Men are different than women in that the upper torso is heavier than the lower, and since the upper body is heavier the weight center shifts to the rear and it's easy to fall over. Figure 2 combines the heels-up position from Picture 1 with the thigh angle of Picture 2, so the weight center for this posture is incorrect.

How to Establish a Stable Weight Center

For the position where one is crouched down with the heels up, the weight center is more stable when you bend forward rather than straightening the upper body. If you bend forward like in the figure below, the arms rest naturally on top of the legs and the shoulders raise slightly.

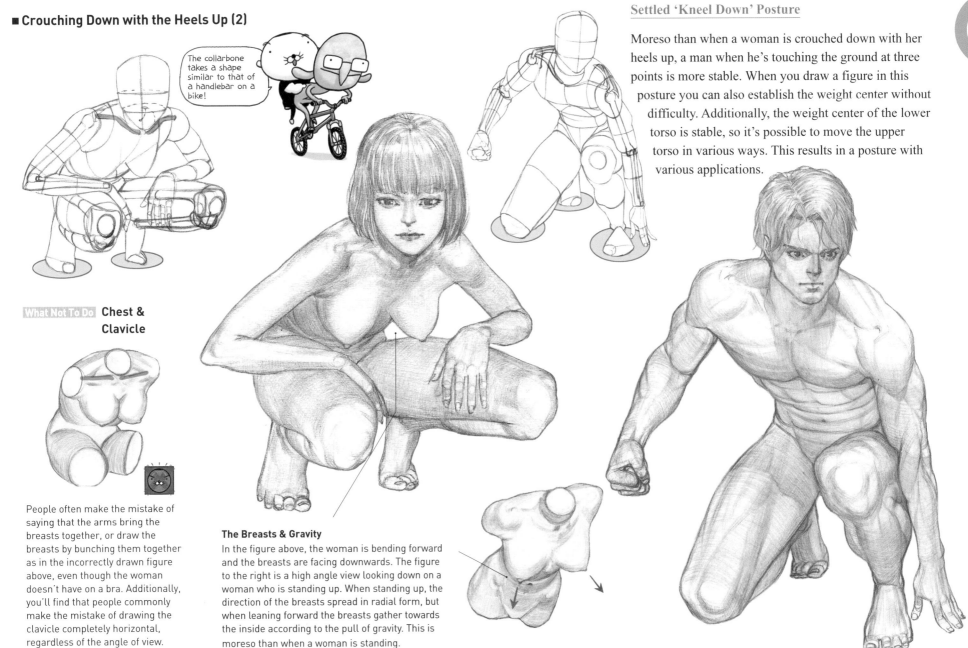

■ Crouching Down with the Heels Up (2)

The collarbone takes a shape similar to that of a handlebar on a bike!

What Not To Do — Chest & Clavicle

People often make the mistake of saying that the arms bring the breasts together, or draw the breasts by bunching them together as in the incorrectly drawn figure above, even though the woman doesn't have on a bra. Additionally, you'll find that people commonly make the mistake of drawing the clavicle completely horizontal, regardless of the angle of view.

The Breasts & Gravity

In the figure above, the woman is bending forward and the breasts are facing downwards. The figure to the right is a high angle view looking down on a woman who is standing up. When standing up, the direction of the breasts spread in radial form, but when leaning forward the breasts gather towards the inside according to the pull of gravity. This is moreso than when a woman is standing.

Settled 'Kneel Down' Posture

Moreso than when a woman is crouched down with her heels up, a man when he's touching the ground at three points is more stable. When you draw a figure in this posture you can also establish the weight center without difficulty. Additionally, the weight center of the lower torso is stable, so it's possible to move the upper torso in various ways. This results in a posture with various applications.

■ Sitting with the Hands to the Ground

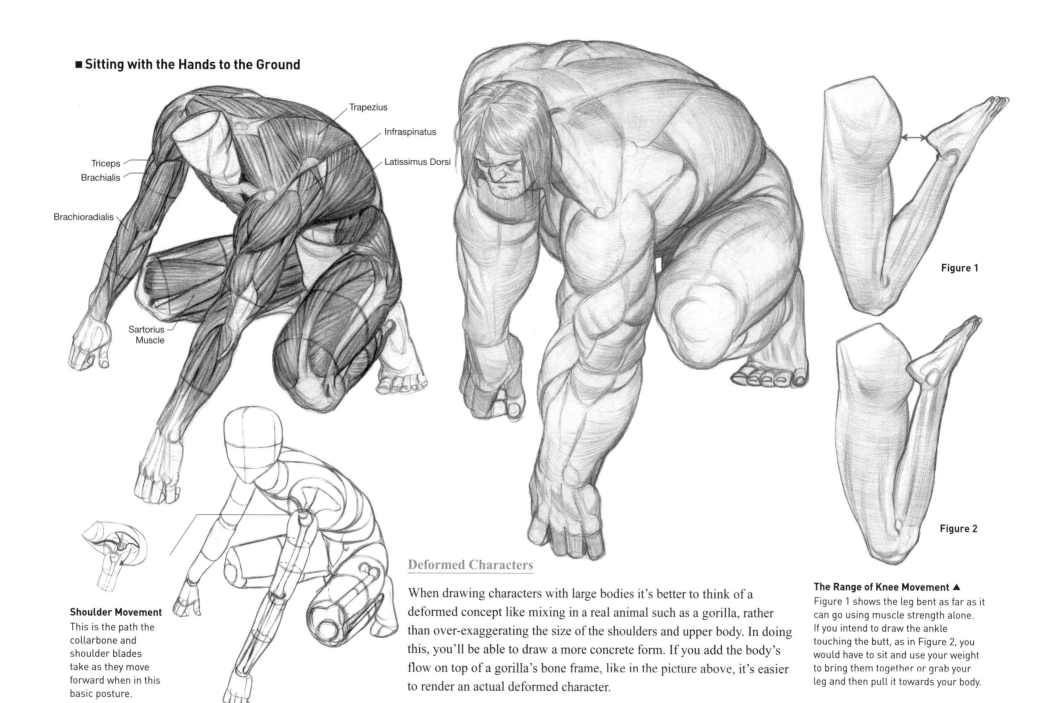

Trapezius

Infraspinatus

Latissimus Dorsi

Triceps

Brachialis

Brachioradialis

Sartorius
Muscle

Shoulder Movement
This is the path the
collarbone and
shoulder blades
take as they move
forward when in this
basic posture.

Figure 1

Figure 2

Deformed Characters

When drawing characters with large bodies it's better to think of a
deformed concept like mixing in a real animal such as a gorilla, rather
than over-exaggerating the size of the shoulders and upper body. In doing
this, you'll be able to draw a more concrete form. If you add the body's
flow on top of a gorilla's bone frame, like in the picture above, it's easier
to render an actual deformed character.

The Range of Knee Movement ▲
Figure 1 shows the leg bent as far as it
can go using muscle strength alone.
If you intend to draw the ankle
touching the butt, as in Figure 2, you
would have to sit and use your weight
to bring them together or grab your
leg and then pull it towards your body.

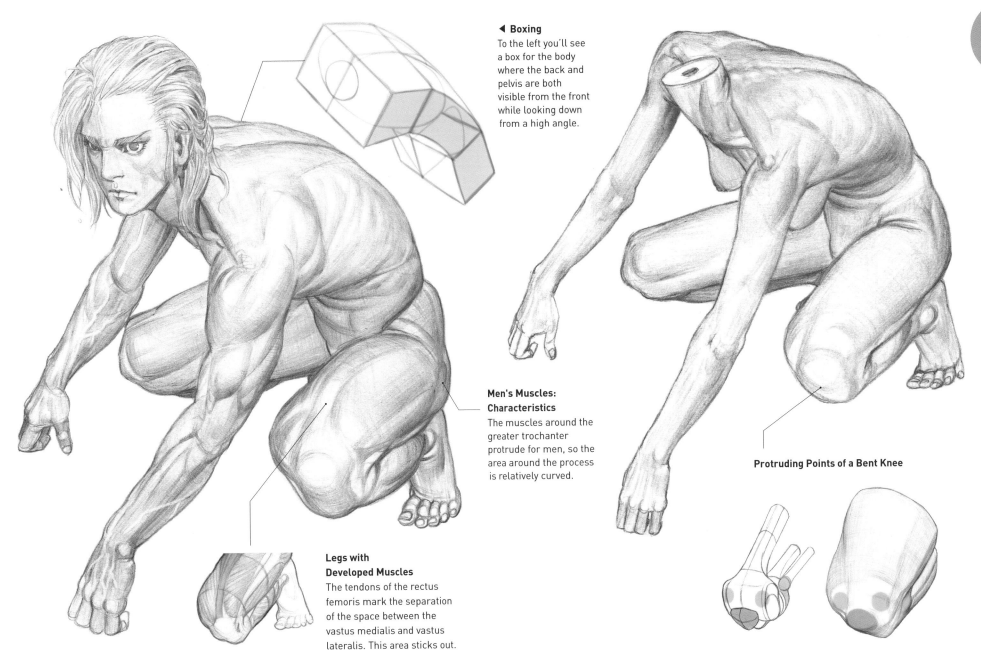

◀ Boxing
To the left you'll see a box for the body where the back and pelvis are both visible from the front while looking down from a high angle.

Men's Muscles: Characteristics
The muscles around the greater trochanter protrude for men, so the area around the process is relatively curved.

Legs with Developed Muscles
The tendons of the rectus femoris mark the separation of the space between the vastus medialis and vastus lateralis. This area sticks out.

Protruding Points of a Bent Knee

■ Both Arms Out to the Sides

The Trapezius & the Angle of the Upper Body

The upper body is bent back, so the trapezius looks lower than normal.

The Latissimus Dorsi, Teres Major Muscle & Armpits ▼

On characters with muscular bodies the latissimus dorsi sticks out, and if the figure is taking a posture where you can clearly see the armpits, then you'll be able to see the latissimus dorsi burrow into the arms. Additionally, the appearance of the latissimus dorsi and its basic form, which wraps around and helps the teres major, can be easily seen from the side when the arms are stretched outwards.

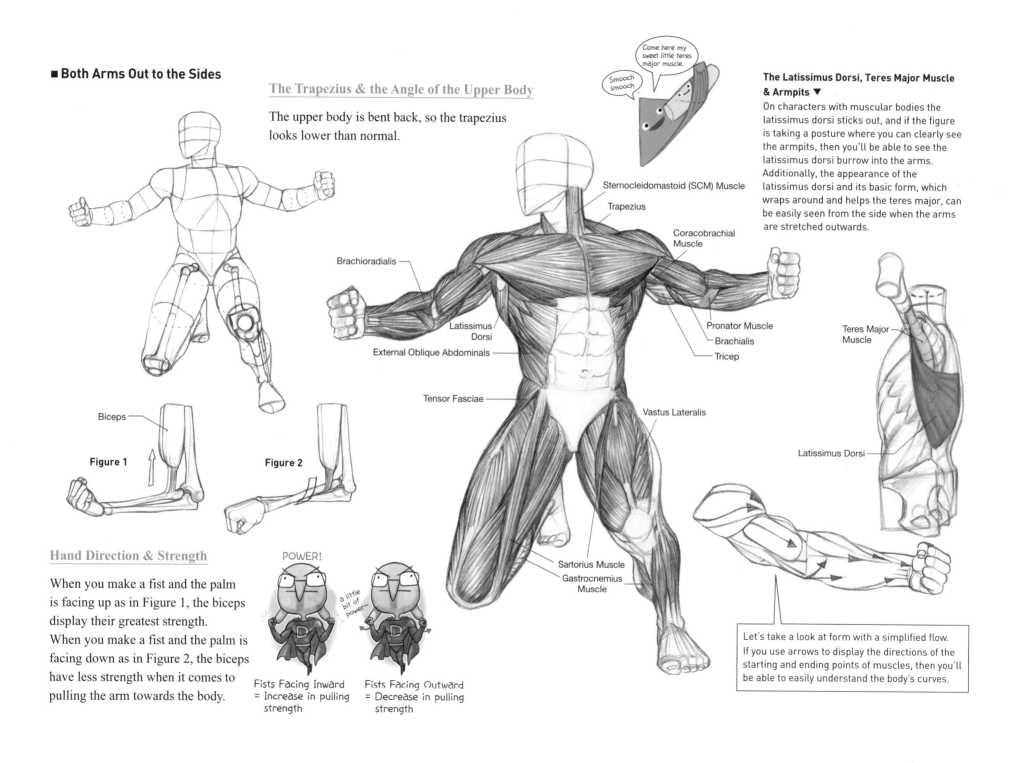

Come here my sweet little teres major muscle.

Smooch smooch

Sternocleidomastoid (SCM) Muscle

Trapezius

Coracobrachial Muscle

Brachioradialis

Latissimus Dorsi

External Oblique Abdominals

Tensor Fasciae

Pronator Muscle

Brachialis

Tricep

Vastus Lateralis

Teres Major Muscle

Latissimus Dorsi

Sartorius Muscle

Gastrocnemius Muscle

Biceps

Figure 1

Figure 2

Hand Direction & Strength

When you make a fist and the palm is facing up as in Figure 1, the biceps display their greatest strength.
When you make a fist and the palm is facing down as in Figure 2, the biceps have less strength when it comes to pulling the arm towards the body.

POWER!

a little bit of power~

Fists Facing Inward = Increase in pulling strength

Fists Facing Outward = Decrease in pulling strength

Let's take a look at form with a simplified flow. If you use arrows to display the directions of the starting and ending points of muscles, then you'll be able to easily understand the body's curves.

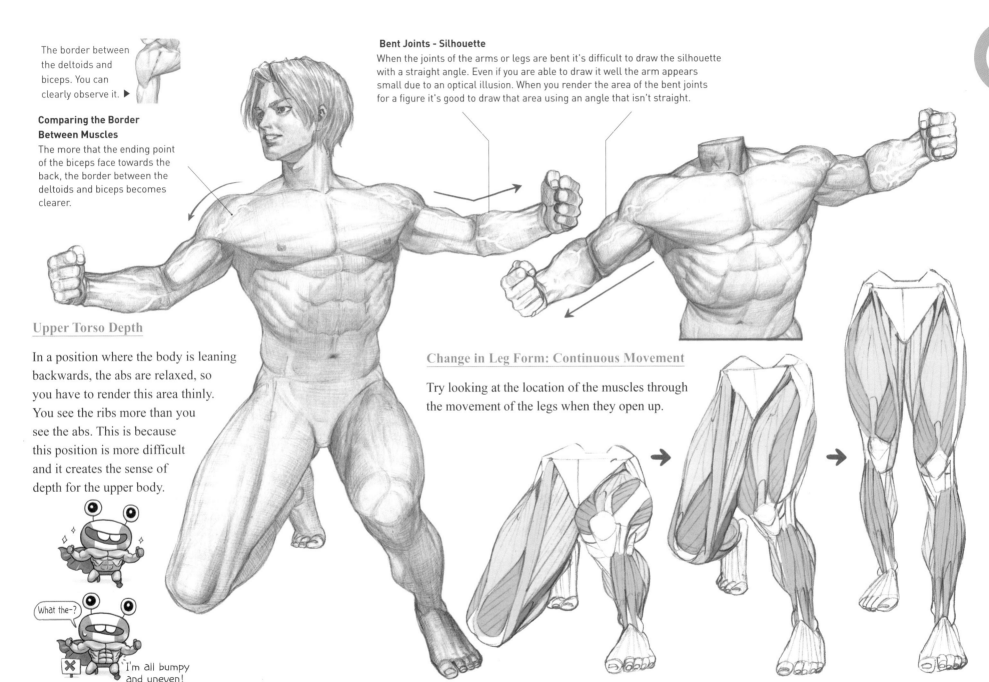

The border between the deltoids and biceps. You can clearly observe it. ▶

Comparing the Border Between Muscles
The more that the ending point of the biceps face towards the back, the border between the deltoids and biceps becomes clearer.

Upper Torso Depth

In a position where the body is leaning backwards, the abs are relaxed, so you have to render this area thinly. You see the ribs more than you see the abs. This is because this position is more difficult and it creates the sense of depth for the upper body.

What the-?

I'm all bumpy and uneven!

Bent Joints - Silhouette
When the joints of the arms or legs are bent it's difficult to draw the silhouette with a straight angle. Even if you are able to draw it well the arm appears small due to an optical illusion. When you render the area of the bent joints for a figure it's good to draw that area using an angle that isn't straight.

Change in Leg Form: Continuous Movement

Try looking at the location of the muscles through the movement of the legs when they open up.

■ Stretching by Raising One Arm

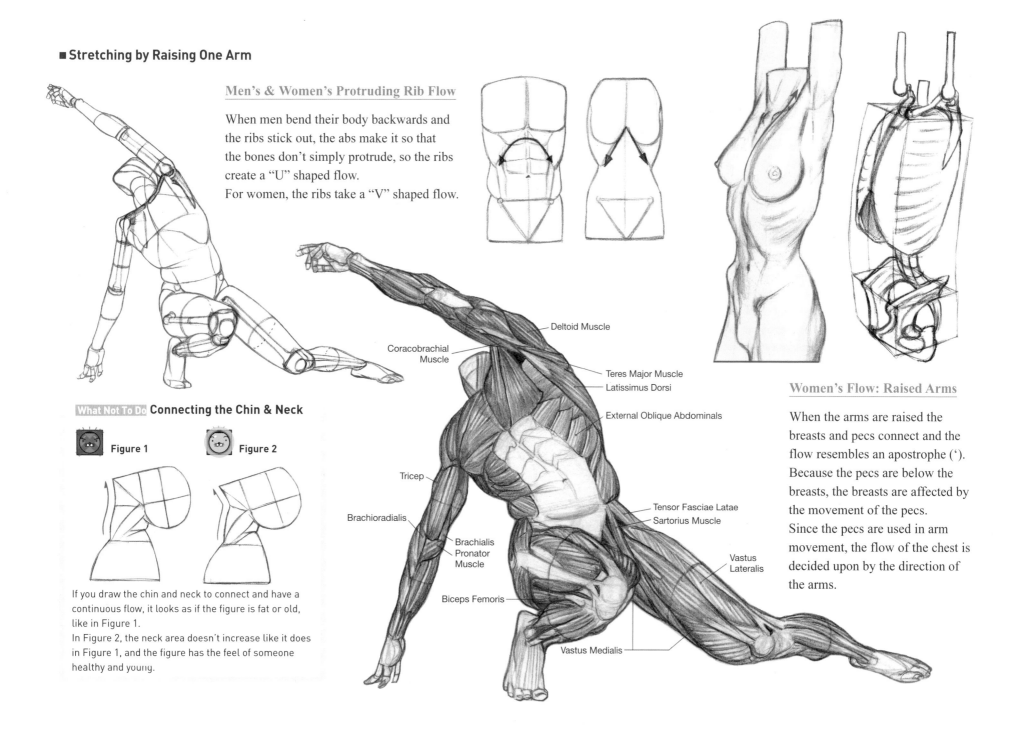

Men's & Women's Protruding Rib Flow

When men bend their body backwards and the ribs stick out, the abs make it so that the bones don't simply protrude, so the ribs create a "U" shaped flow.
For women, the ribs take a "V" shaped flow.

What Not To Do — Connecting the Chin & Neck

Figure 1

Figure 2

If you draw the chin and neck to connect and have a continuous flow, it looks as if the figure is fat or old, like in Figure 1.
In Figure 2, the neck area doesn't increase like it does in Figure 1, and the figure has the feel of someone healthy and young.

Deltoid Muscle
Coracobrachial Muscle
Teres Major Muscle
Latissimus Dorsi
External Oblique Abdominals
Tricep
Tensor Fasciae Latae
Sartorius Muscle
Brachioradialis
Brachialis Pronator Muscle
Vastus Lateralis
Biceps Femoris
Vastus Medialis

Women's Flow: Raised Arms

When the arms are raised the breasts and pecs connect and the flow resembles an apostrophe (').
Because the pecs are below the breasts, the breasts are affected by the movement of the pecs.
Since the pecs are used in arm movement, the flow of the chest is decided upon by the direction of the arms.

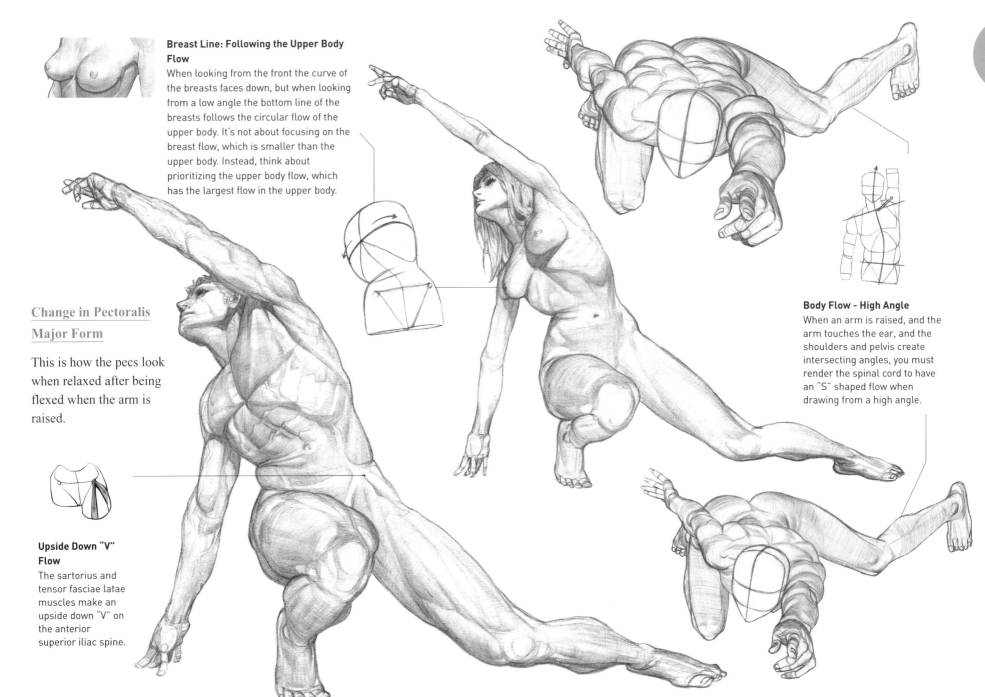

Breast Line: Following the Upper Body Flow

When looking from the front the curve of the breasts faces down, but when looking from a low angle the bottom line of the breasts follows the circular flow of the upper body. It's not about focusing on the breast flow, which is smaller than the upper body. Instead, think about prioritizing the upper body flow, which has the largest flow in the upper body.

Change in Pectoralis Major Form

This is how the pecs look when relaxed after being flexed when the arm is raised.

Upside Down "V" Flow

The sartorius and tensor fasciae latae muscles make an upside down "V" on the anterior superior iliac spine.

Body Flow – High Angle

When an arm is raised, and the arm touches the ear, and the shoulders and pelvis create intersecting angles, you must render the spinal cord to have an "S" shaped flow when drawing from a high angle.

■ Planting Both Knees & One Hand on the Ground

Figure 1

Trapezius Muscles

Tricep

Brachioradialis

Deltoid

Tricep

Bicep

Extensor Carpi Radialis Longus

Extensor Carpi

Sartorius Muscle

Vastus Medialis

Soleus Muscle

Gastrocnemius Muscle

Humbling Gestures

Figure 2

The posture of Figure 2 doesn't have anything wrong with regards to the proportions, weight center or depth. However, the fact that the entire body faces one direction gives the figure a small, humble feel.

Gotta check out the next drawing~

Ana, your movements have great rhythm.

Drawing a Movement to Have Rhythm

When drawing a movement with rhythm, in general many people utilize the method of having the angle of the shoulder and pelvis intersect. However, outside of that there are many other methods that exist, too. Figure 1 shows a posture where the angle of the shoulders and pelvis intersect, while the angle of view and the left/right directions of the upper and lower torso were drawn differently. This gives rhythm to the posture.

A Fully Extended Arm Isn't Actually Straight

The muscles of the arm are arranged like a twisted donut, so this creates a bumpy-like flow. However, this "bumpy-like" quality is a bit vague. If you incorrectly emphasize the muscles, then it will look like the arm is broken. On the other hand if you omit the curve, then it will appear as if the joint area doesn't exist and the arm will look like one large clump. When it comes to the flow of the body get a good feel for it by practicing sketching (croquis), then study anatomy in order to find a more accurate flow.

Shoulders: Boxed Flow
For men, the muscles around the box-shaped line of the collarbone and spina scapulae protrude.

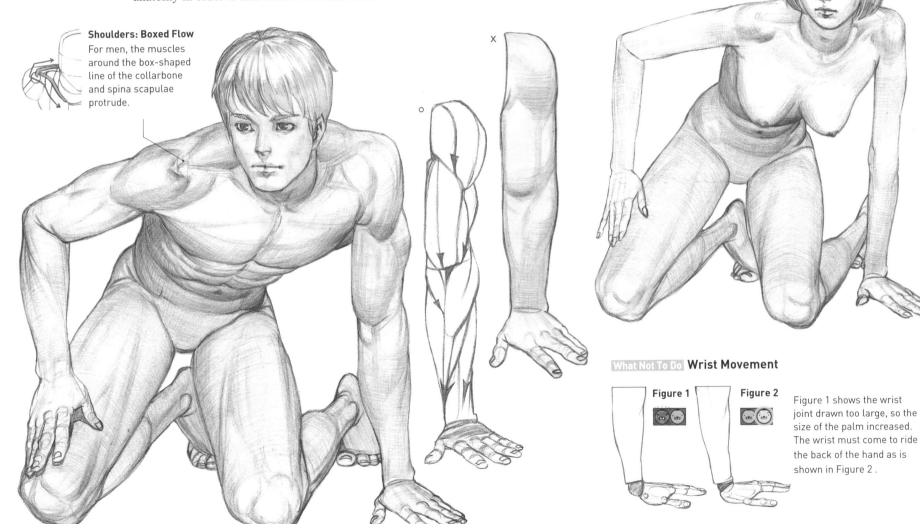

What Not To Do Wrist Movement

Figure 1 Figure 2

Figure 1 shows the wrist joint drawn too large, so the size of the palm increased. The wrist must come to ride the back of the hand as is shown in Figure 2 .

■ Various Seated Positions for Women

Women's Ribs: Upside Down "V" Flow

Women's muscles are thin, so the ribs create the outline for the body. In particular, when bending the upper body backwards or breathing in, the "upside down V" flow of the ribs comes out clearly.

Anterior Superior Iliac Spine

The anterior superior iliac spine is the representative point on women's body that sticks out from the pelvis. Women are different than men in that due to the accumulation of fat on the pelvis the iliac crest is buried beneath, but the anterior superior iliac spine protrudes. If you connect both sides of the anterior superior iliac crest, then you'll be able to know the angle of the pelvis.

Researching Movement Through Continuous Movement ▼
Getting up from sitting on the knees can be broken down into three distinct movements, as is shown below. The first and third movements are static, but the second movement shows the body in the middle of moving. It shows the moment of shifting the weight center forward in order to get up. This type of continual movement practice provides a great help when drawing life-like positions in order to understand movement.

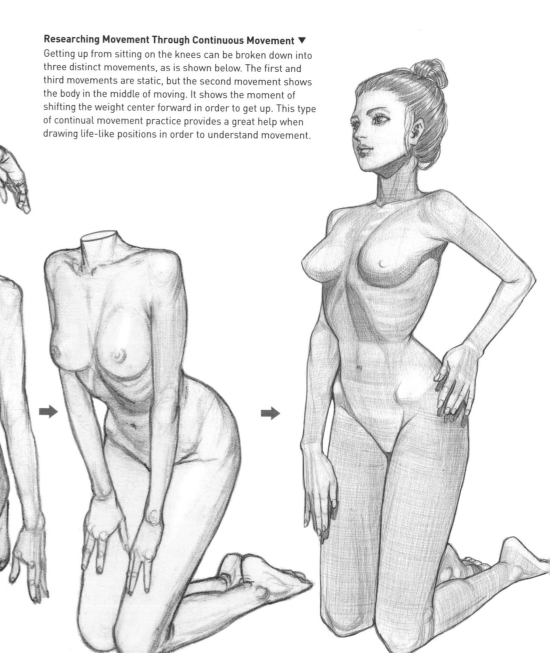

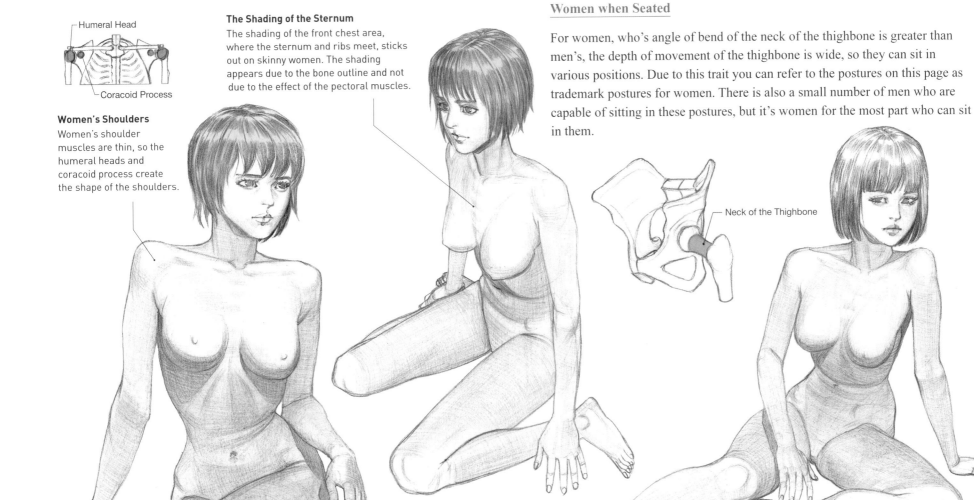

Humeral Head

Coracoid Process

Women's Shoulders
Women's shoulder muscles are thin, so the humeral heads and coracoid process create the shape of the shoulders.

The Shading of the Sternum
The shading of the front chest area, where the sternum and ribs meet, sticks out on skinny women. The shading appears due to the bone outline and not due to the effect of the pectoral muscles.

Women when Seated

For women, who's angle of bend of the neck of the thighbone is greater than men's, the depth of movement of the thighbone is wide, so they can sit in various positions. Due to this trait you can refer to the postures on this page as trademark postures for women. There is also a small number of men who are capable of sitting in these postures, but it's women for the most part who can sit in them.

Neck of the Thighbone

◀ **Curvy Flow of the Lower Torso**
With the exception of men's legs and women with firm, compact legs you must express women's legs with a long curvy line rather than a small flow. For this type of flow it's very effective to get acquainted with it by practicing sketching to study anatomy.

■ Sitting with Both Hands on the Ground

The Shape Above the Bone Structure

Just because it's called "shaping" doesn't mean you do it with simplicity. After first drawing the bone structure inside the body you apply shaping on top. So, in a position where the shoulders affect the silhouette, you must render the different angles of flow caused by the bones. Refer to the circled area in the picture below.

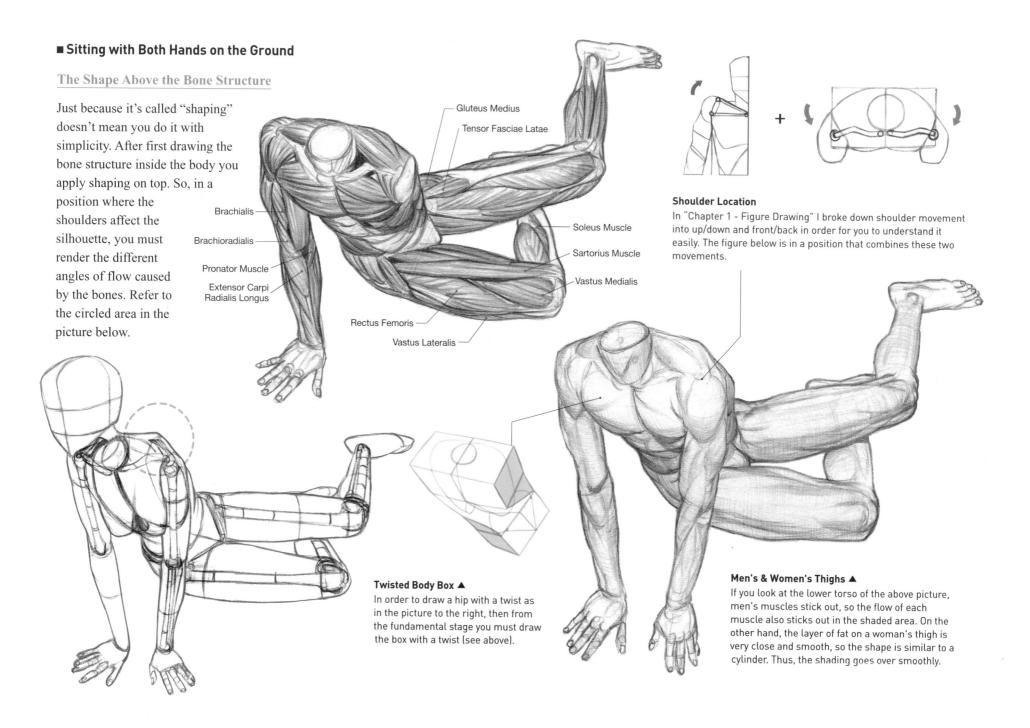

Gluteus Medius

Tensor Fasciae Latae

Brachialis

Brachioradialis

Pronator Muscle

Extensor Carpi Radialis Longus

Soleus Muscle

Sartorius Muscle

Vastus Medialis

Rectus Femoris

Vastus Lateralis

Shoulder Location
In "Chapter 1 - Figure Drawing" I broke down shoulder movement into up/down and front/back in order for you to understand it easily. The figure below is in a position that combines these two movements.

Twisted Body Box ▲
In order to draw a hip with a twist as in the picture to the right, then from the fundamental stage you must draw the box with a twist (see above).

Men's & Women's Thighs ▲
If you look at the lower torso of the above picture, men's muscles stick out, so the flow of each muscle also sticks out in the shaded area. On the other hand, the layer of fat on a woman's thigh is very close and smooth, so the shape is similar to a cylinder. Thus, the shading goes over smoothly.

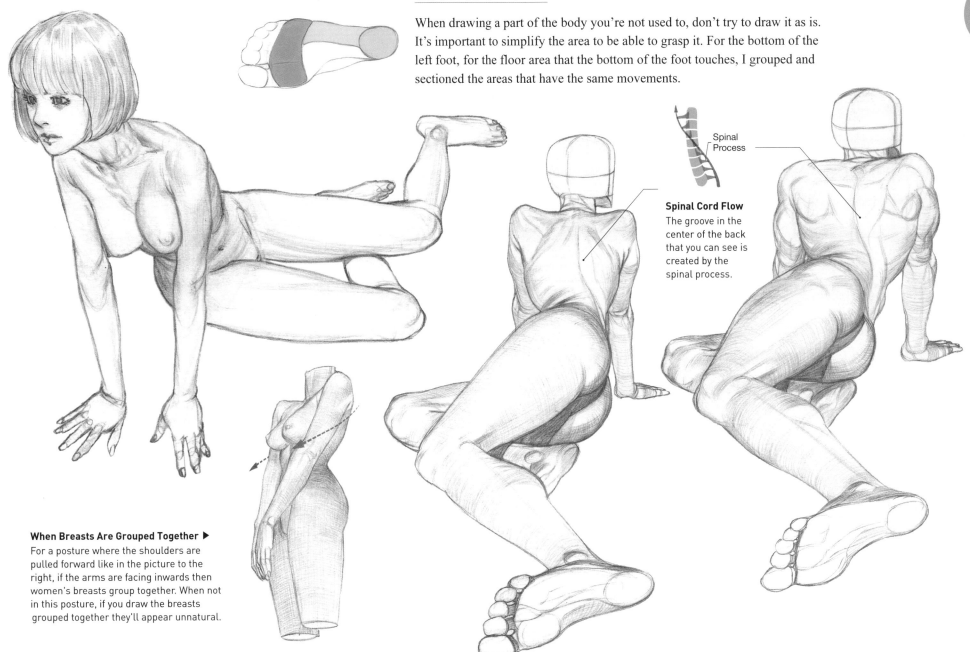

The Bottom of the Foot

When drawing a part of the body you're not used to, don't try to draw it as is. It's important to simplify the area to be able to grasp it. For the bottom of the left foot, for the floor area that the bottom of the foot touches, I grouped and sectioned the areas that have the same movements.

Spinal Process

Spinal Cord Flow
The groove in the center of the back that you can see is created by the spinal process.

When Breasts Are Grouped Together ▶
For a posture where the shoulders are pulled forward like in the picture to the right, if the arms are facing inwards then women's breasts group together. When not in this posture, if you draw the breasts grouped together they'll appear unnatural.

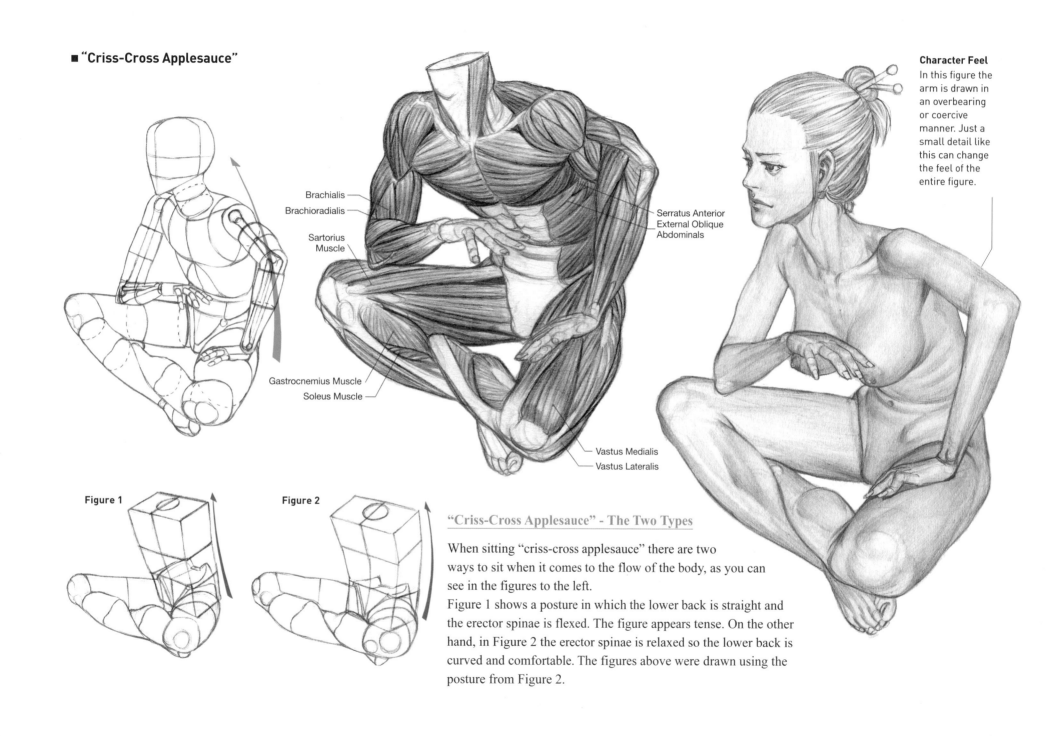

■ "Criss-Cross Applesauce"

Brachialis
Brachioradialis
Sartorius Muscle
Gastrocnemius Muscle
Soleus Muscle

Serratus Anterior
External Oblique
Abdominals

Vastus Medialis
Vastus Lateralis

Character Feel
In this figure the arm is drawn in an overbearing or coercive manner. Just a small detail like this can change the feel of the entire figure.

Figure 1

Figure 2

"Criss-Cross Applesauce" - The Two Types

When sitting "criss-cross applesauce" there are two ways to sit when it comes to the flow of the body, as you can see in the figures to the left.

Figure 1 shows a posture in which the lower back is straight and the erector spinae is flexed. The figure appears tense. On the other hand, in Figure 2 the erector spinae is relaxed so the lower back is curved and comfortable. The figures above were drawn using the posture from Figure 2.

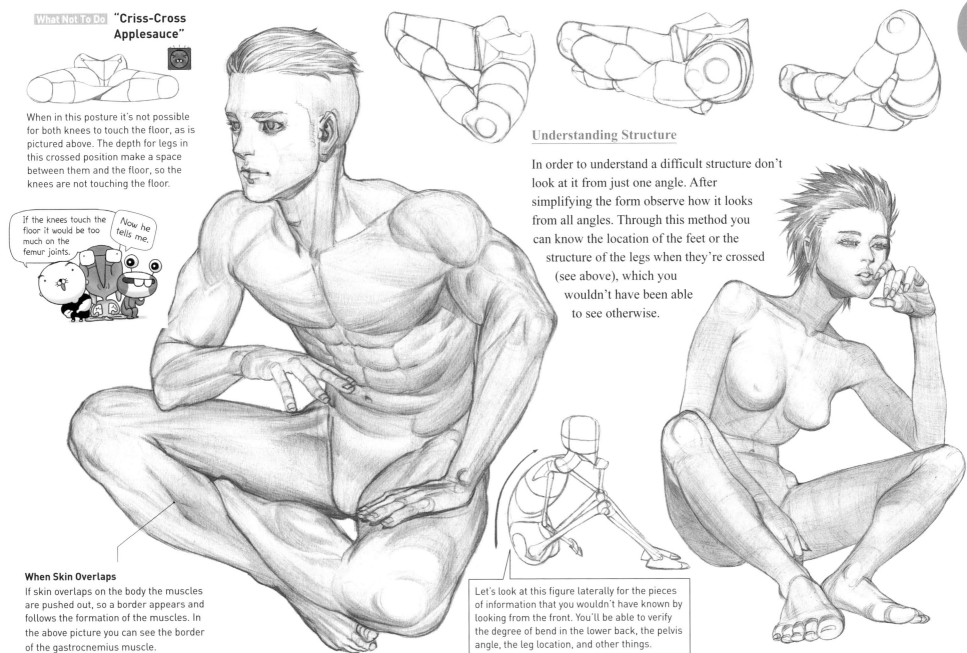

"Criss-Cross Applesauce"

When in this posture it's not possible for both knees to touch the floor, as is pictured above. The depth for legs in this crossed position make a space between them and the floor, so the knees are not touching the floor.

If the knees touch the floor it would be too much on the femur joints.

Now he tells me.

When Skin Overlaps

If skin overlaps on the body the muscles are pushed out, so a border appears and follows the formation of the muscles. In the above picture you can see the border of the gastrocnemius muscle.

Understanding Structure

In order to understand a difficult structure don't look at it from just one angle. After simplifying the form observe how it looks from all angles. Through this method you can know the location of the feet or the structure of the legs when they're crossed (see above), which you wouldn't have been able to see otherwise.

Let's look at this figure laterally for the pieces of information that you wouldn't have known by looking from the front. You'll be able to verify the degree of bend in the lower back, the pelvis angle, the leg location, and other things.

3 Running Stances

■ Running: Diagonal View

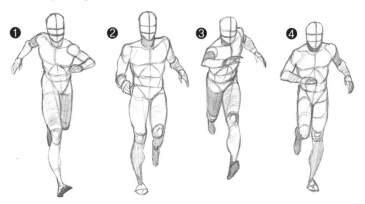

❶ ❷ ❸ ❹

Drawing Running Figures in Motion

Walking or running is something you can see people do everyday, so they're familiar to us all. But, if you draw a figure walking or running in different positions from a frontal view, it's not as simple as you may think. For each movement, the direction for the arms and legs and the weight center are different, and you must accurately know the points for each posture like this in order to render a naturally-looking figure. If you observe the picture to the right, you can see that it most resembles ❶ of the above figures in motion. When you draw a figure in motion like this and think of boxing the upper torso, you'll be able to render the figure in various movements. This allows you to draw more than just the typical movements. Let's take a look into running and walking figures at different moments of motion.

What Not To Do Common Mistakes

Whip!

Are you making his feet whip his butt so he can run faster?

Er... no...

When you tell your students to draw a figure in running motion, one of the common mistakes they make is that they would draw the arm bent at 90 degrees and would wave it front to back, just like a person in an exit sign.
It's true that the angle of the elbows is 90 degrees, but the arms must face towards the body. For example, if the angles of the shoulders and pelvis are horizontal and you look at them from the front, or if the heels touch the butt, the figure ends up looking unnatural.

Characteristics ▲
Due to the arms and legs moving in opposite directions, the upper torso box will have a twist in it. The arm that's out in front twists towards the inside front of the body, and the arm that's out to the rear is greatly bent, so it isn't raised up.

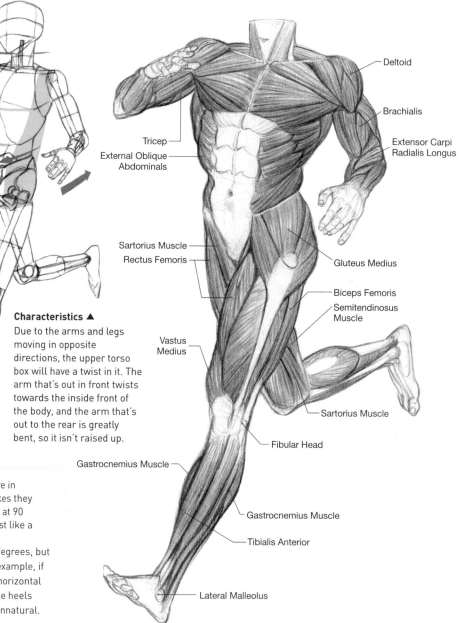

- Deltoid
- Brachialis
- Extensor Carpi Radialis Longus
- Tricep
- External Oblique Abdominals
- Sartorius Muscle
- Rectus Femoris
- Gluteus Medius
- Biceps Femoris
- Semitendinosus Muscle
- Vastus Medius
- Sartorius Muscle
- Fibular Head
- Gastrocnemius Muscle
- Gastrocnemius Muscle
- Tibialis Anterior
- Lateral Malleolus

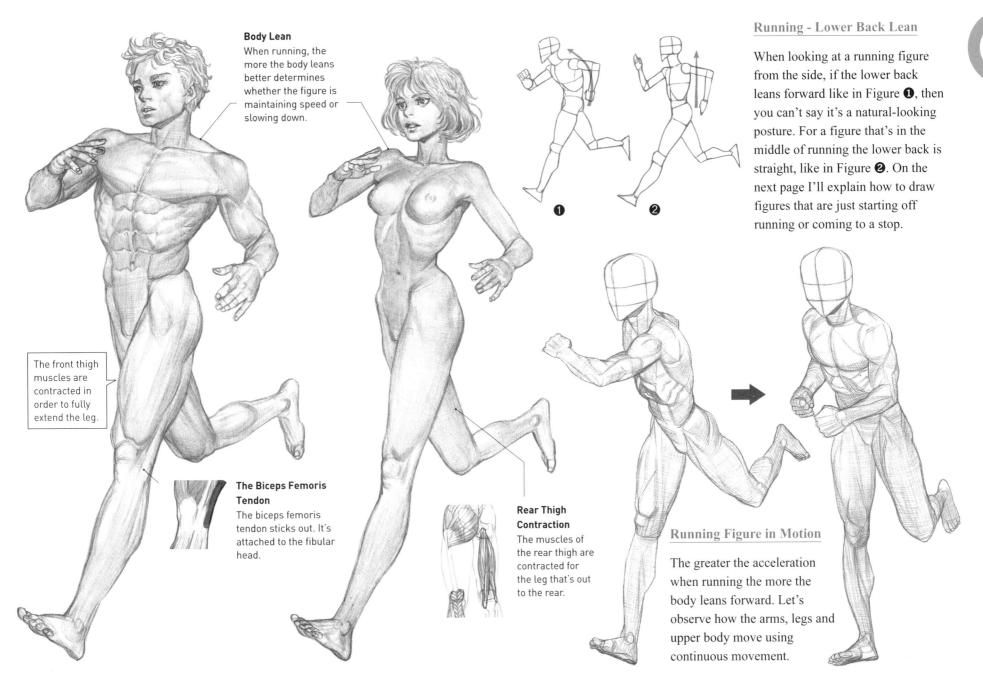

Body Lean
When running, the more the body leans better determines whether the figure is maintaining speed or slowing down.

The front thigh muscles are contracted in order to fully extend the leg.

The Biceps Femoris Tendon
The biceps femoris tendon sticks out. It's attached to the fibular head.

Rear Thigh Contraction
The muscles of the rear thigh are contracted for the leg that's out to the rear.

Running - Lower Back Lean

When looking at a running figure from the side, if the lower back leans forward like in Figure ❶, then you can't say it's a natural-looking posture. For a figure that's in the middle of running the lower back is straight, like in Figure ❷. On the next page I'll explain how to draw figures that are just starting off running or coming to a stop.

❶ ❷

Running Figure in Motion

The greater the acceleration when running the more the body leans forward. Let's observe how the arms, legs and upper body move using continuous movement.

■ Running: Running Starts

Characteristics

As I explained earlier, bending the lower back forward when in a running start posture is indicative of the position you take right after when you begin moving forward. As in Figure 2 below, with a running start posture you place your hands on the ground and bend your back low to the ground. You start off in that position, so after starting to run, the lower back slowly straightens and the body leans forward in order to run faster. The reason that a running start position is low is that after compacting the body as much as possible, like a spring, the body then pops open. It's in this way that the running start position is divided into a variety of ways.

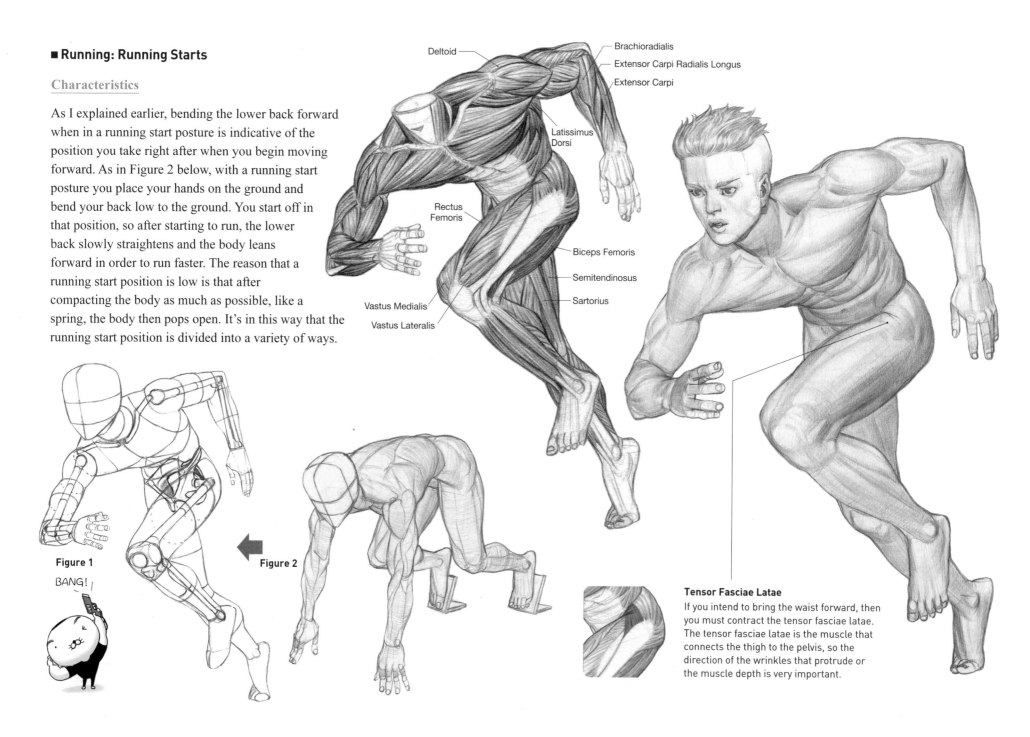

Deltoid

Brachioradialis

Extensor Carpi Radialis Longus

Extensor Carpi

Latissimus Dorsi

Rectus Femoris

Biceps Femoris

Semitendinosus

Sartorius

Vastus Medialis

Vastus Lateralis

Figure 1

BANG!

Figure 2

Tensor Fasciae Latae
If you intend to bring the waist forward, then you must contract the tensor fasciae latae. The tensor fasciae latae is the muscle that connects the thigh to the pelvis, so the direction of the wrinkles that protrude or the muscle depth is very important.

Rendering Acceleration

Figure **❶** shows the body when it leans forward. This character's running speed is increasing. Figure **❷** shows a character whose maintaining or decreasing their running speed. For both postures the lower back is straight and the only difference is the angle.

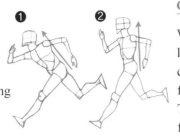

Continuous Motion as Seen from the Side

With running movements, the arms and legs move forwards and backwards, so the characteristics of the motion are more evident from the side rather than from the front. The arm and leg joints mostly move forwards and backwards, so whatever movement you choose to draw it's important to observe it from the side.

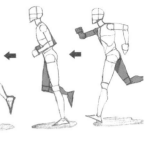

Why the Lower Back Must Be Straight

In all postures outside of a running start position, the lower back must be straight. The reason being that the strength which comes from the feet pressing against the ground isn't absorbed in the lower back and it forces the body to lean forward.

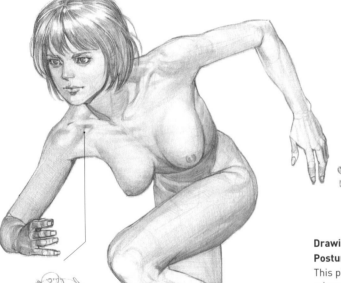

Deltopectoral Triangle

In between the trapezius muscles and the biceps the triangular-shaped empty space that appears is an area of muscle that's not limited to just men, but it also protrudes clearly on skinnier women.

Drawing a Mirrored Posture ▶

This picture above is a mirror of the posture to the left. Through a bent lower back you can come to know the state of a running posture. The arm that's forward covers the body, so it's more complicated to draw the body like this rather than from the left side where the body isn't covered by the arm.

Weight Center for Running Postures

Red light, green light, red...

Swoosh

LIGHT!

Ah!

Screeeech!

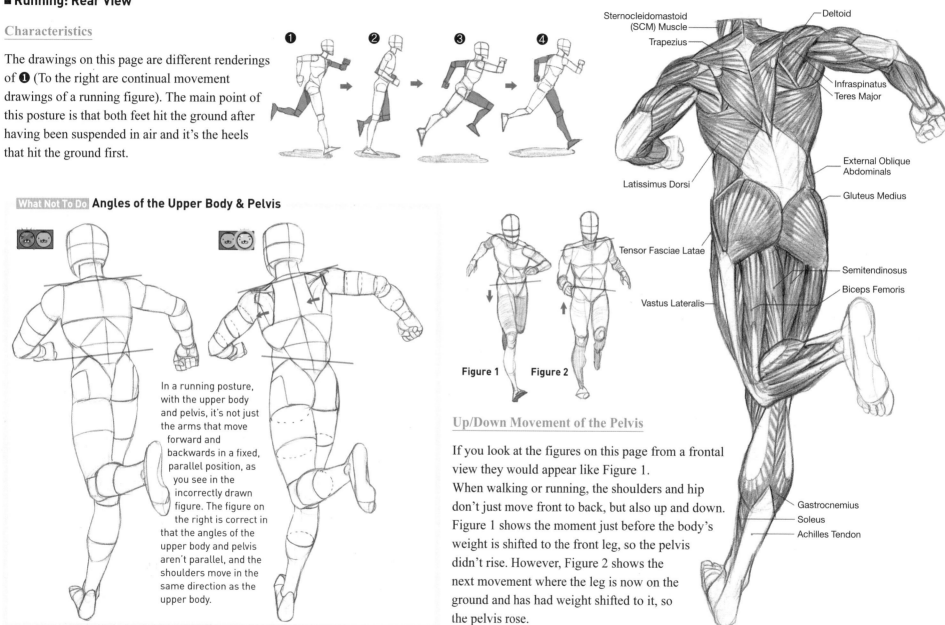

■ Running: Rear View

Characteristics

The drawings on this page are different renderings of ❶ (To the right are continual movement drawings of a running figure). The main point of this posture is that both feet hit the ground after having been suspended in air and it's the heels that hit the ground first.

❶ ❷ ❸ ❹

What Not To Do Angles of the Upper Body & Pelvis

In a running posture, with the upper body and pelvis, it's not just the arms that move forward and backwards in a fixed, parallel position, as you see in the incorrectly drawn figure. The figure on the right is correct in that the angles of the upper body and pelvis aren't parallel, and the shoulders move in the same direction as the upper body.

Figure 1 **Figure 2**

Up/Down Movement of the Pelvis

If you look at the figures on this page from a frontal view they would appear like Figure 1.
When walking or running, the shoulders and hip don't just move front to back, but also up and down. Figure 1 shows the moment just before the body's weight is shifted to the front leg, so the pelvis didn't rise. However, Figure 2 shows the next movement where the leg is now on the ground and has had weight shifted to it, so the pelvis rose.

Sternocleidomastoid (SCM) Muscle
Trapezius
Deltoid
Infraspinatus
Teres Major
Latissimus Dorsi
External Oblique Abdominals
Gluteus Medius
Tensor Fasciae Latae
Semitendinosus
Biceps Femoris
Vastus Lateralis
Gastrocnemius
Soleus
Achilles Tendon

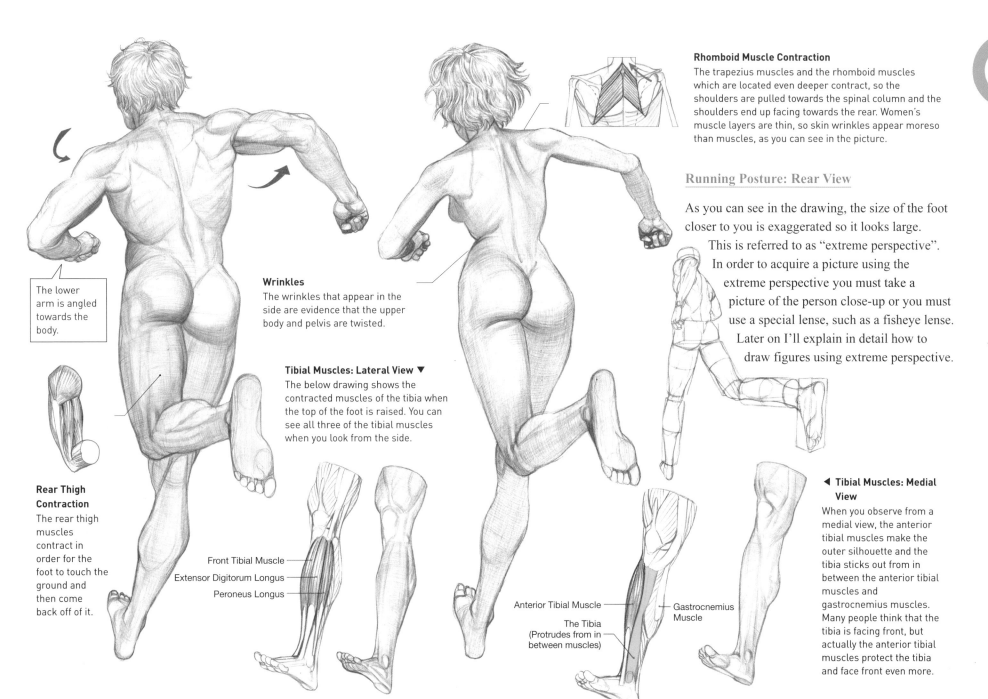

The lower arm is angled towards the body.

Rear Thigh Contraction
The rear thigh muscles contract in order for the foot to touch the ground and then come back off of it.

Wrinkles
The wrinkles that appear in the side are evidence that the upper body and pelvis are twisted.

Tibial Muscles: Lateral View ▼
The below drawing shows the contracted muscles of the tibia when the top of the foot is raised. You can see all three of the tibial muscles when you look from the side.

Front Tibial Muscle
Extensor Digitorum Longus
Peroneus Longus

Rhomboid Muscle Contraction
The trapezius muscles and the rhomboid muscles which are located even deeper contract, so the shoulders are pulled towards the spinal column and the shoulders end up facing towards the rear. Women's muscle layers are thin, so skin wrinkles appear moreso than muscles, as you can see in the picture.

Running Posture: Rear View

As you can see in the drawing, the size of the foot closer to you is exaggerated so it looks large. This is referred to as "extreme perspective". In order to acquire a picture using the extreme perspective you must take a picture of the person close-up or you must use a special lens, such as a fisheye lense. Later on I'll explain in detail how to draw figures using extreme perspective.

◀ Tibial Muscles: Medial View
When you observe from a medial view, the anterior tibial muscles make the outer silhouette and the tibia sticks out from in between the anterior tibial muscles and gastrocnemius muscles. Many people think that the tibia is facing front, but actually the anterior tibial muscles protect the tibia and face front even more.

Anterior Tibial Muscle
The Tibia (Protrudes from in between muscles)
Gastrocnemius Muscle

Drawing Figures from Difficult Angles

When drawing a figure that's taken a position more difficult than a running position, the angles of the upper body and pelvis intersect even more. As I stated earlier, if you intend to render an angle that actually looks difficult, first you must draw the simple shaping of the complicated body. This is because the more simple the form the greater variety of angles there are from which you can view the figure.

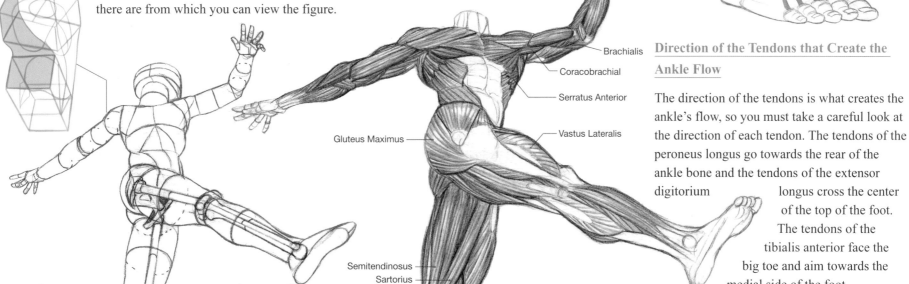

Brachialis

Coracobrachial

Serratus Anterior

Vastus Lateralis

Gluteus Maximus

Semitendinosus

Sartorius

Extensor Digitorum Longus

Tibialis Anterior

Peroneus Longus

Direction of the Tendons that Create the Ankle Flow

The direction of the tendons is what creates the ankle's flow, so you must take a careful look at the direction of each tendon. The tendons of the peroneus longus go towards the rear of the ankle bone and the tendons of the extensor digitorium longus cross the center of the top of the foot. The tendons of the tibialis anterior face the big toe and aim towards the medial side of the foot.

Drawing Faces from Low Angles

For a face where you see the bottom side of the chin, the form isn't familiar to us. This is because we don't commonly see the face from this angle. The actual sides of the face aren't divided up like this, but we're going to take a look at the form by dividing the face into sections for the sake of study.

Low angle, I summon you!

swoosh swoosh

Medial View **Lateral View**

Gastrocnemius Muscle

Soleus Muscle

The soleus muscle—medial and lateral views

The soleus muscle, located deep within the gastrocnemius muscle.

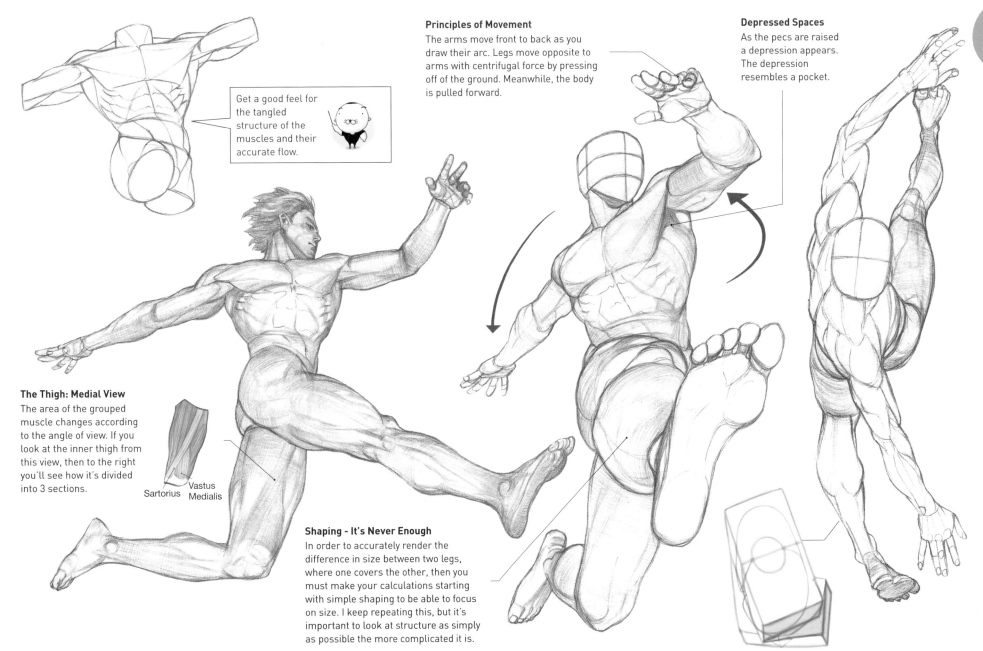

Principles of Movement
The arms move front to back as you draw their arc. Legs move opposite to arms with centrifugal force by pressing off of the ground. Meanwhile, the body is pulled forward.

Depressed Spaces
As the pecs are raised a depression appears. The depression resembles a pocket.

Get a good feel for the tangled structure of the muscles and their accurate flow.

The Thigh: Medial View
The area of the grouped muscle changes according to the angle of view. If you look at the inner thigh from this view, then to the right you'll see how it's divided into 3 sections.

Sartorius Vastus Medialis

Shaping - It's Never Enough
In order to accurately render the difference in size between two legs, where one covers the other, then you must make your calculations starting with simple shaping to be able to focus on size. I keep repeating this, but it's important to look at structure as simply as possible the more complicated it is.

④ Midair Postures

■ Looking at Something Far While Midair

Weight Center

While midair, weight center isn't affected and the body's flow is affected by the direction of movement.
When the body turns in order to look at something while midair, as in the postures on this page, you can only have a natural motion by having the body's direction follow the direction in which the eyes look. This is moreso than just simply turning the head.

What Not To Do Knee Frame

When the knee is bent there's a major difference in form according to how you think of the frame.
If you look at the figure on the right on this page, the silhouette of the bent knee doesn't have a sharp point like the knee which is incorrectly drawn (see above). Instead, you'll see that it has a square shape.

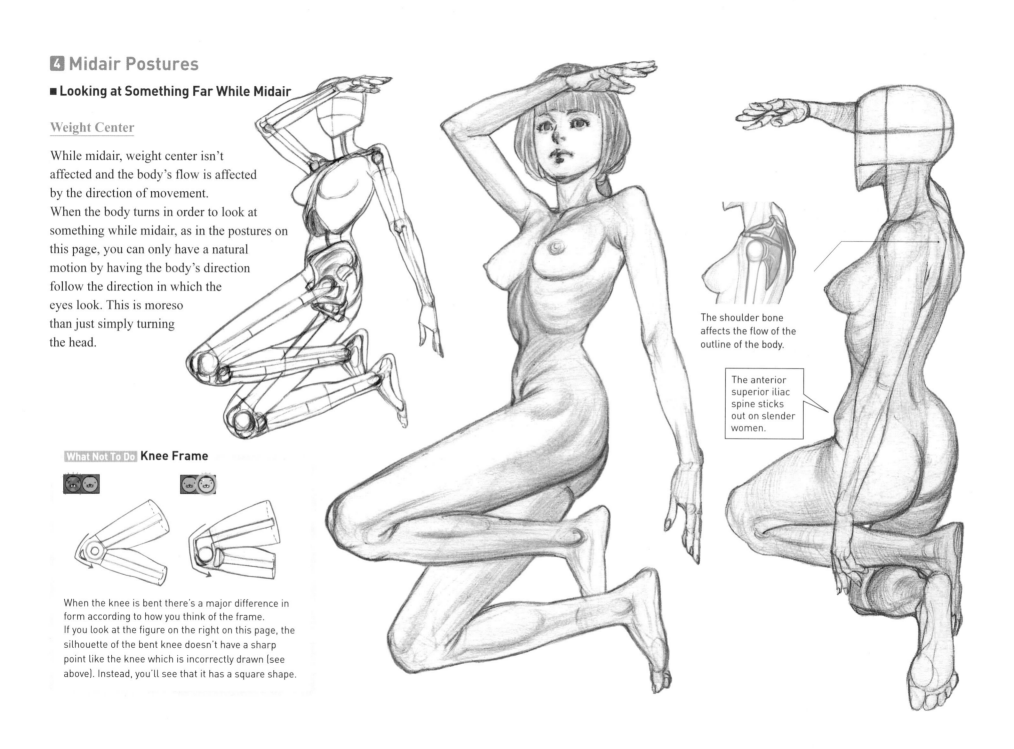

The shoulder bone affects the flow of the outline of the body.

The anterior superior iliac spine sticks out on slender women.

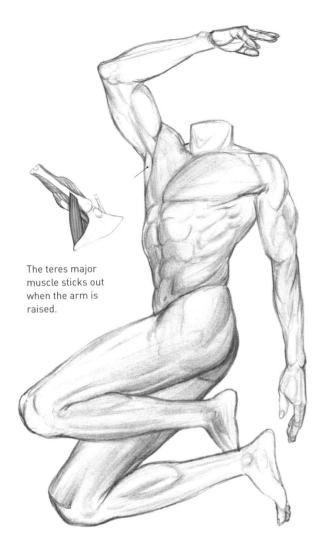

The teres major muscle sticks out when the arm is raised.

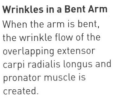

The right arm when it's covered by the head

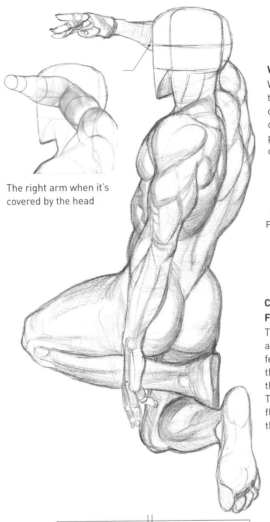

Wrinkles in a Bent Arm

When the arm is bent, the wrinkle flow of the overlapping extensor carpi radialis longus and pronator muscle is created.

Extensor Carpi Radialis Longus

Pronator Muscle

Sartorius Muscle Direction

Rectus Femoris Direction

Change in Thigh Flow

The sartorius and rectus femoris create the silhouette for the thigh's flow. The direction of flow is shown by the red arrows.

The Ankles & Tendon Flow

The tendons of the tibialis anterior create one of the flows most visible on the ankle.

Knee Joint Movement

If the knee is bent just by the strength of the leg, as in the above posture, the heel doesn't touch the butt. One must sit by using the body weight (pictured right) in order for the heels and butt to touch. The length of the thighbone is equivalent to the distance from the tibia to the heel.

■ Various Postures from Low Angles

Low Angles & Foreshortening

Figures 1 and 2 were rendered from the same angle. Figure 1 feels like you're actually looking up at the figure, while on the other hand Figure 2 is bent forward, so there is less of a foreshortening effect. It's in this way that with a slight movement there is a major difference in the feel that an angle gives. So, when drawing a figure from various angles, if you draw a line for the angle when viewed from the side (see the boxed figures) and check where the angle of lean is for the figure, then you'll be able to draw the figure more accurately.

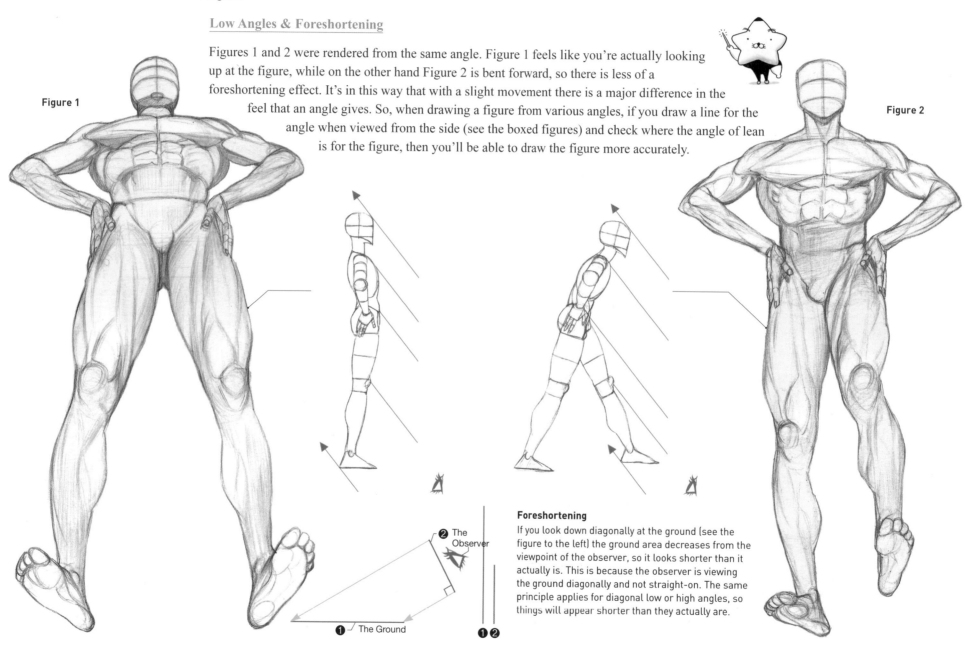

Figure 1

Figure 2

❷ The Observer

❶ The Ground

❶❷

Foreshortening

If you look down diagonally at the ground (see the figure to the left) the ground area decreases from the viewpoint of the observer, so it looks shorter than it actually is. This is because the observer is viewing the ground diagonally and not straight-on. The same principle applies for diagonal low or high angles, so things will appear shorter than they actually are.

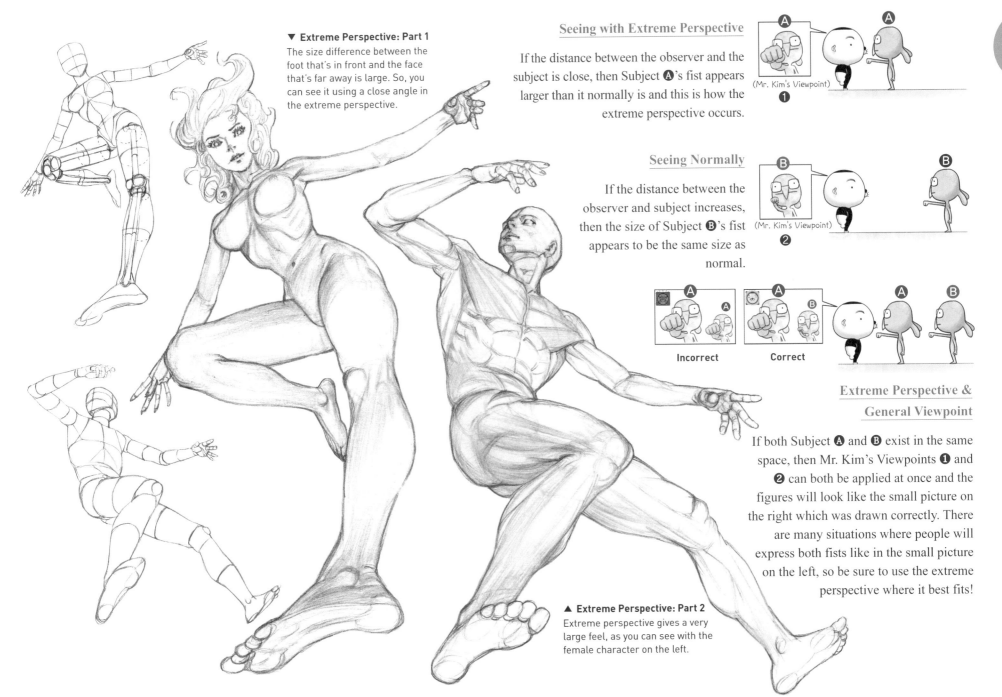

▼ **Extreme Perspective: Part 1**
The size difference between the foot that's in front and the face that's far away is large. So, you can see it using a close angle in the extreme perspective.

Seeing with Extreme Perspective

If the distance between the observer and the subject is close, then Subject Ⓐ's fist appears larger than it normally is and this is how the extreme perspective occurs.

(Mr. Kim's Viewpoint)
❶

Seeing Normally

If the distance between the observer and subject increases, then the size of Subject Ⓑ's fist appears to be the same size as normal.

(Mr. Kim's Viewpoint)
❷

Incorrect Correct

Extreme Perspective & General Viewpoint

If both Subject Ⓐ and Ⓑ exist in the same space, then Mr. Kim's Viewpoints ❶ and ❷ can both be applied at once and the figures will look like the small picture on the right which was drawn correctly. There are many situations where people will express both fists like in the small picture on the left, so be sure to use the extreme perspective where it best fits!

▲ **Extreme Perspective: Part 2**
Extreme perspective gives a very large feel, as you can see with the female character on the left.

■ Curling Up Midair

Shoulder Joints

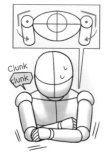

If you think of the shoulder joints to be fixed like a wooden doll, then when you try to fold your arms they don't angle inward towards the inside of the body.

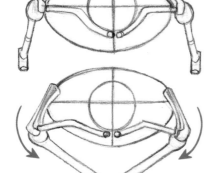

Standing at Attention

This is the location of the clavicle and shoulder blades when standing at attention.

Bringing the Arms Forward

In order to bring the arms forward as much as possible your shoulder blades must also come forward as far as they can.

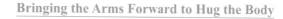

Bringing the Arms Forward to Hug the Body

When you pull the arms forward as much as possible and then intersect them, the body takes a posture where you're able to think about where the limit of angles are and to what degree fat is being pushed.

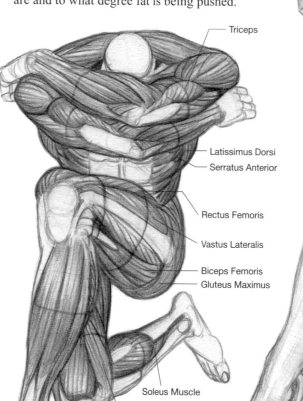

- Triceps
- Latissimus Dorsi
- Serratus Anterior
- Rectus Femoris
- Vastus Lateralis
- Biceps Femoris
- Gluteus Maximus
- Soleus Muscle
- Sartorius Muscle

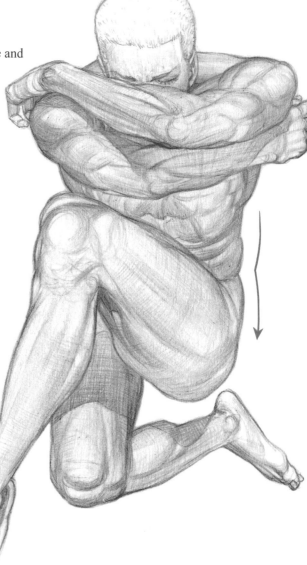

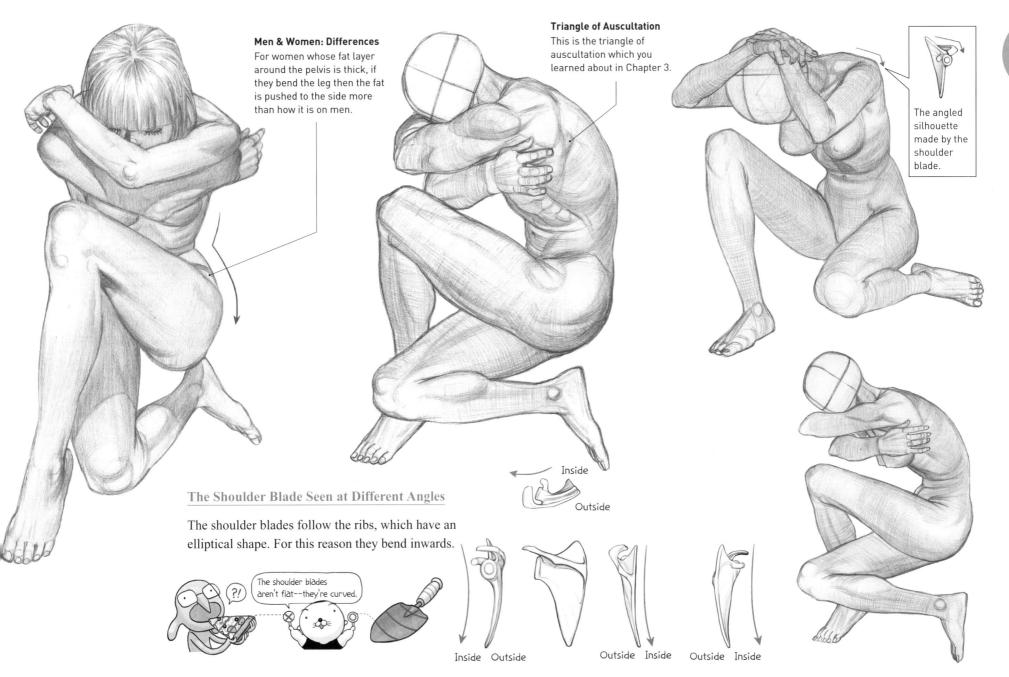

Men & Women: Differences
For women whose fat layer around the pelvis is thick, if they bend the leg then the fat is pushed to the side more than how it is on men.

Triangle of Auscultation
This is the triangle of auscultation which you learned about in Chapter 3.

The angled silhouette made by the shoulder blade.

Inside

Outside

The Shoulder Blade Seen at Different Angles

The shoulder blades follow the ribs, which have an elliptical shape. For this reason they bend inwards.

?!

The shoulder blades aren't flat--they're curved.

Inside Outside

Outside Inside

Outside Inside

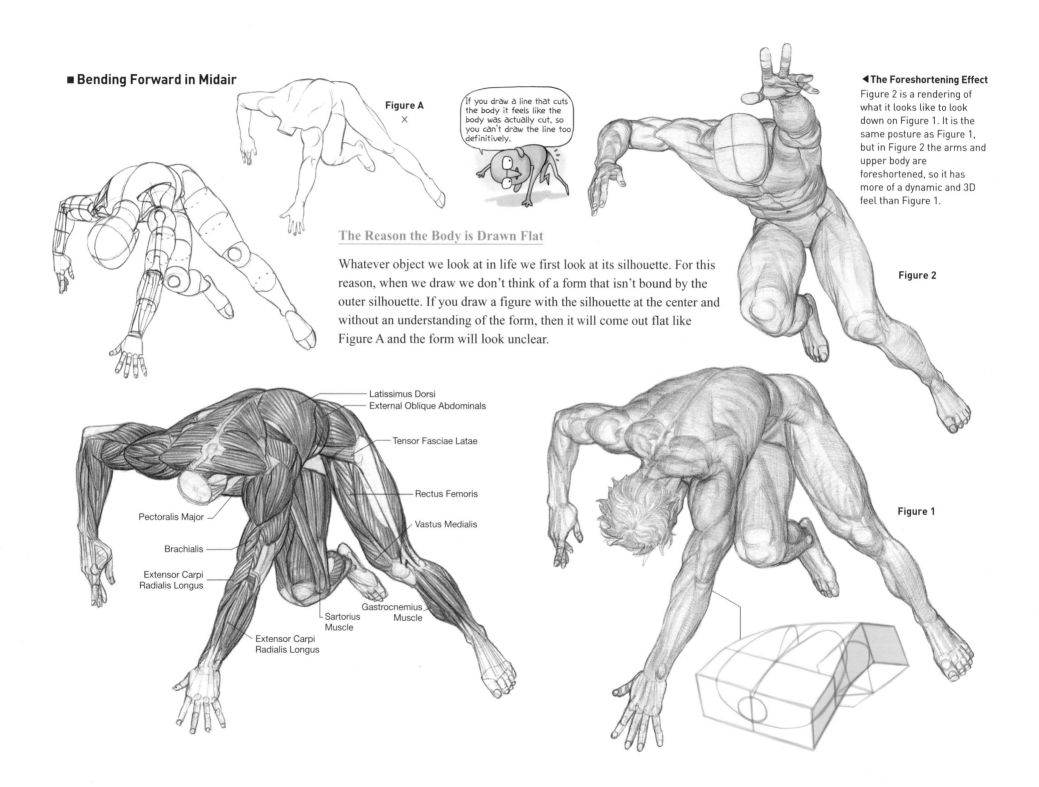

■ Bending Forward in Midair

Figure A

X

If you draw a line that cuts the body it feels like the body was actually cut, so you can't draw the line too definitively.

The Reason the Body is Drawn Flat

Whatever object we look at in life we first look at its silhouette. For this reason, when we draw we don't think of a form that isn't bound by the outer silhouette. If you draw a figure with the silhouette at the center and without an understanding of the form, then it will come out flat like Figure A and the form will look unclear.

◀ The Foreshortening Effect
Figure 2 is a rendering of what it looks like to look down on Figure 1. It is the same posture as Figure 1, but in Figure 2 the arms and upper body are foreshortened, so it has more of a dynamic and 3D feel than Figure 1.

Figure 2

Latissimus Dorsi
External Oblique Abdominals
Tensor Fasciae Latae
Pectoralis Major
Rectus Femoris
Vastus Medialis
Brachialis
Extensor Carpi Radialis Longus
Sartorius Muscle
Gastrocnemius Muscle
Extensor Carpi Radialis Longus

Figure 1

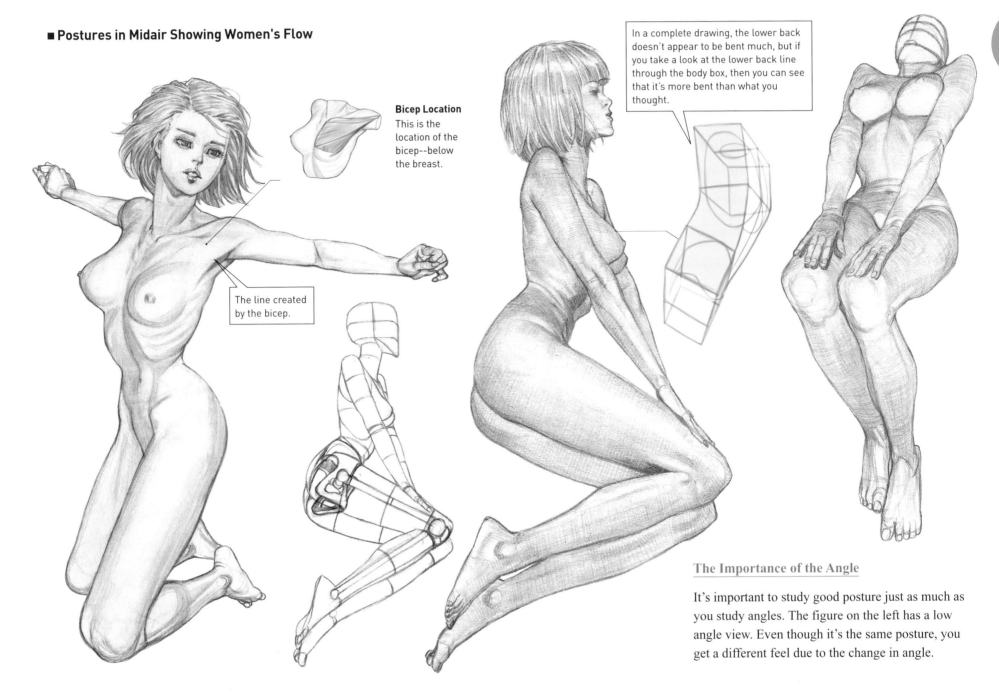

■ Postures in Midair Showing Women's Flow

Bicep Location
This is the location of the bicep--below the breast.

The line created by the bicep.

In a complete drawing, the lower back doesn't appear to be bent much, but if you take a look at the lower back line through the body box, then you can see that it's more bent than what you thought.

The Importance of the Angle

It's important to study good posture just as much as you study angles. The figure on the left has a low angle view. Even though it's the same posture, you get a different feel due to the change in angle.

■ Flying Kick

Characteristics

After you run forward and crouch in order to jump, then the strength you gather to run after releasing the body and the strength to spread the body is gathered at the feet. Then, you strike your opponent. That's what this posture is.
What's characteristic about this motion is that the flow of the bent lower back connects to the leg which is straightened, as the arrow shows.

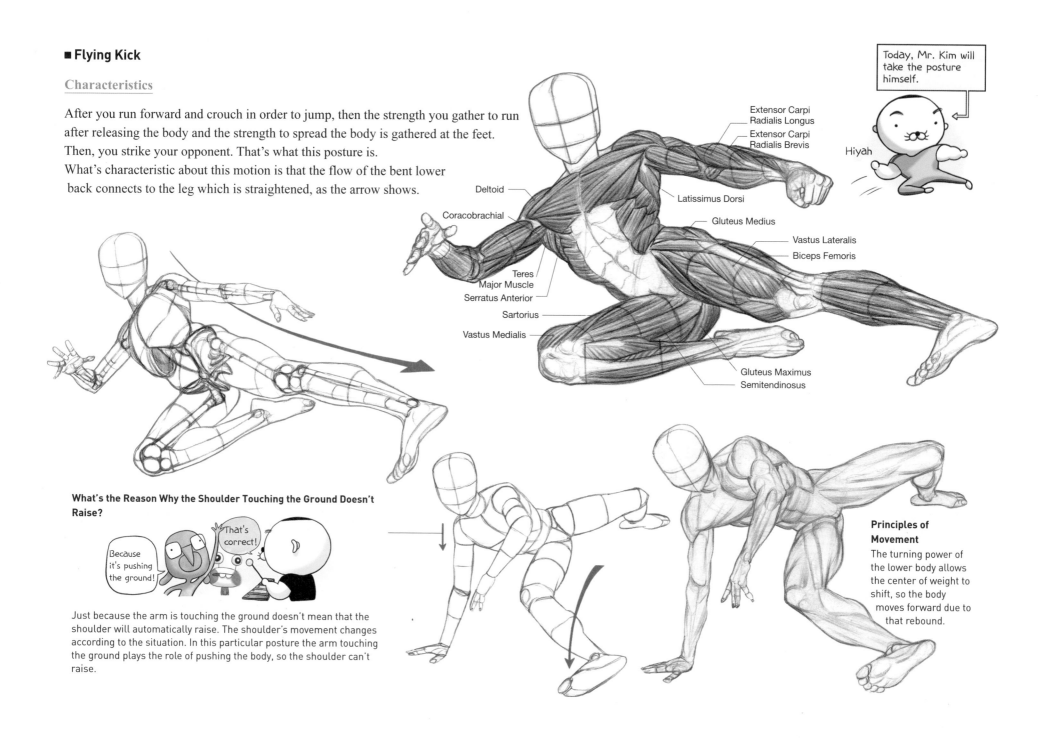

Today, Mr. Kim will take the posture himself.

Hiyah

Extensor Carpi Radialis Longus
Extensor Carpi Radialis Brevis
Deltoid
Coracobrachial
Latissimus Dorsi
Gluteus Medius
Vastus Lateralis
Biceps Femoris
Teres Major Muscle
Serratus Anterior
Sartorius
Vastus Medialis
Gluteus Maximus
Semitendinosus

What's the Reason Why the Shoulder Touching the Ground Doesn't Raise?

Because it's pushing the ground!

That's correct!

Just because the arm is touching the ground doesn't mean that the shoulder will automatically raise. The shoulder's movement changes according to the situation. In this particular posture the arm touching the ground plays the role of pushing the body, so the shoulder can't raise.

Principles of Movement
The turning power of the lower body allows the center of weight to shift, so the body moves forward due to that rebound.

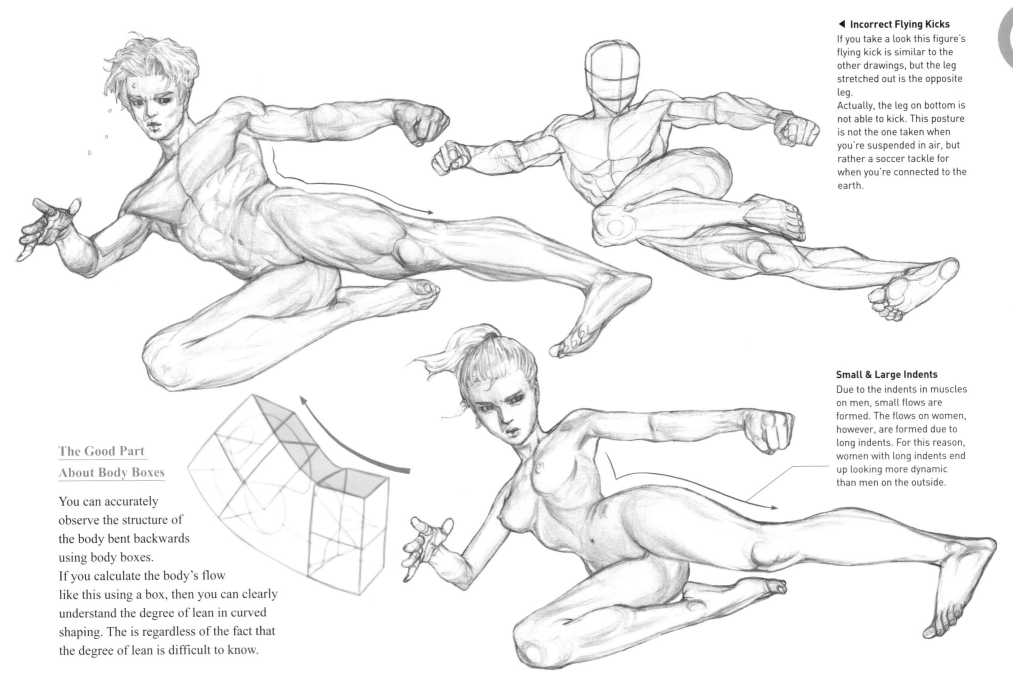

◀ **Incorrect Flying Kicks**
If you take a look this figure's flying kick is similar to the other drawings, but the leg stretched out is the opposite leg.
Actually, the leg on bottom is not able to kick. This posture is not the one taken when you're suspended in air, but rather a soccer tackle for when you're connected to the earth.

Small & Large Indents
Due to the indents in muscles on men, small flows are formed. The flows on women, however, are formed due to long indents. For this reason, women with long indents end up looking more dynamic than men on the outside.

The Good Part
About Body Boxes

You can accurately observe the structure of the body bent backwards using body boxes.
If you calculate the body's flow like this using a box, then you can clearly understand the degree of lean in curved shaping. The is regardless of the fact that the degree of lean is difficult to know.

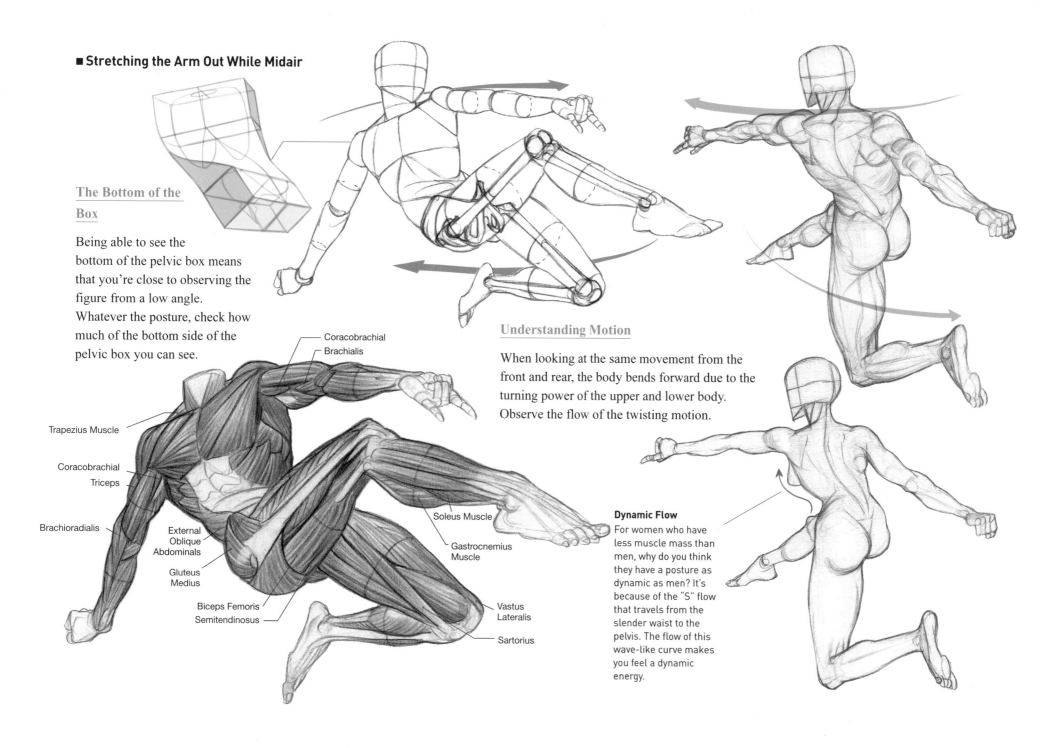

■ Stretching the Arm Out While Midair

The Bottom of the Box

Being able to see the bottom of the pelvic box means that you're close to observing the figure from a low angle. Whatever the posture, check how much of the bottom side of the pelvic box you can see.

Understanding Motion

When looking at the same movement from the front and rear, the body bends forward due to the turning power of the upper and lower body. Observe the flow of the twisting motion.

Coracobrachial
Brachialis

Trapezius Muscle

Coracobrachial

Triceps

Brachioradialis

External Oblique Abdominals

Gluteus Medius

Biceps Femoris
Semitendinosus

Soleus Muscle

Gastrocnemius Muscle

Vastus Lateralis

Sartorius

Dynamic Flow

For women who have less muscle mass than men, why do you think they have a posture as dynamic as men? It's because of the "S" flow that travels from the slender waist to the pelvis. The flow of this wave-like curve makes you feel a dynamic energy.

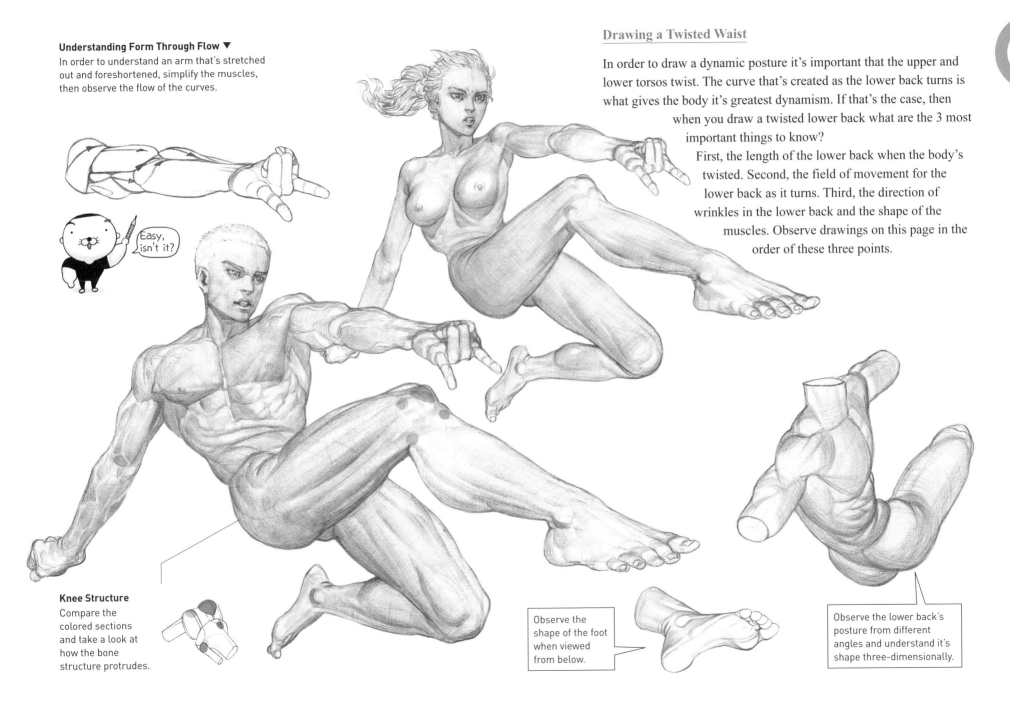

Understanding Form Through Flow ▼

In order to understand an arm that's stretched out and foreshortened, simplify the muscles, then observe the flow of the curves.

Easy, isn't it?

Knee Structure

Compare the colored sections and take a look at how the bone structure protrudes.

Drawing a Twisted Waist

In order to draw a dynamic posture it's important that the upper and lower torsos twist. The curve that's created as the lower back turns is what gives the body it's greatest dynamism. If that's the case, then when you draw a twisted lower back what are the 3 most important things to know?

First, the length of the lower back when the body's twisted. Second, the field of movement for the lower back as it turns. Third, the direction of wrinkles in the lower back and the shape of the muscles. Observe drawings on this page in the order of these three points.

Observe the shape of the foot when viewed from below.

Observe the lower back's posture from different angles and understand it's shape three-dimensionally.

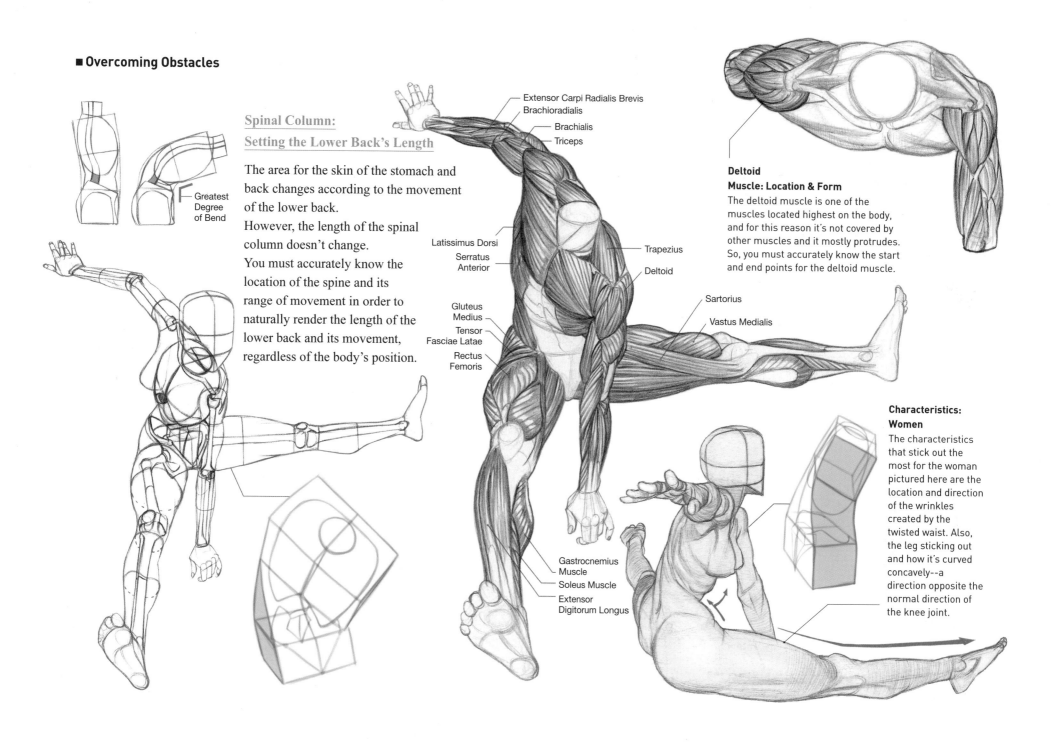

■ Overcoming Obstacles

Greatest Degree of Bend

Spinal Column:
Setting the Lower Back's Length

The area for the skin of the stomach and back changes according to the movement of the lower back.
However, the length of the spinal column doesn't change.
You must accurately know the location of the spine and its range of movement in order to naturally render the length of the lower back and its movement, regardless of the body's position.

Extensor Carpi Radialis Brevis
Brachioradialis
Brachialis
Triceps

Latissimus Dorsi
Serratus Anterior

Trapezius
Deltoid

Gluteus Medius
Tensor Fasciae Latae
Rectus Femoris

Sartorius
Vastus Medialis

Gastrocnemius Muscle
Soleus Muscle
Extensor Digitorum Longus

Deltoid
Muscle: Location & Form
The deltoid muscle is one of the muscles located highest on the body, and for this reason it's not covered by other muscles and it mostly protrudes. So, you must accurately know the start and end points for the deltoid muscle.

Characteristics:
Women
The characteristics that stick out the most for the woman pictured here are the location and direction of the wrinkles created by the twisted waist. Also, the leg sticking out and how it's curved concavely--a direction opposite the normal direction of the knee joint.

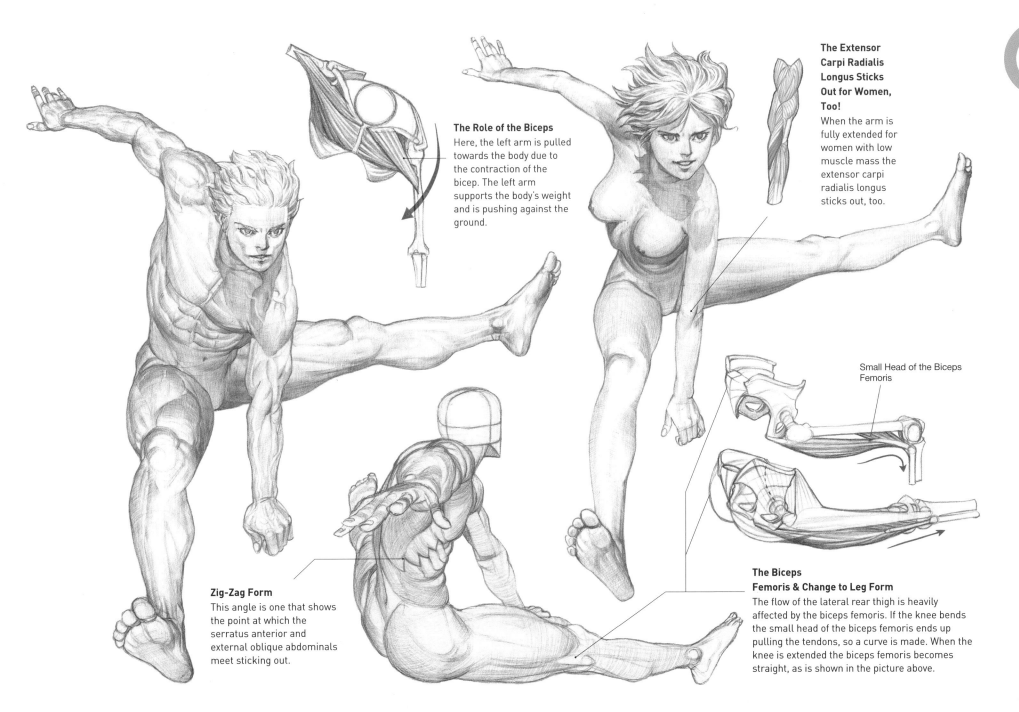

The Role of the Biceps
Here, the left arm is pulled towards the body due to the contraction of the bicep. The left arm supports the body's weight and is pushing against the ground.

The Extensor Carpi Radialis Longus Sticks Out for Women, Too!
When the arm is fully extended for women with low muscle mass the extensor carpi radialis longus sticks out, too.

Small Head of the Biceps Femoris

Zig-Zag Form
This angle is one that shows the point at which the serratus anterior and external oblique abdominals meet sticking out.

The Biceps Femoris & Change to Leg Form
The flow of the lateral rear thigh is heavily affected by the biceps femoris. If the knee bends the small head of the biceps femoris ends up pulling the tendons, so a curve is made. When the knee is extended the biceps femoris becomes straight, as is shown in the picture above.

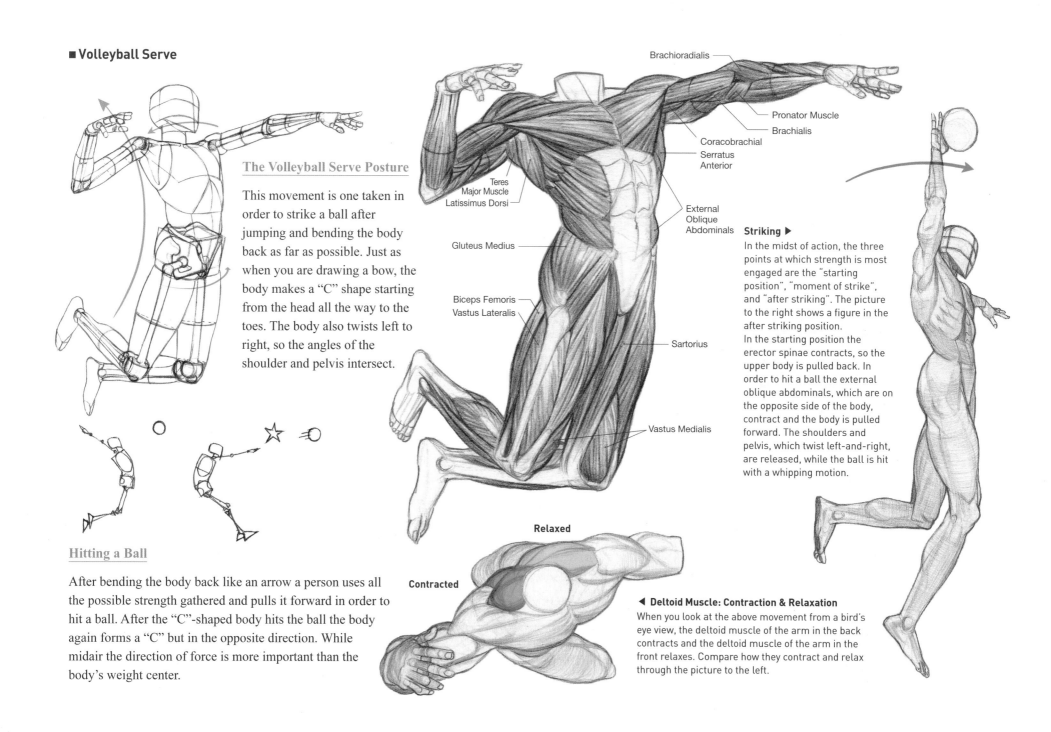

■ Volleyball Serve

Brachioradialis

Pronator Muscle

Brachialis

Coracobrachial

Serratus Anterior

Teres Major Muscle

Latissimus Dorsi

External Oblique Abdominals

Gluteus Medius

Biceps Femoris

Vastus Lateralis

Sartorius

Vastus Medialis

The Volleyball Serve Posture

This movement is one taken in order to strike a ball after jumping and bending the body back as far as possible. Just as when you are drawing a bow, the body makes a "C" shape starting from the head all the way to the toes. The body also twists left to right, so the angles of the shoulder and pelvis intersect.

Striking ▶

In the midst of action, the three points at which strength is most engaged are the "starting position", "moment of strike", and "after striking". The picture to the right shows a figure in the after striking position.

In the starting position the erector spinae contracts, so the upper body is pulled back. In order to hit a ball the external oblique abdominals, which are on the opposite side of the body, contract and the body is pulled forward. The shoulders and pelvis, which twist left-and-right, are released, while the ball is hit with a whipping motion.

Hitting a Ball

After bending the body back like an arrow a person uses all the possible strength gathered and pulls it forward in order to hit a ball. After the "C"-shaped body hits the ball the body again forms a "C" but in the opposite direction. While midair the direction of force is more important than the body's weight center.

Relaxed

Contracted

◀ Deltoid Muscle: Contraction & Relaxation

When you look at the above movement from a bird's eye view, the deltoid muscle of the arm in the back contracts and the deltoid muscle of the arm in the front relaxes. Compare how they contract and relax through the picture to the left.

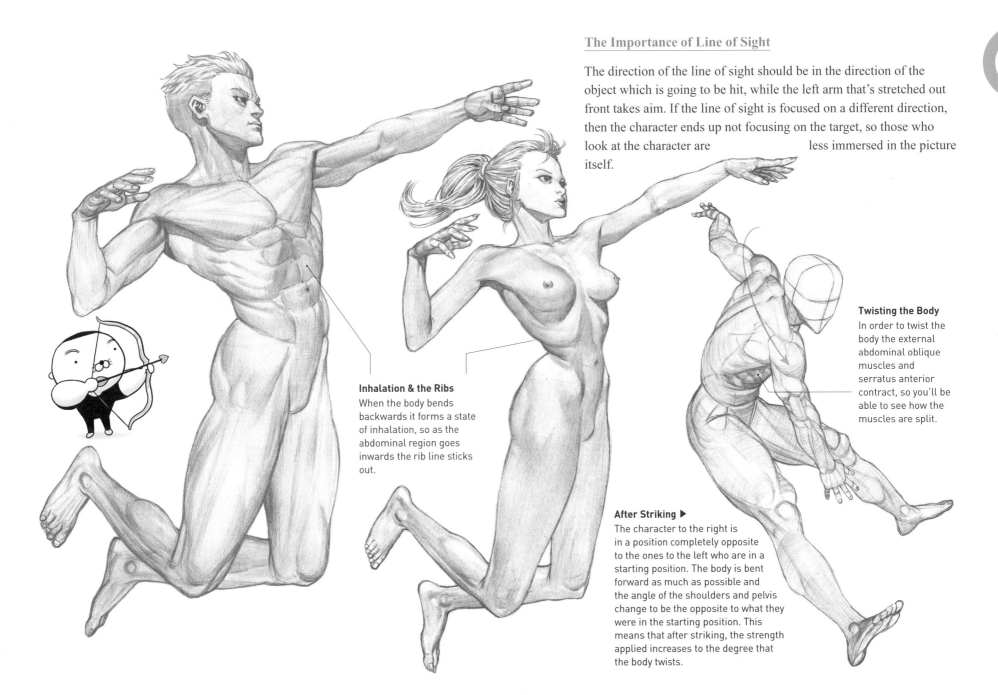

The Importance of Line of Sight

The direction of the line of sight should be in the direction of the object which is going to be hit, while the left arm that's stretched out front takes aim. If the line of sight is focused on a different direction, then the character ends up not focusing on the target, so those who look at the character are less immersed in the picture itself.

Twisting the Body
In order to twist the body the external abdominal oblique muscles and serratus anterior contract, so you'll be able to see how the muscles are split.

Inhalation & the Ribs
When the body bends backwards it forms a state of inhalation, so as the abdominal region goes inwards the rib line sticks out.

After Striking ▶
The character to the right is in a position completely opposite to the ones to the left who are in a starting position. The body is bent forward as much as possible and the angle of the shoulders and pelvis change to be the opposite to what they were in the starting position. This means that after striking, the strength applied increases to the degree that the body twists.

■ Jumping

Bending Backwards

As the upper body bends backwards the arms are raised. In order to inhale the rib line protrudes. The bones don't change in length or depth according to movement, so if you use the bone frame as a standard to apply flesh to the body you'll be able to maintain body ratio, even for figures in difficult postures.

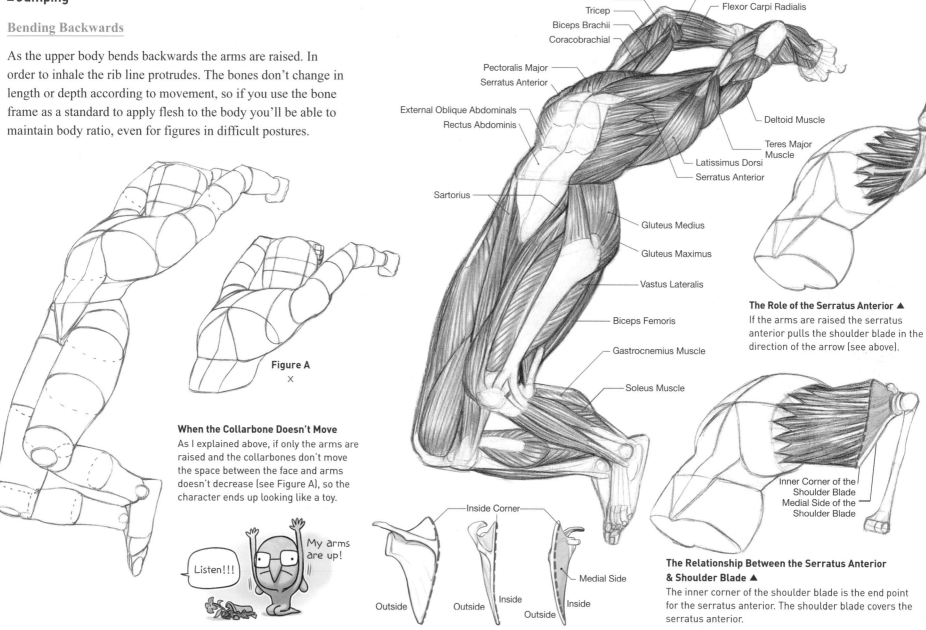

Figure A
✕

When the Collarbone Doesn't Move
As I explained above, if only the arms are raised and the collarbones don't move the space between the face and arms doesn't decrease (see Figure A), so the character ends up looking like a toy.

Listen!!!

My arms are up!

Brachialis
Tricep
Biceps Brachii
Coracobrachial
Pronator Muscle
Flexor Carpi Radialis

Pectoralis Major
Serratus Anterior

External Oblique Abdominals
Rectus Abdominis

Deltoid Muscle

Teres Major Muscle

Latissimus Dorsi
Serratus Anterior

Sartorius

Gluteus Medius

Gluteus Maximus

Vastus Lateralis

Biceps Femoris

Gastrocnemius Muscle

Soleus Muscle

The Role of the Serratus Anterior ▲
If the arms are raised the serratus anterior pulls the shoulder blade in the direction of the arrow (see above).

Inner Corner of the Shoulder Blade
Medial Side of the Shoulder Blade

Inside Corner

Medial Side

Outside

Outside
Inside

Inside
Outside

The Relationship Between the Serratus Anterior & Shoulder Blade ▲
The inner corner of the shoulder blade is the end point for the serratus anterior. The shoulder blade covers the serratus anterior.

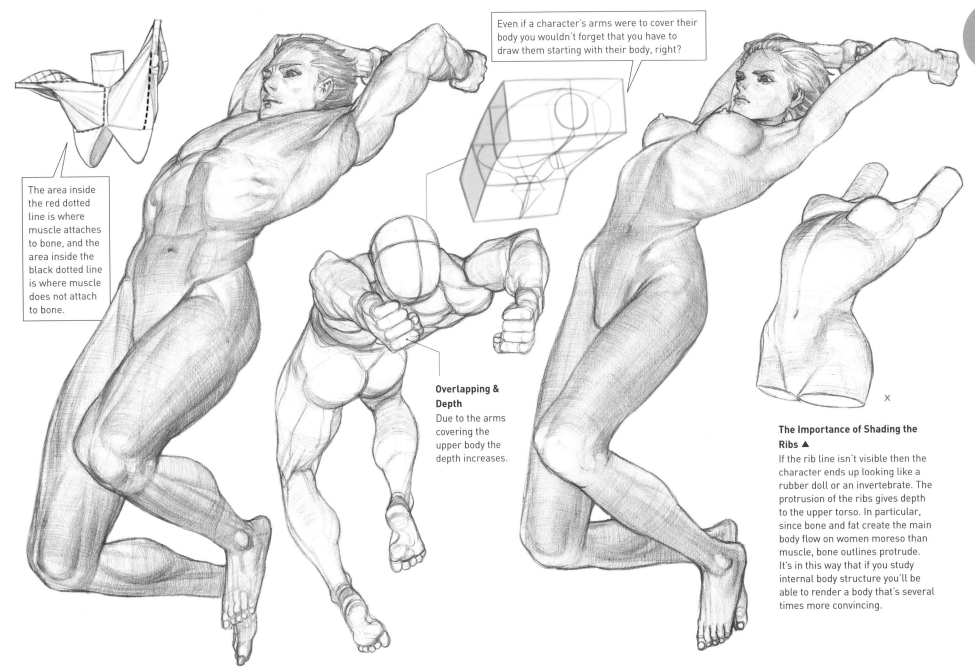

Even if a character's arms were to cover their body you wouldn't forget that you have to draw them starting with their body, right?

The area inside the red dotted line is where muscle attaches to bone, and the area inside the black dotted line is where muscle does not attach to bone.

Overlapping & Depth
Due to the arms covering the upper body the depth increases.

The Importance of Shading the Ribs ▲
If the rib line isn't visible then the character ends up looking like a rubber doll or an invertebrate. The protrusion of the ribs gives depth to the upper torso. In particular, since bone and fat create the main body flow on women moreso than muscle, bone outlines protrude. It's in this way that if you study internal body structure you'll be able to render a body that's several times more convincing.

5 Attack & Defense Postures

■ Basic Hand-to-Hand Combat Stance

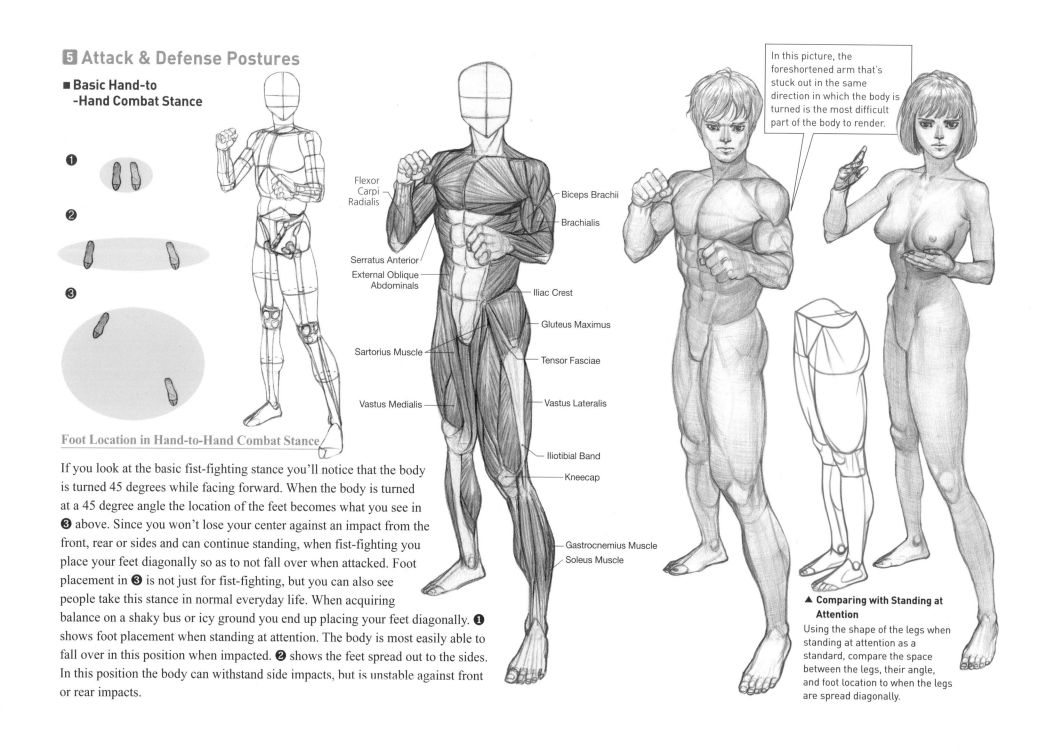

❶

❷

❸

Foot Location in Hand-to-Hand Combat Stance

If you look at the basic fist-fighting stance you'll notice that the body is turned 45 degrees while facing forward. When the body is turned at a 45 degree angle the location of the feet becomes what you see in ❸ above. Since you won't lose your center against an impact from the front, rear or sides and can continue standing, when fist-fighting you place your feet diagonally so as to not fall over when attacked. Foot placement in ❸ is not just for fist-fighting, but you can also see people take this stance in normal everyday life. When acquiring balance on a shaky bus or icy ground you end up placing your feet diagonally. ❶ shows foot placement when standing at attention. The body is most easily able to fall over in this position when impacted. ❷ shows the feet spread out to the sides. In this position the body can withstand side impacts, but is unstable against front or rear impacts.

Flexor Carpi Radialis

Biceps Brachii

Brachialis

Serratus Anterior

External Oblique Abdominals

Iliac Crest

Gluteus Maximus

Sartorius Muscle

Tensor Fasciae

Vastus Medialis

Vastus Lateralis

Iliotibial Band

Kneecap

Gastrocnemius Muscle

Soleus Muscle

In this picture, the foreshortened arm that's stuck out in the same direction in which the body is turned is the most difficult part of the body to render.

▲ Comparing with Standing at Attention

Using the shape of the legs when standing at attention as a standard, compare the space between the legs, their angle, and foot location to when the legs are spread diagonally.

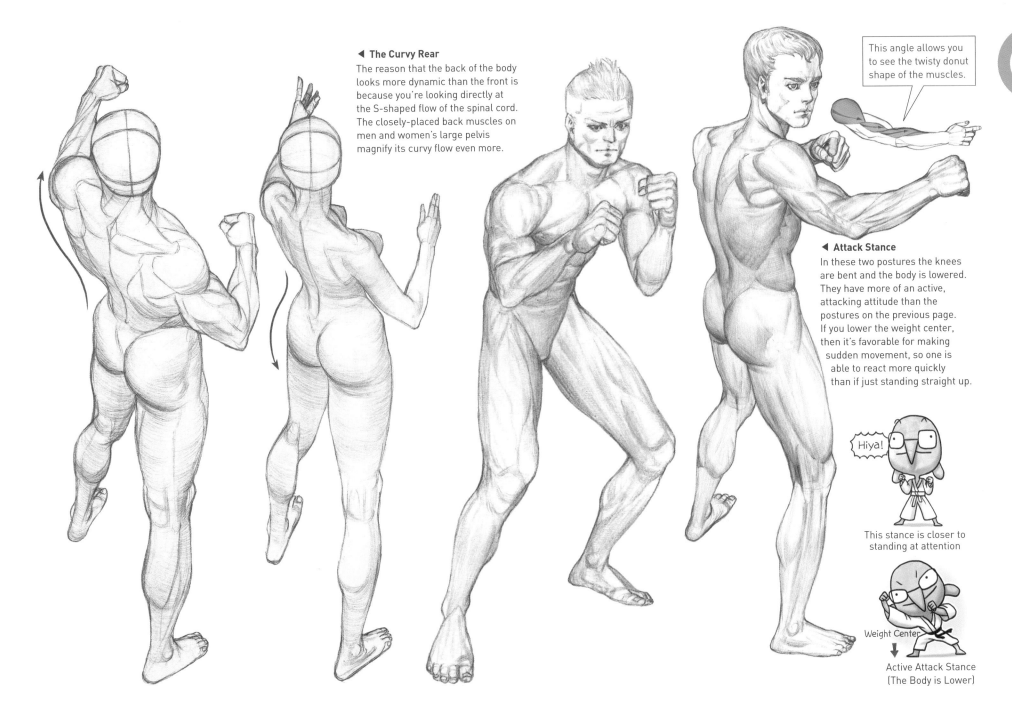

◀ The Curvy Rear
The reason that the back of the body looks more dynamic than the front is because you're looking directly at the S-shaped flow of the spinal cord. The closely-placed back muscles on men and women's large pelvis magnify its curvy flow even more.

This angle allows you to see the twisty donut shape of the muscles.

◀ Attack Stance
In these two postures the knees are bent and the body is lowered. They have more of an active, attacking attitude than the postures on the previous page. If you lower the weight center, then it's favorable for making sudden movement, so one is able to react more quickly than if just standing straight up.

Hiya!

This stance is closer to standing at attention

Weight Center

Active Attack Stance
(The Body is Lower)

■ Attack Posture: One Hand Out

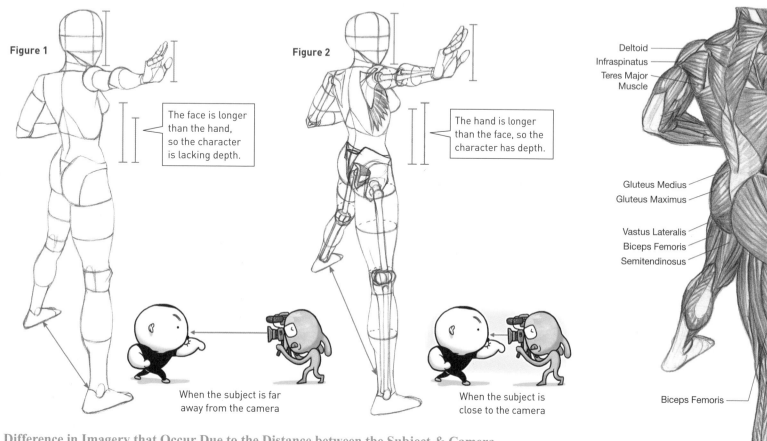

Figure 1

The face is longer than the hand, so the character is lacking depth.

Figure 2

The hand is longer than the face, so the character has depth.

When the subject is far away from the camera

When the subject is close to the camera

Sternocleidomastoid (SCM) Muscle

Brachioradialis

Extensor Carpi Radialis Longus Muscle

Deltoid
Infraspinatus
Teres Major Muscle

Pectoralis Major
Serratus Anterior
External Oblique Abdominal Muscle

Gluteus Medius
Gluteus Maximus

Gluteus Medius
Tensor Fasciae Latae

Vastus Lateralis
Biceps Femoris
Semitendinosus

Rectus Femoris

Vastus Lateralis
Iliotibial Band

Kneecap
Fibular Head

Biceps Femoris

Extensor Digitorum Longus

Difference in Imagery that Occur Due to the Distance between the Subject & Camera

There are two methods one can use when it comes to foreshortening: 1) Using the zoom function to shoot a subject, or 2) Going towards the subject to shoot it. Figure 1 shows a character when the zoom function is utilized. You use this method when you try to render a basic image rather than one with depth. Figure 2 shows a character when the photographer gets close to the subject and shoots. The 3D feel of the subject really comes out, so you use this method when you want to maximize the sense of reality and presence. In American superhero comics, in order to create more of a sense of urgency and dynamism the camera moves closer and the character is depicted from a fixated point of view. This is the method that's used to give the difference in size for an object close up and an object that's behind. Draw the hand stretched out forward larger than the face behind it. This way you give a feel that the situation going on in the drawing is occurring more closely to the reader.

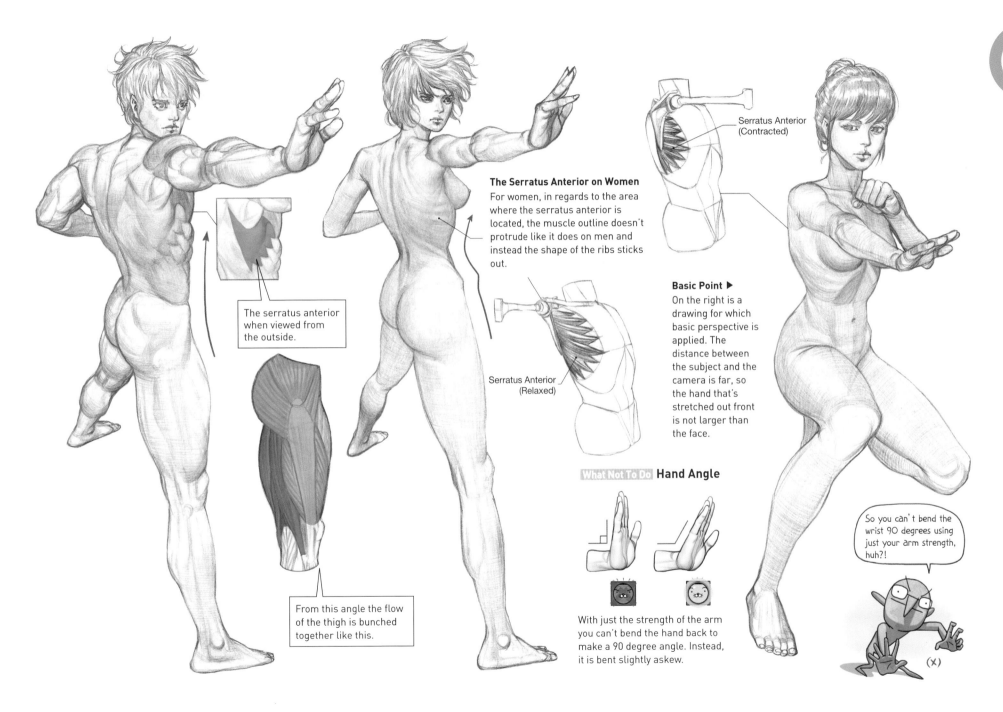

The serratus anterior when viewed from the outside.

The Serratus Anterior on Women
For women, in regards to the area where the serratus anterior is located, the muscle outline doesn't protrude like it does on men and instead the shape of the ribs sticks out.

Serratus Anterior (Relaxed)

Serratus Anterior (Contracted)

Basic Point ▶
On the right is a drawing for which basic perspective is applied. The distance between the subject and the camera is far, so the hand that's stretched out front is not larger than the face.

From this angle the flow of the thigh is bunched together like this.

What Not To Do **Hand Angle**

With just the strength of the arm you can't bend the hand back to make a 90 degree angle. Instead, it is bent slightly askew.

So you can't bend the wrist 90 degrees using just your arm strength, huh?!

(X)

■ Fighting Stance: High Angle

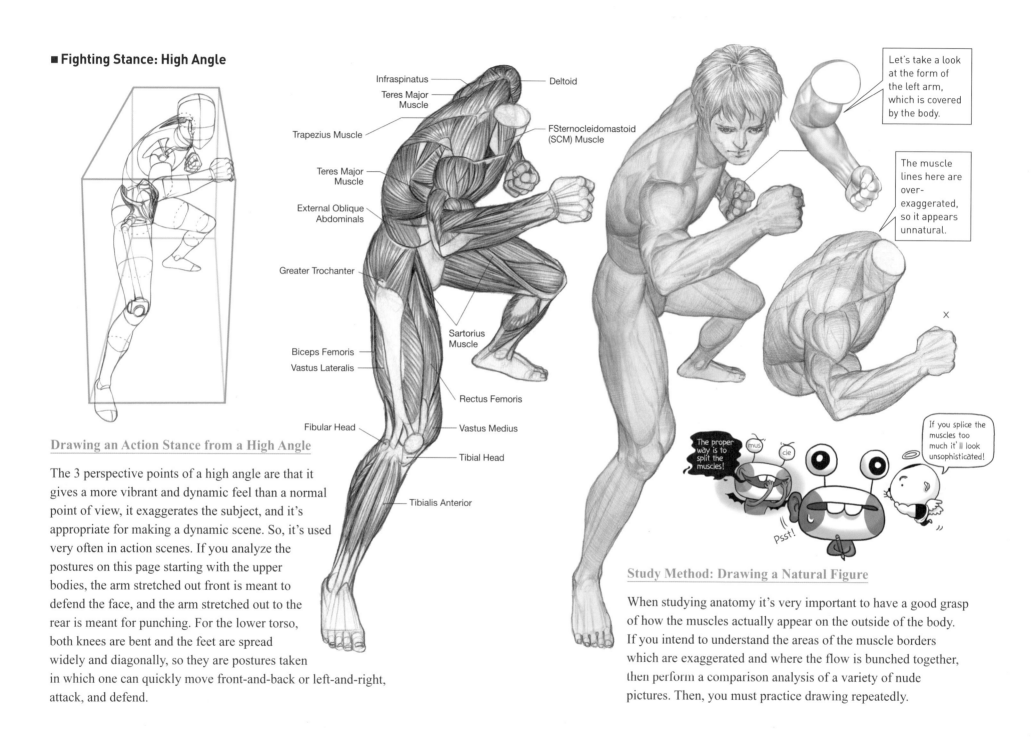

Infraspinatus

Teres Major Muscle

Trapezius Muscle

Deltoid

FSternocleidomastoid (SCM) Muscle

Teres Major Muscle

External Oblique Abdominals

Greater Trochanter

Sartorius Muscle

Biceps Femoris

Vastus Lateralis

Rectus Femoris

Vastus Medius

Fibular Head

Tibial Head

Tibialis Anterior

Let's take a look at the form of the left arm, which is covered by the body.

The muscle lines here are over-exaggerated, so it appears unnatural.

X

The proper way is to split the muscles!

mus cle

If you splice the muscles too much it'll look unsophisticated!

Psst!

Drawing an Action Stance from a High Angle

The 3 perspective points of a high angle are that it gives a more vibrant and dynamic feel than a normal point of view, it exaggerates the subject, and it's appropriate for making a dynamic scene. So, it's used very often in action scenes. If you analyze the postures on this page starting with the upper bodies, the arm stretched out front is meant to defend the face, and the arm stretched out to the rear is meant for punching. For the lower torso, both knees are bent and the feet are spread widely and diagonally, so they are postures taken in which one can quickly move front-and-back or left-and-right, attack, and defend.

Study Method: Drawing a Natural Figure

When studying anatomy it's very important to have a good grasp of how the muscles actually appear on the outside of the body. If you intend to understand the areas of the muscle borders which are exaggerated and where the flow is bunched together, then perform a comparison analysis of a variety of nude pictures. Then, you must practice drawing repeatedly.

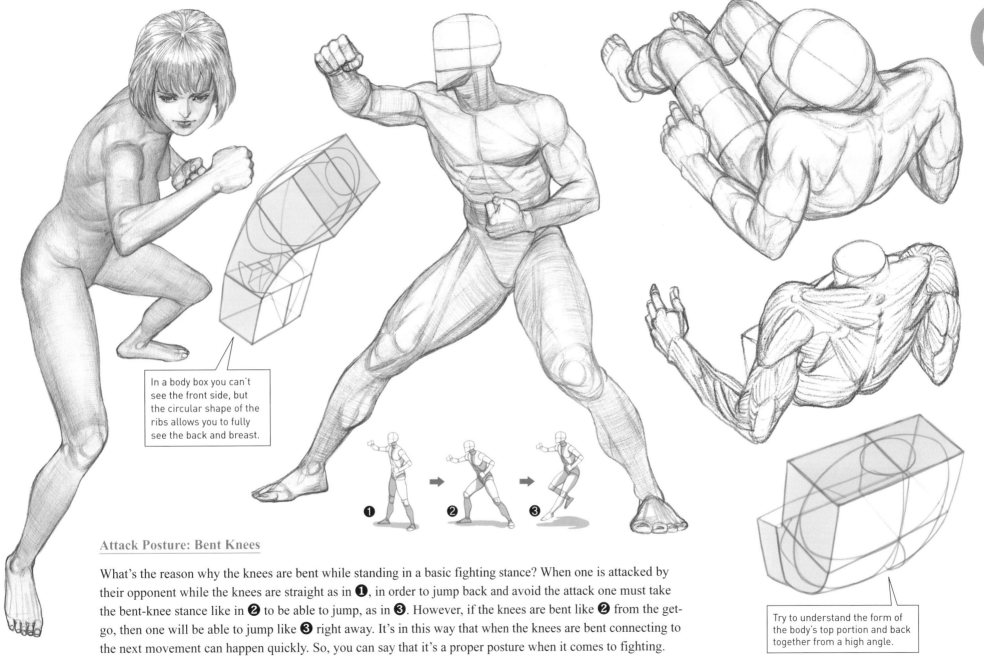

In a body box you can't see the front side, but the circular shape of the ribs allows you to fully see the back and breast.

Try to understand the form of the body's top portion and back together from a high angle.

Attack Posture: Bent Knees

What's the reason why the knees are bent while standing in a basic fighting stance? When one is attacked by their opponent while the knees are straight as in ❶, in order to jump back and avoid the attack one must take the bent-knee stance like in ❷ to be able to jump, as in ❸. However, if the knees are bent like ❷ from the get-go, then one will be able to jump like ❸ right away. It's in this way that when the knees are bent connecting to the next movement can happen quickly. So, you can say that it's a proper posture when it comes to fighting.

❶ ❷ ❸

■ Threatening the Opponent

The Arms: Wrinkle Direction

When you fold the arms, the direction of the wrinkles change according to three different circumstances.
1) Hand direction 2) Whether or not the arms are flexed
3) Muscle mass in the arms
This time we're going to look into wrinkle direction according to hand direction when the arms are flexed.

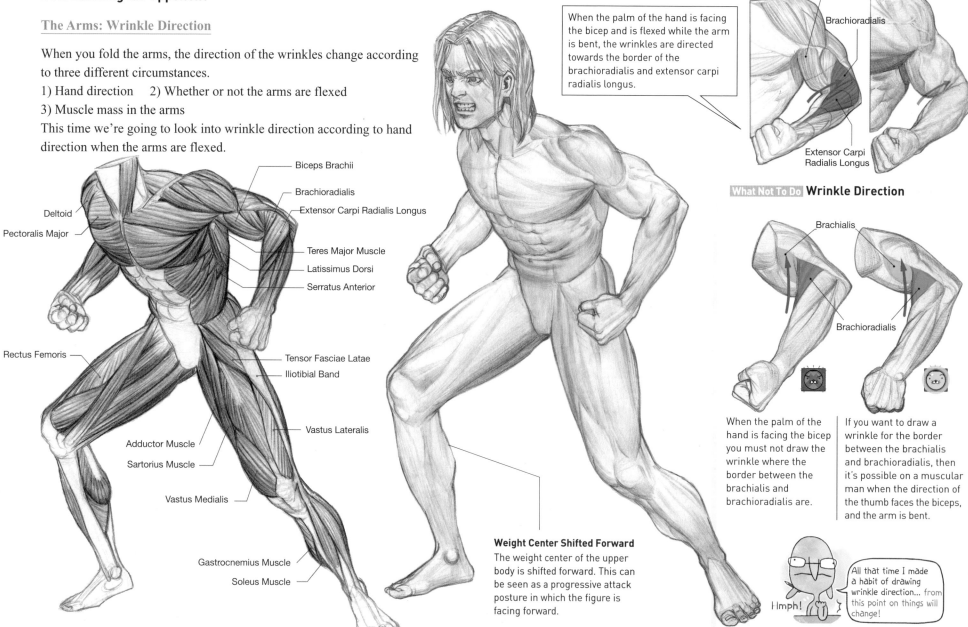

Deltoid

Pectoralis Major

Biceps Brachii

Brachioradialis

Extensor Carpi Radialis Longus

Teres Major Muscle

Latissimus Dorsi

Serratus Anterior

Rectus Femoris

Tensor Fasciae Latae

Iliotibial Band

Vastus Lateralis

Adductor Muscle

Sartorius Muscle

Vastus Medialis

Gastrocnemius Muscle

Soleus Muscle

Biceps Brachii

Brachioradialis

When the palm of the hand is facing the bicep and is flexed while the arm is bent, the wrinkles are directed towards the border of the brachioradialis and extensor carpi radialis longus.

Extensor Carpi Radialis Longus

What Not To Do Wrinkle Direction

Brachialis

Brachioradialis

When the palm of the hand is facing the bicep you must not draw the wrinkle where the border between the brachialis and brachioradialis are.

If you want to draw a wrinkle for the border between the brachialis and brachioradialis, then it's possible on a muscular man when the direction of the thumb faces the biceps, and the arm is bent.

Weight Center Shifted Forward
The weight center of the upper body is shifted forward. This can be seen as a progressive attack posture in which the figure is facing forward.

Hmph!

All that time I made a habit of drawing wrinkle direction... from this point on things will change!

Arm Wrinkles on Women

For women with low muscle mass the wrinkles on the arm that's bent are almost unaffected by the direction of the hand, so the location of the wrinkles always stays the same.

◀ Small Changes in Motion

The knees are bent and the feet are placed diagonally, but this posture gives more of an "advance carefully" feel rather than an attack feel. The reason for this is that both hands are not in attack posture. In order for it to be a fighting stance both the lower and upper body must take an attack posture.

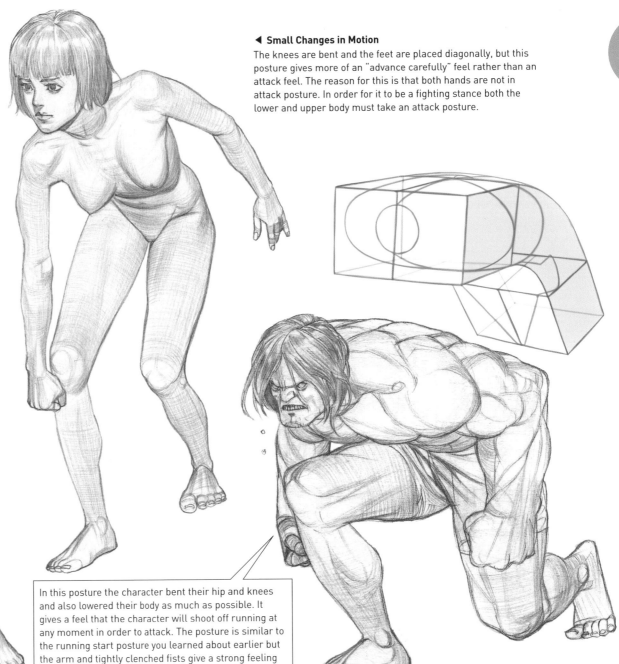

Pressure ▲

This is the same posture as the man, but women have relatively low muscle mass, so you can feel the decrease in the sense of pressure that the muscles give.

In this posture the character bent their hip and knees and also lowered their body as much as possible. It gives a feel that the character will shoot off running at any moment in order to attack. The posture is similar to the running start posture you learned about earlier but the arm and tightly clenched fists give a strong feeling of attack.

■ Threatening, Animal-Like Posture

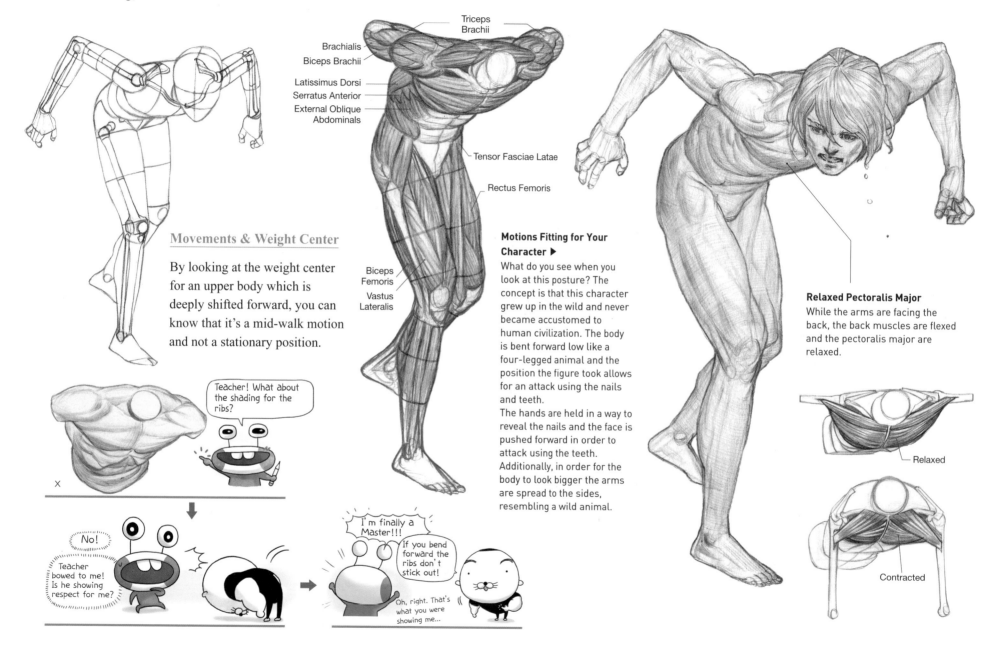

Triceps Brachii

Brachialis
Biceps Brachii

Latissimus Dorsi
Serratus Anterior
External Oblique
Abdominals

Tensor Fasciae Latae

Rectus Femoris

Biceps Femoris

Vastus Lateralis

Movements & Weight Center

By looking at the weight center for an upper body which is deeply shifted forward, you can know that it's a mid-walk motion and not a stationary position.

Teacher! What about the shading for the ribs?

X

No!

Teacher bowed to me! Is he showing respect for me?

I'm finally a Master!!!

If you bend forward the ribs don't stick out!

Oh, right. That's what you were showing me...

Motions Fitting for Your Character ▶

What do you see when you look at this posture? The concept is that this character grew up in the wild and never became accustomed to human civilization. The body is bent forward low like a four-legged animal and the position the figure took allows for an attack using the nails and teeth.

The hands are held in a way to reveal the nails and the face is pushed forward in order to attack using the teeth. Additionally, in order for the body to look bigger the arms are spread to the sides, resembling a wild animal.

Relaxed Pectoralis Major

While the arms are facing the back, the back muscles are flexed and the pectoralis major are relaxed.

Relaxed

Contracted

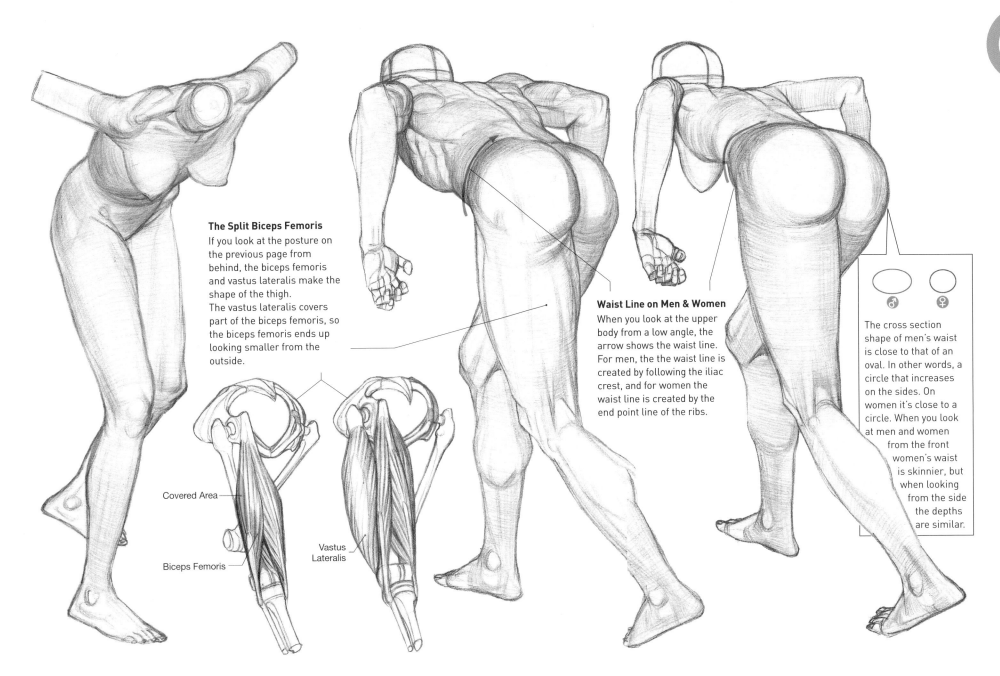

The Split Biceps Femoris
If you look at the posture on the previous page from behind, the biceps femoris and vastus lateralis make the shape of the thigh.
The vastus lateralis covers part of the biceps femoris, so the biceps femoris ends up looking smaller from the outside.

Covered Area

Biceps Femoris

Vastus Lateralis

Waist Line on Men & Women
When you look at the upper body from a low angle, the arrow shows the waist line. For men, the the waist line is created by following the iliac crest, and for women the waist line is created by the end point line of the ribs.

The cross section shape of men's waist is close to that of an oval. In other words, a circle that increases on the sides. On women it's close to a circle. When you look at men and women from the front women's waist is skinnier, but when looking from the side the depths are similar.

■ Attack Posture: Charging Forward

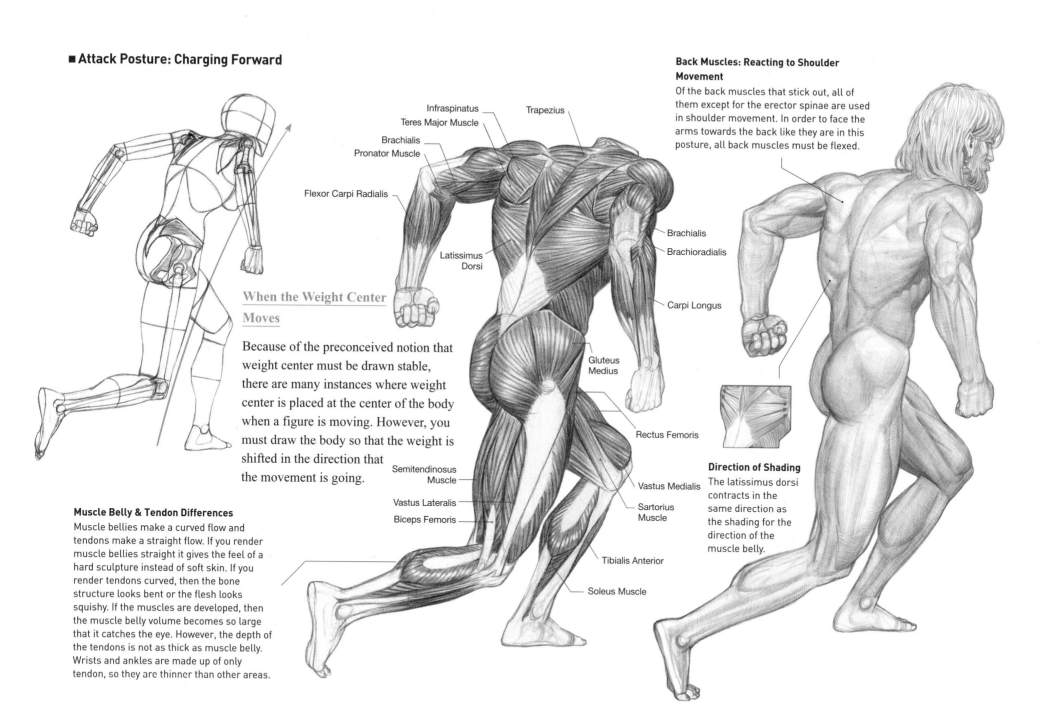

Back Muscles: Reacting to Shoulder Movement

Of the back muscles that stick out, all of them except for the erector spinae are used in shoulder movement. In order to face the arms towards the back like they are in this posture, all back muscles must be flexed.

When the Weight Center Moves

Because of the preconceived notion that weight center must be drawn stable, there are many instances where weight center is placed at the center of the body when a figure is moving. However, you must draw the body so that the weight is shifted in the direction that the movement is going.

Muscle Belly & Tendon Differences

Muscle bellies make a curved flow and tendons make a straight flow. If you render muscle bellies straight it gives the feel of a hard sculpture instead of soft skin. If you render tendons curved, then the bone structure looks bent or the flesh looks squishy. If the muscles are developed, then the muscle belly volume becomes so large that it catches the eye. However, the depth of the tendons is not as thick as muscle belly. Wrists and ankles are made up of only tendon, so they are thinner than other areas.

Direction of Shading

The latissimus dorsi contracts in the same direction as the shading for the direction of the muscle belly.

Infraspinatus
Teres Major Muscle
Brachialis
Pronator Muscle
Flexor Carpi Radialis
Trapezius
Latissimus Dorsi
Brachialis
Brachioradialis
Carpi Longus
Gluteus Medius
Rectus Femoris
Semitendinosus Muscle
Vastus Lateralis
Biceps Femoris
Vastus Medialis
Sartorius Muscle
Tibialis Anterior
Soleus Muscle

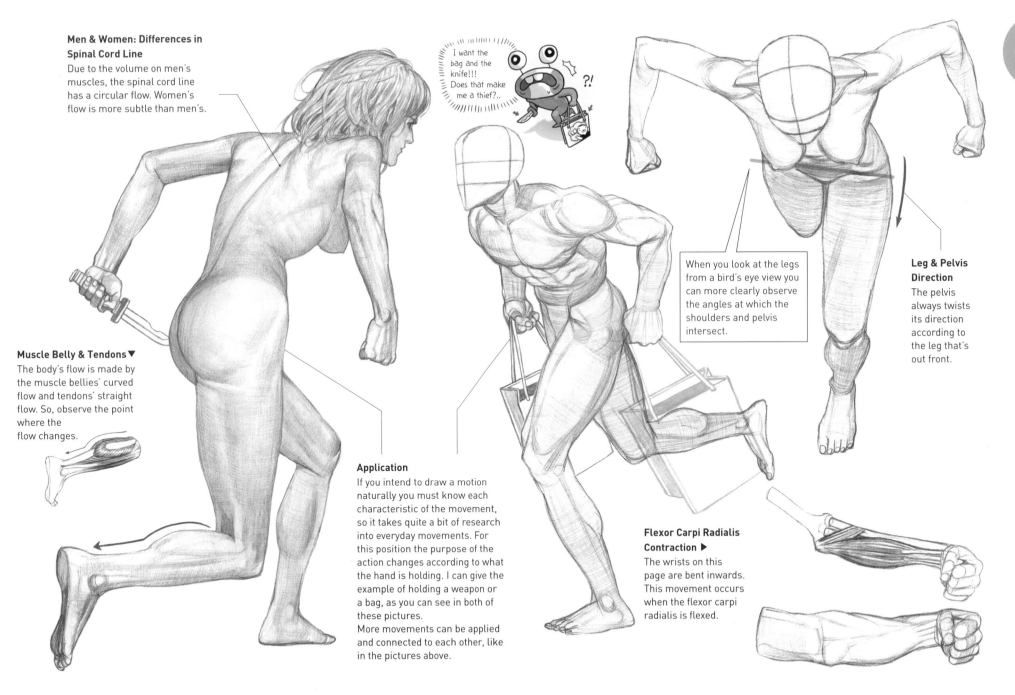

Men & Women: Differences in Spinal Cord Line
Due to the volume on men's muscles, the spinal cord line has a circular flow. Women's flow is more subtle than men's.

Muscle Belly & Tendons ▼
The body's flow is made by the muscle bellies' curved flow and tendons' straight flow. So, observe the point where the flow changes.

I want the bag and the knife!!! Does that make me a thief?..

?!

When you look at the legs from a bird's eye view you can more clearly observe the angles at which the shoulders and pelvis intersect.

Leg & Pelvis Direction
The pelvis always twists its direction according to the leg that's out front.

Application
If you intend to draw a motion naturally you must know each characteristic of the movement, so it takes quite a bit of research into everyday movements. For this position the purpose of the action changes according to what the hand is holding. I can give the example of holding a weapon or a bag, as you can see in both of these pictures.
More movements can be applied and connected to each other, like in the pictures above.

Flexor Carpi Radialis Contraction ▶
The wrists on this page are bent inwards. This movement occurs when the flexor carpi radialis is flexed.

■ Raised Fists

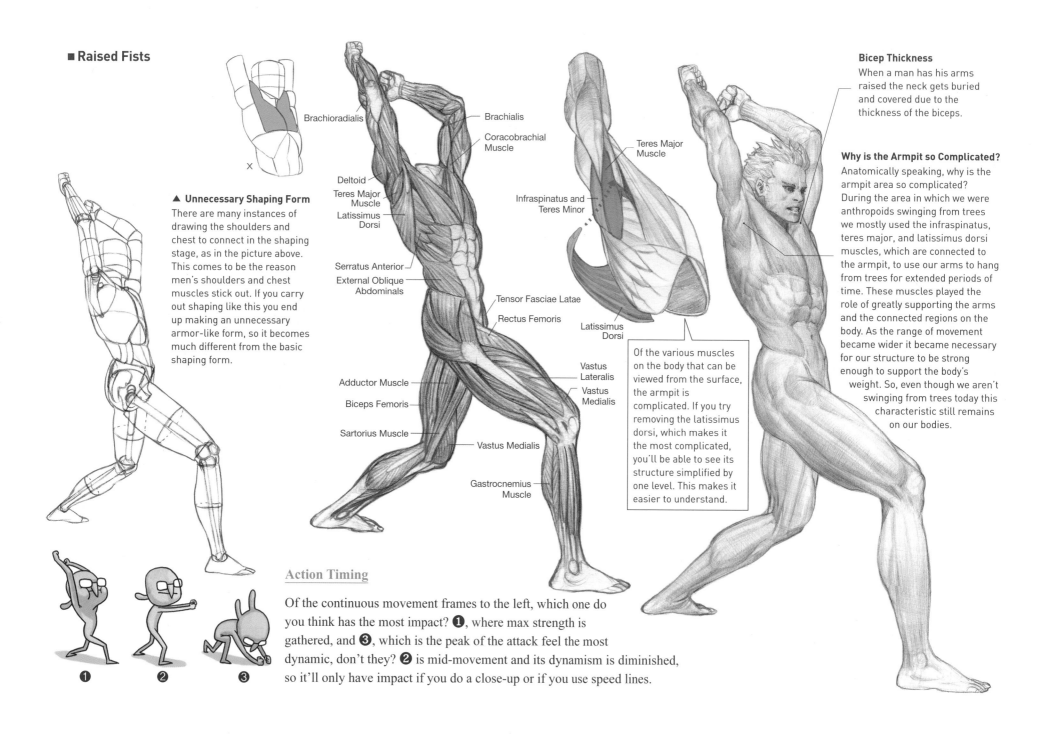

Brachioradialis

Brachialis

Coracobrachial Muscle

▲ Unnecessary Shaping Form
There are many instances of drawing the shoulders and chest to connect in the shaping stage, as in the picture above. This comes to be the reason men's shoulders and chest muscles stick out. If you carry out shaping like this you end up making an unnecessary armor-like form, so it becomes much different from the basic shaping form.

Deltoid

Teres Major Muscle

Latissimus Dorsi

Serratus Anterior

External Oblique Abdominals

Adductor Muscle

Biceps Femoris

Sartorius Muscle

Teres Major Muscle

Infraspinatus and Teres Minor

Tensor Fasciae Latae

Rectus Femoris

Latissimus Dorsi

Vastus Lateralis

Vastus Medialis

Vastus Medialis

Gastrocnemius Muscle

Of the various muscles on the body that can be viewed from the surface, the armpit is complicated. If you try removing the latissimus dorsi, which makes it the most complicated, you'll be able to see its structure simplified by one level. This makes it easier to understand.

Bicep Thickness
When a man has his arms raised the neck gets buried and covered due to the thickness of the biceps.

Why is the Armpit so Complicated?
Anatomically speaking, why is the armpit area so complicated? During the area in which we were anthropoids swinging from trees we mostly used the infraspinatus, teres major, and latissimus dorsi muscles, which are connected to the armpit, to use our arms to hang from trees for extended periods of time. These muscles played the role of greatly supporting the arms and the connected regions on the body. As the range of movement became wider it became necessary for our structure to be strong enough to support the body's weight. So, even though we aren't swinging from trees today this characteristic still remains on our bodies.

Action Timing

Of the continuous movement frames to the left, which one do you think has the most impact? ❶, where max strength is gathered, and ❸, which is the peak of the attack feel the most dynamic, don't they? ❷ is mid-movement and its dynamism is diminished, so it'll only have impact if you do a close-up or if you use speed lines.

❶ ❷ ❸

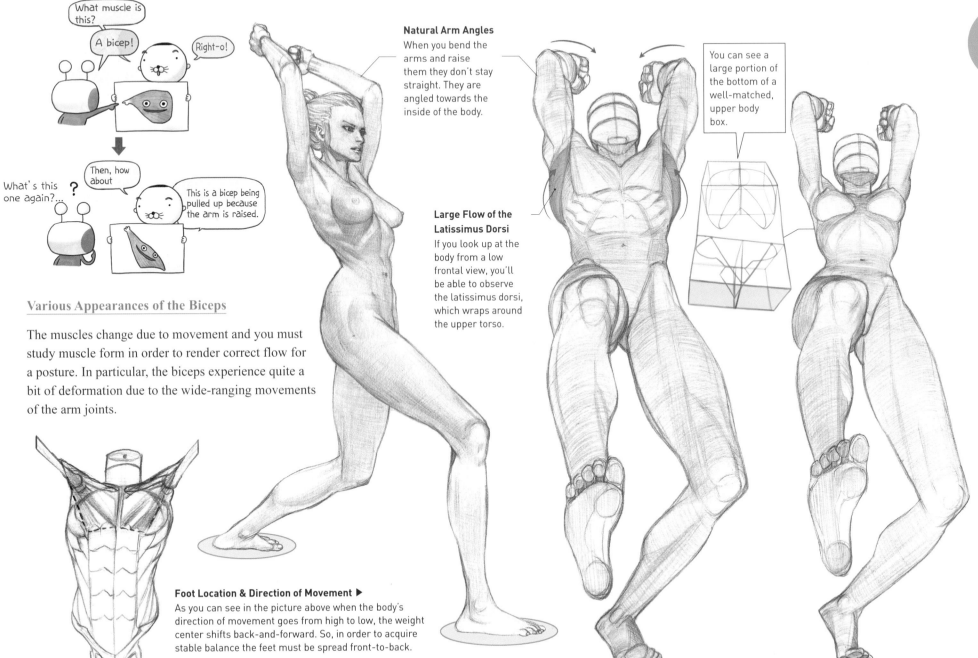

What muscle is this?

A bicep!

Right-o!

What's this one again?...

Then, how about

This is a bicep being pulled up because the arm is raised.

Various Appearances of the Biceps

The muscles change due to movement and you must study muscle form in order to render correct flow for a posture. In particular, the biceps experience quite a bit of deformation due to the wide-ranging movements of the arm joints.

Foot Location & Direction of Movement ▶
As you can see in the picture above when the body's direction of movement goes from high to low, the weight center shifts back-and-forward. So, in order to acquire stable balance the feet must be spread front-to-back.

Natural Arm Angles
When you bend the arms and raise them they don't stay straight. They are angled towards the inside of the body.

Large Flow of the Latissimus Dorsi
If you look up at the body from a low frontal view, you'll be able to observe the latissimus dorsi, which wraps around the upper torso.

You can see a large portion of the bottom of a well-matched, upper body box.

6 Kicking Postures

■ Downward Kick Preparation

Why Are Kicking Postures Difficult to Draw?

Kicking techniques change according to the direction in which the leg is extended and which area of the foot is striking. For this posture, you raise the foot as high as possible to be perpendicular with the ground and strike downwards with the heel in order to hit your opponent. If you do the splits the inside of the groin shows. This makes drawing this area difficult because you must draw the "blind spot" that you don't usually see on people, if you know what I mean.

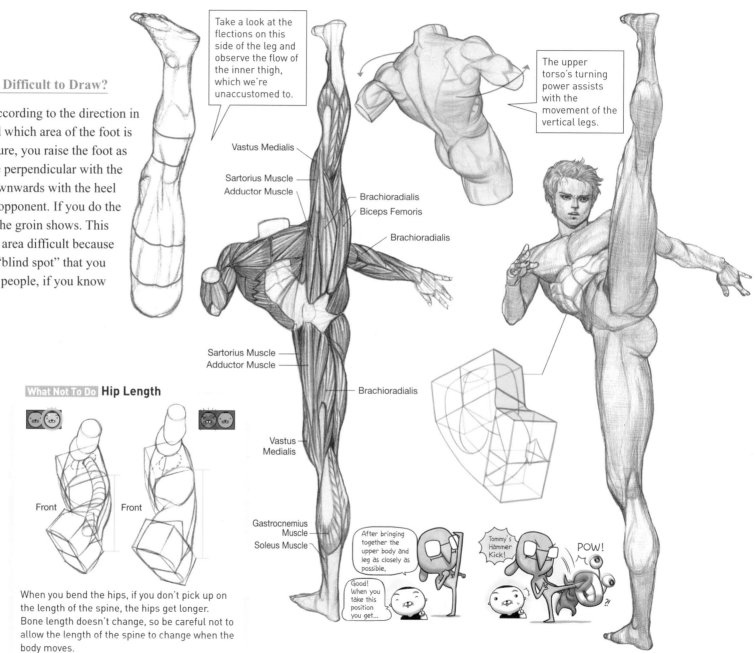

Take a look at the flections on this side of the leg and observe the flow of the inner thigh, which we're unaccustomed to.

The upper torso's turning power assists with the movement of the vertical legs.

Vastus Medialis

Sartorius Muscle
Adductor Muscle

Brachioradialis

Biceps Femoris

Brachioradialis

Sartorius Muscle
Adductor Muscle

Brachioradialis

Vastus Medialis

Gastrocnemius Muscle

Soleus Muscle

After bringing together the upper body and leg as closely as possible,

Good! When you take this position you get...

Tommy's Hammer Kick!

POW!

?!

Toe Direction

In this position the legs are perpendicular to the ground, so the weight center is shifted to the rear. For this reason, the direction of the toes touching the ground face backwards so that you don't fall over.

What Not To Do Hip Length

Front

Front

When you bend the hips, if you don't pick up on the length of the spine, the hips get longer. Bone length doesn't change, so be careful not to allow the length of the spine to change when the body moves.

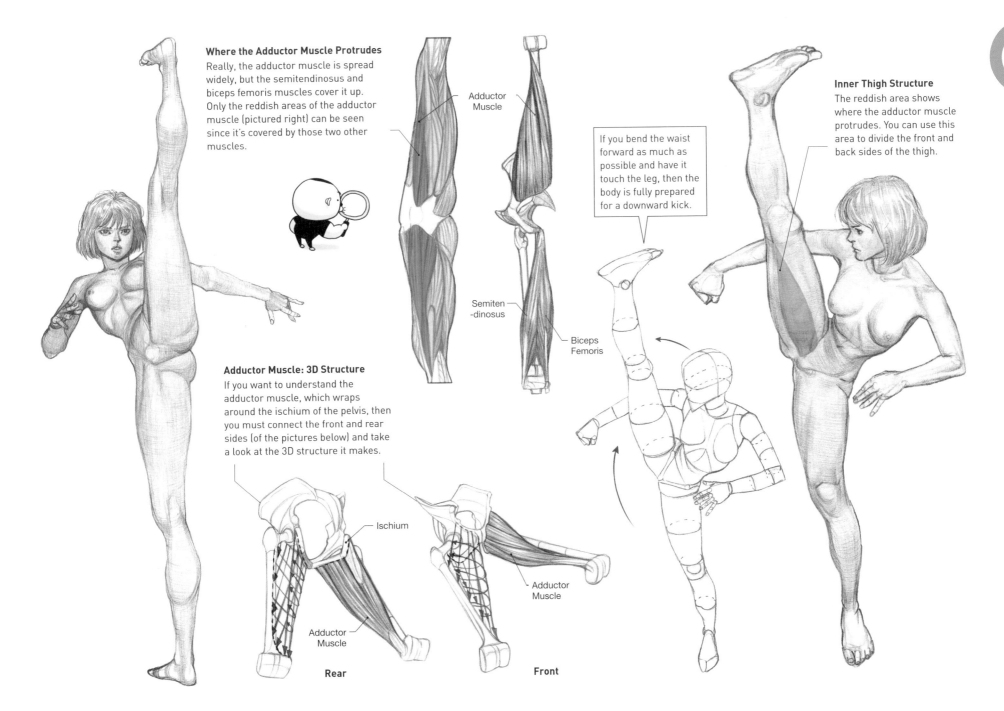

Where the Adductor Muscle Protrudes
Really, the adductor muscle is spread widely, but the semitendinosus and biceps femoris muscles cover it up. Only the reddish areas of the adductor muscle (pictured right) can be seen since it's covered by those two other muscles.

Adductor Muscle

Adductor Muscle: 3D Structure
If you want to understand the adductor muscle, which wraps around the ischium of the pelvis, then you must connect the front and rear sides (of the pictures below) and take a look at the 3D structure it makes.

Semiten -dinosus

Biceps Femoris

Ischium

Adductor Muscle

Adductor Muscle

Rear

Front

If you bend the waist forward as much as possible and have it touch the leg, then the body is fully prepared for a downward kick.

Inner Thigh Structure
The reddish area shows where the adductor muscle protrudes. You can use this area to divide the front and back sides of the thigh.

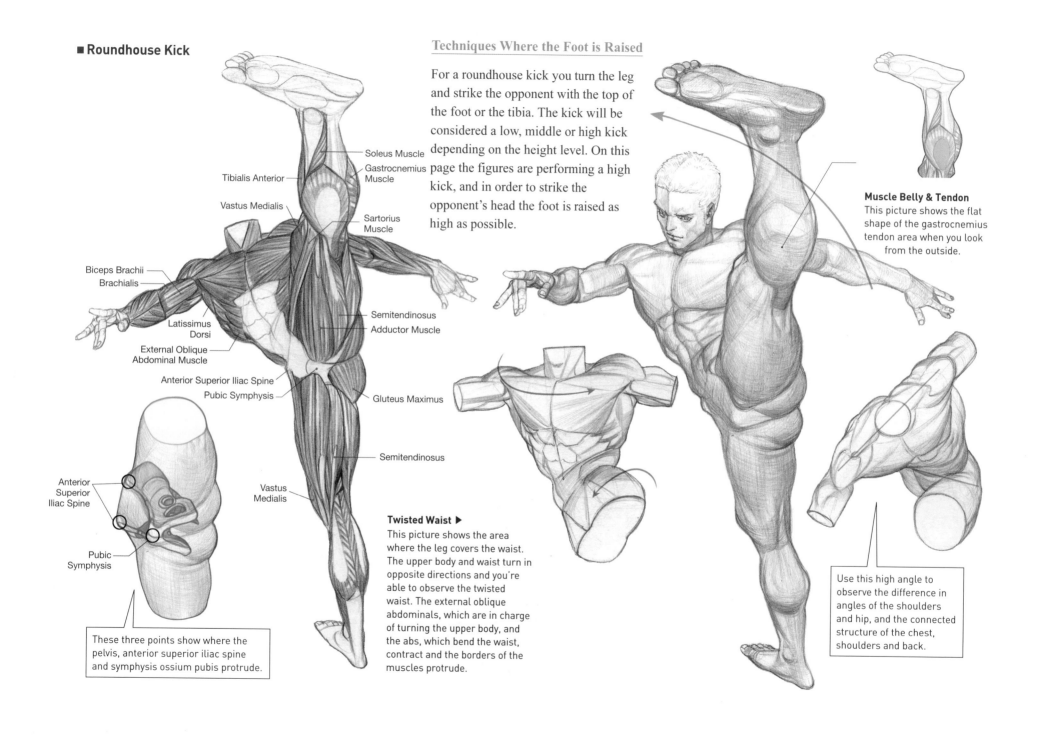

■ **Roundhouse Kick**

Soleus Muscle

Gastrocnemius Muscle

Tibialis Anterior

Vastus Medialis

Sartorius Muscle

Biceps Brachii

Brachialis

Latissimus Dorsi

External Oblique Abdominal Muscle

Anterior Superior Iliac Spine

Pubic Symphysis

Semitendinosus

Adductor Muscle

Gluteus Maximus

Semitendinosus

Vastus Medialis

Anterior Superior Iliac Spine

Pubic Symphysis

These three points show where the pelvis, anterior superior iliac spine and symphysis ossium pubis protrude.

Techniques Where the Foot is Raised

For a roundhouse kick you turn the leg and strike the opponent with the top of the foot or the tibia. The kick will be considered a low, middle or high kick depending on the height level. On this page the figures are performing a high kick, and in order to strike the opponent's head the foot is raised as high as possible.

Muscle Belly & Tendon
This picture shows the flat shape of the gastrocnemius tendon area when you look from the outside.

Twisted Waist ▶
This picture shows the area where the leg covers the waist. The upper body and waist turn in opposite directions and you're able to observe the twisted waist. The external oblique abdominals, which are in charge of turning the upper body, and the abs, which bend the waist, contract and the borders of the muscles protrude.

Use this high angle to observe the difference in angles of the shoulders and hip, and the connected structure of the chest, shoulders and back.

Drawing Step-by-Step

If a person doesn't get a grasp of a major flow and draws each muscle one-by-one, then there'll be many instances where small flows are exaggerated and the bones give the feeling of being twisted. Don't start by looking at the small flows. After rendering the major flow cylindrically draw the smaller flows inside of it.

Shaping the Lower Torso

The reason that the lower torso feels more difficult than the upper is that as long as you're not drawing a superhero, there aren't instances where you draw a character whose lower torso line sticks out. So, you don't get much practice with it. Additionally, the legs are longer and have greater depth than the arms, and in order to bunch everything together and shape them you must look at the drawing using a larger perspective. So, it feels more difficult. In the same way that in the picture to the right the arms are cylindrical, if you also interpret the legs to have a slightly greater cylindrical shape, then you'll be able to easily render foreshortening.

Using the leg that's planted on the ground, you must raise the body in order to attain balance with the leg that's sticking out front.

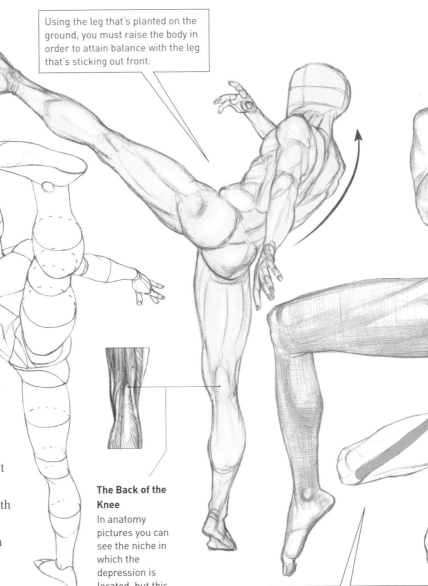

The Back of the Knee

In anatomy pictures you can see the niche in which the depression is located, but this area is filled with fat, so the depression ends up disappearing.

You can see the inside of the right thigh. Here, the sartorius muscle's structure looks simple, but from the angle of the left thigh it doesn't appear simple due to overlapping with different muscles.

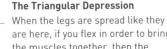

The inner thigh... You're making it so difficult for me!!!

The Triangular Depression

When the legs are spread like they are here, if you flex in order to bring the muscles together, then the sartorius and adductor muscles flex at the same time while the triangular depression is made.

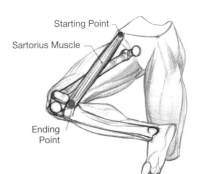

Starting Point

Sartorius Muscle

Ending Point

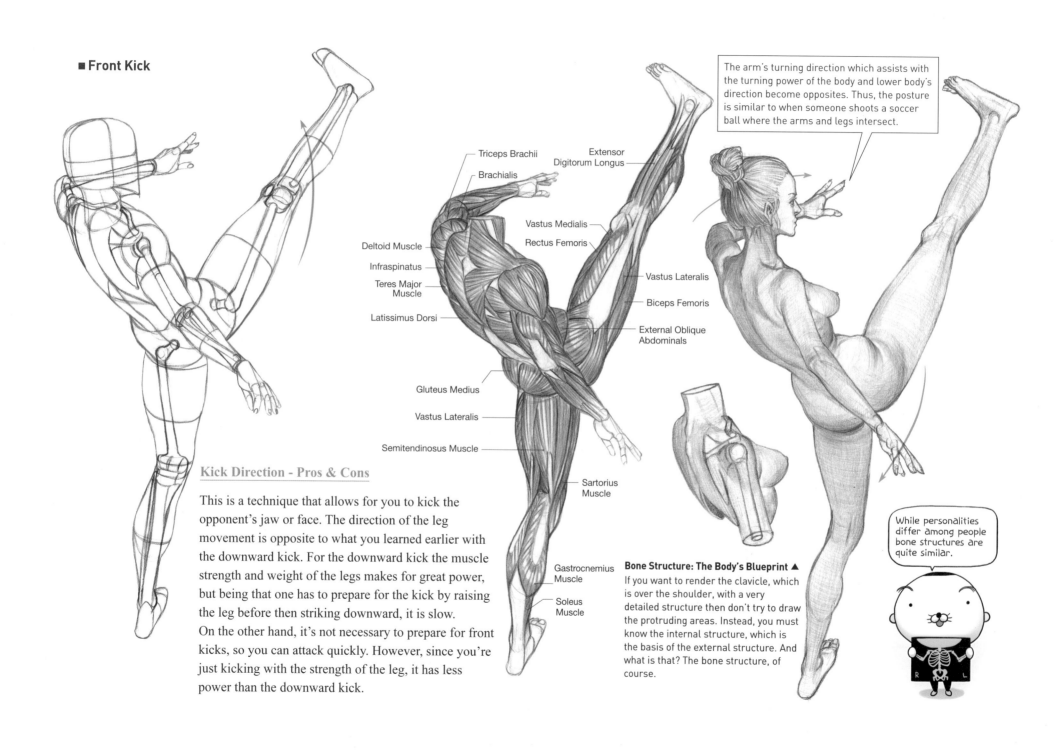

■ Front Kick

The arm's turning direction which assists with the turning power of the body and lower body's direction become opposites. Thus, the posture is similar to when someone shoots a soccer ball where the arms and legs intersect.

Triceps Brachii

Brachialis

Extensor Digitorum Longus

Deltoid Muscle

Infraspinatus

Teres Major Muscle

Latissimus Dorsi

Vastus Medialis

Rectus Femoris

Vastus Lateralis

Biceps Femoris

External Oblique Abdominals

Gluteus Medius

Vastus Lateralis

Semitendinosus Muscle

Sartorius Muscle

Gastrocnemius Muscle

Soleus Muscle

Kick Direction - Pros & Cons

This is a technique that allows for you to kick the opponent's jaw or face. The direction of the leg movement is opposite to what you learned earlier with the downward kick. For the downward kick the muscle strength and weight of the legs makes for great power, but being that one has to prepare for the kick by raising the leg before then striking downward, it is slow.
On the other hand, it's not necessary to prepare for front kicks, so you can attack quickly. However, since you're just kicking with the strength of the leg, it has less power than the downward kick.

Bone Structure: The Body's Blueprint ▲
If you want to render the clavicle, which is over the shoulder, with a very detailed structure then don't try to draw the protruding areas. Instead, you must know the internal structure, which is the basis of the external structure. And what is that? The bone structure, of course.

While personalities differ among people bone structures are quite similar.

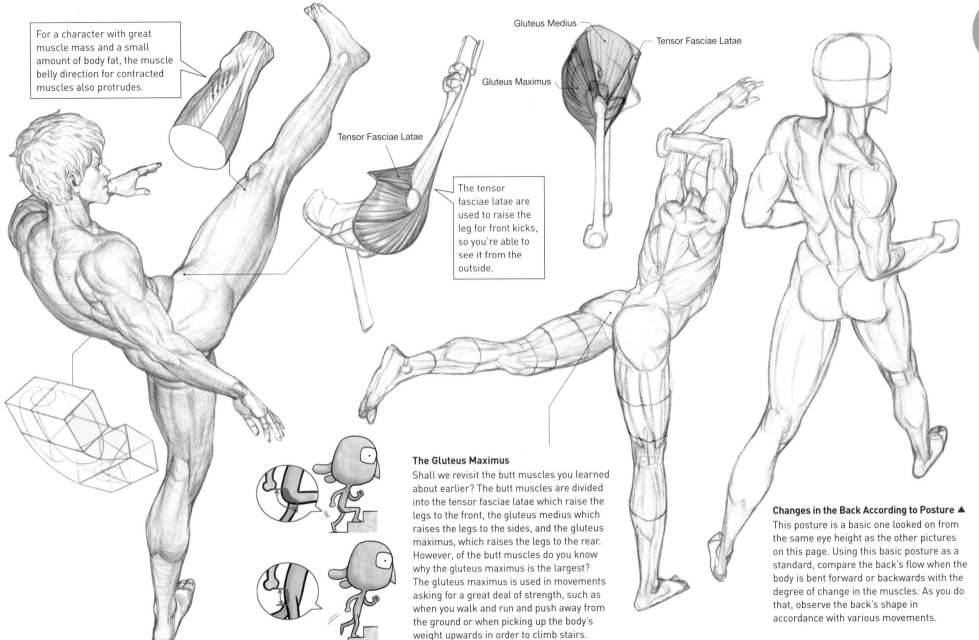

For a character with great muscle mass and a small amount of body fat, the muscle belly direction for contracted muscles also protrudes.

Gluteus Medius

Tensor Fasciae Latae

Gluteus Maximus

Tensor Fasciae Latae

The tensor fasciae latae are used to raise the leg for front kicks, so you're able to see it from the outside.

The Gluteus Maximus
Shall we revisit the butt muscles you learned about earlier? The butt muscles are divided into the tensor fasciae latae which raise the legs to the front, the gluteus medius which raises the legs to the sides, and the gluteus maximus, which raises the legs to the rear. However, of the butt muscles do you know why the gluteus maximus is the largest? The gluteus maximus is used in movements asking for a great deal of strength, such as when you walk and run and push away from the ground or when picking up the body's weight upwards in order to climb stairs.

Changes in the Back According to Posture ▲
This posture is a basic one looked on from the same eye height as the other pictures on this page. Using this basic posture as a standard, compare the back's flow when the body is bent forward or backwards with the degree of change in the muscles. As you do that, observe the back's shape in accordance with various movements.

■ Turning Back Kick

Kicks Which Utilize the Body's Turning Power

For the turning back kick the body turns more than 180 degrees, so it's a technique for attacking the opponent by shifting the centrifugal force to the heel. It is very powerful, but it takes major body movement, so it lacks accuracy.

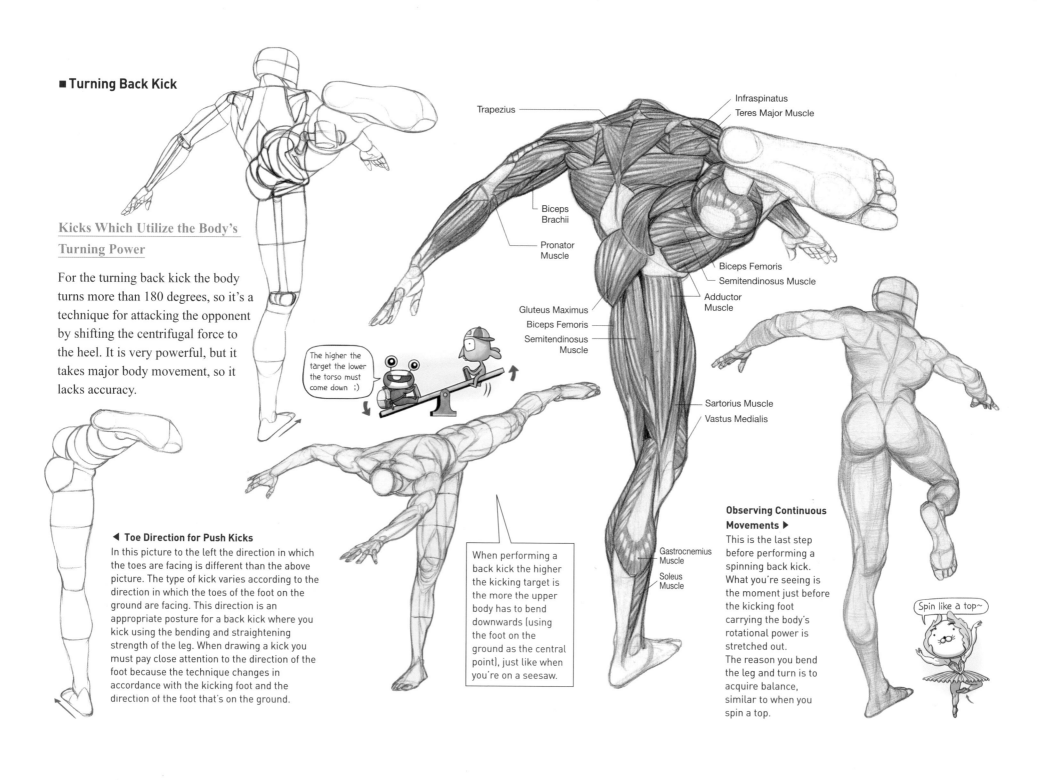

Trapezius

Infraspinatus
Teres Major Muscle

Biceps Brachii

Pronator Muscle

Biceps Femoris
Semitendinosus Muscle

Adductor Muscle

Gluteus Maximus

Biceps Femoris

Semitendinosus Muscle

Sartorius Muscle

Vastus Medialis

Gastrocnemius Muscle

Soleus Muscle

The higher the target the lower the torso must come down ;)

Spin like a top~

◀ Toe Direction for Push Kicks

In this picture to the left the direction in which the toes are facing is different than the above picture. The type of kick varies according to the direction in which the toes of the foot on the ground are facing. This direction is an appropriate posture for a back kick where you kick using the bending and straightening strength of the leg. When drawing a kick you must pay close attention to the direction of the foot because the technique changes in accordance with the kicking foot and the direction of the foot that's on the ground.

When performing a back kick the higher the kicking target is the more the upper body has to bend downwards (using the foot on the ground as the central point), just like when you're on a seesaw.

Observing Continuous Movements ▶

This is the last step before performing a spinning back kick. What you're seeing is the moment just before the kicking foot carrying the body's rotational power is stretched out. The reason you bend the leg and turn is to acquire balance, similar to when you spin a top.

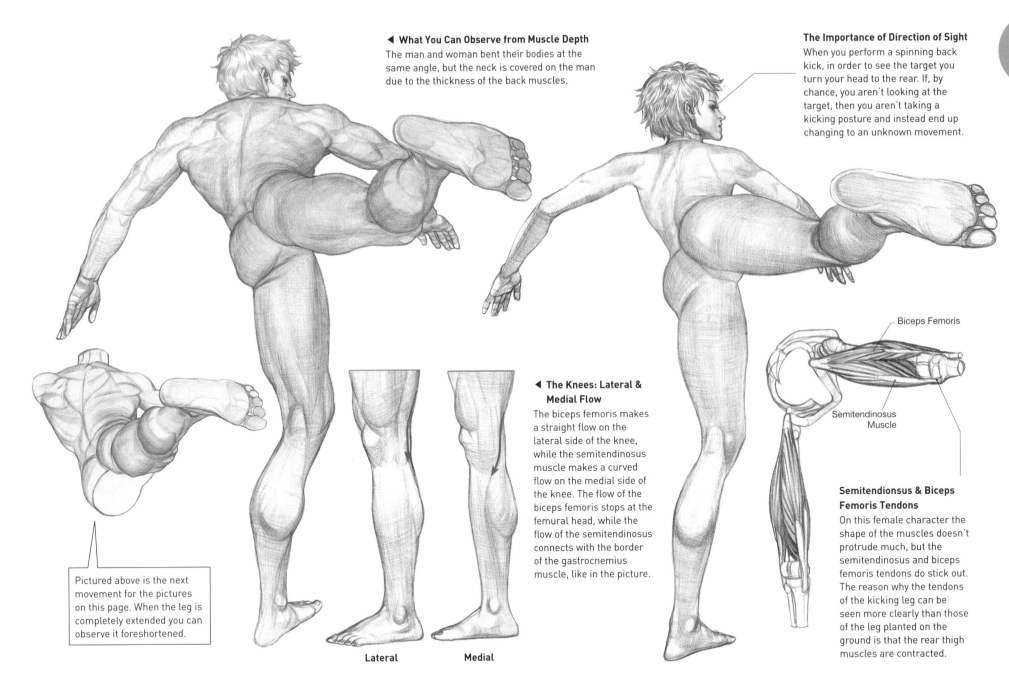

◄ What You Can Observe from Muscle Depth
The man and woman bent their bodies at the same angle, but the neck is covered on the man due to the thickness of the back muscles.

The Importance of Direction of Sight
When you perform a spinning back kick, in order to see the target you turn your head to the rear. If, by chance, you aren't looking at the target, then you aren't taking a kicking posture and instead end up changing to an unknown movement.

Biceps Femoris

Semitendinosus Muscle

◄ The Knees: Lateral & Medial Flow
The biceps femoris makes a straight flow on the lateral side of the knee, while the semitendinosus muscle makes a curved flow on the medial side of the knee. The flow of the biceps femoris stops at the femoral head, while the flow of the semitendinosus connects with the border of the gastrocnemius muscle, like in the picture.

Semitendionsus & Biceps Femoris Tendons
On this female character the shape of the muscles doesn't protrude much, but the semitendinosus and biceps femoris tendons do stick out. The reason why the tendons of the kicking leg can be seen more clearly than those of the leg planted on the ground is that the rear thigh muscles are contracted.

Pictured above is the next movement for the pictures on this page. When the leg is completely extended you can observe it foreshortened.

Lateral

Medial

Understanding Anatomy Through Motion

294
295

7 Punching Postures

■ Straight Punch: Frontal View

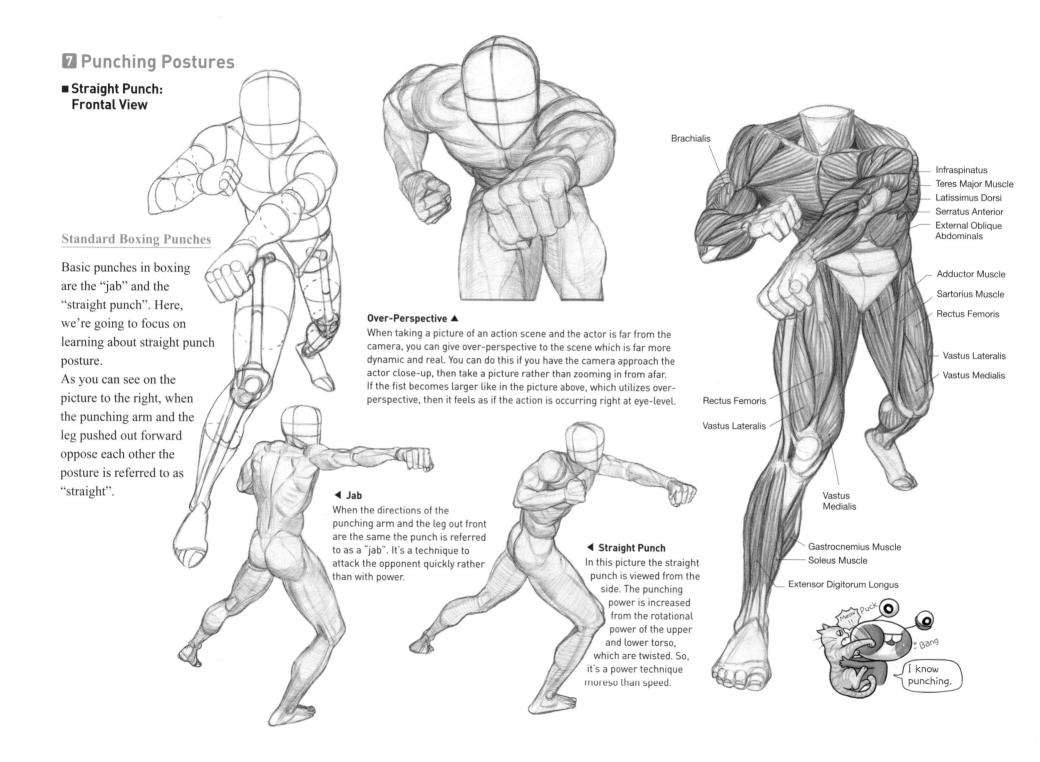

Standard Boxing Punches

Basic punches in boxing are the "jab" and the "straight punch". Here, we're going to focus on learning about straight punch posture.

As you can see on the picture to the right, when the punching arm and the leg pushed out forward oppose each other the posture is referred to as "straight".

Over-Perspective ▲

When taking a picture of an action scene and the actor is far from the camera, you can give over-perspective to the scene which is far more dynamic and real. You can do this if you have the camera approach the actor close-up, then take a picture rather than zooming in from afar. If the fist becomes larger like in the picture above, which utilizes over-perspective, then it feels as if the action is occurring right at eye-level.

◄ Jab

When the directions of the punching arm and the leg out front are the same the punch is referred to as a "jab". It's a technique to attack the opponent quickly rather than with power.

◄ Straight Punch

In this picture the straight punch is viewed from the side. The punching power is increased from the rotational power of the upper and lower torso, which are twisted. So, it's a power technique moreso than speed.

Brachialis

Infraspinatus
Teres Major Muscle
Latissimus Dorsi
Serratus Anterior
External Oblique Abdominals

Adductor Muscle
Sartorius Muscle
Rectus Femoris

Vastus Lateralis
Vastus Medialis

Rectus Femoris

Vastus Lateralis

Vastus Medialis

Gastrocnemius Muscle
Soleus Muscle

Extensor Digitorum Longus

Meow!! Puck

Bang

I know punching.

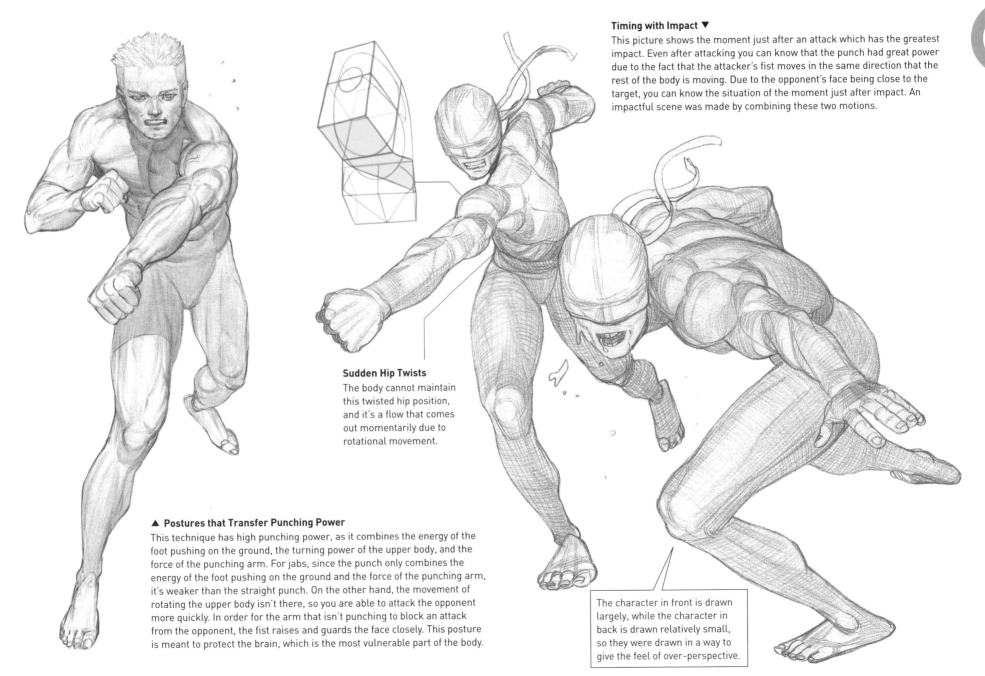

Timing with Impact ▼

This picture shows the moment just after an attack which has the greatest impact. Even after attacking you can know that the punch had great power due to the fact that the attacker's fist moves in the same direction that the rest of the body is moving. Due to the opponent's face being close to the target, you can know the situation of the moment just after impact. An impactful scene was made by combining these two motions.

Sudden Hip Twists

The body cannot maintain this twisted hip position, and it's a flow that comes out momentarily due to rotational movement.

▲ Postures that Transfer Punching Power

This technique has high punching power, as it combines the energy of the foot pushing on the ground, the turning power of the upper body, and the force of the punching arm. For jabs, since the punch only combines the energy of the foot pushing on the ground and the force of the punching arm, it's weaker than the straight punch. On the other hand, the movement of rotating the upper body isn't there, so you are able to attack the opponent more quickly. In order for the arm that isn't punching to block an attack from the opponent, the fist raises and guards the face closely. This posture is meant to protect the brain, which is the most vulnerable part of the body.

The character in front is drawn largely, while the character in back is drawn relatively small, so they were drawn in a way to give the feel of over-perspective.

■ Straight Punch: Diagonal View

Straight Punch

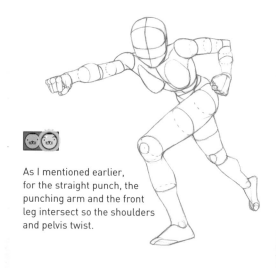

As I mentioned earlier, for the straight punch, the punching arm and the front leg intersect so the shoulders and pelvis twist.

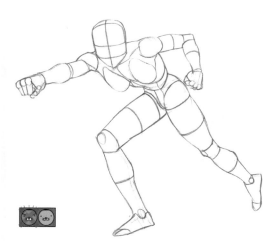

If the punching arm and the front leg are from the same side and the shoulders and pelvis don't intersect, then the punch becomes a jab and not a straight punch.

The Straight Punch Step-by-Step

① ➡ ② ➡ ③

Due to the fact that this is referred to as a punching posture, you may think that it's the arm that comes forward first. But when it comes to the straight punch, the energy starts at the bottom and moves upwards.

First, the lower body gets into position to push against the ground, then that energy is transferred to the hips. Second, the turning power of the hips combines with the energy coming from the lower torso. Third, the energy from the lower torso pushes the arm out and is fully transferred to the fist.

It's just like when you're walking, where the arm and leg of the same side move in unison.

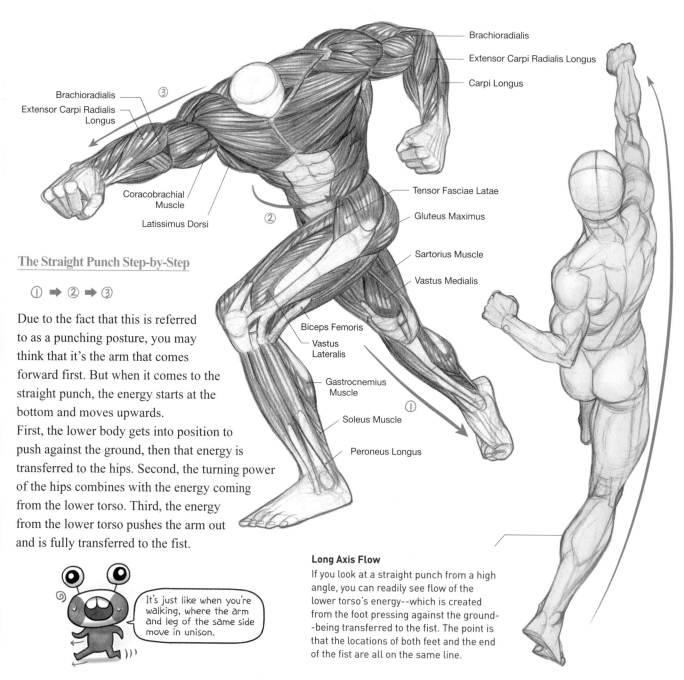

Long Axis Flow

If you look at a straight punch from a high angle, you can readily see flow of the lower torso's energy--which is created from the foot pressing against the ground--being transferred to the fist. The point is that the locations of both feet and the end of the fist are all on the same line.

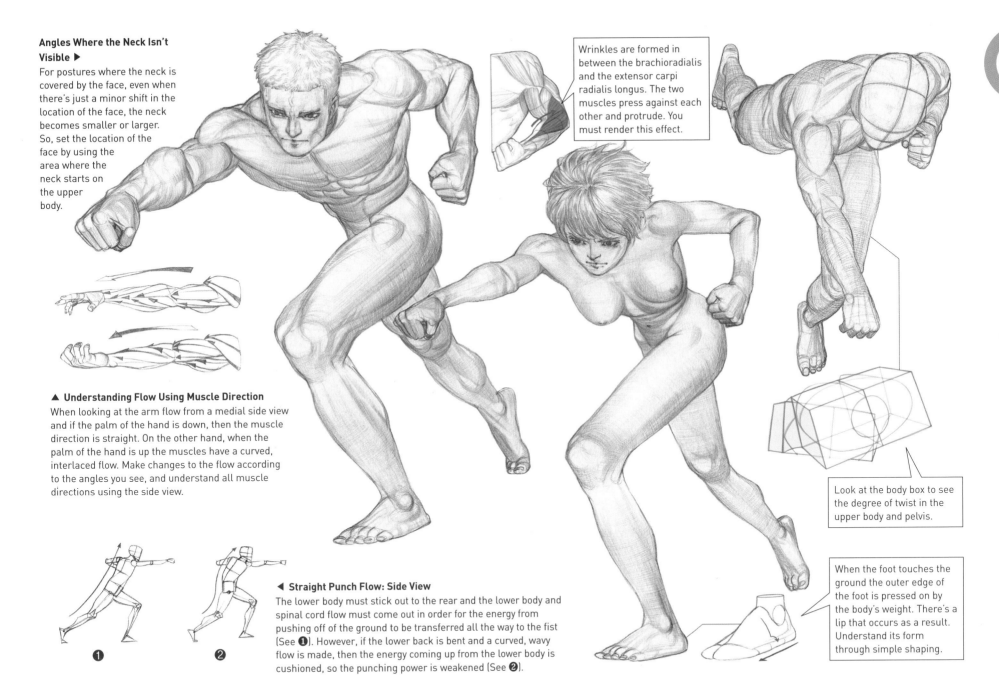

Angles Where the Neck Isn't Visible ▶

For postures where the neck is covered by the face, even when there's just a minor shift in the location of the face, the neck becomes smaller or larger. So, set the location of the face by using the area where the neck starts on the upper body.

Wrinkles are formed in between the brachioradialis and the extensor carpi radialis longus. The two muscles press against each other and protrude. You must render this effect.

▲ Understanding Flow Using Muscle Direction

When looking at the arm flow from a medial side view and if the palm of the hand is down, then the muscle direction is straight. On the other hand, when the palm of the hand is up the muscles have a curved, interlaced flow. Make changes to the flow according to the angles you see, and understand all muscle directions using the side view.

Look at the body box to see the degree of twist in the upper body and pelvis.

◀ Straight Punch Flow: Side View

The lower body must stick out to the rear and the lower body and spinal cord flow must come out in order for the energy from pushing off of the ground to be transferred all the way to the fist (See ❶). However, if the lower back is bent and a curved, wavy flow is made, then the energy coming up from the lower body is cushioned, so the punching power is weakened (See ❷).

❶ ❷

When the foot touches the ground the outer edge of the foot is pressed on by the body's weight. There's a lip that occurs as a result. Understand its form through simple shaping.

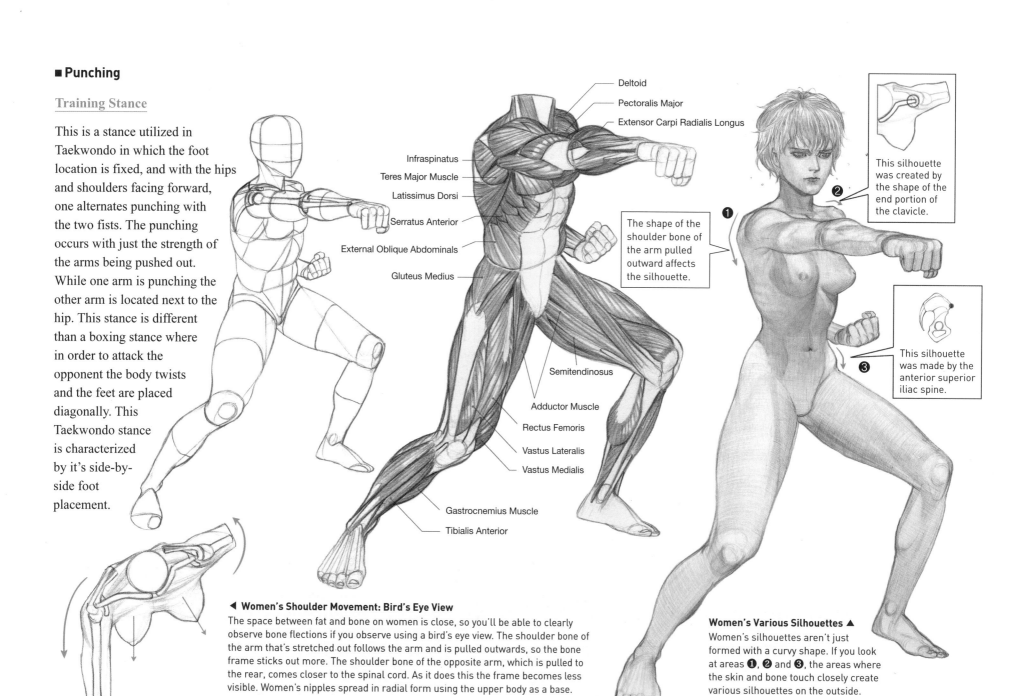

■ Punching

Training Stance

This is a stance utilized in Taekwondo in which the foot location is fixed, and with the hips and shoulders facing forward, one alternates punching with the two fists. The punching occurs with just the strength of the arms being pushed out. While one arm is punching the other arm is located next to the hip. This stance is different than a boxing stance where in order to attack the opponent the body twists and the feet are placed diagonally. This Taekwondo stance is characterized by it's side-by-side foot placement.

Deltoid
Pectoralis Major
Extensor Carpi Radialis Longus
Infraspinatus
Teres Major Muscle
Latissimus Dorsi
Serratus Anterior
External Oblique Abdominals
Gluteus Medius
Semitendinosus
Adductor Muscle
Rectus Femoris
Vastus Lateralis
Vastus Medialis
Gastrocnemius Muscle
Tibialis Anterior

The shape of the shoulder bone of the arm pulled outward affects the silhouette.

This silhouette was created by the shape of the end portion of the clavicle.

This silhouette was made by the anterior superior iliac spine.

◀ Women's Shoulder Movement: Bird's Eye View
The space between fat and bone on women is close, so you'll be able to clearly observe bone flections if you observe using a bird's eye view. The shoulder bone of the arm that's stretched out follows the arm and is pulled outwards, so the bone frame sticks out more. The shoulder bone of the opposite arm, which is pulled to the rear, comes closer to the spinal cord. As it does this the frame becomes less visible. Women's nipples spread in radial form using the upper body as a base.

Women's Various Silhouettes ▲
Women's silhouettes aren't just formed with a curvy shape. If you look at areas ❶, ❷ and ❸, the areas where the skin and bone touch closely create various silhouettes on the outside.

■ **Uppercuts**

Uppercuts

For uppercuts, the body bends back, the hips twist to the side, and the fist starts low and then is extended upwards. It's a technique meant to attack the opponent's jaw.

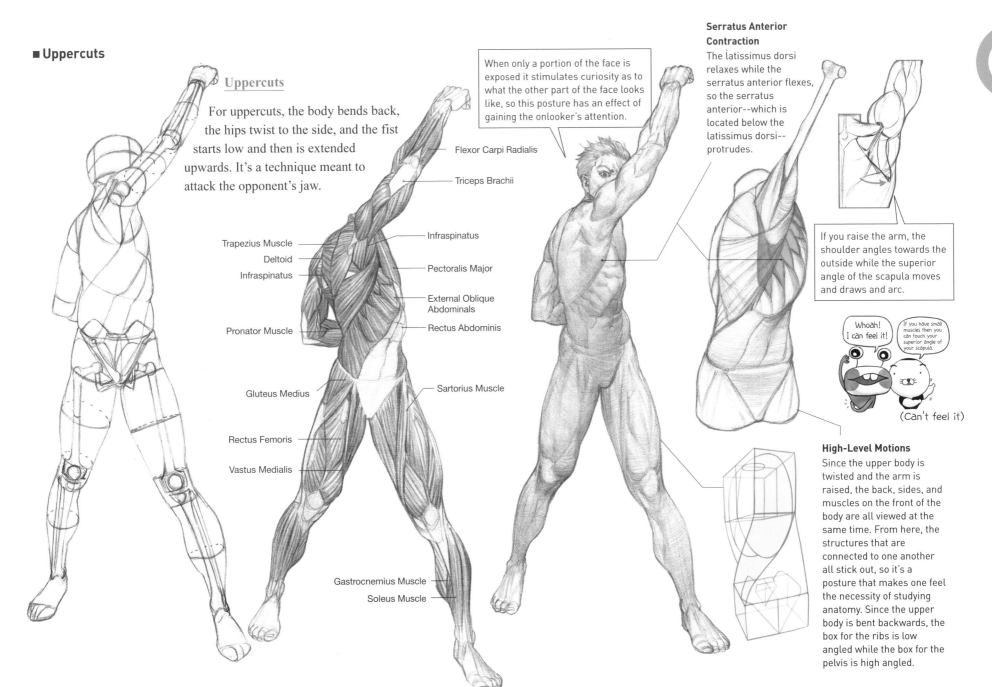

Trapezius Muscle

Deltoid

Infraspinatus

Pronator Muscle

Gluteus Medius

Rectus Femoris

Vastus Medialis

Flexor Carpi Radialis

Triceps Brachii

Infraspinatus

Pectoralis Major

External Oblique Abdominals

Rectus Abdominis

Sartorius Muscle

Gastrocnemius Muscle

Soleus Muscle

When only a portion of the face is exposed it stimulates curiosity as to what the other part of the face looks like, so this posture has an effect of gaining the onlooker's attention.

Serratus Anterior Contraction
The latissimus dorsi relaxes while the serratus anterior flexes, so the serratus anterior--which is located below the latissimus dorsi-- protrudes.

If you raise the arm, the shoulder angles towards the outside while the superior angle of the scapula moves and draws and arc.

Whoah! I can feel it!

If you have small muscles then you can touch your superior angle of your scapula.

(Can't feel it)

High-Level Motions
Since the upper body is twisted and the arm is raised, the back, sides, and muscles on the front of the body are all viewed at the same time. From here, the structures that are connected to one another all stick out, so it's a posture that makes one feel the necessity of studying anatomy. Since the upper body is bent backwards, the box for the ribs is low angled while the box for the pelvis is high angled.

■ Continual Hook Punch

Continuous Punching

When actually boxing, your attack doesn't finish with just one punch, but rather you attack continuously. The figures on this page are taking a posture one uses to punch consecutively.

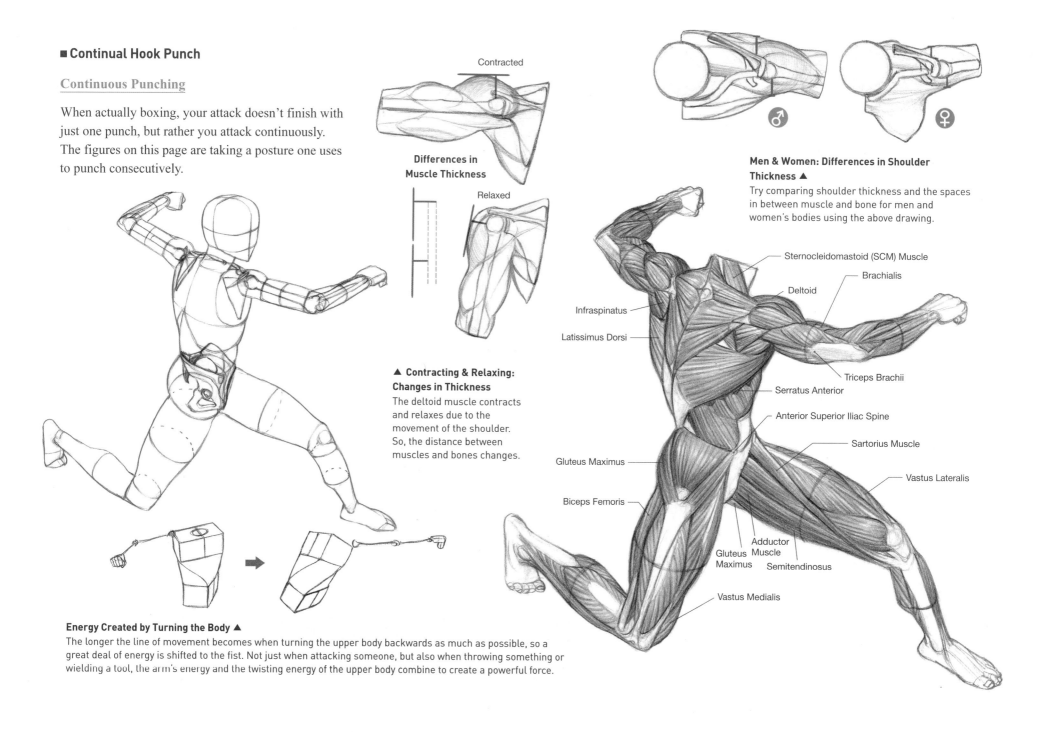

Contracted

Differences in Muscle Thickness

Relaxed

▲ Contracting & Relaxing: Changes in Thickness
The deltoid muscle contracts and relaxes due to the movement of the shoulder. So, the distance between muscles and bones changes.

Men & Women: Differences in Shoulder Thickness ▲
Try comparing shoulder thickness and the spaces in between muscle and bone for men and women's bodies using the above drawing.

Sternocleidomastoid (SCM) Muscle

Brachialis

Deltoid

Infraspinatus

Latissimus Dorsi

Triceps Brachii

Serratus Anterior

Anterior Superior Iliac Spine

Sartorius Muscle

Gluteus Maximus

Vastus Lateralis

Biceps Femoris

Adductor Muscle

Gluteus Maximus

Semitendinosus

Vastus Medialis

Energy Created by Turning the Body ▲
The longer the line of movement becomes when turning the upper body backwards as much as possible, so a great deal of energy is shifted to the fist. Not just when attacking someone, but also when throwing something or wielding a tool, the arm's energy and the twisting energy of the upper body combine to create a powerful force.

Bicep Contraction

For hook punches, the punching arm is thrown towards the middle of the body so the bicep is utilized.

The more the body turns, the more the left arm is pulled back in preparation for a combination.

▲ **Skinny Men**

For men whose muscles aren't developed their silhouettes are similar to that of women's. Since these types of men have less muscle mass, shading occurs due to the outline of the ribs. The trapezius muscle is thin so the neck sticks out and the border of the latissimus dorsi, which appears on the sides of the body below the ribs, isn't clear.

▲ **Hook Punch Characteristics**

As you saw earlier, a "hook" punch stance is when you face the opponent and throw your punches curved, not straight. These punches are more powerful than when throwing your punches straight, however they're easy to block.

The right thigh is largely divided into two areas. It's not a requirement to divide the thigh into these two areas, but the areas change according to the angle of view, direction of light, and whether or not they are flexed or relaxed.

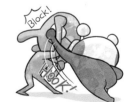

Understanding Anatomy Through Motion

04

302

303

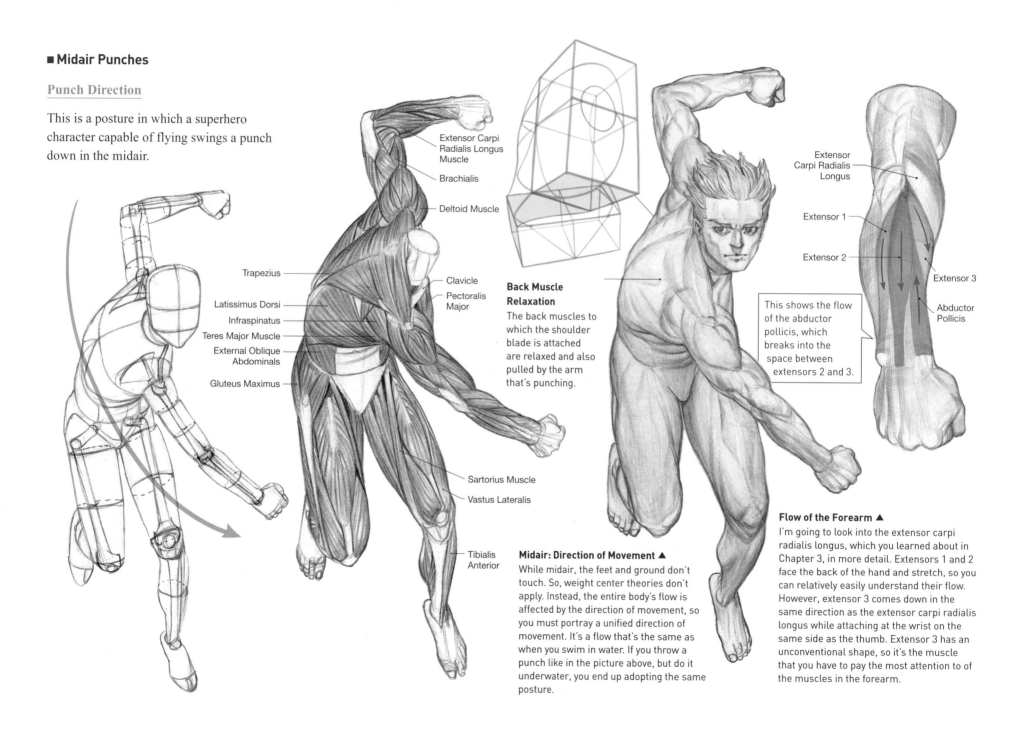

■ Midair Punches

Punch Direction

This is a posture in which a superhero character capable of flying swings a punch down in the midair.

Extensor Carpi Radialis Longus Muscle

Brachialis

Deltoid Muscle

Trapezius

Latissimus Dorsi

Infraspinatus

Teres Major Muscle

External Oblique Abdominals

Gluteus Maximus

Clavicle

Pectoralis Major

Sartorius Muscle

Vastus Lateralis

Tibialis Anterior

Back Muscle Relaxation
The back muscles to which the shoulder blade is attached are relaxed and also pulled by the arm that's punching.

Extensor Carpi Radialis Longus

Extensor 1

Extensor 2

Extensor 3

Abductor Pollicis

This shows the flow of the abductor pollicis, which breaks into the space between extensors 2 and 3.

Midair: Direction of Movement ▲
While midair, the feet and ground don't touch. So, weight center theories don't apply. Instead, the entire body's flow is affected by the direction of movement, so you must portray a unified direction of movement. It's a flow that's the same as when you swim in water. If you throw a punch like in the picture above, but do it underwater, you end up adopting the same posture.

Flow of the Forearm ▲
I'm going to look into the extensor carpi radialis longus, which you learned about in Chapter 3, in more detail. Extensors 1 and 2 face the back of the hand and stretch, so you can relatively easily understand their flow. However, extensor 3 comes down in the same direction as the extensor carpi radialis longus while attaching at the wrist on the same side as the thumb. Extensor 3 has an unconventional shape, so it's the muscle that you have to pay the most attention to of the muscles in the forearm.

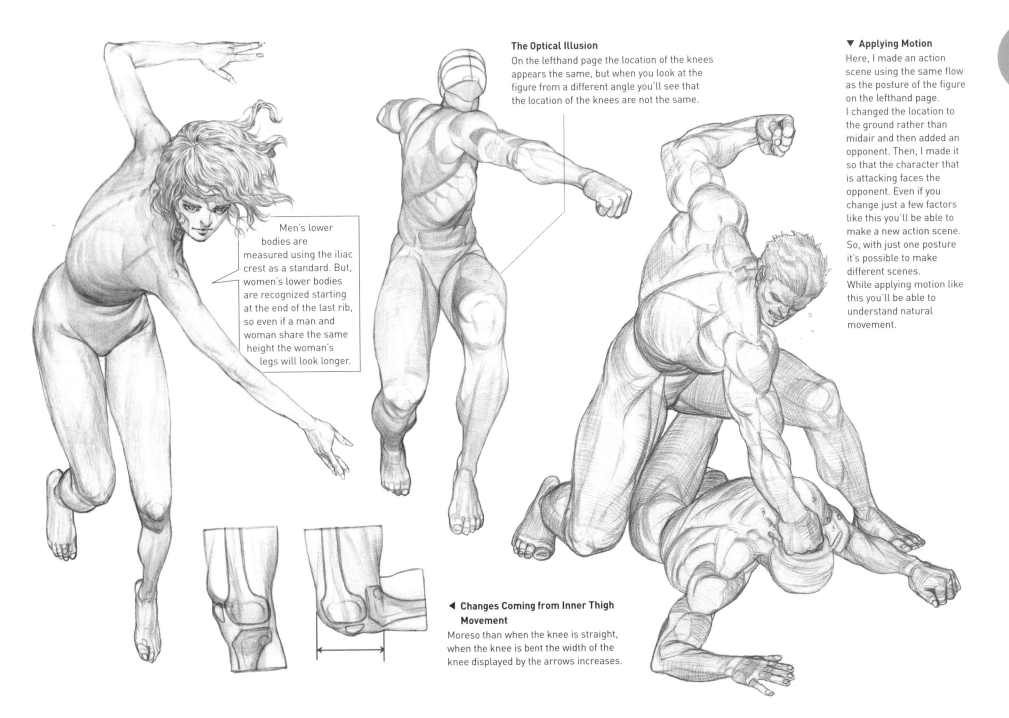

The Optical Illusion
On the lefthand page the location of the knees appears the same, but when you look at the figure from a different angle you'll see that the location of the knees are not the same.

Men's lower bodies are measured using the iliac crest as a standard. But, women's lower bodies are recognized starting at the end of the last rib, so even if a man and woman share the same height the woman's legs will look longer.

◀ **Changes Coming from Inner Thigh Movement**
Moreso than when the knee is straight, when the knee is bent the width of the knee displayed by the arrows increases.

▼ **Applying Motion**
Here, I made an action scene using the same flow as the posture of the figure on the lefthand page. I changed the location to the ground rather than midair and then added an opponent. Then, I made it so that the character that is attacking faces the opponent. Even if you change just a few factors like this you'll be able to make a new action scene. So, with just one posture it's possible to make different scenes. While applying motion like this you'll be able to understand natural movement.

8 2-Person Motion

■ Hand-to-Hand Combat

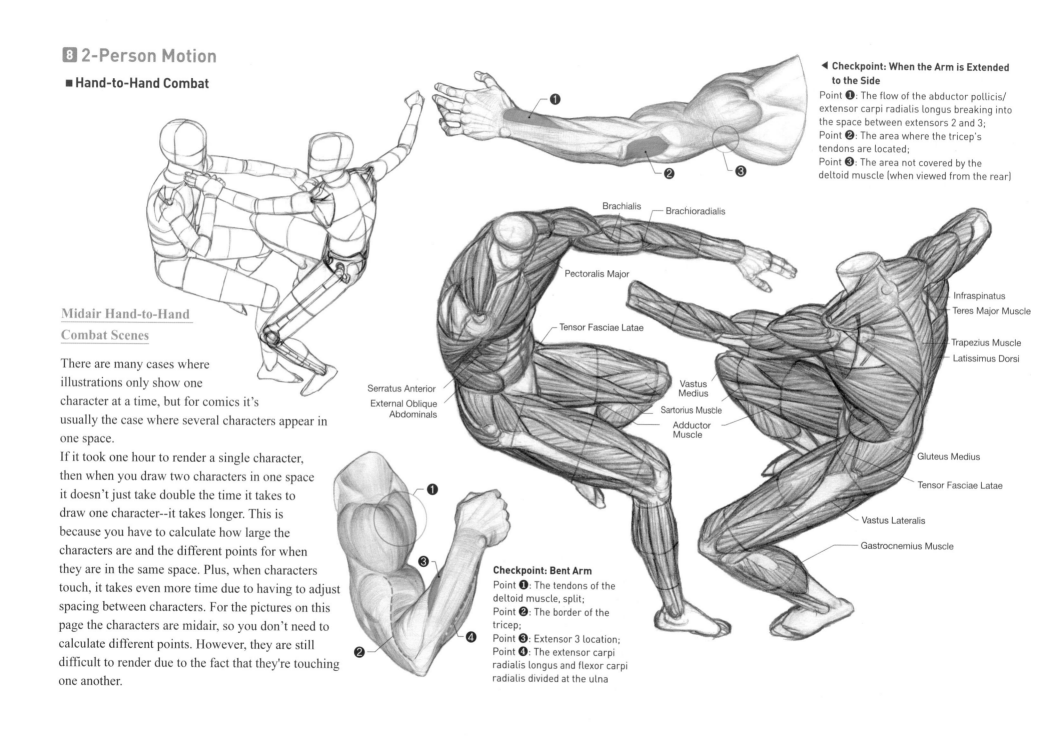

Midair Hand-to-Hand Combat Scenes

There are many cases where illustrations only show one character at a time, but for comics it's usually the case where several characters appear in one space.

If it took one hour to render a single character, then when you draw two characters in one space it doesn't just take double the time it takes to draw one character--it takes longer. This is because you have to calculate how large the characters are and the different points for when they are in the same space. Plus, when characters touch, it takes even more time due to having to adjust spacing between characters. For the pictures on this page the characters are midair, so you don't need to calculate different points. However, they are still difficult to render due to the fact that they're touching one another.

◄ **Checkpoint: When the Arm is Extended to the Side**
Point ❶: The flow of the abductor pollicis/extensor carpi radialis longus breaking into the space between extensors 2 and 3;
Point ❷: The area where the tricep's tendons are located;
Point ❸: The area not covered by the deltoid muscle (when viewed from the rear)

Brachialis
Brachioradialis
Pectoralis Major
Tensor Fasciae Latae
Serratus Anterior
External Oblique Abdominals
Vastus Medius
Sartorius Muscle
Adductor Muscle

Infraspinatus
Teres Major Muscle
Trapezius Muscle
Latissimus Dorsi
Gluteus Medius
Tensor Fasciae Latae
Vastus Lateralis
Gastrocnemius Muscle

Checkpoint: Bent Arm
Point ❶: The tendons of the deltoid muscle, split;
Point ❷: The border of the tricep;
Point ❸: Extensor 3 location;
Point ❹: The extensor carpi radialis longus and flexor carpi radialis divided at the ulna

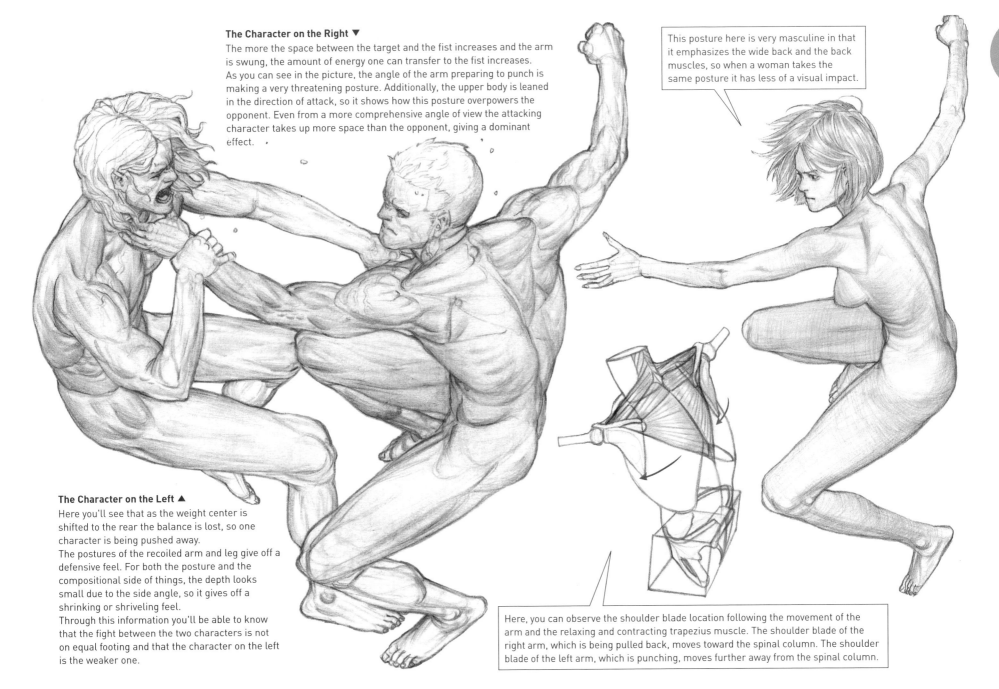

The Character on the Right ▼

The more the space between the target and the fist increases and the arm is swung, the amount of energy one can transfer to the fist increases. As you can see in the picture, the angle of the arm preparing to punch is making a very threatening posture. Additionally, the upper body is leaned in the direction of attack, so it shows how this posture overpowers the opponent. Even from a more comprehensive angle of view the attacking character takes up more space than the opponent, giving a dominant effect.

This posture here is very masculine in that it emphasizes the wide back and the back muscles, so when a woman takes the same posture it has less of a visual impact.

The Character on the Left ▲

Here you'll see that as the weight center is shifted to the rear the balance is lost, so one character is being pushed away.

The postures of the recoiled arm and leg give off a defensive feel. For both the posture and the compositional side of things, the depth looks small due to the side angle, so it gives off a shrinking or shriveling feel.

Through this information you'll be able to know that the fight between the two characters is not on equal footing and that the character on the left is the weaker one.

Here, you can observe the shoulder blade location following the movement of the arm and the relaxing and contracting trapezius muscle. The shoulder blade of the right arm, which is being pulled back, moves toward the spinal column. The shoulder blade of the left arm, which is punching, moves further away from the spinal column.

■ Mid-Hook Punch

Mid-Punch: Characteristics

The postures on this page display the body when the hip is twisted towards the rear and then is in the middle of rotating forward in order to attack using a hook punch. You can think of this posture as a step in the process of punching.

The angle of the shoulders and hips, which are almost identical, tell of the state of the body, which is in the middle of rotating. The angle is located at the character's back, so the leg which is on the same side of the body as the punching fist is pressing against the ground. In this posture you can assuredly get a feel for the strength of the leg.

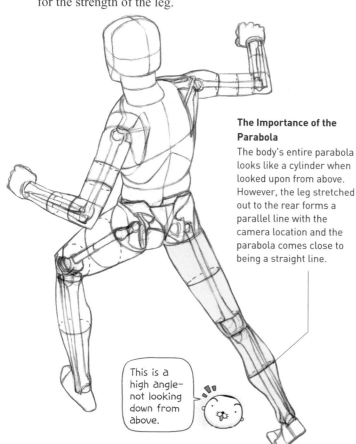

The Importance of the Parabola
The body's entire parabola looks like a cylinder when looked upon from above. However, the leg stretched out to the rear forms a parallel line with the camera location and the parabola comes close to being a straight line.

This is a high angle—not looking down from above.

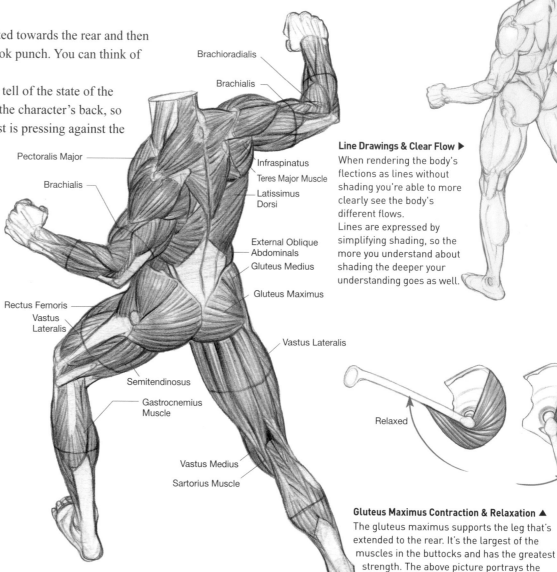

Brachioradialis

Brachialis

Pectoralis Major

Brachialis

Infraspinatus

Teres Major Muscle

Latissimus Dorsi

External Oblique Abdominals

Gluteus Medius

Gluteus Maximus

Rectus Femoris

Vastus Lateralis

Vastus Lateralis

Semitendinosus

Gastrocnemius Muscle

Vastus Medius

Sartorius Muscle

Line Drawings & Clear Flow ▶
When rendering the body's flections as lines without shading you're able to more clearly see the body's different flows.
Lines are expressed by simplifying shading, so the more you understand about shading the deeper your understanding goes as well.

Relaxed

Contracted

Gluteus Maximus Contraction & Relaxation ▲
The gluteus maximus supports the leg that's extended to the rear. It's the largest of the muscles in the buttocks and has the greatest strength. The above picture portrays the greatest scale of contraction and relaxation of the gluteus maximus.

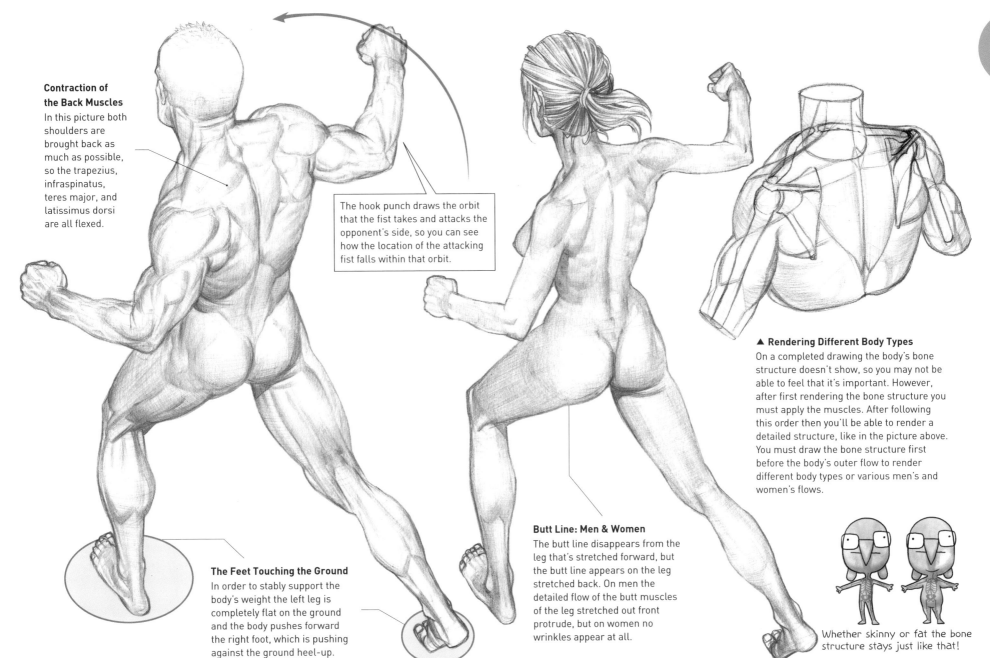

Contraction of the Back Muscles
In this picture both shoulders are brought back as much as possible, so the trapezius, infraspinatus, teres major, and latissimus dorsi are all flexed.

The hook punch draws the orbit that the fist takes and attacks the opponent's side, so you can see how the location of the attacking fist falls within that orbit.

The Feet Touching the Ground
In order to stably support the body's weight the left leg is completely flat on the ground and the body pushes forward the right foot, which is pushing against the ground heel-up.

Butt Line: Men & Women
The butt line disappears from the leg that's stretched forward, but the butt line appears on the leg stretched back. On men the detailed flow of the butt muscles of the leg stretched out front protrude, but on women no wrinkles appear at all.

▲ Rendering Different Body Types
On a completed drawing the body's bone structure doesn't show, so you may not be able to feel that it's important. However, after first rendering the bone structure you must apply the muscles. After following this order then you'll be able to render a detailed structure, like in the picture above. You must draw the bone structure first before the body's outer flow to render different body types or various men's and women's flows.

Whether skinny or fat the bone structure stays just like that!

■ Straight Punch Preparation

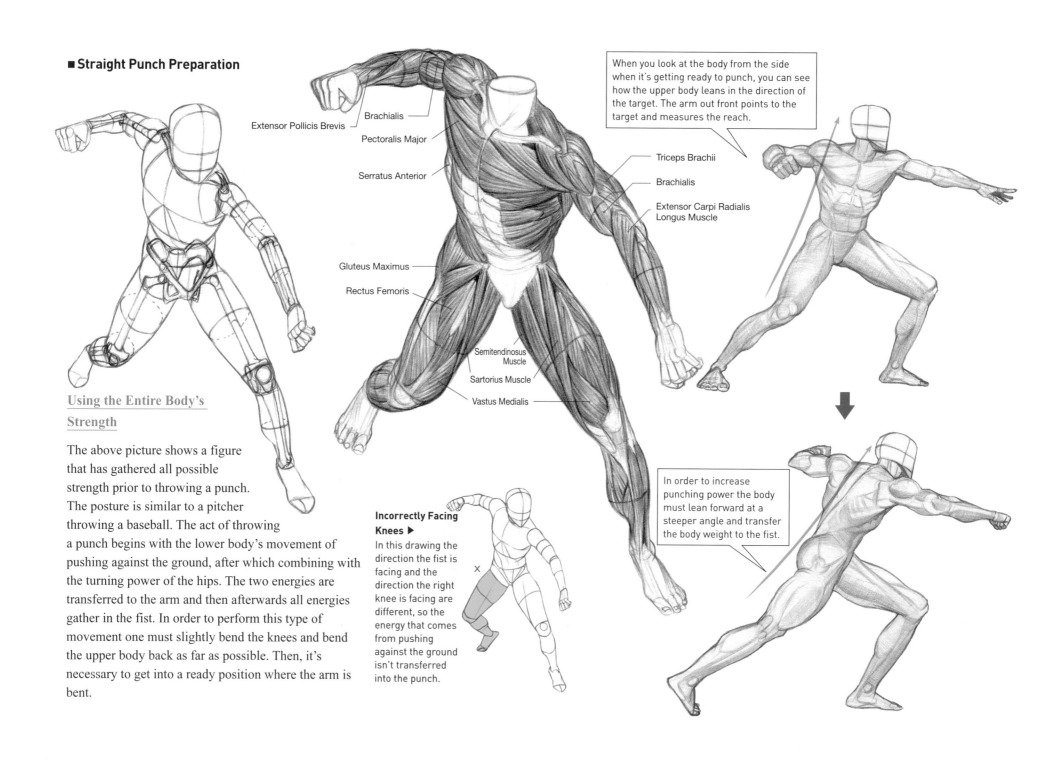

Extensor Pollicis Brevis

Brachialis

Pectoralis Major

Serratus Anterior

Gluteus Maximus

Rectus Femoris

Semitendinosus Muscle

Sartorius Muscle

Vastus Medialis

When you look at the body from the side when it's getting ready to punch, you can see how the upper body leans in the direction of the target. The arm out front points to the target and measures the reach.

Triceps Brachii

Brachialis

Extensor Carpi Radialis Longus Muscle

Using the Entire Body's Strength

The above picture shows a figure that has gathered all possible strength prior to throwing a punch. The posture is similar to a pitcher throwing a baseball. The act of throwing a punch begins with the lower body's movement of pushing against the ground, after which combining with the turning power of the hips. The two energies are transferred to the arm and then afterwards all energies gather in the fist. In order to perform this type of movement one must slightly bend the knees and bend the upper body back as far as possible. Then, it's necessary to get into a ready position where the arm is bent.

Incorrectly Facing Knees ▶
In this drawing the direction the fist is facing and the direction the right knee is facing are different, so the energy that comes from pushing against the ground isn't transferred into the punch.

In order to increase punching power the body must lean forward at a steeper angle and transfer the body weight to the fist.

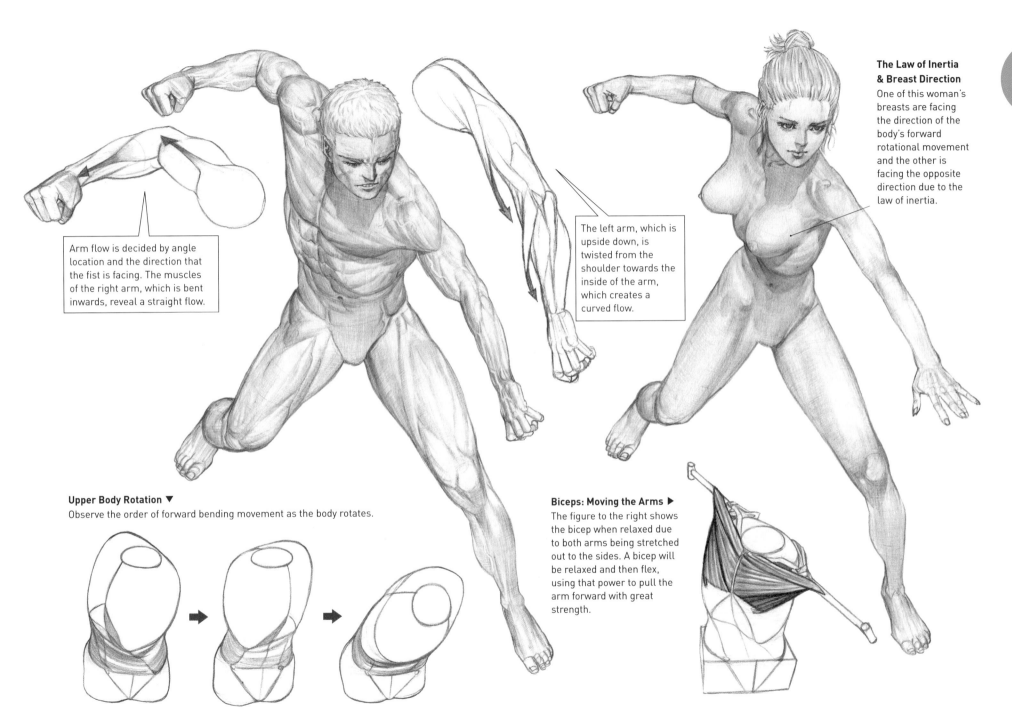

Arm flow is decided by angle location and the direction that the fist is facing. The muscles of the right arm, which is bent inwards, reveal a straight flow.

The left arm, which is upside down, is twisted from the shoulder towards the inside of the arm, which creates a curved flow.

The Law of Inertia & Breast Direction
One of this woman's breasts are facing the direction of the body's forward rotational movement and the other is facing the opposite direction due to the law of inertia.

Upper Body Rotation ▼
Observe the order of forward bending movement as the body rotates.

Biceps: Moving the Arms ▶
The figure to the right shows the bicep when relaxed due to both arms being stretched out to the sides. A bicep will be relaxed and then flex, using that power to pull the arm forward with great strength.

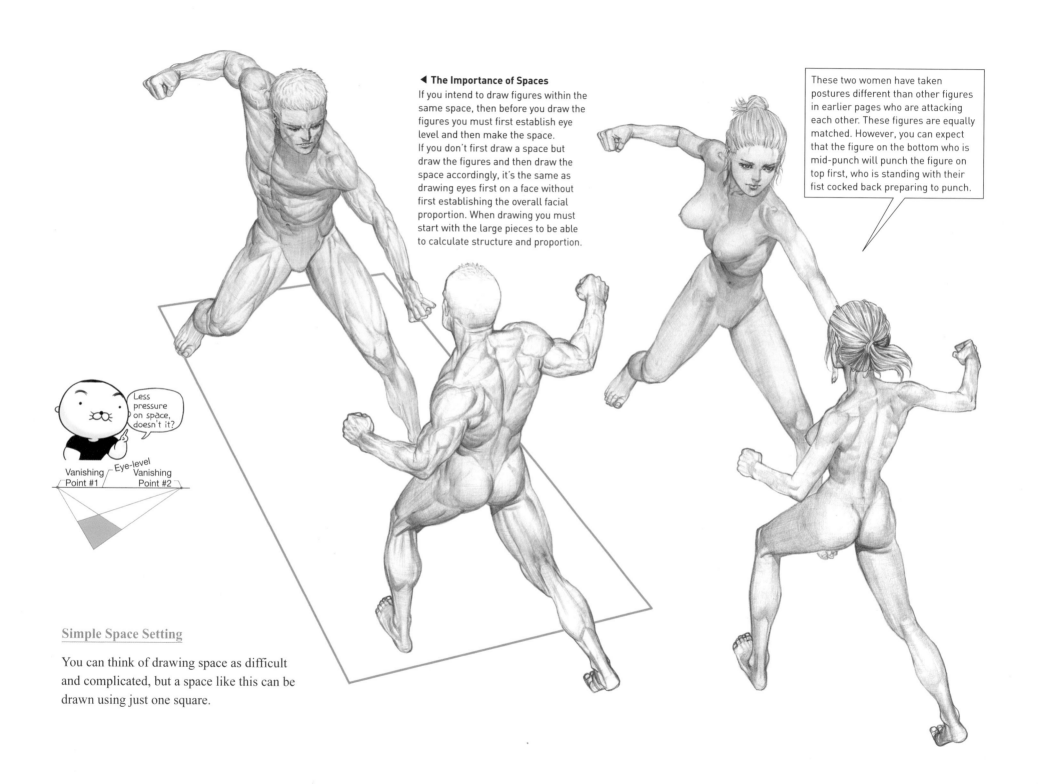

◄ The Importance of Spaces
If you intend to draw figures within the same space, then before you draw the figures you must first establish eye level and then make the space.
If you don't first draw a space but draw the figures and then draw the space accordingly, it's the same as drawing eyes first on a face without first establishing the overall facial proportion. When drawing you must start with the large pieces to be able to calculate structure and proportion.

These two women have taken postures different than other figures in earlier pages who are attacking each other. These figures are equally matched. However, you can expect that the figure on the bottom who is mid-punch will punch the figure on top first, who is standing with their fist cocked back preparing to punch.

Less pressure on space, doesn't it?

Vanishing Point #1 — Eye-level Vanishing Point #2

Simple Space Setting

You can think of drawing space as difficult and complicated, but a space like this can be drawn using just one square.

9 Weapons

■ Wielding Weapons

The Flow Makes the Body

After checking proportion, weight center, and natural movement through shaping, try drawing a simple line for the flow with the major muscles at the center. If you do this you won't be focusing on the shape of minute muscles from the get-go. Instead, you bunch everything together and simplify the major flow. You may say that sketching is the best way to practice, but many students ask how long they have to practice sketching for. Drawings combine theory and sense, so in order to maintain a sense or feel it takes incessant practice.

Drawings with Great Depth

The easiest way to give depth to a figure is to make the flow of the bone structure protrude. You can use the lines below the ribs as perfect examples.

◀ Beware!

After stably rendering proportion and depth, split the sides little by little. Even when you depict the smaller portions the most important thing is to continuously check that the major flow hasn't been ruined. When drawing by hand you must always maintain a far distance between yourself and the drawing. When using a computer to draw you have to repeatedly expand and minimize to be able to see the entire picture.

Wielding an Object ▶

You must put your weight on one foot--the foot facing the weapon you're holding--in order to stand in a posture and maintain a natural weight center. If you hold a heavy object in one hand and try standing on one foot you'll understand what I'm saying.

■ Unsheathing a Sword

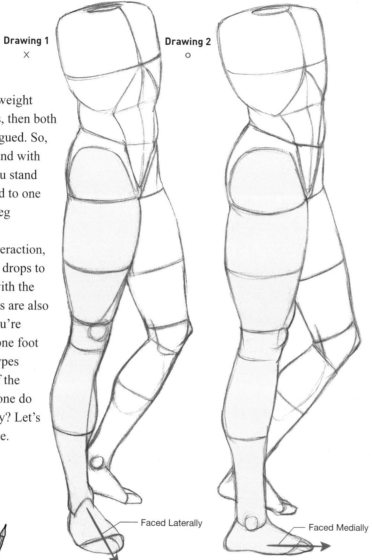

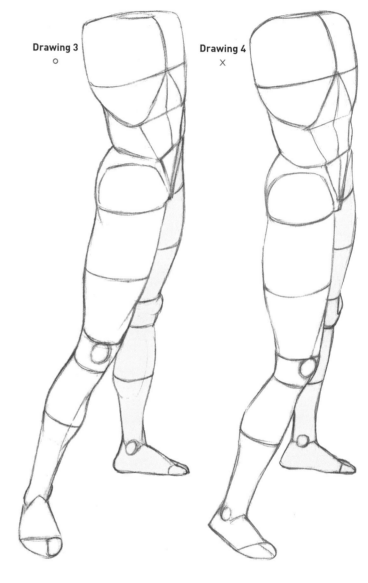

Drawing 1 ✕

Drawing 2 ○

Drawing 3 ○

Drawing 4 ✕

Standing on One Foot

If you stand with your body weight equally allocated to both legs, then both of your legs will become fatigued. So, when you stand you often stand with your weight on one leg. If you stand with your body weight shifted to one leg, the pelvis raises for the leg carrying the weight.

On the other hand, as a counteraction, the shoulder of the same side drops to maintain balance. Together with the angle, the direction of the toes are also important. Postures where you're standing with the weight on one foot can be divided into various types according to toe direction. Of the drawings to the right, which one do you think is standing naturally? Let's take a look at them one by one.

— Faced Laterally

— Faced Medially

When the direction of the toes of the foot carrying the body weight is faced laterally, like in Drawing 1, the knee can't lock and it ends up bending. The toes of the foot carrying the body weight must face medially in order so that even when no strength is given to the leg, the knee joint doesn't bend and the leg supports the weight stably.

If the foot of the leg carrying the body's weight is facing inward, then the opposite foot isn't heavily affected by the angle. What's important is that the toes of the foot carrying the weight must face inward. The posture on the right hand page is the same as Drawing 4.

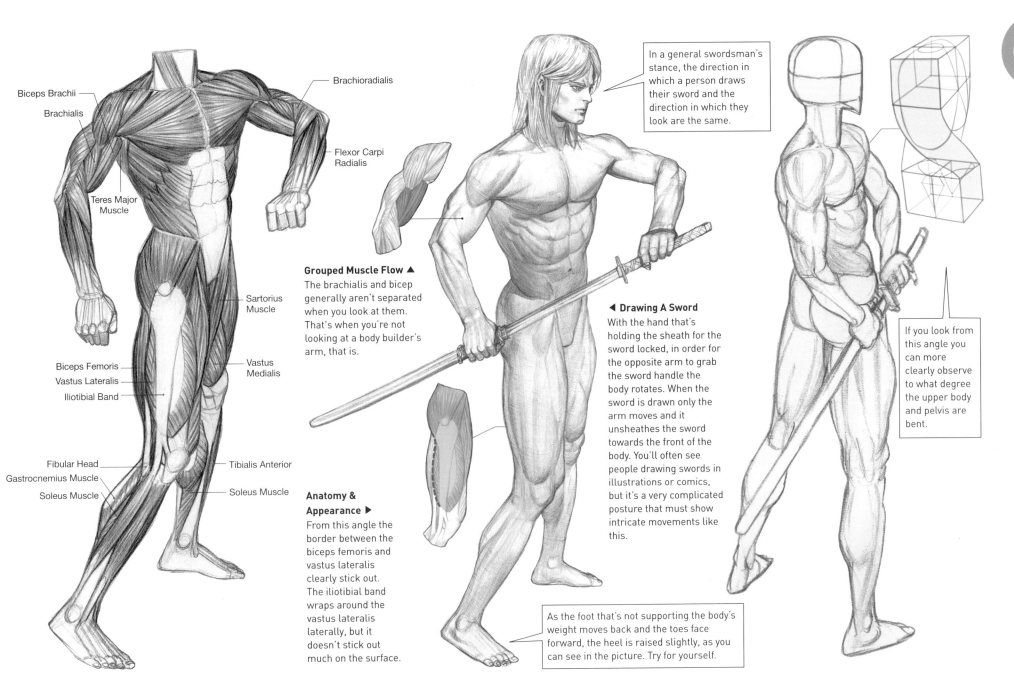

Biceps Brachii

Brachialis

Teres Major
Muscle

Brachioradialis

Flexor Carpi
Radialis

Sartorius
Muscle

Biceps Femoris

Vastus Lateralis

Iliotibial Band

Vastus
Medialis

Fibular Head

Gastrocnemius Muscle

Soleus Muscle

Tibialis Anterior

Soleus Muscle

Grouped Muscle Flow ▲
The brachialis and bicep generally aren't separated when you look at them. That's when you're not looking at a body builder's arm, that is.

Anatomy & Appearance ▶
From this angle the border between the biceps femoris and vastus lateralis clearly stick out. The iliotibial band wraps around the vastus lateralis laterally, but it doesn't stick out much on the surface.

In a general swordsman's stance, the direction in which a person draws their sword and the direction in which they look are the same.

◀ Drawing A Sword
With the hand that's holding the sheath for the sword locked, in order for the opposite arm to grab the sword handle the body rotates. When the sword is drawn only the arm moves and it unsheathes the sword towards the front of the body. You'll often see people drawing swords in illustrations or comics, but it's a very complicated posture that must show intricate movements like this.

As the foot that's not supporting the body's weight moves back and the toes face forward, the heel is raised slightly, as you can see in the picture. Try for yourself.

If you look from this angle you can more clearly observe to what degree the upper body and pelvis are bent.

■ Wielding a Sword with One Hand

Holding a Sword Lightly

If you look at a person whose knees aren't bent and their body isn't greatly twisted, you'll know that it's a posture for holding a sword lightly. Through a ready stance you can make an inference with regards to the strength of the next movement.

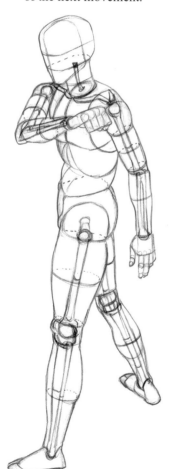

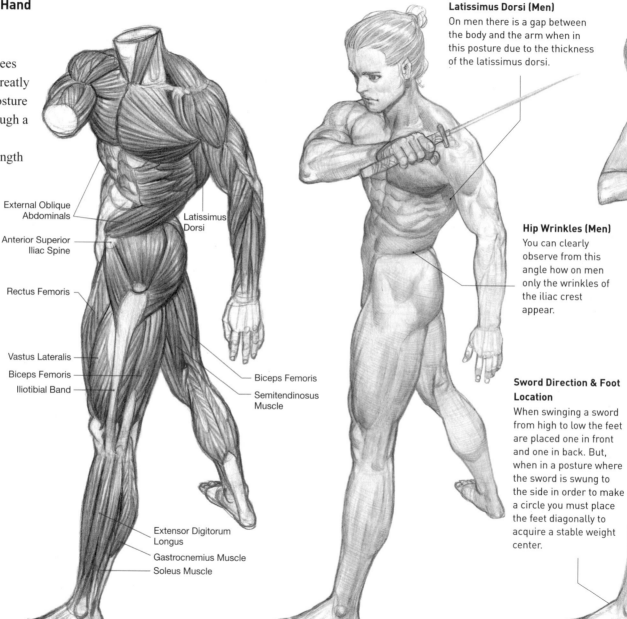

External Oblique Abdominals

Latissimus Dorsi

Anterior Superior Iliac Spine

Rectus Femoris

Vastus Lateralis

Biceps Femoris

Iliotibial Band

Biceps Femoris

Semitendinosus Muscle

Extensor Digitorum Longus

Gastrocnemius Muscle

Soleus Muscle

Latissimus Dorsi (Men)
On men there is a gap between the body and the arm when in this posture due to the thickness of the latissimus dorsi.

Hip Wrinkles (Men)
You can clearly observe from this angle how on men only the wrinkles of the iliac crest appear.

Sword Direction & Foot Location
When swinging a sword from high to low the feet are placed one in front and one in back. But, when in a posture where the sword is swung to the side in order to make a circle you must place the feet diagonally to acquire a stable weight center.

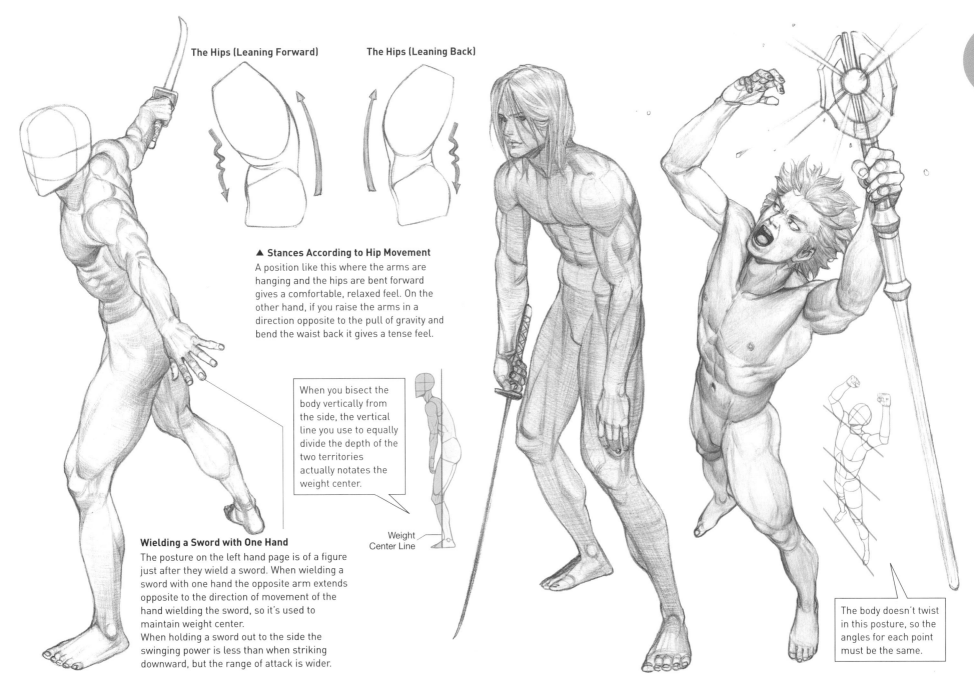

04

The Hips (Leaning Forward)

The Hips (Leaning Back)

▲ **Stances According to Hip Movement**
A position like this where the arms are hanging and the hips are bent forward gives a comfortable, relaxed feel. On the other hand, if you raise the arms in a direction opposite to the pull of gravity and bend the waist back it gives a tense feel.

When you bisect the body vertically from the side, the vertical line you use to equally divide the depth of the two territories actually notates the weight center.

Weight Center Line

Wielding a Sword with One Hand
The posture on the left hand page is of a figure just after they wield a sword. When wielding a sword with one hand the opposite arm extends opposite to the direction of movement of the hand wielding the sword, so it's used to maintain weight center.
When holding a sword out to the side the swinging power is less than when striking downward, but the range of attack is wider.

The body doesn't twist in this posture, so the angles for each point must be the same.

■ Holding a Sword Vertically Close to the Face

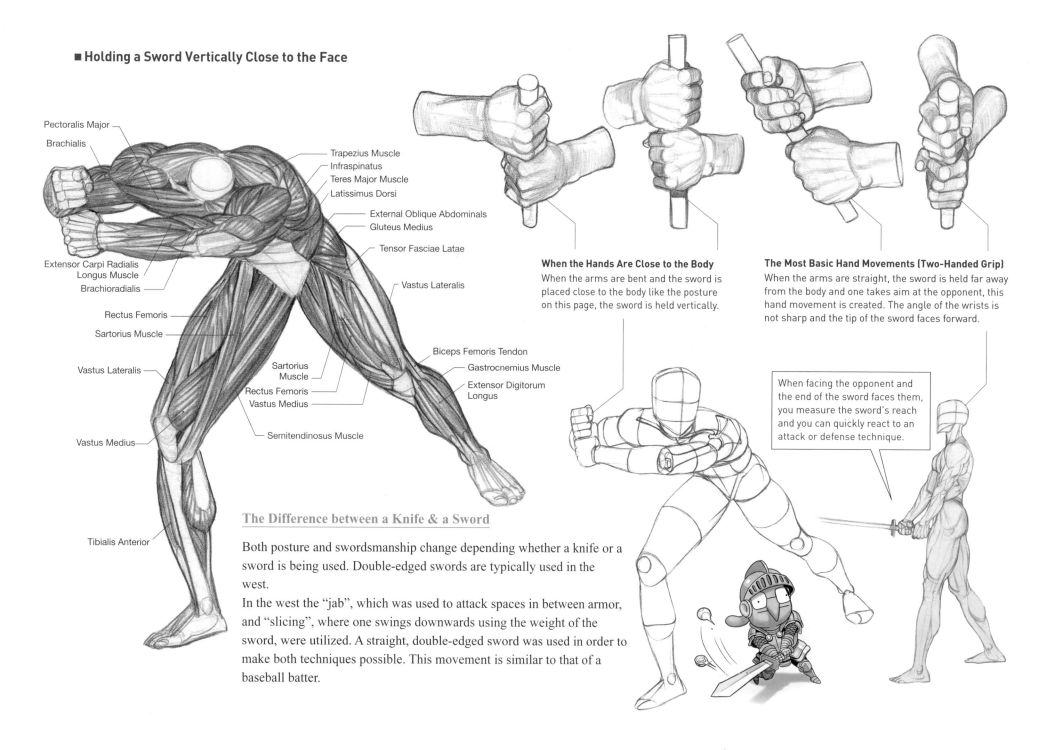

Pectoralis Major

Brachialis

Trapezius Muscle
Infraspinatus
Teres Major Muscle
Latissimus Dorsi

External Oblique Abdominals
Gluteus Medius

Tensor Fasciae Latae

Extensor Carpi Radialis
Longus Muscle
Brachioradialis

Vastus Lateralis

Rectus Femoris

Sartorius Muscle

Biceps Femoris Tendon

Vastus Lateralis

Sartorius
Muscle

Gastrocnemius Muscle

Rectus Femoris

Extensor Digitorum
Longus

Vastus Medius

Vastus Medius

Semitendinosus Muscle

Tibialis Anterior

When the Hands Are Close to the Body
When the arms are bent and the sword is placed close to the body like the posture on this page, the sword is held vertically.

The Most Basic Hand Movements (Two-Handed Grip)
When the arms are straight, the sword is held far away from the body and one takes aim at the opponent, this hand movement is created. The angle of the wrists is not sharp and the tip of the sword faces forward.

When facing the opponent and the end of the sword faces them, you measure the sword's reach and you can quickly react to an attack or defense technique.

The Difference between a Knife & a Sword

Both posture and swordsmanship change depending whether a knife or a sword is being used. Double-edged swords are typically used in the west.

In the west the "jab", which was used to attack spaces in between armor, and "slicing", where one swings downwards using the weight of the sword, were utilized. A straight, double-edged sword was used in order to make both techniques possible. This movement is similar to that of a baseball batter.

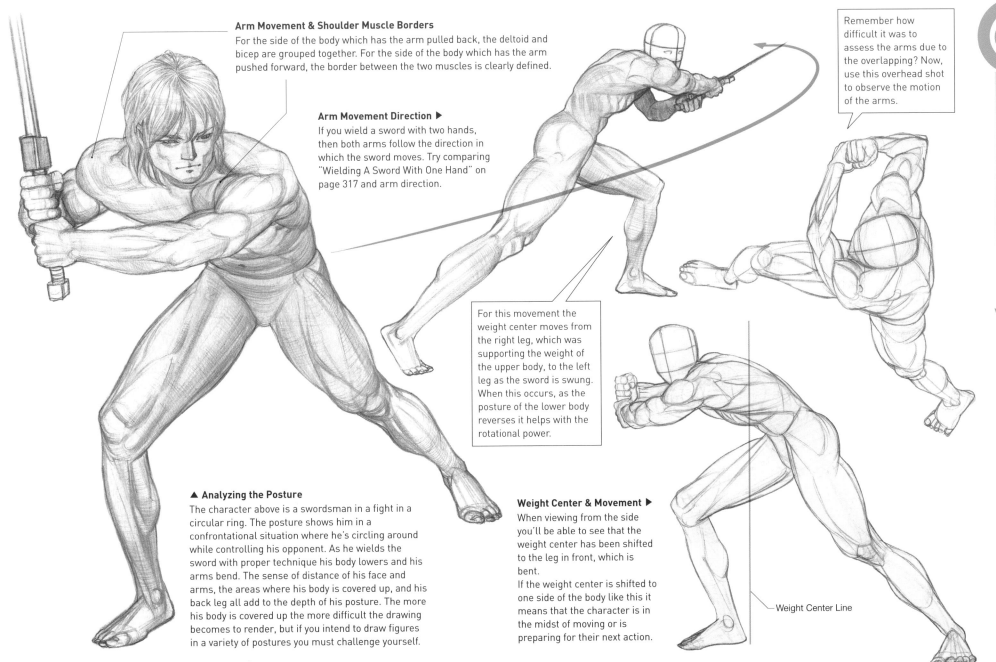

Arm Movement & Shoulder Muscle Borders
For the side of the body which has the arm pulled back, the deltoid and bicep are grouped together. For the side of the body which has the arm pushed forward, the border between the two muscles is clearly defined.

Arm Movement Direction ▶
If you wield a sword with two hands, then both arms follow the direction in which the sword moves. Try comparing "Wielding A Sword With One Hand" on page 317 and arm direction.

Remember how difficult it was to assess the arms due to the overlapping? Now, use this overhead shot to observe the motion of the arms.

For this movement the weight center moves from the right leg, which was supporting the weight of the upper body, to the left leg as the sword is swung. When this occurs, as the posture of the lower body reverses it helps with the rotational power.

▲ Analyzing the Posture
The character above is a swordsman in a fight in a circular ring. The posture shows him in a confrontational situation where he's circling around while controlling his opponent. As he wields the sword with proper technique his body lowers and his arms bend. The sense of distance of his face and arms, the areas where his body is covered up, and his back leg all add to the depth of his posture. The more his body is covered up the more difficult the drawing becomes to render, but if you intend to draw figures in a variety of postures you must challenge yourself.

Weight Center & Movement ▶
When viewing from the side you'll be able to see that the weight center has been shifted to the leg in front, which is bent.
If the weight center is shifted to one side of the body like this it means that the character is in the midst of moving or is preparing for their next action.

Weight Center Line

■ Ready Posture

Defensive Posture

This character is displaying a posture where it's facing an opponent in a ready posture with the side of the body turned towards the opponent in order to protect the heart from a jab.

Passive Lower Body Flow ▶

If you can't decisively bring your leg back then it makes a posture that feels awkward.

The character is standing still, but the curved angle of the lower body creates a dynamic flow.

Dividing Up the Neck

If you look at the neck from the side it's largely divided up into four sections. The sternocleidomastoid muscle protrudes the most. Use it to observe and distinguish between the different sections.

The Sternocleidomastoid Muscle - Contracting

If you contract the left sternocleidomastoid muscle, then the head turns towards the right.

Changes in the Sections (1) ▶

The blue area located in between the sternocleidomastoid and upper trapezius muscles widen and becomes thinner according to the direction in which the head turns. When in this posture the blue area is as wide as it gets. The upper trapezius muscle is connected to the lower part of the back of the head, so you see it as much as you can see the back of the head.

Changes in the Sections (2) ▶

If the head is turned like this the red area appears the smallest, but the blue area on the opposite side of the neck widens. You can't see the back of the head, so nor are you able to see the upper trapezius.

Sternocleidomastoid Muscle

Upper Trapezius Muscle

Sternocleidomastoid Muscle (Relaxed)

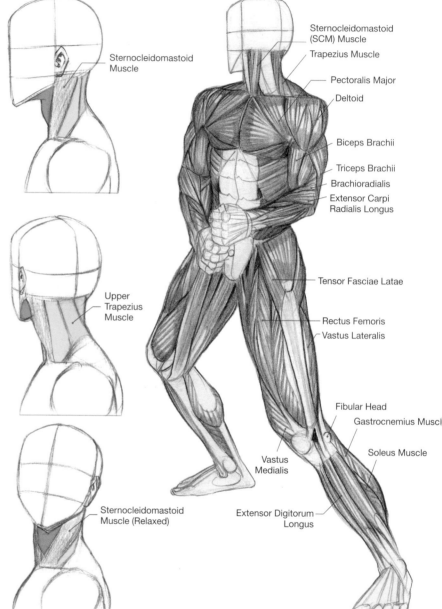
Sternocleidomastoid (SCM) Muscle

Trapezius Muscle

Pectoralis Major

Deltoid

Biceps Brachii

Triceps Brachii

Brachioradialis

Extensor Carpi Radialis Longus

Tensor Fasciae Latae

Rectus Femoris

Vastus Lateralis

Fibular Head

Gastrocnemius Muscl

Soleus Muscle

Vastus Medialis

Extensor Digitorum Longus

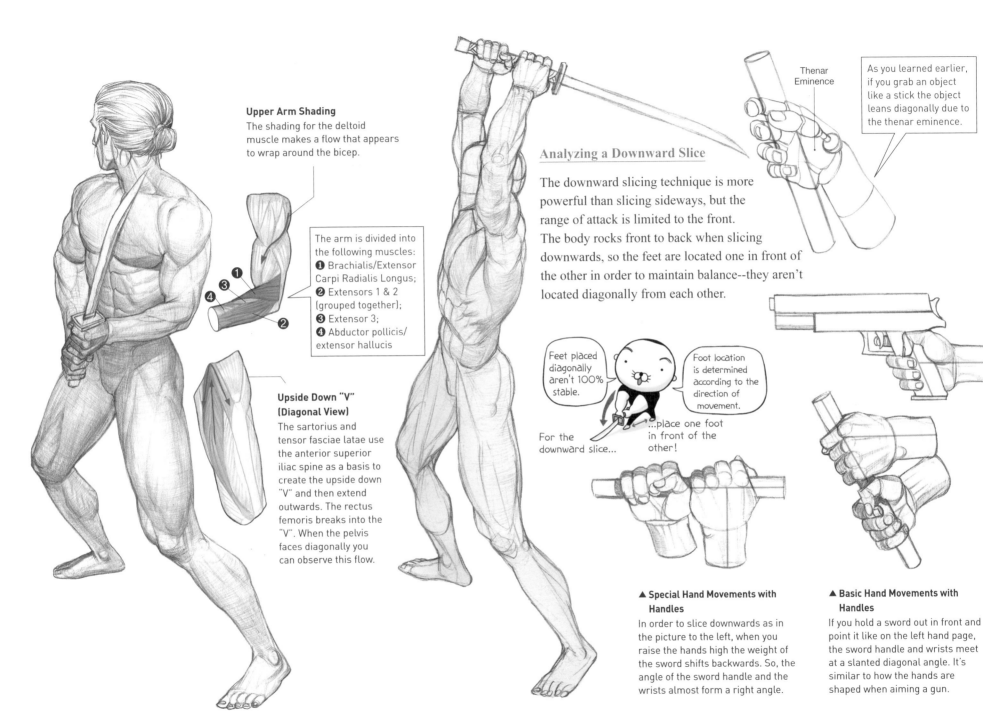

Upper Arm Shading

The shading for the deltoid muscle makes a flow that appears to wrap around the bicep.

The arm is divided into the following muscles:
❶ Brachialis/Extensor Carpi Radialis Longus;
❷ Extensors 1 & 2 (grouped together);
❸ Extensor 3;
❹ Abductor pollicis/ extensor hallucis

Upside Down "V" (Diagonal View)

The sartorius and tensor fasciae latae use the anterior superior iliac spine as a basis to create the upside down "V" and then extend outwards. The rectus femoris breaks into the "V". When the pelvis faces diagonally you can observe this flow.

Analyzing a Downward Slice

The downward slicing technique is more powerful than slicing sideways, but the range of attack is limited to the front. The body rocks front to back when slicing downwards, so the feet are located one in front of the other in order to maintain balance--they aren't located diagonally from each other.

Thenar Eminence

As you learned earlier, if you grab an object like a stick the object leans diagonally due to the thenar eminence.

Feet placed diagonally aren't 100% stable.

Foot location is determined according to the direction of movement.

For the downward slice...

...place one foot in front of the other!

▲ **Special Hand Movements with Handles**

In order to slice downwards as in the picture to the left, when you raise the hands high the weight of the sword shifts backwards. So, the angle of the sword handle and the wrists almost form a right angle.

▲ **Basic Hand Movements with Handles**

If you hold a sword out in front and point it like on the left hand page, the sword handle and wrists meet at a slanted diagonal angle. It's similar to how the hands are shaped when aiming a gun.

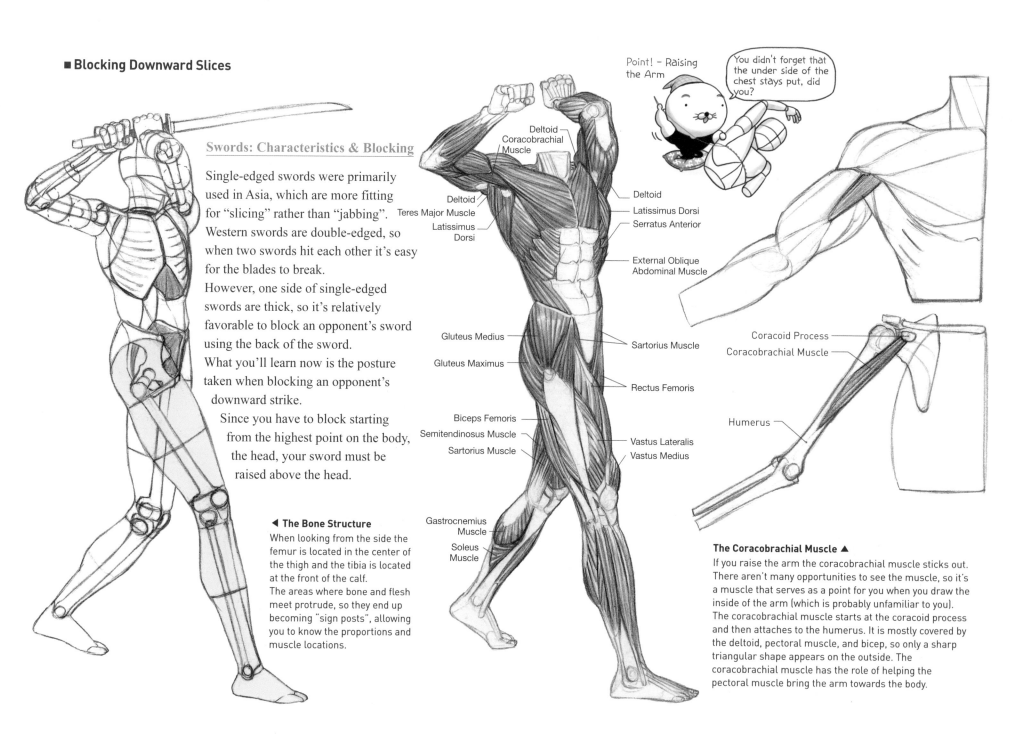

■ Blocking Downward Slices

Swords: Characteristics & Blocking

Single-edged swords were primarily used in Asia, which are more fitting for "slicing" rather than "jabbing". Western swords are double-edged, so when two swords hit each other it's easy for the blades to break.

However, one side of single-edged swords are thick, so it's relatively favorable to block an opponent's sword using the back of the sword.

What you'll learn now is the posture taken when blocking an opponent's downward strike.

Since you have to block starting from the highest point on the body, the head, your sword must be raised above the head.

◀ **The Bone Structure**
When looking from the side the femur is located in the center of the thigh and the tibia is located at the front of the calf.
The areas where bone and flesh meet protrude, so they end up becoming "sign posts", allowing you to know the proportions and muscle locations.

Point! – Raising the Arm

You didn't forget that the under side of the chest stays put, did you?

Deltoid
Coracobrachial Muscle

Deltoid
Teres Major Muscle
Latissimus Dorsi

Deltoid
Latissimus Dorsi
Serratus Anterior

External Oblique Abdominal Muscle

Gluteus Medius
Gluteus Maximus

Sartorius Muscle

Rectus Femoris

Biceps Femoris
Semitendinosus Muscle
Sartorius Muscle

Vastus Lateralis
Vastus Medius

Gastrocnemius Muscle
Soleus Muscle

Coracoid Process
Coracobrachial Muscle

Humerus

The Coracobrachial Muscle ▲
If you raise the arm the coracobrachial muscle sticks out. There aren't many opportunities to see the muscle, so it's a muscle that serves as a point for you when you draw the inside of the arm (which is probably unfamiliar to you).
The coracobrachial muscle starts at the coracoid process and then attaches to the humerus. It is mostly covered by the deltoid, pectoral muscle, and bicep, so only a sharp triangular shape appears on the outside. The coracobrachial muscle has the role of helping the pectoral muscle bring the arm towards the body.

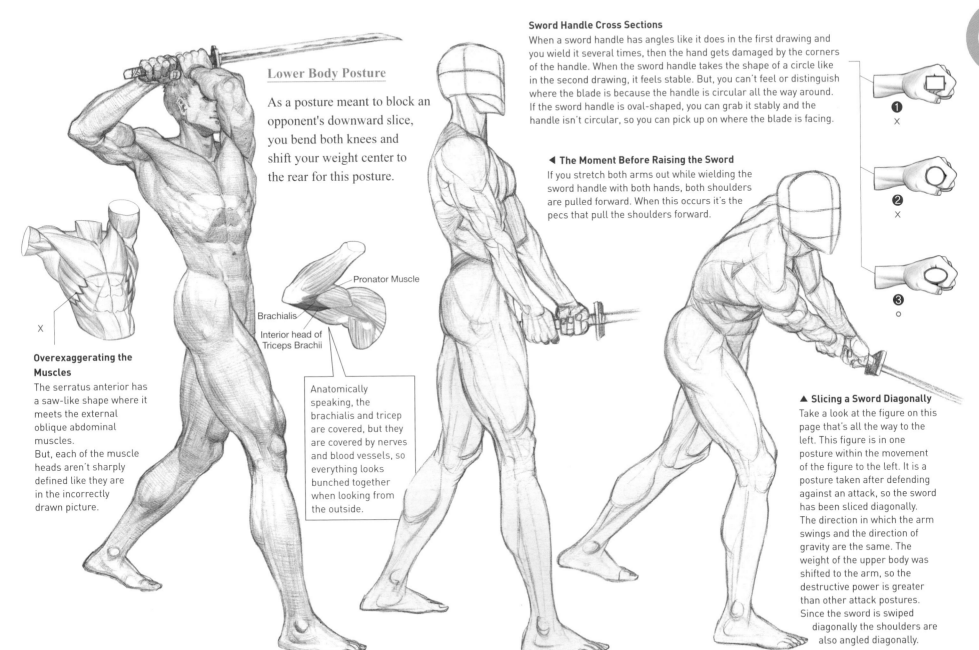

Lower Body Posture

As a posture meant to block an opponent's downward slice, you bend both knees and shift your weight center to the rear for this posture.

Overexaggerating the Muscles

The serratus anterior has a saw-like shape where it meets the external oblique abdominal muscles.
But, each of the muscle heads aren't sharply defined like they are in the incorrectly drawn picture.

Pronator Muscle

Brachialis

Interior head of Triceps Brachii

Anatomically speaking, the brachialis and tricep are covered, but they are covered by nerves and blood vessels, so everything looks bunched together when looking from the outside.

Sword Handle Cross Sections

When a sword handle has angles like it does in the first drawing and you wield it several times, then the hand gets damaged by the corners of the handle. When the sword handle takes the shape of a circle like in the second drawing, it feels stable. But, you can't feel or distinguish where the blade is because the handle is circular all the way around. If the sword handle is oval-shaped, you can grab it stably and the handle isn't circular, so you can pick up on where the blade is facing.

❶
X

❷
X

❸
○

◀ The Moment Before Raising the Sword

If you stretch both arms out while wielding the sword handle with both hands, both shoulders are pulled forward. When this occurs it's the pecs that pull the shoulders forward.

▲ Slicing a Sword Diagonally

Take a look at the figure on this page that's all the way to the left. This figure is in one posture within the movement of the figure to the left. It is a posture taken after defending against an attack, so the sword has been sliced diagonally. The direction in which the arm swings and the direction of gravity are the same. The weight of the upper body was shifted to the arm, so the destructive power is greater than other attack postures. Since the sword is swiped diagonally the shoulders are also angled diagonally.

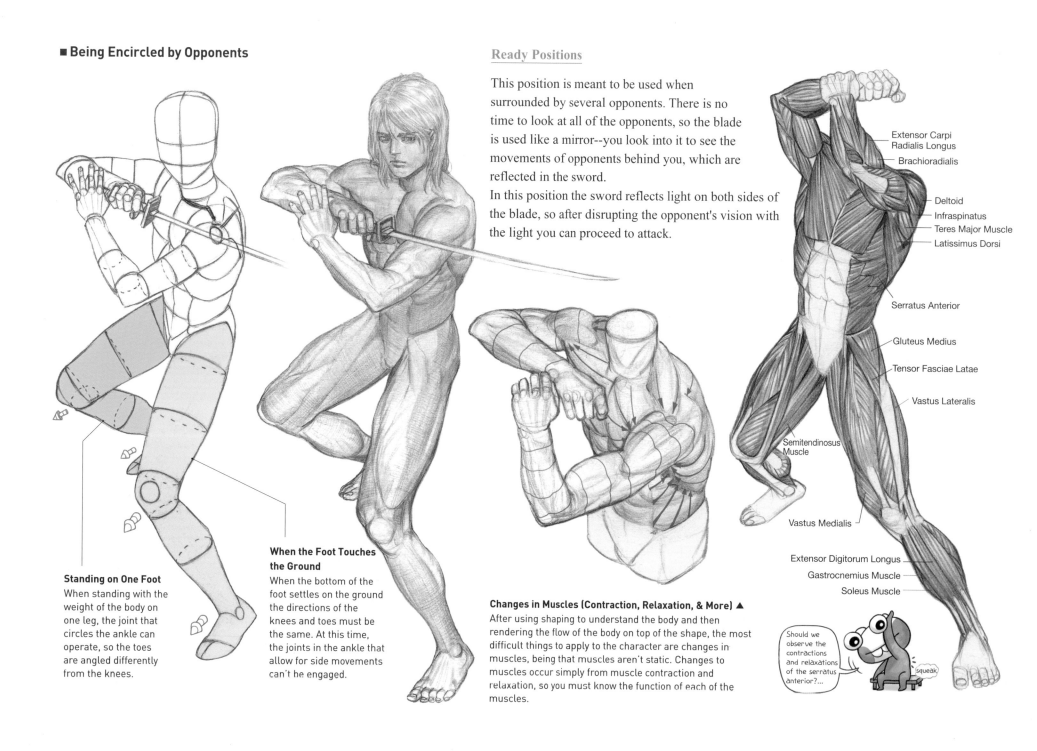

■ Being Encircled by Opponents

Ready Positions

This position is meant to be used when surrounded by several opponents. There is no time to look at all of the opponents, so the blade is used like a mirror--you look into it to see the movements of opponents behind you, which are reflected in the sword.

In this position the sword reflects light on both sides of the blade, so after disrupting the opponent's vision with the light you can proceed to attack.

Extensor Carpi Radialis Longus

Brachioradialis

Deltoid

Infraspinatus

Teres Major Muscle

Latissimus Dorsi

Serratus Anterior

Gluteus Medius

Tensor Fasciae Latae

Vastus Lateralis

Semitendinosus Muscle

Vastus Medialis

Extensor Digitorum Longus

Gastrocnemius Muscle

Soleus Muscle

Standing on One Foot
When standing with the weight of the body on one leg, the joint that circles the ankle can operate, so the toes are angled differently from the knees.

When the Foot Touches the Ground
When the bottom of the foot settles on the ground the directions of the knees and toes must be the same. At this time, the joints in the ankle that allow for side movements can't be engaged.

Changes in Muscles (Contraction, Relaxation, & More) ▲
After using shaping to understand the body and then rendering the flow of the body on top of the shape, the most difficult things to apply to the character are changes in muscles, being that muscles aren't static. Changes to muscles occur simply from muscle contraction and relaxation, so you must know the function of each of the muscles.

Should we observe the contractions and relaxations of the serratus anterior?...

squeak

■ Diagonal Slice Posture

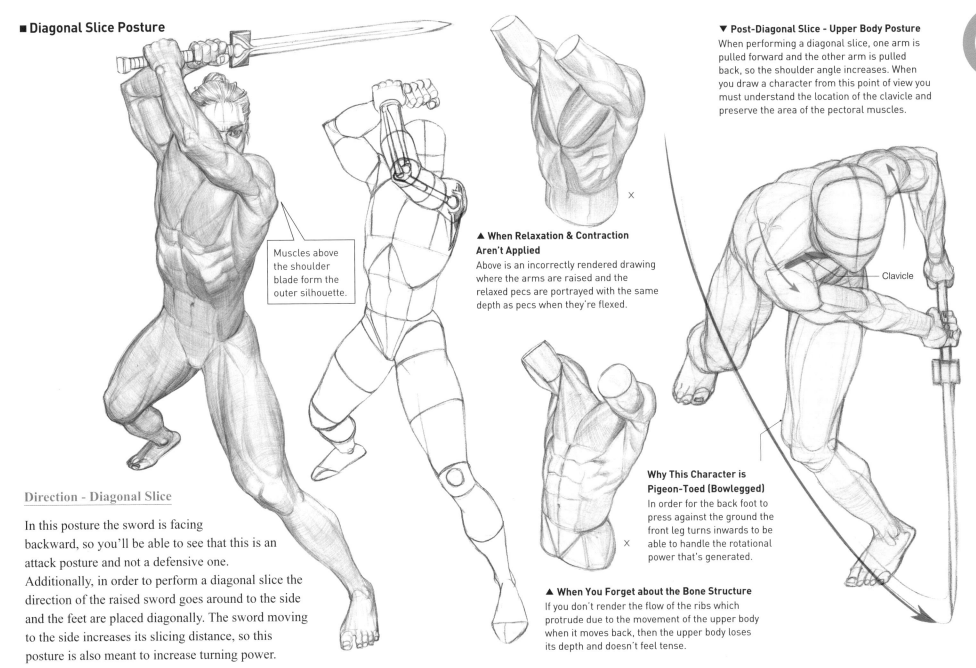

Muscles above the shoulder blade form the outer silhouette.

▼ Post-Diagonal Slice - Upper Body Posture
When performing a diagonal slice, one arm is pulled forward and the other arm is pulled back, so the shoulder angle increases. When you draw a character from this point of view you must understand the location of the clavicle and preserve the area of the pectoral muscles.

Clavicle

▲ When Relaxation & Contraction Aren't Applied
Above is an incorrectly rendered drawing where the arms are raised and the relaxed pecs are portrayed with the same depth as pecs when they're flexed.

Why This Character is Pigeon-Toed (Bowlegged)
In order for the back foot to press against the ground the front leg turns inwards to be able to handle the rotational power that's generated.

▲ When You Forget about the Bone Structure
If you don't render the flow of the ribs which protrude due to the movement of the upper body when it moves back, then the upper body loses its depth and doesn't feel tense.

Direction - Diagonal Slice

In this posture the sword is facing backward, so you'll be able to see that this is an attack posture and not a defensive one.
Additionally, in order to perform a diagonal slice the direction of the raised sword goes around to the side and the feet are placed diagonally. The sword moving to the side increases its slicing distance, so this posture is also meant to increase turning power.

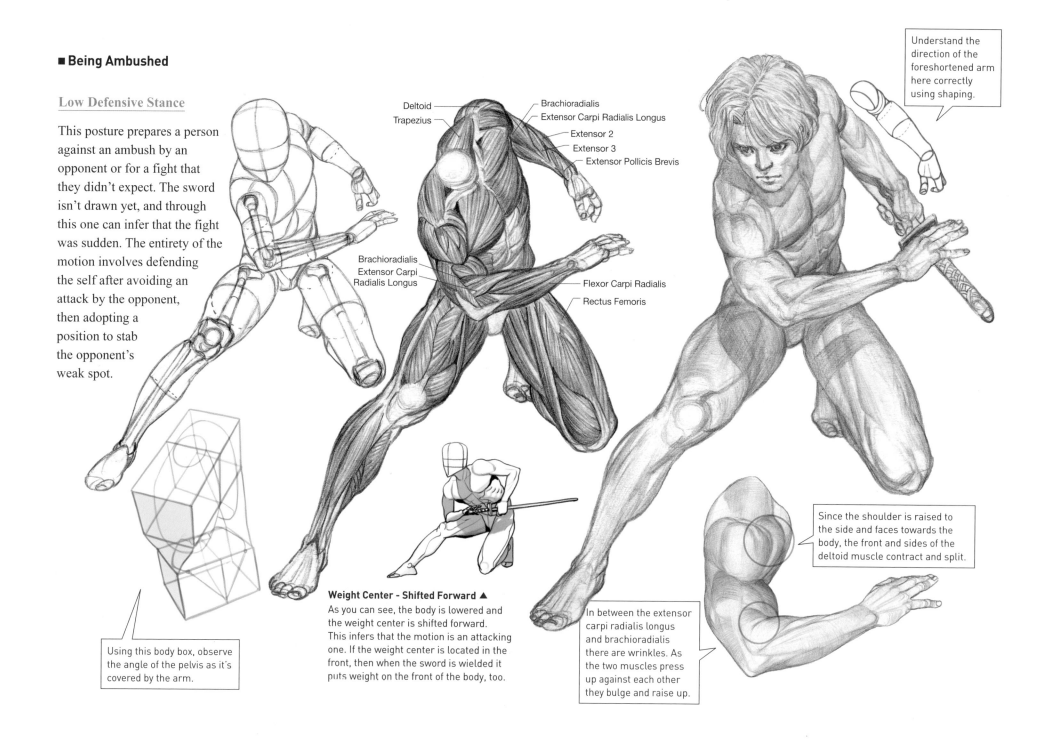

■ Being Ambushed

Low Defensive Stance

This posture prepares a person against an ambush by an opponent or for a fight that they didn't expect. The sword isn't drawn yet, and through this one can infer that the fight was sudden. The entirety of the motion involves defending the self after avoiding an attack by the opponent, then adopting a position to stab the opponent's weak spot.

Understand the direction of the foreshortened arm here correctly using shaping.

Deltoid
Trapezius
Brachioradialis
Extensor Carpi Radialis Longus
Extensor 2
Extensor 3
Extensor Pollicis Brevis

Brachioradialis
Extensor Carpi Radialis Longus

Flexor Carpi Radialis
Rectus Femoris

Using this body box, observe the angle of the pelvis as it's covered by the arm.

Weight Center - Shifted Forward ▲
As you can see, the body is lowered and the weight center is shifted forward. This infers that the motion is an attacking one. If the weight center is located in the front, then when the sword is wielded it puts weight on the front of the body, too.

Since the shoulder is raised to the side and faces towards the body, the front and sides of the deltoid muscle contract and split.

In between the extensor carpi radialis longus and brachioradialis there are wrinkles. As the two muscles press up against each other they bulge and raise up.

Principles of Sword Drawing

The technique here happens as you quickly draw your sword from its sheath and deliver a blow to the opponent. The concept is that as the sword is drawn from its sheath friction is created, and the moment the sword comes out that energy changes into velocity. The slicing motion of the sword then creates an arc as you wield it. It's the same concept as drawing a bowstring and then releasing it. However, it's not a technique that has as much destructive power as how it's portrayed in comics—it's meant to surprise attack an opponent. In the same way gunslingers in the West would have duels to see who's the fastest at drawing their gun, it's said that Japanese samurai would also compete at sword drawing.

Centrifugal Force & Posture ▲

In order to obtain the greatest amount of centrifugal force when swinging a sword, the waist twists and the sheath also moves and turns towards the back, making a path for the sword to turn.

After Swinging One's Sword ▼

When a person swings a sword the lower body, upper body, arms, and wrists all create rotational power. Just like in the punching movements that you learned about earlier on, the strength of the lower body that comes from the back leg pressing against the ground becomes the central energy of movement. You must get acquainted with these movements, as they are applied to all postures where a character swings something. For example, the position that a baseball player at bat adopts after swinging a bat is similar to this position.

Pros & Cons of the Blades

Blades appropriate for carrying out slicing techniques have great killing power, but one can't really show off that power in war where people are wearing armor. So, spears which pierce armor, arrows, or blunt objects one can strike with like iron clubs or axes, are more useful. In Korea, outside of war time we didn't possess weaponry, so we didn't develop blades. However, in Japan the samurai class purposefully trained with blades, so they were widely used and developed.

■ One-Handed Slice (High Angle)

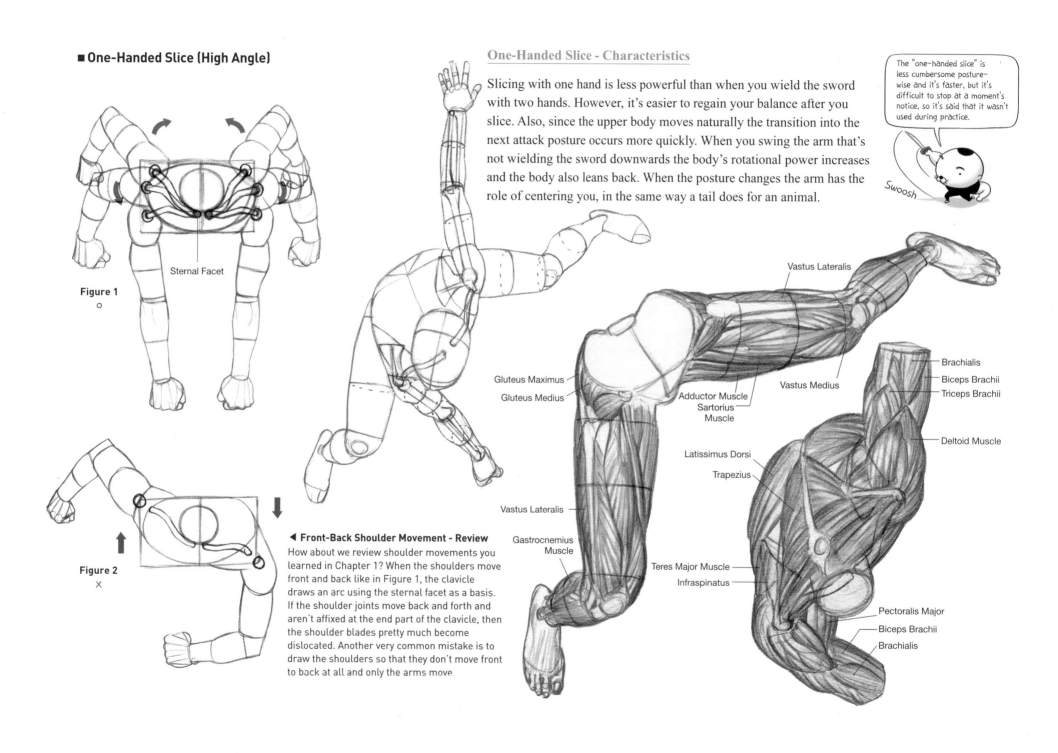

Sternal Facet

Figure 1
○

Figure 2
✕

One-Handed Slice - Characteristics

Slicing with one hand is less powerful than when you wield the sword with two hands. However, it's easier to regain your balance after you slice. Also, since the upper body moves naturally the transition into the next attack posture occurs more quickly. When you swing the arm that's not wielding the sword downwards the body's rotational power increases and the body also leans back. When the posture changes the arm has the role of centering you, in the same way a tail does for an animal.

The "one-handed slice" is less cumbersome posture-wise and it's faster, but it's difficult to stop at a moment's notice, so it's said that it wasn't used during practice.

Swoosh

◄ Front-Back Shoulder Movement - Review

How about we review shoulder movements you learned in Chapter 1? When the shoulders move front and back like in Figure 1, the clavicle draws an arc using the sternal facet as a basis. If the shoulder joints move back and forth and aren't affixed at the end part of the clavicle, then the shoulder blades pretty much become dislocated. Another very common mistake is to draw the shoulders so that they don't move front to back at all and only the arms move.

Vastus Lateralis

Gluteus Maximus

Gluteus Medius

Adductor Muscle
Sartorius Muscle

Vastus Medius

Brachialis
Biceps Brachii
Triceps Brachii

Deltoid Muscle

Latissimus Dorsi

Trapezius

Vastus Lateralis

Gastrocnemius Muscle

Teres Major Muscle

Infraspinatus

Pectoralis Major

Biceps Brachii

Brachialis

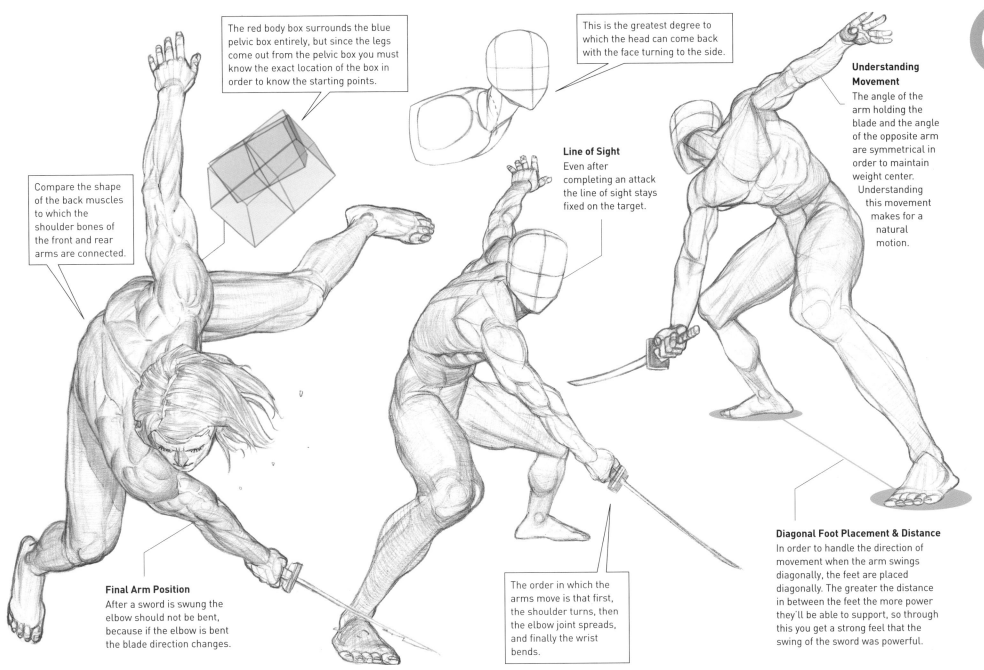

The red body box surrounds the blue pelvic box entirely, but since the legs come out from the pelvic box you must know the exact location of the box in order to know the starting points.

This is the greatest degree to which the head can come back with the face turning to the side.

Understanding Movement
The angle of the arm holding the blade and the angle of the opposite arm are symmetrical in order to maintain weight center. Understanding this movement makes for a natural motion.

Compare the shape of the back muscles to which the shoulder bones of the front and rear arms are connected.

Line of Sight
Even after completing an attack the line of sight stays fixed on the target.

Final Arm Position
After a sword is swung the elbow should not be bent, because if the elbow is bent the blade direction changes.

The order in which the arms move is that first, the shoulder turns, then the elbow joint spreads, and finally the wrist bends.

Diagonal Foot Placement & Distance
In order to handle the direction of movement when the arm swings diagonally, the feet are placed diagonally. The greater the distance in between the feet the more power they'll be able to support, so through this you get a strong feel that the swing of the sword was powerful.

■ After a Single Strike

Diagonal Slice

This posture is one where moving energy dissipates after performing a single strike. You are keeping an eye on the opponent or you have knocked them down, so you don't have to prepare for the next attack. You're not heavily concentrated and nor is all tension released. So, you can imagine a variety of situations that can be occurring.

◀ Hand Direction & Arm Flow

The palm of the red arm is facing forward. On this arm, the ulna and radius sit side-by-side. The back of the blue arm is facing forward. On this arm, the ulna and radius are twisted into an "X" shape. The overall flow of the blue arm for which the bones are twisted is straight, while the flow of the red arm for which the bones aren't twisted takes a turn at one point.

◀ Immobile Shoulders

In this picture the shoulders don't move front and back--only the arms move. This is the most common mistake when it comes to shoulder movement. In this case, the motion becomes stiff, so the drawing appears unnatural.

For the postures on this page the shoulder corresponding to the hand holding the sword is pulled forward, while the shoulder of the opposite arm is pulled back.

Brachialis
Brachioradialis
Pronator Muscle

Infraspinatus
Teres Major Muscle
Deltoid

Trapezius
Pectoralis Major

Sartorius Muscle

Vastus Medius

Tibialis Anterior
Gastrocnemius Muscle
Soleus Muscle

Hiyah!
Shing!
Swoosh

Thud

I have won this duel.

▲ Changes in Shape from the Movement

Using an angle identical to the drawings on this page, let's take a look at how the structure changes anatomically or externally when the front arm is brought back. When the arm is brought out front the pecs contract and the trapezius muscle relaxes. But, if the arm is brought back, it's the opposite-- the pecs relax and the trapezius contracts.

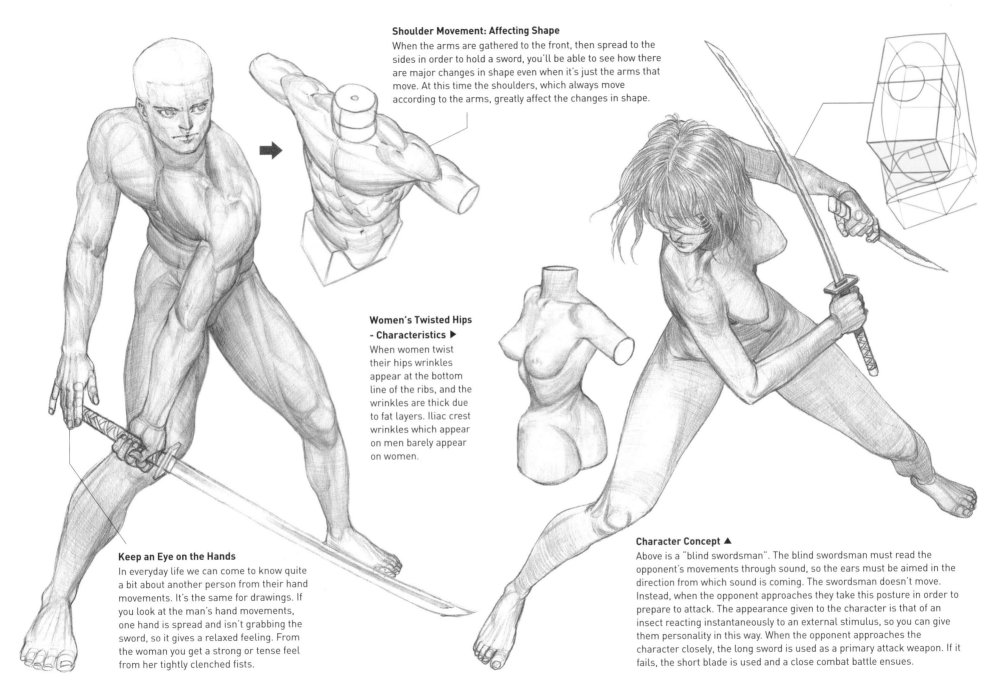

Shoulder Movement: Affecting Shape

When the arms are gathered to the front, then spread to the sides in order to hold a sword, you'll be able to see how there are major changes in shape even when it's just the arms that move. At this time the shoulders, which always move according to the arms, greatly affect the changes in shape.

Women's Twisted Hips - Characteristics ▶

When women twist their hips wrinkles appear at the bottom line of the ribs, and the wrinkles are thick due to fat layers. Iliac crest wrinkles which appear on men barely appear on women.

Keep an Eye on the Hands

In everyday life we can come to know quite a bit about another person from their hand movements. It's the same for drawings. If you look at the man's hand movements, one hand is spread and isn't grabbing the sword, so it gives a relaxed feeling. From the woman you get a strong or tense feel from her tightly clenched fists.

Character Concept ▲

Above is a "blind swordsman". The blind swordsman must read the opponent's movements through sound, so the ears must be aimed in the direction from which sound is coming. The swordsman doesn't move. Instead, when the opponent approaches they take this posture in order to prepare to attack. The appearance given to the character is that of an insect reacting instantaneously to an external stimulus, so you can give them personality in this way. When the opponent approaches the character closely, the long sword is used as a primary attack weapon. If it fails, the short blade is used and a close combat battle ensues.

■ Slicing to the Side

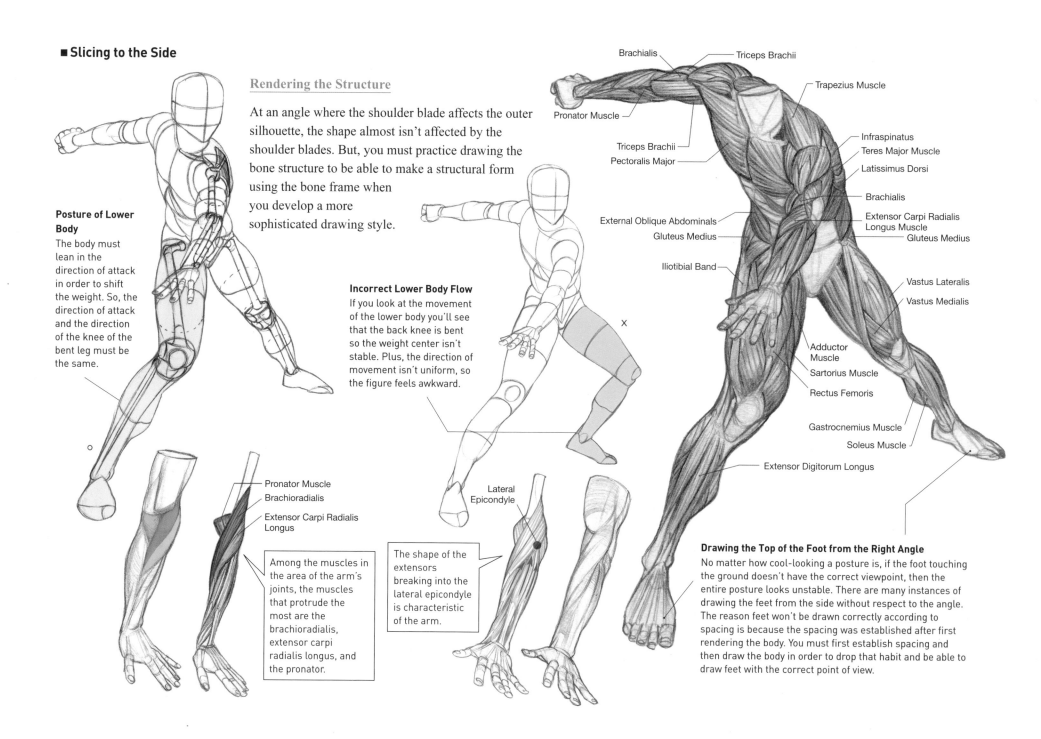

Rendering the Structure

At an angle where the shoulder blade affects the outer silhouette, the shape almost isn't affected by the shoulder blades. But, you must practice drawing the bone structure to be able to make a structural form using the bone frame when you develop a more sophisticated drawing style.

Posture of Lower Body
The body must lean in the direction of attack in order to shift the weight. So, the direction of attack and the direction of the knee of the bent leg must be the same.

Incorrect Lower Body Flow
If you look at the movement of the lower body you'll see that the back knee is bent so the weight center isn't stable. Plus, the direction of movement isn't uniform, so the figure feels awkward.

Pronator Muscle
Brachioradialis
Extensor Carpi Radialis Longus

Among the muscles in the area of the arm's joints, the muscles that protrude the most are the brachioradialis, extensor carpi radialis longus, and the pronator.

The shape of the extensors breaking into the lateral epicondyle is characteristic of the arm.

Lateral Epicondyle

Brachialis — Triceps Brachii
Pronator Muscle
Triceps Brachii
Pectoralis Major
External Oblique Abdominals
Gluteus Medius
Iliotibial Band
Adductor Muscle
Sartorius Muscle
Rectus Femoris
Gastrocnemius Muscle
Soleus Muscle
Extensor Digitorum Longus

Trapezius Muscle
Infraspinatus
Teres Major Muscle
Latissimus Dorsi
Brachialis
Extensor Carpi Radialis Longus Muscle
Gluteus Medius
Vastus Lateralis
Vastus Medialis

Drawing the Top of the Foot from the Right Angle
No matter how cool-looking a posture is, if the foot touching the ground doesn't have the correct viewpoint, then the entire posture looks unstable. There are many instances of drawing the feet from the side without respect to the angle. The reason feet won't be drawn correctly according to spacing is because the spacing was established after first rendering the body. You must first establish spacing and then draw the body in order to drop that habit and be able to draw feet with the correct point of view.

Analyzing Postures

Here is a posture taken after slicing to the side with a dagger. The dagger is lighter than a long sword, so it doesn't heavily affect the weight center. Postures change in accordance with the weight of the weapon being held.

The Eyes

The direction of the eyes must be the same both before and after swinging a sword. Using the eyes you can measure the range of attack and degree to which the body twists.

The Arms & Rotation

Like the other posture in which a character swings the sword sideways, the body twists as far as it can, making a path for rotation to occur. The arms face opposite directions and when the sword is swung the arms maintain that posture and the body turns just like a top does when you spin it.

The Depth of the Thoracic Cage

If you don't render the depth of the thoracic cage and the body's central line has a straight flow like in the incorrectly drawn figure, then the upper body becomes flat, which is incorrect.

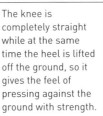

The knee is completely straight while at the same time the heel is lifted off the ground, so it gives the feel of pressing against the ground with strength.

Item Weight ▲

In the same way that you can look at someone and determine the weight of an item they are carrying by that person's weight center, when drawing you must render body flow differently according to the item's weight.
If you render weight and it's sloppy, then readers will be less immersed in the drawing.

Light & Heavy Objects ▲

When lifting a heavy object there are many instances where the angle of the arms slant and the person uses both hands to lift. In this case, the person will bring the object close to the body. The lighter the object the more free the arms are to move. In the above picture the arms are stretched out to the side away from the body, so you can infer that the object is light.

When you swing a sword, the bent leg in the rear spreads while the body's torque increases.

■ Wielding Daggers in Both Hands

Concealing the Body

In this posture the knees are bent and the body is lowered as much as possible, so you can guess that the character is hiding themselves. Both hands are holding a dagger and the arms create an "X". The body's depth is decreased as much as possible, and the character can conceal themselves while simultaneously attack, so this is an effective posture. The weight center is shifted to the rear, so it's a defensive posture first before being an attack posture.

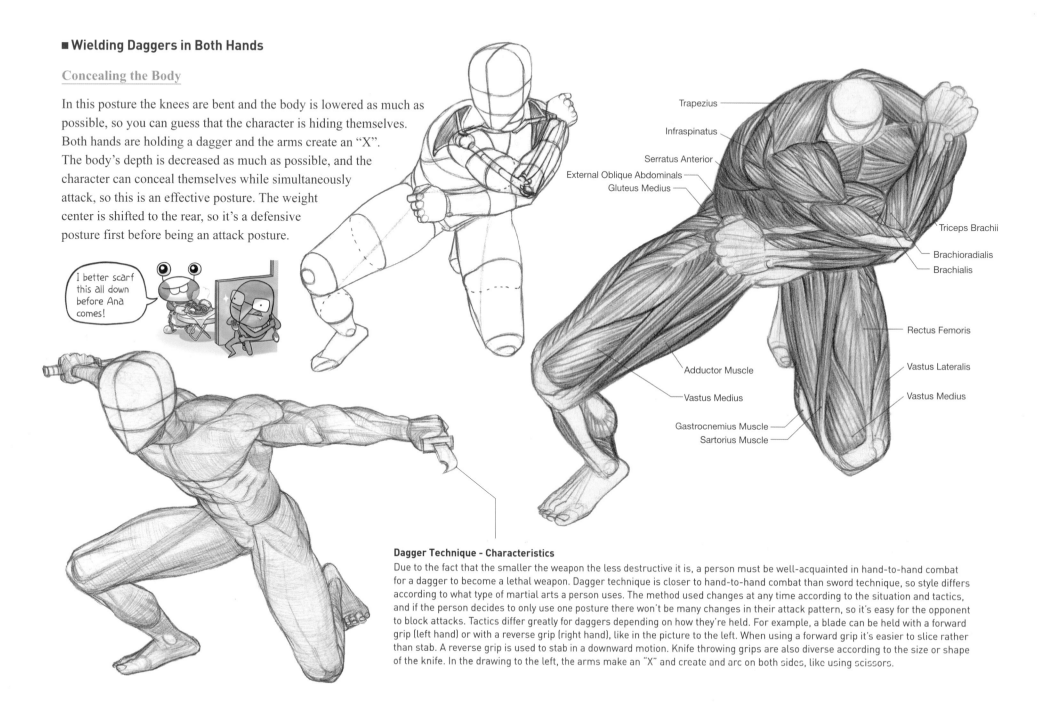

I better scarf this all down before Ana comes!

Trapezius
Infraspinatus
Serratus Anterior
External Oblique Abdominals
Gluteus Medius
Triceps Brachii
Brachioradialis
Brachialis
Rectus Femoris
Adductor Muscle
Vastus Lateralis
Vastus Medius
Vastus Medius
Gastrocnemius Muscle
Sartorius Muscle

Dagger Technique - Characteristics

Due to the fact that the smaller the weapon the less destructive it is, a person must be well-acquainted in hand-to-hand combat for a dagger to become a lethal weapon. Dagger technique is closer to hand-to-hand combat than sword technique, so style differs according to what type of martial arts a person uses. The method used changes at any time according to the situation and tactics, and if the person decides to only use one posture there won't be many changes in their attack pattern, so it's easy for the opponent to block attacks. Tactics differ greatly for daggers depending on how they're held. For example, a blade can be held with a forward grip (left hand) or with a reverse grip (right hand), like in the picture to the left. When using a forward grip it's easier to slice rather than stab. A reverse grip is used to stab in a downward motion. Knife throwing grips are also diverse according to the size or shape of the knife. In the drawing to the left, the arms make an "X" and create and arc on both sides, like using scissors.

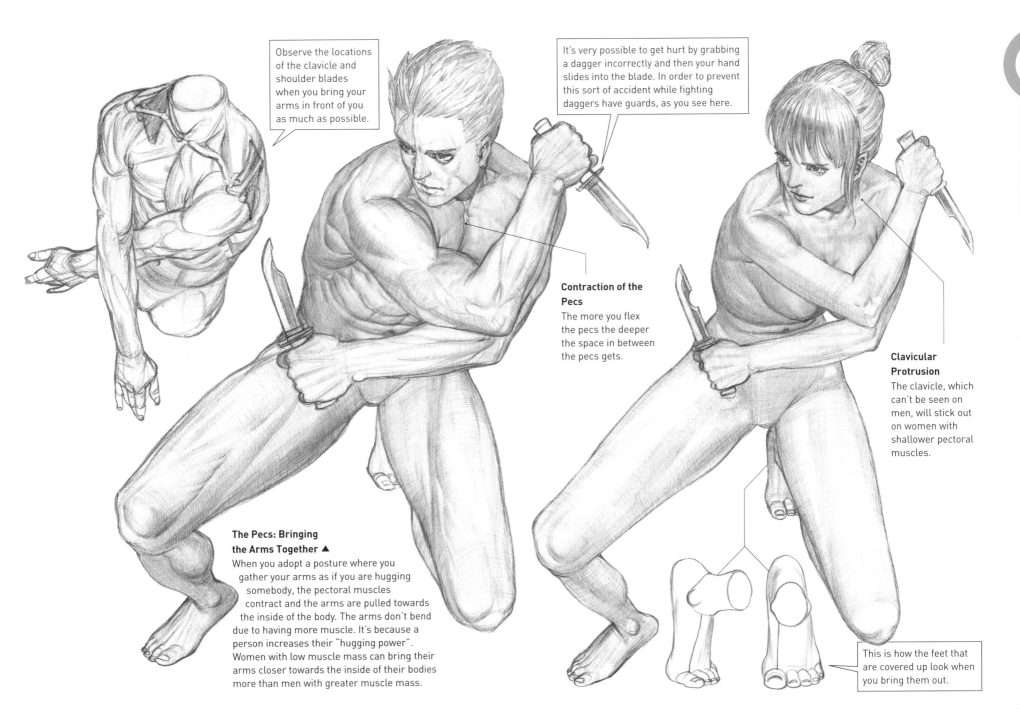

Observe the locations of the clavicle and shoulder blades when you bring your arms in front of you as much as possible.

It's very possible to get hurt by grabbing a dagger incorrectly and then your hand slides into the blade. In order to prevent this sort of accident while fighting daggers have guards, as you see here.

Contraction of the Pecs
The more you flex the pecs the deeper the space in between the pecs gets.

The Pecs: Bringing the Arms Together ▲
When you adopt a posture where you gather your arms as if you are hugging somebody, the pectoral muscles contract and the arms are pulled towards the inside of the body. The arms don't bend due to having more muscle. It's because a person increases their "hugging power". Women with low muscle mass can bring their arms closer towards the inside of their bodies more than men with greater muscle mass.

Clavicular Protrusion
The clavicle, which can't be seen on men, will stick out on women with shallower pectoral muscles.

This is how the feet that are covered up look when you bring them out.

■ Wielding Staffs (1)

Analyzing Postures & the Origins of Staff Fighting

This posture is meant to allow for turning or swinging a staff. If you erect the upper body just a bit, the posture is very similar to that of a baseball player at bat just before they swing. You attack and defend using the torque of a long staff when you turn it. When you do this it also has the effect of confusing the opponent. Staff technique primarily defends against an opponent's attack. Nowadays, staffs are used for practice, while blades and spears are carried during actual battle.

Even for soldiers who haven't practiced a great deal, they can execute a simple attack by facing an approaching enemy and stabbing them, so spears were the most widely used weapon.

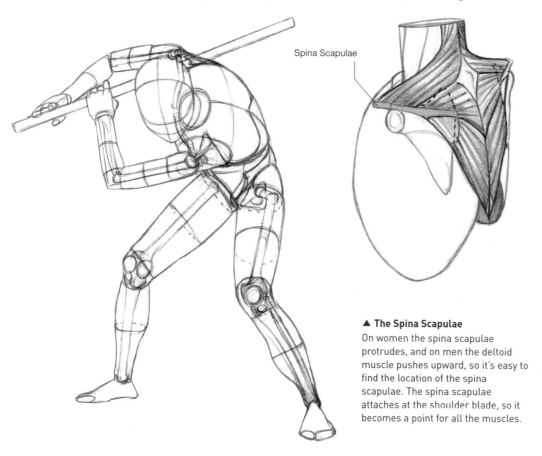

Spina Scapulae

▲ The Spina Scapulae
On women the spina scapulae protrudes, and on men the deltoid muscle pushes upward, so it's easy to find the location of the spina scapulae. The spina scapulae attaches at the shoulder blade, so it becomes a point for all the muscles.

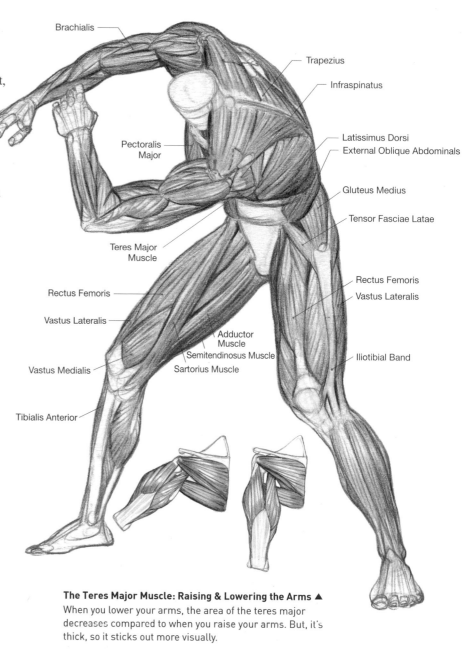

Brachialis
Trapezius
Infraspinatus
Latissimus Dorsi
External Oblique Abdominals
Pectoralis Major
Gluteus Medius
Tensor Fasciae Latae
Teres Major Muscle
Rectus Femoris
Rectus Femoris
Vastus Lateralis
Vastus Lateralis
Iliotibial Band
Adductor Muscle
Semitendinosus Muscle
Vastus Medialis
Sartorius Muscle
Tibialis Anterior

The Teres Major Muscle: Raising & Lowering the Arms ▲
When you lower your arms, the area of the teres major decreases compared to when you raise your arms. But, it's thick, so it sticks out more visually.

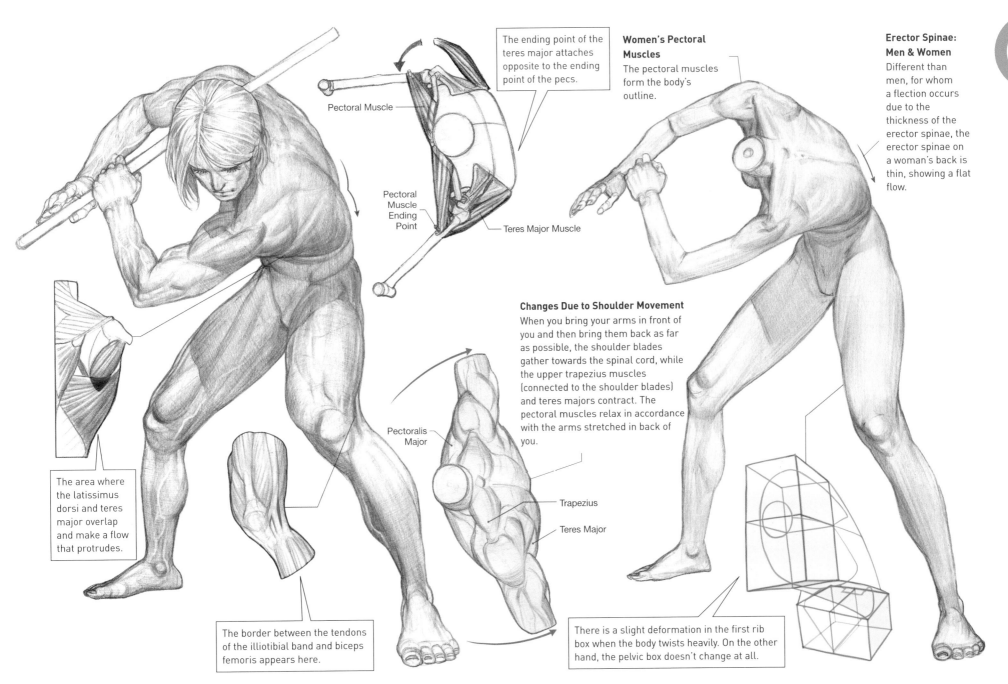

The ending point of the teres major attaches opposite to the ending point of the pecs.

Pectoral Muscle

Pectoral Muscle Ending Point

Teres Major Muscle

Women's Pectoral Muscles
The pectoral muscles form the body's outline.

Erector Spinae: Men & Women
Different than men, for whom a flection occurs due to the thickness of the erector spinae, the erector spinae on a woman's back is thin, showing a flat flow.

The area where the latissimus dorsi and teres major overlap and make a flow that protrudes.

Changes Due to Shoulder Movement
When you bring your arms in front of you and then bring them back as far as possible, the shoulder blades gather towards the spinal cord, while the upper trapezius muscles (connected to the shoulder blades) and teres majors contract. The pectoral muscles relax in accordance with the arms stretched in back of you.

Pectoralis Major

Trapezius

Teres Major

The border between the tendons of the illiotibial band and biceps femoris appears here.

There is a slight deformation in the first rib box when the body twists heavily. On the other hand, the pelvic box doesn't change at all.

■ Wielding Staffs (2)

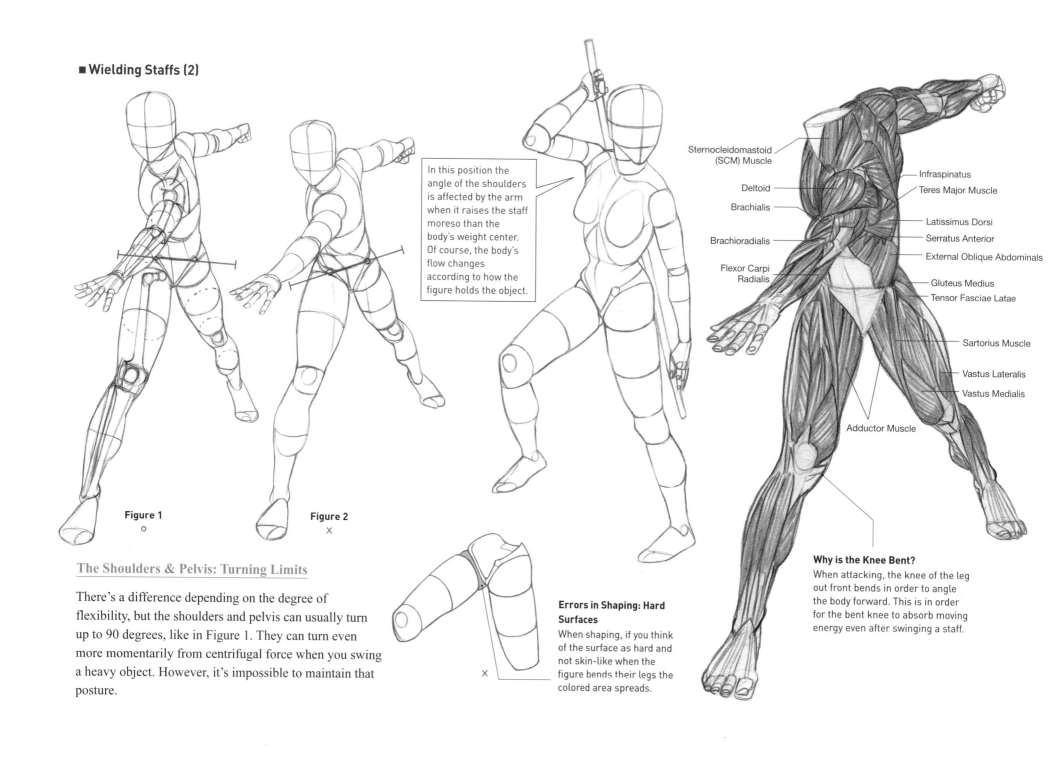

In this position the angle of the shoulders is affected by the arm when it raises the staff moreso than the body's weight center. Of course, the body's flow changes according to how the figure holds the object.

Figure 1

Figure 2

Sternocleidomastoid (SCM) Muscle

Deltoid

Brachialis

Brachioradialis

Flexor Carpi Radialis

Infraspinatus

Teres Major Muscle

Latissimus Dorsi

Serratus Anterior

External Oblique Abdominals

Gluteus Medius

Tensor Fasciae Latae

Sartorius Muscle

Vastus Lateralis

Vastus Medialis

Adductor Muscle

The Shoulders & Pelvis: Turning Limits

There's a difference depending on the degree of flexibility, but the shoulders and pelvis can usually turn up to 90 degrees, like in Figure 1. They can turn even more momentarily from centrifugal force when you swing a heavy object. However, it's impossible to maintain that posture.

Errors in Shaping: Hard Surfaces

When shaping, if you think of the surface as hard and not skin-like when the figure bends their legs the colored area spreads.

Why is the Knee Bent?

When attacking, the knee of the leg out front bends in order to angle the body forward. This is in order for the bent knee to absorb moving energy even after swinging a staff.

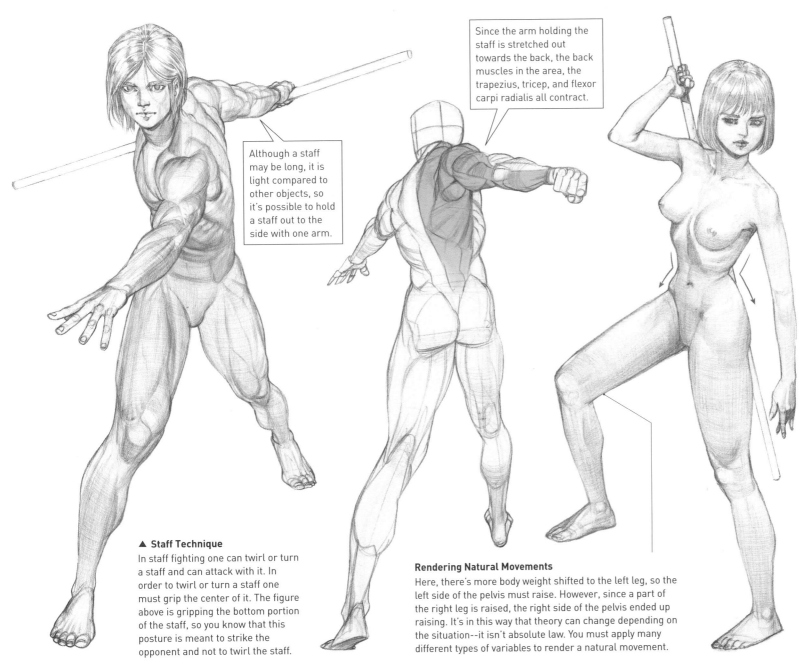

Although a staff may be long, it is light compared to other objects, so it's possible to hold a staff out to the side with one arm.

Since the arm holding the staff is stretched out towards the back, the back muscles in the area, the trapezius, tricep, and flexor carpi radialis all contract.

▲ Staff Technique

In staff fighting one can twirl or turn a staff and can attack with it. In order to twirl or turn a staff one must grip the center of it. The figure above is gripping the bottom portion of the staff, so you know that this posture is meant to strike the opponent and not to twirl the staff.

Rendering Natural Movements

Here, there's more body weight shifted to the left leg, so the left side of the pelvis must raise. However, since a part of the right leg is raised, the right side of the pelvis ended up raising. It's in this way that theory can change depending on the situation--it isn't absolute law. You must apply many different types of variables to render a natural movement.

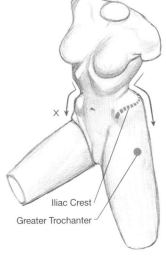

Iliac Crest

Greater Trochanter

Correctly Rendering Pelvic Flow on Women ▲

On women the area of the greater trochanter on the pelvis is the widest.

There are often instances where a person will draw the area of the iliac crest the widest, but this is not correct. Women's body silhouettes slowly narrow as you go from the shoulders downwards, then it starts to widen where the ribs end. So, it's shaped just like an hourglass. Compare with the correctly drawn figure to the left.

■ Jumping with a Spear

Flying Spear

This posture is taken when a person wields a sharp spear then jumps in order to jab an opponent who is located below them.

The overall flow of the body is like drawing a bow in that the person leans back and brings their legs back, then brings that force forward to make a powerful blow.

Moreso than the energy coming from the muscles, the gravitational pull from falling is very deadly.

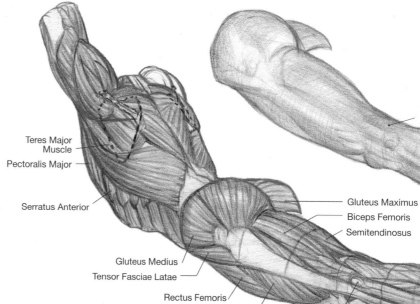

Fat in the Back of the Knee
When the leg is fully extended the biceps femoris and semitendinosus tendons don't protrude. This is because the fat behind the knee is thick and rises.

Teres Major Muscle

Pectoralis Major

Serratus Anterior

Gluteus Maximus

Biceps Femoris

Semitendinosus

Gastrocnemius Muscle

Soleus Muscle

Gluteus Medius

Tensor Fasciae Latae

Rectus Femoris

Vastus Lateralis

Vastus Medialis

Fibular Head

In order to maintain balance during bungee jumping you spread both arms.

◄ Midair & Landing Postures
In a position where the body weight is shifted in the direction of the hand holding the spear (see above) the weight center ends up facing towards the upper body (see the picture to the left). This posture is similar to one used when bungee jumping. On the flip side, in order to land feet-first on the ground then from the jumping position you have to bring your feet under you before landing. Also, you must make your body take a straight shape in midair in order to ease the landing shock.

◄ The Latissimus Dorsi Border
Here you'll observe the shape of the latissimus dorsi as it widely wraps around the entire back. The more muscular a person is the more clear the muscle border is, which travels down from the armpits towards the sacrum (see red dotted lines). This flow doesn't stick out on women with basic body types.

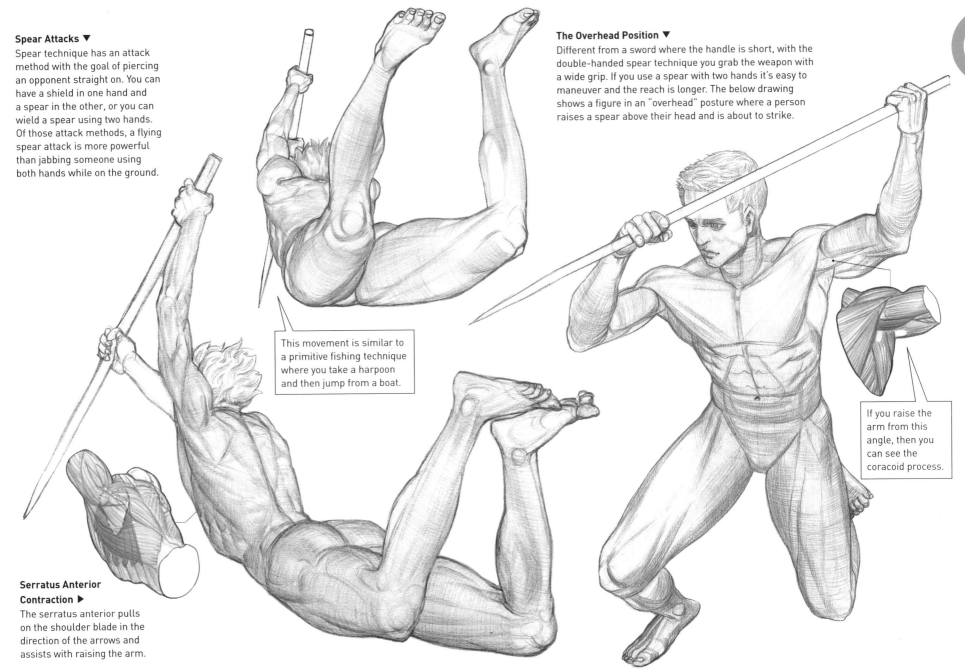

Spear Attacks ▼

Spear technique has an attack method with the goal of piercing an opponent straight on. You can have a shield in one hand and a spear in the other, or you can wield a spear using two hands. Of those attack methods, a flying spear attack is more powerful than jabbing someone using both hands while on the ground.

This movement is similar to a primitive fishing technique where you take a harpoon and then jump from a boat.

Serratus Anterior Contraction ▶

The serratus anterior pulls on the shoulder blade in the direction of the arrows and assists with raising the arm.

The Overhead Position ▼

Different from a sword where the handle is short, with the double-handed spear technique you grab the weapon with a wide grip. If you use a spear with two hands it's easy to maneuver and the reach is longer. The below drawing shows a figure in an "overhead" posture where a person raises a spear above their head and is about to strike.

If you raise the arm from this angle, then you can see the coracoid process.

■ Side-Handle Batons

Characteristics

The side-handle baton (or tonfa) originated from the handle of a farming tool. It forms a guard for the outer arm and reinforces bare-handed martial arts. At the same time, you can strike your opponent by swinging it. Side-handle batons can block an opponent's attack like a shield and they don't have blades, so they have the characteristic of being able to overpower an opponent while not causing great harm. So, it's a weapon that police often use for protection.

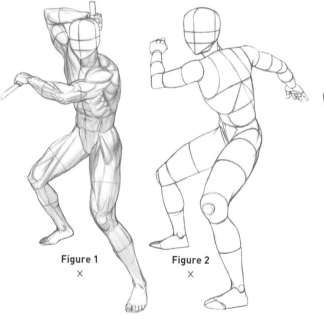

Figure 1
×

Figure 2
×

▲ Stiffness & Unstable Weight Center
If a figure doesn't twist and stands stiff like in Figure 1, or if the weight center is shifted to the rear and they aren't stable when standing, the dynamic feel decreases.

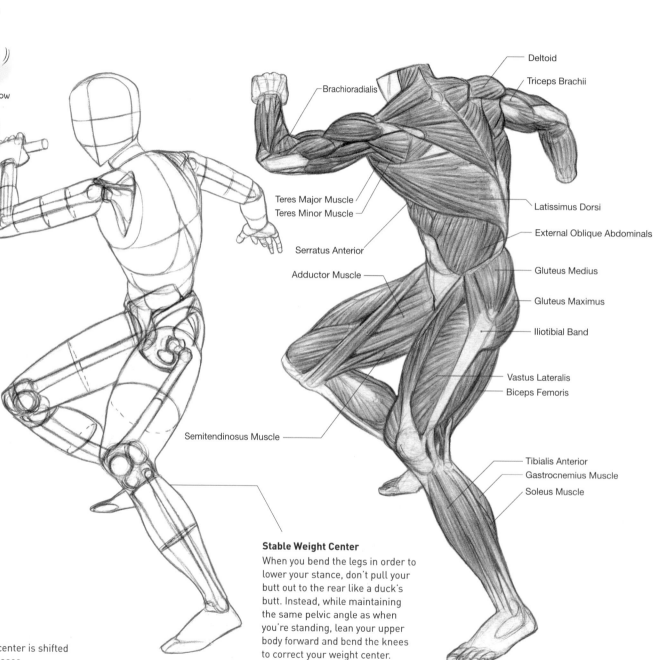

Deltoid
Triceps Brachii
Brachioradialis
Teres Major Muscle
Teres Minor Muscle
Latissimus Dorsi
External Oblique Abdominals
Serratus Anterior
Adductor Muscle
Gluteus Medius
Gluteus Maximus
Iliotibial Band
Vastus Lateralis
Biceps Femoris
Semitendinosus Muscle
Tibialis Anterior
Gastrocnemius Muscle
Soleus Muscle

Stable Weight Center
When you bend the legs in order to lower your stance, don't pull your butt out to the rear like a duck's butt. Instead, while maintaining the same pelvic angle as when you're standing, lean your upper body forward and bend the knees to correct your weight center.

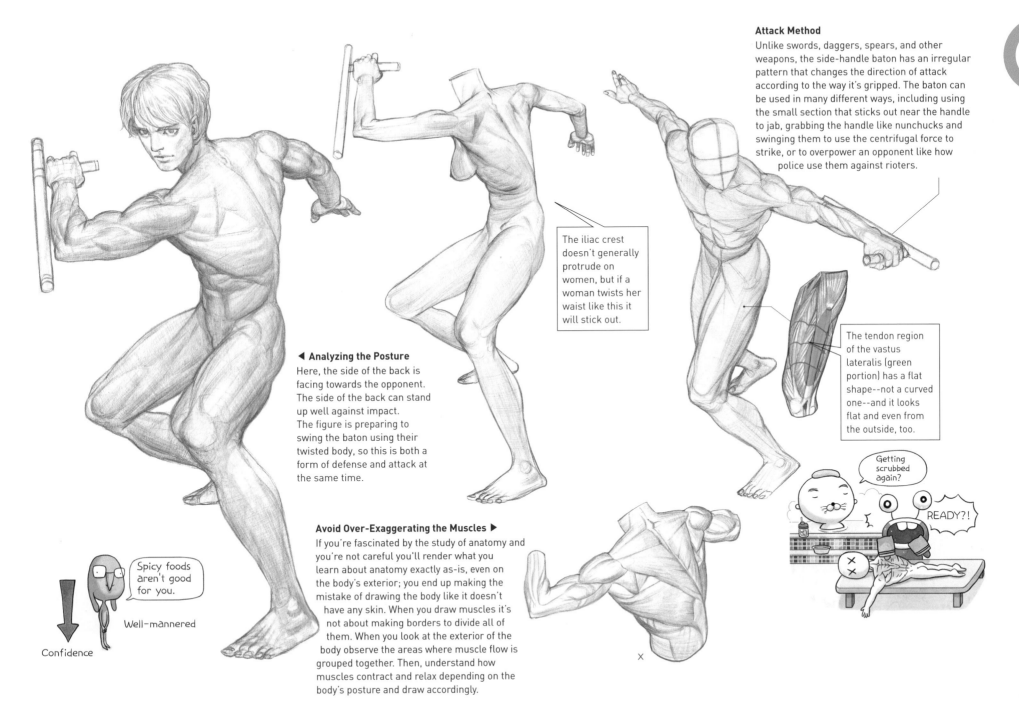

Attack Method

Unlike swords, daggers, spears, and other weapons, the side-handle baton has an irregular pattern that changes the direction of attack according to the way it's gripped. The baton can be used in many different ways, including using the small section that sticks out near the handle to jab, grabbing the handle like nunchucks and swinging them to use the centrifugal force to strike, or to overpower an opponent like how police use them against rioters.

The iliac crest doesn't generally protrude on women, but if a woman twists her waist like this it will stick out.

The tendon region of the vastus lateralis (green portion) has a flat shape--not a curved one--and it looks flat and even from the outside, too.

◀ **Analyzing the Posture**

Here, the side of the back is facing towards the opponent. The side of the back can stand up well against impact.
The figure is preparing to swing the baton using their twisted body, so this is both a form of defense and attack at the same time.

Avoid Over-Exaggerating the Muscles ▶

If you're fascinated by the study of anatomy and you're not careful you'll render what you learn about anatomy exactly as-is, even on the body's exterior; you end up making the mistake of drawing the body like it doesn't have any skin. When you draw muscles it's not about making borders to divide all of them. When you look at the exterior of the body observe the areas where muscle flow is grouped together. Then, understand how muscles contract and relax depending on the body's posture and draw accordingly.

Spicy foods aren't good for you.

Well-mannered

Confidence

Getting scrubbed again?

READY?!

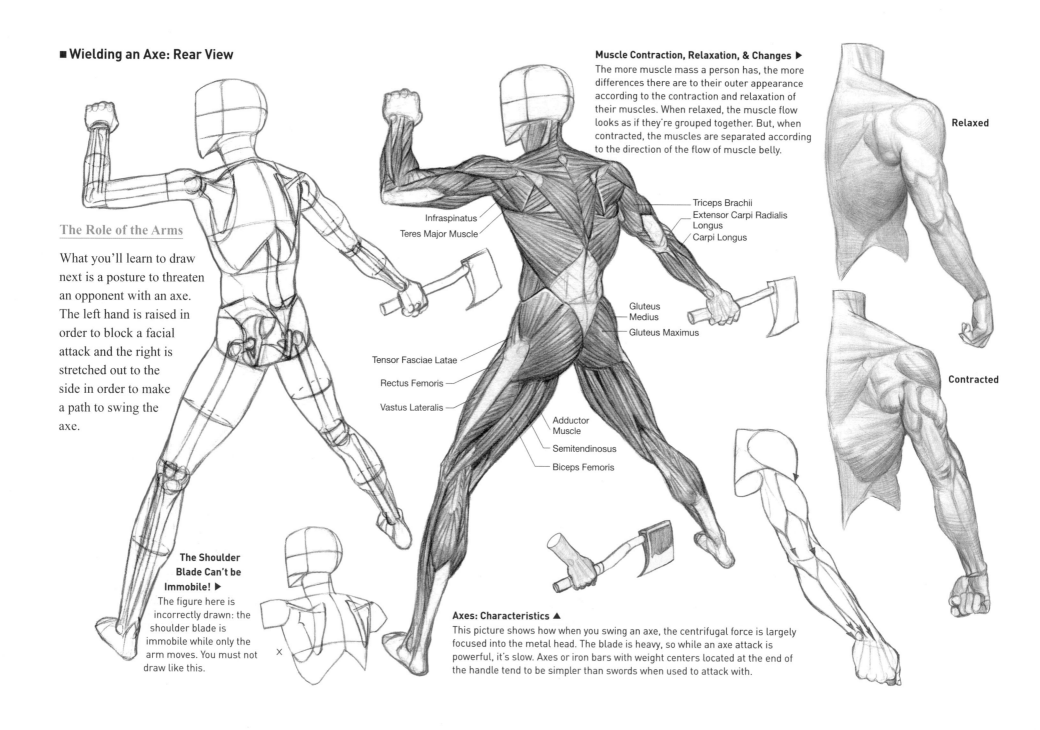

■ Wielding an Axe: Rear View

The Role of the Arms

What you'll learn to draw next is a posture to threaten an opponent with an axe. The left hand is raised in order to block a facial attack and the right is stretched out to the side in order to make a path to swing the axe.

The Shoulder Blade Can't be Immobile! ▶
The figure here is incorrectly drawn: the shoulder blade is immobile while only the arm moves. You must not draw like this.

X

Muscle Contraction, Relaxation, & Changes ▶
The more muscle mass a person has, the more differences there are to their outer appearance according to the contraction and relaxation of their muscles. When relaxed, the muscle flow looks as if they're grouped together. But, when contracted, the muscles are separated according to the direction of the flow of muscle belly.

Infraspinatus

Teres Major Muscle

Triceps Brachii
Extensor Carpi Radialis Longus
Carpi Longus

Gluteus Medius

Gluteus Maximus

Tensor Fasciae Latae

Rectus Femoris

Vastus Lateralis

Adductor Muscle

Semitendinosus

Biceps Femoris

Relaxed

Contracted

Axes: Characteristics ▲
This picture shows how when you swing an axe, the centrifugal force is largely focused into the metal head. The blade is heavy, so while an axe attack is powerful, it's slow. Axes or iron bars with weight centers located at the end of the handle tend to be simpler than swords when used to attack with.

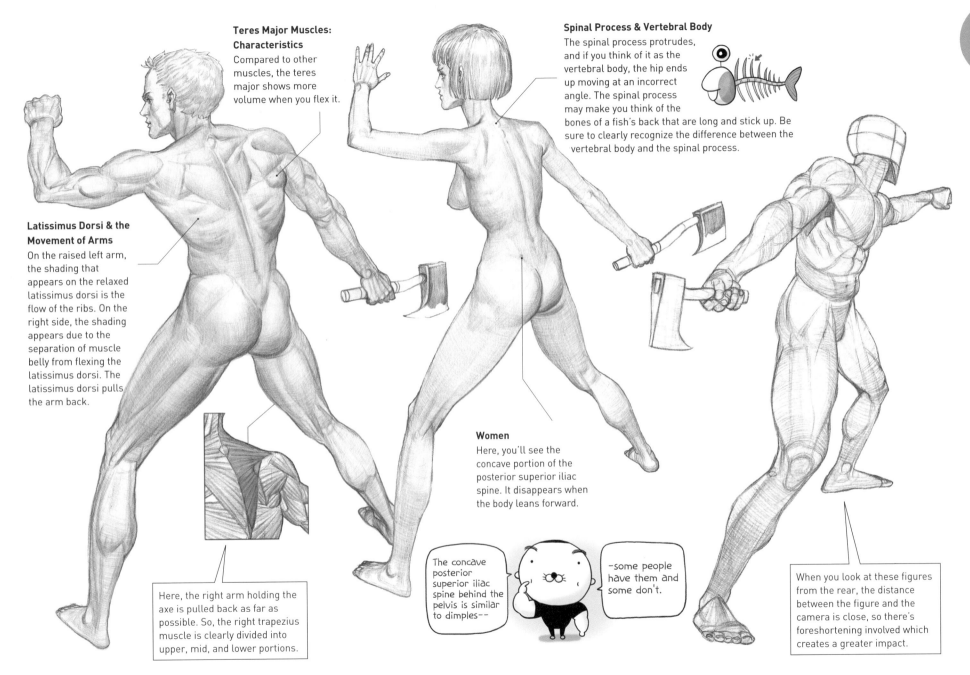

Teres Major Muscles: Characteristics
Compared to other muscles, the teres major shows more volume when you flex it.

Spinal Process & Vertebral Body
The spinal process protrudes, and if you think of it as the vertebral body, the hip ends up moving at an incorrect angle. The spinal process may make you think of the bones of a fish's back that are long and stick up. Be sure to clearly recognize the difference between the vertebral body and the spinal process.

Latissimus Dorsi & the Movement of Arms
On the raised left arm, the shading that appears on the relaxed latissimus dorsi is the flow of the ribs. On the right side, the shading appears due to the separation of muscle belly from flexing the latissimus dorsi. The latissimus dorsi pulls the arm back.

Women
Here, you'll see the concave portion of the posterior superior iliac spine. It disappears when the body leans forward.

Here, the right arm holding the axe is pulled back as far as possible. So, the right trapezius muscle is clearly divided into upper, mid, and lower portions.

The concave posterior superior iliac spine behind the pelvis is similar to dimples--

-some people have them and some don't.

When you look at these figures from the rear, the distance between the figure and the camera is close, so there's foreshortening involved which creates a greater impact.

04

Understanding Anatomy Through Motion

344
345

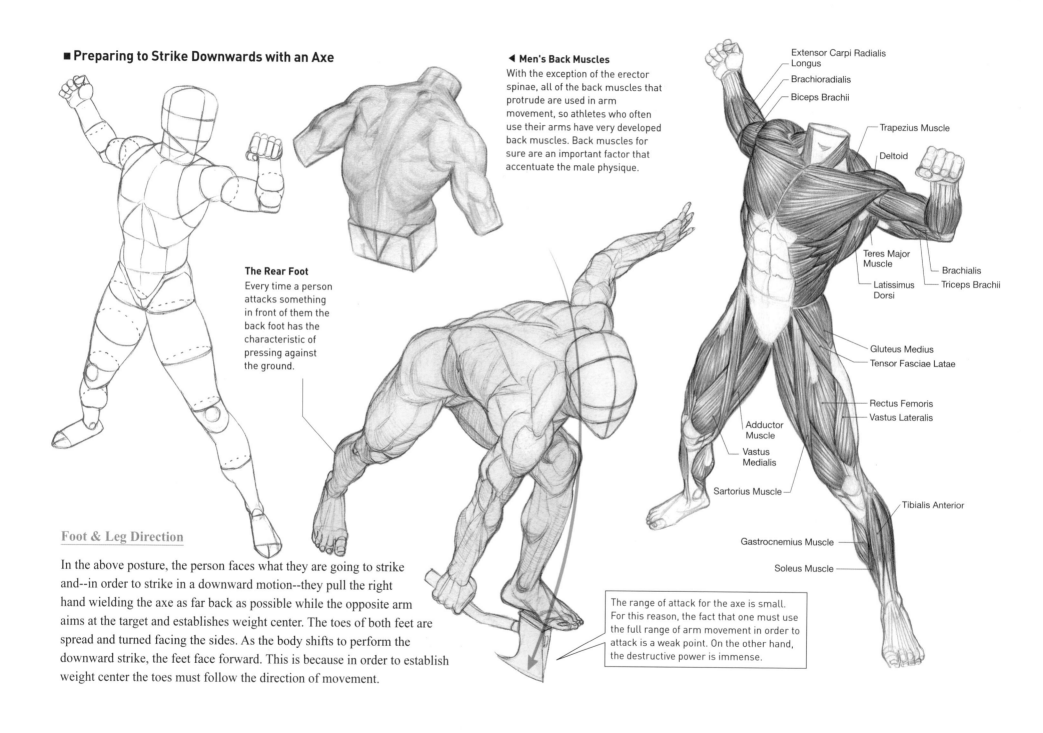

■ Preparing to Strike Downwards with an Axe

◄ Men's Back Muscles

With the exception of the erector spinae, all of the back muscles that protrude are used in arm movement, so athletes who often use their arms have very developed back muscles. Back muscles for sure are an important factor that accentuate the male physique.

The Rear Foot

Every time a person attacks something in front of them the back foot has the characteristic of pressing against the ground.

Extensor Carpi Radialis Longus

Brachioradialis

Biceps Brachii

Trapezius Muscle

Deltoid

Teres Major Muscle

Latissimus Dorsi

Brachialis

Triceps Brachii

Gluteus Medius

Tensor Fasciae Latae

Rectus Femoris

Vastus Lateralis

Adductor Muscle

Vastus Medialis

Sartorius Muscle

Tibialis Anterior

Gastrocnemius Muscle

Soleus Muscle

Foot & Leg Direction

In the above posture, the person faces what they are going to strike and--in order to strike in a downward motion--they pull the right hand wielding the axe as far back as possible while the opposite arm aims at the target and establishes weight center. The toes of both feet are spread and turned facing the sides. As the body shifts to perform the downward strike, the feet face forward. This is because in order to establish weight center the toes must follow the direction of movement.

The range of attack for the axe is small. For this reason, the fact that one must use the full range of arm movement in order to attack is a weak point. On the other hand, the destructive power is immense.

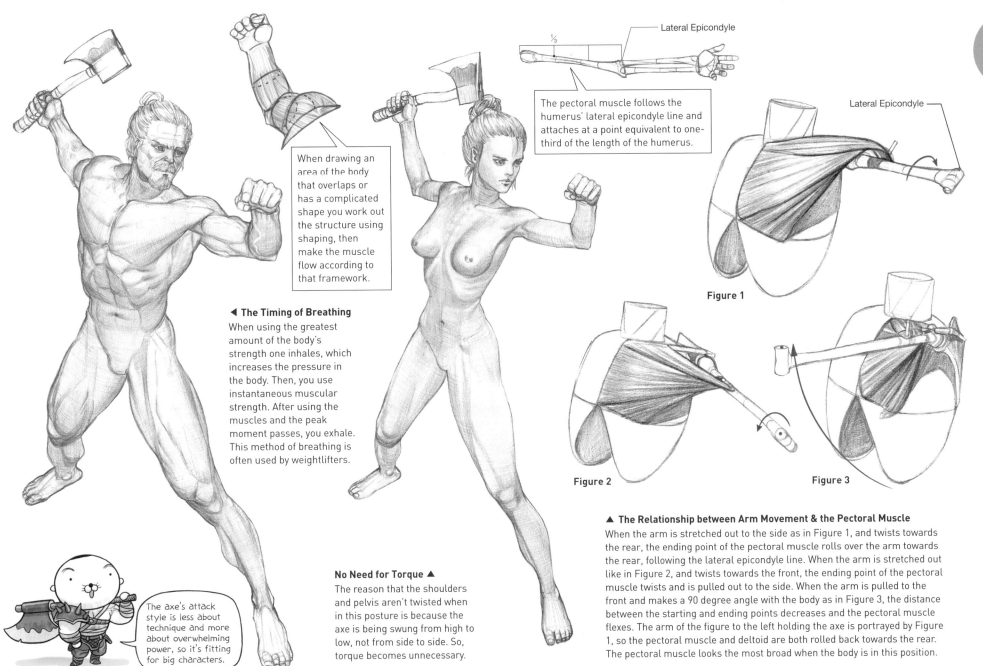

Lateral Epicondyle

The pectoral muscle follows the humerus' lateral epicondyle line and attaches at a point equivalent to one-third of the length of the humerus.

⅓

Lateral Epicondyle

Figure 1

Figure 2

Figure 3

When drawing an area of the body that overlaps or has a complicated shape you work out the structure using shaping, then make the muscle flow according to that framework.

◀ **The Timing of Breathing**
When using the greatest amount of the body's strength one inhales, which increases the pressure in the body. Then, you use instantaneous muscular strength. After using the muscles and the peak moment passes, you exhale. This method of breathing is often used by weightlifters.

The axe's attack style is less about technique and more about overwhelming power, so it's fitting for big characters.

No Need for Torque ▲
The reason that the shoulders and pelvis aren't twisted when in this posture is because the axe is being swung from high to low, not from side to side. So, torque becomes unnecessary.

▲ **The Relationship between Arm Movement & the Pectoral Muscle**
When the arm is stretched out to the side as in Figure 1, and twists towards the rear, the ending point of the pectoral muscle rolls over the arm towards the rear, following the lateral epicondyle line. When the arm is stretched out like in Figure 2, and twists towards the front, the ending point of the pectoral muscle twists and is pulled out to the side. When the arm is pulled to the front and makes a 90 degree angle with the body as in Figure 3, the distance between the starting and ending points decreases and the pectoral muscle flexes. The arm of the figure to the left holding the axe is portrayed by Figure 1, so the pectoral muscle and deltoid are both rolled back towards the rear. The pectoral muscle looks the most broad when the body is in this position.

■ Jumping Axe Strike

Strong & Weak Points

This is a ready position for striking an opponent below you when you are midair. The power is greater than when striking downward while your feet are on the falling. However, it's difficult to get the right ground because you utilize the pull of gravity while timing for the attack, which is a weak point.

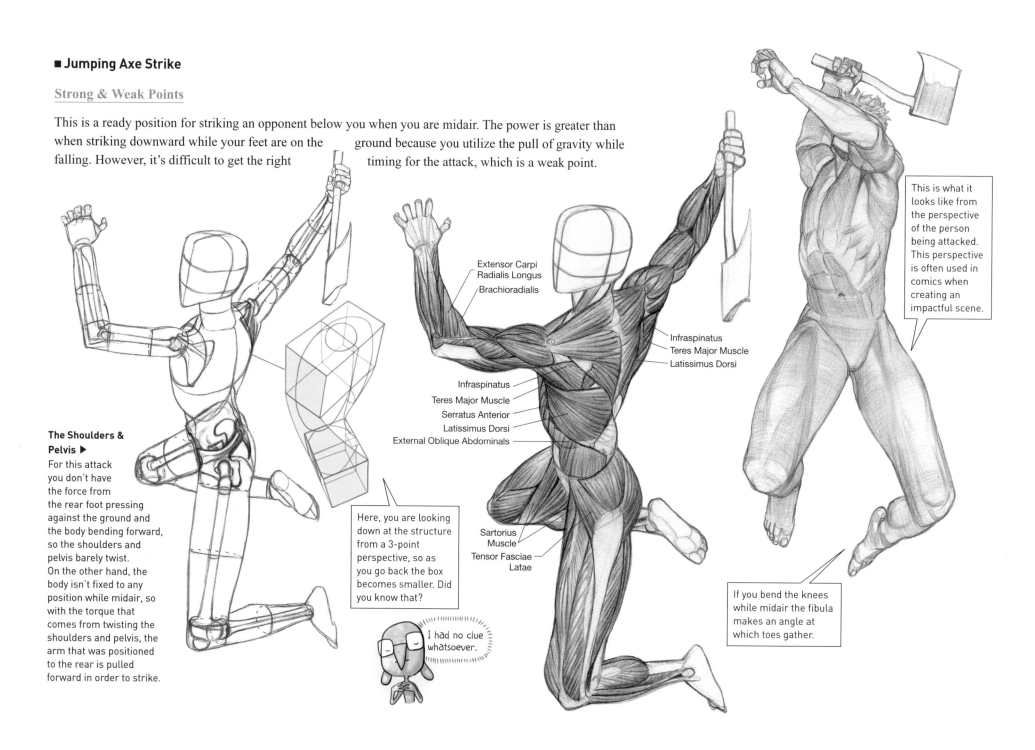

The Shoulders & Pelvis ▶
For this attack you don't have the force from the rear foot pressing against the ground and the body bending forward, so the shoulders and pelvis barely twist.
On the other hand, the body isn't fixed to any position while midair, so with the torque that comes from twisting the shoulders and pelvis, the arm that was positioned to the rear is pulled forward in order to strike.

Here, you are looking down at the structure from a 3-point perspective, so as you go back the box becomes smaller. Did you know that?

I had no clue whatsoever.

Extensor Carpi
Radialis Longus
Brachioradialis

Infraspinatus
Teres Major Muscle
Latissimus Dorsi

Infraspinatus
Teres Major Muscle
Serratus Anterior
Latissimus Dorsi
External Oblique Abdominals

Sartorius
Muscle
Tensor Fasciae
Latae

This is what it looks like from the perspective of the person being attacked. This perspective is often used in comics when creating an impactful scene.

If you bend the knees while midair the fibula makes an angle at which toes gather.

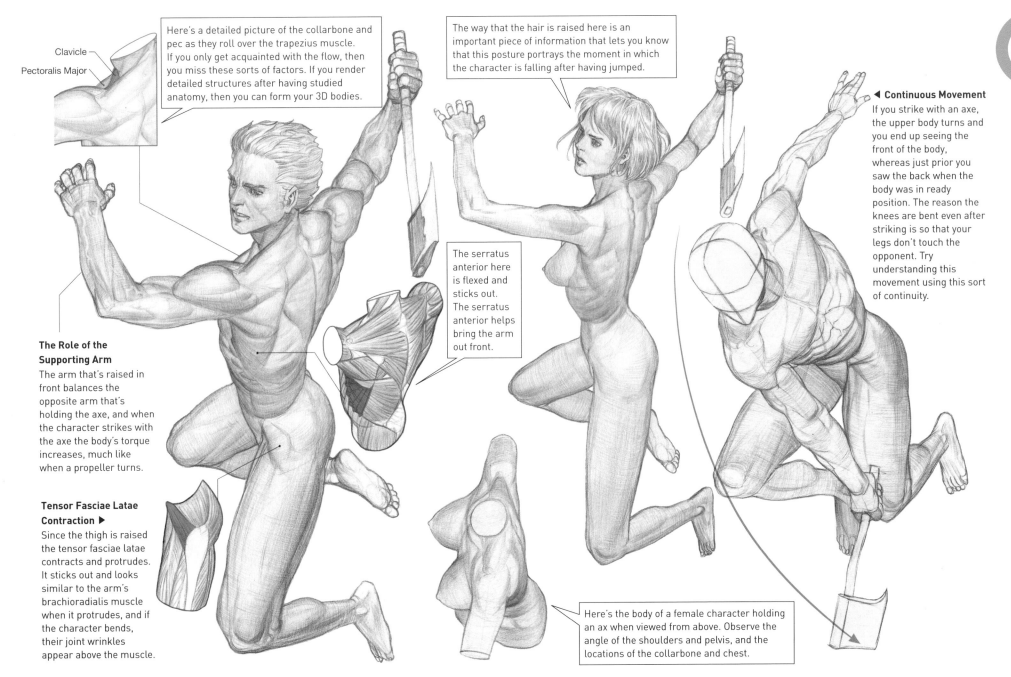

Clavicle

Pectoralis Major

Here's a detailed picture of the collarbone and pec as they roll over the trapezius muscle. If you only get acquainted with the flow, then you miss these sorts of factors. If you render detailed structures after having studied anatomy, then you can form your 3D bodies.

The way that the hair is raised here is an important piece of information that lets you know that this posture portrays the moment in which the character is falling after having jumped.

◄ Continuous Movement
If you strike with an axe, the upper body turns and you end up seeing the front of the body, whereas just prior you saw the back when the body was in ready position. The reason the knees are bent even after striking is so that your legs don't touch the opponent. Try understanding this movement using this sort of continuity.

The Role of the Supporting Arm
The arm that's raised in front balances the opposite arm that's holding the axe, and when the character strikes with the axe the body's torque increases, much like when a propeller turns.

Tensor Fasciae Latae Contraction ▶
Since the thigh is raised the tensor fasciae latae contracts and protrudes. It sticks out and looks similar to the arm's brachioradialis muscle when it protrudes, and if the character bends, their joint wrinkles appear above the muscle.

The serratus anterior here is flexed and sticks out. The serratus anterior helps bring the arm out front.

Here's the body of a female character holding an ax when viewed from above. Observe the angle of the shoulders and pelvis, and the locations of the collarbone and chest.

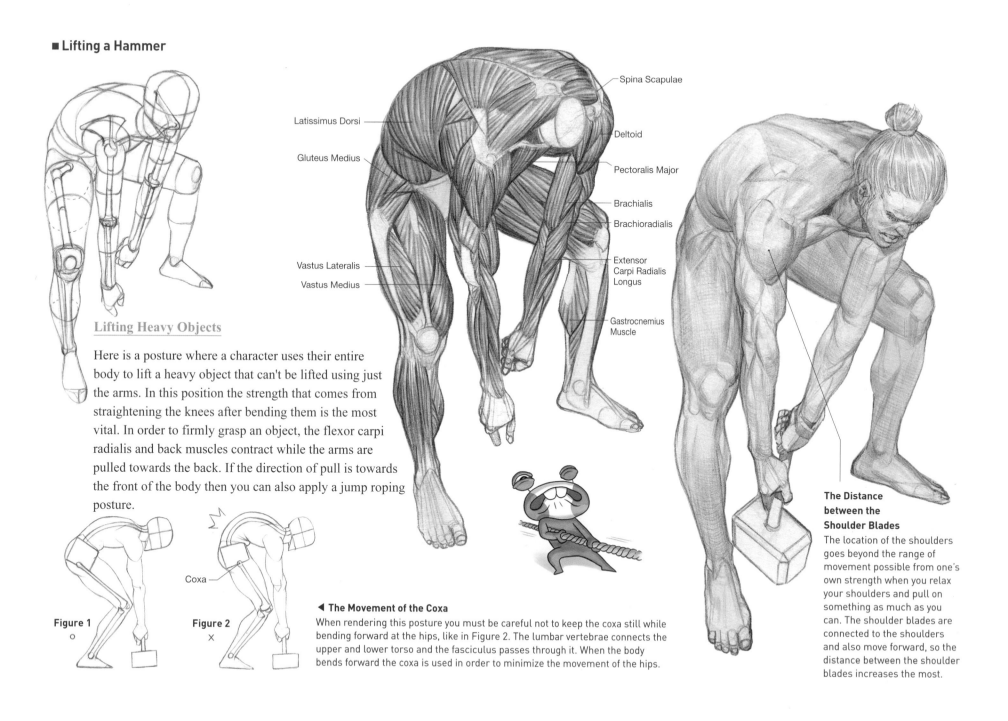

■ Lifting a Hammer

Lifting Heavy Objects

Here is a posture where a character uses their entire body to lift a heavy object that can't be lifted using just the arms. In this position the strength that comes from straightening the knees after bending them is the most vital. In order to firmly grasp an object, the flexor carpi radialis and back muscles contract while the arms are pulled towards the back. If the direction of pull is towards the front of the body then you can also apply a jump roping posture.

Figure 1
o

Figure 2
×

Coxa

Latissimus Dorsi

Gluteus Medius

Vastus Lateralis

Vastus Medius

Spina Scapulae

Deltoid

Pectoralis Major

Brachialis

Brachioradialis

Extensor Carpi Radialis Longus

Gastrocnemius Muscle

◀ The Movement of the Coxa
When rendering this posture you must be careful not to keep the coxa still while bending forward at the hips, like in Figure 2. The lumbar vertebrae connects the upper and lower torso and the fasciculus passes through it. When the body bends forward the coxa is used in order to minimize the movement of the hips.

The Distance between the Shoulder Blades
The location of the shoulders goes beyond the range of movement possible from one's own strength when you relax your shoulders and pull on something as much as you can. The shoulder blades are connected to the shoulders and also move forward, so the distance between the shoulder blades increases the most.

■ Preparing to Swing an Axe

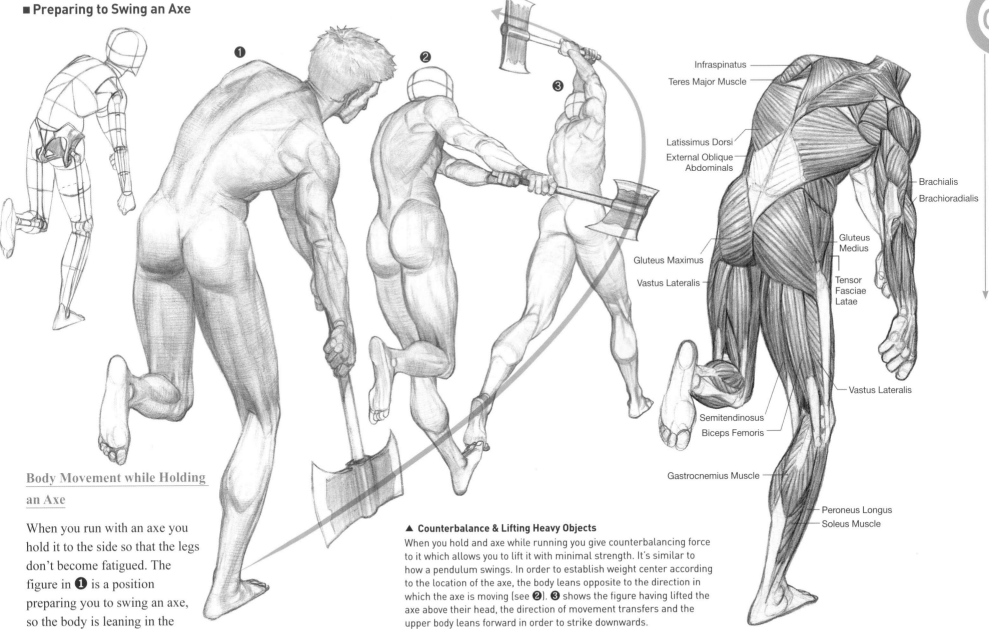

❶ ❷ ❸

Infraspinatus
Teres Major Muscle
Latissimus Dorsi
External Oblique Abdominals
Gluteus Maximus
Vastus Lateralis
Semitendinosus
Biceps Femoris
Gastrocnemius Muscle
Peroneus Longus
Soleus Muscle

Brachialis
Brachioradialis
Gluteus Medius
Tensor Fasciae Latae
Vastus Lateralis

Body Movement while Holding an Axe

When you run with an axe you hold it to the side so that the legs don't become fatigued. The figure in ❶ is a position preparing you to swing an axe, so the body is leaning in the direction of the axe.

▲ Counterbalance & Lifting Heavy Objects

When you hold and axe while running you give counterbalancing force to it which allows you to lift it with minimal strength. It's similar to how a pendulum swings. In order to establish weight center according to the location of the axe, the body leans opposite to the direction in which the axe is moving (see ❷). ❸ shows the figure having lifted the axe above their head, the direction of movement transfers and the upper body leans forward in order to strike downwards.

■ Muscular Characters & Hammers

Getting Proportion Down

When drawing muscular characters who have bodies much different than the average body type, you must shape with proportions different than that of normal shaping. You must apply differences not only in volume, but also in bone structure. After getting a grasp of basic bone structure you must use this as your basis to practice drawing bone structures and volumes for various body types.

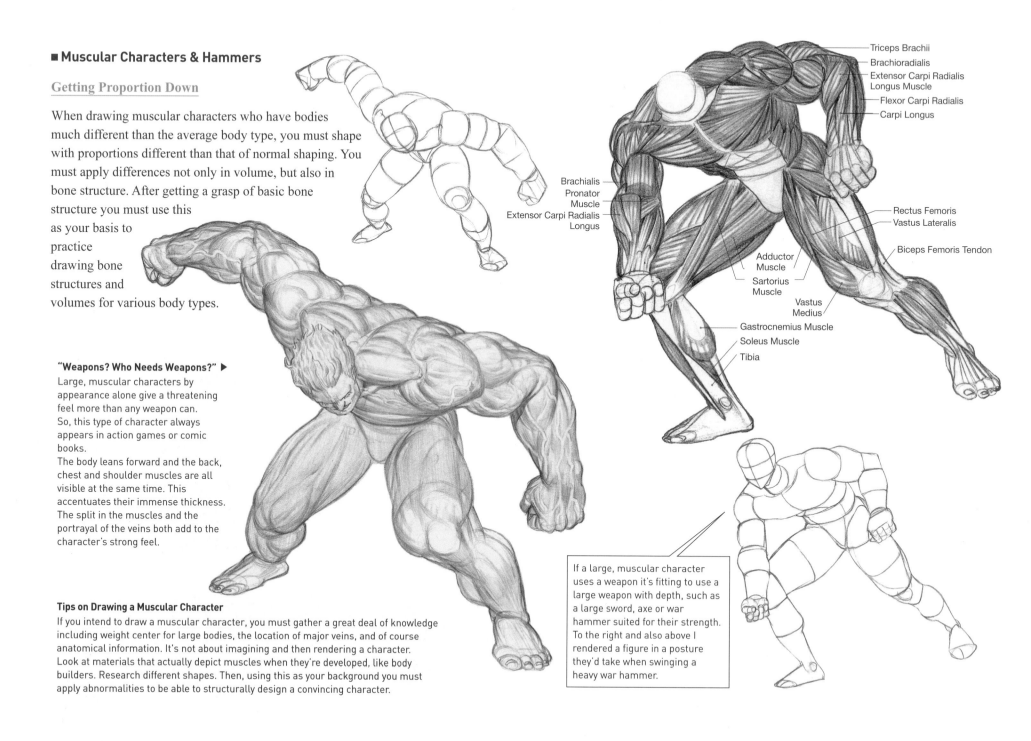

Triceps Brachii
Brachioradialis
Extensor Carpi Radialis Longus Muscle
Flexor Carpi Radialis
Carpi Longus
Brachialis
Pronator Muscle
Extensor Carpi Radialis Longus
Rectus Femoris
Vastus Lateralis
Biceps Femoris Tendon
Adductor Muscle
Sartorius Muscle
Vastus Medius
Gastrocnemius Muscle
Soleus Muscle
Tibia

"Weapons? Who Needs Weapons?" ▶
Large, muscular characters by appearance alone give a threatening feel more than any weapon can.
So, this type of character always appears in action games or comic books.
The body leans forward and the back, chest and shoulder muscles are all visible at the same time. This accentuates their immense thickness. The split in the muscles and the portrayal of the veins both add to the character's strong feel.

Tips on Drawing a Muscular Character
If you intend to draw a muscular character, you must gather a great deal of knowledge including weight center for large bodies, the location of major veins, and of course anatomical information. It's not about imagining and then rendering a character. Look at materials that actually depict muscles when they're developed, like body builders. Research different shapes. Then, using this as your background you must apply abnormalities to be able to structurally design a convincing character.

If a large, muscular character uses a weapon it's fitting to use a large weapon with depth, such as a large sword, axe or war hammer suited for their strength. To the right and also above I rendered a figure in a posture they'd take when swinging a heavy war hammer.

Hand Placement

As I had addressed earlier on, the weight of an object depends on the posture of the character holding the object. In this posture, the location of the hands on the war hammer becomes the most important factor in transferring weight. The character should grab the end of the handle with both hands. One hand goes near the head of the war hammer, so the posture is effective in holding a heavy object. For that reason, when you swing the hammer downwards or just swing in general, the accuracy increases and the character can adopt a stable posture.

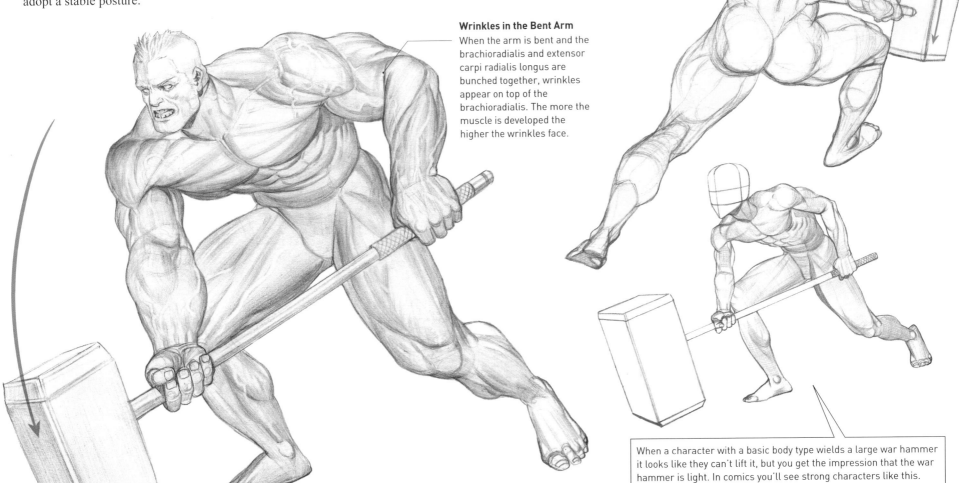

Wrinkles in the Bent Arm
When the arm is bent and the brachioradialis and extensor carpi radialis longus are bunched together, wrinkles appear on top of the brachioradialis. The more the muscle is developed the higher the wrinkles face.

When a character with a basic body type wields a large war hammer it looks like they can't lift it, but you get the impression that the war hammer is light. In comics you'll see strong characters like this.

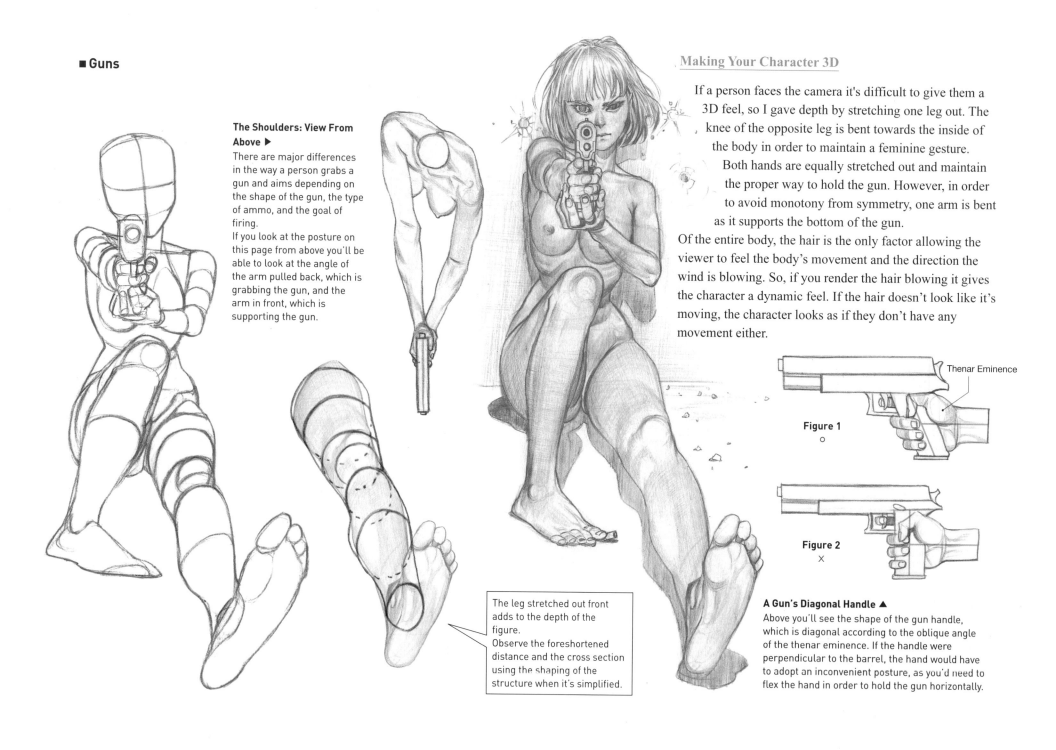

■ Guns

The Shoulders: View From Above ▶

There are major differences in the way a person grabs a gun and aims depending on the shape of the gun, the type of ammo, and the goal of firing.

If you look at the posture on this page from above you'll be able to look at the angle of the arm pulled back, which is grabbing the gun, and the arm in front, which is supporting the gun.

The leg stretched out front adds to the depth of the figure.

Observe the foreshortened distance and the cross section using the shaping of the structure when it's simplified.

Making Your Character 3D

If a person faces the camera it's difficult to give them a 3D feel, so I gave depth by stretching one leg out. The knee of the opposite leg is bent towards the inside of the body in order to maintain a feminine gesture.

Both hands are equally stretched out and maintain the proper way to hold the gun. However, in order to avoid monotony from symmetry, one arm is bent as it supports the bottom of the gun.

Of the entire body, the hair is the only factor allowing the viewer to feel the body's movement and the direction the wind is blowing. So, if you render the hair blowing it gives the character a dynamic feel. If the hair doesn't look like it's moving, the character looks as if they don't have any movement either.

Thenar Eminence

Figure 1
○

Figure 2
✕

A Gun's Diagonal Handle ▲

Above you'll see the shape of the gun handle, which is diagonal according to the oblique angle of the thenar eminence. If the handle were perpendicular to the barrel, the hand would have to adopt an inconvenient posture, as you'd need to flex the hand in order to hold the gun horizontally.

Kneeling ▶

When firing a rifle you press the floor of the stock against your shoulder and place your face above the stock. This posture is meant to absorb the recoil and aim naturally. The ground and lower body are firmly set in a kneeling position more than a standing one, so you can call it a high-accuracy shooting position. However, it's harder to move around while shooting compared to a standing position, so it's difficult to react when fired on. When a person is not alone and with a group of people this posture is taken when they're shooting at an enemy. Also, this posture is used when it's possible to conceal oneself. The prone position, which is different, is the most accurate of the firing positions. Both feet are planted on the ground so there's little recoil and you can hide yourself from enemy attack. As a weak point, it makes you slow to react to an attack coming from the air.

◀ Actual Shooting Postures

Shooting positions you see in comics or movies aren't all based on actual theory. If you try to render shooting postures too real, this will become a hindrance to your creative storytelling as long as it's not a very technical, real-life action comic or movie. If you have basic shooting movements where the arm is stretched out and the pistol is held eye-level, you can try various motions according to the story or production. It's through this that creative scenes are made.

If you go beyond theory, you can do this!

HAHA!

Ting
Thud-thud-thud
Rat-tat-tat

Impromptu Posture ▶

This posture is similar to the prone position, but since both hands aren't grabbing the gun it's not classified as a "prone" position. Assuming there's a situation where one must pull out their pistol quickly, accuracy is sacrificed and a person shoots with just one hand. So, the gun is merely aimed in the direction of the enemy, making this an impromptu posture. It's used when creating a feeling of tension or haste.

10 Foreshortened Postures

■ Standing with Both Hands & One Knee Out in Front of You

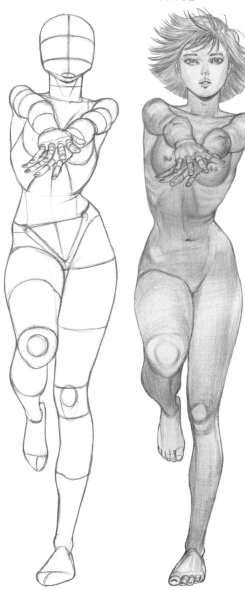

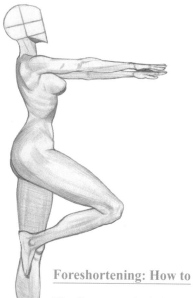

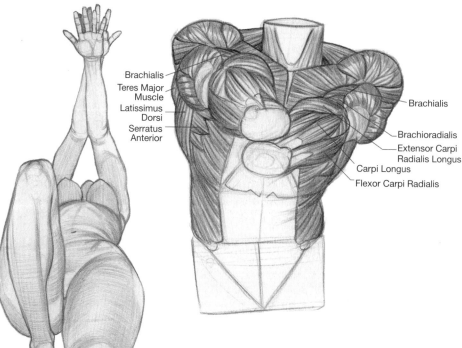

Brachialis
Teres Major Muscle
Latissimus Dorsi
Serratus Anterior

Brachialis
Brachioradialis
Extensor Carpi Radialis Longus
Carpi Longus
Flexor Carpi Radialis

Foreshortening: How to

The figures to the left and right are all in the same position but viewed from different angles.

The arms and bent leg for the figures to the left are foreshortened, while the entire body--with the exception of the arms and bent leg--is foreshortened for the figures to the right.

When rendering a figure that requires foreshortening, there's a high possibility of the overall flow and ratio being incorrect if you draw piece-by-piece starting with the part of the body closest to you.

For this reason, you must understand the body's structure in the order by which body parts stick out from the torso and start with the largest flow. Don't focus on the smaller units, such as the flows of minute muscles. Try practicing widening the field of vision by using shaping.

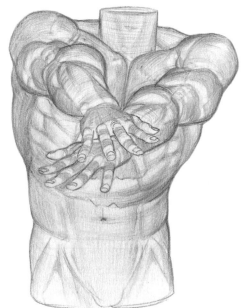

■ Various Postures Utilizing Foreshortening

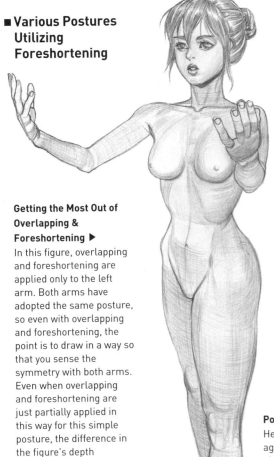

Getting the Most Out of Overlapping & Foreshortening ▶
In this figure, overlapping and foreshortening are applied only to the left arm. Both arms have adopted the same posture, so even with overlapping and foreshortening, the point is to draw in a way so that you sense the symmetry with both arms. Even when overlapping and foreshortening are just partially applied in this way for this simple posture, the difference in the figure's depth becomes greater.

Points to Keep in Mind ▶
Here, the figure is leaning against a wall. The bent leg is placed to prevent the body from slipping and the arm is raised above the head so the hand can support the head, much like a pillow. The upper torso is straight and off the ground, while the lower torso is resting on the ground. So, the figure is bent forward at the waist. Foreshortening occurs for the leg that's stretched out and the hand that's placed on the thigh of that same leg.

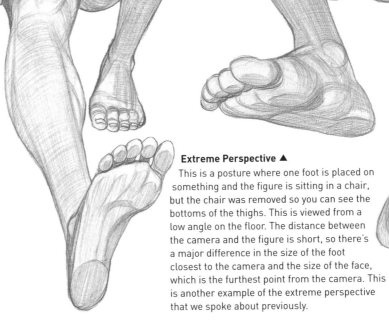

Extreme Perspective ▲
This is a posture where one foot is placed on something and the figure is sitting in a chair, but the chair was removed so you can see the bottoms of the thighs. This is viewed from a low angle on the floor. The distance between the camera and the figure is short, so there's a major difference in the size of the foot closest to the camera and the size of the face, which is the furthest point from the camera. This is another example of the extreme perspective that we spoke about previously.

■ Swimming

Emphasizing Women's Bodily Flow

This posture emphasizes women's flexibility and their curved bodily flow.
You can see the dynamic, trademark flow of how the waist turns rearwards and the pelvis stands out.

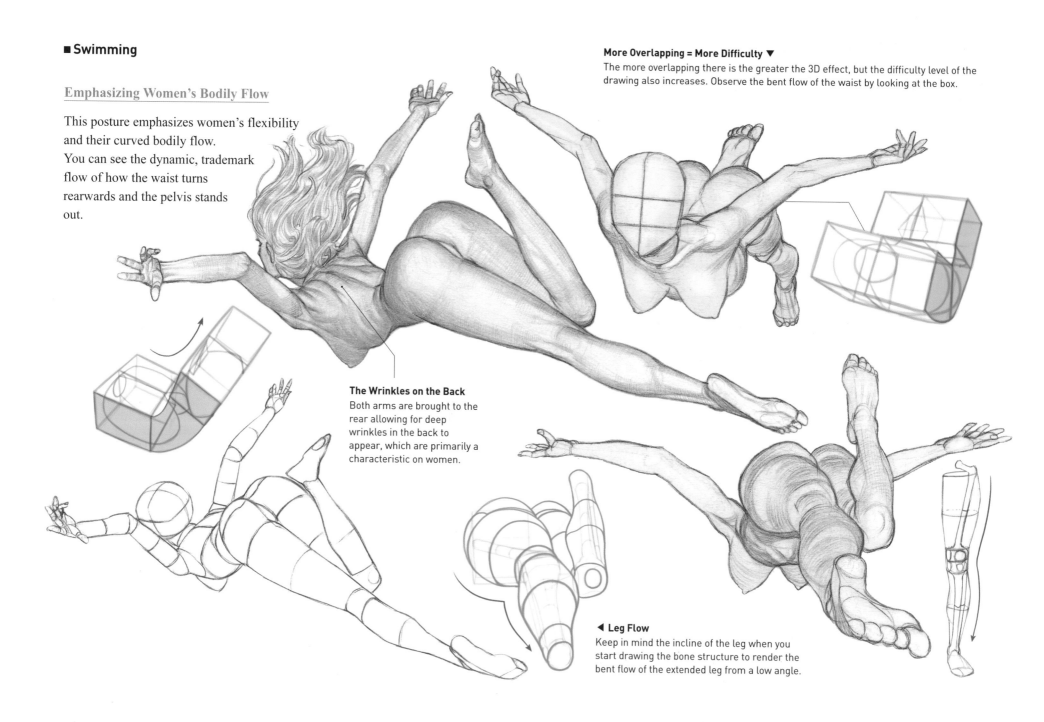

More Overlapping = More Difficulty ▼
The more overlapping there is the greater the 3D effect, but the difficulty level of the drawing also increases. Observe the bent flow of the waist by looking at the box.

The Wrinkles on the Back
Both arms are brought to the rear allowing for deep wrinkles in the back to appear, which are primarily a characteristic on women.

◄ Leg Flow
Keep in mind the incline of the leg when you start drawing the bone structure to render the bent flow of the extended leg from a low angle.

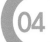

■ **Dancing**

Drawing in Reverse

If you draw a figure starting with the part of the body closest to the camera you end up omitting some covered parts, so the structure becomes frail.
You must start with the upper torso, the main part of the body, to ensure that you draw all the parts and make a sturdy structure. For example, the order in which you render the foreshortened arm is 'shoulder>elbow>wrist>hand'.

Understanding Structure through Penetration ▼
In this figure the upper body is covered by the pelvis so you don't see it. But, the body box penetrates the body and allows you to view the structure. Take a look.

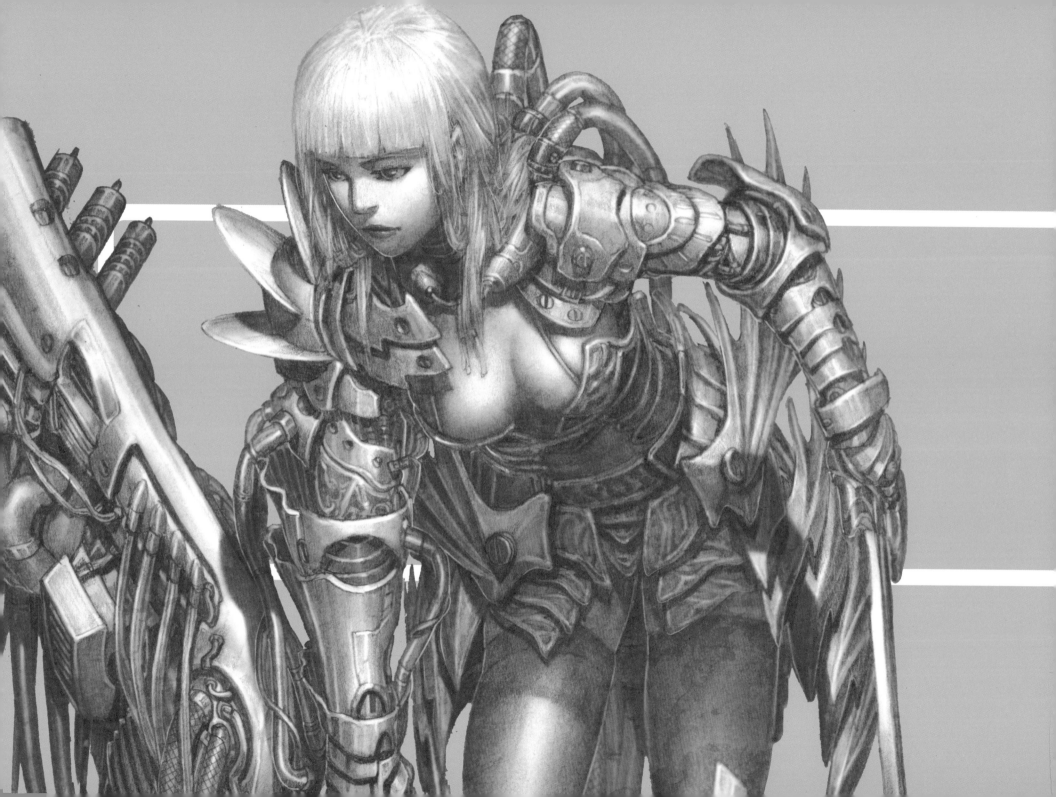

Using the Basics For Your Character Concepts

Now, let's establish the different genres and express them in your character designs.

The World of Characters

In my home country of South Korea, Koreans understand that no matter how well you prepare your seasoning when you cook, the food won't taste good unless your ingredients are fresh. Drawing is the same. No matter how creative and original your concept is, if the body of the character wielding an object isn't stable, the quality of the entire drawing will appear to drop. So, when you haven't yet properly studied the body it wouldn't be in good order to try deformed characters and add various designs to your drawing. If I add to that, "creation" doesn't mean coming up with a design that didn't exist before.

"Creation" means re-combining existing elements to have a new feel, so in order to effectively draw these basic elements you must practice imitating others before you start "creating". We human beings tend to more closely observe human beings rather than other objects because we can relate with other human beings. When drawing it's the same. When you render human beings you end up showing off your power of acute observation. For this reason, the most effective method of practicing drawing in order to build your observational power is not to draw other objects, but to study the human body. If you are able to use these principles to render the structure of the human body to a certain degree, then it becomes relatively easy to draw other entities and non-human characters. In Chapter 1 we used shaping to learn about proportions, depth, and what drives the joints. In Chapters 2 and 3 we used the study of anatomy to learn about the principles surrounding the muscles and their structure, while we solidified the body's flow in Chapter 4. In Chapter 4 we also took a look at various bodily motions to learn how to actually apply all of that information. In Chapter 5, the final chapter, we'll dive into how to render characters from other genres (superheroes, fantasy characters, characters with armor and mechanical body parts, etc.) by utilizing the basics of anatomy. We will also use illustrations to identify major flows and patterns for complicated and flashy action characters as well as research methods of application.

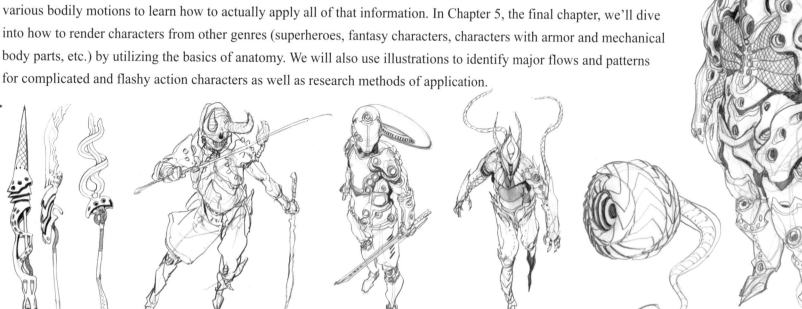

"What is creation," you ask?

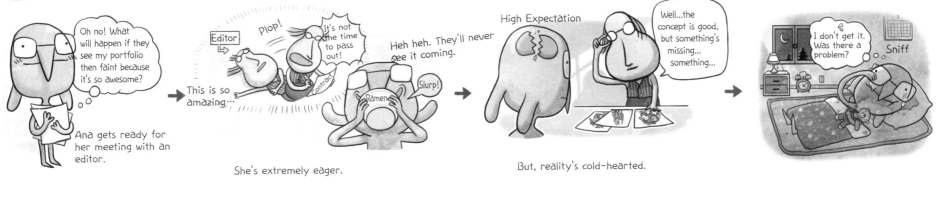

Ana gets ready for her meeting with an editor.

She's extremely eager.

But, reality's cold-hearted.

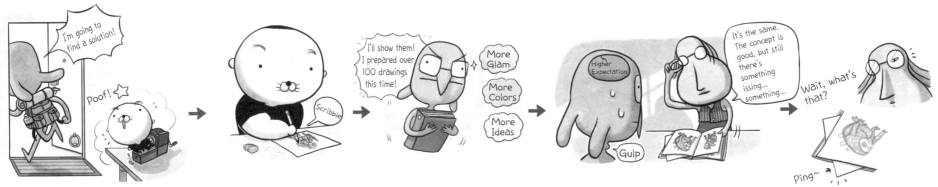

The next morning Mr. Kim suddenly appeared like a genie from Ana's pencil sharpener after she left the house.

Mr. Kim fixes a thing or two with Ana's rejected drawing...hmmmm...

Shortly after, Ana returns for Round 2.

What? Am I having deja vu?

Ana's drawing was received well.

It was all thanks to the help of Mr. Kim.

In the end, Ana had a big realization.

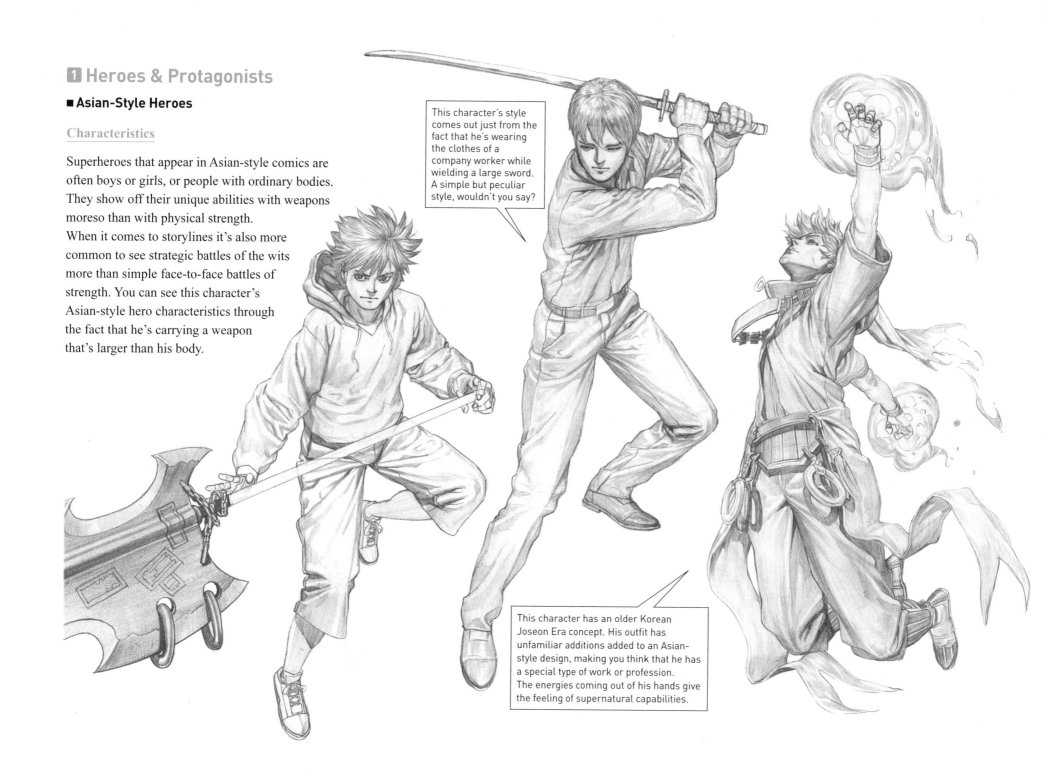

1 Heroes & Protagonists

■ Asian-Style Heroes

Characteristics

Superheroes that appear in Asian-style comics are often boys or girls, or people with ordinary bodies. They show off their unique abilities with weapons moreso than with physical strength.

When it comes to storylines it's also more common to see strategic battles of the wits more than simple face-to-face battles of strength. You can see this character's Asian-style hero characteristics through the fact that he's carrying a weapon that's larger than his body.

This character's style comes out just from the fact that he's wearing the clothes of a company worker while wielding a large sword. A simple but peculiar style, wouldn't you say?

This character has an older Korean Joseon Era concept. His outfit has unfamiliar additions added to an Asian-style design, making you think that he has a special type of work or profession. The energies coming out of his hands give the feeling of supernatural capabilities.

■ Western-Style Heroes

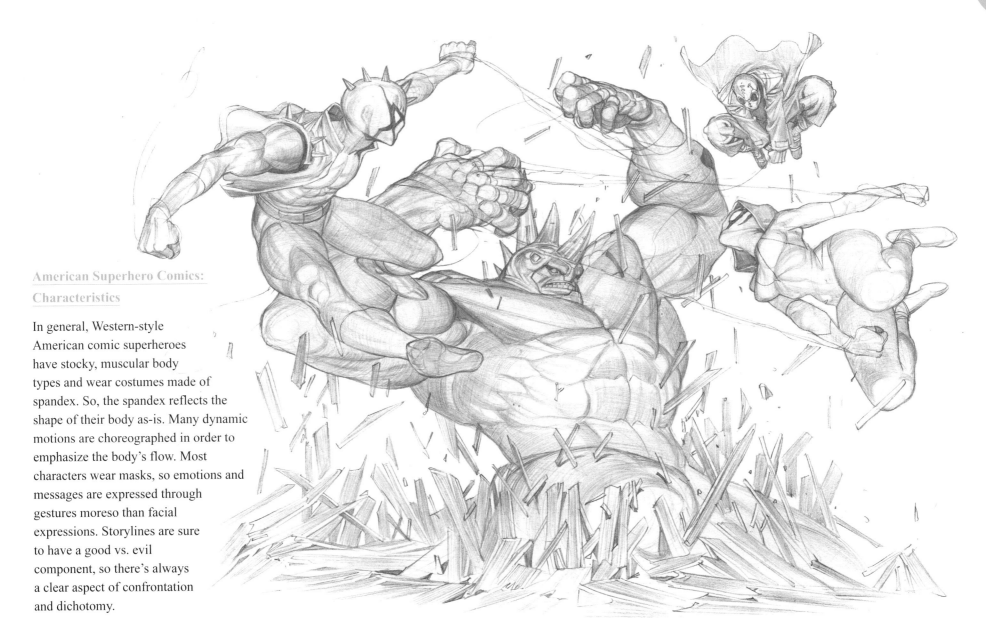

American Superhero Comics: Characteristics

In general, Western-style American comic superheroes have stocky, muscular body types and wear costumes made of spandex. So, the spandex reflects the shape of their body as-is. Many dynamic motions are choreographed in order to emphasize the body's flow. Most characters wear masks, so emotions and messages are expressed through gestures moreso than facial expressions. Storylines are sure to have a good vs. evil component, so there's always a clear aspect of confrontation and dichotomy.

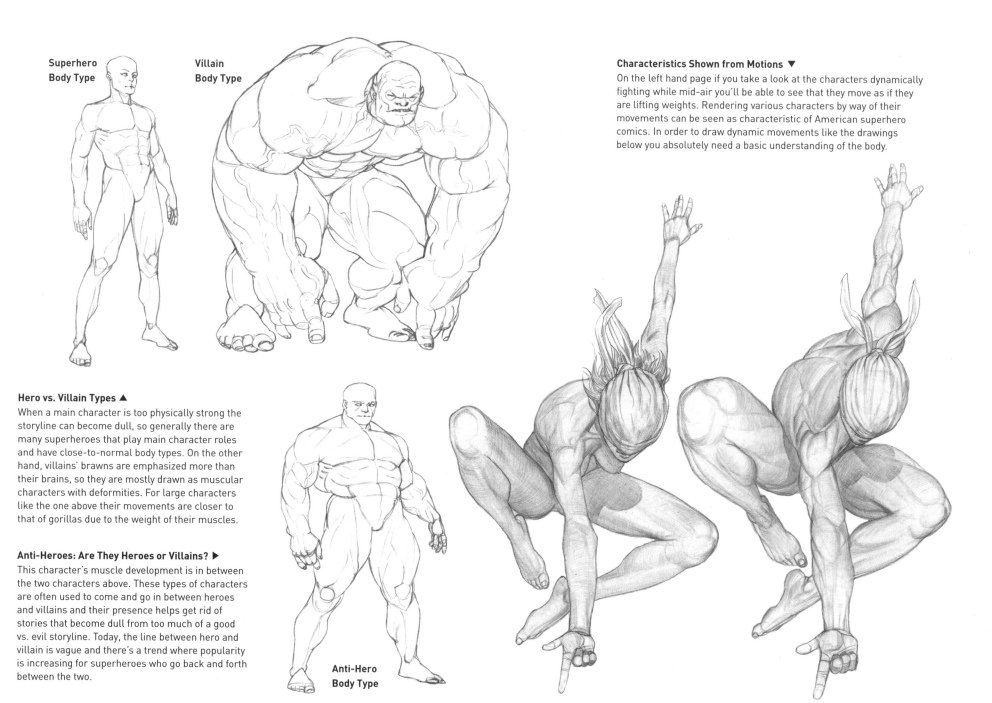

Superhero Body Type

Villain Body Type

Anti-Hero Body Type

Hero vs. Villain Types ▲

When a main character is too physically strong the storyline can become dull, so generally there are many superheroes that play main character roles and have close-to-normal body types. On the other hand, villains' brawns are emphasized more than their brains, so they are mostly drawn as muscular characters with deformities. For large characters like the one above their movements are closer to that of gorillas due to the weight of their muscles.

Anti-Heroes: Are They Heroes or Villains? ▶

This character's muscle development is in between the two characters above. These types of characters are often used to come and go in between heroes and villains and their presence helps get rid of stories that become dull from too much of a good vs. evil storyline. Today, the line between hero and villain is vague and there's a trend where popularity is increasing for superheroes who go back and forth between the two.

Characteristics Shown from Motions ▼

On the left hand page if you take a look at the characters dynamically fighting while mid-air you'll be able to see that they move as if they are lifting weights. Rendering various characters by way of their movements can be seen as characteristic of American superhero comics. In order to draw dynamic movements like the drawings below you absolutely need a basic understanding of the body.

Retired Hero Concept

This character has self-healing capabilities. He has lived several times longer than a normal person and he manages the heaviness of life with alcohol. The character is splayed out on a chair that's old and worn-out like he is, so his posture gives the impression that he's given up on life. The numerous scars and tattoos on his body tell how arduous his past life was. I rendered his facial expression for you to see how tough he was in his younger years.

Tommy decided to try method acting...

Between the chair and the person, which should you draw first? You must draw the chair first, which is bigger than the person. Simply put, it's because a person can't sit when there's no chair to sit on. With the chair you can know the spacing and you can use factors such as the angle of the back of the chair or the space between the armrests as a basis for establishing the man's posture.

Vanishing Point #1 — Eye-level — Vanishing Point #2

▲ Establishing Space
Even if you draw just one person or point, it's important to draw the line of perspective by establishing eye-level. When you draw one chair like in this drawing it's necessary to have perspective.

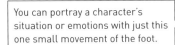

You can portray a character's situation or emotions with just this one small movement of the foot.

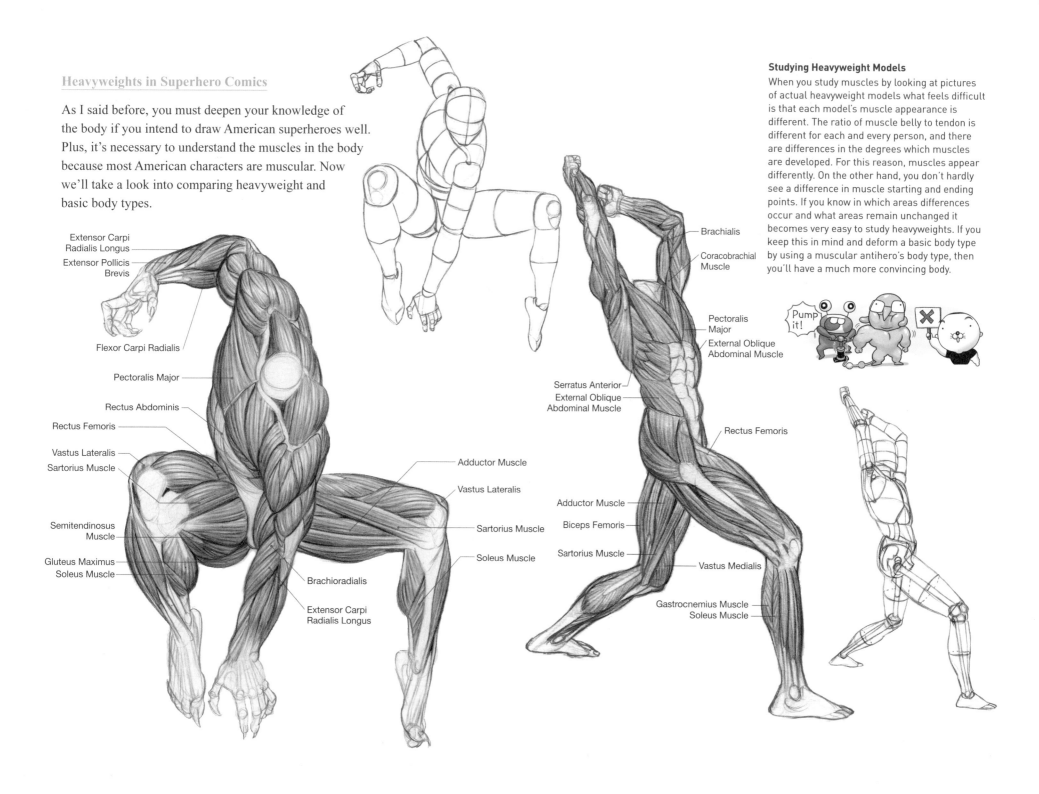

Heavyweights in Superhero Comics

As I said before, you must deepen your knowledge of the body if you intend to draw American superheroes well. Plus, it's necessary to understand the muscles in the body because most American characters are muscular. Now we'll take a look into comparing heavyweight and basic body types.

Extensor Carpi Radialis Longus

Extensor Pollicis Brevis

Flexor Carpi Radialis

Pectoralis Major

Rectus Abdominis

Rectus Femoris

Vastus Lateralis

Sartorius Muscle

Semitendinosus Muscle

Gluteus Maximus
Soleus Muscle

Brachioradialis

Extensor Carpi Radialis Longus

Adductor Muscle

Vastus Lateralis

Sartorius Muscle

Soleus Muscle

Brachialis

Coracobrachial Muscle

Pectoralis Major

External Oblique Abdominal Muscle

Serratus Anterior
External Oblique Abdominal Muscle

Rectus Femoris

Adductor Muscle

Biceps Femoris

Sartorius Muscle

Vastus Medialis

Gastrocnemius Muscle
Soleus Muscle

Studying Heavyweight Models

When you study muscles by looking at pictures of actual heavyweight models what feels difficult is that each model's muscle appearance is different. The ratio of muscle belly to tendon is different for each and every person, and there are differences in the degrees which muscles are developed. For this reason, muscles appear differently. On the other hand, you don't hardly see a difference in muscle starting and ending points. If you know in which areas differences occur and what areas remain unchanged it becomes very easy to study heavyweights. If you keep this in mind and deform a basic body type by using a muscular antihero's body type, then you'll have a much more convincing body.

Pump it!

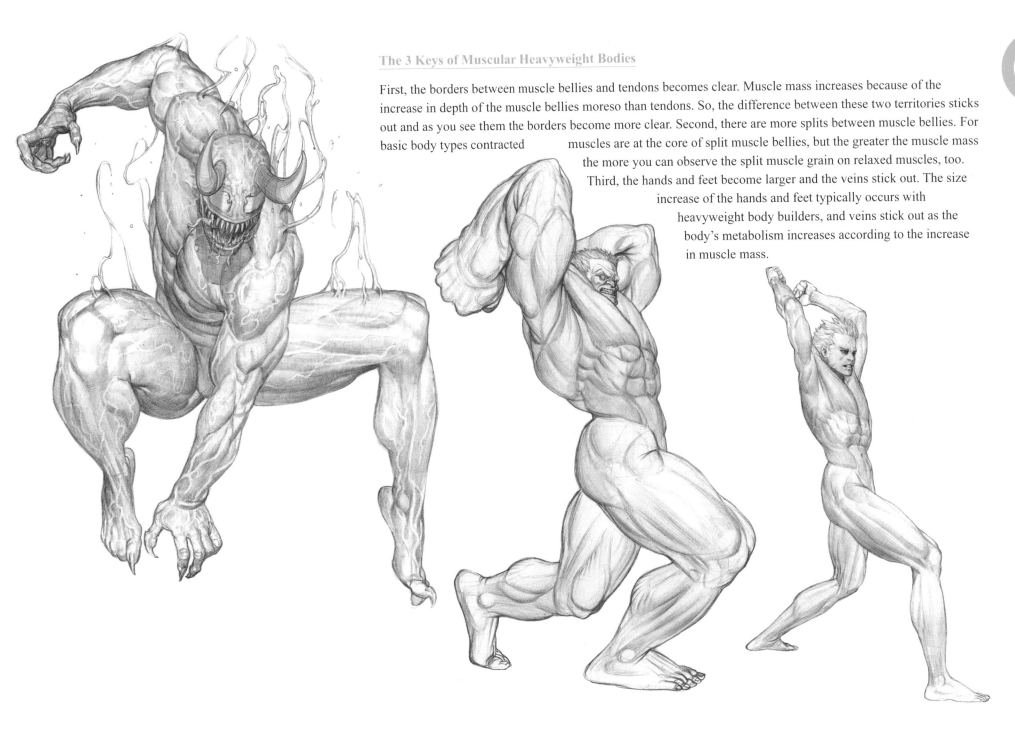

The 3 Keys of Muscular Heavyweight Bodies

First, the borders between muscle bellies and tendons becomes clear. Muscle mass increases because of the increase in depth of the muscle bellies moreso than tendons. So, the difference between these two territories sticks out and as you see them the borders become more clear. Second, there are more splits between muscle bellies. For basic body types contracted muscles are at the core of split muscle bellies, but the greater the muscle mass the more you can observe the split muscle grain on relaxed muscles, too. Third, the hands and feet become larger and the veins stick out. The size increase of the hands and feet typically occurs with heavyweight body builders, and veins stick out as the body's metabolism increases according to the increase in muscle mass.

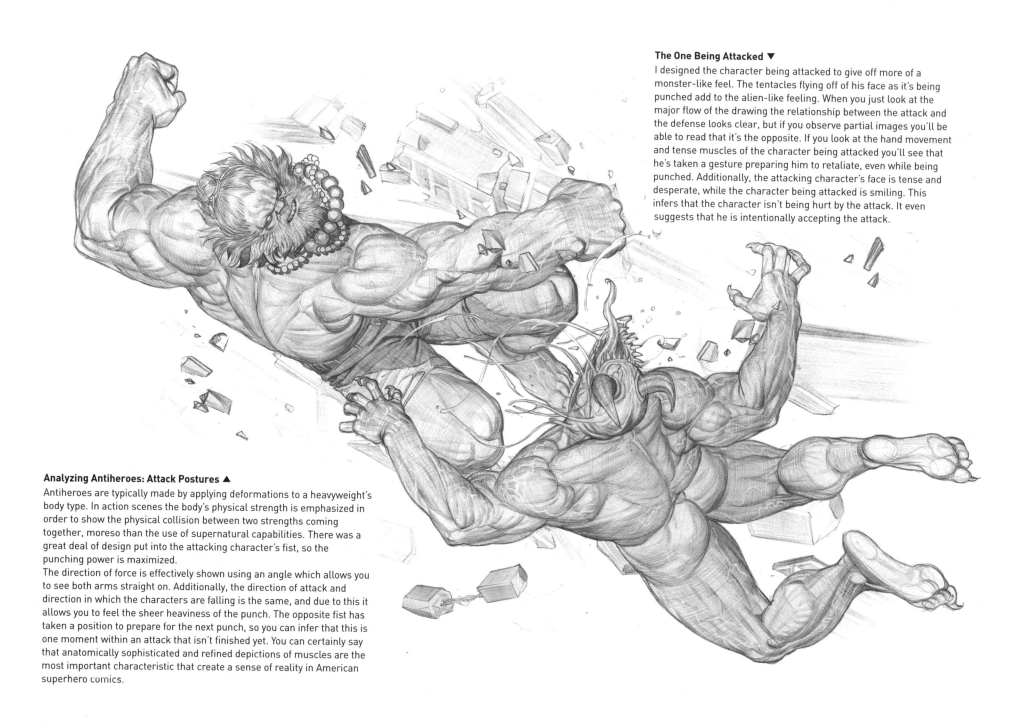

The One Being Attacked ▼

I designed the character being attacked to give off more of a monster-like feel. The tentacles flying off of his face as it's being punched add to the alien-like feeling. When you just look at the major flow of the drawing the relationship between the attack and the defense looks clear, but if you observe partial images you'll be able to read that it's the opposite. If you look at the hand movement and tense muscles of the character being attacked you'll see that he's taken a gesture preparing him to retaliate, even while being punched. Additionally, the attacking character's face is tense and desperate, while the character being attacked is smiling. This infers that the character isn't being hurt by the attack. It even suggests that he is intentionally accepting the attack.

Analyzing Antiheroes: Attack Postures ▲

Antiheroes are typically made by applying deformations to a heavyweight's body type. In action scenes the body's physical strength is emphasized in order to show the physical collision between two strengths coming together, moreso than the use of supernatural capabilities. There was a great deal of design put into the attacking character's fist, so the punching power is maximized.

The direction of force is effectively shown using an angle which allows you to see both arms straight on. Additionally, the direction of attack and direction in which the characters are falling is the same, and due to this it allows you to feel the sheer heaviness of the punch. The opposite fist has taken a position to prepare for the next punch, so you can infer that this is one moment within an attack that isn't finished yet. You can certainly say that anatomically sophisticated and refined depictions of muscles are the most important characteristic that create a sense of reality in American superhero comics.

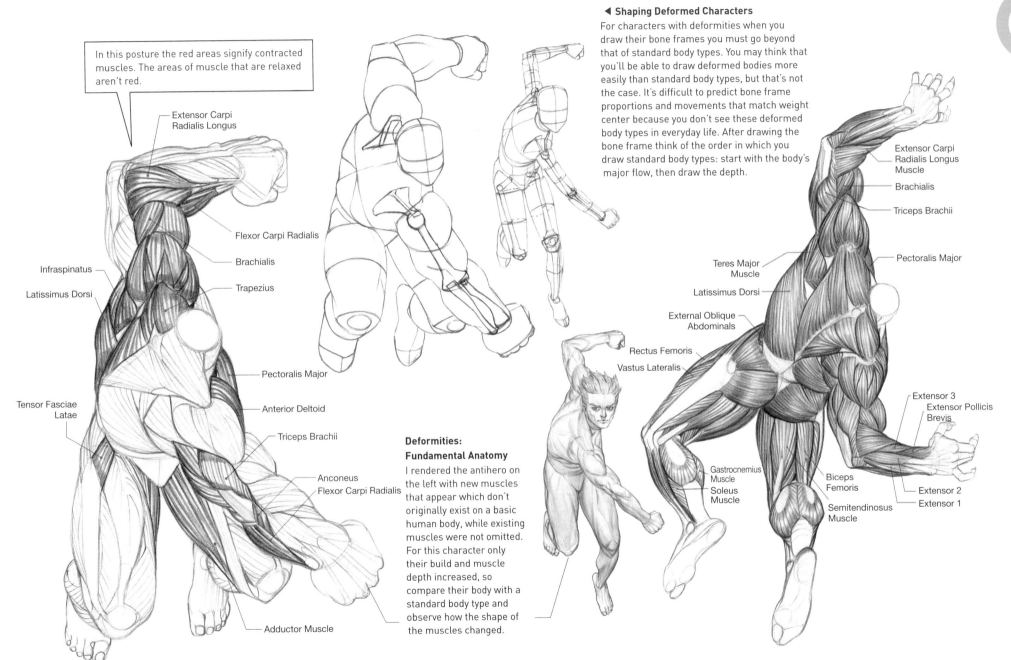

In this posture the red areas signify contracted muscles. The areas of muscle that are relaxed aren't red.

Extensor Carpi Radialis Longus

Flexor Carpi Radialis

Brachialis

Infraspinatus

Latissimus Dorsi

Trapezius

Tensor Fasciae Latae

Pectoralis Major

Anterior Deltoid

Triceps Brachii

Anconeus
Flexor Carpi Radialis

Adductor Muscle

◀ Shaping Deformed Characters

For characters with deformities when you draw their bone frames you must go beyond that of standard body types. You may think that you'll be able to draw deformed bodies more easily than standard body types, but that's not the case. It's difficult to predict bone frame proportions and movements that match weight center because you don't see these deformed body types in everyday life. After drawing the bone frame think of the order in which you draw standard body types: start with the body's major flow, then draw the depth.

Deformities:
Fundamental Anatomy

I rendered the antihero on the left with new muscles that appear which don't originally exist on a basic human body, while existing muscles were not omitted. For this character only their build and muscle depth increased, so compare their body with a standard body type and observe how the shape of the muscles changed.

Extensor Carpi Radialis Longus Muscle

Brachialis

Triceps Brachii

Pectoralis Major

Teres Major Muscle

Latissimus Dorsi

External Oblique Abdominals

Rectus Femoris

Vastus Lateralis

Extensor 3
Extensor Pollicis Brevis

Gastrocnemius Muscle
Soleus Muscle

Biceps Femoris

Extensor 2
Extensor 1

Semitendinosus Muscle

■ Villains

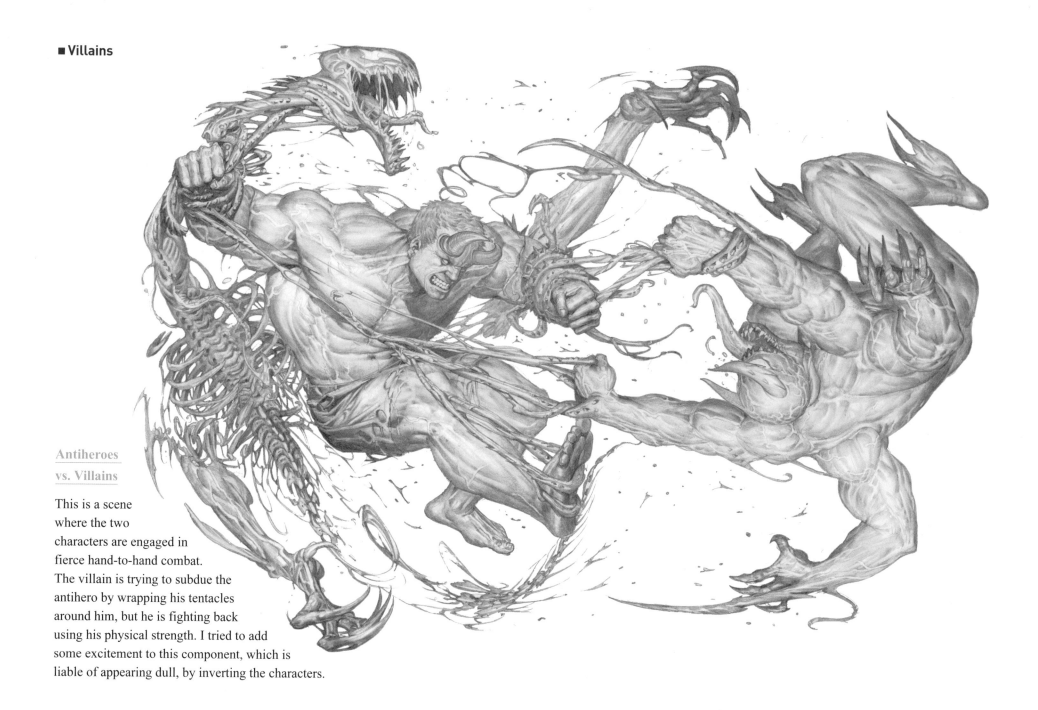

Antiheroes
vs. Villains

This is a scene
where the two
characters are engaged in
fierce hand-to-hand combat.
The villain is trying to subdue the
antihero by wrapping his tentacles
around him, but he is fighting back
using his physical strength. I tried to add
some excitement to this component, which is
liable of appearing dull, by inverting the characters.

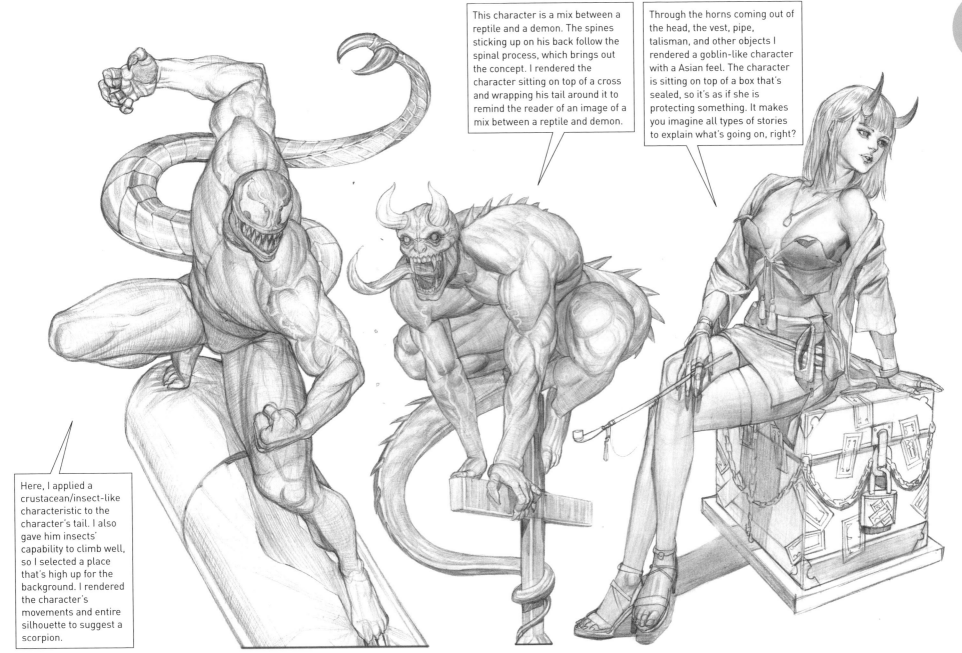

This character is a mix between a reptile and a demon. The spines sticking up on his back follow the spinal process, which brings out the concept. I rendered the character sitting on top of a cross and wrapping his tail around it to remind the reader of an image of a mix between a reptile and demon.

Through the horns coming out of the head, the vest, pipe, talisman, and other objects I rendered a goblin-like character with a Asian feel. The character is sitting on top of a box that's sealed, so it's as if she is protecting something. It makes you imagine all types of stories to explain what's going on, right?

Here, I applied a crustacean/insect-like characteristic to the character's tail. I also gave him insects' capability to climb well, so I selected a place that's high up for the background. I rendered the character's movements and entire silhouette to suggest a scorpion.

2 Fantasy Characters

■ Beasts

Beasts are a mixture of human together with animal tails, wings, legs, or other body parts. They originated in Eastern and Western mythology and are often utilized in fantasy books or games. You must support characters with anatomical knowledge of animals in order to create a convincing character.

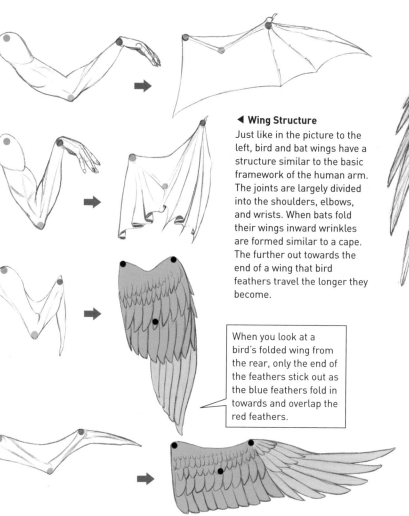

◄ Wing Structure
Just like in the picture to the left, bird and bat wings have a structure similar to the basic framework of the human arm. The joints are largely divided into the shoulders, elbows, and wrists. When bats fold their wings inward wrinkles are formed similar to a cape. The further out towards the end of a wing that bird feathers travel the longer they become.

When you look at a bird's folded wing from the rear, only the end of the feathers stick out as the blue feathers fold in towards and overlap the red feathers.

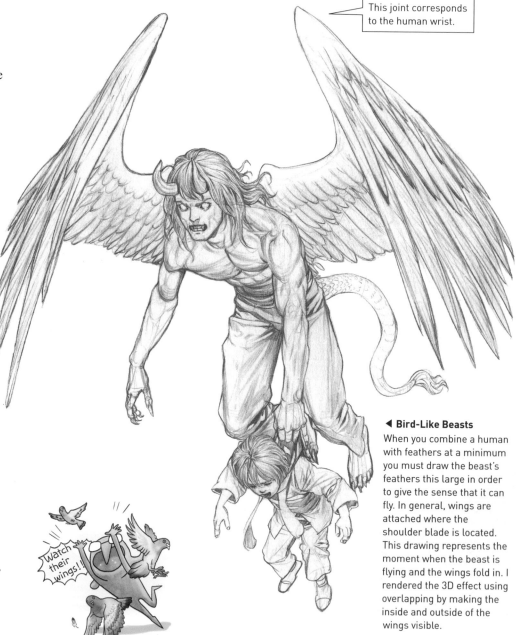

This joint corresponds to the human wrist.

◄ Bird-Like Beasts
When you combine a human with feathers at a minimum you must draw the beast's feathers this large in order to give the sense that it can fly. In general, wings are attached where the shoulder blade is located. This drawing represents the moment when the beast is flying and the wings fold in. I rendered the 3D effect using overlapping by making the inside and outside of the wings visible.

Watch their wings!!

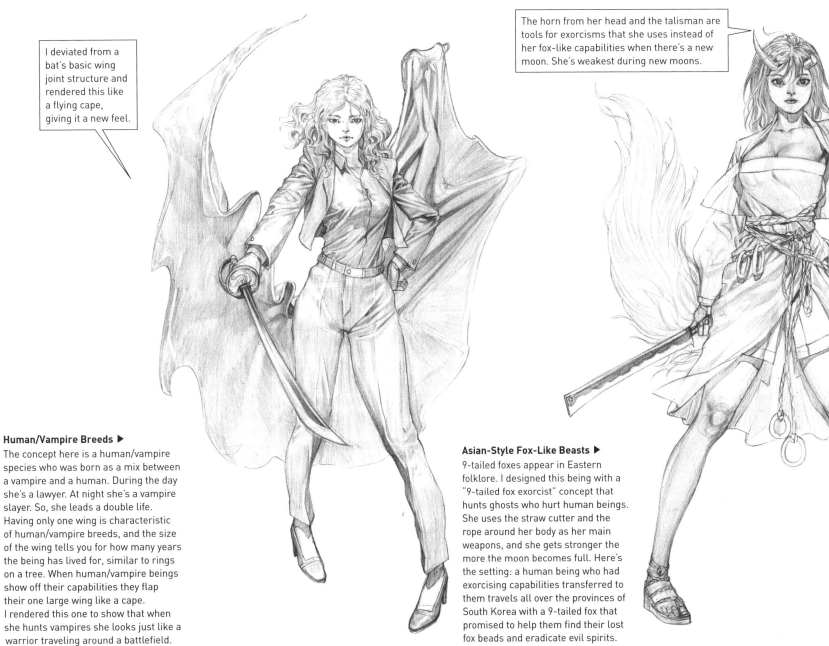

I deviated from a bat's basic wing joint structure and rendered this like a flying cape, giving it a new feel.

The horn from her head and the talisman are tools for exorcisms that she uses instead of her fox-like capabilities when there's a new moon. She's weakest during new moons.

Human/Vampire Breeds ▶
The concept here is a human/vampire species who was born as a mix between a vampire and a human. During the day she's a lawyer. At night she's a vampire slayer. So, she leads a double life. Having only one wing is characteristic of human/vampire breeds, and the size of the wing tells you for how many years the being has lived for, similar to rings on a tree. When human/vampire beings show off their capabilities they flap their one large wing like a cape. I rendered this one to show that when she hunts vampires she looks just like a warrior traveling around a battlefield.

Asian-Style Fox-Like Beasts ▶
9-tailed foxes appear in Eastern folklore. I designed this being with a "9-tailed fox exorcist" concept that hunts ghosts who hurt human beings. She uses the straw cutter and the rope around her body as her main weapons, and she gets stronger the more the moon becomes full. Here's the setting: a human being who had exorcising capabilities transferred to them travels all over the provinces of South Korea with a 9-tailed fox that promised to help them find their lost fox beads and eradicate evil spirits.

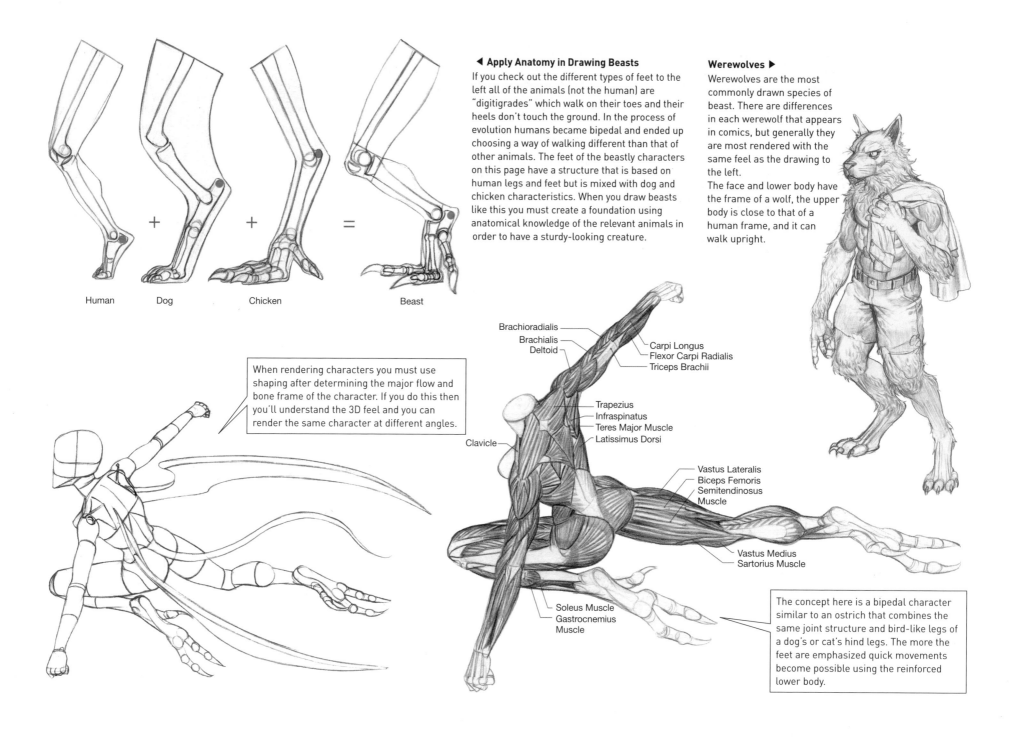

◄ Apply Anatomy in Drawing Beasts

If you check out the different types of feet to the left all of the animals (not the human) are "digitigrades" which walk on their toes and their heels don't touch the ground. In the process of evolution humans became bipedal and ended up choosing a way of walking different than that of other animals. The feet of the beastly characters on this page have a structure that is based on human legs and feet but is mixed with dog and chicken characteristics. When you draw beasts like this you must create a foundation using anatomical knowledge of the relevant animals in order to have a sturdy-looking creature.

Werewolves ▶

Werewolves are the most commonly drawn species of beast. There are differences in each werewolf that appears in comics, but generally they are most rendered with the same feel as the drawing to the left.
The face and lower body have the frame of a wolf, the upper body is close to that of a human frame, and it can walk upright.

Human + Dog + Chicken = Beast

When rendering characters you must use shaping after determining the major flow and bone frame of the character. If you do this then you'll understand the 3D feel and you can render the same character at different angles.

Brachioradialis
Brachialis
Deltoid
Carpi Longus
Flexor Carpi Radialis
Triceps Brachii

Trapezius
Infraspinatus
Teres Major Muscle
Latissimus Dorsi

Clavicle

Vastus Lateralis
Biceps Femoris
Semitendinosus Muscle

Vastus Medius
Sartorius Muscle

Soleus Muscle
Gastrocnemius Muscle

The concept here is a bipedal character similar to an ostrich that combines the same joint structure and bird-like legs of a dog's or cat's hind legs. The more the feet are emphasized quick movements become possible using the reinforced lower body.

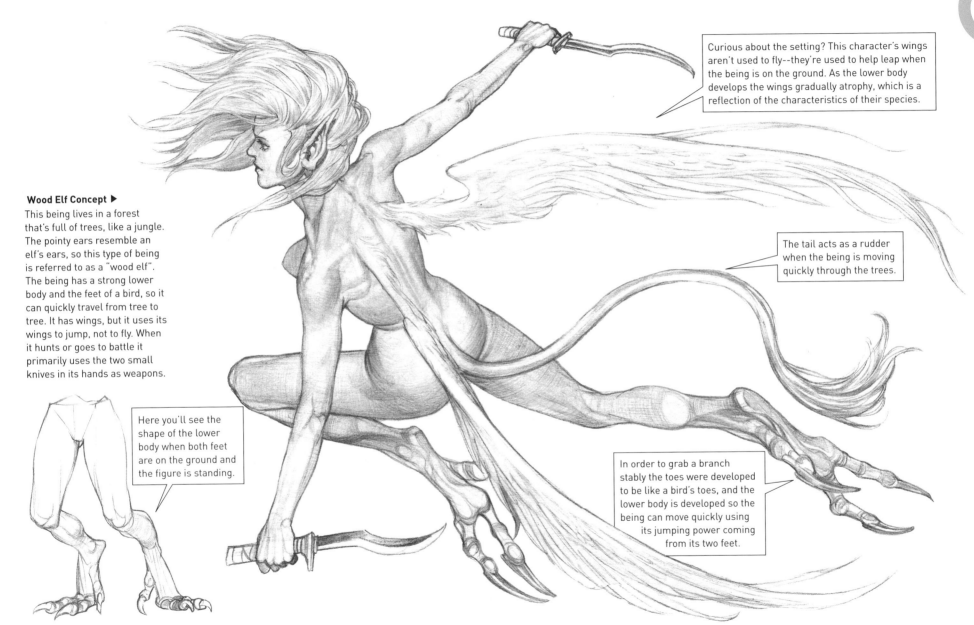

Curious about the setting? This character's wings aren't used to fly--they're used to help leap when the being is on the ground. As the lower body develops the wings gradually atrophy, which is a reflection of the characteristics of their species.

The tail acts as a rudder when the being is moving quickly through the trees.

Wood Elf Concept ▶

This being lives in a forest that's full of trees, like a jungle. The pointy ears resemble an elf's ears, so this type of being is referred to as a "wood elf". The being has a strong lower body and the feet of a bird, so it can quickly travel from tree to tree. It has wings, but it uses its wings to jump, not to fly. When it hunts or goes to battle it primarily uses the two small knives in its hands as weapons.

Here you'll see the shape of the lower body when both feet are on the ground and the figure is standing.

In order to grab a branch stably the toes were developed to be like a bird's toes, and the lower body is developed so the being can move quickly using its jumping power coming from its two feet.

■ Humans

◀ **The Human World**

Of all the species in the world humans are the weakest physically. Using a high level of intelligence as a foundation human beings manufactured weapons and formed societies, thus supplementing a weak physique. Humans developed the technique of manipulating steel to protect the body with steel weapons and armor, and with strong cohesion humans are able to win many battles against other species. So, humans possess the greatest amount of territory. Soldiers in human society, which fall into a class structure, are given armor based on the family from which they come and their rank. Human nations are formed with family at the core. For this reason, war between families occurs more often than war between different species, while society is entering into decline.

> This is a design for a villain starting a war against all the other species, breaking the peace treaty in the midst of the downfall of human beings.

Basic Armor Structure

If you think of the process of putting armor on it'll help you understand armor form. The armor is structured in a way to cover the front and back of the body and is inserted on the arms and legs, so in order to move parts are divided among the joints. The armpits have cracks that appear in accordance with the movement of the arms, so it's an area that can easily be attacked. For this reason a disk is used to patch that area. Using this basic structure the different faces are split and various factors are added, so several types of forms are developed. In general armor form is symmetrical, so the ability to understand three dimensional aspects through shaping is particularly necessary.

Shoulder

Body

Arm

Leg

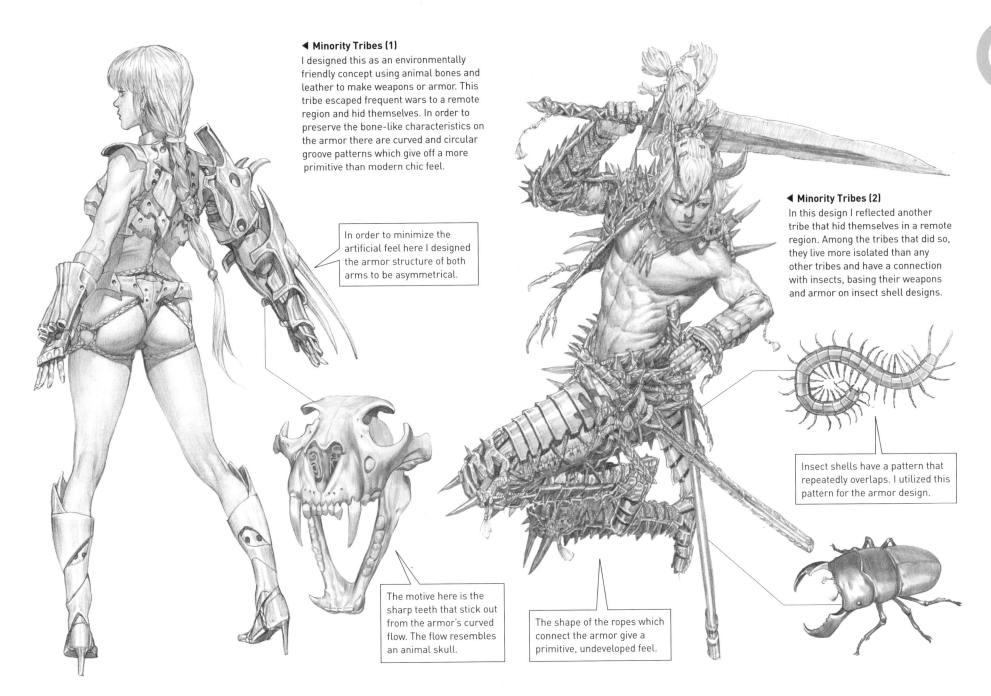

◀ Minority Tribes (1)
I designed this as an environmentally friendly concept using animal bones and leather to make weapons or armor. This tribe escaped frequent wars to a remote region and hid themselves. In order to preserve the bone-like characteristics on the armor there are curved and circular groove patterns which give off a more primitive than modern chic feel.

In order to minimize the artificial feel here I designed the armor structure of both arms to be asymmetrical.

The motive here is the sharp teeth that stick out from the armor's curved flow. The flow resembles an animal skull.

◀ Minority Tribes (2)
In this design I reflected another tribe that hid themselves in a remote region. Among the tribes that did so, they live more isolated than any other tribes and have a connection with insects, basing their weapons and armor on insect shell designs.

Insect shells have a pattern that repeatedly overlaps. I utilized this pattern for the armor design.

The shape of the ropes which connect the armor give a primitive, undeveloped feel.

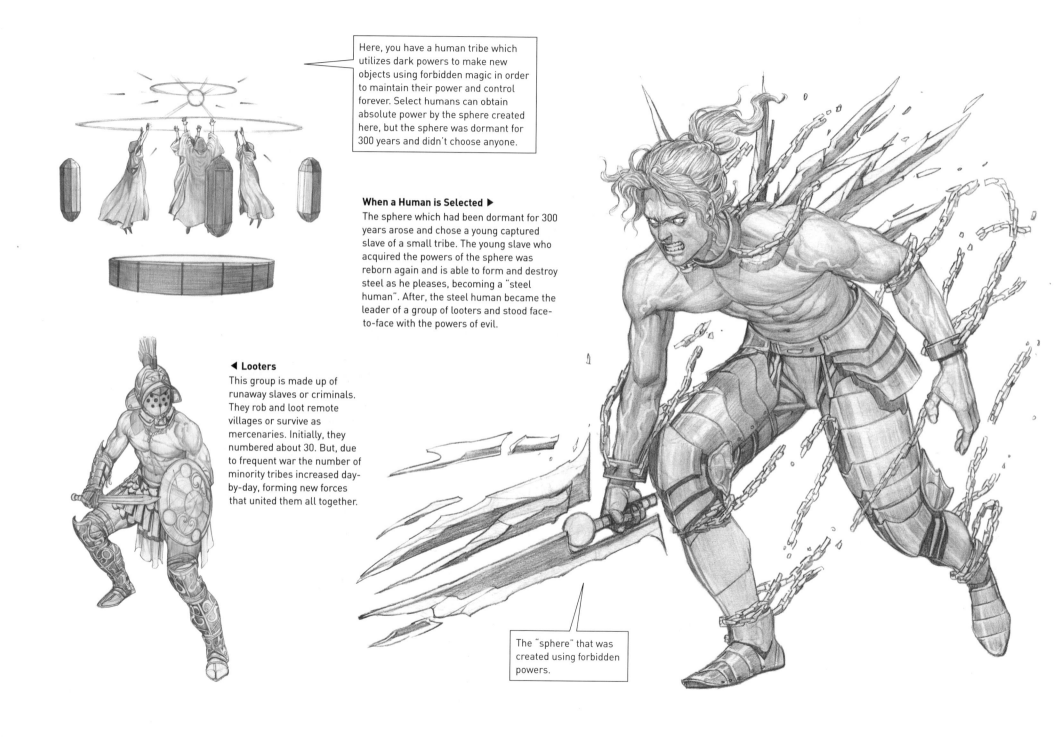

Here, you have a human tribe which utilizes dark powers to make new objects using forbidden magic in order to maintain their power and control forever. Select humans can obtain absolute power by the sphere created here, but the sphere was dormant for 300 years and didn't choose anyone.

When a Human is Selected ▶
The sphere which had been dormant for 300 years arose and chose a young captured slave of a small tribe. The young slave who acquired the powers of the sphere was reborn again and is able to form and destroy steel as he pleases, becoming a "steel human". After, the steel human became the leader of a group of looters and stood face-to-face with the powers of evil.

◀ Looters
This group is made up of runaway slaves or criminals. They rob and loot remote villages or survive as mercenaries. Initially, they numbered about 30. But, due to frequent war the number of minority tribes increased day-by-day, forming new forces that united them all together.

The "sphere" that was created using forbidden powers.

■ Orcs

The "Orc" Concept

Orcs are a very dangerous type developed solely for war. They primarily use war hammers fitting for their large bodies to inflict major damage. Their armor is heavy, so they don't use basic rope to affix it, but rather chains. They treat horns of animals they've hunted as spoils and like using them to decorate their armor with. Most orcs have low levels of intelligence and are very aggressive, but this character is the leader of a group of them. With level-headed judgment, this character possesses the strategic capability to map out high-level strategies and has the disposition of a tribe leader. Additionally, even though he is very strong, he practices principles where doesn't engage in unnecessary battles or looting.

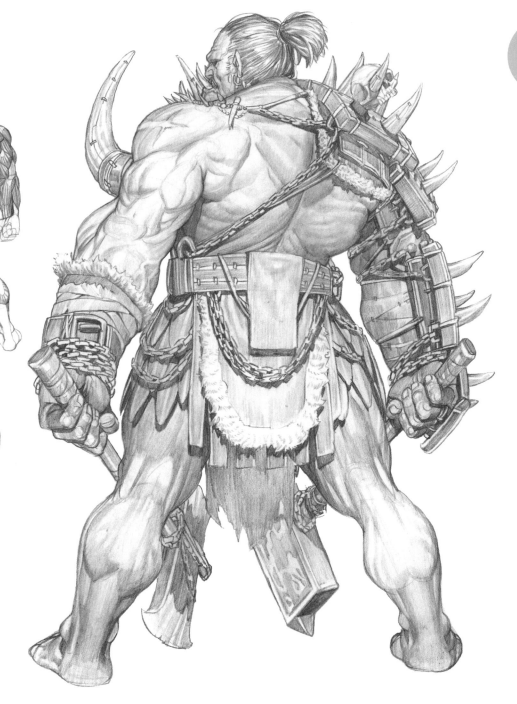

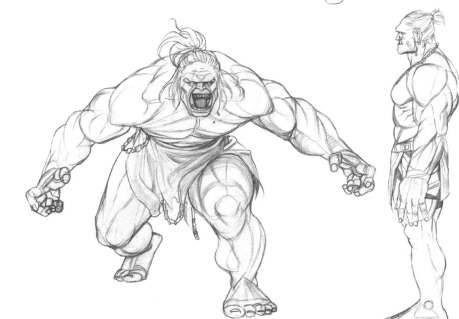

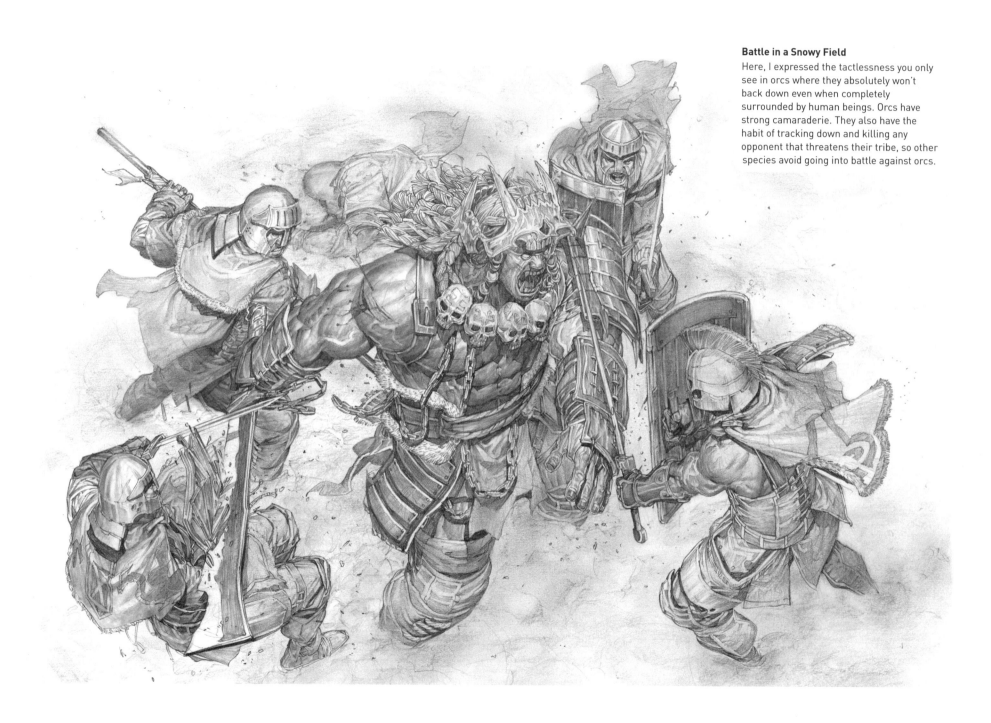

Battle in a Snowy Field
Here, I expressed the tactlessness you only see in orcs where they absolutely won't back down even when completely surrounded by human beings. Orcs have strong camaraderie. They also have the habit of tracking down and killing any opponent that threatens their tribe, so other species avoid going into battle against orcs.

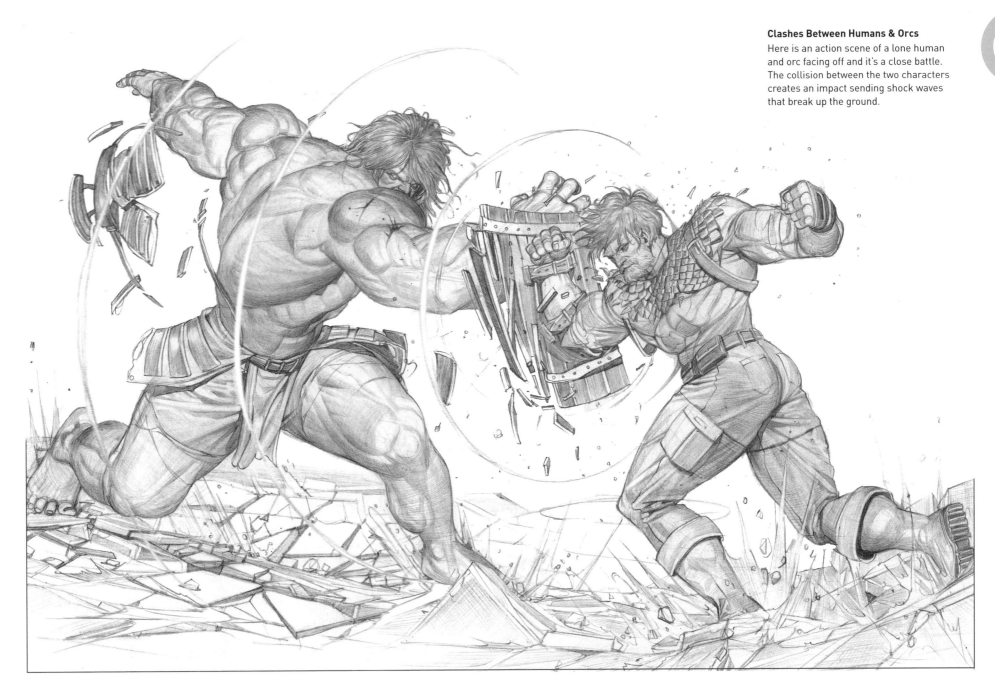

Clashes Between Humans & Orcs
Here is an action scene of a lone human and orc facing off and it's a close battle. The collision between the two characters creates an impact sending shock waves that break up the ground.

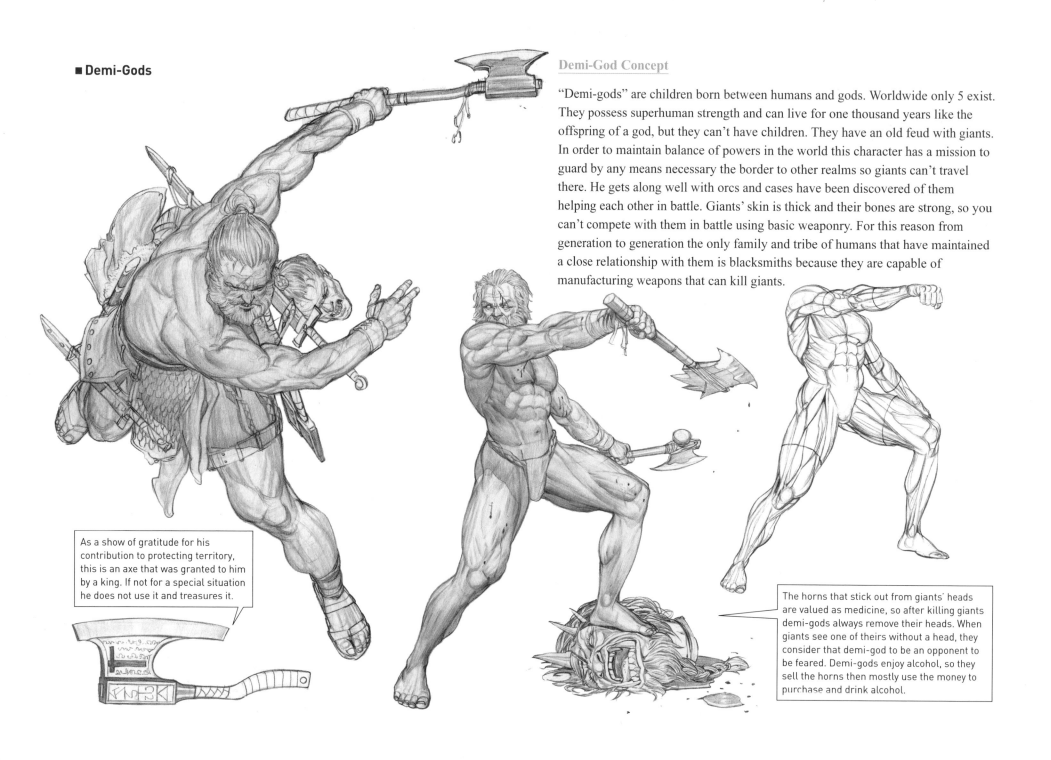

■ Demi-Gods

Demi-God Concept

"Demi-gods" are children born between humans and gods. Worldwide only 5 exist. They possess superhuman strength and can live for one thousand years like the offspring of a god, but they can't have children. They have an old feud with giants. In order to maintain balance of powers in the world this character has a mission to guard by any means necessary the border to other realms so giants can't travel there. He gets along well with orcs and cases have been discovered of them helping each other in battle. Giants' skin is thick and their bones are strong, so you can't compete with them in battle using basic weaponry. For this reason from generation to generation the only family and tribe of humans that have maintained a close relationship with them is blacksmiths because they are capable of manufacturing weapons that can kill giants.

As a show of gratitude for his contribution to protecting territory, this is an axe that was granted to him by a king. If not for a special situation he does not use it and treasures it.

The horns that stick out from giants' heads are valued as medicine, so after killing giants demi-gods always remove their heads. When giants see one of theirs without a head, they consider that demi-god to be an opponent to be feared. Demi-gods enjoy alcohol, so they sell the horns then mostly use the money to purchase and drink alcohol.

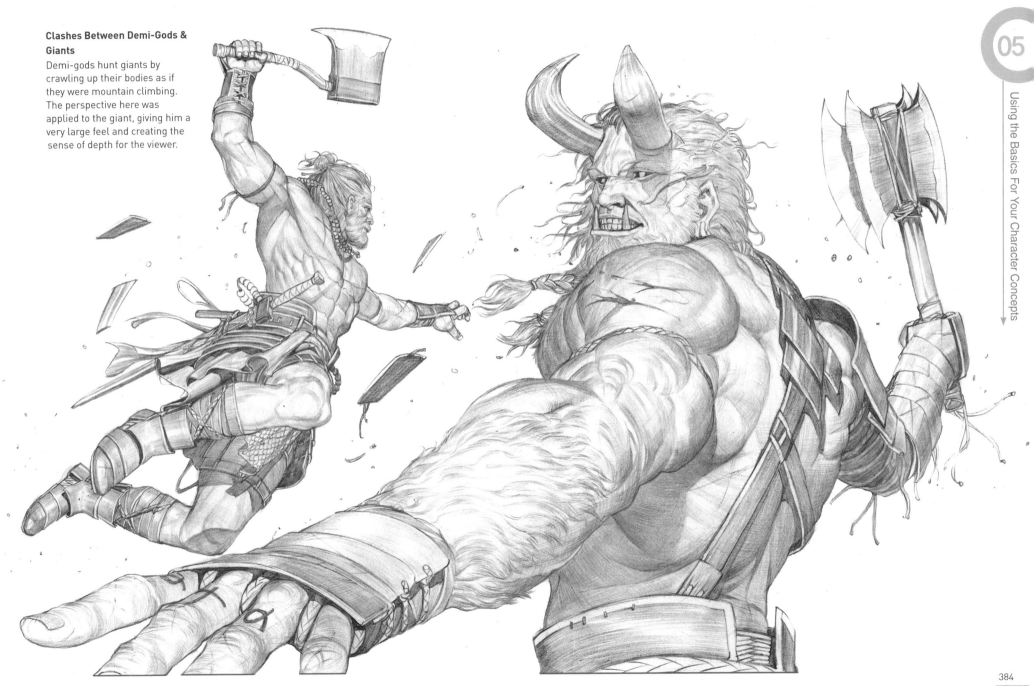

Clashes Between Demi-Gods & Giants

Demi-gods hunt giants by crawling up their bodies as if they were mountain climbing. The perspective here was applied to the giant, giving him a very large feel and creating the sense of depth for the viewer.

❸ Mechanical Characters

■ Mechanical Characters & Shaping

Mechanical characters are certainly a combination of shaping. When you shape human bodies and mechanical characters you segment large shapes into small shapes, so the method of drawing them is very similar. If, today, you have good shaping habits then you'll be able to render mechanical beings without difficulty. However, if you can't find the major flow of a mechanical being that has a complicated form it means that you lack a habit of being able to interpret forms using shaping.

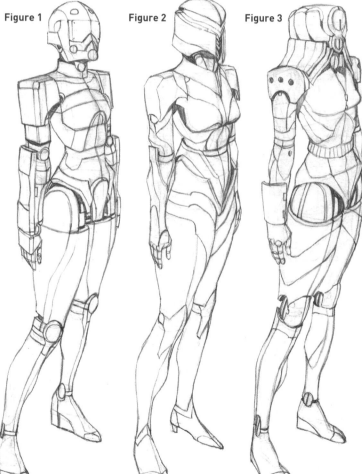

Figure 1 Figure 2 Figure 3

◀ Making Patterns

When designing mechanics rather than just splitting the sides it's better to find a few design concepts and then go from there. Figure 1 was drawn by making patterns out of the straight angles. Figure 2 was drawn by making patterns out of the curved flows. Figure 3 was drawn by minimizing the angled parts and turning the smooth curves into the figure's major flow. It's in this way that you must select a few patterns and then draw in order for your unified, refined design to come out.

The Concept ▶

Here, I depicted the process of the assembly of an android within a large, capsule-like machine. In order to preserve the futuristic feel I streamlined the flow of the structure.
Additionally, in order to avoid having the design be too consistent I intersected the complicated and simple portions and gave more dynamism to the flow. The part where the chest opens and you're able to see the inside of the android was designed similar to how the organs actually look, and I made some particularly diverse patterns.

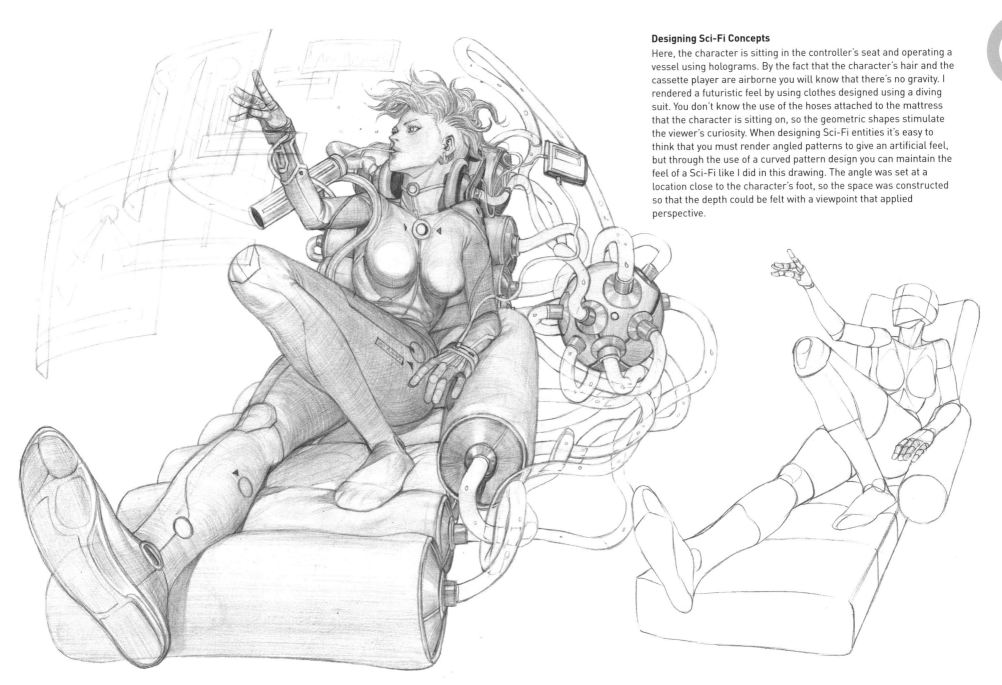

Designing Sci-Fi Concepts

Here, the character is sitting in the controller's seat and operating a vessel using holograms. By the fact that the character's hair and the cassette player are airborne you will know that there's no gravity. I rendered a futuristic feel by using clothes designed using a diving suit. You don't know the use of the hoses attached to the mattress that the character is sitting on, so the geometric shapes stimulate the viewer's curiosity. When designing Sci-Fi entities it's easy to think that you must render angled patterns to give an artificial feel, but through the use of a curved pattern design you can maintain the feel of a Sci-Fi like I did in this drawing. The angle was set at a location close to the character's foot, so the space was constructed so that the depth could be felt with a viewpoint that applied perspective.

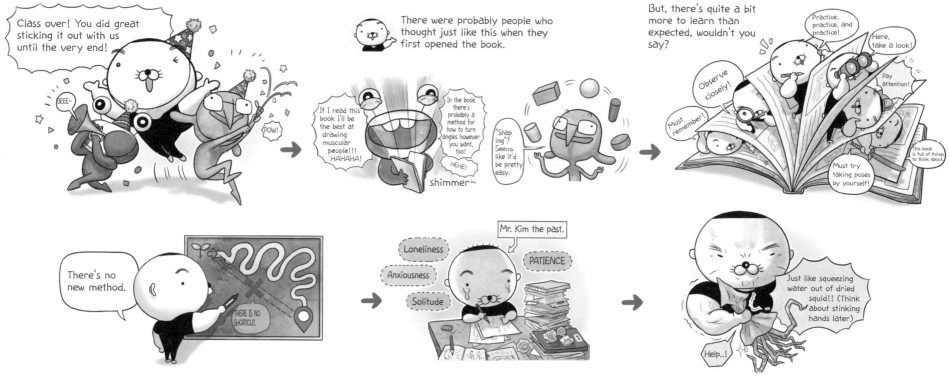

In order to draw the human body well using this book I want to let you know that there's no other way but to understand structure and principles.

And if you want to apply what you learned to your drawings then you must spend many hours practicing.

It's only by doing this that when you draw you'll develop the hardcore, pumped-up concentration.

Everyday you'll be surrounded by your eraser shavings.

Rather than saving all your practice drawings approach practice with an intent to get rid of them...

...then you'll certainly be approaching closer and closer to your goal.

It's That Time...

When you begin studying the human body if you don't set the precedence within yourself the fact that a great deal of time and effort are necessary to do it, then you'll ask questions like, "Why is this so difficult?", and "Why is this taking so long to get?". Then, your enthusiasm will slowly fade. It's hard enough to draw the human body while looking at an actual model, so it's only natural that creating a figure without using a model is difficult. If you get "drawer's block" you lay your pencil down and then start worrying about your abilities. I also had a time in life when I questioned my own abilities. I thought I lacked a natural talent in expressing sensuous feelings to me, so I only did my best to learn the basics.

But, even to this day every single moment spent drawing a human body feels difficult for me. The more I draw the easier it gets...? Absolutely not. Drawing is difficult for me every time. My wish would be for us all to not think of happiness as an easy drawing, but rather to make it a goal to enjoy the very moments in which you are completely engrossed in a drawing. I can't stop thinking about the drawings I made that are missing something and I'm dying to fix them, but I'm putting those feelings behind me and closing the book by acknowledging and thanking everyone who helped out.

Sanghee Park of Sang Company, who time and time again suffered to re-design all of the book's pages to match the drawings; artist Eunbi Yeom, who drew the adorable characters to look like star candy made from hardtack in this heavy book, and artist Jeonghyeon Seok, who connected me with SungAnDang Publishing Company. Every time I had writer's block I would fervently crack open *Stonehouse's Anatomy Note*. To everyone at SungAnDang Publishing Company who had patience with me when I was behind schedule and took into consideration and changed many things to go in the direction I wanted them to; Professor Kwanhyeon Yoon, who contributed an artist's imagination and raised the accuracy of the book even when there were parts that got past the professional illustrator's eyes, and Professor Hyeonse Lee, my hero, who from the bottom of his heart became a lighthouse to a lost seafarer for me and pushed me to achieve my dream: I will become a student who always devotes himself and allows these feelings of respect and gratitude for you all to become his driving force. Lastly, to the readers, I would like to thank you all for patiently waiting until the book was complete and reading through to the end. Thank you.

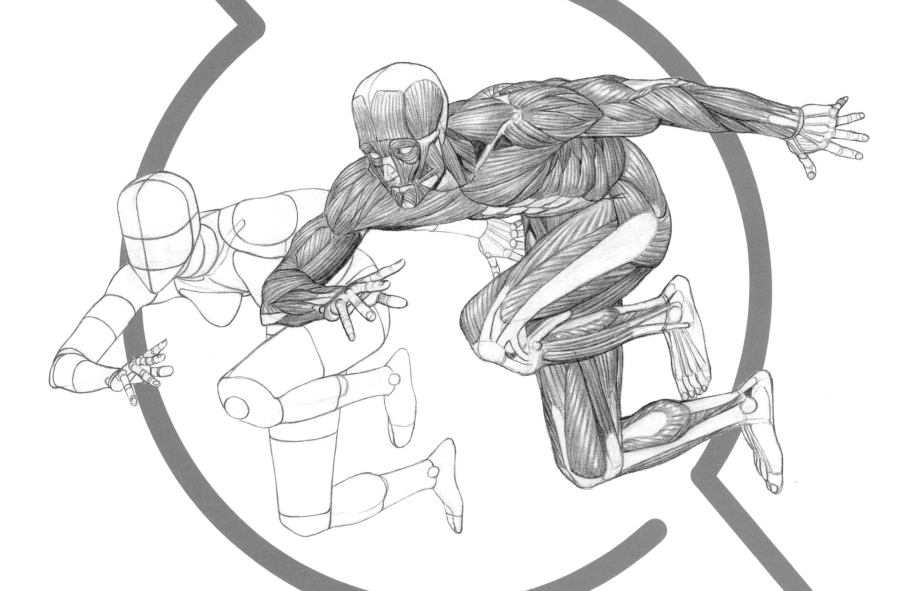

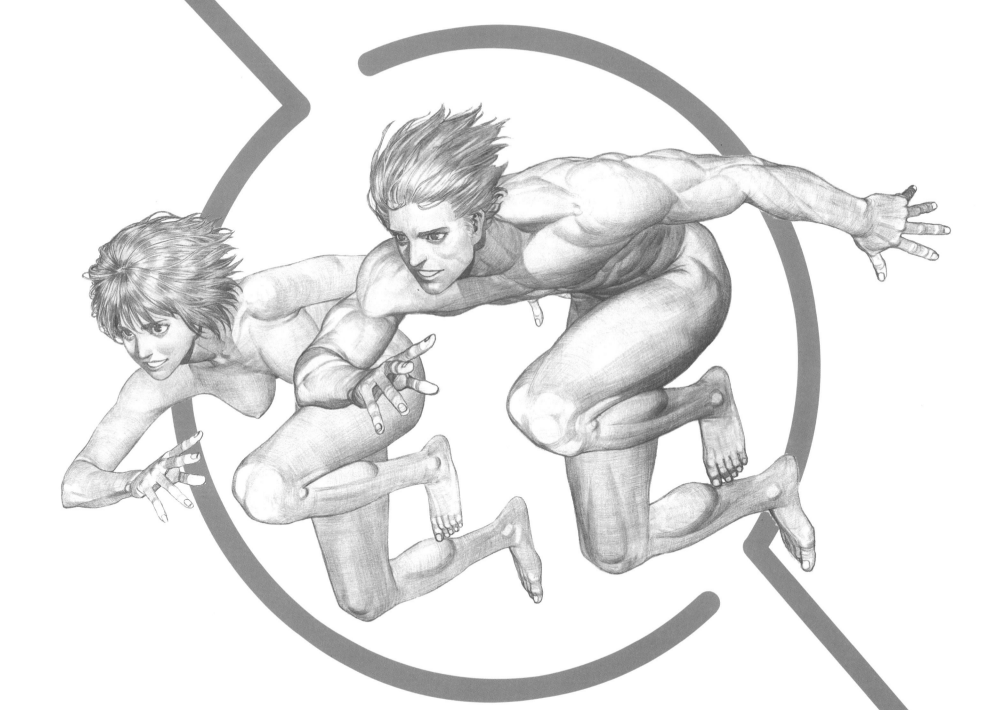

For sales or permission outside of the Republic of Korea, please contact
Joonwon Lee at jwlee@cyber.co.kr,
+82-2-3142-4151, or +82-10-4624-6629

Rockhe Kim's ANATOMY DRAWING CLASS

First Edition in 2023
Copyright © 2023 by SungAnDang

SungAnDang Publishing Company
04032 Cheomdan Building 3rd Fl., Yanghwa-ro 127, Mapo-gu, Seoul, Republic of Korea (TEL: +82-2-3142-0036)
10881 Moonbal-ro 112, Paju Book City, Paju, Gyeonggi-do, Republic of Korea (TEL: +82-31-950-6300, +82-31-955-0510)
For more information, visit www.cyber.co.kr

ISBN: 978-89-315-8617-6 (13600)
Price | USD 60.00

Author | Rockhe Kim
Translator | Robert Holloway
Proofreader | Marrwho Hasati
Character Illustration | Yeom Eunbi